Gustave Caillebotte

URBAN IMPRESSIONIST

This catalogue is presented as a
benefit of your membership. The exhibitions
and programs of the Los Angeles County
Museum of Art would not have been
possible without your support.

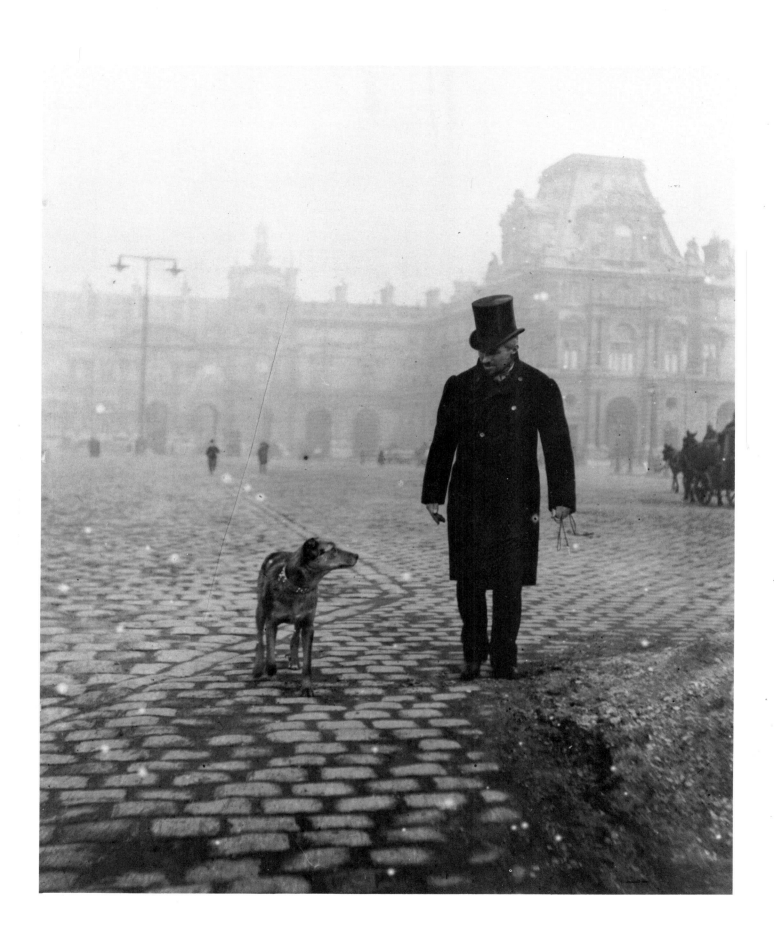

Gustave Caillebotte

URBAN IMPRESSIONIST

ANNE DISTEL

DOUGLAS W. DRUICK

GLORIA GROOM

RODOLPHE RAPETTI

WITH JULIA SAGRAVES
AND AN ESSAY BY
KIRK VARNEDOE

La Réunion des Musées Nationaux
Musée d'Orsay, Paris

The Art Institute of Chicago

WITH Abbeville Press Publishers
New York London Paris

This book was published in conjunction with the exhibition "Gustave Caillebotte: Urban Impressionist."

EXHIBITION DATES:
Galeries Nationales du Grand Palais, Paris
16 September 1994–9 January 1995

The Art Institute of Chicago
18 February–28 May 1995

Los Angeles County Museum of Art
22 June–10 September 1995

The exhibition and catalogue were made possible by Sara Lee Corporation. Additional support was provided by a grant from the National Endowment for the Arts. The exhibition has also received support in the form of an indemnity from the Federal Council on the Arts and Humanities. Travel assistance was generously provided by United Airlines. The presentation in Los Angeles was made possible by Cantor Fitzgerald in honor of its fiftieth anniversary.

SUSAN F. ROSSEN
Executive Director of Publications

KATHERINE HOUCK FREDRICKSON
Associate Director of Publications, Production

MANINE ROSA GOLDEN
Production Associate

TERRY ANN R. NEFF
Project Coordinator

ADAM JOLLES
Editor

CRIS LIGENZA
Editorial Secretary

JOHN GOODMAN
Translator

Designed by Betty Binns, Brooklyn, New York

Typeset by Angela Taormina, New York

Color separations by Bussière, Paris

Printed by Arnoldo Mondadori Editore, S.p.A., Verona, Italy

Front cover: *Paris Street; Rainy Day* (detail), 1877 (cat. 35).

Frontispiece: Martial Caillebotte. *Gustave Caillebotte and his dog Bergère on place du Carrousel,* Feb. 1892. Photograph. Private collection.

Back cover: *The Pont de l'Europe,* 1876 (cat. 29).

"Odd Man In: A Brief Historiography of Caillebotte's Changing Roles in the History of Art" by Kirk Varnedoe is copyright © Kirk Varnedoe, 1995.

Copyright © 1995
The Art Institute of Chicago

Hardcover edition published in 1995 with Abbeville Publishing Group, New York.

FIRST EDITION

10 9 8 7 6 5 4 3 2 1

Library of Congress Cataloging-in-Publication Data

Gustave Caillebotte, urban impressionist / Anne Distel . . . [et al.].
p. cm.
Exhibition catalog.
Includes bibliographical references (p –)
ISBN 0-86559-139-3 (softcover)
ISBN 0-7892-0041-4 (hardcover)

1. Caillebotte, Gustave, 1848–1894—Exhibitions. 2. Impressionism (Art)—France—Exhibitions. I. Distel, Anne.
ND553.C243A4 1995
759.4—dc20 94-34903

French edition: ISBN 2-7118-3047-0, published under the title *Gustave Caillebotte, 1848–1894.*

Curators of the Exhibition

ANNE DISTEL
Chief Curator at the Musée d'Orsay, Paris

DOUGLAS W. DRUICK
Searle Curator of European Painting
Prince Trust Curator of Prints and Drawings,
The Art Institute of Chicago

GLORIA GROOM
Associate Curator of European Painting,
The Art Institute of Chicago

RODOLPHE RAPETTI
Curator at the Musée d'Orsay, Paris

Contents

Acknowledgments

This homage to Gustave Caillebotte could not have been conceived without the indefatigable efforts that his brother Martial Caillebotte made in his memory. From generation to generation, his descendents have shown the same good will; this exhibition would have been impossible without their constant and enthusiastic assistance. The exhibition and catalogue were made possible by Sara Lee Corporation. Additional support was provided by a grant from the National Endowment for the Arts. The exhibition has also received support in the form of an indemnity from the Federal Council on the Arts and Humanities. Travel assistance was generously provided by United Airlines. We would like to express our deepest gratitude to all of those who have made this exhibition and its accompanying catalogue possible. For those who wish to remain anonymous, our thanks are no less sincere.

Marie Berhaut, who dedicated her life to making known Caillebotte's work, passed away on 10 November 1993, too early to have seen this exhibition. This catalogue is dedicated to her memory.

JOSEPHINE ALBANESE
ALEX APSIS
MME ARRIBILLAGA
COLIN B. BAILEY
GERI BANIK
SUSAN BARNES
D. R. BEECH
CÉCILE BELLELLE
LOUIS BETHULEAU
KAY BEYER
MME BILLARD
BETTY BINNS
ALEXIS BRANDT
RICHARD R. BRETTELL
JANET M. BROOKE
JACK BROWN
MYRIAM BRU
JACQUES BRUNHES
HELEN BRUNNER
FRANK BUGNION
ISABELLE CAHN
MICHEL CAVANNE
PHILIP CAZEAU
HÉLÈNE CHARBEY
JANE CLARKE
HOLLIS CLAYSON
JOE COCHAND
JEAN PAUL COLLAERT
PHILIP CONISBEE
TRACIE COSTANTINO
JEAN COUDANE
ME PASCAL COURTIER
SAM CROUCH
TRAMMELL CROW
FRANCE DAGUET
LOUIS AND MARIE JEANNE DAURELLE
MARIANNE DELAFOND
LYN DELLIQUADRI
CLARISSE DELMAS
BRIGITTE DELOFFRE
BENJAMIN DOLLER
MANOU DUFOUR
HENRI DUPAIN
CHRISTOPHE DUVIVIER
ELIZABETH W. EASTON
MARIE PAULE ENSLEN
LAURE FABRE-ROUSSEAU
MARINA FERETTI
REBECCA FISH
KATHERINE HOUCK FREDRICKSON
MME FUNCK-BRENTANO
NAHUM GELBER

CAROLINE GENET-BONDEVILLE
FRANCK GIRAUD
CAROLINE GODFROY-DURAND-RUEL
MANINE GOLDEN
JOHN GOODMAN
SARAH GUERNSEY
BARBARA GUGGENHEIM
EILEEN HARAKAL
SIMONE HARTMAN
GREGORY HEDBERG
FRANÇOISE HEILBRUN
JEAN FRANÇOIS HEIM
TOM HINSON
AY-WHANG HSIA
JOAN K. INCIARDI
BOBBY JOHNSON
ADAM JOLLES
CÉLINE JULHIET-CHARVET
FRÉDÉRIQUE KARTOUBY
PETER KROPMANS
MAUREEN LASKO
MLLE LAURHEILE
YANN LEDUC
ANDRÉ LEJEUNE
FRANÇOISE LEMAIRE
SÉGOLEN LE MEN
MME LEONARDI
JEAN CLAUDE LEPAIN
MME LEPAVEC
CRIS LIGENZA
DOMINIQUE LOBSTEIN
PIERRE YVES LOUIS
MARC LUCAS
ANNE DE MARGERIE
MICHAEL MARRINAN
PETER MARZIO
MICHEL MELOT
ODILE MENEGAUX
HÉLÈNE MILLET
ACHIM MOELLER
HÉLÈNE MUGNIER
ME PHILIPPE NARBEY
PHILIPPE NÉAGU
TERRY ANN R. NEFF
ALAIN NICOLLIER
ANN NITZE
CHRISTOPHE NOBILÉ
MONIQUE NONNE
ALAIN NOURRY
GISÈLE OLLINGER-ZINQUE
MICHAEL PARKE-TAYLOR
GREG PERRY

CLAUDE PETRY
LILLY PHIPPS
JEAN PAUL PINON
GEORGE PRESTON
RON PUSHKA
MICHEL RATARD
ANNE ROQUEBERT
SUSAN F. ROSSEN
M. ROUX
CAROL SANKER
JEAN JACQUES SAUCIAT
SCOTT SCHAEFER
ROLAND SCHAER
PATRICE SCHMIDT
DOROTHY SCHROEDER
EVE SCHWARTZ
GEORGE SHACKELFORD
KEVIN SHARP
ALAN SHESTACK
GLORIA SIGNORELLI
PATTERSON SIMS
MARY SOLT
LAURENT STANICH
MARYANNE STEVENS
PETER C. SUTTON
MARIE DE THESY
PHILIPPE THIÉBAUT
R. M. THUNE
MARIA TITTERINGTON
JUDY VALENTINE
KITTY VALKIER
KAREN VICTORIA
DAVID VAN ZANTEN
JEAN FRANÇOIS VIVIER
NATHALIE VOLLE
C. EDWARD WALTER
HERBERT WEISSENSTEIN
ALEC WILDENSTEIN
GUY WILDENSTEIN
PIERRE WITTMER

Lenders

Public Institutions

France

Musée Baron Gérard, Bayeux: 19

Musée Marmottan, Paris: 36, 81, 114

Musée d'Orsay, Paris: 3, 60, 84, 89, 109

Musée Pissarro, Pontoise: 11, 12

Musée des Beaux-Arts, Rennes: 28

Musée des Beaux-Arts, Rouen: 79

Germany

Wallraf-Richartz Museum, Cologne: 110

Switzerland

Musée du Petit Palais, Geneva: 29

United States

Indiana University Art Museum, Bloomington: 16

Museum of Fine Arts, Boston: 93

The Art Institute of Chicago: 35

Kimbell Art Museum, Fort Worth: 31

Milwaukee Art Museum: 25

The Minneapolis Institute of Arts: 82

Seattle Art Museum: 76

Private Collectors

Mrs. Noah L. Butkin: 78

Josefowitz Collection: 83, 85, 86, 91, 92, 105, 106, 113, 116

Montgomery Gallery/Kemper Corporation: 101

Anonymous Lenders: 1, 2, 4, 5, 6, 7, 8, 9, 10, 13, 14, 15, 17, 18, 20, 21, 22, 23, 24, 26, 27, 30, 32, 33, 34, 37, 38, 39, 40, 41, 42, 43, 44, 45, 46, 47, 48, 49, 50, 51, 52, 53, 54, 55, 56, 57, 58, 59, 61, 62, 63, 64, 65, 66, 67, 68, 69, 70, 71, 72, 73, 74, 75, 77, 80, 87, 88, 90, 94, 95, 96, 97, 98, 99, 100, 102, 103, 104, 107, 108, 111, 112, 115, 117

Foreword

As the result of a bequest as famous as it was controversial, the name of Gustave Caillebotte—painter, avant-garde collector, and benefactor—remains associated with the introduction of Impressionism into French museums. He left the French government forty masterpieces of late nineteenth-century French painting now in the Musée d'Orsay, Paris, among them *The Balcony* by Edouard Manet, *Ball at the Moulin de la Galette* by Pierre Auguste Renoir, *Gare Saint-Lazare* by Claude Monet, and *L'Estaque* by Paul Cézanne.

Remarking with penetrating foresight on the artist's contributions to the 1880 Impressionist exhibition, Joris Karl Huysmans called Caillebotte "a great painter . . . certain of whose canvases will ultimately take their place among the best." In the twentieth century, Caillebotte the painter has been less well known, but over the last forty years art historians, notably Marie Berhaut in France and Kirk Varnedoe in the United States, have revealed him to be a major and singular figure in the art of his time. Even so, until now, no international retrospective of his work has been mounted.

The homage currently bestowed upon Caillebotte first in the Galeries Nationales du Grand Palais, Paris, and now in the United States allows us to take an accurate measure of him, a multifaceted artist of wide-ranging interests: a jurist by training, he was also a collector of remarkable insight, a talented naval architect, an accomplished competitive sailor, a world-class philatelist, and a devoted horticulturist.

Organized by the Réunion des Musées Nationaux/Musée d'Orsay, Paris, and The Art Institute of Chicago, this exhibition extends a tradition of fruitful collaboration that has already made possible the exhibitions "A Day in the Country: Impressionism and the French Landscape" in 1984–85 and "The Art of Paul Gauguin" in 1988–89. The presence in Chicago of Caillebotte's masterpiece *Paris Street; Rainy Day*, one of the signal images in the Art Institute's collection, makes the museum the appropriate site for the first American venue of this historic retrospective. We are pleased that it has become possible to send the exhibition to the Los Angeles County Museum of Art, our partner in "A Day in the Country," and to introduce this artist to a broader American audience.

We would like to express our gratitude to the directors of the major public institutions who have consented to loan works within their purview. We are especially grateful to the descendents of Gustave Caillebotte's brother Martial as well as to the private collectors who have so generously agreed to part with their works over an extended period. These latter works constitute more than three-quarters of the paintings and drawings on exhibit, some of which have not been shown publicly for over a century.

The choice of works was made by Anne Distel, Chief Curator, and Rodolphe Rapetti, Curator, both at the Musée d'Orsay, and, at the Art Institute, Douglas W. Druick, Searle Curator of European Painting and Prince Trust Curator of Prints and Drawings, and Gloria Groom, Associate Curator of European Painting. From a production consisting of some five hundred canvases executed over a twenty-year period, they have selected eighty-nine paintings and twenty-eight drawings from public and private collections in Europe and the United States.

They have collaborated, along with independent scholar Julia Sagraves, on the catalogue, which is preceded by an essay by Kirk Varnedoe, Chief Curator of Painting and Sculpture at The Museum of Modern Art, New York, who in 1976 organized the first Caillebotte retrospective in the United States. We hope that this undertaking will widen appreciation of the work of an Impressionist painter who, even today, has yet to be given his due.

FRANÇOISE CACHIN
Director of the Musées de France
President of the Réunion des Musées Nationaux

JAMES N. WOOD
Director and President
The Art Institute of Chicago

Odd Man In

A BRIEF HISTORIOGRAPHY OF CAILLEBOTTE'S
CHANGING ROLES IN THE HISTORY OF ART

KIRK VARNEDOE

Chief Curator of Painting and Sculpture,
The Museum of Modern Art, New York

Despite the rhetoric of its early advocates, the success of Impressionism did not arrive by destiny. It required, beyond the achievements on the canvases and the serendipity of circumstance, hard work on the part of several individuals—among whom Gustave Caillebotte was one of the most dedicated. He haggled and negotiated to keep the group together through periods of fractious disagreement; and when he had to, he rented the exhibition space, paid for the advertising, bought frames, and hung the pictures. In what would now be called the management and marketing aspects of Impressionism, he was an indispensable asset.

Caillebotte further fueled the movement by buying paintings from his needy colleagues. Yet more than just a source of charity, he was also a collector with uncannily astute judgment. Several of the Impressionist artists were his close friends, and their "moment" shaped his taste definitively: he never acquired works by Georges Seurat or Paul Gauguin, for example, or any other Symbolist or Post-Impressionist artist (with the obvious exception of Cézanne), despite ample opportunity. Nor did he ever buy canvases from friends and contemporaries of lesser talent, such as De Nittis or Béraud or Guillaumin. Personal connections helped form, but never deformed, Caillebotte's remarkable eye for quality. By that acumen and by his farsighted bequest of his collection to France under conditions that ensured it would be taken seriously, he again affirmed himself as central to Impressionism's achievements.

Caillebotte's own art is, however, the more problematic part of his role in history. His career was uneven and relatively brief. It yielded a range of fully competent landscapes and portraits, occasionally inspired still lifes, a notable and sometimes idiosyncratic vein of indoor and outdoor domestic genre scenes, and, above all, a striking, singularly poetic series of images of urban life. His treatment of the society and settings of his day has often led him to be compared with Realist writers such as Duranty, Huysmans, and Zola; but actually Caillebotte has, at his best, a very different kind of force, by virtue precisely of the *un*novelistic spareness of structure and lack of extraneous incident in his scenes. The dozen or so indelibly memorable images he created between 1875 and 1882 seem more to foretell the devices of later cinema; and in these important respects—as regards their construction of space, distinctive viewpoints, and assertive compositional architecture—they rival or outstrip the art of his more illustrious colleagues in inventiveness.

It is unavoidable, even if awkward and ultimately less than informative, to broach the general question as to whether Caillebotte was "as good as" the other Impressionist painters. Without belaboring the obvious caveats about relative criteria of "good," a short and simplified answer would have to be "no." He had neither Edgar Degas's skills as a draftsman nor Monet's as a colorist, and his development was not as extensive as those of his fellows. Yet comparing picture for picture —and speaking both as a historian of modern art and on more purely subjective aesthetic grounds—I would value any one of Caillebotte's best works (e.g., *Floor-Scrapers* [cat. 3], *Young Man at His Window* [cat. 59], *Boulevard Seen from Above* [cat. 69], and especially the monumental *Pont de l'Europe* [cat. 29] and *Paris Street; Rainy Day* [cat. 35]) as a more important, original, and rewarding painting than any Pissarro, all but a handful of Renoirs, and a fair number of Monets from the same period. In these particular pictures, and with all the familiar qualifications that should surround such a judgment, Caillebotte's achievement as an artist is at least as complex and enduringly interesting as that of his peers. This cannot be anything other than a personal assessment, but I suspect that I am far from alone in making it.

Each of these paintings has a singularity that does not characterize, say, Monet's various views of Argenteuil, or Pissarro's suburban scenes, or Renoir's nudes. Yet beyond stylistic similarities, these pictures and others close to them (e.g., *Luncheon* [cat. 72], *A Traffic Island, Boulevard Haussmann* [cat. 68]) also share a psychological or emotive "family resemblance" embodying a specific artistic personality that is distinct from that of any of Caillebotte's contemporaries, and dim or absent in the rest of his own work. We could well imagine that several painters of the day might have created *The Place Saint-Augustin* of 1877–78 (cat. 32) or the *Sailboats in Argenteuil* of c. 1888 (cat. 109); however pleasing they may be, they convey little of the originality and pose us few of the challenges of the major early canvases. The intriguing circumstances of Caillebotte's life as a wealthy young man in the midst of a contested avant-garde struggle, and certainly his comprehension of the complexities of Paris in his day, must lie behind and bear on all the pictures he made; but without his series of ambitious early achievements, we would hardly care. It is that select cluster of images from his brief years in the public eye—the wanderers with the umbrellas, the men scraping the floorboards, the vertiginous downward stare—that makes us want to know more about their author and the stories behind them. These are also, un-

like the sailboat scenes and landscapes that settle so naturally into the secondary ranks of Impressionism, pictures that aggressively "don't fit" into the traditional ways of understanding the period; and thus they have provided a stimulating irritant for the minds of art historians.

The story of these paintings is still being written, and the present catalogue will no doubt add considerably to it; but the part that involves their neglect and recuperation—the story of the long silence that seems to have surrounded them for most of the century since Caillebotte's death, and of their eventual return to the limelight—can at least be outlined here, in terms of some particular historical and art-historical circumstances. The *Floor-Scrapers*, the *Pont de l'Europe*, and Caillebotte's other principal pictures were in fact extensively discussed and debated within the immediate critical writing about the Impressionist exhibitions in which he appeared; but as he had no need to sell them, his paintings stayed largely in his hands (and eventually passed to his brother and his brother's descendents). After he stopped exhibiting at the age of thirty-four, and except for the retrospective following his death twelve years later, they were rarely seen; and without reproductions in general circulation, they were largely forgotten when histories of Impressionism were written. Caillebotte was remembered, if at all, for his bequest.

When in the 1950s the artist's descendents began to sell some of his paintings, illustrations of the work began to become available. Then art-historical currents regarding later nineteenth-century art shifted in a way that favored reconsideration of his art; and this started to happen, not coincidentally, around the time in the 1960s that The Art Institute of Chicago acquired his masterpiece *Paris Street; Rainy Day*. (My own fascination with the artist began, for example, when *Paris Street* appeared on the cover of the 1969 exhibition catalogue *The Past Rediscovered: French Painting 1800–1900*.) The 1974–75 exhibition "The Impressionist Epoch," which commemorated the first Impressionist show, featured Caillebotte only as a bit player, with one small work; but by the time of the more in-depth consideration of Impressionism in the 1986 exhibition "The New Painting: Impressionism, 1874–1886," he was one of the stars of the show, represented by fifteen exhibited canvases and seven supplemental illustrations in the catalogue. If Caillebotte made history in the 1870s, history remade Caillebotte in the 1970s; and then as before, it was possible to see this artist as an exemplary intersection of major forces at play —in the collisions between entrenched and new ideas, and in the vicissitudes of the market in the broadest sense.

When Caillebotte resurfaced in the 1970s, he seemed somewhat like a cultural coelacanth, an evolutionary misfit dredged from the depths of early modern art, whose unfamiliar hybrid features challenged existing views of the organization of the field. A basic conundrum that had already prompted critical debate when the pictures were first shown was revived in retrospective, historical terms. His paintings did not show the brightly colored fields of broken brush strokes we had been taught were the essence of Impressionism; they had on the contrary a dry, tight facture that seemed to belong more with the regressive painters of the Salon, for whom we had cultivated a derisive contempt. Yet this artist and these images of contemporary life had inhabited the center of the Impressionist movement; and, in unsettling ways, both he and they seemed very, very interesting.

Caillebotte raised two important kinds of issues. On the one hand, he provoked *category* questions. Seeming both Impres-

sionist and Academic, modern and conservative, his art made those divisions look rigidly simplistic. In the 1970s, moreover, that was not accepted as just a one-off oddity, like the occasional mammal that also lays eggs. Instead, it added to a mounting roster of anomalies that threatened to invalidate the whole taxonomy that had formerly ranked winners and losers in later nineteenth-century art according to a narrow idea of what constituted the mainstream of twentieth-century art. (This doubt about historical labels arose in a period when formalist notions of a Cubist-derived "main line" of progress in modern art were also losing credibility among contemporary artists and critics, following the advent of Pop art and Minimalism; some parallels, in fact, were drawn at the time between Caillebotte's aesthetics and those of 1970s artists who also challenged the canonical "modern" category.)

As the interest of Caillebotte's pictures seemed to be less a matter of innovative technique or form and more a matter of dramatically conceived subjects, he also raised questions of *context*. His detailed vistas of Third Republic Paris begged topographical identification, of the kind that led historians to reckon with the histories of iron bridges, railroad stations, new boulevards and building types, and urbanism in general; and these lines of inquiry accorded well with broader patterns of 1970s scholarship (on nineteenth-century art particularly) that encouraged closer examination of the social and historical conditions surrounding the work of art. In fact, Caillebotte reemerged into art history just when a broader idea of "content" began to receive more attention than questions of style, and when the appeal of context was ascending over the rubble of discredited categories. Pictures that had been exhaustively analyzed for their intrinsic forms suddenly seemed to shine with fresh meaning when reset against the foil of extrinsic, associated images and texts. Furthermore, the notion of bypassing retrospective labels and rankings to recur to the texts and terms of the 1870s, and of seeing Impressionist art as a window onto the concerns of its own time rather than as an anticipation of ours, was an intellectual ideal that then held the prestige of an ethical crusade. By debunking a notion of art's autonomy that had been fostered by annexing paintings into transcendent categories of formalist "modernism," and insisting instead on a work's embeddedness in its immediate environment of material and social circumstances, this new historicism honored the general, appealing principle of an ecological, organic connectedness—between all aspects of a society, and between art history and other disciplines.

Hostility to received ideas of what constitutes "quality" or "progress" was most blatantly evident in the eagerness of 1970s curators and academicians to revive Salon lions like Jean Léon Gérôme and William Bouguereau; and in the climate of the moment, the consideration of these conservative, "establishment" artists seemed paradoxically liberating and anti-authoritarian. It offered the savor of forbidden fruit, and suggested an upstart, independent-minded openness to the fuller range of history's complexities. Looking seriously at artists such as Gérôme—or Caillebotte—was an implicit rejection of the idea that "advanced" technique or formal properties determined an artwork's importance; and since emphasis on a picture's content, as opposed to its style, involved disrespecting specialized formalist jargon or mystifying criteria of judgment, it had an antimandarin, democratizing, or even populist edge.

In academic art history, these reconsiderations of the nineteenth century allowed for new areas of specialization in a crowded field; and the emphasis on contextual description

opened up a virtually limitless terrain of material to research, footnote, and publish. (For an American academia overtenured after the expansive days of the 1960s, these considerations were not trivial.) In other markets, too, the changes brought expanded opportunities: the emergence of interest in lesser-known artists was promoted by art dealers eager to open new audiences for a broader range of items that were available and relatively cheap. Caillebotte was, in this context, ripe for investment in all the senses: relatively unstudied by academics, he also offered collectors a certifiable Impressionist—with all the trappings from top hats to sailboats and gardens—at bargain, well-below-Monet prices. (The value of some of Caillebotte's paintings increased by multiples of ten or more in just the last half of the 1970s.)

There was within "revisionism," then, an unlikely and largely unspoken congruence between value-questioning scholarly revisions and value-creating commercial interests. Similarly, those who were apparently united in opposition to outdated definitions of modernism, and hence, of Impressionism, were often actually deeply opposed to one another. Some of the most doctrinaire of the "democratizing" leftist revisionists were staunchly elitist in their contempt for the revival of Salon painters, and in their insistence on the primacy of "difficult" avant-garde work; while those who sought to redefine the modern tradition found themselves attacked by colleagues who wanted only to certify its death and get on with a postmodernist writing of history. Yet Caillebotte's revival was one of several phenomena that were propelled to varying degrees by all these waves and fashions together, in ways that did not appear so evidently paradoxical at the time. If Caillebotte was by birth a child of 1848, he was by this rebirth an offspring of 1968, and of the contradictory climate of intellectual upheaval that had followed on that pivotal political year.

Since then, of course, the art market has changed, and so has the market of ideas in art history. The revisionists of the 1970s produced students who are now tenured and are themselves producing the next wave of young scholars, a generation born well after 1968 which will enter a sharply altered field of nineteenth-century studies. And in 1994, oddly enough, that field seems—in ways that will doubtless affect fresh reconsiderations of Impressionism and of Caillebotte—to have turned a circle toward a new reign of categories and hierarchies.

"Modernism" is perhaps the prime example. Following its widely reported death, this abstract category now seems more indispensable as an intellectual shibboleth—more reified, more believed in, and more deforming—than it ever was in its ostensible prime. No longer seen just as a formalist aesthetic fiction to be debunked, the notion of a "logic of modernism" or a "modernist project" is now ritually invoked as a formidably real and all-pervasive historical force shaping thought and social relations. In recent views of the art of the past century and a half, artists and images are once again being extricated from their local circumstances and inserted (now in condemnation rather than praise) into larger stories of the progress of "modernism"—as they are also being set into parallel stories of the body, the gaze, and the spectacle. Along the way, formerly specific descriptive terms such as "space" or "site" have also metamorphosed into disembodied, metaphoric frames of psychological or sociological reference. As ways of explaining and giving meaning to the art of the past, such global categories of current understanding are today embraced with fresh conviction as subsuming and transcending the contingencies of immediate historical conditions.

Context, meanwhile, has become hypostatized as a focus of concern, with the "foregrounding" of what used to be thought of as background. The examination of what is *not* in a given work of art has proven to be an appealingly unconstrained and open-ended endeavor, and the task of providing a convincing connection between this associated material and the work of art itself has come to seem secondary or irrelevant to many practitioners of a new anthropology of images. A study that might formerly have embedded a Manet nude within a web of popular erotic imagery would now more likely go straight at pornography as more representative of broader currents. This more drastic leveling of visual representations, while self-professedly political, has nonetheless shed any of the former taint of populism. It is more typically associated with the resurgent prestige of specialized jargons about large theoretical concepts, and thus with a freshly defiant vision of art history as a mandarin enterprise of rarefied knowledge; by some occult balance, as the material observed becomes more demotic, the ideas applied often become more steeply clubbish.

If a "new Caillebotte" is shaped from within these parameters, he will surely be less of a misfit; his art will be seen less as an anomaly and more as a legible, even paradigmatic, expression of decodable historical circumstances and categories. His distinctive vision may, for example, be more solidly assimilated to something called modernism, though this will likely not be to his credit as a progressive force of liberation; he is more probably ripe for portrayal as a representative of modernism's ostensibly intrinsic discontents—for example, his pictures embodying (in the authority of their perspectives) the oppressively rationalizing, dominant optic of the leisured and empowered urban male; or his peculiar compositions revealing (in their tensions) the intrinsic contradictions of conflicted social spaces in maturing capitalism. Along the way, we will certainly learn much more about the particulars of the artist's family, his relationships, and the contexts of his life, both immediate and general; but to the extent that those dozen or so remarkable images come to be comfortably understandable in terms of these encapsulations, there will inevitably be some risks with the gains. Categories and contexts help us to see Caillebotte's images as examples of, or windows onto, other phenomena; yet the more successful that process is, the more it may tend to efface rather than illuminate the individuality of his art.

Categories are, after all, only abstractions we use as shorthands to deal with accumulated contingencies; we misuse them when we imply that they generate these contingencies, or determine a particular individual or act. Individuals make up these categories, but these categories do not make up individuals. This is just as true for "modernist" as a broad sociological term as it was for "modernist" as a narrow formalist term; and whether it is "Impressionist" or "wealthy Third Republic male," the issue was not and is not how such labels define Caillebotte, but how he redefines them. Contextual examination has its own parallel pitfall: each background that is used to explain an event or object, in turn itself begs interpretation within some broader context, and so on into infinitely expanding circles with steadily decreasing relevance to the subject at hand. (The ultimate extension of this holistic idea, to paraphrase Bertrand Russell, is the premise that we cannot talk about any one thing unless we talk about everything.) Yet an artwork that arises from within countless overlapping contexts is not finally determined by any; it has a specificity that

emerges from the unique convergence of many in its creation, and then expands in meaning through still others it subsequently traverses—as even our schematic sketch of Caillebotte's recent critical fortunes already suggests.

With determinist ideas of context, as with essentialist notions of categories, our constant temptation is to invert the order of things, and reckon that individualities like Caillebotte's become meaningful when they are seen to reveal and conform to larger, more basic and potent elements of history—to "isms," or movements, or unfolding struggles between vast social forces. Yet from the unpredictable variations that drive Darwinian evolution upward through every level of human chronicle, individualities and unique contingencies are not secondary epiphenomena of history, but rather its basic motor. This is nowhere more evident than in works of art, which endure to the degree that they do not fit exactly, but supersede the niches in which they were created and each of the shifting labels imposed on them. A quirky, uncontrollable specificity lies both at the *root* of history (or nature) and at its *crown;* it is both the spark of events and, through art and interpretation, their afterglow.

This is one of the reasons Caillebotte's "misfit" nature has been so instructive. In their episodic, interrupted eccentricity, Caillebotte's historiographic fortunes also point out with particular clarity some elementary lessons about both art history's limitations and its open-endedness. Since the artist is dead, no amount of documentation will ever recapture a complete reckoning with his view of the world, or understanding of him as an individual. We can compile in denser and finer-grained detail analytic accounts of the things he shared with others, from the available conventions of perspective to the character of his arrondissement; but the very things that we sense are critical to the impact of the most personal pictures—the motivations for the choice and framing of subject, the decisions as to what to put in and what to leave out, and so on—are the contingent elements of his private individuality on which we can only speculate without hope of confirmation. And, since the art endures, that speculation can never pretend to finality.

In the face of these humbling limitations, historians can be seduced by twin forms of hubris. Reading Caillebotte's mind through his art, we may imply that we see as clearly as he the larger issues and dilemmas he faced, or even that in our retrospect we know more about his situation than he did. Such presumptions entail a denial of the real weight of history's mortal finalities, and a false arrogance toward our predecessors. The matching delusion, which allows us to believe our accounts of his pictures can be definitive, is equally arrogant toward those who will supplant us, see around our blinders, and add something new to the process.

Those of us who had the chance to try to contribute something to the understanding of Caillebotte in the 1970s, and who hold the happy memory of having "known" him and these images when they seemed more unknown, wait attentively now to discover him and them anew in the work of others. Each individual, inevitably subjective viewpoint asks questions and proposes insights that leave behind a residue of data and judgments to be corrected, rejected, or amended as time and viewers change. The resulting field of dispute is the only terrain for consensus a plural society can have about its culture. As we have seen, the contingencies of history have, for a great variety of often contradictory reasons, accorded Caillebotte's pictures shifting values in several senses. This process, ongoing and unpredictable, accords the works an "autonomy" that, far from being a denial of history, is intrinsic to its processes. The complexly layered, emergent specificity that results is as close as we can get to an analogue for the intricate uniqueness of the personality that made the pictures originally and that, in elusive residue, makes them compelling still; it is one of history's substitutes for the irretrievable, as cultural innovation and continuity are consolations for human loss.

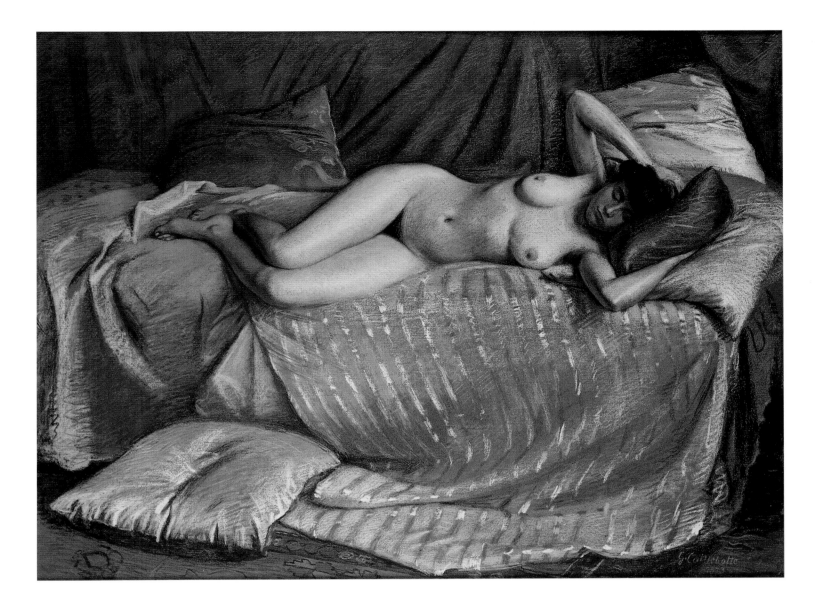

Gustave Caillebotte. *Nude Reclining on a Divan*, 1873.
Pastel; 87 × 113 cm. Iris and B. Gerald Cantor Collection, Los Angeles.

Figure 1. Anonymous. *Gustave Caillebotte*, c. 1878.
Photograph. Private collection.

Introduction

ANNE DISTEL

Among the dates that might serve as benchmarks in a history of Impressionism, some are self-evident, like those of the first and last exhibitions of the group, in 1874 and 1886. But another date, less well known, also merits consideration: 5 February 1876, when Renoir and Henri Rouart signed a letter inviting Gustave Caillebotte to exhibit with a group of painters the following spring on the premises of the dealer Paul Durand-Ruel.[1] The letter's tone suggests that the correspondents were not close, but its contents indicate that Renoir and Rouart knew the young artist, and that he had grasped the full significance of their first exhibition, held in 1874 on boulevard des Capucines—on which occasion a hostile critic had coined the neologism "Impressionist." A few days later, Monet recorded in his account books that he had sold several paintings to "M. Caillebotte painter"[2]—a windfall for the artist, whose serious collectors could then be counted on the fingers of one hand. Thus the month of February 1876 saw the emergence of one of the major figures of the last quarter of the nineteenth century: Gustave Caillebotte (see fig. 1), "Impressionist" painter, benefactor, and collector.

Caillebotte accepted the invitation, and in early April 1876 eight numbers appeared under his name in the catalogue of the second Impressionist exhibition. Notably, he sent the two versions of *Floor-Scrapers*, *Young Man at His Window*, *Young Man Playing the Piano*, and *Luncheon* (cats. 3, 5, 59, 71, and 72). So it was that, exhibiting with Degas, Monet, Morisot, Pissarro, Renoir, Sisley, and several others, the young painter underwent his baptism by fire, for the preceding year his work had been rejected by the jury of the official Salon and he had resolved to turn his back on it. In the absence of precise statements by the artist himself, analysis of his works as well as of contemporary criticism, both favorable and unfavorable (cited in the individual catalogue entries), will allow us to assess the achievement of Caillebotte the painter, who, like Athena, seems to have been born fully armed, although, unlike Athena, it is not easy to designate his artistic parentage. His painting has a certain affinity with that of Degas, especially in its subject matter, as opposed to that of Manet, who had decided not to participate in the Impressionist exhibitions, but whose work was a constant point of reference for all the group's members. There are echoes of the bright, trenchant color combinations characteristic of Renoir's figure paintings of the 1860s, for example, *The Lovers*, also known as *The Sisleys* (c. 1868; Wallraf-Richartz Museum, Cologne). But while we, secure in our knowledge of what was to come, perceive something resolutely "modern" in Caillebotte's painting, many contemporary critics judged it to be the work of a diligent and quite orthodox student of Léon Bonnat who had somehow gotten mixed up with a band of "extremists."[3]

Caillebotte gave clear evidence of his priorities some months later, and in a surprising way: his brother René had just died at age twenty-six, and he responded to this blow by resolving —a notion simultaneously bourgeois and romantic—that he himself should draw up a will:

It is my wish that sufficient funds be allocated from my estate to finance in 1878, under the best possible conditions, the exhibition of the painters known as Intransigents or Impressionists. It is rather difficult for me to estimate today what the necessary sum might be; it could go up to thirty, forty thousand francs or even more. The painters to figure in this exhibition are: Degas, Monet, Pissarro, Renoir, Cézanne, Sisley, Mlle Morizot [*sic*]. I name these without excluding others.

I leave to the State the paintings in my possession; however, as I want this gift to be accepted, and in such guise that these paintings not end up in an attic [storage room] or a provincial museum but rather in the Luxembourg and later in the Louvre, a certain lapse of time will be necessary before the execution of this clause, until the public may, I do not say understand, but admit this painting. Twenty years or so might be required; in the meantime my brother Martial, or failing him another of my heirs, will keep them.

I ask Renoir to be my testamentary executor and to accept a painting to be chosen by him; my heirs will insist that he take an important one.[4]

Confronted by the beyond, Gustave Caillebotte thought only of painting; self-effacing in the extreme, he neglected to mention his own name, invoking instead his friends, "the painters known as Intransigents or Impressionists." He clearly felt that it was his role to use the money allotted him by Providence (he was exceptionally rich for a young man, having inherited much of his father's considerable fortune in 1874) to support the collective effort of a group of painters somewhat older than he was whom he saw as his superiors. Giuseppe De Nittis had recommended that he "make art and tell the jury to get lost," and he did so, both in his own work and by supporting the art he had chosen.[5] The "thirty, forty thousand francs or even more" estimated by him as the probable cost of organizing a suitable exhibition was comparable to the annual budget of a wealthy Parisian family; when he bought canvases from

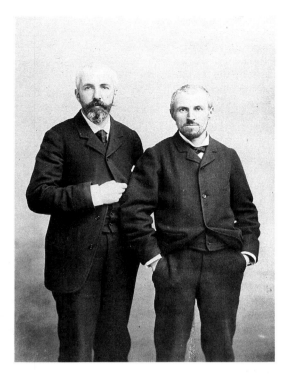

his friends he was generous and rarely turned down requests for an advance. The very idea of speculation was foreign to him, which could not be said of all the group's collectors; and then, he bequeathed his paintings to the French State.

Such a decision was quite unusual at the time. It was not uncommon for museums, in Paris and elsewhere, to have their collections enlarged through bequests, but these most often consisted of Old Master paintings or objects that had achieved general acceptance, as opposed to works decried by the majority of the public, as were the paintings by the "Impressionists." One important precedent, however, was the bequest of Alfred Bruyas. In 1868 this art lover, who was close to Eugène Delacroix and, above all, to Gustave Courbet, left his collection to his home town, Montpellier; it included many works by Courbet, which was unheard of.[6] There was no possibility at this date of the State purchasing canvases by Manet and the Impressionists, but it was increasingly clear to many contemporaries that the government's acquisition policy was in need of reform: it was not until 1875 that it decided to purchase two relatively minor works by Jean François Millet at his estate sale. Admittedly, the funds then available for such acquisitions were quite limited, and Millet was by that time an expensive artist, but the State had also failed to buy a single work by Courbet.[7] Caillebotte knew perfectly well that the paintings by his colleagues in his collection, whether already owned by him or acquired later,[8] would initially provoke dismay, or worse—thus, the stipulated conditions. Subsequent events were to prove his fears justified. But his provisions for an exhibition in 1878—a date probably chosen to coincide with the Universal Exhibition planned for Paris that year—soon became pointless: Caillebotte was very much alive in 1877 and played a major role in what we now call the third Impressionist exhibition.

His participation in this exhibition was perfectly consistent with the double program he had laid out for himself: to be an Impressionist painter, and to publicize and defend the work of the group's other members. Beginning in January 1877, he did everything in his power to help organize the exhibition.[9] It marked his debut as Impressionist "impresario," a role he was to play for several years.

His submissions—*Paris Street; Rainy Day*; *The Pont de l'Europe*; *Portraits in the Country*; the portrait of his mother, *Portrait of Mme Martial Caillebotte*; and *House-Painters* (cats. 35, 29, 19, 73, and 15)—exemplify, by their subject matter and their strikingly original compositions, "The New Painting" defined by the novelist and critic Edmond Duranty in the pamphlet published under that title in 1876. Caillebotte had taken up themes inspired by contemporary life the preceding year, and he now proceeded to inflect them in ways that set his work apart from the painting of the contemporaries whom he admired. His crisp, precise handling distinguishes his art from that of both Manet (who was drawn to similar subject matter) and Monet; his cool, restrained palette is starkly opposed to the iridescent jubilation characteristic of Renoir; unlike Cézanne, Pissarro, Sisley, and even Monet, he was uninterested in landscape devoid of figures; his often monumental formats, their scale doubtless a reflection of his youthful enthusiasm, contrast with the modest dimensions preferred by his colleagues (save for the large decorative panels exhibited by Monet).

His own paintings attracted considerable attention, as is evidenced by the press he received; but Caillebotte also contributed to the enterprise by lending works by his colleagues Degas, Monet, Pissarro, and Renoir, identifying himself only by his initials.[10] It is instructive to compare his role with that of Rouart, also an exhibiting artist (though represented by far fewer works than Caillebotte), collector, and lender, notably of works by Degas. In the end, however, it is the differences between Caillebotte and Rouart that are most significant. Rouart—an engineer, polytechnician, and director of an advanced metallurgical factory, then preparing submissions to the Universal Exhibition of 1878 which would win him the Légion d'honneur[11]—remained an amateur painter and a collector

of rather mainstream taste, despite his interest in his exhibiting colleagues; certainly he had not set out to make his collection into a manifesto, as had Caillebotte.

Caillebotte's resolve is further evidenced by the fact that in 1877 he made a point of putting several of his own paintings on the block at Hôtel Drouot in Paris, along with canvases by Pissarro, Renoir, and Sisley.[12] When we consider Caillebotte's wealth and the smarting failure of a previous auction mounted by members of the group in 1875, his taste for defiant gestures and the depth of his identification with his less well-heeled colleagues become apparent.

He comported himself similarly in subsequent years,[13] but despite his tireless energy, problems seem to have proliferated. The Impressionist exhibitions were becoming increasingly tricky to organize, due to both personal rivalries and material difficulties. There was no exhibition in 1878, but in 1879 Caillebotte was again prominently featured: his many submissions (see cats. 23–28, 60, 62, and 74) included works from the *Oarsmen* series, portraits, and *Rue Halévy, Sixth-Floor View*, and he once more lent works by his colleagues, which demonstrates that his collection was continually expanding.[14] He was especially generous toward Monet, helping him to get through a stretch that was difficult both personally and professionally.

Beginning in 1880, the gathering tensions erupted: Caillebotte did indeed take part in the exhibition of that year—although with a less spectacular series of works than previously (see cats. 66, 75, 77, and 79)—but Monet and Renoir did not, which meant that Caillebotte had to deal with Degas on his own. Caillebotte was absent from the 1881 show and was just "retrieved" for the one in 1882; although his contributions were important (see cats. 65, 67, 69, 80, and 93), this was the last of the series in which he participated. Dissension among the artists, who increasingly exploited whatever opportunities came their way, even at the expense of the group enterprise, does not sufficiently explain Caillebotte's withdrawal. Other interests had begun to stake their claims on his time and energy.

"Is it known that the painter Caillebotte, who was a passionate gardener and boatsman, was also one of our most devoted collectors of postage stamps? For many years, his mornings were consecrated exclusively to the classification and examination of new stamps sent to him from just about everywhere."[15] This obituary notice reveals another face, or rather several other faces (see fig. 2) of the artist: Caillebotte the *timbrophile*, or "stamp-lover" (to use a contemporary appellation)—and a formidable one, too, if we are to believe specialists in the field.[16] With his brother Martial (see fig. 3), whose principal activity was musical composition (see cat. 71), Caillebotte became a serious stamp collector around 1877 or 1878. This occupation, which began as a fad among wealthy high-school students during the Second Empire, was becoming a highly developed specialty with its own clubs, magazines, and exchange market. As with all his undertakings, Caillebotte gave himself over to it completely, mastering its arcana and entering into its polemics, occasionally in print.[17] But this collecting activity came to a close after about ten years, at the time of

Martial's marriage, which brought the two brothers' shared fraternal life to an end.[18] It seems probable that other factors also played a role in this decision, for Caillebotte was becoming increasingly involved in less sedentary pursuits.

The first of these was horticulture. After the death of the artist's mother in 1878, the family's Yerres property, whose park and river had provided the painter with so many motifs, was sold. In 1881 Gustave and Martial Caillebotte purchased another property on the banks of the Seine at Petit Gennevilliers, across from Argenteuil, a stretch of riverside landscape celebrated in many canvases by Manet and Monet. Around 1888 Gustave settled there permanently with the young woman who had shared his life since at least 1883, Charlotte Berthier.[19] He gradually created a magnificent garden on this property, complemented by a large greenhouse for the cultivation of exotic plants, notably orchids. Here again his correspondence with Monet[20] and old photographs (see figs. 4 and 5) reveal the considerable attention lavished by Caillebotte on his now-vanished garden, which began to appear in his paintings (see cats. 102 and 112).

But the choice of Petit Gennevilliers had been determined above all by another passion shared by the two brothers: pleasure boating, or as the French then called it, *le yachting*. In Yerres the proximity of the river had encouraged Gustave to become a boating enthusiast (see fig. 6), and some of his works

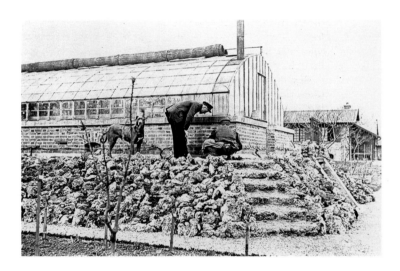

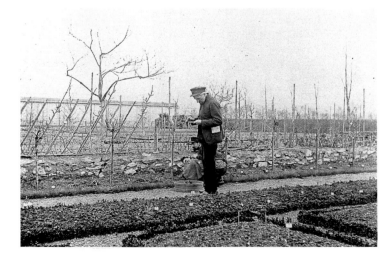

Figure 4 (top right). Martial Caillebotte. *Gustave Caillebotte with his gardener and his dog beside the greenhouse at Petit Gennevilliers*, Feb. 1892. Photograph. Private collection.

Figure 5 (right). Martial Caillebotte. *Gustave Caillebotte with his gardener at Petit Gennevilliers*, Feb. 1892. Photograph. Private collection.

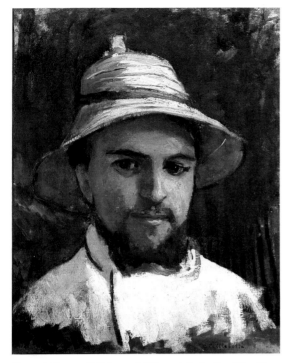

Figure 6. Gustave Caillebotte. *Self-Portrait in Boating Attire* (?), c. 1872. Oil on canvas; 44 × 33 cm. Private collection.

picture amateur rowers (see cats. 24, 25, and 28). From 1879 the two brothers began to acquire solid reputations among sailboating aficionados.[21] A list of the regattas won by Gustave and his friends in the environs of Argenteuil (see figs. 7 and 8), as well as off the Normandy coast, between 1879 and 1893, his last season,[22] and the succession of his boats give an indication of just how much time, energy, and money he invested in this activity, to the detriment of his painting. A born experimenter, Caillebotte never rested content with theories[23]: with the aid of his friend Maurice Brault, an engineer, in 1882 he started to design his own sailboats (see fig. 9), and beginning in 1886 he

Figure 7. Martial Caillebotte. *Boats and the Argenteuil bridge seen from Petit Gennevilliers*, 1891/92. Photograph. Private collection.

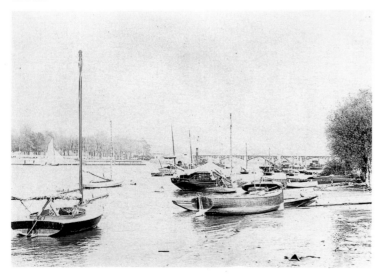

financed his own boat construction yard in Petit Gennevilliers.[24] This is not the place to assess Caillebotte's impact on the practice of sailing in a period rich in experimentation,[25] but it should be noted that his title of naval architect was well deserved.

Although after 1882 sailing and sailboats seem to have consumed the lion's share of his time, he never forgot painting entirely. Caillebotte continued to paint, and he even found in new activities new subject matter (see cat. 109). On the other hand, he all but ceased exhibiting his work. Since he had no need to support himself, he remained on the fringe of the art market. However, he did take part in the large show mounted in New York by the Parisian dealer Durand-Ruel in 1886, which brought together most of the participants in the Impressionist exhibition.[26] His contributions effectively constituted a miniature retrospective of his career, but it seems that the public in the New World was indifferent to his work. Two years later, in 1888, he sent paintings to the exhibition of Les XX in Brussels, which showcased a range of advanced painting that might, for the sake of convenience, be designated Post-Impressionist; he also exhibited at Galerie Durand-Ruel in Paris.[27] The savage critical response to his submission to Les XX (see cat. 105) must have discouraged him. Caillebotte's withdrawal from the scene can be measured by a remark made by Vincent van Gogh to his brother in a letter concerning this last exhibition: "There will be some of Caillebotte's pictures—I have never seen any of his stuff, and I want to ask you to write me what it is like."[28] The young generation of artists eventually forgot him, just as he neglected to keep up with new developments. On the other hand, he grew closer to Monet and Renoir.[29] One result of this growing intimacy was the idea of holding monthly Impressionist dinners at Café Riche. Present on several of these occasions, the critic Gustave Geffroy left the following bemused description of the discussions that took place between Renoir and Caillebotte:

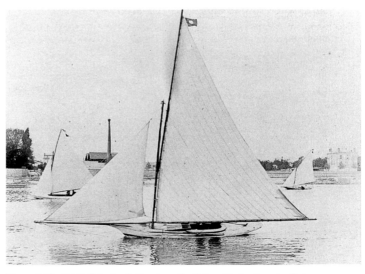

Figure 8. Martial Caillebotte. *Sailboats on the Seine with the Argenteuil riverbank in the distance*, 1891/92. Photograph. Private collection.

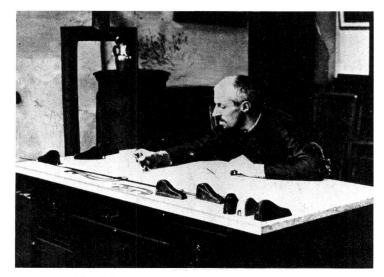

Figure 9. Martial Caillebotte. *Gustave Caillebotte at his naval architect's drafting table*, 1891/92. Photograph. Private collection.

The first [Renoir], nervous and sarcastic, with bantering voice and a kind of mephistophelianism that marked his face, already tormented by illness, with irony and bizarre laughter, took malicious pleasure in exciting the second [Caillebotte], who was sanguine and irascible, his expressive face passing from red to violet, and even black, when his opinions ran afoul of those of Renoir, who loved to counter them with a flippant self-confidence. He then showed an intensity that bordered on anger but somehow remained inoffensive. The debates focused not only on views about art and painting, but on all subjects relating to literature, politics, and philosophy, and Caillebotte, who was a great reader of books, magazines, and newspapers, unabashedly jumped into the fray. Renoir had become conversant with everything by buying an encyclopedic dictionary in which he found arguments "to put Caillebotte on the spot." [30]

Materially Monet and Renoir now had less need of Caillebotte, although this did not preclude them from occasionally dipping into their friend's purse. In 1890 Monet solicited funds from him in connection with the initiative to purchase Manet's *Olympia* from the artist's widow, with the intention of giving it to the State. Caillebotte contributed one thousand francs, thus becoming one of the fund's largest subscribers. Monet subsequently spent several months struggling with the administration, trying to convince it to accept the gift and to exhibit the work in the Musée du Luxembourg and then, at the proper time,[31] in the Musée du Louvre, as opposed to dispatching it to a provincial museum. The terms at issue in these negotiations are strongly reminiscent of the will drawn up by Caillebotte in 1876. This debate over the fate of the *Olympia* was a real *affaire*: it was followed closely by the press, and various political agendas were brought to bear on it. But it ended happily, for Monet, whose determination was unflappable, eventually managed to convince the government to accept his conditions. Thus was Manet "admitted"—although six years after his death. This episode is a kind of prologue to what was soon to become l'affaire Caillebotte.

On 21 February 1894, Gustave Caillebotte died in Petit Gennevilliers; he was only forty-five years old. Camille Pissarro wrote to his son: "Caillebotte has died suddenly of brain paral-

ysis. He is one we can mourn, he was good and generous and, what makes things even worse, a painter of talent."[32] This short text is virtually the only assessment of Caillebotte penned by his peers that has come down to us. There were many expressions of sympathy or regret, but neither Monet[33] nor Renoir ever really stated his views about Caillebotte's painting, perhaps preferring to remain silent instead of risking the appearance of ingratitude to a man to whom they both were unquestionably indebted and of whom they were quite fond. The rather stiff grace of Caillebotte's world, the chilly perspective views down the plunging streets of the new city that so enchant us today, like a naive evocation of a bygone world, were probably too far removed from their own sensibilities to appeal to them, and the instinctive prejudice against amateurs is not to be discounted in this case. Caillebotte freely chose to remain somewhat aloof, preferring to avoid artistic notoriety. But his death suddenly reminded his contemporaries of his existence.

On 11 March 1894, Renoir, in a letter addressed to Henry Roujon, Minister of Fine Arts, informed the administration, in his capacity as testamentary executor, of Caillebotte's bequest of "a collection of about sixty works by Messieurs Degas, Césanne [*sic*], Manet, Monet, Renoir, Pissarro, Sisley, Millet, a drawing by Gavarni"[34] (see figs. 10 and 11). On 13 March the administrative process was set in motion that would bring the matter, as was customary, before the advisory committee of the Musées Nationaux, composed of curators from the various departments, which was to deliberate on the proposed bequest beginning 19 March. On 20 March, the committee accepted the collection for the Musée du Luxembourg, which was devoted to contemporary painting. But what began so simply and straightforwardly was to degenerate into an imbroglio that still makes passions run high.[35] Two mutually opposed parties emerged, each with its own priorities. To simplify, on one side was the national administration, which ceaselessly maintained that a lack of space precluded them from exhibiting dozens of works "admitted" as documents of a marginal movement with a certain historical interest but for which it otherwise had little esteem. On the other were Martial Caillebotte and Renoir (advised by Albert Courtier, Gustave's notary and friend, and Monet, whose recent experience with the

Figure 10. Martial Caillebotte. *Martial Caillebotte at the piano in his apartment*, 1895/96. Photograph. Private collection. The paintings hanging on the wall are *Portrait of Mme Martial Caillebotte* by Gustave Caillebotte (cat. 73) and *A Street in Louveciennes* by Alfred Sisley (Appendix III, fig. 60).

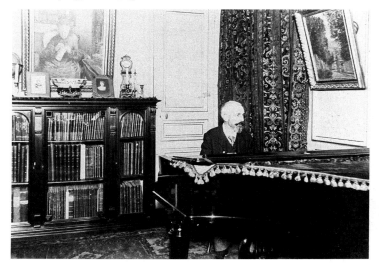

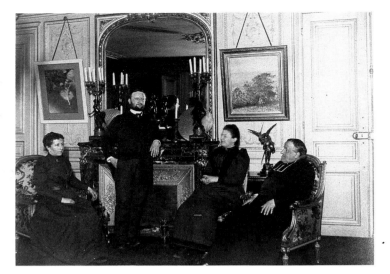

Figure 11. Martial Caillebotte. *Family gathering at the home of Martial Caillebotte*, 1895/96. Photograph. Private collection. From left to right: Mme Martial Caillebotte, M. and Mme Georges Minoret, Abbé Alfred Caillebotte; on the wall, *Ballet (The Star)* by Degas (Appendix III, fig. 15), and *Seashore* by Gustave Caillebotte (Berhaut 1994, no. 225).

Olympia gift was relevant), who required formal guarantees that the totality of the bequest would be exhibited at the Musée du Luxembourg. Meanwhile the press tracked and stirred up the debates. There would be little point in providing a detailed account here of the unfolding conflict, especially since Marie Berhaut and Pierre Vaisse have recently examined the episode, basing their account on a careful study of the relevant documents, many of which they also published.[36] We wish only to summarize the stakes in the polemic, and add to the already substantial dossier a previously unpublished document: the artist's estate inventory (Appendix I).

In defense of the administration, it should be said at the start that straightforward execution of Caillebotte's will, drafted almost twenty years earlier and intentionally never modified by him, posed serious problems. Space was in notoriously short supply at the Musée du Luxembourg, and integration of the full bequest not only would have entailed a substantial remodeling, but would have violated a rule stipulating that the museum exhibit no more than three works by any one artist, for Caillebotte's collection included more than ten works by some.[37] However, even though Léonce Bénédite, the museum's curator, favored acceptance of the bequest, he did so while stressing "the freedom of action that would be assured the Luxembourg's curatorial staff if, all tendencies being henceforth represented at the Luxembourg, the curator had no further need to worry about making good these gaps, very difficult to fill, and could solicit the financial intervention of the State only in view of acquiring exceptional and noncontroversial works."[38] These words clearly indicate that his enthusiasm for the artists in Caillebotte's collection was at best limited. Martial Caillebotte and Renoir, cautioned by Monet, had doubts about the administration's good faith and required guarantees before handing over the works, even though their principal concern was that the bequest be accepted.[39] Bénédite, on his end, perhaps encouraged by certain members of the administration (for example, Roger Marx or Armand Dayot, who had contributed to the *Olympia* subscription fund), was determined to obtain the works for the museum. It soon became clear that

a choice among them would have to be made; the artists themselves were afraid of being represented by sketches (in principle excluded from the Luxembourg's rooms) or works of insufficient quality, purchased by Caillebotte with the sole intention of aiding his colleagues financially. The administration was quick to take up this argument,[40] and thus it was that the Musées Nationaux, in agreement with Caillebotte's heirs and executor, accepted only forty of the proposed works, which it formally agreed to exhibit. The terms were accepted in January 1895 and made official by a document dated 26 February 1896.[41]

In this reduced form, the collection was finally presented to the public on 9 February 1897, in a newly constructed addition to the Musée du Luxembourg, where it was installed in a special room along with Manet's *Olympia*; Renoir's *Young Girls at the Piano*, a painting acquired by the State in 1892 at the urging of Stéphane Mallarmé; and *Young Woman in Ball Dress* by Berthe Morisot, who had recently died.[42] Pissarro, although rather satisfied with the canvases shown, complained about their presentation "in a corridor and with paintings hung one next to the other."[43] Monet was less severe; informing Gustave Geffroy of the new gallery's having opened, he added the following postscript: "It won't be too bad, I think, but the two Cézannes are not sufficiently well placed. I offered to have one (*L'Estaque*), which is so beautiful, hung where one of mine is, but to no avail."[44] The collection brought to the Musées Nationaux several masterpieces that even today number among the jewels of Impressionist painting in the Musée d'Orsay, where they are now housed. Thanks to Gustave Caillebotte, Impressionism entered the Parisian museum scene in force, hastening public recognition of its artists, and in all likelihood encouraging future donors (for example, Etienne Moreau-Nélaton and Isaac de Camondo), but also prompting an outcry from connoisseurs, who criticized the curators for having turned down some superb Cézannes.[45] On 28 February 1897, the opening of the Caillebotte Room was protested in a published letter addressed to the minister by the Académie des Beaux-Arts, and a few days later the same ultraconservative tide resulted in a senator's intervention, but these were last-ditch efforts of little significance.[46]

In all the ruckus surrounding the fate of the bequest, the posthumous retrospective exhibition of Gustave Caillebotte's own works, which took place at Galerie Durand-Ruel in June 1894, attracted scant attention. The critics were sympathetic and respectful, but nothing more.[47] However, Renoir and Monet personally took part in the selection and installation of their friend's paintings,[48] and the show also had the full support of Martial Caillebotte. Durand-Ruel, who had previously exhibited works by Caillebotte, sold a few on this occasion to regular clients, all of them important collectors of Impressionist painting: the renowned baritone Jean Baptiste Faure bought two; the merchant Edmond Decap, four; the man of letters Adolphe Tavernier, two; François Murat, a former city councilman, one; and a friend of Faure's, Jean Blum, two. Almost all the canvases purchased were Argenteuil boating scenes.[49] The critics noted that the large version of *Floor-Scrapers* (cat. 3) was accepted as a gift by the State for the Musée du Luxembourg, thanks to Renoir, who had suggested that it be added to the Caillebotte bequest, to which was also appended *View of Rooftops (Snow)* (cat. 60). After the exhibition, most of the paintings were returned to Martial Caillebotte and other members of the family, as well as to some of Caillebotte's friends: the painters Degas, Monet, and Renoir, but also M.

de Boulongne, Paul Hugot, Eugène Lamy, A. Cassabois, Richard Gallo, the notary Albert Courtier, Chauvin, and Emile Jean Fontaine, all members of his circle who also appear in a number of his canvases.[50] Thus distributed and largely out of view, the works entered a period of obscurity. Aside from a modest homage at the Salon d'Automne of 1921, it was not until 1951, when an exhibition was mounted at Wildenstein's Galerie Beaux-Arts in Paris, that the public could once more see and assess a substantial portion of the oeuvre, as opposed to associating Caillebotte's name exclusively with his bequest and his *Floor-Scrapers*. This resurrection was due largely to Marie Berhaut, who began to study the artist in the prewar years.[51]

A bit later, in 1964, the large *Paris Street; Rainy Day* (cat. 35) entered the collection of The Art Institute of Chicago, launching the American legacy of Gustave Caillebotte, which was further invigorated by the exhibition orchestrated by Kirk Varnedoe in Houston and Brooklyn in 1976–77. The centenary of Gustave Caillebotte's death now provides us with an occasion to celebrate his production as an artist, but it is also worth remembering that when he began his career as a painter, he had the generosity and foresight to offer to the public works by Cézanne, Degas, Manet, Pissarro, and Sisley that he knew to be masterpieces.

NOTES

1 See Chronology, 1876.

2 Ibid.

3 The term *outranciers* was used by Arsène Alexandre in his preface to the catalogue of a Renoir exhibition at Durand-Ruel in 1892; on the reception of works by Caillebotte in 1876, see the discussion in cat. 3.

4 Poletnich 1894b. For the French text, see Chronology, 1876.

5 See the cited letter in Chronology, 1875.

6 Alfred Bruyas confirmed and completed his bequest with a codicil to his will, dated 20 Nov. 1876; he died on 1 Jan. 1877; see *Chronique des arts et de la curiosité* (20 Jan. 1877), pp. 24–25; and C. Georgel, "La Donation Bruyas au musée Fabre de Montpellier: une tradition et une exception," in Paris, Musée d'Orsay, *La Jeunesse des musées*, exh. cat. (1994), pp. 247–49. Monet could have spoken to Caillebotte about Bruyas, whom he knew through the painter Frédéric Bazille, a native of Montpellier. Before his death in the Franco-Prussian War in 1870, Bazille had played a role vis-à-vis Monet and Renoir similar to that of Caillebotte after 1876.

7 In 1865 Napoleon III purchased a work by the painter for the civil list with his own money, but it entered the collection of the Musées Nationaux only in 1881; the first direct acquisition was made in 1878. It should be noted, however, that Courbet's conviction as an ex-communard complicated the prospect of such purchases considerably.

8 Aside from the Monets (see Chronology, 1876), it is impossible to determine what works were in Caillebotte's possession when he drew up this will. Of the two small drawings by Millet that Caillebotte eventually gave to the Musée du Louvre (inv. RF 4019 and RF 4020; Appendix III, figs. 1 and 2), one bears a stamp from the Millet studio sale at Hôtel Drouot, Paris, 10–11 May 1875, and it is possible that Caillebotte acquired it on that occasion. Note that Léon Bonnat was a great collector of drawings by Millet, as were Rouart and several other collectors of Impressionist work.

9 See Chronology, 1877.

10 For details about Caillebotte's loans to the exhibition, see Chronology, 1877. All the works lent by him are now in the Musée d'Orsay. It seems likely that number 181 in the catalogue of the 1877 Impressionist exhibition, *Allée sous-bois, à Montfoucault*, is the work now known as *Chemin sous-bois* (1877; Musée d'Orsay, Paris) and not the *Sous-bois avec un homme et une femme assise* (1876; private collection); see Appendix III, fig. 46, and Pissarro and Venturi 1939, no. 371, where it is said to have been number 165 in the 1877 exhibition, which is surely an error. Caillebotte was to lend a *Petit Bois de peupliers en plein été* to the 1879 exhibition, listed in the catalogue as number 184, which could be either of these works.

11 Distel 1987, p. 117.

12 See Chronology, 1877.

13 See Chronology, 1878–82.

14 See Chronology, 1879.

15 Obituary in *Le Rappel*, 2 Mar. 1894.

16 See Beech 1993.

17 See Chronology, 1884 and 1885.

18 An article in the *Philatelic Record* 12, 244 (Dec. 1890) is the source for this summary chronology; it also states that what then remained of the collection was sold at auction in London toward the end of 1890. The obituary in *Le Rappel* (see note 15) states that, at the time of sale, the collection was worth no less than 400,000 francs, a figure almost equal to the price paid for the family house on rue de Miromesnil in Paris ten years earlier. Even allowing for exaggeration and taking into account monetary fluctuations and changes in the collection's cash value, this figure clearly indicates that the two brothers had made a considerable investment in their philatelic passion. According to *Le Rappel*, the principal purchaser was a British collector, T. K. Tapling; reportedly he replaced his collection with that of the Caillebotte brothers, which was more systematic than

his own. Shortly after, in 1891, he left all of his holdings to the British Museum; they are now in the British Library in London.

19 See the codicil to Gustave Caillebotte's will, cited in Chronology, 1883.

20 See Chronology, 1891.

21 It is not known exactly when the two brothers abandoned rowboats in favor of the sailboats of Argenteuil. We have suggested 1877 or 1878 (see Chronology), but, given the speed with which Gustave began to make his mark in matters close to his heart, the second date seems the more plausible, for he appears to have won his first regattas in the fall of 1879 (see Chronology).

22 See Appendix IV under these years.

23 Beginning in July 1881, he wrote a column in the specialized magazine *Le Yacht* (see Appendix IV).

24 For details, see Appendix IV.

25 On this point, see Charles and Vibart 1993, pp. 91–114.

26 See Chronology, 1886.

27 See Chronology, 1888.

28 Van Gogh 1991, vol. 2, p. 571.

29 See Chronology, 1884–85, 1888, and 1891.

30 Geffroy 1922, p. 155.

31 A rule then in force stipulated that works by artists who had been dead for at least ten years were to be transferred to the Louvre.

32 See the letter from Camille Pissarro in Paris to his son, Lucien, dated "1 Mar." (Bailly-Herzberg 1988, letter 991). Several of the obituaries (including one that appeared in *Le Figaro* on 25 Feb. 1894) mention "a prolonged illness."

33 Monet said only that he preferred *Young Man at His Window* (cat. 59) to the *Floor-Scrapers* (cat. 3).

34 Archives du Louvre, Paris, P8 1896.

35 See Vaisse 1983 and the response by Chardeau 1983, published in extenso in the preface to Pontoise 1984.

36 Vaisse and Berhaut 1983 [1985], pp. 201–39. Marie Berhaut did not publish all of Renoir's letters to the administration, but those she omitted only confirm meetings or acknowledge receipt of correspondence. Also previously unpublished, but much more interesting, are letters from Sisley and Pissarro expressing their views concerning the choice of their works (Appendix II). Furthermore, one of the documents in Berhaut's dossier (ibid., p. 233, no. 21) is incomplete: it lacks a paragraph containing the list of works initially submitted to the administration for examination by Caillebotte's heirs and testamentary executor, an important passage that proved useful to the present author in assessing the estate inventory. It is also worth noting that, by coincidence, the date of this examination, 19 March, was the very day of the auction at Galerie Georges Petit of the collection of Théodore Duret, a critic and friend of Manet. This sale irritated the artists whose paintings were involved (they accused Duret of speculation), but it was undeniably a test of the current market viability of Impressionist works. The results were middling. Interestingly the administration seized this occasion to buy one of its first Impressionist paintings, *Young Woman in Ball Dress* by Berthe Morisot (1879; Musée d'Orsay, Paris), who was the only major Impressionist not represented in Caillebotte's collection.

37 See G. Lacambre, "Les Achats de l'Etat aux artistes vivants: le musée du Luxembourg," in Paris, Musée d'Orsay, *La Jeunesse des musées*, exh. cat. (1994), pp. 269–77.

38 Proceedings of the Advisory Committee of the Musées Nationaux, 20 Mar. 1894 (Archives du Louvre, Paris); see Vaisse and Berhaut 1983 [1985], p. 224.

39 A letter from Martial Caillebotte to Renoir dated 18 Apr. 1894 is clear on this point (ibid., p. 227).

40 See especially the report from Bénédite to the director of the Musées Nationaux dated 22 June 1894 (ibid., p. 228).

41 There is nothing exceptional about the administrative delay, given the complexity of the matter in question. For pertinent documents, see ibid., pp. 231, and 233–34. For detailed information about the selection of works, see the discussion of the estate inventory and the letters by Sisley and Pissarro published below (Appendices I and II). The two Millet drawings were immediately accessioned for the Louvre.

42 On the purchase of the Berthe Morisot, see notes 36 and 49.

43 Letter from Camille Pissarro to his son Lucien, dated 29 Apr. 1897 (Bailly-Herzberg 1989, letter 1395).

44 Letter from Monet to Geffroy dated 1 Feb. 1897 (Wildenstein 1991, letter 2964 [1364 bis]). On 16 Feb. 1896, Geffroy wrote in Le Journal: "It's a corridor that's not very long, in which all the canvases touch one another, and not very wide, such that all the canvases are face à face to a truly excessive degree." I am unaware of any photograph of this installation, but a small sketch, probably by Bénédite, now in the archives of the Musées Nationaux (2HH1, attrib. 1895) seems to represent this hanging. It shows Renoir's Ball at the Moulin de la Galette above his Railway Bridge at Châtou, The Reader, and Banks of the Seine at Champrosay, all of which are flanked by The Swing (left) and Torso of a Woman in Sunlight (right). In the case of Monet, The Luncheon hangs above Church at Vétheuil (Snow), The Rocks of Belle-Ile, and Hoarfrost, flanked by Gare Saint-Lazare atop The Tuileries (left) and Apartment Interior atop Regattas at Argenteuil (right).

45 On this point, see the discussion of Gustave Caillebotte's estate inventory in Appendix I.

46 For the letter of protest from members of the Académie des Beaux-Arts, as well as an excerpt from the proceedings of the Senate meeting of 15 Mar. 1897 (speech by Senator Hervé de Saisy), see Vaisse and Berhaut 1983 [1985], pp. 234–37. An article by A. de Lostalot in the 20 Mar. 1897 issue of L'Illustration observes that, while inciting the anger of the institute "is certainly no certificate of merit, neither is it a condemnation without the possibility of appeal." The tone of these remarks suggests that "average" opinion was by this time prepared to tolerate the Impressionists, and on occasion to appreciate them.

47 See, for example, Geffroy 1894: "Caillebotte was a man of conviction, and what he left behind surpasses the work of an amateur. He might have found [in art] only a pretext for creating diversion in his life, making do with facility and superficiality in his painting. He was his own master, sure of his future, and he had passions for gardening and boating. All the same, he subjected himself to the labor of painting. If he'd had to make his own way in the world, he would doubtless have been tenacious, and would have made more of a mark on the art of his time. Nonetheless, he leaves a series of honorable works, and a few characteristic ones."

48 See the letter from Monet to Geffroy dated 31 May 1894 (Wildenstein 1991, letter 2914 [1244a]); and the letter from Renoir to Martial Caillebotte, undated, in which he announced that the exhibition was to open "at the end of May toward the 30th," adding that, as to the frames, there was "a small joiner's shop that will take care of all that for an acceptable price" (unpublished letter, family archives). It would seem that the idea of mounting such an exhibition was in the air, for the obituary in Le Rappel (27 Feb. 1894) specified that Caillebotte had died "at the moment his friends were planning an exhibition of his works."

49 A bit more than half the works shown were for sale at prices that varied, according to annotated exhibition catalogues (family archives; Durand-Ruel archives, Paris), from 300 to 4,000 francs, this last figure being the price of The Bezique Game (cat. 80) and Paris Street; Rainy Day (cat. 35). In these same years, canvases from Monet's Rouen Cathedral series sold for 10,000 francs; an early Degas could fetch 30,000 francs; Renoir's Dancing at Bougival (1882–83; Museum of Fine Arts, Boston) sold for 13,000 francs; and Morisot's Young Woman in Ball Dress brought 4,500 francs (see note 36). Marie Berhaut noted the purchases made by Faure (Berhaut 1994, nos. 216 and 275). Caroline Godfroy-Durand-Ruel and France Daguet have graciously informed us that the prices he paid for these works were, respectively, 1,200 and 600 francs (reflecting a reduction of the figures of 1,500 and 800 francs annotated in the catalogue). It was Faure who arranged Jean Blum's purchase of two works (Berhaut 1994, nos. 348 and 439, for 400 francs each instead of the annotated 500 and 600 francs). As for the works acquired by Decap (Berhaut 1994, nos. 263 [cat. 103], 334, 484 [cat. 113], and an unidentified Bord de Seine, Argenteuil), he paid 1,500 francs each for the first two and 500 francs each for the last two. Tavernier purchased a La Seine à Argenteuil (The Seine at Argenteuil, for 400 instead of 500 francs) and a Digue à Argenteuil (Embankment at Argenteuil, 400 francs) neither of which has been identified by Berhaut. Murat bought Berhaut 1994, no. 478 (500 francs). With the addition of the names of the two financiers Ernest May and Léon Clapisson, we have listed all the collectors, aside from Caillebotte's family and friends, whose interest in his art prior to 1900 is documented. Ernest May probably owned works by the artist as early as 1879: he lent a pastel, The Yerres Valley (Berhaut 1994, no. 92), to the 1879 Impressionist exhibition (see also Berhaut 1994, nos. 91 and 272). As for Clapisson, it was at his sale on 28 Apr. 1894 that Martial Caillebotte repurchased two of his brother's pastels (Berhaut 1994, nos. 171 and 172). It is worth adding that the dealer Ambroise Vollard was also interested in Caillebotte: on 24 May 1897, he bought one lot of works from the "Caillebotte brother"; on 2 Apr. 1898, he purchased a Caillebotte at Hôtel Drouot, then another lot from Martial Caillebotte on 25 Oct. 1899. He resold some of these holdings to regular clients: Denys Cochin (May 1897), Olivier Sainsère (26 July 1897), the Dutchman Hoogendijk (3 June 1899), the Berliner J. Elias (5 May 1911), Count Doria (27 July 1912), and other dealers (Rosenberg, 16 July 1899). Martial's address appears in Vollard's address book, and it seems probable that, if the latter had not died in 1910, the commercial dispersion of Gustave's work that began with these transactions would have continued (Vollard account-book, Bibliothèque du Louvre, Paris).

50 The annotated exhibition catalogue notes that number 84, Yellow Roses (Berhaut 1994, no. 240), had been reserved for Degas; the canvas figured in the sale of the Degas collection at Galerie Georges Petit in Paris on 26–27 Mar. 1918, as number 7, Flowers. Monet, who owned several works by Caillebotte (cats. 36 and 81), also possessed a canvas entitled Flowers (cat. 114). Is it the one in question in a letter from Monet to Durand-Ruel dated 30 Mar. 1894 (Wildenstein 1979, letter 1235): "You will be so kind as to send me my Cézanne and the canvas of flowers that Martial Caillebotte is supposed to have left with you for me?" Was the Cézanne also a gift from Martial? Renoir must have received a work by Caillebotte at about the same time, but he is known to have possessed several (Berhaut 1994, nos. 257, 277, 418, and 485), some of which were presumably given to him by Gustave himself.

51 Marie Berhaut was the first to attempt a systematic catalogue of Caillebotte's oeuvre, in Paris 1951.

Catalogue

The catalogue entries are written by:

ANNE DISTEL (A. D.)

DOUGLAS W. DRUICK (D. D.)

GLORIA GROOM (G. G.)

RODOLPHE RAPETTI (R. R.)

JULIA SAGRAVES (J. S.)

Gustave Caillebotte did not systematically sign and date his works. After his death, his brother Martial Caillebotte and his estate executor, Pierre Auguste Renoir, added signatures to some of them; others were stamped with the cachet "G. Caillebotte" in blue (see Berhaut 1994, p. 60). These instances have been noted in the catalogue when it was possible to verify them by examination of the work.

Full citations for exhibitions and publications referenced in the entries are provided in the list of exhibitions and general bibliography at the back of the volume.

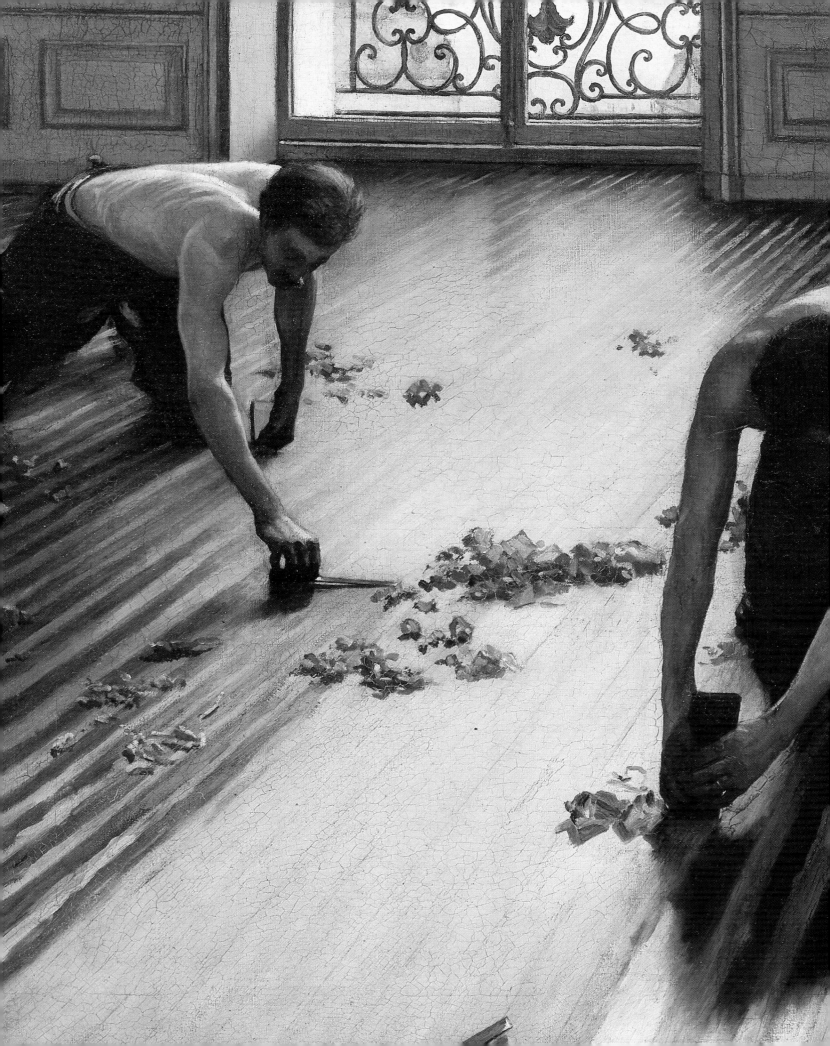

G.Caillebotte

In April 1876, two years after the Impressionists' first exhibition, which had created something of a stir in the Parisian art world, the group—then still called the "Independents" or "Intransigents," and sometimes the "Intentionalists" or "Impressionalists"—once more presented work to the public, this time at the dealer Durand-Ruel's premises on rue Laffitte. The exhibition featured works by Degas, Monet, Morisot, Pissarro, Renoir, and Sisley, as well as Béliard, Bureau, Cals, Lepic, Levert, Ottin, Jr., and Rouart—all veterans of the first exhibition. While there had been many defections in the interim, the group also had gained some new recruits: Desboutin, Jacques François (a pseudonym adopted by a woman painter), Legros, Jean Baptiste Millet (brother of the more renowned Jean François Millet), Tillot, and, above all, Caillebotte. They took care to schedule their exhibition prior to the official Salon to make it clear that they were not, in any strict sense, the *refusés* of its jury. Only after the opening did it become known that Manet, who had again refrained from joining their ranks (despite the fact that he was widely regarded as their leader), had been rejected by the Salon jury and was organizing a public showing of his work in his studio on rue de Saint-Pétersbourg.

Gustave Caillebotte was then a young painter of twenty-seven years, only recently emancipated from the highly orthodox tutelage of his teacher, Bonnat—in 1879 the columnist Montjoyeux maintained that Caillebotte was working in his master's studio as late as 1876—and the Ecole des Beaux-Arts, and had yet to exhibit his work. How did he come to find himself in such company?

One thing is certain: it was Rouart and Renoir who formally solicited his participation in their enterprise at the beginning of February 1876 (see Chronology). But how did they know him? All answers must be hypothetical: Henri Rouart, who was fifteen years older than Caillebotte, was his neighbor on rue de Lisbonne; they had similar backgrounds, for both were the sons of bourgeois Parisian parents who had raised them to be independent property owners (and both of their fathers worked for the army, with Rouart supplying braid and Caillebotte providing heavy-duty textiles [beds, blankets, etc.], which he was also contracted to maintain). Henri Rouart, who in addition to being a painter was also a polytechnician and engineer, was already one of the most committed financial supporters of his relatively impoverished colleagues, especially Renoir. Furthermore, he was a good friend of Degas, who Pissarro was to claim much later had been responsible for introducing Caillebotte to the group. And certainly all these artists were acquainted with the Italian painter Giuseppe De Nittis, who, after having enjoyed a notable success at the Salon of 1872 with his *Road from Naples to Brindisi (Italy)* (cat. 1, fig. 1),

had taken part in the group's 1874 exhibition, despite the fact that he was to have another gratifying success at the Salon of 1875 with his *Place de la Concorde after the Rain* (ch. 3 intro., fig. 12). It was he who noted that Caillebotte was refused by the jury that same year. This network of relations, along with the experience of having been rejected by the Salon at the dawn of his career, is sufficient to explain Caillebotte's joining the group.

What were Caillebotte's artistic predispositions in 1876? A few days before the outbreak of the Franco-Prussian War in 1870, he earned his law degree, the fruit of a course of study doubtless approved, and perhaps imposed, by his father; he may have received rudimentary drawing instruction as a part of his secondary education, but it was probably not before 1871 that he began his formal apprenticeship in painting. Little is now known of Caillebotte's experience in Bonnat's private studio: he probably frequented it from at least 1871 (he had acquired sufficient skill to qualify for admission to the Ecole des Beaux-Arts in February 1873), and he may have remained there until the beginning of 1876, as already noted. We do not know why he chose this master.[1] Léon Bonnat (1833–1922) was not yet the conspicuous figure he was to become in the course of the 1880s; unlike Jean Léon Gérôme (1824–1904) or even Alexandre Cabanel (1823–1889), the most fashionable teacher at the time, he did not yet have a studio at the Ecole des Beaux-Arts, even though he often figured on the many examination juries that periodically assessed its students' progress. In any event, Bonnat, whose own training had been underwritten by Bayonne, his native city, and who had won—barely—the Prix de Rome, was celebrated at age forty as a painter of Spanish and orientalist subjects, as the author of a *Christ* (1874; Musée du Petit Palais, Paris) whose virile realism caused a sensation at the Salon of 1874, and as a portraitist (his austere *Portrait of Mme Pasca* [1874; Musée d'Orsay, Paris] was a great success at the Salon of 1875). These qualifications might well have drawn Caillebotte to him. It was probably Bonnat who urged Caillebotte to apply to the Ecole des Beaux-Arts in 1873. But the young painter seems to have been even less attentive to his studies at the school and to the teaching of its professors (Cabanel, Gérôme, Pils, and Yvon[2]) than were Degas and Renoir, the only members of the future Impressionist group to cross its threshold before him. Caillebotte's career, like that of every young artist in this period, really began with his submission of a work to the jury of the official 1875 Salon; and his activities as an "Independent" commenced with his exhibiting at least one work in the spring 1876 exhibition of the Impressionists at Durand-Ruel that had been refused by that same jury.[3]

Caillebotte's first showing revealed a mature painter: press commentary on the work by this previously unknown debu-

tant was exceptional, both in its frequency and its extent. In an ensemble of nearly three hundred works (almost a quarter of which were prints) by nineteen artists, Caillebotte exhibited no fewer than eight paintings, rather large ones hanging in the best room, which meant that his canvases were shown to much better advantage than they would have been in the crush of the official Salon, whose catalogue included, depending on the year, between 2,000 and 4,000 entries by anywhere from 1,500 to 2,000 artists. The paintings by Caillebotte most often cited were the two versions of *Floor-Scrapers* (cats. 3 and 5; not often distinguished from one another), *Young Man Playing the Piano* (cat. 71), *Young Man at His Window* (cat. 59), and *Luncheon* (cat. 72); these are also the images with the most unmistakable subjects. The three other works in the catalogue—two entitled *Jardin* and another entitled *Après Déjeuner* (doubtless the "*Oarsman* half-reclining near a table" admired only by Georges Rivière)—have not been identified.[4]

It is regrettable that the exhibition's two most famous commentators, Stéphane Mallarmé and Henry James,[5] each of whom wrote an account of the exhibition for the English-speaking public, failed to mention Caillebotte. Thus it is the opinions of professional critics, gifted in varying degrees, that have come down to us. All of them attempted to characterize the group; and, whether pro—for the Impressionists had their early defenders—or con, they all sought to situate the newcomer within it. Their most venomous opponents, for exam-

ple, Albert Wolff and Georges Maillard, who let fly against Degas, Monet, Pissarro, and Renoir, neglected to mention Caillebotte[6]—a compliment of sorts; another unsympathetic critic, Emile Porcheron, even wrote that "the canvases of M. Caillebotte [are] the least bad of the exhibition."[7] There were many who, opposed "to the exclusive adepts of the blot," emphasized that Caillebotte, like Degas, would make "a finer impression among the better painted, better drawn works in the official Salon."[8] Supporters of "The New Painting" celebrated by Edmond Duranty,[9] while predicting a fine future for the young artist, tried to pin down his artistic parentage: he was said to be a "Realist" following in the footsteps of Courbet and Manet[10]; but his vigorous draftsmanship reminded Philippe Burty of the Florentine primitives[11]; and Georges Rivière declared him to be "a student of M. Degas."[12] As for Emile Zola, the most outspoken champion of Manet and his colleagues, his assessment amounts to a dismissal, though one couched in reserved terms and accessible only to readers in Marseilles and St. Petersburg: "Caillebotte has some *Floor-Scrapers* and a *Young Man at His Window*, astonishing in their relief. But this is very much anti-artistic painting, tidy painting, a mirror, bourgeois in its precision. Tracings of the truth, without the painter's original expression, are poor things."[13] But this harsh note was largely drowned out by the consensus view, nicely summed up by Emile Blémont: "M. Caillebotte is a newcomer to be welcomed."[14] A. D.

NOTES

1 One of the rare known accounts of Bonnat's teaching is that of the young Danish painter Larits Tuxen, who entered the master's studio in the fall of 1875 after having abandoned his first choice, that of Cabanel, because it was overcrowded. He reported that Bonnat's studio was open from eight in the morning until ten-thirty at night, that most of the work done there was after the live model, and that the atmosphere, despite the inevitable students' high jinks, was very conducive to hard work (letter from L. Tuxen in Paris to J. Lange, dated 21 May 1878, cited in Randers Museum, *Modested Paris, 1880'Ernes Avant-garde* [1983], pp. 49–50; I am grateful to B. Skibsted for translating this letter for me).

2 According to De Nittis, who was a student of Gérôme, Caillebotte taught his friend's young son the following mocking refrain: "Ah! ah! ah! Que la vie serait belle / Si j'étais, ça, si j'étais, ça, si j'étais Cabanel. / Ah! ah! ah!" ("Ah! ah! ah! How beautiful life would be / If I were, if I were, if I were Cabanel") (De Nittis 1990, p. 138).

3 Whether out of ignorance or tact, the critics of 1876 did not mention this rejection—except for Emile Blémont, who on 9 Apr. observed in *Le Rappel*: "M. Caillebotte was not admitted last year by the jury with one of the paintings he now shows us. A point very much to the discredit of . . . the members of the official jury." The canvas in question was probably the large version of *Floor-Scrapers* (cat. 3).

4 G. Rivière 1876, as cited in Dax 1876. See Berhaut 1994, no. 2.

5 Mallarmé 1876; James 1876.

6 Wolff 1876; Maillard 1876.

7 Porcheron 1876.

8 Lostalot 1876b. The same assessment is also made in Lostalot 1876a; similar views were expressed by Bertall 1876b, Bigot 1876, Boubée 1876, Enault 1876, and Olby 1876.

9 Duranty 1876; repr. and trans. in San Francisco 1986, pp. 477–84 and 37–44, respectively. Duranty cited no names, but in a discussion of the subject matter preferred by the new "school," he alluded to *Young Man Playing the Piano* (cat. 71) (in conjunction with Degas's *Portraits in an Office [New Orleans]*), *Luncheon* (cat. 72), and original perspective views similar to those found in Caillebotte's work (see pp. 482 and 44).

10 See Baron Schop 1876, Chaumelin 1876, and Silvestre 1876.

11 Burty 1876a.

12 G. Rivière 1876, as cited in Dax 1876; on the relation between Caillebotte's work and that of Degas, see also note 9.

13 Zola 1876a; a portion of this article (including the discussion of Caillebotte) was published in Russian (Zola 1876b); see Zola 1991, pp. 314 and 353.

14 Blémont 1876.

1
A Road near Naples

(Une Route à Naples)

c. 1872
Oil on canvas
40 × 60 cm
Stamped lower right
Berhaut 1978, no. 3; Berhaut
1994, no. 6

Private collection

Principal Exhibitions
Paris 1894, no. 14, as *Une Route à
Naples (1872)*, priced at 500
francs (according to an annotat-
ed catalogue in the Durand-Ruel
archives, Paris); Paris 1951, no. 1;
London 1966, no. 1; New York
1968, no. 1; Houston and Brook-
lyn 1976–77, no. 4; Marcq-en
Baroeul 1982–83, no. 1.

Selected Bibliography
Berhaut 1968, p. 6; Berhaut 1978,
p. 8; Varnedoe 1987, no. 3; Balan-
da 1988, pp. 56–57; Wittmer 1990,
pp. 268 and 275.

It was under this title and the date 1872 that this painting was exhibited, apparently for the first time, after Caillebotte's death in 1894. Little is known about the trip the artist seems to have made to Naples with his father. During this sojourn Caille-botte probably visited the Italian painter Giuseppe De Nittis, a former student of Gérôme then trying to make a name for himself in France, who in fact exhibited *Road from Naples to Brindisi (Italy)* (fig. 1) at the 1872 Salon, where it was well received. This very small work features a rustic carriage similar to the one depicted by Caillebotte. The rectangle be-hind the front seats of the carriage seems to be the back of a stretched canvas with the tip of a painter's cap visible above and a palette with multicolored patches to the side. Caillebotte's image alludes only vaguely to the Neapolitan landscape.

With its plunging perspective and the dark shad-ow cast by the horse in the harsh light, this youth-ful canvas already bears the stamp of the artist's personality and suggests that his apprenticeship was quite advanced by this time. It is also possible that the work was painted during an unconfirmed Neapolitan journey by the artist in 1875.[1] A. D.

1 See Chronology, 1875.

Figure 1. Giuseppe De Nittis
(Italian; 1846–1886). *Road from
Naples to Brindisi (Italy)*, c. 1872.
Oil on canvas. Location and
dimensions unknown.

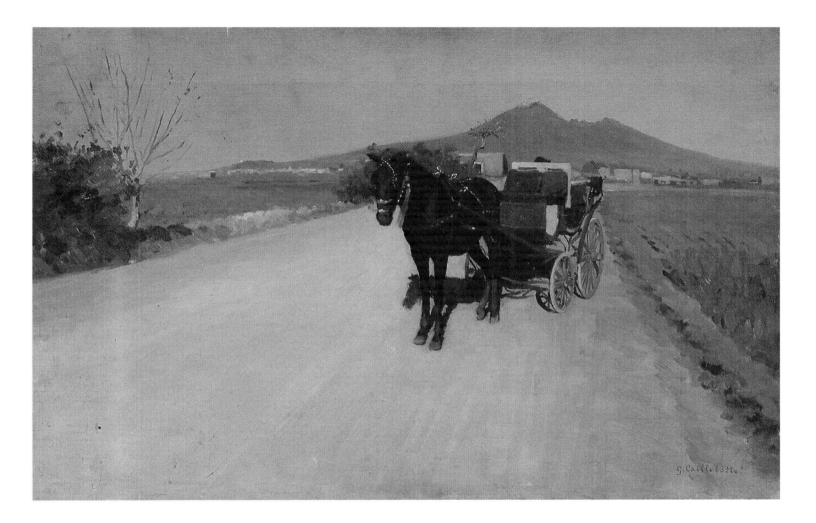

2
Studio Interior
(Intérieur d'atelier)

1872/74

Oil on canvas

81 × 65 cm

Stamped lower right

Berhaut 1978, no. 5; Berhaut 1994, no. 10

Private collection

Principal Exhibitions
Paris 1951, no. 2; New York 1968, no. 2; Houston and Brooklyn 1976–77, no. 5.

Selected Bibliography
Berhaut 1968, p. 7; Berhaut 1978, p. 8; Varnedoe 1987, no. 6; Balanda 1988, pp. 58–59; Lacambre 1988, p. 183, fig. 302; Wittmer 1990, pp. 262–63.

Is this Caillebotte's own studio, as is suggested by the initials *G. C.* visible on the back of a canvas turned against the wall, or that of a friend? There is no sure answer, nor is it possible to ascribe a precise date to this early work. From about 1874 Caillebotte had a studio in his parents' home on rue de Miromesnil, on the fourth floor above a porch overlooking rue de Lisbonne, but prior to that time he might well have used another of the house's many rooms.

Caillebotte's composition reflects a well-established tradition associated with the artist's studio; among its most recent exemplars were Eugène Delacroix's *Studio Corner; The Stove* (c. 1825; Musée du Louvre, Paris) and two paintings by Frédéric Bazille (1865; Musée Fabre, Montpellier; and 1867; Virginia Museum of Fine Arts, Richmond), the latter more casually composed than Caillebotte's carefully ordered image.

Kirk Varnedoe attempted to identify the various objects depicted. The most clearly recognizable one is a small plaster replica of Jean Antoine Houdon's *écorché* ("flayed figure") with an outstretched arm, an indispensable pedagogical aid for anatomy students since the end of the eighteenth century. Some of the pictures hanging on the wall are probably by Caillebotte (e.g., the small, unframed landscape sketch), while others are perhaps by another artist (e.g., the framed, waist-length study of a woman). The most interesting objects are those that reflect the current vogue for Japanese art: the plates and vases appear to be Japanese porcelains intended for everyday use, while the paper lanterns and the two oblong panels on the wall to the left are certainly of Japanese origin. Geneviève Lacambre identified the latter as triptychs, perhaps mounted on cardboard, by *ukiyo-e* artists active in the 1860s, perhaps Yoshitora or Yoshikazu, some of whose prints, featuring striking oblique perspectives, represent strangers being received by geishas in teahouses in Yokohama. Varnedoe identified them not as prints but rather as reproductions of paintings in the *yamato-e* style. Though it is known that Caillebotte's father, followed by his sons Gustave and Martial, collected old ceramics, especially from Rouen, there is no documentation of their having acquired Japanese objects, such as those widely collected in France after the Paris Universal Exhibition of 1867. On the other hand, it seems clear that Caillebotte, like his Impressionist colleagues, was drawn to many of the systems of spatial representation characteristic of the Japanese. A. D.

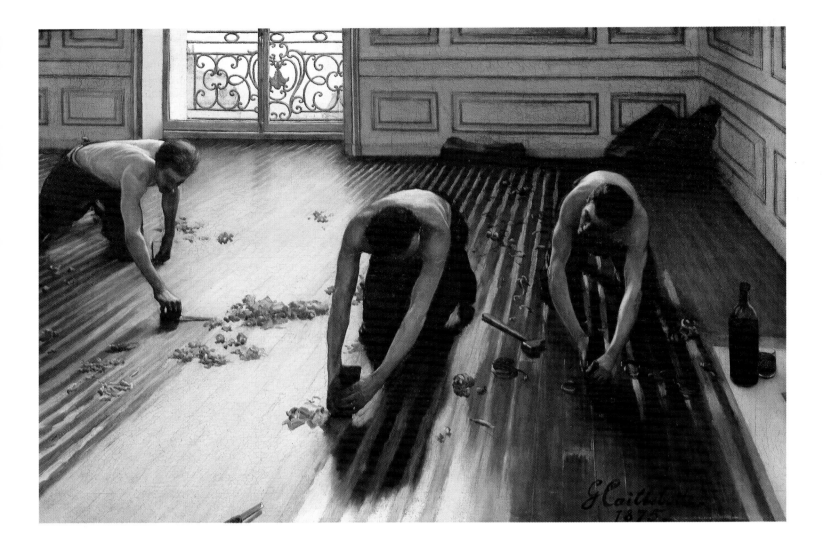

3
Floor-Scrapers
(Raboteurs de parquets)

1875

Oil on canvas

102 × 146 cm

Signed and dated lower right:
G. Caillebotte / 1875

Berhaut 1978, no. 28; Berhaut
1994, no. 34

Musée d'Orsay, Paris (Gift of the
artist's heirs, 1894; RF 2718)

Principal Exhibitions
Paris 1876, no. 17 or 18; New York
1886, no. 30, as *The Planers*, priced
at 3,300 francs (according to an
annotated catalogue in the
Durand-Ruel archives, Paris); Paris
1894, no. 29, as "belonging to the
Musée du Luxembourg"; Houston
and Brooklyn 1976–77, no. 8; San
Francisco 1986, no. 19.

Contemporary Criticism
Baignères 1876; Baron Schop 1876;
Bertall 1876a and b; Bigot 1876;
Blémont 1876; Boubée 1876; Burty
1876a and b; Chaumelin 1876;
Enault 1876; Lostalot 1876a; Olby
1876; Porcheron 1876; Pothey 1876;
G. Rivière 1876, cited in Dax 1876;
Silvestre 1876; Zola 1876a and b;
Baron Schop 1877; Burty 1877;
Mantz 1877; Montjoyeux 1879.

Selected Bibliography
Geffroy 1894, p. 289; Sertat 1894;
G. Rivière 1921, p. 101; Geffroy
1922, p. 93; Paris 1951, no. 7; Ster-
ling and Adhémar 1958, no. 151;
Bodelsen 1968, p. 336; Nochlin
1971, pp. 157 and 263; Adhémar
and Dayez 1973, p. 139; Berhaut
1977, p. 43; Rosenblum 1977,
p. 52; Berhaut 1978, pp. 29, 33, and
50; Thomson 1984, p. 81; Varnedoe
1987, no. 8; Balanda 1988, pp. 64–
65; Herbert 1988, p. 19; Chardeau
1989, pp. 14–19; Rosenblum 1989,
p. 322; Wittmer 1990, pp. 294–95;
Roquebert 1991–92, no. 21; Weis-
berg 1992, p. 55.

Film
Les "Raboteurs" de Caillebotte, di-
rected by Cyril Collard, choreo-
graphed by Angelin Preljocaj, music
by Thierry Lancino, produced by
the Musée d'Orsay, Paris, 1989.

When the first critical accounts of the 1876 exhibition appeared, its catalogue had not yet been printed and this painting's title, *Raboteurs de parquets*, had not yet been definitively assigned. Whether it was called *Parqueteurs à l'ouvrage*[1] or *Racleurs de parquet*,[2] the work instantly attracted notoriety because of its surprising subject. One conservative critic, Louis Enault, summed up the prevailing view as follows:

> The subject is doubtless vulgar, but we under-stand how it might tempt a painter. . . . These ro-bust fellows who unabashedly put aside any en-cumbering clothing . . . , thus present an artist wanting to paint nudes with torsos and shoulders that other craftsmen would not expose so freely. The floor-scrapers of M. Caillebotte are certainly not at all badly painted, and the perspective effects have been well studied by an eye that sees accu-rately. I regret only that the artist did not choose his types more carefully, or that, from the moment he had accepted what reality offered him, he did not claim for himself the right, which I can assure him no one would have denied him, to interpret them more freely. The arms of his floor-scrapers are too thin, and their chests too narrow. Do the nude, gentlemen, if the nude suits you. . . . But ei-ther make your nude beautiful or leave it alone.

The message is clear; doubtless this was the principal rationale behind the work's probable rejection by the jury of the 1875 Salon, mentioned by the critic Emile Blémont.[3] It also suggests why the official Salon catalogues of these years include so few depictions of workers, except for peasants, who were deemed acceptable. And they were often incorporated into ancient, Italian, Moroccan, or Breton subjects, considered sufficiently distant in time or place to permit a certain "interpretive" freedom. As Richard Thomson and Anne Roque-bert have recently reminded us, the young Henri de Toulouse-Lautrec, who like Caillebotte was a student of Bonnat, as late as about 1884 painted a male model in the pose and heroic dress of a cele-brated ancient statue (an exercise recommended by Thomas Couture in his *Méthodes et entretiens d'atelier*) rather than a contemporary worker un-dertaking a menial task (fig. 1). Bonnat, however, according to one of his students, the Danish artist Laurits Tuxen, encouraged his students to favor the true over the beautiful and to respect the spe-

cific character of their models[4]; but this advice pertained to studio practice and the depiction of professional models who had been selected pre-cisely in view of their suitability for historical or religious subjects. Caillebotte's floor-scrapers, by contrast, are men at work, and they can be construed only as such. Likewise, when Couture urged his students to draw people in the street, in their natural milieus, he did so with the aim of sharpening their eyes and quickening their hands, not with the intention of endorsing such subject matter for its own sake. In his discussion of Caille-botte's *Floor-Scrapers*, Pierre Wittmer cited a pas-sage from Delacroix's *Journal* (7 Sept. 1856) in which the diarist reported having observed from his window the different colors of the flesh of a floor-scraper, nude from the waist up, and the building's exterior wall; the great painter, so ad-mired by the Impressionists, was content to make such an observation but not do a painting of it.

It is amusing to note that, for a member of a prosperous bourgeois family such as Caillebotte's, opportunities to paint laborers at work would have arisen as a matter of course; in fact, Varnedoe and Marie Berhaut have both reported that, according to a family tradition, the image depicts a room in the family's house on rue de Miromesnil. In fact, work was undertaken in the Caillebotte residence in 1874, and then in the building next door, which was also owned by the family, but neither old de-scriptions nor the present state of these premises allows us to determine the precise location of such renovations and thus confirm the anecdote.

There is no denying, however, that this choice of subject constituted a deliberate challenge to offi-cial doctrine and instantly situated the artist in the Realist current: "In his *Floor-Scrapers*, Caillebotte declares himself to be a Realist as crude and intel-ligent, in his own way, as Courbet, as violent and precise, again in his own way, as Manet," affirmed Marius Chaumelin. By way of exploring the impli-cations of these comparisons, it might be worth determining what works by Courbet Caillebotte could have actually seen. In any event, *Floor-Scrapers* is somewhat reminiscent of *The Stone-breakers* (1849; destroyed, formerly Gemäldega-lerie, Dresden), which Courbet exhibited at the Salon of 1850–51, although the latter's moralizing character was more pronounced and had already occasioned sarcastic commentary from the critic

continued on page 38

Figure 1. Henri de Toulouse-Lautrec
(1864–1901). *Academy: the Marble-Polisher*,
c. 1884. Oil on canvas; 65 × 81 cm. Private
collection, New York.

Enault. The comparison with Manet obviously had more to do with a common penchant for combative dissidence than with any shared subject matter. Instead, Caillebotte's documentary exactitude, which here resulted in precise visual description of the workers' tools, the way they were used, and even such details as the wedding ring worn by the laborer in the center, is more analogous to the sharp eye of Degas, the bourgeois who explored the world of laundresses (several works with such themes figured in the 1876 exhibition) in compositions that so enchanted the Goncourt brothers. Both Georges Rivière and Arthur Baignères stressed this relationship. Finally, Emile Zola, who, when Caillebotte painted this canvas, was himself exploring the city's popular neighborhoods in preparation for his novel *L'Assommoir* (Paris, 1877), here saw a "tracing of the truth," although he did not care for the handling, which he found "bourgeois in its precision."[5] In short, the choice of such a subject was sufficient to align Caillebotte with those who, "undertaking vast series on the world's people, priests, soldiers, peasants, workers, merchants," were inventing "The New Painting," described by Duranty which paralleled the contemporary Naturalist strain in literature. Recently, Robert Rosenblum observed that Caillebotte's "three men oddly echo, in reverse, Millet's famous trio of gleaning women from the 1857 Salon [*Gleaners*; Musée d'Orsay, Paris], translating their agrarian remoteness into the immediacy of urban laborers who are building a new and modern Paris." Linda Nochlin, for her part, stressed that Caillebotte, like Degas and Monet, painted "the labor of the urban proletariat" without producing visual manifestos and without insisting on this theme "as the *point* of the painting"[6]—as in the work of several contemporary English graphic artists, for example. It should also be noted that Caillebotte's image does not indulge in the picturesque pathos of urban types so characteristic of the paintings of Jean François Raffaëlli, his exact contemporary. Caillebotte's sober figures, resembling butterflies pinned in a box, make for a memorable composition that, in the end, transcends its specific context to become a symbol of manual labor in general.

In addition to the subject matter, contemporary critics faulted Caillebotte's treatment of perspective, which, while not incorrect (one even wrote that his eye "sees accurately"), struck them as "bizarre" and even "a bit mad, since instead of working on a horizontal plane the unfortunates [the floor-scrapers] move over a floor that is inclined and threaten to slip down onto the unsuspecting spectator."[7] No one professed to find it *japonais*, as we tend to today—perhaps incorrectly, given the little we do know about the painter's interest in Japanese prints. On the other hand, Caillebotte's spatial system is not so very different from that used by Degas in his famous painting *Portraits in an Office (New Orleans)* (1873; Musée

des Beaux-Arts, Pau), exhibited at the same time as *Floor-Scrapers*. The point of view chosen by Caillebotte, with its plunging perspective, tilted upward so as to eliminate all but a low strip of the room's far walls, and its off-center vanishing point, is clearly a deliberate provocation intended to challenge the eye's ingrained habits of perception. The artist seems to have carefully jumbled the reference points in his glistening space: it is difficult, for example, to trace an exact schema of the orthogonals, which converge on a point outside the frame, even though the floorboards suggest that such a system is self-evident. Veritable illusionist tricks—such as the tool cropped by the composition's lower edge, the long shadows, and the wine bottle and glass (which seem out of scale)—engage the viewer's gaze, which is already startled by the pronounced *contre-jour* effect.

This vertiginous space instantly evokes for twentieth-century viewers the conventions of photography and film. Although he stressed the absence of any documentation proving that Caillebotte used photographs, Gabriel Weisberg suggested that he was aware of the medium's potential and conceived his several compositions around the *Floor-Scrapers* theme as a series (see cat. 5). This hypothesis is appealing but difficult to sustain, for photographs of interiors were rare in this period. It should also be noted that, although Gustave's brother Martial was indeed an excellent photographer, his earliest known exposures date from December 1891 (see Introduction, figs. 4, 5, and 7–11). There is no evidence of either brother's having been interested in photography prior to that time.

As opposed to the flagrant modernity of Caillebotte's subject and the originality of his composition, the critics of 1876 were in agreement about the painter's traditional craftsmanship: "M. Caillebotte knows how to draw and deigns to paint," allowed the obscure Simon Boubée. This view finds confirmation in the various preparatory drawings (cats. 6–14) and in the small painted sketch (cat. 4), which differs slightly from the final composition. They reveal that the artist followed traditional procedures already rejected by Monet and Renoir by this time. A technical examination of the painting[8] demonstrated that Caillebotte did not alter his overall composition in the course of work; his only modifications involved the handling of details (arms, hands) and the bottle; the pronounced cracking of the surface suggests a certain haste in the actual execution (indicating that underlying layers of paint had not had time to dry before new ones were applied), perhaps because of a rush to submit the work to the Salon jury. Pigment analysis (in X-ray florescence) demonstrated the presence of cobalt blue in the floor-scrapers' pants, obscured at first glance by the brown shadows and the intense bluish-gray tone of the walls. The proximity in the Musée d'Orsay of the *Portrait of Mme Pasca* by Bonnat, dated 1874 and exhibited

Figure 2. Anonymous. *Caillebotte as a Floor-Scraper,* c. 1882. Caricature clipped by Etienne Moreau-Nélaton from an unidentified source. Musée du Louvre, Paris.

CAILLEBOTTE (C. DE). — Un des plus jeunes pères de l'impressionnisme. A débuté par rabotes desparquets, puis paysagiste. A découvert aux Parisiens les beautés du panorama de la place de l'Europe, et les horizons de la rue Lafayette. S'adonne aujourd'hui aux natures mortes... à l'usage des millionnaires. Quand il passe devant une boutique dont l'étalage lui plaît, il entre, le couvre d'or — l'étalage — et le fait porter à son atelier pour lui servir de modèle.

at the Salon of 1875, and *Floor-Scrapers* points up the similar palette used in these two works, characterized by a restrained color scheme—brown, beige, and gray with ocher-based golden highlights—and a high degree of tonal control. In any event, although Bonnat apparently maintained, again according to Tuxen, that "one doesn't see brush strokes in nature," here his student ignored this advice. In his treatment of the little pile of wood shavings bathed in light, Caillebotte revealed his sensitivity to and taste for free handling.

Having attracted considerable attention when exhibited in 1876, the composition was put on the auction block at Hôtel Drouot—a gesture of solidarity, since the painter was scarcely in need of money—with works by Pissarro, Renoir, and Sisley on 28 May 1877,[9] on which occasion it was repurchased by the artist. It was even exhibited in New York in 1886 by Durand-Ruel. Thus the painting remained a presence in the minds of critics and Caillebotte's friends. There was even a caricature that identified him with his *Floor-Scrapers* (fig. 2). On the artist's death in 1894, Renoir, his testamentary executor, decided to supplement his bequest to the State with one of his friend's own paintings. With the approval of Martial Caillebotte, he selected *Floor-Scrapers*. Monet, who was also consulted, endorsed this choice, but suggested as an alternative the *Young Man at His Window* (cat. 59), which he remembered well enough to describe, adding that it "would be less conventional than *Floor-Scrapers*."[10] Renoir indeed queried Martial about it,[11] but the painting was no longer in his possession. Thus it was *Floor-Scrapers* that entered the Musée du Luxembourg, then the Louvre (1929), the Jeu de Paume (1947), and finally the Musée d'Orsay (1986), thereby becoming definitively associated with Caillebotte's name. A. D.

1 Lostalot 1876a.

2 Silvestre 1876.

3 See ch. 1 intro. n. 3.

4 See ch. 1 intro. n. 1.

5 Zola 1876b.

6 Nochlin 1971, p. 157.

7 Enault 1876, Lostalot 1876a, and Mantz 1877.

8 Undertaken by the Research Laboratory of the Musées de France, conducted by Myriam Eveno, Jean Paul Rioux, and Maurice Solier, with the assistance of Anne Roquebert.

9 Geffroy 1922; Bodelsen 1968.

10 Letter from Giverny, dated 6 Mar. 1894, in Wildenstein 1979, vol. 3, letter 1233 *bis*.

11 Unpubl. note, family archives.

4
Floor-Scrapers (Sketch)

(Raboteurs de parquets [esquisse])

1875
Oil on canvas
26 × 39 cm
Berhaut 1978, no. 27; Berhaut 1994, no. 33

Private collection

Principal Exhibitions
Paris 1921, no. 2702; London 1966, no. 3; New York 1968, no. 3; Houston and Brooklyn 1976–77, no. 9; Marcq-en-Baroeul 1982–83, no. 2; Pontoise 1984, no. 2.

Selected Bibliography
Varnedoe 1987, p. 56, fig. 8j; Chardeau 1989, p. 19.

In this first sketch for the large *Floor-Scrapers* of 1875 (cat. 3), the basic compositional scheme is already in place. The most notable differences are in the disposition of the wall moldings, the wider window, which here reveals a different view of the facing buildings (perhaps seen from a lower floor), and, above all, the posture of the floor-scraper to the left. The subsequent change in this figure's pose tends to direct the eye toward the central figure. The floor-scraper on the right looks down, whereas in the large version he tilts his head up to observe his colleague.

Varnedoe noted that the stroke made with a brush handle across the bottom of the canvas suggests that Caillebotte had decided to crop the image at that level.[1] Berhaut noted that Renoir owned a *Floor-Scrapers*, probably a sketch, that was in his son's possession in 1943,[2] but has since been lost. A. D.

1 See Houston and Brooklyn 1976–77, no. 9.
2 See Berhaut 1994, no. 34.

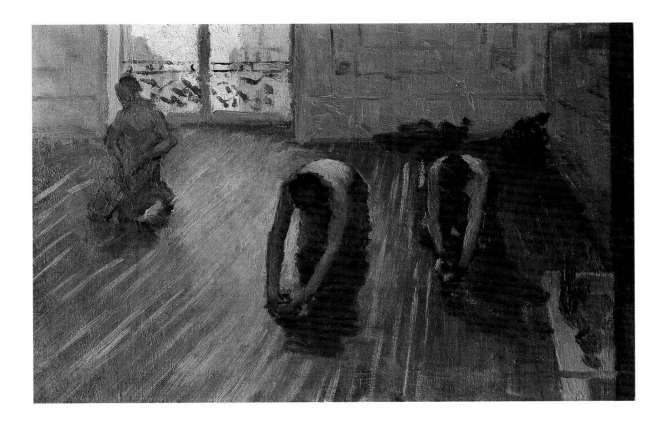

5
Floor-Scrapers (Variant)
(Raboteurs de parquet [variante])

1876
Oil on canvas
80 × 100 cm
Signed and dated lower left:
G. Caillebotte 1876
Berhaut 1978, no. 29; Berhaut 1994, no. 35

Private collection

Principal Exhibitions
Paris 1876, no. 17 or 18; Paris 1894, no. 13, as *belonging to M. Daufresne;* Paris 1921, no. 2708; Paris 1951, no. 5; Chartres 1965, no. 2; Houston and Brooklyn 1976–77, no. 10; Pontoise 1984, no. 3; San Francisco 1986, no. 20.

Contemporary Criticism
See the authors cited for cat. 3, especially Bertall 1876; Boubée 1876; Lostalot 1876a; and Porcheron 1876.

Selected Bibliography
Bodelsen 1968, p. 336; Berhaut 1978, p. 50; Varnedoe 1987, no. 9; Balanda 1988, pp. 66–67; Chardeau 1989, pp. 21–22, and 25; Weisberg 1992, pp. 55–58.

Clearly dated 1876, this variation on the floor-scraper theme, in a squarer format than the Musée d'Orsay canvas (cat. 3), was also presented at the 1876 Impressionist exhibition. The critics discussed it in general terms along with the large version; but two of them, Bertall and Porcheron, also commented on the young apprentice seated in the background. Porcheron, although quite antagonistic toward the Impressionists, was prepared to make an exception for Caillebotte, although he objected to the posture of this small figure, who "has abandoned his work to pursue a hunt over his own person that cleanliness would have rendered unnecessary." He was mistaken, however: the young man is not looking for lice, but rather working on one of his tools, as is confirmed by the preparatory drawings for the figure (see fig. 1 and cat. 9). Several drawings for this composition survive (cats. 6–9). Weisberg has proposed that one (cat. 6) suggests Caillebotte's use of photographs in working up this painting, but his appealing hypothesis is not supported by any tangible evidence. This drawing

Figure 1. Gustave Caillebotte. *Study for* Floor-Scrapers, drawing facsimile published in "Le Salon de 1876," *Zigzags à la plume à travers l'art,* 28 May 1876.

demonstrates that from the beginning Caillebotte attributed great importance to the cracks between the floorboards, which delineate most of the space. The present canvas, more stripped-down than the Orsay version, still strikes a notably contemporary chord, especially in the sparse decor of the utilitarian space and the emphasis on the laborers' work clothes and knee pads. The light is harsher and a more varied palette has been used, but the final effect remains rather chilly.

Like the large composition, this canvas was included in the sale of "45 paintings by MM. Caillebotte, Pissarro, Renoir, Sisley" organized by the artists themselves at Hôtel Drouot in Paris, on 28 May 1877,[1] but was repurchased by the artist and given to a relative on his mother's side of the family.
A. D.

1 Bodelsen 1968, p. 336.

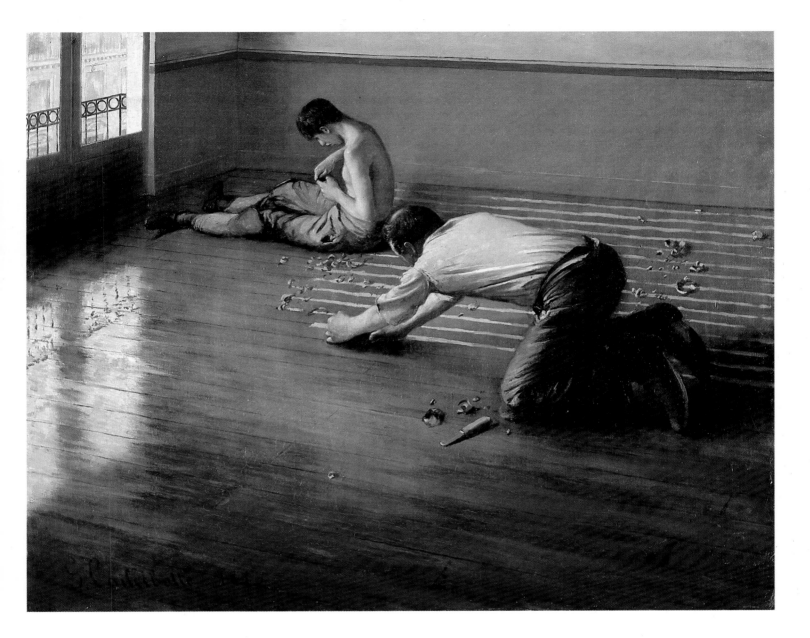

All the surviving drawings on this theme are included here, with the exception of Berhaut 1994, no. 33A. We also reproduce another drawing that is known to us only through an illustration published in a contemporary magazine (see cat. 5, fig. 1). A. D.

6
Study of Two Floor-Scrapers

1875/76
Graphite on buff laid paper
31.4 × 48.4 cm
Stamped lower right
Private collection

Principal Exhibitions
Marcq-en-Baroeul 1982–83, no. 45 (?).

Selected Bibliography
Varnedoe 1987, p. 59, fig. 9f; Chardeau 1989, p. 22;
Weisberg 1992, p. 55.

7

Study of a Kneeling Floor-Scraper, in Profile, Facing Left

With a small, barely visible study (of a head?) at upper left

1875/76

Conté crayon on gray laid paper

Countermark: PL BAS

42.7 × 30.8 cm

Annotation lower right: *11*

Stamped lower right

Private collection

Selected Bibliography
Varnedoe 1987, p. 58, fig. 9c; Chardeau 1989, p. 25.

This preparatory study of a floor-scraper should be compared with the figure of the older man in the 1876 canvas (cat. 5), as should another, more developed drawing (cat. 8).

8

Study of a Kneeling Floor-Scraper, in Profile, Facing Left

1875/76

Graphite on gray laid paper

Countermark: ED et C^ie; embossed stamp: J. Bazire, 45 Bd MALESHERBES

47.9 × 30.5 cm

Stamped lower right

Private collection

Principal Exhibitions
Houston and Brooklyn 1976–77, no. D-2; Marcq-en-Baroeul 1982–83, no. 43 (?); Pontoise 1984, no. 26 (?).

Selected Bibliography
Varnedoe 1987, p. 58, fig. 9a; Chardeau 1989, p. 24.

9

Two Studies of a Young Man Seated, in Profile, Facing Left

1875/76
Graphite on white laid paper
47.6 × 31.1 cm
Stamped lower right and middle left
Private collection

Principal Exhibitions
Houston and Brooklyn 1976–77, no. D-6; Pontoise 1984, no. 29 (?).

Selected Bibliography
Varnedoe 1987, p. 58, fig. 9d; Chardeau 1989, p. 23.

These two studies are also related to the 1876 canvas (cat. 5).

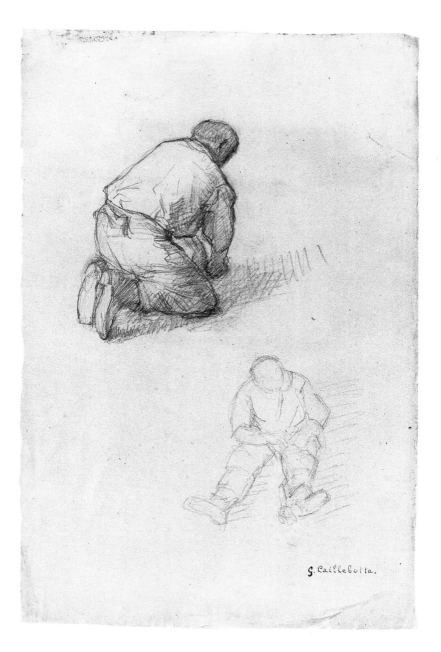

G. Caillebotte.

10

Two Studies of Floor-Scrapers: Seated Man from the Front; Kneeling Man in Three-Quarter Rear View, Facing Left

1875/76
Graphite on buff laid paper
48 × 30.2 cm
Stamped lower right
Private collection

Principal Exhibitions
Houston and Brooklyn 1976–77, no. D-5; Marcq-en-Baroeul 1982–83, no. 44 (?);
Pontoise 1984, no. 30 (?).

Selected Bibliography
Varnedoe 1987, p. 58, fig. 9e; Chardeau 1989, p. 18.

These figures, both fully dressed, do not recur in either of the paintings.
Caillebotte clearly indicated the play of light and shadow.

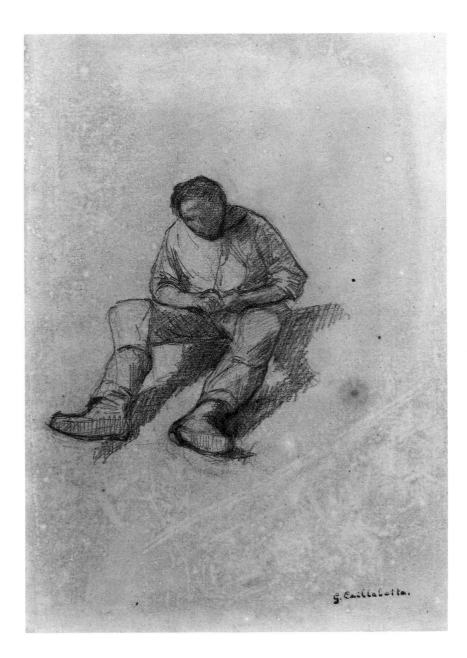

11

Study of a Seated Man Viewed from the Front

1875/76
Graphite on buff paper
43.5 × 30.8 cm
Stamped lower right
Musée Pissarro, Pontoise (acquired in 1987)

Principal Exhibitions
Houston and Brooklyn 1976–77, no. D-3.

Selected Bibliography
Varnedoe 1987, p. 58, fig. 9b; Chardeau 1989, p. 18.

This figure repeats one on another sheet (cat. 10), articulating the play of light and shadow with greater emphasis; the face remains a blur.

12

Three Studies of Floor-Scrapers: Two Studies of Hands; Study of a Kneeling Man from the Front

1875
Graphite on cream paper
48 × 30.8 cm
Stamped lower right
Berhaut 1978, no. 27B; Berhaut 1994, no. 33B

Musée Pissarro, Pontoise (acquired in 1987)

Principal Exhibitions
Pontoise 1984, no. 31 (?).

Selected Bibliography
Varnedoe 1987, p. 56, fig. 8i; Chardeau 1989, pp. 16, 19, and 22.

This sheet of studies seems most closely related to the large composition of 1875 (cat. 3), if only because of the floor-scraper's nude torso. Additionally, the detail of hands grasping a tool corresponds to an area of the canvas that seems to have been repeatedly reworked.

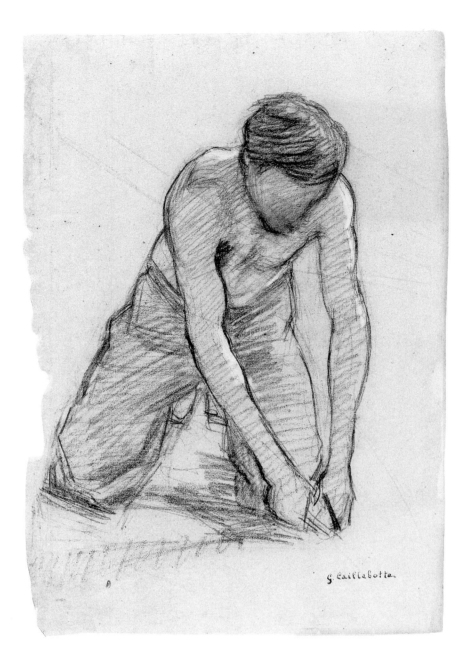

13

Study of a Kneeling Floor-Scraper, Bare-Chested, Viewed from the Front

1875
Conté crayon heightened with white gouache on buff laid paper
47.3 × 31.5 cm
Stamped lower right
Private collection

Principal Exhibitions
Houston and Brooklyn 1976–77, no. D-4; Marcq-en-Baroeul 1982–83, no. 42 (?); Pontoise 1984, no. 27.

Selected Bibliography
Varnedoe 1987, p. 56, fig. 8f; Chardeau 1989, p. 16.

This figure is a more developed treatment of one in another drawing (cat. 12), and documents the painter's revision of the third floor-scraper on the left in the large canvas (cat. 3), whose posture changed completely between the first painted sketch (cat. 4) and the final composition.

14
Study of a Balcony Railing Viewed through a Window
1875

Charcoal on gray-blue laid paper

Countermark: Marais

30 × 46 cm

Stamped lower right

Private collection

Selected Bibliography
Varnedoe 1987, p. 56, fig. 8h; Chardeau 1989, p. 19.

The railing in this sketch corresponds to that in the large composition of 1875 (cat. 3); its decorative ironwork pattern had not yet been defined in the small painted sketch (cat. 4).

15
House-Painters
(Peintres en bâtiments)

1877
Oil on canvas
87 × 116 cm
Signed and dated lower right:
G. Caillebotte 77
Berhaut 1978, no. 48; Berhaut
1994, no. 53

Private collection

Principal Exhibitions
Paris 1877, no. 6; Paris 1894, no.
50, priced at 2,000 francs (according to an annotated catalogue in the Durand-Ruel
archives, Paris); Paris 1921, no.
2710; Paris 1951, no. 15; Chartres
1965, no. 5; London 1966, no. 7;
New York 1968, no. 11; Houston
and Brooklyn 1976–77, no. 24;
Marcq-en-Baroeul 1982–83, no. 8.

Contemporary Criticism
Burty 1877; Lepelletier 1877;
Mantz 1877; G. Rivière 1877a
and b.

Selected Bibliography
Geffroy 1894, p. 289; Sertat 1894;
Bernac 1895, p. 310; G. Rivière
1921, p. 159; Geffroy 1922, p. 93;
Berhaut 1968, p. 28; Bodelsen
1968, p. 336; Werner 1968, p. 45;
Berhaut 1978, pp. 33 and 50;
Varnedoe 1987, no. 17; Balanda
1988, pp. 76–77; Herbert 1988,
p. 20; Chardeau 1989, pp. 52–61;
Weisberg 1992, pp. 58 and 281
n. 11.

At the Impressionist exhibition of 1877, where they were shown publicly for the first time, *House-Painters* was more or less eclipsed by the large compositions *Paris Street; Rainy Day* and *The Pont de l'Europe* (cats. 35 and 29), and was not much discussed by the critics. The composition was seen as a Realist portrayal of the "Parisian landscape"[1] or as evidence of "a curiosity, rare today, about strictly professional types and occupations"[2] reminiscent of *Floor-Scrapers* (cat. 3), exhibited the previous year. Georges Rivière pointed out that "these workers, who conscientiously pack their pipes [i.e., take their time with preliminaries] while contemplating the work before them, are rather well observed."[3] This is a remark by a bourgeois who closely monitors the industry of those in his employ.

While the critics easily recognized the intersection depicted in *Paris Street; Rainy Day*, no one identified the long rectilinear street, indubitably modern, in the Pont de l'Europe neighborhood or close to rue de Miromesnil where the painters are working on the front of a wine-merchant's shop. Once again, we find the "bizarre" perspective so characteristic of Caillebotte. The street forms a large X shunted to the left and is peopled by several of the types that tend to frequent the artist's urban landscapes: a man in a top hat; a hurrying, solitary woman; carriages; and, of course, the painters on their pyramidal ladders who, in this instance, seem to have just completed their work. The main figure is cropped at mid-thigh and is shifted to the left, as if to deliberately disturb the conventional compositional scheme. The relatively static poses of the figures were already established in a small painted sketch (fig. 1). By contrast, the surviving preparatory drawings include a series of "instantaneous" views featuring acrobatic poses not retained in the final version.[4]

Gabriel Weisberg suggested that Caillebotte may have used photographs or optical devices of some sort, notably in connection with a schematic, squared sketch of the man in the foreground (see

Figure 1. Gustave Caillebotte. *Sketch for* House-Painters, 1877. Oil on canvas; 60 × 73 cm. Private collection.

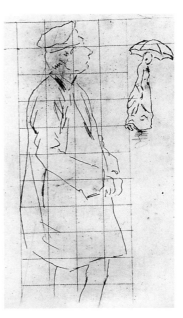

Figure 2. Gustave Caillebotte. *Study for* House-Painters, 1877. Graphite; dimensions unknown. Private collection.

fig. 2). Solid proof is lacking, but the language of photography is indeed consistent with this figure, which is highly finished and has clearly delineated features, while the other figures remain blurry. Weisberg also saw the influence of photography in the work's palette. Contemporaries criticized the slate-gray tones used by Caillebotte in his 1877 submissions, failing to acknowledge that this wan, chalky color scheme, with its grays, beiges, olive greens, and rusts, was wonderfully evocative of the melancholy that pervaded the rectilinear streets of a new Paris then in the process of being repopulated.

Like *Floor-Scrapers*, *House-Painters* figured in the auction of "45 paintings by MM. Caillebotte, Pissarro, Renoir, Sisley" organized by the artists themselves and held at Hôtel Drouot in Paris on 28 May 1877.[5] According to Gustave Geffroy, the artist repurchased it on that occasion for 301 francs.

A. D.

1 Mantz 1877.
2 Burty 1877.
3 G. Rivière 1877b.
4 See Varnedoe 1987, pp. 84–87; and Chardeau 1989, pp.
56–61.
5 Bodelsen 1968, p. 336.

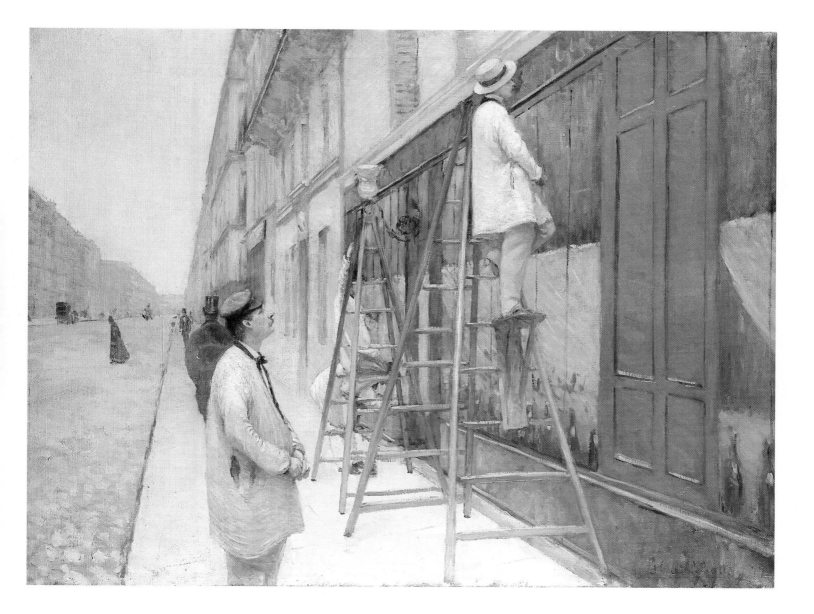

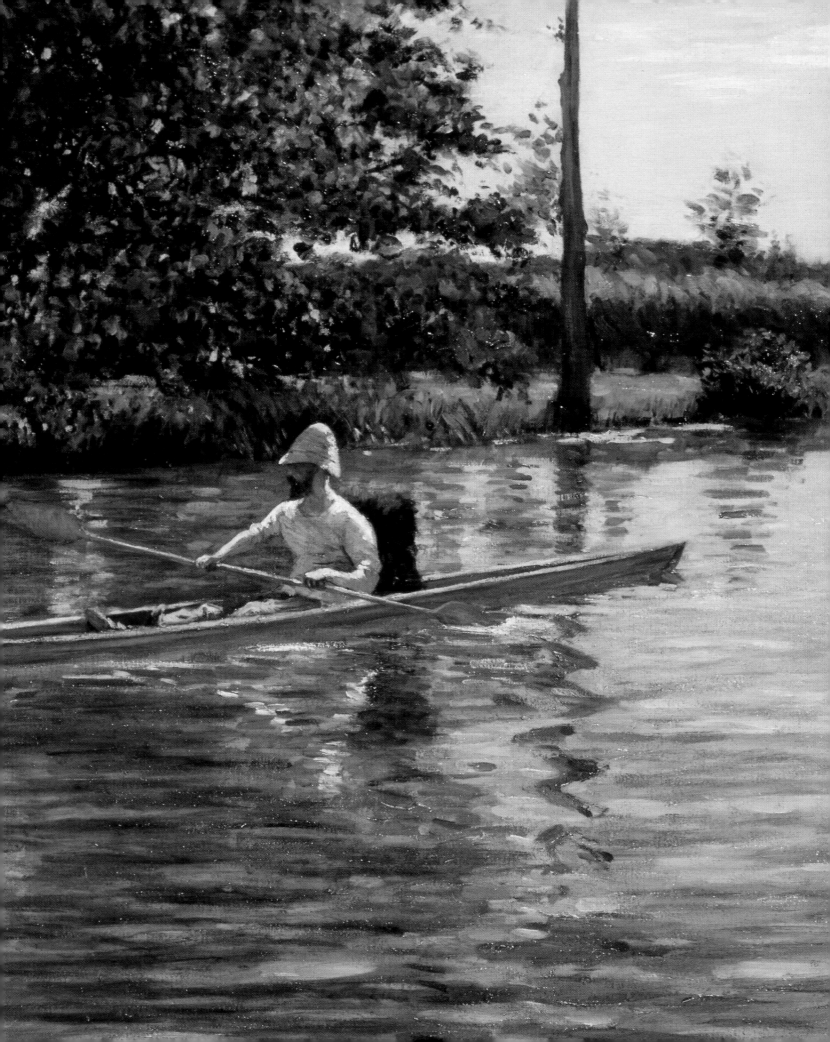

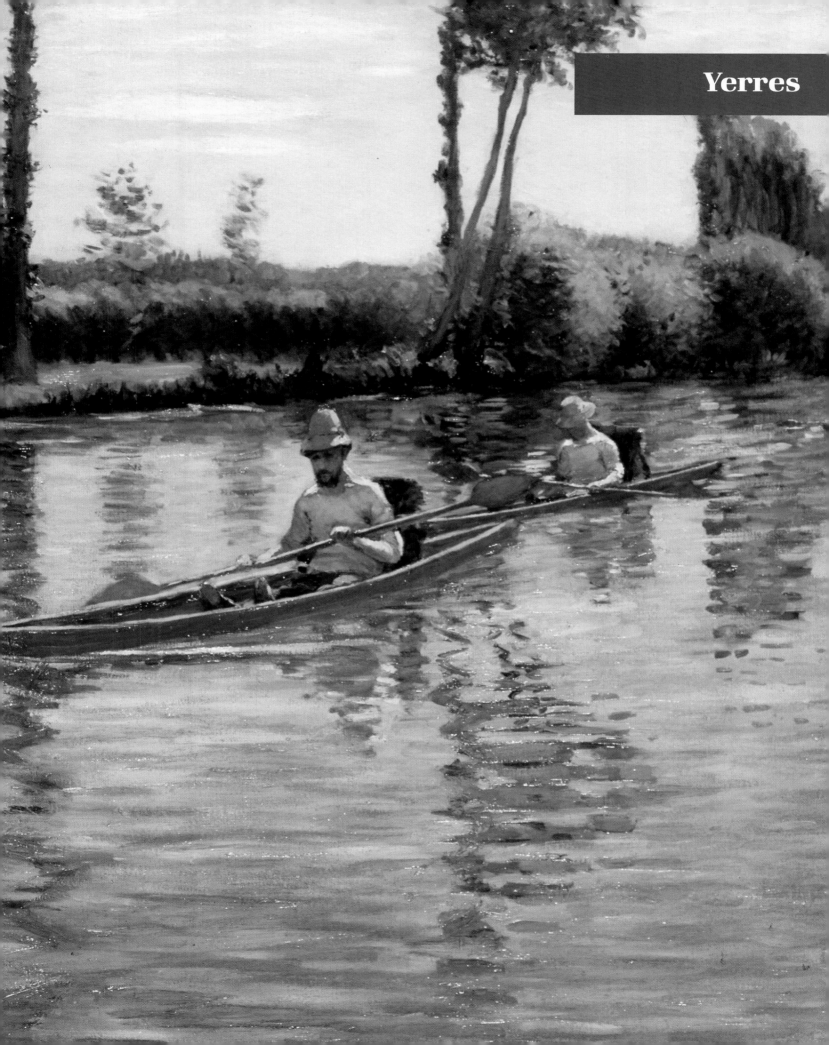

A Country House

Yerres is the name of both a very old village about twelve and a half miles southwest of Paris and the river that runs through it. It was here, in 1860, that Gustave Caillebotte's father purchased a country property.[1] By chance, and as a result of the tract's recent acquisition by the township of Yerres, this summer residence—an elegant, Neoclassical structure with subsidiary buildings sited in a large park along the river—has been preserved (see fig. 1).[2]

It was described at the time the Caillebotte family moved in:

This property is situated in the Yères Valley [*sic*] and is adjacent to the small river of the same name; it consists of a large and beautiful residence and various subsidiary structures detailed below; two cottages facing the house, one of which serves as the gardener's residence, with contiguous outbuildings. Park extending along the river in the English style, planted with large and beautiful trees both indigenous and exotic, shrubbery, walks, lawns; island formed by an arm of the river, iron bridges, large and magnificent ice-cellar in the form of a grotto, surmounted by an outcropping of rock and a labyrinth with a kiosk, small ice-cellar to the side under a rustic pavilion, wells with pump and reservoir for service to the house, etc. Beautiful kitchen garden, with numerous espaliers and broad lawn beyond, in which is a small building, artificial river with two bridges over it, one of wood with a kiosk, and the other of stone; wooden barn with slate roof, the whole amounting to a surface area of approximately eleven hectares, twenty-three ares, twenty-nine centiares.

This description is followed by one of the house, whose main facade is said to face a lawn with a pool and a central fountain featuring a white marble sculptural group. Moving on to the interior, the "large and beautiful dining room" is said to have "walls and ceiling decorated with gilded paneling and coffering; in the paneling, eight large landscapes painted on canvas and signed by Corot and Barbot."[3] Then one entered

"a white and gold salon decorated with ionic columns and panels with painted allegorical figures that are most effective and by an artist's hand, the rest of the walls covered in a damask fabric, fireplace in antique yellow; then a billiard room with gilded paneling; to the right a small salon . . . hung with tapestries; to the left, another small salon with bookcases; all these rooms are decorated with mirrors, oak-parquet flooring in a chevron pattern." Many bedrooms—some of them sumptuous, featuring "platformed alcoves with columns"—are distributed through the upper two floors; the description even mentions, on the third floor, "a large storage room that could be used as a painting studio." The inventory concludes with an enumeration of the outbuildings: "hen-house, cow-barn, dairy, laundry, stables and carriage house, rabbit-hutch, rubbish disposal etc.," all separated from the main building by a hemicycle or exedra "decorated with bases and columns surmounted by busts and antique vases," a portion of which still survives.

Neither the architect nor the construction date of this ensemble is known, but it was probably built in the very first years of the nineteenth century. It should be emphasized that Martial Caillebotte, Sr., who was to build a residence for himself and his family in Paris shortly afterward, here settled for an "old" house. The English park with its garden structures was conceived after a model that had been admired for decades; it has recently been studied by Pierre Wittmer.[4] Furthermore, the purchaser of the house was obliged also to take the mahogany furniture with gilt-bronze fittings, features indicating these pieces were in the Empire style, then unfashionable but nonetheless rather prized by members of the bourgeoisie under the Second Empire. The Caillebottes retained and added to this set of furnishings. Mme Caillebotte took care to fill the cupboards with impressive china and crystal: a "service in white porcelain with red and gold filigree decoration, of about four hundred fifty pieces, a Creil faience service with blue decoration of about three hundred pieces, a cut-

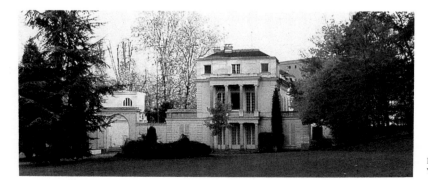

Figure 1. The property of Martial Caillebotte, Sr. in Yerres as it appears today.

glass service in a diamond pattern of about three hundred pieces, [another] cut-glass service in a diamond pattern of one hundred thirty pieces." M. Caillebotte stocked the wine cellar with fine vintages.[5] It was the family's summer residence, a pleasure house not meant for crop farming: the latter function was served by the farm at Champfleury, near Meaux, which the senior Caillebotte had purchased previously.[6] In short, although contemporary yearbooks did not designate this complex as a château (an appellation reserved, in the Yerres township, for the domain of baron Gourgaud, who was also the mayor), its character was such that its possession was a clear sign of the owner's prosperity.

Gustave Caillebotte was twelve years old when his parents acquired the property; since he boarded during the school year, it was here that, during his adolescence, he spent time with his family over summer vacations. The house and park were later to provide subject matter for his painting: he was to depict not only the property itself—the garden, the kitchen garden, the adjacent river—but also the way of life that prevailed there, a mode of existence that has long since vanished. The large house was used not only by the immediate Caillebotte family, but also by a few relatives, and there were servants to be provided for as well. This residence, which with its several garden pavilions had doubtless seen brilliant and frivolous days in the past, now adapted to the tranquil rhythms of family life,[7] which in this instance entailed regular religious observances: a chapel was erected in the park, and Abbé Alfred Caillebotte, the painter's elder half-brother, presided over masses there.[8] As idleness was frowned upon, the women read—there was a substantial library on the main floor[9]—or embroidered (see cat. 19). But amusements for the younger members of the family were not in short supply; these included billiards (see cat. 18), hunting (for René Caillebotte, the artist's younger brother[10]), and, above all, the opportunities for diversion provided by the adjacent river (see cats. 23–28).

Boating

Paradoxically, the name of the Yerres river does not appear in any of the titles of Caillebotte's works before 1879,[11] when the artist stopped painting in Yerres: in fact, the property was sold shortly after the death of his parents.[12] Also in 1879, some of Caillebotte's paintings representing boaters were publicly exhibited for the first time. Although the critic Georges Rivière mentioned "a boatsman half reclining near a table" as having figured in the 1876 exhibition,[13] a work as yet unidentified, the known paintings devoted to this subject are all clearly dated either 1877 or 1878.

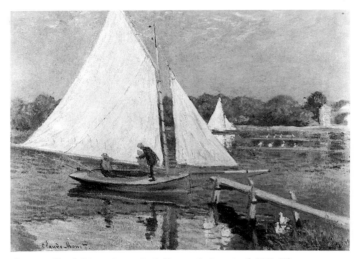

Figure 2. Claude Monet (1840–1926). *Boaters in Argenteuil*, 1874. Oil on canvas; 59 × 79 cm. Private collection.

In painting boatsmen or *canotiers* (a French term designating both sailors and rowers who were nonprofessionals), Caillebotte was not innovating but rather exploring a theme that had become important in his day, and one that Monet had been among the first to take up.[14] Beginning in 1872, Monet, now settled in Argenteuil, one of the principal centers of nautical activity in the Paris region, painted sailboats gliding over the Seine; in the background of a work from 1874, for example, we see light yawls zipping across the water: two reddish-orange lines against a blue and green ground rowed by four men each, tiny white brush strokes that catch the light (see fig. 2). Renoir's twin painting also includes a yawl (1874; Portland Art Museum). But it was Manet who, with his *Argenteuil* (fig. 3), shown at the 1875 Salon (when all the critics referred to it as *Les Canotiers d'Argenteuil*), fixed in paint the definitive figure of the boatsman, a personage who had appeared previously not only in Naturalist literature—in the work of Guy de Maupassant, for example[15]—but also in contemporary song and vaudeville. Manet evoked a type and a milieu, both inseparable in his view from their feminine element, as they were also to be for Renoir, notably in his famous *Luncheon of the Boating Party* (1880–81; Phillips Collection, Washington, D.C.). Caillebotte, however, focused exclusively on rowing, concentrating his attention on the physical exertion involved in this "leisure" activity, and this represents something of a departure, as has recently been noted by Robert Herbert.[16]

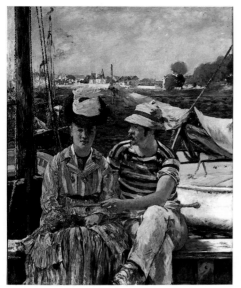

Figure 3. Edouard Manet (1832–1883). *Argenteuil*, 1874. Oil on canvas; 149 × 115 cm. Musée des Beaux-Arts, Tournai.

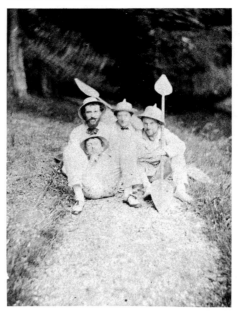

Figure 4. Anonymous. *Gustave Caillebotte (on the right) with some of his boating friends*, 1877/79. Photograph. Private collection.

These painters were observing the small world of boating analyzed in the article *"Canotage"* in Larousse.[17] Although he acknowledged a debt to Théophile Gautier and the prince de Joinville, son of King Louis-Philippe, both of whom were aristocrats (although they traveled in very different circles), as well as to a shipowner in Le Havre, the author of the article stressed the coexistence of several kinds of boaters. The *canotier*, recognizable by his attire—jersey, pants, and footwear made of linen, with a straw boater or linen cap on his head— was usually "a child of Paris." He might be a true sportsman, belonging to a club and providing sustenance for his soul while strengthening his body, or he might be a *balladeur* [sic], a noisy and boisterous person more comfortable in the adjacent taverns than on the water; he is accompanied by a *canotière* who, according to Larousse, tends to be a woman who "more or less recently has thrown off all constraint and, since that moment . . . , has so exerted herself in efforts to recover her dignity that she would be quite embarrassed to admit how many false steps she'd taken." The author of the article also acknowledges, however, the existence of a quite decorous mode of family boating. But this was unquestionably a Parisian theme, and a critic hostile to the Impressionists, Georges Lafenestre (a future curator at the Louvre), reproached them on the occasion of the 1879 exhibition as follows: "If they go into the country, it's on Sunday with a throng of city-dwellers, pushing as far as Asnières and Bougival, at most to Fontainebleau, to seek out what's least rustic there, the taverns painted in loud colors, the pretentiously dressed-down *canotiers*, and the *canotières* in shoddy flounces."[18]

Rowboating—or *le rowing*, as French initiates called it—was an English import that rapidly attained popularity in France during the Second Empire. Caillebotte, who had a river at his feet, plenty of leisure time, and the means to purchase any boat he chose, was an enthusiast of the sport, as evidenced by a contemporary photograph (fig. 4). In his paintings, he

presented us with a catalogue of small craft, from classic rowboats (cat. 23); to a scull with two alternating oarsmen, for more serious adepts (cat. 24); and light *périssoires*—flat-bottomed canoes—for single paddlers (cats. 25 and 28). Note, however, the absence of a craft said by Larousse to be the veritable jewel of the racing circuit: the fragile, one-man scull made of cloth-covered pontooning favored by champions. Rather than racing, Caillebotte's boaters seem to exert themselves only moderately. Specialist publications of the day[19] contain a great deal of information about clubs and competitions along the Seine, from Asnières to Billancourt and Charenton, from Bougival to Bezons and Chatou, and occasionally even about those on the Marne, but they say little or nothing about the Yerres, where boating was probably pursued only by Caillebotte and a few young men from the surrounding area. Whereas Manet, Monet, Renoir, and even Sisley (in England) chose to depict the best-known public boating spots, Caillebotte's approach to the sport was more personal, reflecting its role in his own life.

The technical awareness lacking in Caillebotte's Impressionist friends, who were indeed most interested in the diversions ancillary to the sport itself, is to be found, however, and in still more acute form, in another of Caillebotte's contemporaries: the American painter Thomas Eakins. His famous series on rowing (see fig. 5) predates Caillebotte's, but a connection between the two artists seems unlikely. It should be noted, however, that Eakins, who was a Gérôme student, had some contact with the Bonnat studio, if only through the painter William Sartain, like Caillebotte a student of this master, who entered the Ecole des Beaux-Arts only six months earlier than Caillebotte. The latter's images of athletic men in their *périssoires*, which impressed 1870s viewers as emphatically "modern," were not exclusively a product of an Impressionism smitten with the open air and modernity; they were also shaped by a more generally pervasive Naturalist current. This spiritual affinity between Eakins—whose work seems

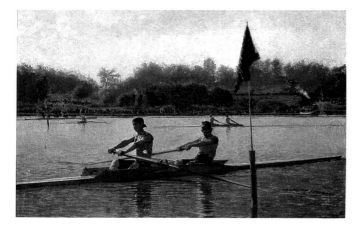

Figure 5. Thomas Eakins (American; 1844–1916). *The Biglin Brothers Turning the Stake*, 1873. Oil on canvas; 102 × 153 cm. The Cleveland Museum of Art (Hinman B. Hurlbut Collection).

so American to European eyes—and Caillebotte perhaps partly explains the widespread American interest in the painter of rowers on the Yerres, but the latter are at best distant cousins of those on the Schuylkill in Philadelphia: while Caillebotte's rowers approach the sport more or less as a diversion, their American counterparts are serious competitors.

The canvases painted in Yerres are pendants to Caillebotte's "Parisian landscapes," to repeat a phrase used by the contemporary critic Paul Mantz.[20] Caillebotte here evoked Parisians amusing themselves in the summer, as Manet, Monet, and Renoir had done before him. As with his urban subjects, he projected his personal life into these works with an insistence that gives them an idiosyncratic quality absent from canvases by contemporary genre painters such as the Italian Giuseppe De Nittis and the English James Tissot, who treated similar subject matter but in ways that emphasized cosmopolitan elegance and decorum.[21] A. D.

NOTES

1 This property was acquired from the heirs of Mme Martin Guillaume Biennais, the widow of the famous Empire jeweler, for 136,000 francs plus taxes by Martial Caillebotte, Sr. at an auction held in Paris on 12 May 1860. He may have already been familiar with this property, for one of the Biennais daughters had married Jules Pinçon de Valpinçon, whose surname was also that of the mother of Martial's second wife, Adèle Zoé Boissière. The house was sold furnished and is carefully described in the auction records (Archives départementales de l'Essone, 4Q1, 1678 or 1679), a document provided us by Pierre Wittmer, whom we would like to thank for his assistance in all matters pertaining to Caillebotte, especially those concerning the park at Yerres.

2 The property has belonged to the township since 1973. Its main buildings and the garden pavilions were added to the supplementary inventory of historic monuments by prefectorial decree 93-1277, dated 5 Oct. 1993.

3 This is the only documentary reference to these works, which are no longer in place. We have discovered nothing in the course of research that might be of help in identifying them, but it seems likely that Barbot was responsible for most of the decoration.

4 See Wittmer 1990.

5 See Poletnich 1878a.

6 See Chronology, 1852.

7 One of the previous owners (all of whom are listed in the document cited in note 1) was the restaurant owner Pierre Frédéric Borrel, who had purchased the famous Rocher de Cancale on rue Montorgueil in Paris; he was the owner of the Yerres property from 1824 until 1843, when he went bankrupt. Borrel had been preceded by the marquis de Mandat, its owner from 1806 to 1824, and Pierre Henri Chauveau, prior to 1806.

8 See Chronology, 1863 and 1864.

9 The books were exempted from the initial sale transaction and thus do not figure in the inventory, but Martial, Sr. could very well have purchased them subsequently; upon his death, 832 titles were inventoried, including dictionaries and encyclopedias of all kinds, volumes treating both ancient and modern history, travel books, religious works, and novels; among the authors represented were Buffon, Byron, Chateaubriand, Helvétius, La Harpe, Massillon, Mercier, Scott, and Voltaire.

10 See René Caillebotte's requests for hunting licenses in 1875 and 1876 (Municipal Archives, Yerres, OW 117), about which the author was informed by Pierre Wittmer and Cécile Bellelle, who is in charge of the Yerre township's archives and records office.

11 See the titles of the works exhibited in 1879 in the Chronology.

12 Martial Caillebotte, Sr. died on 24 Dec. 1874, his wife succumbed shortly after, on 20 Oct. 1878; the property must have been sold in 1879 or later, but we do
not know the precise date of this transaction.

13 G. Rivière 1876, cited in Dax 1876; see also Berhaut 1994, no. 2.

14 Before Monet, one might cite Courbet's surprising *Woman in a Podoscaphe* (1865; Murauchi Art Museum, Tokyo), in which the figure paddles while sitting on a light craft made of two long narrow floats held together by a crossbar, tossed about by the waves. It should be kept in mind that Monet and Renoir treated subject matter similar in spirit, namely the bathing spot at La Grenouillère on the Ile de Croissy near Bougival, from 1869.

15 The first version of his short novel *Sur L'Eau* appeared in 1876 (see G. Maupassant, *Contes et nouvelles* [Paris, 1978], p. 1281).

16 Herbert 1988, p. 245.

17 P. Larousse, *Grande Dictionnaire universal de XIXᵉ siècle*, vol. 3, pt. 1 (Paris, 1866–79; repr. Paris, 1982), pp. 283–84.

18 Lafenestre 1879.

19 For example, *Le Yacht*, which published regular columns devoted to *le rowing* (on *Le Yacht*, see Chronology, 1878; and Appendix IV).

20 Mantz 1877.

21 On the specific theme of rowing, see notably De Nittis's *Léontine De Nittis in a Rowboat* (1874; private collection). Tissot painted the English boating scene in *The Henley Regatta* (c. 1877; Leander Club, Henley-on-Thames) and *The Thames* (1876; Wakefield Art Gallery and Museums), in which some British critics perceived Parisians of dubious morality. There are many scenes comparable to *Portraits in the Country* (cat. 19). Another fashionable genre painter, Ferdinand Heilbuth, treated these subjects in his typically affected way, with results that differ markedly from Caillebotte's paintings (Galerie Georges Petit, Paris, *L'Atelier Ferdinand Heilbuth* [17–18 May 1890]).

16
The Yerres, Rain
(L'Yerres, effet de pluie)

1875
Oil on canvas
81 × 59 cm
Signed and dated lower left:
G. Caillebotte 75
Stamped lower right
Berhaut 1978, no. 21; Berhaut
1994, no. 21

Indiana University Art Museum,
Bloomington (Gift of Mrs.
Nicholas H. Noyes, 71.40.2)

Principal Exhibitions
Houston and Brooklyn 1976–77,
no. 7.

Selected Bibliography
Rosenblum 1977, p. 52; Berhaut
1978, p. 8; Varnedoe 1987, no. 7;
Balanda 1988, pp. 60–61; Wittmer
1990, pp. 14, 72, 77, 156–57, and
269.

Unusually for a work so early in Caillebotte's career, this canvas is clearly dated, thus providing a chronological benchmark. It is also one of the painter's first completed landscapes. The motif is a view from the graded riverbank in the Yerres park, probably taken from a kiosk situated at the spot. Intent here, as so often, on devising an unusual compositional scheme, Caillebotte used the wood or masonry retaining wall in the foreground to introduce a strong diagonal contrasting with the vertical rhythms of the trees on the opposite bank; the widening ripples on the water's surface, drawn in perspective—the subject's only suggestion of animation—serve to shift the viewer's attention between these two elements. The river is deserted. The work's traditional title suggests that rain is the cause, but, just as contemporary critics were amazed not to "see" any rain dampening the umbrellas in *Paris Street; Rainy Day* (cat. 35), we might well question the aptness of this title. As Kirk Varnedoe has noted, bubbles and insects can create similar effects on a water surface in fine weather.

The palette is relatively restrained, while both foliage and water have been treated as solid, opaque bodies. The insistent decorative rhythms characteristic of this landscape make it a particularly original invention for its date. A. D.

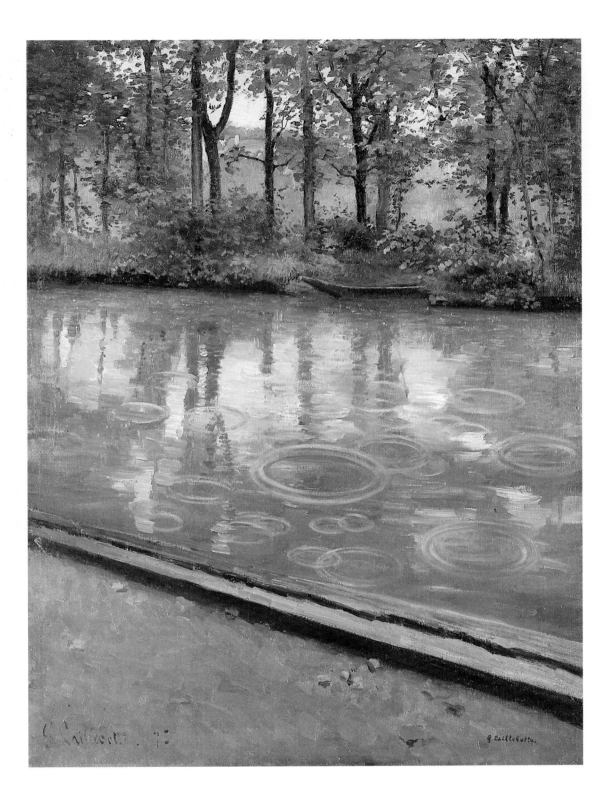

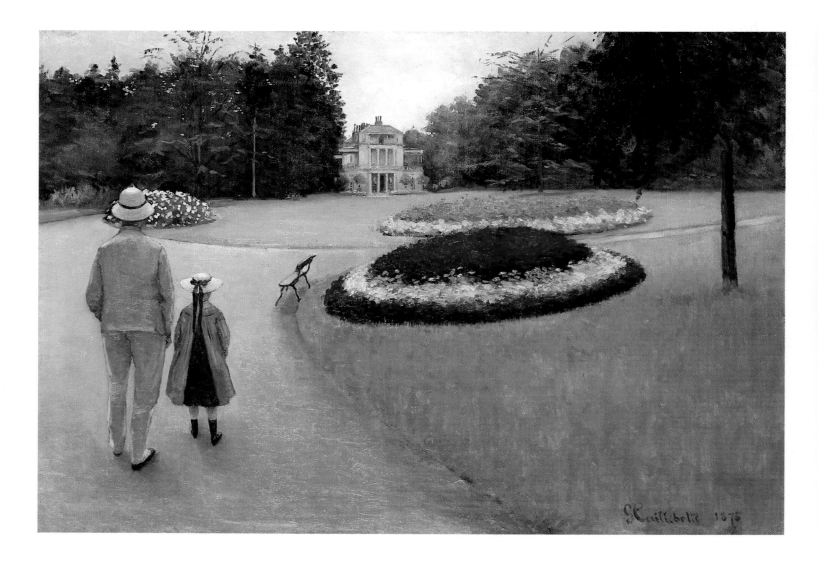

17

The Park on the Caillebotte Property at Yerres

(Le Parc de la propriété Caillebotte à Yerres)

1875

Oil on canvas

65 × 92 cm

Signed and dated lower right:
G. Caillebotte 1875

Berhaut 1978, no. 34; Berhaut 1994, no. 25

Private collection

Selected Bibliography
Wittmer 1990, pp. 16, 53, 66–68, 70, and 209.

Although it is tempting to identify this as one of the canvases entitled *Jardin* exhibited by Caillebotte in 1876,[1] there is no mention of this work in the contemporary criticism of the artist, and it is possible that it was not shown publicly in his lifetime. It was given (probably by the painter himself) to the family's custodian and steward, Jean Baptiste Matthieu Daurelle (1839–1893). The man seen from the back is not readily identifiable, but the little girl is probably Zoé Caillebotte, born in 1868, the youngest daughter of the artist's uncle Charles Caillebotte (see cat. 19), whom he painted several times in 1877 and 1878 (see Berhaut 1994, nos. 68, 71, 114, and 118).

While *Portraits in the Country* (cat. 19) depicts a group of women intent on their domestic occupations close to the house, here we are some distance away from it in the security of a well-ordered park, although the garden facade, with its elegant pediment, columns, and boxed orange trees, is still clearly visible. Essentially, Caillebotte treated the figures as accessories in a portrait of the park. Pierre Wittmer has identified the flowers in the round bed as impatiens and begonias, here arranged by an experienced gardener into a perfect form.

Although at first glance this view of the park might seem nondescript, it is in fact another example of Caillebotte's penchant for surprising compositions: he peopled the foreground with figures pushed to the side and turning their backs to the viewer. They are painted very simply in gray tones, complemented by a few yellow highlights in the straw hats (the man's decorated with a barely discernible blue band and the girl's with a black ribbon). They gaze beyond the lawn and through an opening in a transverse walk to the house in the background. The pink-gray brush strokes of the foreground walk, which shade into a purplish-blue, are horizontal, while those of the yellow-green grass, beneath which an intense gray is visible, are vertical; the vibrant carmine of the flower border is further animated by criss-crossing strokes that give it texture; the hues of the lawn in the middle ground are uniformly applied, but the details in the flower bed and, finally, the foliage in various shades of green, suggesting a variety of arborial species standing out against the clear gray sky, introduce a certain vivacity into this otherwise intentionally restrained image. If one were to look for models for the surface handling, the most likely candidates would probably be works by Monet prior to 1870, which feature the same clarity of contrast and economy of means. But there is a notable difference: at no time did Caillebotte allow his hand to take pleasure in free brush strokes.

Like *Portraits in the Country* (cat. 19), this painting, which eschews easy sentimentality and evokes with a notably light touch the theme of the inevitability of the life cycle—here embodied in figures of youth and adulthood—presents us with the image of an ordered world as seen by an amiable, indulgent eye not devoid of bemusement. The temptation to read the distancing and isolation of the figures in psychological terms should probably be resisted, for this spacing was most likely determined by compositional considerations. A. D.

1 See Berhaut 1994, p. 69.

18
Billiards

(Le Billard)

c. 1875

Oil on canvas

65 × 81 cm

Berhaut 1978, no. 25; Berhaut 1994, no. 27

Private collection

Principal Exhibitions
Houston and Brooklyn 1976–77, no. 12.

Selected Bibliography
Varnedoe 1987, no. 11; Balanda 1988, pp. 62–63; Wittmer 1990, pp. 54, 77, 78, and 201.

This unfinished painting is one of the rare works depicting the interior of the Caillebottes' Yerres house. Our present knowledge of the residence, based on the inventory drawn up after the death of the artist's parents, confirms the degree of fidelity with which Caillebotte rendered his subject. The billiard room, somewhat dark like all the rooms on the ground floor, nonetheless featured six windows facing the park hung with "curtains in red cretonne with a hunting motif"; also recognizable are the billiard table "made of rose- and citron-wood," one of the "six banquettes with mahogany tip-up seats covered with red fabric," four of the "eight mahogany chairs, with red morocco upholstery," "a small hanging billiard light with two copper lamps," and probably, on a wall bracket, one of the two "large vases in the Etruscan style." The figure, posed as if about to shoot but lacking his billiard cue, is reduced to a silhouette; his identity remains a mystery.

Figure 1. Edgar Degas (1834–1917). *The Billiard Room at Ménil-Hubert*, 1892. Oil on canvas; 50 × 65 cm. Musée d'Orsay, Paris.

The painting's subject afforded Caillebotte an opportunity to explore perspective and *contre-jour* effects. The green cloth of the billiard table and the red tones of the carpet are both echoed in the fragmentary views of the park, creating a visual relay between inside and outside. The completed areas, dominated by uniform, opaque passages, are strongly contrasted.

Degas also represented a billiard room, the one in the country house of his friend Paul Valpinçon (see fig. 1), in 1892, confiding to his friend the sculptor Paul Bartholomé: "I wanted to paint and set to work on some billiard-room interiors. I thought I knew a bit of perspective, I knew none and thought it might be replaced by procedures with perpendiculars and horizontals, measuring the corners in space with will power alone. I had a hard time."[1] Chronology aside, this detail throws into relief the interest shared by Caillebotte and Degas in a specific decor, one common in bourgeois interiors of the time, but perceived very differently through their respective sensibilities: Degas described the paintings and tapestries on the walls of the Valpinçon house, giving us a picture of an interior filled with objects; Caillebotte, by contrast, introduced a figure, probably one of his intimates, and opened the decor onto the exterior. Although Degas can often be sensed as a likely influence on Caillebotte's early work, in this instance the thematic congruence would seem to have been fortuitous. A. D.

1 Guérin 1931, p. 196.

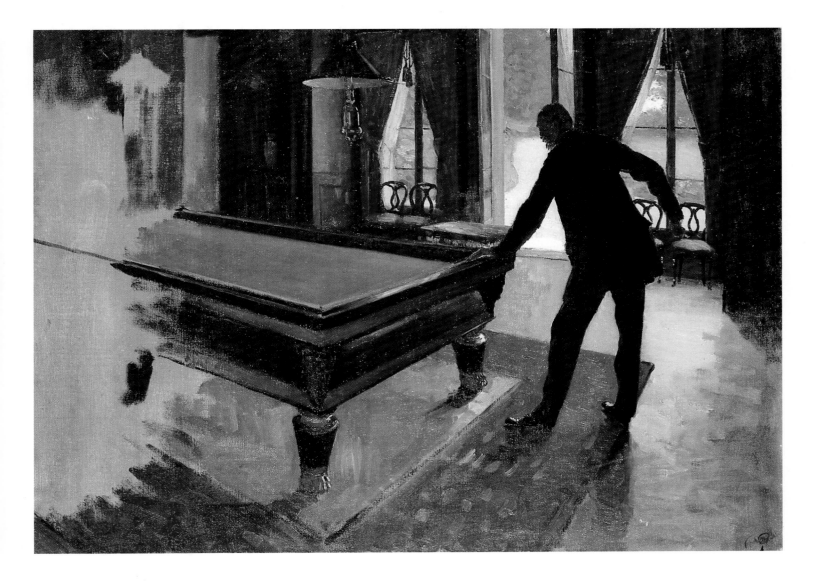

19
Portraits in the Country
(Portraits à la campagne)

1876

Oil on canvas

98.5 × 110 cm

Signed and dated lower left: *G. Caillebotte / 1876*

Berhaut 1978, no. 31; Berhaut 1994, no. 40

Musée Baron Gérard, Bayeux

Principal Exhibitions
Paris 1877, no. 3; Paris 1951, no. 89; Houston and Brooklyn 1976–77, no. 15.

Contemporary Criticism
Ballu 1877a and b; Bigot 1877; Chevalier 1877; Grimm 1877; Jacques 1877; L. G. 1877; Lafenestre 1877; Mantz 1877; G. Rivière 1877a.

Selected Bibliography
Berhaut 1948, p. 145; Berhaut 1978, p. 41; Varnedoe 1987, no. 14; Balanda 1988, pp. 70–71; Wittmer 1990, pp. 73, 78, 196–98, 264, and 273–75.

When first exhibited in 1877, *Portraits in the Country* received less attention than the large *Paris Street; Rainy Day* (cat. 35), but it was also the object of less negative commentary. Several critics praised its originality, its "bizarre though accurate" perspective,[1] and the precision of its lighting effects.[2] Paul Mantz, however, was less indulgent: "M. Caillebotte has not learned perspective. The women he has grouped in his *Portraits in the Country* sit on a rising ground that is not made to reassure the eye. The greenery in the background presses forward too insistently." More interesting is the assessment of an anonymous critic who signed himself "Jacques":

Portraits in the Country: an entire family, mother, daughter, grandmother, friend, sewing and crocheting diligently near a white summer house, whose half-open windows send out puffs of bourgeois fragrance, done with a finish that frightens me a little. On the side, linden trees, agreeably symmetrical, disappear into the distance, shading flower beds, where the harsh red colors of the geraniums, surrounded by grass, spring forward, spreading a cheerful clarity behind this dull assemblage of bored provincial women.

This analysis is couched in terms that appeal to contemporary sensibilities, evincing less concern with problems in linear perspective than with the idiosyncratic equilibrium of the composition—note its curiously disassociated couples—and the opposition of intense hues (the flower bed in the background) with the more neutral grays, beiges, and blacks.

We are perhaps more interested than were Caillebotte's contemporaries in these women from another era, all of them portraits. In the foreground is Marie Caillebotte, born in 1854, the painter's cousin, daughter of his uncle Charles Caillebotte (1813–1885), and who married, in 1875, a distant cousin, Augustin Caillebotte. In the middle ground, the young wife's mother, Mme Charles Caillebotte (born in 1822, she died sometime after 1894), who is in mourning (she had lost her eldest son, Maurice, in 1874), faces Mme Hue, seated on the bench. Beyond is the artist's mother, also in mourning (for her husband, who also died in 1874). In the shadow of boxed orange trees (a sign of

prosperity: the twenty such trees on the property were valued at twenty thousand francs in the estate inventory), which effectively delineate a small, open-air salon in which the family could gather in fine weather (see also fig. 1), the women sew and read, surrounded by the accessories called for by their industrious occupations: small round tables, sewing-basket, tambour frame. Thus this group of females differs rather subtly from Frédéric Bazille's *Family Gathering* of 1867 (fig. 2). Kirk Varnedoe aptly compared Caillebotte's painting with Léon Bonnat's *Portrait of the Artist's Family* (1853; Musée Bonnat, Bayonne), which belongs to a venerable tradition of intimist subjects. Contemporaries were alert to this affinity, for Georges Lafenestre, a young critic with ties to Bonnat's circle and a future curator at the Louvre, absolved *Portraits in the Country* of the sin of Impressionism, judging it to be "more artistic and more true" than the other works presented by the artist at the 1879 exhibition.

Caillebotte described a milieu, his own, which was neither that of Monet nor of Renoir—although both painted women sewing in the summer shade—but which had much in common with that of Bazille, Degas, and Manet, to complete our summary exploration of social strata, a domain subject to infinite nuance. In addition to the work's content, Caillebotte's original formal strategies should also be noted, especially the arrangement of the figures in rapidly receding perspective, as in his large compositions, and the juxtaposition of detailed passages with broadly executed areas in which the paint has been thickly applied, virtually without modulation, in a palette rich in contrast and dominated by the purplish-blues so favored by the artist.

The painting, which belonged to Mme Charles Caillebotte, was subsequently owned by her youngest daughter, Zoé Caillebotte (see cat. 17), and later by Mme Fermal, in whose memory it was given by M. and Mme Chaplain to the Musée Baron Gérard, Bayeux. A. D.

1 G. Rivière 1877a.
2 Ballu 1877a and b; and Chevalier 1877.

Figure 1. Gustave Caillebotte. *The Orange Trees*, 1878. Oil on canvas; 154 × 116 cm. Collection of John A. and Audrey Jones Beck, on permanent loan to The Museum of Fine Arts, Houston.

Figure 2. Frédéric Bazille (1841–1870). *The Family Gathering*, 1867. Oil on canvas; 152 × 230 cm. Musée d'Orsay, Paris.

20

The Gardeners

(Les Jardiniers)

1875/77

Oil on canvas

90 × 117 cm

Signed on the back: *G. C.*

Berhaut 1994, no. 80

Private collection

Selected Bibliography
Wittmer 1990, pp. 70, 77, 122–23, and 133–35.

This painting, which has remained in the family of Jean Daurelle, the Caillebottes' custodian and steward (see cat. 17), was recently located by Pierre Wittmer. It offers another example of Caillebotte's originality in his choice of themes, for these gardeners are not peasants—a canonical subject—but rather laborers of a kind often affiliated with bourgeois households of the time. Without the slightest resort to anecdote (which, in contemporary terms, would have made the work conform to the norms of genre painting; see fig. 1), Caillebotte depicted these men at their work like the floor-scrapers or the house-painters (see cats. 3, 5, and 15). They are barefoot so as not to crush the planted furrows, and in their professional clothing. The presence of market garden cloches for growing melons (the bell-like glass covers)[1] evokes a culture of luxury in a prosperous family's kitchen garden. The series of espaliers along the walls fitted with carefully rendered trellises and oblique iron wires, and the hotbeds for cuttings and nonindigenous ornamental plants contribute to this atmosphere. In some respects, Caillebotte's image could be said to resemble a rigorous inventory by a notary, but to an equal extent it is the joyous paean of a Parisian ravished by the emerging spring shoots, as well as conveying something of the deep satisfaction felt by an owner inspecting his profitable, impeccably maintained kitchen garden.

Caillebotte bathed his composition in a uniform light generated by an unmodulated blue sky, just a bit more intense at the right. The rather dry handling did not preclude an apt use of color: the ground's beige or purplish-gray hues (varying with the degree of dampness) respond to the flesh tones of the figures; an entire range of bluish-grays—the gardeners' aprons, the glass cloches, the trellises in their mauve shadows—reverberates with the many green hues of the vegetation. Amidst these equal tonal values, the white of the shirts and the delicate pinks of the background stand out sharply.

This work may have influenced *Garden in Grez* (fig. 2), an 1884 painting by the Swede Karl Nordström, whose portrait had been painted in 1882 by his friend Christian Krohg, who represented the artist in front of a window overlooking this same garden (see cat. 67, fig. 2). Although there is no documentary proof, perhaps these young men from the North are to be numbered among Caillebotte's disciples. A. D.

1 The estate inventory drawn up after the death of the artist's father listed one hundred market garden cloches, as well as two wheelbarrows, and six copper and four zinc watering cans; the latter are depicted in *The Gardeners*.

Figure 1. Philippe Jacques Linder. *A Sojourn in the Country*, c. 1877. Oil on canvas. Location and dimensions unknown.

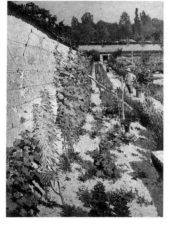

Figure 2. Karl Nordström (Swedish; 1855–1923). *Garden in Grez*, 1884. Oil on canvas; 108 × 73 cm. Konstmuseum, Göteborg (Pontus Furstenberg Bequest).

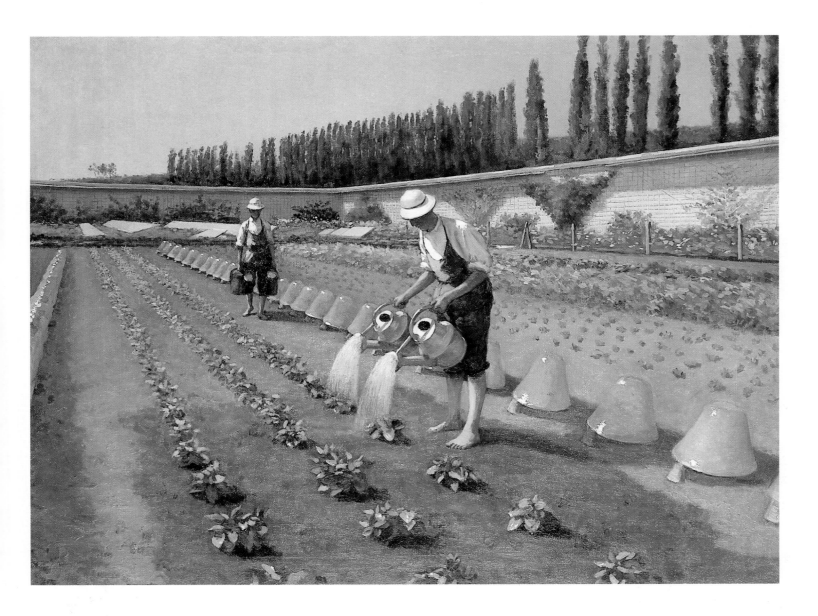

21

The Kitchen Garden, Yerres

(Le Jardin potager, Yerres)

1875/77

Oil on canvas

60 × 73 cm

Berhaut 1978, no. 60; Berhaut 1994, no. 81

Private collection

Selected Bibliography
Wittmer 1990, pp. 70, 77, and 121.

Caillebotte here painted another section of the kitchen garden, in this case devoid of figures. Faithful to a reality that appealed to his taste for an ordered nature, he squared the space with taut flower beds and paths whose rigorous symmetry is softened somewhat by cast shadows. The exuberance of the vegetation allowed him to use his preferred greens, blues, and purplish-grays—the basis for the criticism of "indigomania" often leveled against him. A. D.

22
The Wall of the Kitchen Garden, Yerres

(Le Mur du jardin potager, Yerres)

1875/77

Oil on canvas

27 × 41 cm

Berhaut 1978, no. 65; Berhaut 1994, no. 75

Private collection

Selected Bibliography
Wittmer 1990, pp. 106–107.

Caillebotte probably never intended to exhibit this oil sketch, but it provides insight into his creative process. Very likely painted after nature, this small canvas features colored masses strictly contained within the lines of a rigid perspective scheme. At the same time, Caillebotte studied the play of light and shadow, heightening the contrast between them. Marie Berhaut compared this painting with a pastel (Berhaut 1994, no. 76) bearing the date 1877, which provides an important chronological reference point for this series of views of the Yerres kitchen garden. In any event, the title, *Jardin*, given to as yet unidentified canvases in the catalogue of the 1876 exhibition, warrants the supposition that Caillebotte began work on this theme as early as 1875. A. D.

23

Boating Party, also known as Oarsman in a Top Hat

(Partie de bateau, also known as *Canotier en chapeau haut de forme)*

1877/78
Oil on canvas
90 × 117 cm
Signed lower left: *G. Caillebotte*
Stamped lower right
Berhaut 1978, no. 93; Berhaut 1994, no. 122

Private collection

Principal Exhibitions
Paris 1879, no. 8; Paris 1894, no. 60, as *Promenade en bateau (1878),* priced at 2,000 francs (according to an annotated catalogue in the Durand-Ruel archives, Paris); Paris 1951, no. 30; Chartres 1965, no. 10; London 1966, no. 18; New York 1968, no. 28; Houston and Brooklyn 1976–77, no. 34; Marcq-en-Baroeul 1982–83, no. 10; Yerres 1987, without no.

Contemporary Criticism
Draner 1879.

Selected Bibliography
Roberts 1966, p. 386; Sutton 1966, p. 17; Berhaut 1968, p. 31; Berhaut 1978, pp. 34 and 41; Varnedoe 1987, no. 21; Herbert 1988, p. 245; Wittmer 1990, pp. 72, 77, 171, and 302.

It is thanks to the caricature by Draner (fig. 1)—for the language used by other critics is imprecise—that we can confidently identify this work as number 8 in the fourth Impressionist exhibition, in 1879, where it was shown under the title *Partie de bateau.* Although the model's features are carefully individualized, we know nothing about him except what is implied by his clothing, namely that he is probably a Parisian bourgeois. Caillebotte here depicted the type of the occasional oarsman, a young city-dweller who has removed his jacket but retained his hat (providing Draner with a pretext for his wacky paraphrase); he is pictured rowing in a stable, well-built rowboat (perhaps the large one said in the Yerres inventory to be stored in a boathouse at the back of the property). The river is very likely the Yerres, but no distinctive topographical features are visible, and the title offers no help in situating the scene.

The use of such a radically cropped figure in the foreground recalls Manet's *Boating* of 1874 (fig. 2), which Caillebotte could have seen in the older artist's studio in 1876, and which was shown in the 1879 Salon. But the similarity is probably fortuitous, for *Boating Party* features several of Caillebotte's most distinctive compositional methods, notably an exaggerated foreground and a plunging perspective, signaled by the small boat in the background whose scale is singularly reduced. Caillebotte is even closer to his model than Manet was; it is as though only the rower's feet prevented him from moving closer still. As in *Oarsmen* (cat. 24), Caillebotte detailed the strong hands that grip the oars and provide the sole indication of real physical exertion. Except for the warmer colors of the boat's wood, the palette is organized around contrasts between dense greens and the grays, violets, and bluish tones so widely criticized in 1879; likewise, the vigorous handling—"tenacious masonry" (*"maçonnerie acharnée"*), in the words of Duranty[1]—was found disagreeable, although its energy seems well-suited to the subject. A. D.

1 Duranty 1879.

Figure 1. Draner (pseud. for Jules Renard, 1833–c. 1900). *(Steam)boating Party,* detail from "Chez MM. les Peintres indépendants, par Draner," *Le Charivari,* 23 Apr. 1879.

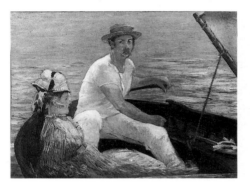

Figure 2. Edouard Manet (1832–1883). *Boating,* 1874. Oil on canvas; 97 × 130 cm. The Metropolitan Museum of Art, New York (Bequest of Mrs. H. O. Havemeyer).

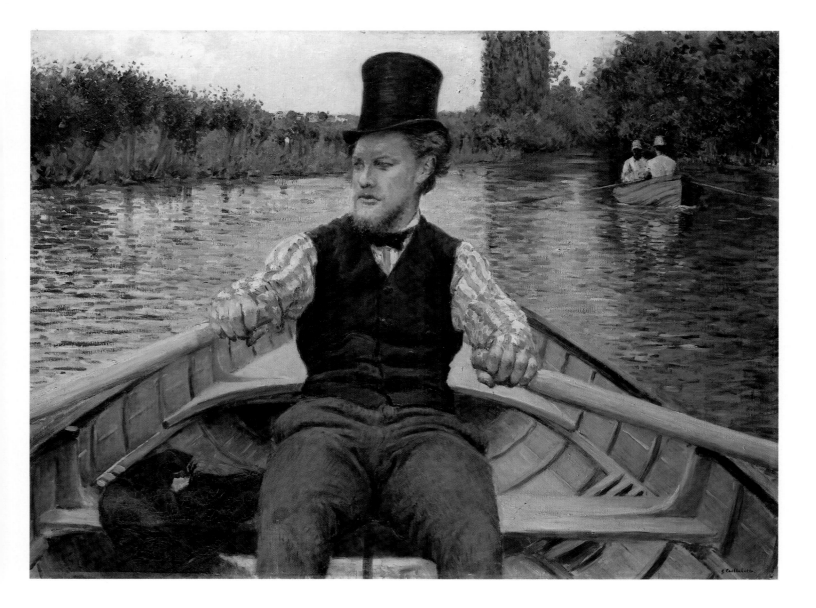

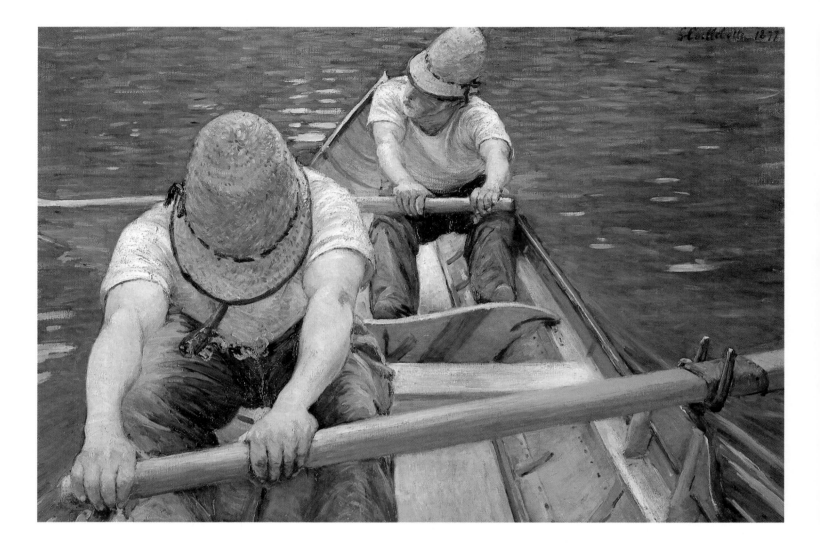

24
Oarsmen
(Canotiers)

1877

Oil on canvas

81 × 116 cm

Signed and dated upper right:
G. Caillebotte 1877

Berhaut 1978, no. 75; Berhaut
1994, no. 83

Private collection

Principal Exhibitions
Paris 1879, no. 7; New York 1886,
no. 272, as *The Rowers,* priced at
1,750 francs (according to an an-
notated catalogue in the Durand-
Ruel archives, Paris); Paris 1894,
no. 90, as *Rameurs (1877),* priced
at 2,000 francs (according to
an annotated catalogue in the
Durand-Ruel archives, Paris);
Paris 1951, no. 17; London 1966,
no. 9; New York 1968, no. 15;
Houston and Brooklyn 1976–77,
no. 33; Marcq-en-Baroeul 1982–83,
no. 9; Yerres 1987, without no.

Contemporary Criticism
Bec 1879; Burty 1879; Draner
1879.

Selected Bibliography
Berhaut 1968, p. 13; Berhaut
1977, p. 47; Berhaut 1978, pp.
33–34, and 41; Varnedoe 1987,
no. 20; Balanda 1988, pp. 82–83;
Herbert 1988, p. 245; Chardeau
1989, pp. 76–79; Wittmer 1990,
pp. 72, 77, 167, and 279.

Between the extremes represented by *Boating Party* and *Périssoires* (cats. 23 and 25), *Oarsmen* offers an image of the sport involving a moderate degree of exertion: two men in standard boating attire, jerseys, and straw hats are shown rowing in a sturdy boat; one man's face is hidden and the other's is only vaguely delineated, which obliges the viewer to focus on the two pairs of arms, symbols of effort and movement. The artist's point of view is that of someone standing in the boat or looking down on it from a bridge, allowing for a plunging, arrowlike compositional scheme, moderated somewhat by the horizontals of the oars, the front rower's seat, and the splashing wavelets, only a few of which are affected by the hull's advance.

The work's originality made it irresistible to the caricaturists: Draner (fig. 1) simplified it in the process of interpreting it (unless there was another version that is now lost, which seems unlikely); curiously, Bec (fig. 2), who reproduced the composition more or less accurately, cropped the head of the second oarsman in a rather labored attempt at a joke: M. Roch, the Paris executioner, had just died, as is confirmed in the issue of *L'Illustration* dated 3 May 1879. Was Bec poking fun at the arbitrary croppings often criticized in Impressionist work, or was he responding to an earlier state of the painting? Only examination under ultraviolet and infrared rays would allow us to answer this question definitively. In any event, a drawing squared for transfer[1] has exactly the same composition, but it is not easy to determine its precise relationship to the picture. Is it a preparatory study, or was it done after the fact, despite the squaring? Should it be understood in the same way as a small

tracing also squared for transfer in the margin of a study for *Paris Street; Rainy Day* (see cat. 44), and thus, as Kirk Varnedoe suggested, be seen as evidence of the work's having been based on a small photograph or camera-lucida image? Once again, decisive evidence is lacking, but the explanation seems plausible.

The above-mentioned caricatures, illustrated commentaries confirming the attention attracted by *Oarsmen,* provide the only known contemporary accounts dealing explicitly with the work. Critics of the time made do with general discussions of the boating theme. Caillebotte's simplified color harmonies—here constructed around blue-green, yellow, and a touch of purplish-pink—and his broad handling tended to irritate the reviewers. Even Philippe Burty, who had appreciated the novel subject matter and controlled draftsmanship of *Floor-Scrapers* (cat. 3), refused to follow Caillebotte as his work evolved. However, a judicious blending of all the "modern" ingredients judged so harshly at the time—its subject, compositional scheme, and handling—makes *Oarsmen* one of the artist's most significant works. A. D.

1 Berhaut 1994, no. 83A.

Figure 2. Bec. *M. Caillebotte could ask to replace the late M. Roch; for he often suppresses a head—he could even paint in his spare time,* detail from "Coup d'oeil sur les indépendants," *Le Monde parisien,* 17 May 1879.

Figure 1. Draner (pseud. for Jules Renard, 1833–c. 1900). *Oarsmen. What is he doing?,* detail from "Chez MM. les Peintres indépendants, par Draner," *Le Charivari,* 23 Apr. 1879.

25
Périssoires

(Périssoires)

1877

Oil on canvas

103 × 156 cm

Signed and dated lower left:
G. Caillebotte 1877

Berhaut 1978, no. 76; Berhaut
1994, no. 86

Milwaukee Art Museum (Gift
of the Milwaukee Journal
Company in honor of Miss
Faye McBeath, M1965.28)

Principal Exhibitions
Paris 1879, no. 9 or 10; New York
1886, no. 186 (?), as *Paddling
Canoe,* priced at 2,000 francs
(according to an annotated
catalogue in the Durand-Ruel
archives, Paris); Paris 1894, no.
30, as *Périssoires (1877)—belong-
ing to M. Lamy*; New York 1968,
no. 14; Houston and Brooklyn
1976–77, no. 35, Ann Arbor
1979–80, no. 7.

Contemporary Criticism
Bec 1879.

Selected Bibliography
Berhaut 1968, p. 27; Varnedoe
1987, no. 22; Balanda 1988,
pp. 94–95; Herbert 1988, p. 246;
Wittmer 1990, pp. 72 and 161.

The largest of the boating paintings, *Péris-soires* was shown at the 1879 exhibition, as is attested by Bec's schematic rendering (fig. 1). It might also have been the work exhibited in New York at Durand-Ruel in 1886, because of the high price assigned it, justifiable by its large format and high finish. But there is another viable candidate, which also figured in the 1879 exhibition: the sec-ond version of *Périssoires* (Berhaut 1994, no. 87), only slightly smaller than the first but with a more casual compositional scheme. These two paintings evidence the artist's particular interest in these precarious flat-bottomed canoes with the aptly suggestive name (from the French verb *périr*: to perish, to sink).[1]

Once again, Caillebotte evoked a familiar scene on the Yerres—which was narrow and bordered by trees where it flowed past his parents' proper-ty—picturing amateur rowers with a modicum of expertise but not caught up in the heat of competi-tion. In the present version, the faces of the oars-men are relatively well defined; one of them has

the features of Eugène Lamy, a friend and sporting companion of Caillebotte's, of whom the artist also painted a more formal portrait.[2]

Dynamic perspective devices are absent, for the artist here aimed at creating calming rhythms through the repeated *périssoires*, the sequence of vertical tree trunks, and the handling of the water, which reflects the figures in soft color harmonies.
A. D.

1 See also *Périssoires* (cat. 28) and *Rower Reaching for His Périssoire* (Berhaut 1994, no. 123).

2 See Berhaut 1994, no. 403.

Figure 1. Bec. *The City Council should commission M. Caille-botte to decorate the quays of Paris, reproducing this interest-ing motif as many times as necessary from Bercy to the Point du Jour. You've already done quite a bit, M. Caillebotte,* detail from "Coup d'oeil sur les indépendants," *Le Monde parisien,* 17 May 1879.

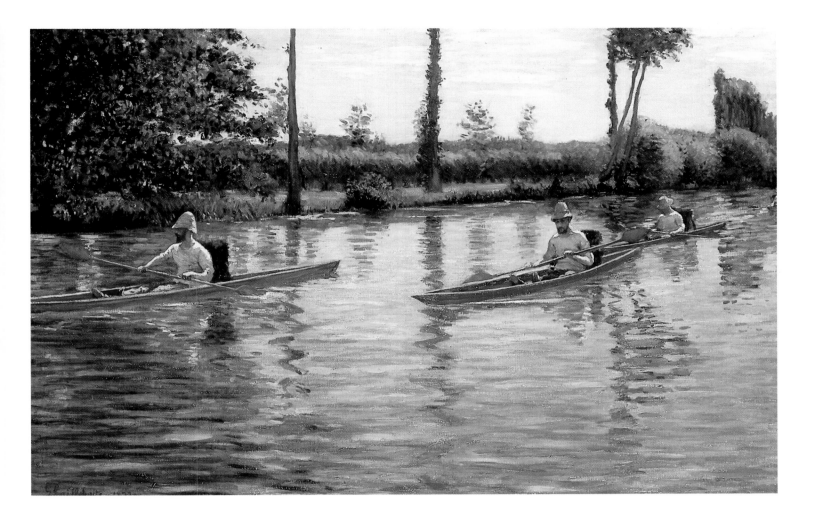

26
Fishing
(*Pêche à la ligne*)

1878

Oil on canvas

157 × 113 cm

Signed and dated lower right:
G. Caillebotte 78

Berhaut 1978, no. 89; Berhaut
1994, no. 118

Private collection

Principal Exhibitions
Paris 1879, no. 23; Paris 1951, no.
26; New York 1968, no. 22; Houston and Brooklyn 1976–77, no.
37; Yerres 1987, without no.

Selected Bibliography
Berhaut 1978, p. 41; Wittmer
1990, pp. 19, 72, 77, 231–33,
and 277.

Decorative Triptych

In 1879 this and the two paintings that follow were exhibited as a trio of "decorative panels" constituting a single ensemble; they are here reunited for the first time. All three depict summer diversions along a riverbank. Caillebotte resorted once again to his familiar Yerres repertory: the *périssoires* were previously painted in 1877 (cat. 25), and, while the fisherman's identity remains unknown, Marie Berhaut reported a family tradition according to which the young girl in *Fishing* is Zoé Caillebotte, the painter's cousin, depicted by him in 1875 (cat. 17). As for *Bathers*, it is based on a pastel dated 1877 (fig. 1), also shown in 1879, which creates a stronger impression of having been executed from life than does the painting. Draner's caricature (fig. 2), while incorporating the catalogue number assigned the oil, features the superb striped bathing suit of the pastel. On the other hand, it is without doubt the diver from the painting that is reproduced in a drawing[1] published in the 17 July 1880 issue of *La Vie moderne*; the accompanying caption, *Paris, Summer—At the Grenouillère*, is an indication of the Parisian public's tendency to associate such subject matter with the famous bathing spot and tavern on the Ile de Croisy in the Seine, popularized by newspaper illustrators as well as by the well-known canvases by Monet and Renoir of 1869.[2]

These drawings indicate that the paintings attracted attention, but none of the critics who published accounts of the 1879 exhibition specifically mentioned them. Only Louis Leroy, who has the dubious honor of having invented the term "Impressionist," referred mockingly to the "whitish gleams on the water in number 25," which is to say, *Périssoires*. Regarding another painting (no. 13, entitled in the catalogue *Oarsman Reaching for His Périssoire*)—but his remarks are just as applicable to the other rowing pictures, notably *Périssoires*—Leroy penned the following indictment, no less cutting for being playful: "These grassy waves have the freshness and solidity of a green meadow before haytime; and what makes [the water] still more appealing is that two rowers plough through it, without apparent fatigue, with their oars. Tough guys, to navigate through the greensward like this!"

The constantly reiterated comments about the faulty vision of the Impressionists in general and Caillebotte in particular, "haunted by purple and blue rays," prompted Paul Sébillot to propose the following defense:

His *Périssoires*, his rowing *Oarsmen*, always impress from a distance as works interesting for their investigations of light and *plein-air* effects. I imagine that certain of his compositions used as decoration in an apartment, isolated, calmed down somewhat by surroundings of gilded paneling, would lose the crude and violent aspect they have in the light in which they are presently exhibited. Works of this nature should be seen apart, for they find neighbors intolerable.[3]

Was this remark made spontaneously, or was it based on conversation with the artists themselves? The phrase "decorative panels," used by Caillebotte to characterize this set of works, lends support to the second hypothesis. In their earlier catalogues, the Impressionists carefully appended to their titles the qualifiers "sketch," *"ébauche,"* or even *"projet de tableau,"* in hopes of exempting them-

continued on page 82

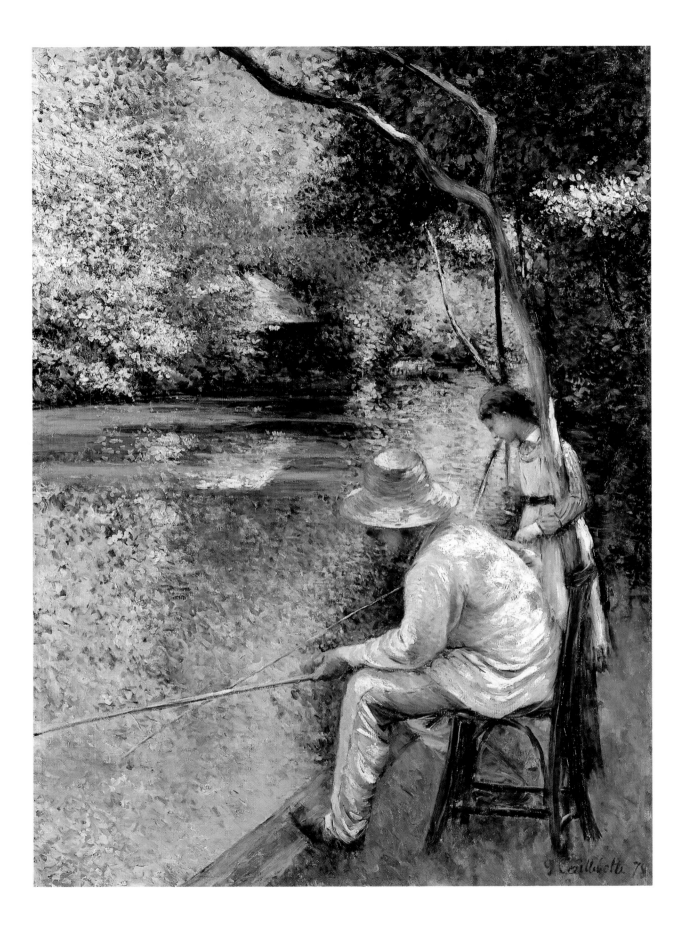

27

Bathers

(Baigneurs)

1878

Oil on canvas

157 × 117 cm

Signed and dated lower right:
G. Caillebotte 78

Berhaut 1978, no. 90; Berhaut
1994, no. 119

Private collection

Principal Exhibitions
Paris 1879, no. 24; Paris 1894, no.
115; Paris 1951, no. 27; London
1966, no. 15; New York 1968, no.
23; Yerres 1987, without no.

Contemporary Criticism
Draner 1879.

Selected Bibliography
Berhaut 1968, p. 29; Berhaut
1978, p. 41; Wittmer 1990, pp. 72,
77, 175, and 277.

selves from criticism attacking their lack of "finish,"
an aspect of their production about which they felt
vulnerable. It was in all likelihood partly as a result
of such concerns—for summary handling was tra-
ditionally sanctioned in "decorative" painting,
which was not intended for close scrutiny—that
Monet, in 1876, exhibited a "decorative panel" that
was none other than *The Luncheon*, which Caille-
botte himself acquired (see Appendix III, fig. 22),
and then, in 1877, hedged his bets by describing his
Turkeys (1877; Musée d'Orsay, Paris), painted for
the businessman Ernest Hoschedé, as an "unfin-
ished decoration." In 1879, when Caillebotte exhib-
ited his decorative panels, one of Degas's works, a
painting in distemper, was listed in the catalogue as
Essai de décoration (détrempe).

However, this recurrence was not determined
only by preemptive caution. It also reflects the aspi-
rations of "The New Painting," whose adherents
dreamed of covering the walls set aside for "official"
art in a modern Paris then under construction. In
April 1879, Manet submitted to the prefect of the
Seine a plan to decorate the city-council meeting
room in the new city hall with paintings depicting
"Paris—Les Halles Market, Paris—Railroads, Paris—
Port, Paris—Underground, Paris—Racetracks and
Gardens"; that same year Renoir, too, tried to
muster support for an official decorative commis-
sion, and the articles he published in *L'Impression-
niste* in 1877 indicate his interest in the problem of
integrating architecture and decor. Monet was per-

haps the only member of the group to complete
such a project on a rather large scale, in the deco-
rations for Hoschedé; these included, in addition
to *The Turkeys*, three large panels: *Corner of the
Garden at Montgeron, The Pond at Montgeron* (both
1876; Hermitage Museum, St. Petersburg), and *The
Hunt* (1876 Durand-Ruel collection, Paris), probably
intended for the Château de Rottembourg in Mont-
geron, only a few miles from Yerres. Contact be-
tween Caillebotte and this enthusiast of Impres-
sionist painting is not documented, but he certainly
knew Monet's ensemble, which was split up—we
do not know whether it was ever installed—some
time after 1878, the year Hoschedé went bankrupt
as a consequence of his unbridled passion for col-
lecting. Two of Caillebotte's friends, the painter De
Nittis and the critic Duret, purchased certain of its
elements.[4]

Caillebotte's decorative panels are variations on
compositions he had produced earlier. His penchant
for boating images has already been discussed; he
had treated the fishing theme in a small canvas
featuring two fishermen in a rapidly receding per-
spective[5]; likewise, *Bathers* was preceded by a work
whose format is close to that of the decorative
panel and whose strident palette is dominated by
blues,[6] featuring male nudes oddly reminiscent of
those in the Cézanne *Bathers* in Caillebotte's collec-
tion (see Appendix III, fig. 4).

Comparison of these earlier efforts with the three
decorative panels reveals a tendency to moderate
the strong spatial recessions and to close off views
of the sky with foliage handled like the generic *ver-
dures* in old tapestries. The vegetation and the river

continued on page 85

Figure 1. Gustave Caillebotte. *Bathers*, 1877. Pastel;
75 × 95 cm. Musée des Beaux-Arts, Agen.

Figure 2. Draner (pseud. for Jules
Renard, 1833–c. 1900). *The artist
has carefully lathered his water with
Marseilles soap*, detail from "Chez
MM. les Peintres indépendants, par
Draner," *Le Charivari*, 23 Apr. 1879.

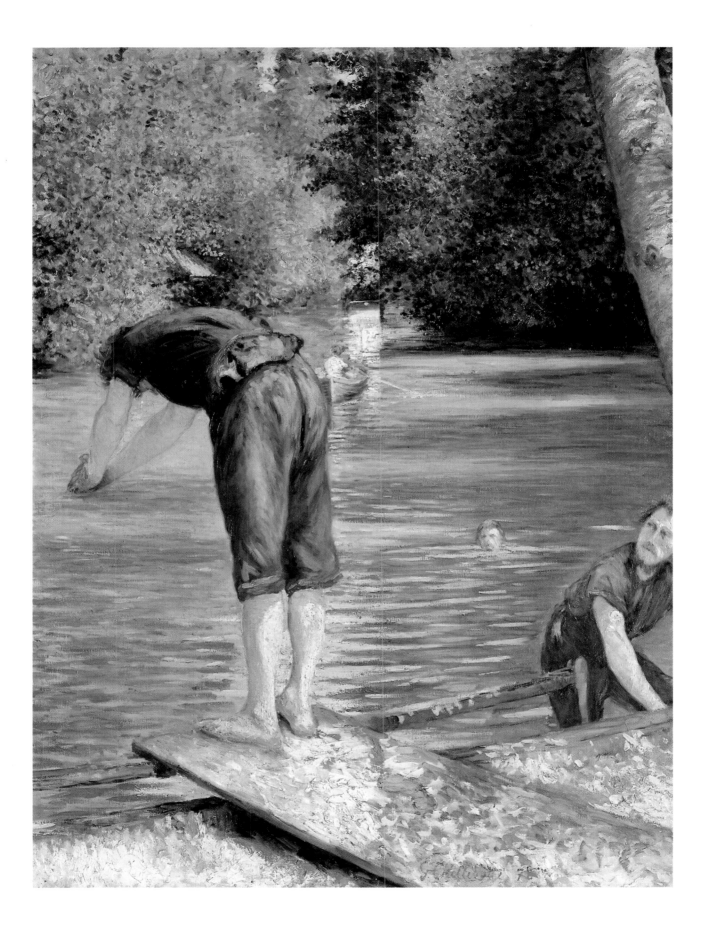

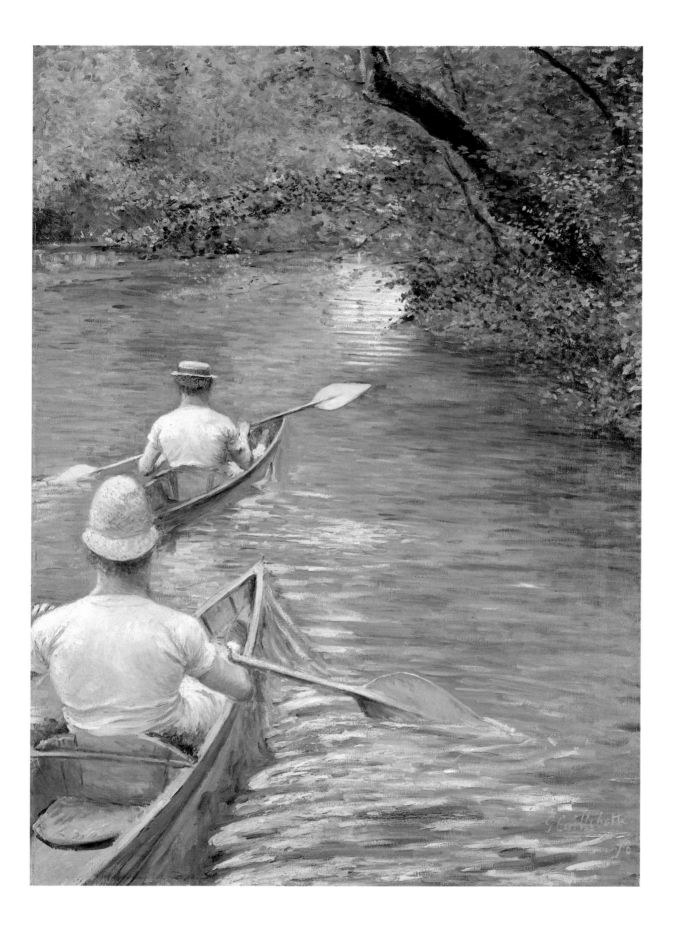

28
Périssoires

(*Périssoires*)

1878

Oil on canvas

155 × 108 cm

Signed and dated lower right:
G. Caillebotte / 78

Berhaut 1978, no. 91; Berhaut
1994, no. 120

Musée des Beaux-Arts, Rennes
(Wildenstein gift, 1951)

Principal Exhibitions
Paris 1879, no. 25; Paris 1951, no.
28; London 1966, no. 16; New
York 1968, no. 24.

Contemporary Criticism
Leroy 1879.

Selected Bibliography
Varnedoe 1987, p. 104, fig. 23a;
Wittmer 1990, p. 165.

are rendered in rhythmic brush strokes previously unknown in Caillebotte's work and almost certainly inspired by Monet's. But, in addition to emulating an admired colleague, here the artist clearly invoked a venerable tradition, if only by his chosen theme, linked to that of the Seasons, pictured in countless decorations in the past but here adapted by Caillebotte to suit the needs of his own time.

We do not know whether Caillebotte's ensemble was installed as such during the artist's lifetime. It is perhaps tempting to imagine its having been designed to replace the Barbot and Corot paintings in the dining room at Yerres (see intro.). This was not the only decorative scheme conceived by Caillebotte. At the end of his career, in 1890, he undertook another series of panels representing sailboats at Petit Gennevilliers, intended for the Paris apartment of his brother Martial.[7] And he also executed a series of floral compositions for door pan-

els in the dining room at Petit Gennevilliers (see cat. 117) that are reminiscent of those painted by Monet for Durand-Ruel in 1882–85 and by Renoir for the Château de Wargemont, owned by his friend Bérard, about 1880. As did his Impressionist friends, Caillebotte sought to renew the French decorative tradition, thereby adding a link to the chain further extended at the century's close by the Nabis, who favored themes that would have been congenial to Caillebotte. A. D.

1 Berhaut 1994, no. 119A.
2 See ch. 2 intro. n. 14.
3 Sébillot 1879.
4 See Chronology, 1878.
5 See Berhaut 1994, no. 117.
6 See ibid., no. 121.
7 See ibid., no. 406.

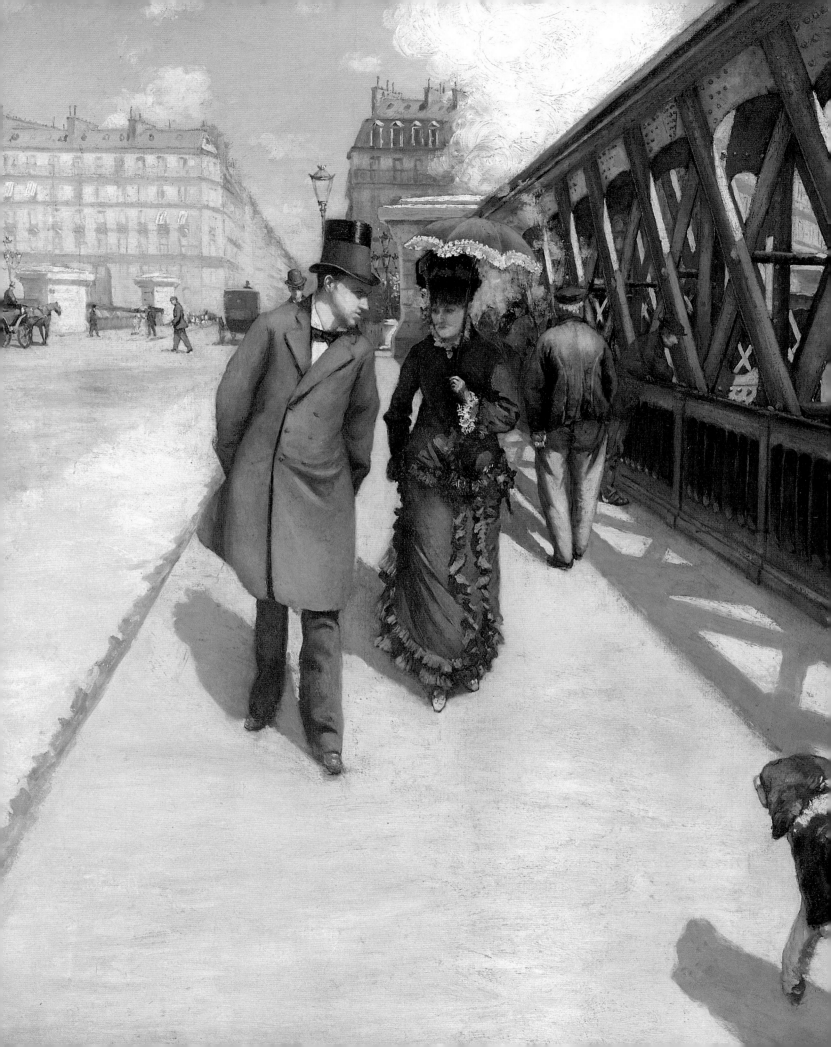

The Street

Paris was transformed into a modern and international capital in the mid-nineteenth century when the crowded, dirty corridors of the old city center were replaced by an elaborate system of wide streets and tree-lined boulevards. These new streets were designed to accommodate a growing, increasingly middle-class Parisian population that lived, conducted business, and played out-of-doors more than ever before. The street, in particular the boulevard, was without question the most important and visible social space of the new French capital. One late nineteenth-century observer went so far as to describe the boulevard as the "spot" where the city gathered and concentrated itself, the center of its moral activity: "I do not exactly mean that the boulevard is Paris; but surely, without the boulevard we should not understand Paris."[1]

Beginning with Charles Baudelaire, those writing about modern life in Paris have similarly characterized it as one led chiefly in public, and best observed on the new city streets and boulevards.[2] The archetypal figure in this literature is the man on the street, the boulevardier or *flâneur*[3] for whom: "The street becomes a dwelling . . . he [the *flâneur*] is as much at home among the facades of the houses as a citizen is in his four walls. To him the shiny, enameled signs of business are at least as good a wall ornament as an oil painting is to a bourgeois in his salon. The walls are the desk against which he presses his notebooks; news-stands are his libraries and the terraces of his cafés are the balconies from which he looks down on his household after his work is done."[4] This *flâneur* not only inhabits the street, but, as "the man of the crowd,"[5] he strolls along, surreptitiously studying it and the social types with whom he shares its pleasures. As the observer of modern life, the *flâneur* has been variously likened to a detective[6]; to a "prince who is everywhere in possession of his incognito"[7]; to a scientist who, in the words of Walter Benjamin, goes "botanizing on the asphalt"[8]; and finally to an artist, a "man of the world" who transforms or translates the ephemeral and contingent spectacle of modernity into something eternal and poetic.[9] This artist-*flâneur* is, quite simply, the painter of modern life.

It should come as no surprise, then, that Gustave Caillebotte, one of the proclaimed painters of modern life in the 1870s, so often chose to paint the street. He was joined in this venture by many of his colleagues, both Independent and Salon artists, who in the mid-to-late 1870s turned frequently to this motif of urban modernity. Predictably, the writer and art critic Edmond Duranty, in his influential 1876 essay "The New Painting," gave the space and subject of the street an important place in his definition of the new Realism.[10] Yet, no Impressionist painter other than Caillebotte—with the exception of Manet, perhaps—seems to have confronted the street so directly (see cat. 38)

and so persistently over the course of his or her artistic career. The street was the subject of two of Caillebotte's most important modern history paintings, *Paris Street; Rainy Day* (cat. 35) and *The Pont de l'Europe* (cat. 29), shown together in the third Impressionist exhibition, in 1877.

One might also argue that the street is a principal organizing space in Caillebotte's art, even when the subject is ostensibly different. One of his earliest known canvases, *A Road near Naples* (cat. 1), for example, eschews the dramatic countryside of southern Italy in favor of an unnamed road. While the twin summits of a scenic mountain[11] loom in the far distance, they are overwhelmed in Caillebotte's picture by the wide expanse of roadway that dominates the foreground and covers over half the canvas. In the middle of this roadway, blocking the view of the town beyond, Caillebotte prominently placed a single horse and carriage, within which may be what some have identified as a man painting, his hat barely visible over the top of a canvas stretcher. If the image indeed depicts an artist at work, it is possible that he is Caillebotte's friend and fellow painter Giuseppe De Nittis, since it is generally thought that the picture was painted during Caillebotte's stay with the De Nittis family in Naples during the summer of 1872.[12] It is also possible, however, to consider the working artist as representing Caillebotte himself, and *A Road near Naples* as an early, telling self-portrait of the modern artist literally reflecting—as in a mirror—his place in the street.[13] The painter, turned away from the spectacular landscape behind, concentrates instead on the road before him. Here, in *A Road near Naples*, Caillebotte appears to have declared streetscape to be the landscape of his art, while at the same time working out its compositional formula. The arrangement of pictorial elements, especially the oblique positioning of the road, and its sharp, perspectival plunge created by the presence of two separate vanishing points, would reappear in several of Caillebotte's most ambitious Paris street pictures, including *The Pont de l'Europe* and *House-Painters* (cat. 15).

Other early paintings executed in Naples or at the Caillebotte family estate at Yerres feature similar compositions, and nearly all are of roads or other closely related passageways. Caillebotte painted waterways in such works as *On the Bank of a Canal near Naples* (Berhaut 1994, no. 7), *On a Riverbank, Morning Mist* (Berhaut 1994, no. 31) and *The Yerres, Rain* (cat. 16), in which he explored the visual homology between the bordering road or pathway and the river it followed. He also painted railways, most notably in his *Landscape with Railroad Tracks* (Berhaut 1994, no. 5)—a very distinctive composition that he would later develop in numerous city scenes, including the Kimbell *Pont de l'Europe* (cat. 31), and, especially in relationship to the street, *Rue Halévy, Balcony View* (cat. 61) and

A Balcony (cat. 65). Even in his depictions of the Caillebotte family gardens at Yerres, the artist chose to emphasize the man-made pathways of the elaborate park (see cat. 21) and the manner in which the elements of the garden (flower bed, garden wall) were organized and structured according to these circulation routes. Caillebotte's own pictorial efforts at Yerres to combine the attributes of the street and the park can be compared with and were perhaps a response to recent efforts in the capital city to do the same with the boulevard. In *The Park on the Caillebotte Property at Yerres* (cat. 17), Caillebotte even recorded the opportunities for strolling that such garden boulevards offered the vacationing *flâneur* displaced from his accustomed urban milieu. Most of these early paintings suggest a vantage point from the garden pathways themselves. Caillebotte seemingly felt compelled, like the artist depicted in *A Road near Naples*, to take his easel and paints "to the street" even when in the country.

The new streets of Paris were prominently featured in Caillebotte's publicly exhibited cityscapes of the late 1870s and early 1880s, and it is for these sometimes monumental depictions of the quartier de l'Europe and the quartier de l'Opéra that the painter is perhaps best remembered today. Nevertheless, Caillebotte appears to have carried his "boulevard vision" with him wherever he went: in Parc Monceau (see cat. 34), at Trouville, Etretat (see cat. 100), Argenteuil, and Petit Gennevilliers (see cat. 105). Even several of his still lifes featuring produce or meats in a shop window imply a viewing position from the street (see ch. 6 intro.). Born and raised in Paris during the Second Empire when the capital was transfigured by new thoroughfares, Caillebotte revealed himself in the 1870s to be an artist-*flâneur*, the painter of modern life as it had been transformed and defined by the street. Writing at the time of the Impressionist exhibition of 1877, the critic Jacques characterized the subject matter taken up by some members of the group: "So four Impressionists have given themselves the mission of reproducing Paris. M. Caillebote [*sic*] has chosen the street; M. Renoir, popular dance venues; M. Degas, the theater and the café-concert; Mlle Berthe Morisot, the bedroom. Aside from this, a few excursions into the country, naturally, but always rendered by the brushes of Parisians."[14]

The paradox is that when Caillebotte painted the streets of Paris in the 1870s, and in so doing declared the modernity of his art, he chose an urban space with a profound history: "To do a complete history of the boulevards would be to write a narrative of the most important events transpiring in Paris over the last hundred years."[15] In addition to providing circulation routes and functioning as sites of social and commercial exchange, the Paris street had for centuries been the principal

space for public ceremony and celebration—for the public display of power as well as revolutionary opposition to it. More recently, in 1830 and 1848, the streets of the capital became not only the site of such political struggles, but a weapon, as revolutionaries constructed barricades from paving stones. The Paris street was thereby indelibly marked with the history of social conflict.

Soon after the establishment of the Second Empire in 1851, the government of Napoleon III began its ambitious twenty-year effort to erase through wholesale destruction and rebuilding the recent memories of street fighting, and to reclaim the Paris street—and the capital itself—for the imperial government. Napoleon III, along with his powerful prefect of Paris, Baron Georges Eugène Haussmann, took up again the so-called "Artists' Plan" of 1793 and incorporated it into their own comprehensive street-realignment program.[16] Old streets were demolished in the name of public hygiene and slum clearance, and replaced under the banner of progress with eighty-five miles of grand boulevards. These modern, relentlessly uniform streets were furnished with gaslights, sidewalks, benches, kiosks, and a new sewer system. Glamorous new shops, restaurants, cafés, hotels, and theaters quickly lined their sides. As a result of these transformations, along the streets of Haussmann's new city, pleasure now ostensibly substituted for conflict, and modernity for revolution.

Haussmann's street projects also constituted a major program of public works in Paris. They ensured steady employment for a potentially dangerous segment of the working class, and, in so doing, the imperial goverment hoped to gain the confidence of this class. Moreover, it was believed that the new boulevards would prove to be "antiriot" streets, capable of deterring socially subversive activities. Many cut through lower-class *quartiers* that had previously been hotbeds of insurrection, and it was presumed that their unprecedented width would both prevent the construction of revolutionary barricades and facilitate the speedy deployment of government troops to the city center. These social aims of Haussmann's new boulevards are evident from the elaborate street festivals organized to celebrate their completion—festivals in which an image of social diversity and harmony was carefully orchestrated (see fig. 1). Moreover, their socially supervisory function was reflected in the resulting panoptic organization of the new urban landscape, wherein straight-lined boulevards converged radially on a few monuments or squares of particular symbolic significance.

When, in 1877, Caillebotte painted his famous streetscapes, his subject was thus laden with historical associations and, in the wake of the dramatic events of the recent "terrible year" of

Figure 1. Félix Thorigny (1824–1870). *The Opening of Boulevard Malesherbes, 13 Aug. 1861*, 1861. Engraving; 26 × 35.5 cm. Musée Carnavalet, Paris.

1870–71—the war with Prussia, the Siege of Paris, and the establishment and subsequent repression of the revolutionary Commune government—that had also taken place in the streets of the capital, especially with associations of civil war and its aftermath. Nevertheless, it was not only Caillebotte's chosen motif that resonated with historical significance. His mode of artistic expression also had a complex and meaningful past as part of a tradition that was itself closely allied to the revolutionary circumstances of the street. Cityscape, and especially streetscape, had for years recorded the grand ceremonies—and revolutions—of the capital. Cityscapes, moreover, had also functioned as important visual confirmations of Paris's recovery from the horrors of war and civil conflicts. The revival of the eighteenth-century *veduta* tradition in the First Empire, and again in the early years of the July Monarchy, for example, can be understood at one level as having been fueled by a demand for images of national reconstruction, as they generally depicted the bustling commercial activity of the recovering capital city, and especially the safety and peacefulness of its streets. Nevertheless, it was distinctly after the revolution of 1830 that the street emerged as a favored subject within the highly politicized imagery of the Parisian cityscape. Romantic painters and writers turned to the street, the barricade, and the pavement as a means of giving their art a political content, as the fights in and over the streets in 1830 and 1848 were preserved in unforgettable images (see figs. 2 and 3). To represent the street was to represent a politically contested urban space, the principal arena where the "people" periodically expressed their collective power and where the governing bodies of "order" were forced to address or suppress such public displays. As the writer, artist, and politician Victor Hugo wrote in his journal during these years: "The most excellent symbol of the people is the paving stone."[17]

The mid-century transformations of the city only increased artistic and public interest in street imagery, and streetscapes proliferated, especially in the form of prints and photographs. Although the transformations were seemingly intended to erase the history of the old city streets, they only sharpened

Figure 2. Eugène Delacroix (1798–1863). *Liberty Leading the People*, 1830. Oil on canvas; 260 × 325 cm. Musée du Louvre, Paris.

Figure 3. Ernest Meissonier (1815–1891). *The Barricade, Rue de la Mortellerie, June 1848*, or *Memory of Civil War*, 1850–51. Oil on canvas; 29 × 22 cm. Musée du Louvre, Paris.

Figure 4. Edouard Manet (1832–1883). *The 1867 Paris Universal Exhibition*, 1867. Oil on canvas; 108 × 196.5 cm. Nasjonalgalleriet, Oslo.

the political edge of a pictorial tradition that would preserve their memory. "Old Paris" could be romanticized for either its monarchist or Republican revolutionary history. Likewise, images of *"Paris démoli,"* pictures of the city's actual or imminent destruction in the wake of Haussmann's rebuilding campaign, could be mourned in a subtly implied criticism of the imperial regime or, alongside pictures of the "new Paris," embraced and even celebrated in the name of progress.[18]

The completion of the new imperial city was celebrated at the Paris Universal Exhibition in 1867, the same year that a group of avant-garde painters took up in earnest Parisian cityscape. The spectacle of the modern city was of interest to those painters who themselves claimed to be modern—specifically Manet, Monet, and Renoir, painters who would become Caillebotte's colleagues in the 1870s. In a group of bright, airy canvases dating to 1867, all three celebrated the "new Paris" in a series of modern *vedute* (see fig. 4).[19] These artists appear to have chosen, however, to compensate for or soften the architectural severity of Haussmann's achievements, in part through the sketchiness of their own technique, and with images that revel in the movement of the crowd, the color and wide expanse of the sky, and the natural elements of the city such as rivers, trees, and gardens. Significantly, the new streets themselves do not figure prominently, if at all, in these paintings. Moreover, both Manet and Renoir clearly conveyed the many pleasures—promenading, boat excursions on the Seine, or simply viewing—that the new city offered to all Parisians. Such paintings of urban social mixing during the late Second Empire appear to address, albeit ambiguously, the widespread criticism that Haussmann's transformations had caused Paris to become socially divided, with the working class permanently relocated to the city's perimeter or *banlieue*.

During the turmoil of 1870–71, painters generally abandoned cityscapes, just as, for the most part, they left the city itself. Shortly after the repression of the Commune in May 1871, however, the leading ranks of French artists and painters returned to Paris and took up representing the city—especially its streets—with unprecedented enthusiasm. Indeed, by the time Caillebotte (who had, it seems, remained in Paris during

the Siege[20]) exhibited his trio of streetscapes at the Impressionist exhibition in 1877, he was doing so amidst a general proliferation of Paris street imagery that would reach its peak and be openly celebrated during the 1878 Paris Universal Exhibition.[21] This imagery and the exhibition extolled the virtues of the city, in particular its new streets. However, unlike in 1867, this celebration of modernity and the pleasures of modern city life was also a declaration of national recovery and renewal. This recuperation was in part economic, as the German indemnity was paid off and the French economy nearly back on its feet. It was also, however, a matter of large-scale physical repair (see fig. 5). On 5 June 1871, the following note pressing for national support for such reconstruction had appeared in the *Journal officiel:*

We must neither conceal nor exaggerate these losses. Paris has been deprived of most of its palaces. The Tuileries, the Palais Royal, the Hôtel-de-Ville, the palais du quai d'Orsay are now only ruins. Millions will be required to restore them to the splendid state that was theirs but three weeks ago. Merely repairing their walls, rebuilding their roofs, repositioning or replacing a few statues will entail enormous sacrifices for the city. It will be wise to do it, so as not to leave the streets seeming so devastated.[22]

By 1878 the city had regained so much of its prewar appearance that visitors would describe it as "Paris herself again."[23]

The 1878 Paris Universal Exhibition was also a celebration of the triumph of moderate Republicanism.[24] Perhaps even more so than the imperial government before it, the coalition of men who worked together during the 1870s to establish a Republican government were anxious to wipe away the memories of revolution and to diffuse both the imperial and revolutionary associations of the Paris street. Thus, the stabilization of the republic in the years between 1876 and 1879 was accompanied by a national, and overtly Republican, reclamation of the street. In 1876 the government announced its intention to complete Haussmann's unfinished avenue de l'Opéra in time for the upcoming Universal Exhibition (see fig. 6).[25] Such a large-scale street project was an important demonstration of

the Republican government's commitment to public works, and it provided needed employment for the very members of the building and construction trades who had participated in such great numbers in the recent uprising. This highly visible undertaking also afforded the new government an ideological opportunity to substitute for insurrection a public image of work, social cooperation, and technological progress in association with the street (see fig. 7).

Avenue de l'Opéra was celebrated at the 1878 Universal Exhibition, the first national festival since the war. It was at this exhibition, moreover, that the street was reclaimed for public pleasure and sociability. "Paris herself again" meant a rebuilt city, but also a rebuilt society, and by 1878 not only had the streets of Paris regained their physical integrity, but their inherently democratic nature had also been restored: "Paris, the city of equality, the democratic city par excellence, resolved to have within its boundaries a promenade that represented and served the needs of the crowd, and that belonged to everyone. Respectful of old memories, it left undisturbed the work of the past, the Tuileries, the Palais Royal, the Luxembourg; but at the same time it lovingly devised a true promenade of the future, a veritable garden of the emancipated nation; the boulevards."[26]

There has been much discussion in recent, revisionist art-historical literature about the complicity of the Impressionist painters in Haussmann's transformation of the city, their acceptance of the increasingly middle-class character of the capital that was the result of these transformations, their making into art the spectacle of the city as a space of pleasure, and the way in which they turned their easels away from the very real social tensions and ills of the quickly industrializing city.[27] Little has been done, however, to distinguish between the activities and paintings of modern painters before 1870–71 and during the period directly following that watershed year. In fact, there has been a tendency to consider the late Second Empire and early Third Republic in a continuum, and thus a general

failure to be historically specific about the ideological contents and meanings of Impressionist paintings dating to the first decade of the Third Republic. Caillebotte's monumental 1877 streetscapes, however, demand just this distinction and historical specificity.

It was in fact within the context of the postwar, post-Haussmann, Republican reconstruction of the capital that the Impressionist painters first showed their work, and it was often using the rhetoric of national recovery that critics discussed Impressionism, and the arts in general, during the 1870s.[28] Moreover, many of the Paris cityscapes, particularly the street-scapes produced and shown publicly during the 1870s, are permeated with memories of war, depicting reconstruction (see fig. 8), and often the street recovered for pleasure and commerce (see fig. 9, and cat. 64, fig. 1). Such imagery replaced that of recent hardship, destruction, and war itself (see figs. 10 and 11). Many of these new cityscapes in fact feature sites where fighting had been particularly heavy.[29]

Indeed, in the postwar search for the causes of the recent national tragedy, it was Haussmann's urban achievements that were often targeted for criticism. For many, architecture, like the street, was a reflection of the political and social order that produced it. Haussmann's monotonous facades had often been criticized as "parade architecture," and the "tyranny of the straight line" hailed as the handiwork of an authoritarian regime, supported by a single class of moneyed bourgeois. Artists and architects in the early Third Republic began to call for a more diverse cityscape, one appropriate to a democratic and specifically Republican regime built on the reconciliation of a variety of classes.[30]

Caillebotte's *House-Painters* (cat. 15), a smaller canvas shown in 1877 alongside the monumental *Paris Street* and *Pont de l'Europe*, can be understood in the context of this postwar renewal and the ideological recoding of the Paris street. Here, a group of house-painters are at work on a storefront. Significantly, they are adding the only color to a

Figure 7. *First Construction Done by Electric Light*, from *L'Illustration*, 24 Feb. 1877, p. 125. The Newberry Library, Chicago.

Figure 6. Attributed to Giuseppe De Nittis (Italian; 1846–1886). *Excavation of Avenue de l'Opéra*, 1878. Oil on canvas; 46 × 64 cm. Musée Carnavalet, Paris.

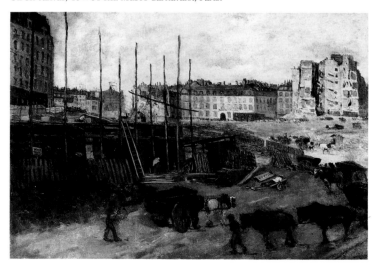

Figure 8. Giuseppe De Nittis (1846–1886). *Place des Pyramides*, 1876. Oil on canvas; 92 × 74 cm. Musée d'Orsay, Paris.

Figure 9. Pierre Auguste Renoir (1841–1919). *The Grand Boulevards*, 1875. Oil on canvas; 52.1 × 63.5 cm. Philadelphia Museum of Art (The Henry P. McIlhenny Collection in memory of Frances P. McIlhenny).

Figure 10. *Shooting on Rue de la Paix during the Week of 22 Mar., at Two O'Clock in the Afternoon*, from *Le Monde illustré*, 1 Apr. 1871. Northwestern University Library, Evanston.

Figure 11. *Remains of the Barricade on Rue de Rivoli*, May 1871. Photograph. H. Roger Viollet Collection.

streetscape otherwise painted "in a very gray and very sullen mode of handling."[31] While this street is unidentified, its regular facades and sharply plunging perspective associate it with Haussmann. The Republican rebuilding of Paris in the 1870s entailed recapturing its beauty, its diversity, and its color—an effort in which the Impressionist painters were certainly complicit; Caillebotte's painting shares in that complicity.

In 1877 *House-Painters* was understood as a witty picture, a visual pun of sorts,[32] directed at critics who at the time derogatively associated the work of the Independents with that of "house-painters," a designation they thought appropriate to artists who left their works unfinished and were nothing better than "sign painters working for coal dealers and moving men."[33] In his review of the Impressionist exhibition of that year, the critic Emile Bergerat explained the origin of the term *impressionniste:* "Impressionists, so be it. But the significance

of the word and the novel aspect of the thing call for a bit of clarification. In house-painting manuals, the phrase *peinture d'impression* is used to designate the first, prime coat applied by a worker to canvas or panel. This is doubtless the justification of the name "Impressionists" adopted by twenty or so young artists. . . ."[34] Caricatures poking fun at the Impressionists confirm the wide circulation of Bergerat's pejorative association. In this context Caillebotte's painting seems to suggest that "house-painters" could be a positive label in 1877. Was Caillebotte responding to this criticism by underscoring the inadvertent truth of the association? Was he indeed identifying the Independents with house-painters—working painters—in the sense that his métier and that of his Impressionist colleagues could be related to the work of the *petit bourgeois* artisan, and insofar as the project of both was to *paint* the city? If so, *House-Painters* underscores the social democracy many believed to be at the heart of the postwar Republican project.[35] After all, Caillebotte himself, one of the "industrious rich,"[36] embodied and lived the characteristically modern instability of class designations. He was, on the one hand, an independent, working artist, painting some 500 canvases in his short career, several of them monumental in size and highly labor-intensive. He was also, however, a comfortably well-off *haut bourgeois*, a man of leisure with a guaranteed fixed income.[37] As a member of the Impressionist group, Caillebotte was both artist and amateur, painter and collector. While working and exhibiting with his colleagues, he bought and promoted their art, often displaying his own paintings alongside works from his collection. Finally, Caillebotte's very involvement with the Impressionists, who themselves formed a heterogeneous social group in the 1870s, brought him into contact with social spheres that might not have otherwise intersected with his own.

In 1877 the sympathetic critic Georges Rivière appears to have understood the pictorial metaphor suggested by Caillebotte's *House-Painters*, for, after describing "these workers who conscientiously pack their pipes [i.e., take their time with preliminaries] while contemplating the work before them . . . ," he went on to call Caillebotte himself "a laborer, a bold seeker on whom I think we can base solid hopes."[38] It seems possible to understand Caillebotte's house-painters both as urban workers painting the city over again, and as the pictorial counterparts of the Impressionist painters themselves, who in a sense were aiming to do the same.[39]

Like the *Floor-Scrapers* (cats. 3 and 5) shown in 1876, *House-Painters* is also a picture that testifies to the Impressionist interest in decoration, and to the extent to which they conceived their own artistic production as a form of *décoration*.[40] Such an identification would have been a natural response to the general association being forged in the early years of the Third Republic between a strong national modern art—Art Nouveau—and the revival of the French eighteenth-century tradition that stressed the unity of the arts and crafts. Using the pictorial metaphor of *House-Painters*, Caillebotte recalled and associated himself with such eighteenth-century French masters as Jean Antoine Watteau and Jean Baptiste Siméon Chardin, artists who had painted shop signs in addition to easel paintings and who were frequently commissioned to decorate the interiors of the Parisian residences of the upper bourgeoisie.[41]

Caillebotte's colleague Renoir was particularly concerned with decoration, and convinced of the need for painters to participate directly in the decoration and recoloring of the capital. In 1877 he wrote a series of articles on the subject for *L'Impressionnisme*, Rivière's review published in conjunction with and in support of the Impressionist exhibitions. In one article, "L'Art décoratif contemporain," Renoir criticized contemporary architects for failing to understand the sculpture and painting that they commissioned to decorate their buildings, concluding that: "until a new generation of architects appears to overturn the current coterie with a new educational agenda, we should have artists oversee the construction of monuments. I am convinced that the results would have an originality and even a unity that can only be asked of those who can simultaneously be the head and the arm."[42] That Caillebotte might have shared Renoir's views, especially those concerning the participation of painters in the (re)decoration of the Paris streetscape, is indicated by his investment in a short-lived company aimed at developing the artistic uses of MacLean cement, a white building material that could easily be tinted. In 1877 Renoir did at least five paintings on a surface of MacLean cement, a material that presumably would have made it much easier for painter-decorators to participate in the remaking of the city.

In the context of this relationship between the Impressionist enterprise and the Republican agenda for the streets of Paris, it is important to recall the very locations of the Impressionist exhibitions. While certainly chosen for marketing purposes, these sites also gave the shows important ideological contexts. The first three exhibitions were held in the area around boulevard des Capucines, the financial and commercial center of the city, and the economic heart of the national push for postwar recovery in the early years of the Third Republic. Several of the rooms in the apartment at 6, rue le Peletier, rented for the 1877 exhibition, even looked out onto the district's bustling grand boulevards. The next two exhibitions were sited directly on the new streets of the Third Republic: in 1879 in "a recently completed structure" at 28, avenue de l'Opéra, and in 1880 at 10, rue des Pyramides, at the corner of that newly extended street and the older rue Saint-Honoré.[43] In 1880 the space housing the exhibition itself was still under construction, and the sounds of building and work must have provided a meaningful environment for viewing the exhibition. The critic Marius Vachon mused: "Last year [the Impressionist group] set up camp on avenue de l'Opéra, coping with the wet plaster on the first floor of a new building; this year, again, it has pitched its tents in the damp mezzanine of a barely completed pile on rue des Pyramides. Is this predilection for new premises intended by the Independents as some kind of symbolism?"[44] Moreover, contemporaries often remarked upon the continuity of the street and the interior exhibition space of the Impressionist shows. In 1880 one reviewer wrote: "While rain can disturb one's stroll, such is not the case in the exhibitions and other establishments, which can provide shelter for *flâneurs*. So yesterday there was a crush at the Impressionists."[45] To visit an Impressionist exhibition in the late 1870s was to come in from the rain, and to go for an imaginary promenade through the streets of a city made beautiful and colorful again in paint.

It is in the context of this postwar reconstruction and the imminent national celebration of this recovery in 1878 that Caillebotte's 1877 pair of streetscapes must be situated (cats. 29 and 35). It is also important to consider these ambitious, modern-history paintings as a pair. The artist's careful installation of them in the same exhibition room, combined with their remarkably large scale, similar subject matter, like color,

and comparable viewpoints, suggests that he indeed intended them as pendants.[46]

Kirk Varnedoe identified the site depicted in *Paris Street; Rainy Day*—information that the artist failed to provide in his title for the painting[47]—as the radial intersection of rues de Moscou, Clapeyron, Turin, and Saint-Pétersbourg, in the quartier de l'Europe (eighth arrondissement). Most commentators on the painting have surmised that Caillebotte chose this particular site because it was familiar to him, located only blocks away from the family home on rue de Miromesnil. Moreover, the quartier de l'Europe, bordering that of the Batignolles, was the district where Manet rented a studio in the 1870s, and it was the part of Paris then considered the preferred site of "The New Painting." The quartier de l'Europe, finally, was largely the product of late Haussmannization. As Varnedoe pointed out, all the streets and buildings featured in *Paris Street* were built during the artist's lifetime. When Caillebotte set both his 1877 streetscapes in this newly finished section of Paris, he clearly proclaimed his own modernity. These were pictures that not only depicted the modern city, but were obviously allied with the work of Manet and the school of modern Realist painting.

Frequently overlooked in analyses of *Paris Street* and its "pendant," *The Pont de l'Europe,* is that they focus on areas that had been of strategic importance and that had witnessed particularly heavy street fighting during the repression of the Commune. The writer Maxime du Camp watched these events from his apartment near Gare Saint-Lazare. A large barricade built on place de Clichy, only a block north of the intersection featured in *Paris Street,* became the center of intense conflict. As du Camp described it: "Between the *fédérés* on the barricades and our soldiers seeking cover as best they could behind the supports of the Pont de l'Europe or at the corner of rue Mosnier, gunfire was continuous from eight in the morning until nightfall . . . the sidewalks of the Pont de l'Europe seemed literally to have been metallized by the impacting bullets."[48]

Although *Paris Street* yields only the subtlest indications of these recent revolutionary events, it nevertheless appears to depict a particular moment in the history of the capital city. It is possible to consider Caillebotte's picture of Haussmannian Paris after a rainfall as an analogous portrait of the modern city just beginning to recover after the hard times—the rainy weather—of 1870–71. In this respect,[49] and in its remarkably similar composition and ground-level viewpoint, *Paris Street* recalls the earlier *Place de la Concorde after the Rain* painted by Caillebotte's friend De Nittis, exhibited at the Salon of 1875 (fig. 12). De Nittis also chose a site of recent conflict whose restoration demonstrated national recovery. The war-torn and barricaded square of 1871 became, in De Nittis's painting of only four years later, an image of prevailing calm, of streets and sculptures repaired, and of the city cleansed by a gentle rain. Silhouetted against a rain-swept, smooth pavement clearly reclaimed from the conflicts of war for the pleasures of promenaders are obviously contrasting social types, a kind of democracy of the Paris street considered by most Republicans to be a necessary part of national recovery in the 1870s.[50]

Why Haussmann's Paris? As Varnedoe pointed out, these were streets and buildings constructed during the Second Empire. Even without this information, however, it is possible to see the signs of Haussmann's handiwork in Caillebotte's painting. The straight, sharply plunging perspective lines of the streets radiating off the square are characteristically Haussmannian. Moreover, Caillebotte's unspecific title sug-

Figure 12. Giuseppe De Nittis (Italian; 1846–1886). *Place de la Concorde after the Rain*, 1875. Oil on canvas; dimensions unknown. Government Palace, Istanbul.

gests that the street he depicted could, in fact, be any Paris street, and that they had all begun to look the same. This was a frequent criticism of Haussmann's transformations. The literary and social critic Victor Fournel, for example, argued that, as a result of the prefect's carefully regulated, homogeneous facades, Paris had only one street. Haussmann had created "a monotonous uniformity of banal magnificence, by imposing the same geometric and rectilinear street [facades], which extend into perspective views these rows of buildings, always the same."[51] *Paris Street* reiterates this architectural monotony in the carefully rendered repetition of rhythmically aligned limestone buildings and the endlessly echoing expanse of paving blocks, all of which is painted in a nearly unrelieved gray-green. One critic in 1877 even chastised Caillebotte for submitting such a work, complaining that, "The canvas is too large; the view, dreary and boring."[52]

Others have scrupulously analyzed the painting's composition, its organization around a "giant plus sign" whose axes are clearly articulated by the heads of the principal figures and by the long post of the gaslight featured prominently in the center of the canvas. *Paris Street* is an insistently ordered painting, dominated and directed by the architectural order of the urban landscape it describes. As a result, despite the motion suggested by the figures, the picture appears remarkably still, as if enervated by its own insistent structure, frozen in the damp chill of the weather and within the rigid limestone facades.[53] A recent study of the picture has demonstrated how the numerous figures have been "regimentally aligned"[54] according to the rules of the golden section.[55] Their faces turned away, barely individualized or hidden under identical, steel-framed umbrellas of recent invention,[56] these anonymous figures, almost uniformly dressed in gray or black, are as monotonous as the street itself. They appear listless,[57] spiritless, without direction, aptly described by Varnedoe as "strolling somnambulants."[58] The exception is the couple striding directly toward the viewer in the right foreground of the painting. By their size, placement, individualized features,[59] and relative alertness,[60] this fashionable bourgeois *flâneur* and his female companion dominate and define the social character of this street. Carefully and hierarchically ordered, anonymously homogeneous, *Paris Street*

would seem to represent any number of residential districts planned by Haussmann and subsequently occupied by the upper middle class.

There are signs to suggest, however, that the order represented had been only recently, and therefore somewhat precariously, restored. Critics in 1877 often complained that, in Caillebotte's painting of a rainy day, there is no rain.[61] Nevertheless the strollers continue to hold open their umbrellas, apparently unaware or unsure of whether the rain has stopped.[62] This cold and damp Paris street appears to be an uncertain, even inhospitable, unwelcoming space, its over-insistent regularity and cleanliness almost psychologically disturbing. It is a space where umbrellas may indeed continue to be necessary for protection, even when there is no longer any rain. In addition to offering cover from the weather, an umbrella was considered at the time as a kind of "defensive arm," requiring a wide passing distance between oneself and one's fellow pedestrians.[63] Umbrellas impose social separation, carving out private from public space. Certainly, the notable presence of steel-framed umbrellas in *Paris Street* reinforces the modernity of the image, dating this portrait of Haussmannian Paris clearly to the postwar decade. But they also intensify the unsociability of Caillebotte's chosen urban space: few figures appear to communicate or to engage another's gaze, and even the two principal figures seem deliberately to avoid eye contact with the viewer and with his or her pictorial surrogate, the passerby cut off at the right.

Additionally, it is possible to consider the striking, organizing presence of the gaslight, which, in the words of one contemporary critic, "displays its disagreeable perpendicular smack in the center of the picture."[64] As Varnedoe pointed out, in 1877 the type of gaslight depicted by Caillebotte would have been considered old technology in a painting of otherwise striking modernity. By that time, in most of Paris, this older model had been replaced by the shorter and more elegantly designed Oudry lamps. Varnedoe has suggested that the presence of this gaslight in Caillebotte's painting marks it as a picture of a peripheral urban space, a new suburb rather than the city center. It is possible, however, that the anachronism served other meaningful purposes as well. This was, after all, the standard lamppost in Haussmannian Paris until 1865. Dominating Caillebotte's image, it thus acts as another visual indicator identifying this as an imperial Paris street. Its strong vertical thrust, moreover, reiterates the rigid, hierarchical organization of this street. Finally, as an anachronism, it draws attention to itself, and acts as a reminder of the heavy burden of history that this new city continued to carry.

Indeed, the gaslight seems to reinforce the suggestion that this street is a precarious space and that, as one of Haussmann's panoptic landscapes, it needs to be kept well-lit and safe at night. Gaslights were frequently associated in the nineteenth century with a fear of the street, especially its mysteries and dangers after dark. Indeed, according to Balzac, gaslights were one of the first things to be broken in a revolution.[65] A dark street with broken gaslights was considered the terrain of both criminal and insurrectionary activity, and such gaslights had been a noteworthy element in recent, revolutionary streetscape art.[66] The presence of such a tall, straight, and very conspicuous gaslight in Caillebotte's streetscape may imply, on the one hand, that this street is one unmarked by such disturbances, adding to the peacefulness and tranquility of the image. Indeed, the gaslight's promise of illumination would seem to complement the faint rosy-yellow light of the sky, and

thus underscore the image's prevailing suggestion of renewal. Nevertheless, the dominating, central placement of this same gaslight may also suggest a lingering fear underlying its compositional importance, a fear at once masked and revealed by the picture's insistent stillness.

Vying for attention with this gaslight is the thickly painted, sweeping expanse of assiduously aligned and perfectly clean paving stones that occupies the whole lower left quadrant of the painting (see cats. 37 and 38). One critic stated: "It is a spacious crossroads, its sidewalks and paving stones cleansed by celestial waters, like the wretched bricks of Amsterdam by Dutch housewives. Each of the paving stones stands out with unprecedented precision. They can be counted, measured, and studied from the point of view of a geologist, a chemist, a geometer, or a street paver."[67] On the one hand, the compulsively ordered, smooth, glistening stones could have been a reassuring image, replacing the memory of their all-too-recent removal in the making of revolutionary barricades. On the other hand, however, these paving stones apparently could still act as a powerful reminder. Even when the same critic, for example, wrote that "I have difficulty recognizing [here] my old and always slippery Parisian paving stones," the "meticulously cleaned"[68] newer ones brought to mind these older stone streets, and presumably their historical associations, just the same.

It is possible to understand Caillebotte's painting, then, as a representation of modern Paris restored: a view of Paris only recently and partially cleansed of its history, that history betrayed by the dominating presence of the gaslight and by the overly smooth and ordered paving stones. It can be considered as a visual compendium of the physical and social character of the Haussmannian street: its order, its homogeneity and monotony, its psychological alienation and social divisions, and even the underlying threat of civil unrest that it worked so hard—and ultimately failed—to displace. In this sense, *Paris Street* can also be considered a portrait of Haussmann's city after the recent storm, a representation of postwar Paris as it was suspended at a kind of historical crossroads following the crisis of 1870–71. Indeed, in Caillebotte's image, the streets of the capital city are still in the process of recovering, as implied by the scaffolding in the far background of the painting, directly to the left of the gaslight, and symbolically suggested by the pharmacy that Caillebotte distinguished from the otherwise anonymous storefronts of the streetscape. Moreover, in the background, almost directly behind the *flâneur*, appears a worker like those featured in Caillebotte's *House-Painters*. Is he responsible for the richly painted, copper-rust storefronts at the right, the only chromatic relief in an otherwise monotonously gray-green canvas? The signs of recovery in *Paris Street* appear to be color and differentiation, but also work and commerce—principles all celebrated in Caillebotte's pendant painting, *The Pont de l'Europe*, in *House-Painters*, and in the Impressionist enterprise itself.

In his 1877 review, the critic Jacques expressed well the unsettling modernity of Caillebotte's representation of the Haussmannian street, but preferred his *Pont de l'Europe*, "whose sober composition is more truthful and at the same time more graceful."[69] Others, such as Charles Bigot, agreed, and even went so far as to claim that, while *The Pont de l'Europe* was the work of an "Impressionist," *Paris Street* was not: "Is M. Caillebotte indeed an 'Impressionist'? Yes, if one looks at his *Pont de l'Europe* and his *Portraits in the Country*; no, if one looks at his other submissions, above all his large demonstra-

tion picture [grand tableau à effet] *Crossroads of Rue de Moscou in Rainy Weather* The subject lacks interest, as do the figures and indeed the painting."[70]

The Pont de l'Europe was actually painted before *Paris Street*, in 1876, the year of Caillebotte's first showing with the Impressionist group. It too depicts a section of the quartier de l'Europe rebuilt during the Second Empire and is, therefore, also a painting of modern Paris, but of a quite different sort. The Pont de l'Europe, inaugurated in 1868, replaced two stone tunnels that had provided the sole means of access to Gare Saint-Lazare, the railroad station located directly east of the site. The new iron bridge not only opened up the space below for increased railroad traffic, but its radiating spokes accommodated the six local streets that fed into the area. Unlike the radial Haussmannian intersection featured in *Paris Street*, however, this modern bridge owed its design and construction to the Compagnie de l'Ouest.[71] In *The Pont de l'Europe*, moreover, it is the structure of this technologically modern bridge that dominates, its metal trellis screening out the surrounding buildings that were so carefully studied in *Paris Street*.

In what appear to be important and meaningful ways, Caillebotte constructed *The Pont de l'Europe* very differently than its "pendant," *Paris Street*. Instead of being rigidly organized around a "giant plus sign" or cross, *The Pont de l'Europe* is structured about a distorted X that repeats the form of the bridge itself and the iron trellises that compose it.[72] This organization not only exaggerates the deep perspectival plunge of the street, but it expands the scene, giving it a broad, lateral character not unlike the span of metal that takes up nearly half the canvas, placing it in direct contrast to the vertical and panoptic symmetry of *Paris Street*. The X-composition also furthers the illusion of accelerating movement toward the X's vortex, a movement reinforced by the dog that runs parallel to the line of the bridge rail.[73] This compositional vector should also be considered alongside the comparatively stilled, directionless motion of *Paris Street*. It implies a movement, moreover, befitting the site. The passing trajectories of the couple and the dog mimic the back-and-forth movement of the trains arriving and departing along similar iron rails from Gare Saint-Lazare below.[74]

The X-composition also emphasizes the relationship between the two different types of men depicted in *The Pont de l'Europe*. The left-to-right line of the X is dominated by a strolling, top-hatted gentleman, a *flâneur*, followed by another fashionable man, his bowler hat just visible behind the former's right shoulder. The right-to-left line of the X, by contrast, is occupied by a male figure dressed in a worker's smock and cap. This worker leans over the railing and gazes down at the trains below. Another similarly dressed, presumably working-class, man walks into the painting along this same compositional line, having just passed the *flâneur* and the female figure strolling to the side and just behind him. The two legs of the painting's X-composition, then, are those of the *bon bourgeois* and the *petit bourgeois*, and the composition brings these two social groups together on the same sidewalk with emblematic clarity.[75] This implied relationship is reinforced by the gaze that the *flâneur* appears to cast in the direction of the leaning worker, a gaze that is the very crux of the X-composition and the painting's principal focal point. It is also a relationship realized by the viewer's own gaze. As shown elsewhere,[76] Caillebotte composed his *Pont de l'Europe* with two centers of vision: the principal one, at the crux of the X-composition, focused on the *flâneur*'s head; and another at

the crux of the X formed by the iron girders of the bridge, centered on the worker's head (see cat. 30). The viewer's gaze is therefore necessarily double, split between these two compositional focal points and therefore oscillating between the two different social groups indicated by them.[77]

It has been suggested that the *flâneur* in *The Pont de l'Europe* may be a self-portrait (see frontispiece). If this is the case, the distinctly emphasized, albeit tense, relationship between this figure and the worker dressed in smock and cap, at whom he seems to stare, seems particularly significant. This second figure is dressed like Caillebotte's house-painters, and in fact appears identical to the man standing on the sidewalk in the smaller painting. Given Caillebotte's apparent identification with the working painter, it may also be possible to consider *The Pont de l'Europe* as an image that addresses Caillebotte's own dual social identification.

The gaze that this artist-*flâneur* directs toward the worker, however, is indeterminately shared with the fashionably dressed female carrying a parasol, whom Caillebotte placed between the *flâneur* and the worker on the sidewalk. Unlike the woman in *Paris Street*, it is not clear whether she accompanies the *flâneur*, even though she glances rather suggestively toward him. The ambiguity of her gaze and that of the *flâneur* seems to be a conflation of two earlier sketches: in one (fig. 13) she is clearly behind the *flâneur*, and his glance unmistakably directed at the leaning figure; in the other (fig. 14), they obviously walk together, and his head appears to be turned in conversation with her rather than toward the worker. In the final painting, the woman's social position is as unclear as her relationship with the *flâneur*. If indeed she was unchaperoned, her class would have been in question, since respectable or "honest" women in late nineteenth-century France did not usually go out in public alone. Could she possibly be a high-class prostitute or demimondaine?[78] If so, her social transgression typifies the "is she or isn't she" anxieties of the day surrounding unregulated prostitution. Moreover, placed between the *petit* and *bon bourgeois* and at the crossing of the X-composition that binds them together, she can also be seen to embody the middle-class social movement indicated by Caillebotte's *Pont de l'Europe*.[79]

Such social mixing was in fact pervasive in the area around Gare Saint-Lazare, where the classes came into daily contact.[80] Caillebotte's image, however, may have carried other, more national political implications. Like the site depicted in *Paris Street*, that of *The Pont de l'Europe* also witnessed particularly heavy fighting during the recent unrest, and the sidewalks, as emphasized in Caillebotte's image, were "metallized by the impacting bullets," as du Camp observed. In Caillebotte's bright and sunny painting, however, the subtle indicators of these conflicts are far less prominent: there is no dominating gaslight,[81] and the "street" is in fact a sidewalk, made not out of paving stones but smoothly planed asphalt; the postwar recovery seems less equivocal. Moreover, the roomy, airy expanse of this sidewalk, unlike the narrow, crowded one in *Paris Street*, allows pedestrians ample passing distance, permitting them to share its space comfortably with dissimilar social types, and even a dog. Indeed, the most striking aspect of *The Pont de l'Europe* is the peaceful, if still a bit tense and cautious, presence of two different bourgeois groups on this sidewalk. Rather than a vertically and hierarchically arranged streetscape, *The Pont de l'Europe* is an expansive, horizontal city view, the compositional leveling underlining the social leveling suggested by its subject.[82]

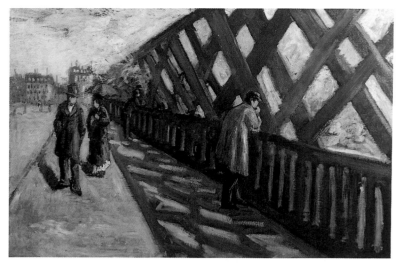

Figure 13. Gustave Caillebotte. *Sketch for* The Pont de l'Europe, 1876. Oil on canvas; 82 × 120 cm. Albright-Knox Art Gallery, Buffalo.

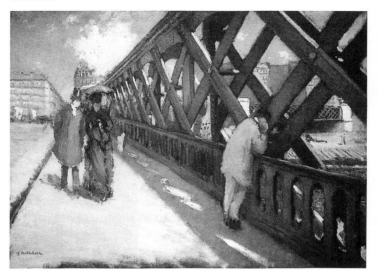

Figure 14. Gustave Caillebotte. *Sketch for* The Pont de l'Europe, 1876. Oil on canvas; 54 × 73 cm. Private collection.

Unlike *Paris Street*, a picture of Haussmannian social homogeneity and alienation, *The Pont de l'Europe* can be considered as a remarkably Republican streetscape of social diversity, wherein the presence of the worker was both compositionally and ideologically necessary.[83] An emblem of technological development, the Pont de l'Europe was a testament to the cooperation of bourgeois investment and *petit bourgeois* labor under advanced industrial capitalism. As such, it promised the nation bright days of continued social and technological progress under the Republican regime[84] that in 1877 was promoting just this sort of technological development and social cooperation. Even the very different methods by which the pictures were constructed reinforces this comparison. As demonstrated elsewhere,[85] the architectural space of *Paris Street* was the focus of that composition and determined Caillebotte's placement of the figures. This is apparent from the drawings and oil sketches that preceded the final picture. By contrast, the people featured in *The Pont de l'Europe* were its structuring pictorial elements, and the artist radically altered the architectural space to achieve an X-composition that would highlight the relationship between the two socially diverse figures.[86]

Nevertheless, while indeed drawn together compositionally, these two social groups do remain distinct in Caillebotte's image. It is a picture of social compromise and coexistence, but not assimilation, as the two principal figures (and the two sorts of middle classes they represent) are separated by a broad section of pavement, made even broader by Caillebotte's compositional manipulations. Moreover, the social difference between the two figures is never in question, as they are given distinct costumes and demeanors. Indeed, as a study in social types, *The Pont de l'Europe* was not unlike earlier available physiologies that aimed, in the words of Walter Benjamin, "to give people a friendly picture of one another" and thus help "fashion the phantasmagoria of Parisian life."[87]

Hung in the same room in the exhibition of 1877, *The Pont de l'Europe* and *Paris Street* must have offered a striking contrast.[88] *Paris Street* is set on the rainy, late afternoon of a gray

winter day; *The Pont de l'Europe* depicts the city on a bright, blue, warm, spring or summer morning.[89] Even in these most simple but quintessentially Impressionist terms, *The Pont de l'Europe* is the more "positive," more *veduta*-like of the pair.[90] However, *The Pont de l'Europe* may have also stood in contrast to its pictorial "pendant" in the very different historical moment that it appears to evoke. Not Haussmannian Paris, Caillebotte's *Pont de l'Europe* is a modern streetscape that seems to pay homage to the beauty of industry and private initiative, as well as to social movement and compromise—in short, a modern, *Republican* street. It was perhaps on the basis of this identification that one could indeed claim that it was the more "Impressionist" of Caillebotte's 1877 pair.[91]

Caillebotte would never again so boldly address the subject of the Paris street and its social stakes, nor feature it as the subject of a large-scale, modern-history painting. In fact, the artist appears to have lost interest altogether in such monumental, publicly oriented pictorial statements. In 1878, the year of the Universal Exhibition, Caillebotte painted a number of smaller views looking down from the upper floors of a nearby building onto rue Halévy, toward both place and avenue de l'Opéra (see cats. 61 and 62). These views, which are framed by clues to the artist's position "inside looking out," herald Caillebotte's increasing detachment from the life and complex political history of the Paris street. This detachment was also signaled by a change from his linear, clearly focused academic style to the broken brushwork and pictorial ambiguity of classically defined Impressionism. By 1880, in his series of balcony views along boulevard Haussmann, this disengagement from the street is nearly complete, as the street below is increasingly overtaken by the signs of nature or those of Caillebotte's own artmaking. In *View through a Balcony Grille* (cat. 66), for example, shown at the Impressionist exhibition that year, it is the curvilinear, organic design of the balcony itself that is the painting's principal fascination. Unlike the relentlessly modern iron trellises of the large *Pont de l'Europe*, whose massive size and bold, perpendicular design both

structure and visually complement the street it upholds, the delicately wrought iron grille of the much smaller, later picture overwhelms and screens out the view of the street behind,

blurring and flattening it into something both decorative and —significantly for Caillebotte's later life and work—distinctly private. J. S.

NOTES

1 F. Sarcey, "The Boulevards of Paris," in R. H. Davis et al., *The Great Streets of the World* (New York, 1892), p. 71.

2 See Baudelaire 1964.

3 Significantly, the *flâneur* was an exclusively male type, as recently pointed out by a number of feminist historians. See, for example, Wolff 1985, pp. 37–48; and Pollock 1988, pp. 50–90.

5 This was also the title of a story by Edgar Allan Poe, as mentioned by both Baudelaire (1964, p. 7) and Benjamin (1973, p. 48).

6 Benjamin 1973, p. 40.

7 Baudelaire, in ibid., p. 40.

8 Ibid., p. 36.

9 Baudelaire 1964, pp. 6–7, and 16.

10 Duranty 1876. Of "The New Painting," Duranty wrote that the "very first idea was to eliminate the partition separating the artist's studio from everyday life, and to introduce the reality of the street. . . . It was necessary to make the painter come out of his sky-lighted cell, his cloister, where his sole communication was with the sky—and to bring him back among men, out into the real world" (repr. and trans. in San Francisco 1986, pp. 482 and 44, respectively).

11 Possibly the volcanic Vesuvius, a site that from the earliest ambitious efforts at landscape painting in the eighteenth century had been an especially popular subject with French artists. See, for example, Pierre Jacques Volaire's *Eruption of Mount Vesuvius in 1771* (c. 1779; The Art Institute of Chicago).

12 See Berhaut 1978, p. 6 and Berhaut 1994, no. 6; and Varnedoe 1987, no. 3; both cited M. Pittaluga and E. Piceni's catalogue raisonné *De Nittis* (Milan, 1963). See also Chronology, 1872 and 1875.

13 According to conversations between Marie Berhaut and the descendents of the artist, Caillebotte would often paint from a position literally in the street. In the case of *Paris Street* and *The Pont de l'Europe*, for example, it is believed that he worked from inside a glass-enclosed omnibus (see Berhaut 1978, p. 48 n. 9).

14 Jacques 1877.

15 See the entry "*Boulevard*" in P. Larousse, *Grand Dictionnaire universel du XIX^e siècle* (Paris, 1866–79; repr. Paris, 1982), pp. 1096–97; and idem, vol. 16, pt. 1, p. 403.

16 The earlier "Artists' Plan" proposed an extensive network of new Paris streets, including the important axes later defined by rue de Rivoli and boulevard Saint-Michel. On the "Artists' Plan" and the Second Empire transformations, in particular, see D. H. Pinkney's now classic *Napoleon III and the Rebuilding of Paris* (Princeton, 1958); and, more recently, J. de Cars and P. Pinon, *Paris Haussmann* (Paris, 1991).

17 V. Hugo, *Journal 1830–1848*, cited in Costanzo 1981, p. 124.

18 See Costanzo 1981, esp. chs. 6–8.

19 See also Monet's *Garden of the Princess, Louvre* (1867; Allen Art Museum, Oberlin); and Renoir's *Pont des Arts* (1867; Norton Simon Foundation, Pasadena).

20 Caillebotte was mobilized from 26 July 1870 to 7 Mar. 1871 as part of the Garde Nationale Mobile de la Seine (see Chronology, 1870 and 1871). It is not clear, however, whether he remained in Paris during the civil conflicts of the spring of 1871.

21 See Costanzo 1981, pp. 296ff.

22 *Journal officiel*, 5 June 1871, cited in A. Joanne, *Paris illustré en 1870 et 1877, guide de l'étranger et du Parisien* (Paris, 1877), pp. xiv–xv.

23 See G. A. Sala, *Paris Herself Again* (London, 1882), recounting his 1878 visit to the city.

24 On the moderate Republican political bases of the 1878 Universal Exhibition, see, for example, T. van Joest, "L'Exposition Universelle de 1878," *Monuments historiques* 144 (Apr.–May 1986), special issue on "La République," pp. 31–36.

25 On the avenue de l'Opéra project, see A. Daumard, "L'Avenue de l'Opéra de ses origines à la guerre de 1914," *Bulletin de la Société de l'histoire de Paris et de l'Ile-de-France*, 1967, pp. 157–95; and A. Sutcliffe, *The Autumn of Central Paris: The Defeat of Town Planning 1850–1970* (Montreal, 1971), esp. pp. 49–53.

26 Joanne (note 22), pp. 43–44.

27 See especially Clark 1984; and Herbert 1988.

28 See P. Tucker, "The First Impressionist Exhibition in Context," in San Francisco 1986, pp. 93–117; and on Monet in this context, Tucker 1982, as well as "The First Impressionist Exhibition and Monet's *Impression, Sunrise*: A Tale of Timing, Commerce, and Patriotism," *Art History* 7 (Dec. 1984), pp. 465–76.

29 Place de la Concorde was always a highly politicized space and the site near which two important revolutionary barricades were built in May 1871: one spanning rue Royale and the other on rue de Rivoli where it intersects with rue Saint-Florentin. It was also the subject of a rather ironic painting by Degas entitled *Place de la Concorde (Viscount Lepic and His Daughters)* (c. 1873; State Her-

mitage Museum, St. Petersburg). Although Degas showed that by 1873 the square was again a safe space for bourgeois promenades, Lepic and his daughters appear uneasy on this historical street—a discomfort articulated by the radically fragmented and startlingly centrifugal composition.

30 Architectural diversity and equilibrium were also celebrated at the 1878 Paris Universal Exhibition, where the traditional stone palace of the Trocadéro was paired with the modern iron-and-glass exhibition hall on the Champ-de-Mars.

31 Lepelletier 1877.

32 See G. Rivière 1877b.

33 E. Carjat, "L'Exposition du boulevard des Capucines," *Le Patriote français*, 27 Apr. 1874.

34 Bergerat 1877. In his review of the 1880 Impressionist exhibition, the critic Goetschy wrote that "M. Guillaumin, who let it be said in passing seems to me one of the funniest practical jokers that house-painters have bequeathed to Impressionism" (Goetschy 1880).

35 Importantly, however, the workers in Caillebotte's picture wear traditional white painter's garb, not the blue smock of the ordinary worker. Despite the identification Caillebotte appears to have forged between artist and artisan, he did not represent them as wholly equivalent social groups. The artists here are distinguished by their dress, but also by their demeanor. They are at ease in the street, and at leisure with their work, so much so that one critic would later describe the painting as an "image of strolling" (to be compared to such "images of work" as the *Floor-Scrapers*; see Geffroy 1894).

36 Monjoyeux 1879. Ronald Pickvance suggested that Caillebotte himself might have helped prepare this review, and if so it stands as a powerfully self-conscious statement regarding what might be termed the artist's own social "duality" (see Pickvance 1986, p. 252).

37 The fortune of more than two million francs that Caillebotte's father had amassed as a supplier of military bedding was left to his wife and sons upon his death in 1874. Certainly the assurance of such financial security played no small part in Caillebotte's decision to become a painter. However, despite Gustave's millionaire status, he seems to have chosen quite purposely to live modestly, more as a *bon bourgeois* than as a *haut bourgeois*. Upon his mother's death in 1878, he and his brother Martial sold the luxurious family mansion on fashionable rue de Miromesnil, as well as the family estate at Yerres, and they settled together in an apartment on busy boulevard Haussmann. The next year, the critic Montjoyeux (or Caillebotte; see note 36) commented upon this choice: "And I know very few who, as much as he, would have forgotten that they were property owners, keeping in mind only that they were obliged to become famous. Famous or not, M. Caillebotte is a brave one. His apartment on boulevard Haussmann, which could be luxurious, has only the simple comforts of a man of taste. He lives there with his brother, a musician." In 1880 the novelist and critic Joris Karl Huysmans wrote that Caillebotte's decision to move found its parallel in the social class most frequently represented in his art: "M. Caillebotte is the painter of the prosperous bourgeoisie, of business and finance, making more than enough for their needs, without for all that being very wealthy, living close to rue La Fayette or in the vicinity of boulevard Haussmann." Huysmans contrasted Caillebotte's social milieu with that depicted in the work of fellow Impressionist Mary Cassatt: "Here, it is still the bourgeoisie, but it is no longer that of M. Caillebotte; it is a prosperous world, but more refined, more elegant" (Huysmans 1880).

38 G. Rivière 1877b. It is not clear whether Rivière literally believed the workers are packing their pipes, or whether he was speaking idiomatically of their leisurely demeanor. In using the term "*travailleur*" ("workman" or "laborer"), it is also possible that the critic, while underscoring the pictorial metaphor of "working painters," also intended to distinguish and defend Caillebotte's work ethic. Under the entry for "*Ouvrier, ière*" ("Workman" or "Laborer"), Larousse states: "The word *ouvrier* designates a man in relation to his work; *travailleur* presents him in connection with the trouble he takes, with his effort, with his toil. A good *ouvrier* is one who performs well the work for which he is trained; a good *travailleur* is someone who doesn't waste time, who works with ardor and fortitude" (Larousse [note 15], vol. 11, pt. 2, pp. 1594–98); and idem, vol. 17, pt. 3, pp. 1660–61). It appears, then, that the social group designated by the term "*travailleur*" was more ambiguous than that of "*ouvrier*"; in the context of the above characterization of Caillebotte, the apellation "*travailleur*" was thus more appropriate for the artist.

39 Note too that a ladder, like those in *House-Painters*, appears in the foreground of Manet's *Rue Mosnier with Flags* (1878; Mr. and Mrs. Paul Mellon, Upperville, Virginia), a painting that celebrates the national holiday of 30 June 1878 and France's final rehabilitation from the events of 1870–71. This ladder has been identified by some as that of a window-repairman working on Manet's studio window, out of which it is thought the artist looked to paint this picture. However, it is also possible that the ladder in Manet's painting is a reference to his own identification with house-painters, a proclamation of his participation in painting the city over again, in Republican colors. Manet's pictorial celebration, more-

the city over again, in Republican colors. Manet's pictorial celebration, more-over, is profoundly marked with the memories of 1871 (the one-legged man), and it is these memories that appear to motivate much of Impressionist cityscape of the 1870s.

40 In 1877 Monet exhibited his monumental "unfinished decoration," *The Tur-keys* (1877; Musée d'Orsay, Paris), and Renoir his *Dahlias* (location unknown; possibly *The Garden of Rue Cortot* [1876; Carnegie Institute, Pittsburgh], which seems to fit Rivière's description of the painting as "a splendid decoration, a large panel with magnificent red dahlias seen in a tangle of grass and vines" [G. Rivière, "L'Exposition des impressionnistes," *L'Impressionniste*, 6 Apr. 1877]).

41 Caillebotte's *House-Painters* has often been mistitled *Sign-Painters*, most re-cently in Weisberg 1992, p. 57. "Sign-painters," interestingly enough, was another term used to deride the Impressionists at the time of their early exhibitions. For example, Charles Bigot wrote in 1877 that the intransigence of Cézanne was such that "sign-painting itself is surpassed" (Bigot 1877).

42 Un Peintre [Renoir], "L'Art décoratif contemporain," *L'Impressionniste*, 28 Apr. 1877.

43 For 1877, see Brettell 1986, esp. pp. 194–98; for 1879, see Havard 1879; and for 1880, see Havard 1880. Rue des Pyramides was conceived in Nov. 1876 as an extension of avenue de l'Opéra and as another highly symbolic street linking the Right and Left banks over rue de Rivoli and through the remains of the de-stroyed Tuileries palace (see Sutcliffe [note 25], p. 52).

44 Vachon 1880.

45 Le Sphinx 1880.

46 On the installation, see Brettell 1986. Many of the critics reviewing the 1877 exhibition also considered them as pendants, discussing the two paintings to-gether or in quick succession. Baron Schop even retitled the paintings clearly as such: *Paris Street, Rainy Day* and *The Pont de la Place de l'Europe, Sunny Day* (Baron Schop 1877).

47 Presumably the site was easily recognizable to contemporary viewers.

48 Maxime du Camp, *Les Convulsions de Paris* (Paris, 1879), vol. 2, pp. 392–93.

49 Significantly, De Nittis set both of his versions of *Place des Pyramides*, unmis-takable scenes of the city's postwar reconstruction, in rainy weather, and in the more finished version, apparently just after a storm (see fig. 8; the less finished painting is in the Galleria d'Arte Moderna, Milan).

50 In 1877 some critics compared and contrasted *Paris Street* with recent works by De Nittis. In a generally negative review of the painting, Léon de Lora wrote that "M. De Nittis, treating the same subject, would have produced a very agree-able small picture; M. Caillebotte, more ambitious, produces an oversized one in which all its possible qualities are diluted" (Lora 1877).

51 Victor Fournel, *Paris nouveau et Paris futur* (Paris, 1865), p. 221; cited in Varnedoe 1987, p. 214.

52 Lora 1877.

53 "The air through which the active yet lifeless figures of M. Caillebotte move is heavy, gray, full of dull mist" (Lepelletier 1877).

54 Varnedoe 1987, p. 90.

55 On the strict compositional organization of the painting, see Galassi 1987, pp. 27–40.

56 The curved, steel-frame umbrella was invented by Samuel Fox of Deepcar, Sheffield, in 1874 (see Ian McNeil, *An Encyclopaedia of the History of Technology* [London and New York, 1990], p. 853).

57 This listlessness, some claimed, was matched by the artist's own lifeless tech-nique. One critic complained that while Caillebotte's painting was "carefully studied . . . , the execution is perhaps a bit slack" (A. P. 1877).

58 Varnedoe 1987, p. 90.

59 This prompted many to conclude that they are, in fact, portraits. The couple has been variously identified. Anne Distel recently suggested that the man is the Impressionist collector Charles Deudon, who at the time had a grand apartment at 13, rue de Turin, one of the streets depicted in the painting (Anne Distel, "-Charles Deudon [1832–1914], collectionneur," *Revue de l'Art* 86 [1989], p. 61). A notation on a related drawing (cat. 43) indicates that the young woman's name was possibly Clotilde.

60 In a scene otherwise devoid of incident, this couple's attention appears to be caught by something, but it is, all the same, something *outside* the monotonous space of Caillebotte's picture.

61 See, for example, Ballu 1877a; and G. Rivière 1877a. Thomas Grimm even tried to explain this absence with the suggestion that it was snowing: "The open um-brellas have white reflections, but there are no flakes on the clothing. . . . It must be that rain affected the artist as if it were snow" (Grimm 1877). Rain was used by many of Caillebotte's contemporaries to impart atmospheric unity to their paintings and to transform the stark streetscapes of modern cities into beautiful images. In leaving the rain out of *Paris Street; Rainy Day*, it seems as if Caillebotte invoked but then denied this picturesque transformation of Haussmann's Paris.

62 As one critic put it in 1877, "M. Gustave Caillebotte exhibits *Paris Street (rainy weather)*, whose figures seemed to us like people strolling about with open um-brellas an hour before a downpour" (Lafenestre 1877).

63 Bertall, in his 1877 review of the painting, remarked upon "half-length tall fel-lows armed with umbrellas" (Bertall 1877). See also the Larousse entry on *"Para-pluie"* ("Umbrella"), where the umbrella is described as a "preservative" measure and a "defensive arm": "We are not talking about those umbrellas whose handles contain stilettos, as in a cane; no, it is the umbrella itself, and the terror it spreads abroad when it opens majestically, that serves as an effective protective meas-ure . . . against tigers!" (Larousse [note 15], vol. 12, pt. 1, pp. 197–98). See also Sala (note 23), p. 264: "An umbrella may be a companion, a friend, a staff, a protector, a weapon. . . ."

64 Sébillot 1877.

65 "What do they break when there are riots in Paris?—The street lamps." As cited in the entry for *"Réverbère"* ("Street lamp") in Larousse (note 15), vol. 13, pt. 2, p. 1104.

66 Théophile Gautier wrote of the protective presence of the gaslight: "Thanks to street lamps, to the police force, to police commissioners, to the city con-stables and police spies, nothing mysterious transpires there" (in Larousse [note 15], vol. 13, pt. 2, p. 1104). For the use of gaslights in contemporary revolutionary art, see Manet's 1871 lithograph *The Barricade*.

67 Lepelletier 1877. This was an aspect of the painting frequently remarked upon by the critics in 1877.

68 Ibid.

69 Jacques 1877.

70 Bigot 1877.

71 The bridge was actually the joint venture of the Compagnie de l'Ouest (Clerc and Delaitre, engineers) and the Société Fives Lill Cail (Loupe, engineer).

72 Varnedoe (1974, p. 28) described this X-composition as follows: "One bar follows the curb at the lower left, and then, bending slightly, the upper silhouette of the girders. The second bar is defined by the lower railing edge (or shadow) on the right, and continued at the upper left by the recession line of the distant buildings." See also cat. 29 and Galassi 1987, pp. 28–34, for a discussion of the way in which Caillebotte manipulated the space to accentuate this X-composition, and to "speed up" the visual trajectory into the plunging space of the picture.

73 Varnedoe called the dog a "spatial arrow" (1974, p. 58, no. 7). The dog in Caillebotte's *Pont de l'Europe* is in many ways the pictorial counterpart to the man carrying an umbrella at the far right of *Paris Street*. Unlike the dog, however, the man is partially cut off by the edge of the canvas and there are no indicators that he is actually moving into the picture. His immobility, then, is in direct contrast to the dog's free and rapid movement into the space of *The Pont de l'Europe*. Richard Thomson argued elsewhere that this dog is a metaphor for the *flâneur*, with his independence and sexual freedom (see Thomson 1982, pp. 323–37).

74 This movement is further suggested in the painting by the white puffs of steam rising above the bridge structure, and by the train engine visible at the extreme right.

75 The composition of the Kimbell *Pont de l'Europe* (cat. 41) also functions in much the same manner. In the larger painting, the dog, which hurries toward the *flâneur*, but whose tail points to the *ouvrier*, may also be seen as giving form to the relationship being forged between these two social groups.

76 Galassi 1987, pp. 28–34.

77 Also appropriate to such a Republican image was Caillebotte's inclusion of the brightly dressed Republican soldier in the painting's far background, the pictorial counterpart to the house-painter in *Paris Street*. In the postwar decade, France took particular pride in the reform and reconstruction of its army, which became an instrument not only for defense, but for moral and social regeneration. Pressure for compulsory service had made the army itself more socially mixed, and thus the presence of such a soldier in *The Pont de l'Europe* would have further reiterated the relationship between the two social groups depicted. Caillebotte would show *A Soldier* (Berhaut 1994, no. 185) in the Impressionist exhibition of 1879. He also took seriously his own military service throughout his life.

78 The quartier de l'Europe, especially around the train station, housed in the 1870s a number of well-known, deluxe brothels (capitalizing on the increased male traffic at the time of the Universal Exhibition). Although this woman, if a prostitute, was probably "high-class," operating independently of such houses, the reputation of this area as one offering illicit sex would certainly have influenced a contemporary viewer's understanding of why Caillebotte placed this woman so prominently in his picture.

79 On prostitution and its role in modern French painting of the 1870s and 1880s, see Clayson 1991.

80 A *petit bourgeois* might use the trains to come into the city to work, or to escape the city on weekends. A *bon bourgeois* (like Caillebotte) might also use the trains in order to commute (in the summer, for example, to a rented country villa in Argenteuil or Chatou) or to escape the capital for seaside vacations along the Normandy coast. See C. P. D., "Le Pont métallique de la Place de l'Europe," *Illustration: Journal universel*, 21 Mar. 1868, p. 235. According to this writer, Gare Saint-Lazare dispatched and received an average of 232 passenger trains each weekday, and 406 on Sundays.

81 Although a gaslight is present in the background of the painting, at the composition's vortex, its form is nearly hidden by that of the top-hatted *flâneur*.

82 By masking the tall, stone forms of the two pylons that actually supported the bridge (see Varnedoe 1974, p. 28), Caillebotte further eliminated any references to verticality in his painting.

83 "The figure of the workman . . . is audacious. . . . However, it is a necessity. The painter could not leave the entire foreground of his canvas completely empty. He was astute to realize this" (Jacques 1877).

84 One could argue, in fact, that Monet's 1877 series devoted to Gare Saint-Lazare, which reverberates with movement and is saturated with light and air, carried with it the same Republican association of social and technological progress. See, in particular, the critic writing for *Le Rappel*: "The *Train Stations*, noisy, full of steam, by M. Claude Monet, not to mention this artist's beautiful landscapes, so honest, arrest and seduce the mind. They give off something like the soul of this contemporary world whose forward march can no longer be stopped, aided as it is by the Locomotive" (Anonymous 1877a). The positive, progressive, and democratic meanings carried by Monet's and Caillebotte's paintings would thus have reinforced each other when shown side by side in 1877. That railways and bridges were Republican subjects in these postwar years is indicated by the fact that in 1879 Manet included them (along with public markets, parks, racetracks, and underground activities) in a series of paintings on the theme of *le ventre de Paris* ("the underbelly of Paris"), with which he proposed to decorate the ceiling of the newly rebuilt Hôtel de Ville.

85 See Galassi 1987, pp. 34–39; and the dossier on *Paris Street; Rainy Day*.

86 See ibid., pp. 28–34.

87 Benjamin 1973, pp. 38–39.

88 *Paris Street* must have contrasted equally with Renoir's monumental *Ball at the Moulin de la Galette* (Appendix III, fig. 49). According to Bigot, "the large picture of *Ball at the Moulin à La Galette* . . . and M. Caillebotte's *Umbrellas* could be in different Salons" (Bigot 1877). Renoir's picture, like Caillebotte's *Pont de l'Europe*, was of an entirely different mood, celebrating the pleasures of social mixing, especially by avant-garde artists. Caillebotte acquired Renoir's painting after the 1877 exhibition and included it in his *Self-Portrait at the Easel* of 1879 (cat. 87).

89 The times of day can be deduced by the direction of the shadows, and the seasons of the year would have been obvious to contemporary viewers by the different fashions. Varnedoe confirmed that the couple featured in *Paris Street* wear the winter clothing of the *bourgeois élégante*, while the dress and parasol of the woman in *The Pont de l'Europe* are summer attire (Varnedoe 1974, p. 58, no. 14).

90 Critics in 1877 generally preferred *The Pont de l'Europe* to *Paris Street*. See Jacques 1877; and Anonymous, "La Journée à Paris: L'exposition des impressionnalistes," *L'Evénement*, 6 Apr. 1877. Rivière even argued that the somewhat smaller size of *The Pont de l'Europe* made it more attractive: "*Pont de l'Europe* is a rather pretty [study of the] effect of sunlight, more engaging than *Rainy Day* because its dimensions are smaller" (G. Rivière 1877b).

91 Interestingly enough, it was *The Pont de l'Europe*, and not *Paris Street*, that Caillebotte chose to reproduce that year in the 21 Apr. issue of Rivière's *L'Impressionniste*.

29

The Pont de l'Europe

(Le Pont de l'Europe)

1876
Oil on canvas
124.7 × 180.6 cm
Signed and dated lower right:
G. Caillebotte / Paris 1876
Berhaut 1978, no. 44; Berhaut
1994, no. 49

Musée du Petit Palais, Geneva

Principal Exhibitions
Paris 1877, no. 2; Paris 1894, no.
6; Annecy 1964, no. 4; Geneva
1965, no. 2; Paris 1965, no. 2;
Geneva 1968, no. 13; Geneva 1974,
no. 5; Houston and Brooklyn
1976–77, no. 16; San Francisco
1986, no. 39; Paris and Tokyo
1988, no. 198.

Contemporary Criticism
Anonymous 1877a and b; A. P.
1877; Baron Schop 1877; Bertall
1877; Bigot 1877; Burty 1877;
Chevalier 1877; Jacques 1877;
Lafenestre 1877; Lepelletier 1877;
Maillard 1877; G. Rivière 1877a
and b; Vassy 1877.

Selected Bibliography
Thiébault-Sisson 1894; Berhaut
1951, no. 20; Nochlin 1971, p. 157;
Rewald 1973, p. 392; Varnedoe
1974, pp. 28–29, 41, and 58–59;
Varnedoe 1976, pp. 94–99;
Berhaut 1977, pp. 45–46; Rosen-
blum 1977, pp. 46 and 50;
Berhaut 1978, pp. 33 and 43;
Thomson 1982, pp. 323–37; Clark
1984, pp. 73–74, and 78; Bocke-
mühl 1985, pp. 13–35; Galassi
1987, pp. 27–40; Rand 1987, pp.
67–71; Varnedoe 1987, no. 15; Ba-
landa 1988, pp. 74–75; Herbert
1988, pp. 20, 22–24, 28, 31, and
34; Chardeau 1989, pp. 36–51.

Figure 1. Giuseppe De Nittis (Italian;
1846–1886). *Under the Railroad
Viaduct*, 1875. Oil on canvas; 41 × 50
cm. Gaetano Marzotto, Valdagno.

In 1876, when Caillebotte chose the Pont de l'Europe as the subject of what would become one of his most important publicly exhibited works, he did so amidst a profusion of painted images that attest to a shared interest on the part of both Salon and Independent artists during the postwar decade in depicting this recently constructed iron bridge (1865–68) and the urban activity associated with it. In the Salon of 1874, for example, Manet had shown his *Railroad* (cat. 31, fig. 1), on the far right of which, though nearly completely obscured by steam, are the iron trellises and one of the stone pillars of the bridge. Probably painted about the same time as Caillebotte's picture, Giuseppe De Nittis's *Under the Railroad Viaduct* (fig. 1) is another view of the bridge from below, in many respects comparable to Monet's *Pont de l'Europe* (1877; Musée Marmottan, Paris), which was shown along with Caillebotte's canvas at the Impressionist exhibition of 1877. Undoubtedly painted during the same period was Jean Béraud's *Pont de l'Europe* (fig. 2), which is closer to Caillebotte's image in its vantage point—on the metal structure—and even more so in its concern with the social significance of the bridge.

Why was the Pont de l'Europe such a favored site for modern painters in the 1870s? First, the bridge was particularly remarkable for the way it linked six disparate streets into a harmoniously integrated, radial design (see fig. 3). There was no single point from which this architectural harmony could be appreciated in its entirety, except from above. Every view from without and within the Pont de l'Europe was a partial one, and both photographers and painters in the mid-1870s (Caillebotte included) appear to have delighted in the way the bridge's metal spans artfully interrupted and framed their modern urban landscapes.

The Pont de l'Europe was also convenient: Caillebotte's family home and studio at 77, rue de Miromesnil were located not far from the bridge, and he probably often boarded trains at Gare Saint-Lazare. Furthermore, the Pont de l'Europe was located in the quartier de l'Europe, which, along with the neighboring and newly refashioned Batignolles district, had been the favored site for modern painting since the 1860s, when Manet set up his studio there and began painting its socially diverse inhabitants, especially the "marginals" increasingly displaced by Haussmann's transformations. By the mid-to-late 1870s, however, the bridge may have been one of the few remaining spaces in this *quartier* where such social mixing continued to take place. With its broad streets and sidewalks and its expansive, central area, complete with two traffic islands, the Pont de l'Europe was a space where social difference could be comfortably experienced and easily viewed.

Both Béraud and Caillebotte chose to emphasize the sociality encouraged by the wide spaces of the Pont de l'Europe. In Béraud's painting, however, the people appear to walk aimlessly, randomly dispersed across the broad expanse of the street. The receding focus and forward movement of Caillebotte's much larger image are in clear contrast. As the viewer's gaze shifts between these two centers of attention, it also oscillates between the surface

Figure 3. A. Lamy. *Bridge Erected at the Site of Place de l'Europe, above the Western Railway Line*, from *L'Illustration*, 21 Mar. 1868, p. 235. The Newberry Library, Chicago.

Figure 2. Jean Béraud (1849–1936). *The Pont de l'Europe*, c. 1875. Oil on canvas; 48.3 × 73.7 cm. Location unknown.

and depth implied by the elements placed parallel (background buildings) and obliquely (bridge rail) to the picture plane. This back-and-forth visual movement mimics the movement of the trains below, and additionally reinforces the X-composition of the image and the symbolic social relationships implied by it.

The comparison with Béraud's painting is also interesting for the sexual content that the images appear to share. Béraud's version is dominated by a fashionably dressed woman who seemingly taps her parasol on the ground to call her little dog, prominently placed in the center foreground. She has distracted the top-hatted gentleman at the left, who looks at her across the path of his more modestly dressed companion. Béraud leaves open the meaning of this look and the status of the woman, so coquettishly dressed in comparison with the other female figures in the picture and so clearly associated with the lap dog, then an almost obligatory accessory of the modern courtesan.[1] Caillebotte's *Pont de l'Europe* suggests a similar, potentially sexually charged exchange, where the *flâneur* is apparently distracted by the fashionably dressed woman he has just passed, who, in turn, seems to glance suggestively toward him. Importantly, competing with this implied sexual exchange in *The Pont de l'Europe*, however, is a social one: the *flâneur* appears equally, if not more, distracted by the figure of the worker in whose direction he seems to stare. J. S.

1 See Thomson 1982.

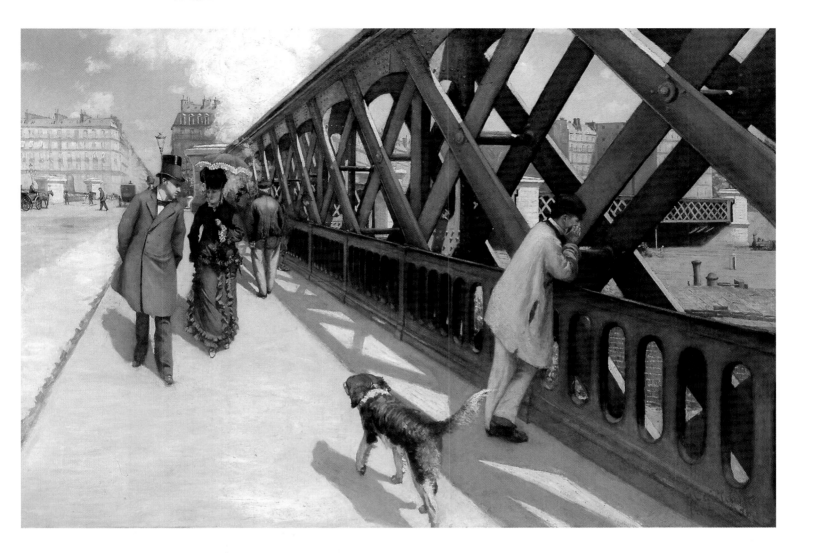

30

The Pont de l'Europe (Study)

(Le Pont de l'Europe [étude])

1876

Oil on canvas

55.5 × 45.7 cm

Berhaut 1978, no. 41; Berhaut 1994, no. 47

Private collection

Principal Exhibitions
New York 1968, no. 8 (?); Houston and Brooklyn 1976–77, no. 20.

Selected Bibliography
Bockemühl 1985, pp. 13–35; Varnedoe 1987, p. 79, fig. 15t; Chardeau 1989, p. 49.

Caillebotte made a number of drawings and painted studies and sketches in preparation for his monumental *Pont de l'Europe* (cat. 29). This particular study dramatically demonstrates the artist's careful rendition of two centers of vision in the final composition. This development began with a small oil sketch in which the main elements of the scene and the principal figures were freely brushed in (ch. 3 intro., fig. 13). In a sequence of drawings, Caillebotte appears to have abstracted and progressively manipulated the elements of this architectural space in order to reinforce the X-composition and the perspectival plunge of the bridge and sidewalk that would, in the final image, be centered on the head of the top-hatted man, the *flâneur* frequently identified as a self-portrait. However, these same drawings show a simultaneous and almost independent development of the right foreground of the picture, the span of iron rail and trellis that is the subject of this study and that the white-smocked laborer would come to occupy in the final picture. After the first oil sketch, this area of the composition was increasingly distorted—deliberately, it appears, made too high and the distance between the girders too wide in receding proportion to the rest of the bridge. In a second oil sketch (fig. 1), this distortion is particularly evident, but it would become less so as the image was cropped in a third sketch (ch. 3 intro., fig. 14), and

cropped again while also being laterally stretched in the final painting. Perhaps this study was painted after the last sketch and before the final canvas in an investigation of the limits of such cropping, more extreme here than in a similar, related study (fig. 2), which, with its leaning figure, corresponds more closely to the final image. In the drawings, sketches, and even to a certain degree in the final version, this separate picture within a picture, defined by the composition's second plane of projection, centered on the worker's head, is revealed by the conspicuous bend in the line of the bridge rail.

Caillebotte's manipulations gave both the *flâneur* and the laborer their own places on the Pont de l'Europe, and dramatized the relationship and proximity of these two spaces and their occupants in the final picture. Yet the worker is notably absent from this study, in which the artist reveals his fascination with the abstract composition made by the iron members and the arbitrary way they frame the view beyond. This study may have inspired the bold composition of Caillebotte's second *Pont de l'Europe* (cat. 31), seemingly painted in 1877 but never shown publicly. Moreover, the extreme contrast between near and far, and the dominating presence of a screen of iron (albeit of a quite different sort) would be taken up again four years later in the comparably sized *View through a Balcony Grille* (cat. 66). J. s.

Figure 1. Gustave Caillebotte. *Sketch for* The Pont de l'Europe, 1876. Oil on canvas; 32 × 45 cm. Musée des Beaux-Arts, Rennes.

Figure 2. Gustave Caillebotte. *Study for* The Pont de l'Europe, 1876. Oil on canvas; 73 × 60 cm. Private collection.

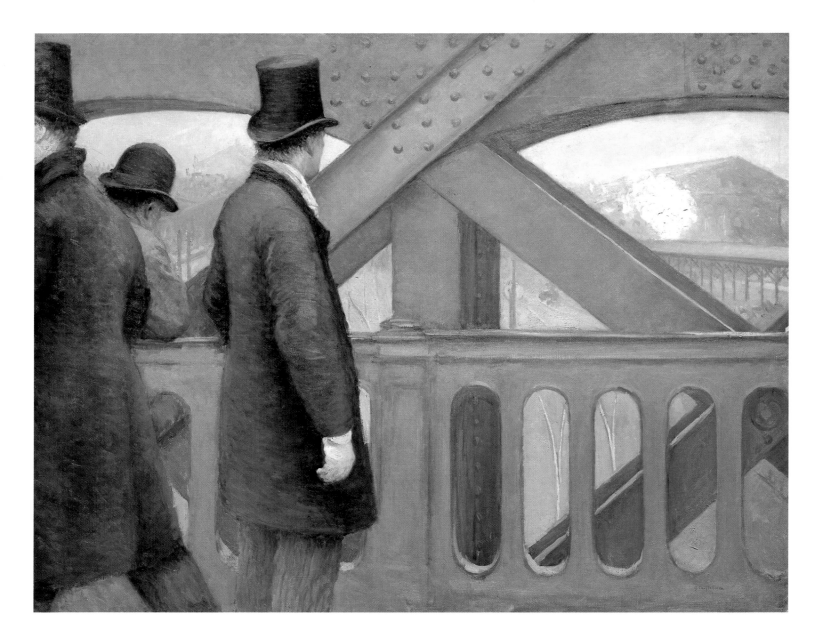

31

The Pont de l'Europe (Variant)

(Le Pont de l'Europe [variante])

1876/77 or c. 1880[1]

Oil on canvas

105 × 131 cm

Stamped lower right

Berhaut 1978, no. 46; Berhaut 1994, no. 51

Kimbell Art Museum, Fort Worth

Principal Exhibitions

Paris 1951, no. 10; London 1966, no. 5; Houston and Brooklyn 1976–77, no. 22; Los Angeles et al. 1984–85, no. 29.

Selected Bibliography

Roberts 1966, p. 345; Berhaut 1978, pp. 43–44; Bockemühl 1985, pp. 13–35; Pillsbury and Jordan 1985, pp. 409–418; Rand 1987, pp. 67–71; Varnedoe 1987, no. 16; Chardeau 1989, pp. 50–51; Wittmer 1990, p. 21.

Probably developing out of a study (cat. 30) for the monumental *Pont de l'Europe* (cat. 29),[2] this painting, almost as large, was likely intended for the Impressionist exhibition of 1877. Caillebotte seems to have decided in the end not to include it, however, and it remained one of the only painting of its size that he never displayed in his lifetime.

The picture depicts two men, their backs to the viewer, who, without interacting, look intently through the iron trellis of the Pont de l'Europe. Each gazes toward Gare Saint-Lazare, the glass and iron railway station just visible in the far right background and framed by an opening in the metal bridge. At the left, through a similar aperture, and compositionally balancing the train station, is the barely discernible roof of the newly completed Opéra.

Their faces hidden from view, these men appear to be anonymous figures, "everymen" of late nineteenth-century Paris. Their contrasting attire, however, is evidence of their class difference. The man leaning on the iron rail appears to be a *petit bourgeois*, a member of the new social stratum that had emerged in France during the nineteenth century as a result of industrialization. His lowly position on the social scale is suggested by his bent posture and by his placement at the far left of the calibrated rail that dominates the image. Although he wears the blue smock of the working class, his conspicuously fashionable bowler suggests his upward mobility and his material capacity to be a fashion consumer.[3] He is probably both a laborer and businessman, possibly a shopkeeper. By contrast, the man farther toward the middle of the canvas, in top hat, gray frock coat, and pristine white scarf, appears to be a *bon bourgeois*, a member of the true middle class. His prominently displayed, soft, clean hand[4] clearly indicates that he is not a manual laborer.

Caillebotte's picture of these two representatives of the middle classes, standing near one another without interacting, together gazing at the spectacle of the railroad beyond, is a particularly telling image, for it was industrialization and the accompanying social changes that had indeed brought the lower and middle classes closer together. Distinctions within the middle classes were increasingly blurred over the course of the nineteenth century, and movement became more fluid. This mobility (evoked in Caillebotte's painting by a second *bon bourgeois*, exiting the left side of the canvas) and especially the tensions and anxiety it caused are considered by many to be definitive features of modernity.

Caillebotte's image is much like that of an instantaneous "slice-of-life" caught by a camera. Indeed, it has been suggested that the artist might have used photography as a compositional aid or source for his paintings.[5] This technological modernity of artistic means and effects is matched in the Kimbell painting, moreover, by the technological modernity of the chosen site. Like the Geneva painting, the Kimbell *Pont de l'Europe* features the iron bridge built in 1865–68 over the tracks of the Compagnie de l'Ouest, in the eighth arrondissement, not far from what was then the Caillebotte family home on rue de Miromesnil. This metal structure, which was dismantled in 1930, replaced two stone tunnels that could not accommodate the expansion in the 1850s and 1860s of the western railway and its station. Completed some ten years before Caillebotte painted it, the Pont de l'Europe was the emblem of modern engineering in Paris, foreshadowing the famous Eiffel Tower built for the 1889 Universal Exhibition.

The Kimbell *Pont de l'Europe*, then, is an image about two city men who differ in class but share a view: of the railroad, of the city in motion, and of modern Paris at work. They are transfixed by the spectacle of modern technology, as if held firmly by the crossed and bolted iron girders of the Pont de l'Europe itself. In the 1870s the futures of both classes depended on their harnessing the power of industrialization for their mutual progress. If technology, industrialization, and the railroad had brought the middle classes closer together, then they also had to be the means of ensuring their peaceful coexistence.

Yet the two men in Caillebotte's painting are not only looking through the iron trellis at Gare Saint-Lazare; they can also be read as looking at a painting within Caillebotte's painting—at a *picture* of Gare Saint-Lazare, suggesting that it is not just the spectacle of the railroad and modernity that unites them, but a representation of that spectacle in paint on canvas. The structural elements of the Pont de l'Europe, flattened against the plane of the canvas and cut off by its edges, merge at the top and bottom with the picture's frame, and metaphorically extend that frame into the space of the picture to enclose the view of the railroad station. Furthermore, instead of the conventional spatial organization of foreground (figures), middle ground (trellis), and background (distant railway), Caillebotte's composition does not seem to have a true middle ground: the space in which the two life-size figures stand is not so much a foreground space *inside* the painting, but rather an extension of the space *in front of* the painting. Here, the viewer joins the two painted spectators on the Pont de l'Europe in

continued on page 108

Figure 1. Edouard Manet (1832–1883). *The Railroad*, 1872–73. Oil on canvas; 93 × 114 cm. National Gallery of Art, Washington, D.C.

the activity of looking, and completes the composition by imaginatively occupying the notably empty space at the right.

The two viewers Caillebotte painted in the Kimbell *Pont de l'Europe*, like the implied viewer before it, can be likened to the middle-class spectators who visited the Impressionist exhibition in 1877. That year they would have seen Monet's series on Gare Saint-Lazare (see Appendix III, fig. 24), painted from within the building, hanging in the same room as, and possibly adjacent to, Caillebotte's principal entries.[6] The middle classes would thus be united by the activity of looking at paintings, especially paintings such as Monet's series celebrating the beauty of technology, industry, mobility, and commerce—of modern Paris at work.

If the Kimbell *Pont de l'Europe* had been exhibited in 1877, it would undoubtedly immediately have called to mind Manet's *Railroad* (fig. 1), shown just three years earlier at the Salon. The paintings share a bold juxtaposition of foreground figures, flatly painted but brought into sharp focus, with a more sketchily rendered background view of steamy Gare Saint-Lazare and its tracks. In both cases, foreground and background, figures and cityscape, are abruptly demarcated by an iron structure: a garden fence in Manet's image and the girders of the newly built Pont de l'Europe in Caillebotte's painting. Despite these similarities, however, the two pictures differ in remarkable and meaningful ways. The iron fence in Manet's image appears to function like a cage enclosing the female figures, confining them and excluding them from the urban life featured in the background.

There is little or no space in Manet's picture for the viewer to enter, and even the view beyond has been rendered inaccessible by the smoke, which obscures all detail. In contrast, the metal elements of the Pont de l'Europe in Caillebotte's painting do not confine, but instead appear to facilitate and structure our view of the city—in this case a determinedly male one. The bold X formed by the iron girders certainly reasserts the X-composition of the Pont de l'Europe that is its very subject; but, perhaps even more importantly, it functions compositionally like a magnet, drawing viewers to the scene and joining them in the shared activity of looking. A sketch for the final painting shows how Caillebotte drew attention to this X-structure and its capacity to unite by cropping his original conception at the top, bottom, and right sides, while at the same time bringing the bowler-hatted *petit bourgeois* closer to the top-hatted *bon bourgeois* with whom he stands. This joining is further emphasized by the X-formations of the railroad track junctions that Caillebotte cleverly painted between the metal openings of the bridge. Finally, unlike Manet's closed-off space, the notably asymmetrical composition of Caillebotte's *Pont de l'Europe* invites the viewer to join in the socializing activity of gazing at the spectacle—both real and painted—of modern, industrial Paris below. J. S.

1 Varnedoe (1987, no. 16) suggested a date of c. 1880 for this painting, arguing that in its style, spatial construction, and mood, it shares much with such later "blue" pictures as *Interior* (cat. 63) and *Man on a Balcony* (cat. 67). Nonetheless, the Kimbell picture's ambitious scale and subject (the distinctively public urban space of the Pont de l'Europe, in contrast to the more private, interior spaces of these later pictures), and especially its relationship to several studies for the Geneva painting (see cat. 30), argue for the earlier date by closely associating it with Caillebotte's large streetscapes of 1877.

2 Though, as Varnedoe has pointed out, this viewpoint is situated at a different point along the bridge, closer to its midpoint (see Varnedoe 1987, no. 16 n. 2).

3 See F. M. Robinson, *The Man in the Bowler Hat: His History and Iconography* (Chapel Hill and London, 1993).

4 Varnedoe (1987, no. 16) identified the hand as gloved. Whether a bare hand or gloved, however, the point remains the same: the hand does not show the evidence of manual labor.

5 On Caillebotte's use of photography and photographic methods, see Varnedoe and Galassi, "Caillebotte's Space," in Varnedoe 1987, pp. 20–26.

6 On the 1877 exhibition installation, see Brettell 1986, pp. 189–202. It is interesting to note in this discussion of Impressionist "views" of modern life that Monet's *Arrival of the Normandy Train, Gare Saint-Lazare* (1877; The Art Institute of Chicago) was installed next to a window that looked out over the boulevards of the quartier de l'Opéra, the *quartier* featured in the picture within Caillebotte's picture. On the installation of Monet's painting, see Bigot 1877.

32

The Place Saint-Augustin

(La Place Saint-Augustin)

1877/78

Oil on canvas

54 × 65 cm

Stamped lower right

Berhaut 1978, no. 112; Berhaut 1994, no. 103

Private collection

Principal Exhibitions
Paris 1879 (not in catalogue); Paris 1894, no. 93; Paris 1951, no. 24; Houston and Brooklyn 1976–77, no. 39.

Contemporary Criticism
Bec 1879.

Selected Bibliography
Berhaut 1968, p. 30; Berhaut 1978, pp. 34 and 44; Georgel 1986, pp. 74–75; Varnedoe 1987, no. 26; Chardeau 1989, pp. 80–81; Wittmer 1990, pp. 12 and 279.

Along with its pendant, *The Pépinière Barracks* (cat. 33), this small streetscape depicts a view from place Saint-Augustin, the city square not far from Caillebotte's family home on rue de Miromesnil. Place Saint-Augustin was yet another product of the Second Empire transformations of the capital, formed when the fashionably new boulevards Malesherbes and Haussmann were cut through the former slums of the western districts. In this pair of paintings, Caillebotte appears to have rethought his monumental, publicly exhibited streetscapes of 1877, *Paris Street; Rainy Day* (cat. 35) and *The Pont de l'Europe* (cat. 29), casting them in a more recognizably Impressionist mode. This new style meant not only smaller canvases and a different technique, but it called for something less didactic than modern-history painting—something more private, decorative, and ambiguous in its meaning.

The Place Saint-Augustin is in many ways a smaller, more Impressionist counterpart to *Paris Street*. The vista is down a similar, relentlessly aligned street, in this case the recently built boulevard Haussmann, whose name leaves no doubt as to the specific nature of this "rue de Paris." The gray-blue color of the smaller canvas resembles the predominantly gray-green palette of the larger one; both suggest a damp, misty day in which indistinct, anonymous strollers scurry across the street. Both paintings are constructed similarly, with a large foreground figure (or figures) on one side juxta-posed with a sweeping perspectival plunge on the other. Even the expanse of carefully placed, parallel brush strokes marking the street's surface at the far right recalls the meticulously aligned paving stones of *Paris Street*. Finally, and most importantly perhaps, the figure that dominates both images is a smartly dressed, top-hatted *flâneur*, who unmistakably dominates and defines the social character of modern urban life.

Yet despite these similarities, *The Place Saint-Augustin* is noticeably more Impressionist than *Paris Street*, as if the sharply focused portrait of Haussmannian Paris had been veiled by a gauze of broken brushwork, and the social message of the larger picture thereby softened as well. Notably, the architectural severity of this Haussmannian "rue de Paris" has been appreciably camouflaged by the boulevard trees—the natural landscape that would soon replace the streetscape in Caillebotte's own art and come to be the defining subject matter of Impressionism itself. In fact, the greatest affinities lie not with *Paris Street*, but with the less carefully finished studies for it (see cats. 36 and 37). This painting actually demonstrates the dilemma of Impressionism: the classification as a finished work of what formerly had been considered a sketch.
J. S.

33
The Pépinière Barracks

(La Caserne de la Pépinière)

1877/78

Oil on canvas

54 × 65 cm

Signed (by Renoir) lower right:
G. Caillebotte

Berhaut 1978, no. 113; Berhaut
1994, no. 104

Private collection

Principal Exhibitions
Paris 1894, no. 8; Paris 1951, no.
25; Paris 1957, no. 36; London
1966, no. 13; New York 1968, no.
18; Houston and Brooklyn 1976–
77, no. 40; Marcq-en-Baroeul
1982–83, no. 11.

Selected Bibliography
Berhaut 1968, p. 30; Berhaut
1978, pp. 34 and 44; Varnedoe
1987, no. 27.

The *Pépinière Barracks* is one of a pair of streetscapes (see cat. 32) in which Caillebotte reworked themes from his large street pictures of 1877 in a more discernibly Impressionist manner. Like *The Place Saint-Augustin*, *The Pépinière Barracks* was painted from a perspective within Place Saint-Augustin, only this time the view is up rue de la Pépinière, the street next to boulevard Haussmann, featured in *The Place Saint-Augustin*. In fact, the block of buildings between these two thoroughfares is repeated in each of the two pendants in such a way that, when hung side by side, they afford a single, panoramic vista from inside the square.

Just as it is possible to consider *The Place Saint-Augustin* as the counterpart to *Paris Street; Rainy Day* (cat. 35), *The Pépinière Barracks* relates in several important aspects to Caillebotte's *Pont de l'Europe* (cat. 29). First, as compared with its pendant, it appears to be a similarly warmer picture, in both its palette and the sunny weather conditions depicted. The rectilinear severity and homogeneity of the Haussmannian streets are also less prominent, replaced here by a distinctively irregular roofline and a winding prospect—signs of an older Paris. The historic rue de la Pépinière, laid down in the eighteenth century, was in fact one of the few remnants of "old Paris" in this Haussmannian district. Its architectural variety is apparently matched in *The Pépinière Barracks*, moreover, by a representation of social diversity. Almost in the center middle ground of the image, standing on or just beyond the edge of a traffic island in the square, are

two men, one slightly taller in a top hat, the other a little shorter in what may be a bowler. They stand face-to-face, possibly in conversation. This meeting of two contrasting middle-class figures appears to connect the barracks to the socially symbolic content of the Pont de l'Europe images that preceded it. It is as if the two men looking out on Gare Saint-Lazare in the Kimbell *Pont de l'Europe* (cat. 31) have turned to each other and spoken. Just behind these two figures, barely distinguishable by his red trousers, is a soldier presumably walking toward the large military barracks on the left, the Caserne de la Pépinière itself. This military figure is likewise a quotation from the background of *Pont de l'Europe*, and appropriate to a like picture of social diversity.

In the context of this relationship between the two paintings, it is interesting that *The Pépinière Barracks* was first owned by Eugène Daufresne, Caillebotte's mother's cousin, who is featured in a portrait by the artist dated 1878 (see ch. 5 intro., fig. 3). Daufresne apparently also owned one of the sketches for *The Pont de l'Europe* (ch. 3 intro., fig. 14), which was also more Impressionist than the final picture in both its scale and style. J. S.

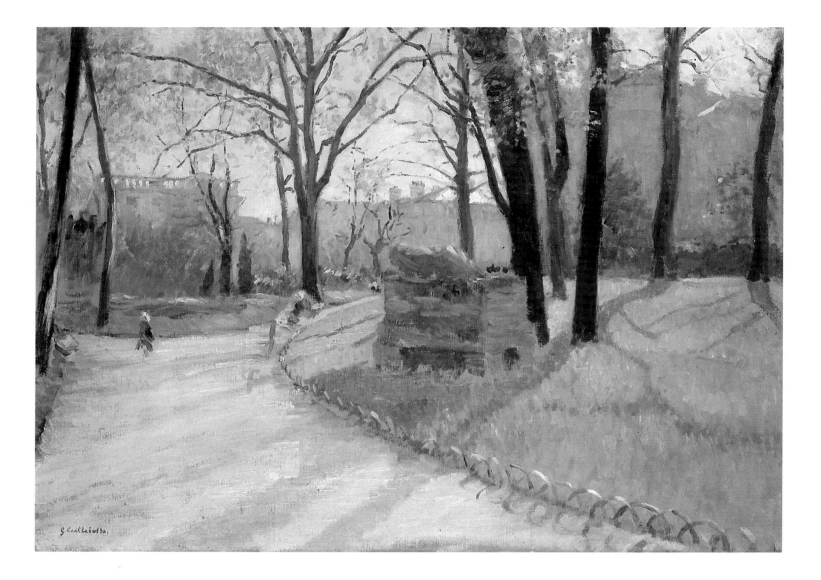

114

34

The Parc Monceau

(Le Parc Monceau)

1878

Oil on canvas

65 × 81 cm

Stamped lower left

Berhaut 1978, no. 111; Berhaut 1994, no. 102

Private collection

Principal Exhibitions
London 1966, no. 17; New York 1968, no. 25.

Selected Bibliography
Roberts 1966, p. 386; Berhaut 1978, p. 44.

At the same time that they were painting and exhibiting pictures of the area around Gare Saint-Lazare, Caillebotte and his friend Monet appear also to have shared an interest in another very different kind of urban space: the public city garden, and, in particular, Parc Monceau. The park was located only blocks away from where Caillebotte lived throughout most of the 1870s. It was originally laid out in the eighteenth century as a private, picturesque garden. During the French Revolution, it was declared the property of the State, but in the ensuing decades it continued to pass in and out of private ownership, while also falling into general disrepair and disuse. It was only during the Second Empire, when the State firmly reclaimed and restored it, that Parc Monceau became "one of the most agreeable promenades in Paris."[1]

The only other known painting by Caillebotte set in Parc Monceau (fig. 1), dated 1877, recalls Monet in both its brushwork and composition. However, Caillebotte's image resembles not so much Monet's own views of the park, but instead his *Apartment Interior* (Appendix III, fig. 23), which Caillebotte owned at the time. In both works, a wide, smooth passageway (garden path, floor), tipped dramatically forward, cuts through the center of the picture. At the end of this corridor stands a solitary, strangely diminished, indistinct figure, encased and nearly overwhelmed by the surrounding plant life. In depicting Parc Monceau in this manner, Caillebotte likened the space of his neighborhood garden to private interior space, at once comforting and menacing.

A very different spirit pervades Caillebotte's second painting of the park. Though undated, it is thought to have been done in 1878 because of its affiliation with Monet's documented Parc Monceau paintings of that year. Unlike Monet's views and even Caillebotte's first painting, however, the

scene here is not one of the lush summer park, but instead a relatively desolate, early spring view. The trees sprout only a few leaves and the grass has only just begun to turn green. The sparse growth reveals more of the Haussmannian buildings surrounding the park, making more permeable the boundaries between city and garden. Here Caillebotte demonstrated his sense of the increasing interchangeability of urban space in modern Paris, as streets became increasingly gardenlike and gardens more like streets.

Moreover, instead of emphasizing the sociality of Parc Monceau, as Monet did in 1878, Caillebotte showed only one figure in the garden, dramatically diminutive as in his first painting. In contrast to the figure's small size is the large stone object in the right foreground, undoubtedly one of the many ruins dotting the picturesque garden. As elsewhere, Caillebotte selected a modern site marked by history. Significantly, this historicized space is depicted during spring, the season of rebirth and recovery; from the ruined rock of history grow the green signs of a promising future. Indeed, it seems that Caillebotte's painting was itself an important transitional work in his oeuvre. In its low viewpoint, looming garden path, and even in its predominantly gray-green palette, it recalls the large street subjects that Caillebotte showed in 1877, which were also about recovery and new life (see ch. 3 intro.). In its view of the city through the filter of nature, it shares much as well with the balcony scenes shown by Caillebotte in the Impressionist exhibition of 1882 (see ch. 4 intro.). These artistic transitions, significantly, coincided with changes in Caillebotte's personal life, including the death of his mother in 1878. Perhaps this image mirrored his own sense that life must go on despite death. It was indeed one of the last pictures that Caillebotte painted of the area around his family home on rue de Miromesnil, and was probably done just before he and his brother Martial sold the property to start anew in an apartment in the quartier de l'Opéra.
J. S.

1 See the entry "*Monceau*" in P. Larousse, *Grand Dictionnaire universel du XIX^e siècle*, vol. 11, pt. 1 (Paris, 1866–79; repr. Paris, 1982), p. 428.

Figure 1. Gustave Caillebotte. *The Parc Monceau*, 1877. Oil on canvas; 50 × 65 cm. Private collection.

35

Paris Street; Rainy Day

(Rue de Paris; temps de pluie)

1877

Oil on canvas

212.2 × 276.2 cm

Signed and dated lower left:
G. Caillebotte 1877

Berhaut 1978, no. 52; Berhaut 1994, no. 57

The Art Institute of Chicago (Charles H. and Mary F. S. Worcester Collection, 1964.336)

Principal Exhibitions
Paris 1877, no. 1; Paris 1894, no. 47, as *Une Rue de Paris; effet de pluie;* Paris 1951, no. 13; Portland 1956, no. 78; Dayton 1960, no. 56; Minneapolis 1969, no. 7, as *Place de l'Europe on a Rainy Day;* Houston and Brooklyn 1976–77, no. 25; San Francisco 1986, no. 38.

Contemporary Criticism
Anonymous 1877a and b; A. P. 1877; Ballu 1877; Baron Schop 1877; Bertall 1877; Bigot 1877; Burty 1877; Chevalier 1877; Grimm 1877; Jacques 1877; L. G. 1877; Lafenestre 1877; Lepelletier 1877; Lora 1877; Mancino 1877; Mantz 1877; G. Rivière 1877a and b; Sébillot 1877; Vassy 1877; Zola 1877.

Selected Bibliography
Crevelier 1894; Berhaut 1968, p. 17; Nochlin 1971, pp. 168–69, and 264; Varnedoe 1974, pp. 29, 41, and 58; Varnedoe 1976, pp. 94–99; Berhaut 1977, pp. 42–43; Rosenblum 1977, pp. 47–48; Berhaut 1978, pp. 34 and 44; Varnedoe 1979–80, pp. 42–61; Clark 1984, p. 15; Bockemühl 1985, pp. 13–35; Georgel 1986, pp. 74–75; Brettell 1987, pp. 45–46; Varnedoe 1987, no. 18; Herbert 1988, pp. 22–23; Chardeau 1989, pp. 63–71.

Gustave Caillebotte's ambitious modern history painting *Paris Street; Rainy Day* (cat. 35), much like his *Floor-Scrapers* (cats. 3 and 5), shown the previous year, secured the artist critical appreciation at the Impressionist exhibition in 1877 for its "science of design and arrangement."[1] According to one reviewer, it was a canvas "that, despite the bizarre quality of some of its details and its jerky handling . . . would still figure honorably beside pictures receiving the approval of the Champs-Elysées [official Salon] jury."[2] Indeed, in the relative finish of its brushwork, in the well-studied rationality of its composition, and especially in its impressive size, *Paris Street*—despite the shocking modernity of its subject—must have looked familiarly academic in 1877, betraying Caillebotte's recent study with the Salon artist Léon Bonnat. It even prompted one critic to exclaim that "M. Caillebotte is an Impressionist in name only," because in comparison to many of his colleagues who were being derided for daring to exhibit sketches as finished works of art, this painting demonstrated that Caillebotte "knows how to draw and paint more seriously. . . ."[3] The fact that Caillebotte followed an academic rather than "Impressionist" method in many of the large paintings of his early career is evidenced by a group of preparatory drawings and oil sketches for *Paris Street*, through which the artist developed and altered his original conception for the picture. These studies and sketches certainly attest to the "considerable effort" described by the critic Georges Rivière in 1877 in reference to the painting, and "how difficult it was and how much skill was necessary to complete a canvas of these dimensions."[4] Nevertheless, they also demonstrate the lengths to which the artist went in order to construct an image that would appear at once both obsessively ordered and precariously fragile—a construction that constitutes the very basis of the picture's meaning.

A small graphite and charcoal drawing (cat. 39) documents what was probably an early—if not the first—scheme for the picture.[5] Here, Caillebotte set down the basic elements of the architectural site,[6] most of which would remain unchanged or be only slightly altered in the final painting. He appears to have first freely sketched many of the buildings and other structures, and then reinforced the linear severity of his perspective (the balcony lines and paving stones) using a straightedge.[7] These lines of reinforcement are the first indication by which the artist would expressively transform his image "from a literal representation of the site to an ordered vision based on the site."[8]

It is worth remarking that the lamppost was already an integral part of this early conception, and that one of the few details indicated is the scaffolding that appears, as it would in the final painting, in the far middle distance just to the left of this

lamppost. Both of these elements would contribute significantly to the final image. The lamppost clearly divides the sheet in two and defines the vertical axis of what Kirk Varnedoe called the "giant plus sign," or cross, around which the complex composition of the painting was organized.[9] A firmly drawn horizontal element on this post locates the horizontal axis, which is further reinforced by the baselines of the background structures. Other vertical zigzag lines and connected X's indicate the future placement of figures or other nonarchitectural elements. As shown elsewhere, these spots, while apparently random, were in fact selected in accordance with an obscure but carefully calibrated and mathematically proportioned surface design, ordered according to the laws of perspective and the golden section.[10]

Despite this order, however, and the bilateral symmetry suggested by it and the centrally placed lamppost, there are also indications in this early drawing of the asymmetrical relationship Caillebotte would develop between the left and right halves of his painting. Here, the left half is dominated by the backwardly rushing perspective lines of the buildings and pavement. These lines converge at multiple points, scattering the focus of vision across the distant cityscape in a way that complements the arrangement of vertical figures. It is on this left side, moreover, that Caillebotte initially concentrated these figures, whose heights relative to the lamppost suggest an orderly recession into the far distance. The right half of the drawing, relatively empty of such vertical indications, is dominated instead by the enlarged, cropped building at the right and by the horizontal edge of the sidewalk, which disrupts the perspectival plunge into space. The view on the right half is of the city up close and abruptly disconnected from its architectural backdrop. Furthermore, the curve of this sidewalk and the curvilinear mark above it (signifying the top of the umbrella of the painting's principal figure group) break with the strict perpendicular structure of the composition, and work together as a kind of surface focal point at odds with the multiple receding foci at left. Finally, a few perpendicularly placed marks indicate that Caillebotte had experimented in this drawing with rendering the paving stones that would ultimately fill most of the left half of the painting. Significantly, however, these initial marks are situated at the composition's dividing line, and are studied in apparent contrast with the depiction of the smooth asphalt of the sidewalk in the drawing's right half.

All of the other drawings directly related to *Paris Street* are studies of figures independent of the architectural context. Many of these were probably done before the painted sketch now in the Musée Marmottan (cat. 36). Two figure drawings, for example, and a related oil study feature full frontal

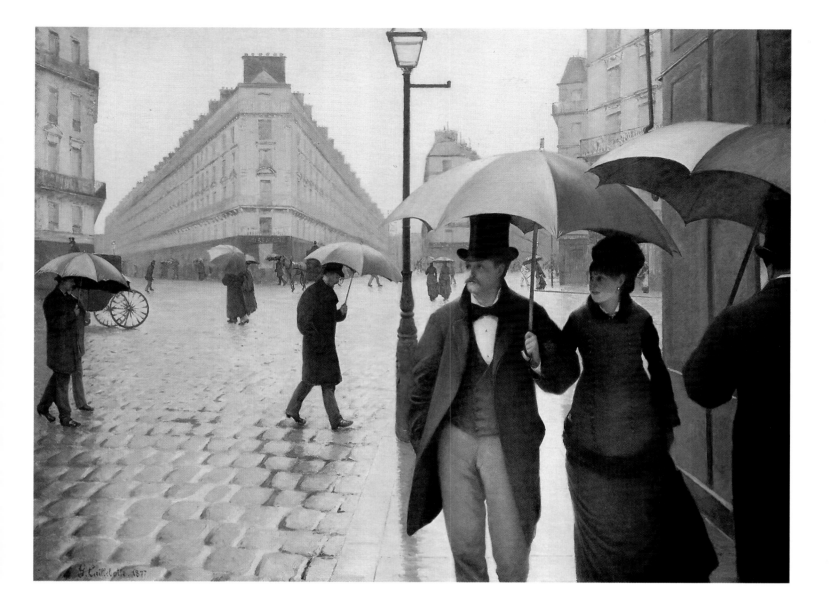

views of the bourgeois *flâneur* and his companion, the most important compositional addition from the initial site drawing to the painted sketch.[11] As a group, these three studies demonstrate the artist's technique. One of them, a graphite contour drawing on tracing paper (cat. 40), is gridded over like those smaller drawings that Caillebotte is thought to have traced from photographs or photographic plates.[12] A further development (cat. 41) shows how Caillebotte then shaded in these outlines with charcoal to describe tonal values—more complete in the male figure, whose facial features are also faintly suggested. It is this figure, in particular, that appears to have required careful forethought. Last in this preparatory series was probably a small painted study of the couple (cat. 42), which is not only Caillebotte's final small study of the figures, before working in larger dimensions, but also reveals the method he likely employed when painting both the oil sketch and the final canvas itself.[13] Here, Caillebotte drew the dark gray contours of the figures and umbrella with narrow brush strokes on the lighter gray ground of the canvas. He then set off these silhouettes from the ground by painting both the negative spaces between the contour lines and the surrounding canvas a lightened blue-gray. Finally, he broadly brushed in the darker blue-gray of the umbrella and the grays and whites of the male figure's costume, highlighting them further with white additions. He left out the facial features of both figures until the final painting. As a result of this method—a kind of cutting and pasting of figure silhouettes—the people of Caillebotte's *Paris Street* appear strongly contoured and disengaged, even alienated from the space in which they have been placed.

In addition, there are three drawings related to the man with an umbrella in right profile and positioned directly to the left of the lamppost in the final painting. One of these (cat. 44) is again an outline study in graphite on tracing paper. It is also gridded over, as if enlarged from a smaller gridded tracing, such as the one of the *Oarsmen* with which it shares the sheet and which is thought to have been copied directly from a photographic plate.[14] The tonal values of this outline figure were then developed in a Conté-crayon and graphite drawing (cat. 45) on gray-blue paper, the color of which would have simulated well the gray ground of both the oil sketch and the final painting. No facial features are developed in either of these figure studies, suggesting, along with the other existing drawings, that Caillebotte may have left for last the portraitlike elements of his modern-history painting. A third drawing, in graphite and charcoal on paper (cat. 46), featuring what appears to be the same man, is particularly interesting because it implies that Caillebotte considered having this central figure step up onto the sidewalk, an idea he then abandoned in both the oil sketch and final picture. Such a figure would have been a strong pictorial link between the two halves of Caillebotte's composition; the fact that he rejected such an idea seems only to confirm his intended, and increasingly emphatic, bisection of the final image.

A graphite and charcoal drawing of two men with umbrellas passing each other (cat. 47) might be an early, but again abandoned, conception for the two male figures at the left in both the oil sketch and final painting. On its own, this drawing appears to be a clever exploration of the dehumanizing effect of the large, modern, steel-framed umbrellas that seem to transform the silhouette of two men into a single, two-headed creature—their umbrellas substituting for their heads. In the final picture, these two men are clearly shown walking side by side.

Two other, partial oil studies probably preceded the Marmottan sketch. One of these (cat. 38) is a close-up study of paving stones,[15] in which Caillebotte explored both the visual and tactile correspondence between his thick, roughly applied strokes of paint and the texture of the irregularly hewn surfaces of the rocks. With parallel dabs of white against gray, he clearly worked out a visual alignment for the stones structured by a series of parallel lines still visible under the layer of paint. While the painting method indicated in this small oil study is similar to that of the figure drawings above (moving from outline to tonal shading to detail), here the application of paint is remarkably loose, more "Impressionist" in its sketchiness. Another partial oil study of the pavement (cat. 37), also sketchlike in style, expands the field of vision to the entire lower-left quadrant of the painting and includes two figures that appear unrelated to either the oil sketch or the final painting.

All of the aforementioned drawings, sketches, and studies probably formed the basis for the full oil sketch (cat. 36) in which many of the final figure arrangements were placed in the preconceived architectural scheme, even if their exact disposition still appears unresolved (especially the two figures in the left-middle background). The insertion of these figures makes the asymmetrical contrast between the two sides of Caillebotte's composition even more evident, the frontally depicted figures and their umbrellas in the right foreground overwhelming the smaller, profiled people at the left. Caillebotte further emphasized this contrast between near and far by lengthening the composition at the bottom and stretching it laterally at the left. This enlargement required that the bisecting presence of the lamppost be lengthened as well; Caillebotte achieved this by adding a vertical shadow extending almost to the bottom edge of the canvas.

Compared to the final picture, the oil sketch is brighter, its colors—the yellow in the sky and bright blue of the building at the right, for example—purer, more intense, and less shrouded in the overall gray-green of the final painting. By its very nature, the oil sketch is also more "Impressionist," the kind of work for which Caillebotte's colleagues were drawing critical disdain in the 1870s. It is interesting in this regard to note that Caillebotte gave this sketch to his friend Claude Monet, who later hung it in his bedroom in Giverny,[16] a privately decorative context also in direct contrast to the publicly oriented message of the final painting.

Before or while working on his final painting,

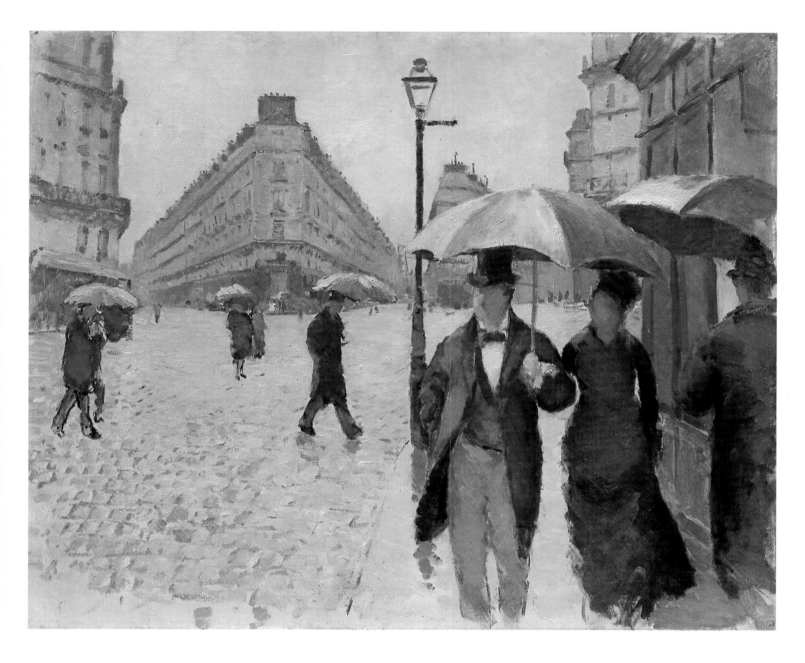

36
Sketch for Paris Street; Rainy Day

1877
Oil on canvas
54 × 65 cm
Berhaut 1978, no. 51; Berhaut
1994, no. 56

Musée Marmottan, Paris

Principal Exhibitions
Houston and Brooklyn 1976–77,
no. 26.

Selected Bibliography
Daulte and Richebé 1971, no. 80;
Daulte and Richebé 1981, no. 108;
Georgel 1986, pp. 74–75; Delafond
1987, no. 94; Varnedoe 1987, p. 95,
fig. 18v; Balanda 1988, pp. 78–79;
Chardeau 1989, p. 65; Wittmer
1990, p. 303.

Caillebotte appears to have made some additional figure drawings for women who, though notably absent from the oil sketch, would be subsequently added to the right background of the final painting. One sheet (cat. 48) studies two women who were placed, though differently proportioned, in an approximately similar spatial relationship in the final composition. Two drawings (cats. 49 and 50) of another woman seen from the back with an umbrella have been associated (because of similarities in costume and gesture) with the *flâneur*'s female companion, but these seem even more closely related to the woman holding an umbrella in the center background of the painting, directly to the left of the *flâneur*'s head. It is interesting that in the more fully worked of these two drawings, the woman holds a larger umbrella, as she would in the final painting and as seems appropriate in an image about the isolating capabilities of this rainy weather implement. Significantly, however, the sharp diagonal of her umbrella pole—a diagonal continued in the contour of her right hip and hiked-up skirt—is altered in the final image, where her umbrella is aligned with the vertical poles of the lamppost and the *flâneur*'s umbrella, between which she is positioned. The diagonal—suggesting in the drawings that the rain is blowing from the left—would certainly have disrupted the insistent perpendicularity and resultant immobility of the final picture. There, this disruption has been transferred to the cut-off male figure in the right foreground who, in direct contrast with the oil sketch, now holds the pole of his umbrella at a startlingly abrupt angle, and whose own "success" in passing the couple in front of him is thus in doubt.

This same woman, studied from the back, is also paired with a frontal study of a man in two other drawings on tracing paper (cats. 51 and 52). In what appears to be the first of these (possibly taken from a photograph), Caillebotte explored the overlap of the back and front views (the two figures apparently having just passed each other), moving the man forward a bit from his original blocked-in position. A second tracing sets down more firmly this expanded distance between the figures, in keeping with the general mood of the final work, but the unexpected lengthening of the composition required the artist to patch in an additional square of tissue at the bottom of the sheet. Both the woman and the man were then individually studied in separate drawings, the man twice in Conté crayon on gray-blue paper (cats. 53 and 54). Unlike the woman, however, this man does not appear in the oil sketch or final painting, perhaps because frontally disposed and facially individualized, he would have competed for attention with the principal couple.[17] Perhaps, too, his inclusion would have meant painting more hands, with which Caillebotte seems to have struggled,[18] as evidenced by repeated studies of the man's hands on one of the gray-blue-paper drawings (cat. 54), and by critics who would still complain in 1877 of "a certain hand that gives the impression of poor draftsmanship."[19]

Possibly it was at this point in developing his composition from sketch to final painting that Caillebotte returned to his original drawing and considered cropping the image. The finished canvas shows evidence of such cropping on all sides, but also, once again, a lateral stretching, perhaps most evident in the lengthened backward plunge of the architectural block in the left background and in the increased space between the head of the woman and the edge of the building at the right. As a result of this cropping and stretching, the composition was not only strengthened, but the gaslight and its shadow now loomed the full vertical distance of the finished canvas, emphatically bisecting and ordering the structure of the image. This vertical ordering is further emphasized by the straightened-out curve of the sidewalk edge, and is even echoed in the now vertically aligned buttons on the waistcoat of the *flâneur*. Despite this insistent order, however, Caillebotte, in moving from the oil sketch to the final canvas, added several elements that impart a latent instability to the image. One is the obtrusively diagonal umbrella post at the far right (accentuated by Caillebotte's moving the man's elbow even closer to the woman), which, along with the now sharpened points of all the umbrellas, suggests that this imminent pass in the right foreground will be an awkward one—that the man and the approaching woman will have to negotiate their respective positions on the sidewalk.

Several drawings grouped with but unrelated to the oil sketch and final painting of *Paris Street* are interesting for the information they provide about the artist's pictorial decisions. Two of these (cats. 56 and 57), though similar in some compositional respects to *Paris Street*, are clearly architectural studies of a very different sort of intersection. While their tunneling perspectives suggest Haussmann's style, the distinctively unaligned facades of what appear to be much older buildings (especially apparent in cat. 56) are in direct contrast to the ruled, architectural severity of *Paris Street*. Other unused figure drawings indicate a similar diversity ultimately inappropriate to Caillebotte's image of Haussmannian homogeneity, especially one (cat. 55) whose foremost figure is comparable to the worker on the sidewalk in Caillebotte's *House-Painters* (cat. 15), a picture about the social diversification and colorful transformation of the Haussmannian street. That Caillebotte was thinking about and working on these two street paintings together in 1877 is indicated by a drawing (see cat. 15, fig. 2) of this same house-painter on a sheet that also includes a study of one of the background women added in the end to *Paris Street*. J. S.

1 L. G. 1877.

2 Lepelletier 1877.

3 Anonymous 1877a.

4 G. Rivière 1877a.

5 Peter Galassi (1987, p. 28) suggested that this drawing, though not on tracing paper, could have been based on a photograph, as its ruled perimeter lines approximate the size of a common French photographic plate of the period. The use of photographs as an aid to painting was in itself

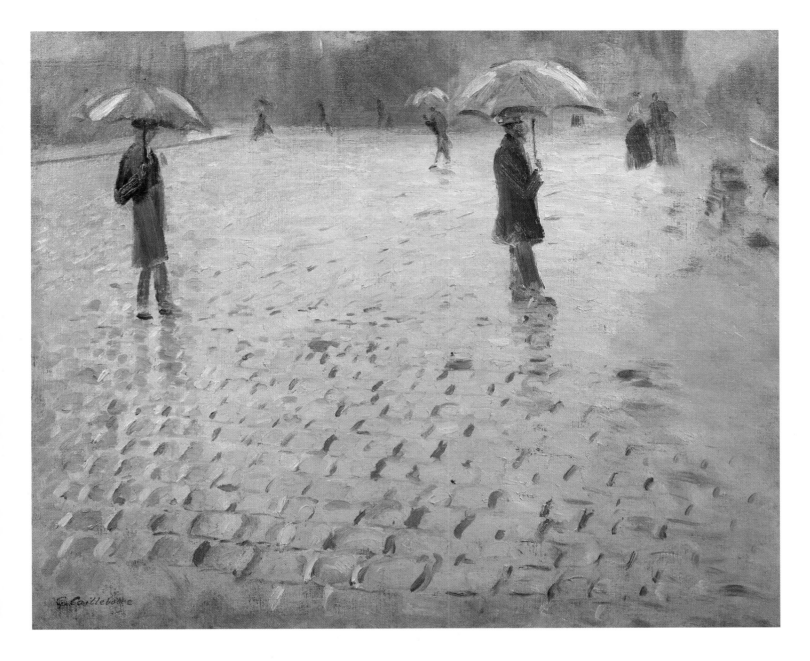

37

Study for Paris Street; Rainy Day
1877
Oil on canvas
54 × 65 cm
Signed lower left: *G. Caillebotte*
Berhaut 1978, no. 49; Berhaut 1994, no. 54

Private collection

Selected Bibliography
Varnedoe 1987, p. 95, fig. 18x.

nothing revolutionary in 1877, but in fact by then a standard tool in the studios of many academic and especially Realist artists.

6 The radial intersection of rues de Moscou, Clapeyron, de Turin, and de Saint-Pétersbourg in the quartier de l'Europe (see ch. 3 intro.).

7 Thereby combining in one drawing the similar construction obtained after three such drawings for *The Pont de l'Europe* (see Galassi 1987, p. 34).

8 Ibid.

9 See Varnedoe 1987, no. 18.

10 See Galassi 1987, pp. 34–39.

11 A graphite drawing of a woman seen from the rear with an umbrella, and inscribed with the name Clotilde (cat. 43), has also been identified as a separate study for the *flâneur*'s companion.

12 See note 14.

13 As Varnedoe pointed out, the sequence of these three studies is not self-evident, since details of the studies, oil sketch, and final painting (especially the shaded portions of the underside of the umbrella and the protruding flap of the gentleman's left pocket) often conflict with any proposed sequential arrangement. The sequence suggested here, however, is the most logical and is consistent with Caillebotte's other known drawings for *Paris Street; Rainy Day*. Any conflicts can be explained by the fact that Caillebotte probably went back to, and possibly even altered, earlier drawings as his work on the painting progressed.

14 This drawing for *Oarsmen* (cat. 24) was then enlarged in another squared drawing on tracing paper, in which tonal variations were indicated with shading (see Varnedoe 1987, p. 98, fig. 20d). The second drawing, in which Caillebotte examined both the man with the umbrella and the oarsmen, suggests that the artist was working on both *Paris Street* and *Oarsmen* in 1877. It is an image that also comments upon the city-country dialectic in Caillebotte's life and work, as if the melancholy, lifeless image of a rainy day in Paris provoked nostalgic thoughts of sunny days in the surrounding countryside. A letter from Caillebotte to Pissarro in the summer of 1879 refers specifically to this aspect of modern urban existence: "I am always very happy to see you but I cannot say for sure that I won't be in the country shortly. Several times now I've come down to leave and the moment I reach the bottom of the stairs the rain began again. This weather is really vile . . . " (Berhaut 1994, letter 22, p. 275).

15 The size of the stones in the study—much larger than those in the oil sketch but approximating those of the final painting—strongly suggests that this study could have also been painted after the sketch and before or even during work on the final canvas.

16 The sketch was found in Monet's bedroom upon his death in 1926 (see Berhaut 1994, no. 56, citing Geffroy 1924, p. 187).

17 He does resemble, however, a figure leaning over the rail in the middle ground of *The Pont de l'Europe* (cat. 29) and studied in a related drawing (see Chardeau 1989, p. 47).

18 See, for example, studies for *Floor-Scrapers* (see cat. 12) and *The Bezique Game* (see Chardeau 1989, p. 91).

19 Ballu 1877.

38
Study of Paving Stones (left)
1877
Oil on canvas
32.5 × 40 cm
Stamped lower right
Berhaut 1994, no. 559

Private collection

Principal Exhibitions
Houston and Brooklyn 1976–77, no. 28; Paris 1989, no. 48.

Selected Bibliography
Varnedoe 1987, p. 95, fig. 18w; Wittmer 1990, pp. 78 and 215.

39
Perspective Study of Streets
1877
Graphite and charcoal on buff paper
30 × 46 cm

Private collection

Principal Exhibitions
Houston and Brooklyn 1976–77, no. D-14.

Selected Bibliography
Varnedoe 1987, p. 90, fig. 18d; Chardeau 1989, p. 65.

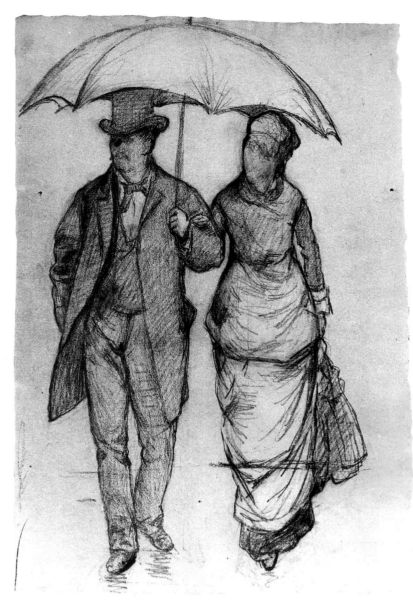

40
Study of a Couple Seen from the Front under an Umbrella, Squared for Transfer

1877
Graphite on tracing paper
30.8 × 23.5 cm
Stamped lower right
Private collection

Selected Bibliography
Varnedoe 1987, p. 92, fig. 18m; Chardeau 1989, p. 66.

41
Study of a Couple Seen from the Front under an Umbrella

1877
Graphite and charcoal on buff paper
47 × 30.9 cm
Berhaut 1978, no. 50A; Berhaut 1994, no. 55A

Private collection

Principal Exhibitions
Houston and Brooklyn 1976–77, no. D-15.

Selected Bibliography
Varnedoe 1987, p. 92, fig. 18k; Chardeau 1989, p. 66.

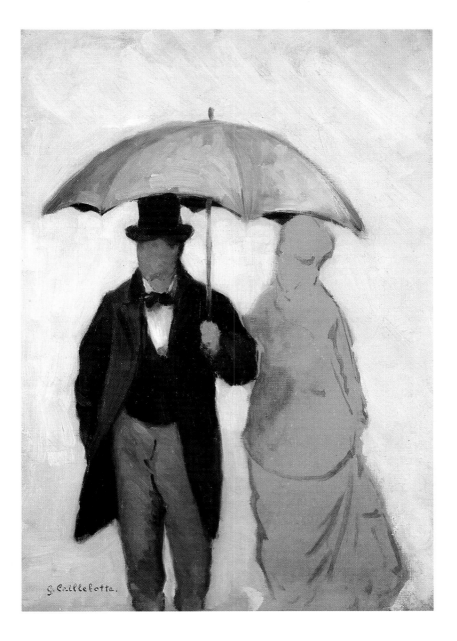

42

Study of a Couple under an Umbrella

1877
Oil on canvas
46 × 32 cm
Stamped lower left
Berhaut 1978, no. 50; Berhaut 1994, no. 55

Private collection

Principal Exhibitions
Houston and Brooklyn 1976–77, no. 27; Marcq-en-Baroeul 1982–83, no. 35.

Selected Bibliography
Varnedoe 1987, p. 92, fig. 18j; Chardeau 1989, p. 66.

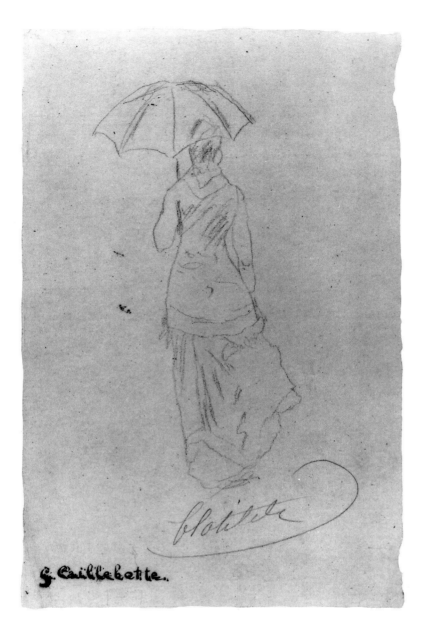

43

Study of a Woman with an Umbrella, Seen from the Rear

1877
Graphite on tracing paper
23.5 × 15.4 cm
Inscription lower center: *Clotilde*
Stamped lower left

Private collection

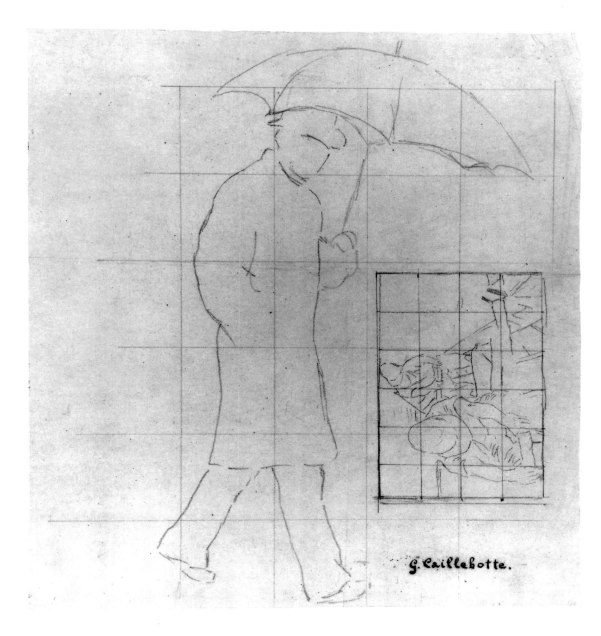

44

*Study of a Man under an Umbrella
Facing Right, with Compositional
Study for* Oarsmen, *both Squared
for Transfer*

1877
Graphite on tracing paper
30.7 × 27.5 cm
Stamped lower right
Private collection

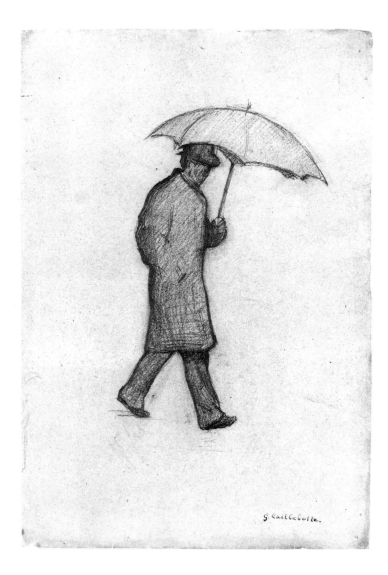

45
Study of a Man under an Umbrella Facing Right

1877
Conté crayon and graphite on gray-blue laid paper
48.5 × 31.5 cm
Stamped lower right

Private collection

Principal Exhibitions
Houston and Brooklyn 1976–77, no. D-17; Marcq-en-Baroeul 1982–83, no. 56;
Pontoise 1984, no. 24 (?).

Selected Bibliography
Varnedoe 1987, p. 94, fig. 18r; Chardeau 1989, p. 68.

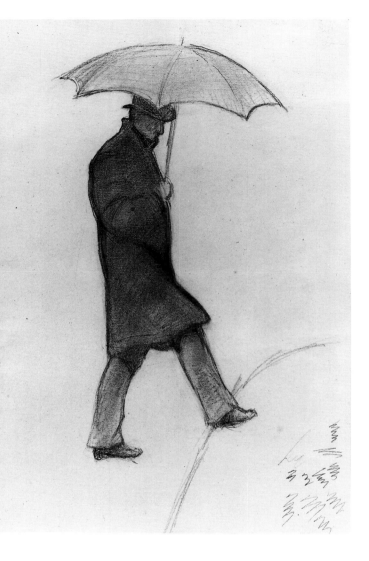

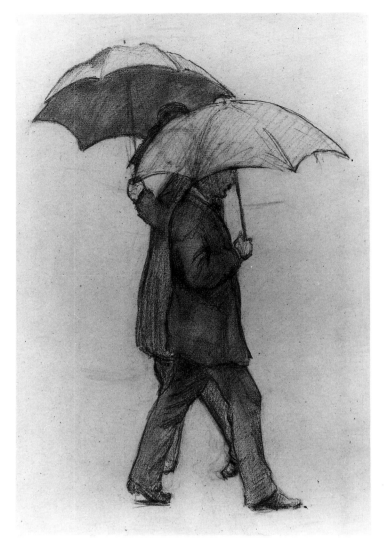

46

Study of a Man under an Umbrella Facing Right

1877
Graphite and charcoal on buff paper
45.1 × 39.2 cm

Private collection, courtesy of Brame and Lorenceau, Paris

Selected Bibliography
Varnedoe 1987, p. 94, fig. 18s; Chardeau 1989, p. 69.

47

Study of Two Men under Umbrellas Walking Past Each Other

1877
Graphite and charcoal on cream paper
46.1 × 30 cm

Private collection

Principal Exhibitions
Marcq-en-Baroeul 1982–83, no. 55.

Selected Bibliography
Varnedoe 1987, p. 94, fig. 18q; Chardeau 1989, p. 68.

48

Two Studies of a Woman under an Umbrella: One from the Back, the Other in Profile Facing Left

1877

Graphite on buff laid paper

Countermark: Michallet

47.9 × 30.9 cm

Inscription under the woman seen from the back: *Femme à gauche / du groupe de deux / personnes, qui / s'encradrent* [?] *à l'arrière / entre le personnage principal / du 1er plan et le lampadaire*

Inscription under the woman seen in profile: *femme qui va descendre / du trottoir au coin de / la maison de droite / à l'arrière-plan*

Stamped lower right

Berhaut 1978, no. 50B (partial reproduction); Berhaut 1994, no. 55B (partial reproduction)

Private collection

Principal Exhibitions
Pontoise 1984, no. 25.

Selected Bibliography
Varnedoe 1987, p. 95, fig. 18t; Chardeau 1989, p. 71.

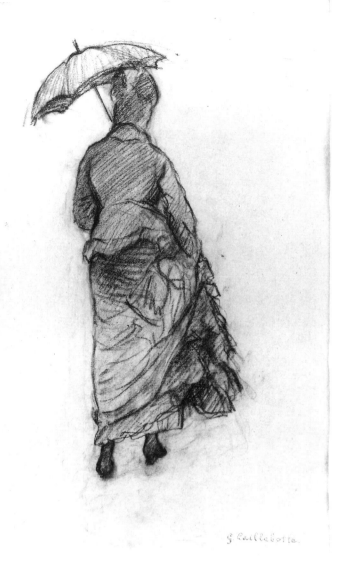

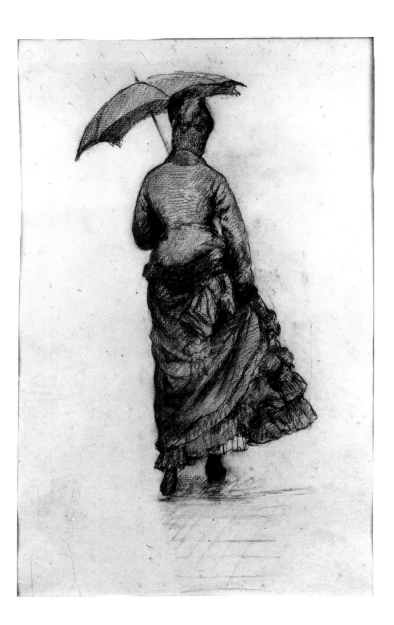

49

Study of a Woman with a Small Umbrella, Seen from the Back

1877
Graphite and charcoal on gray-blue paper
47 × 31.7 cm
Stamped lower right
Private collection

Principal Exhibitions
Marcq-en-Baroeul 1982–83, no. 57 (?).

Selected Bibliography
Varnedoe 1987, p. 95, fig. 18u; Chardeau 1989, p. 71.

50

Study of a Woman with a Large Umbrella, Seen from the Back

1877
Graphite on cream paper
47 × 31.7 cm
Private collection

Principal Exhibitions
Houston and Brooklyn 1976–77, no. D-16.

Selected Bibliography
Chardeau 1989, p. 71.

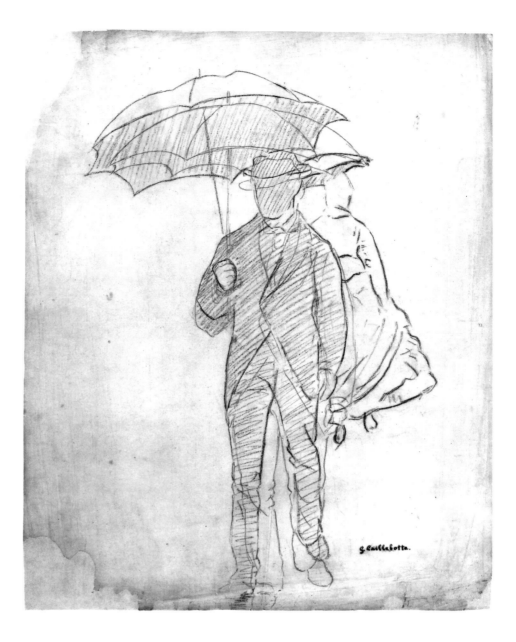

51

*Study of a Man under an Umbrella Seen
from the Front, with the Silhouette of a
Woman under an Umbrella in the
Right Background*

1877
Charcoal or Conté crayon and graphite on tracing paper
62.1 × 45.5 cm
Stamped lower right
Private collection

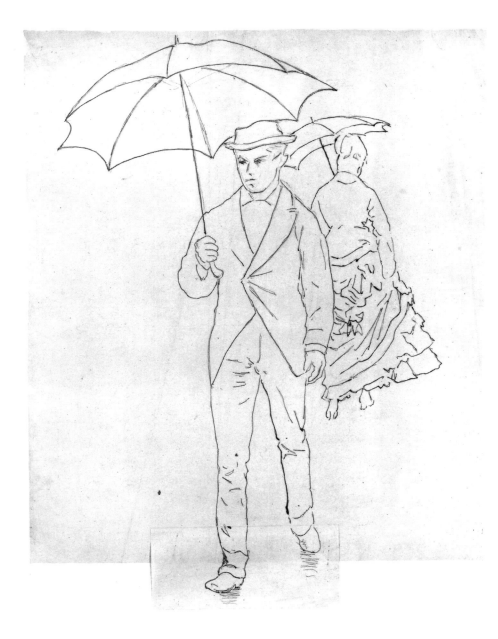

52

Study of a Man under an Umbrella Seen from the Front, with the Silhouette of a Woman under an Umbrella in the Right Background

1877
Graphite and pen and sepia ink on tracing paper, with paper addition at bottom
59.1 × 42.9 cm

Private collection

Selected Bibliography
Varnedoe 1987, p. 92, fig. 18l; Chardeau 1989, p. 71.

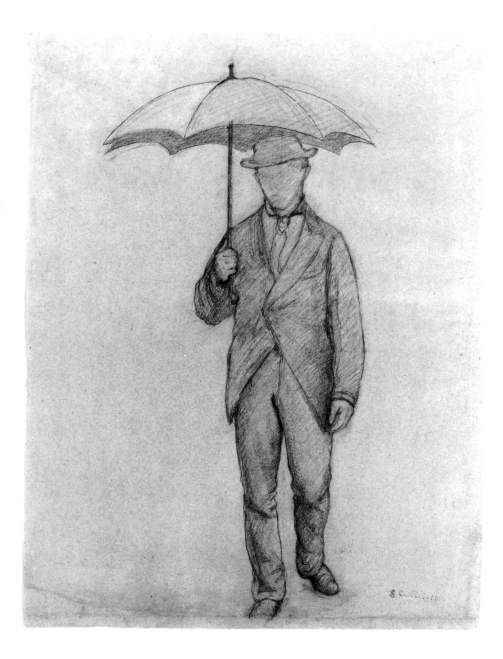

53

Study of a Man under an Umbrella Seen from the Front

1877

Conté crayon on gray-blue laid paper

60.4 × 44.5 cm

Stamped lower right

Private collection

Selected Bibliography
Varnedoe 1987, p. 94, fig. 18n; Chardeau 1989, p. 70.

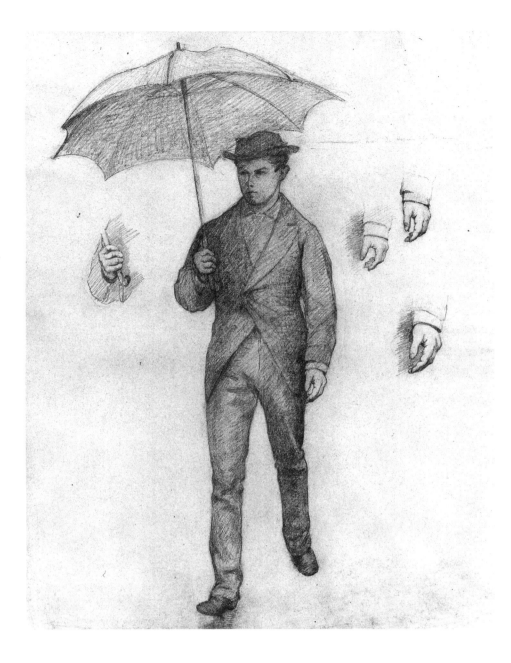

54

Study of a Man under an Umbrella Seen from the Front, with Studies of Hands

1877
Conté crayon on gray-blue paper
62 × 48.2 cm
Private collection, courtesy of Brame and Lorenceau, Paris

Principal Exhibitions
Houston and Brooklyn 1976–77, no. D-18.

Selected Bibliography
Varnedoe 1987, p. 94, fig. 18p; Chardeau 1989, p. 70.

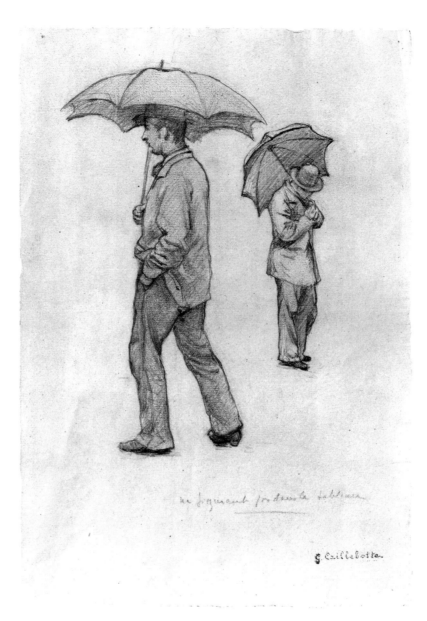

55

Study of a Man under an Umbrella in Profile and Facing Left, with the Silhouette of Another Man under an Umbrella in the Right Background

1877

Graphite and Conté crayon on buff laid paper

46.3 × 29.7 cm

Inscription lower right: *ne figurent pas dans le tableau*

Stamped lower right

Berhaut 1978, no. 50D (partial reproduction); Berhaut 1994, no. 55D (partial reproduction)

Private collection

Selected Bibliography
Varnedoe 1987, p. 94, no. 180; Chardeau 1989, p. 69.

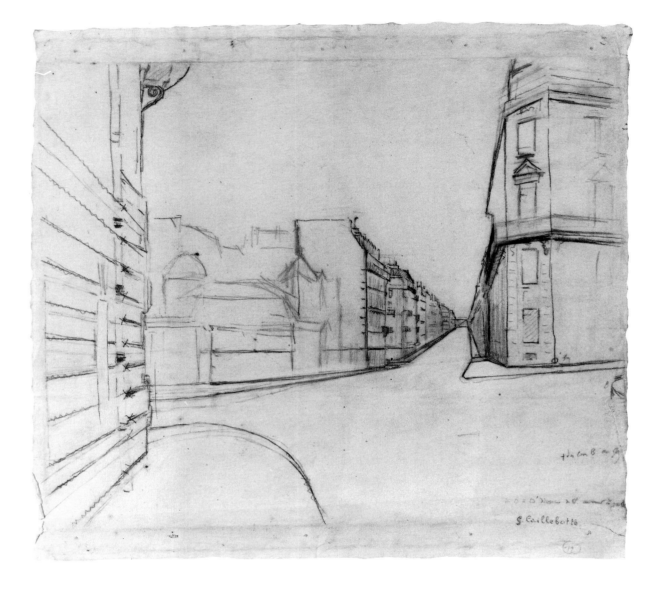

56
Perspective Study of Streets
c. 1877
Graphite and Conté crayon (?) on laid paper
43.5 × 47 cm
Inscription lower right: *+ du coin [?] B au gaz [?] de 0 à 0' distance de 0' au mur à gauche*
Annotation lower right: ⑫
Stamped lower right

Private collection

Selected Bibliography
Varnedoe 1987, p. 90, fig. 18e; Chardeau 1989, p. 64.

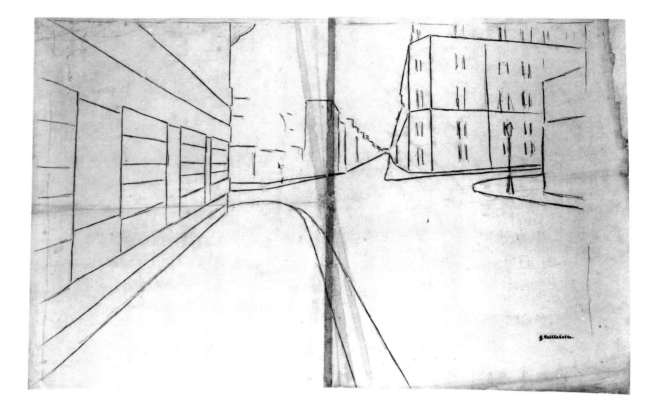

57

Perspective Study of Streets

c. 1877

Graphite and Conté crayon on tracing paper

62 × 92.5 cm

Stamped lower right

Private collection

Selected Bibliography
Varnedoe 1987, p. 90, fig. 18f; Chardeau 1989, p. 64.

58
Perspective Study of Paving
Stones

c. 1877
Graphite on tracing paper
54.2 × 42.6 cm
Stamped lower left
Private collection

Selected Bibliography
Chardeau 1989, p. 65.

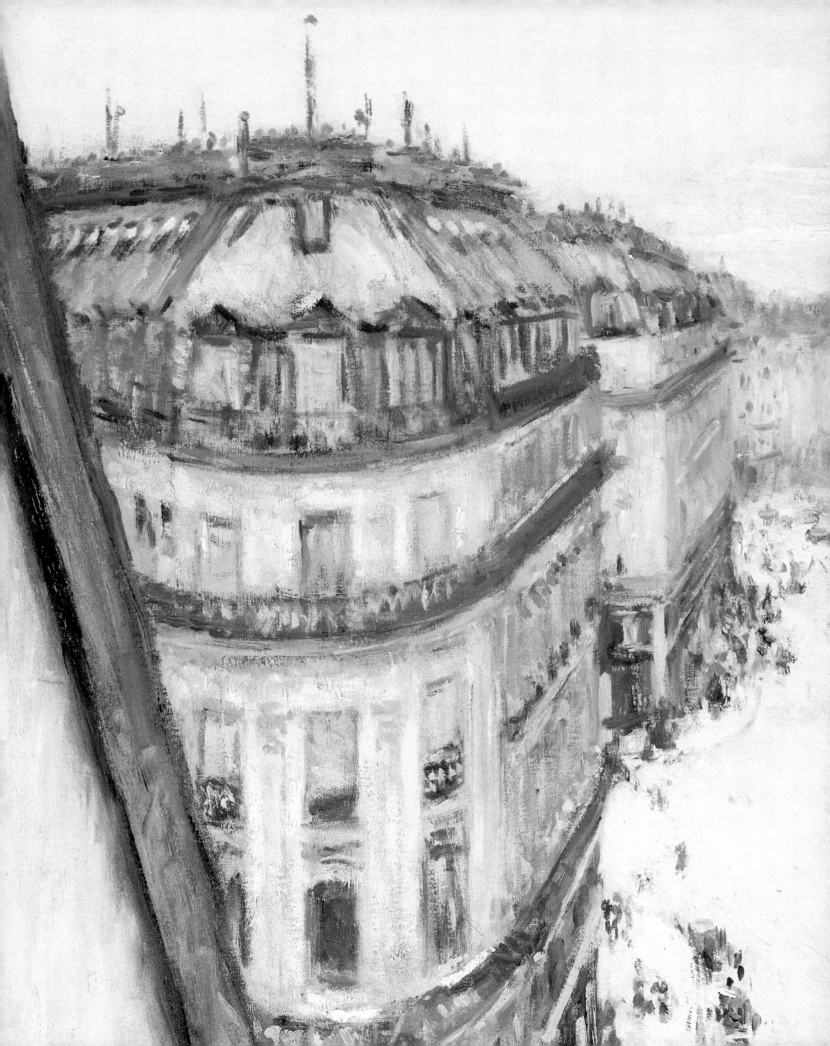

Caillebotte's participation in the second Impressionist exhibition proved decisive. Exhibiting for the first time with painters whose cause he had made his own over the preceding two years, the artist presented an ensemble reflective of his ambitions, one that strikes us today as having been composed entirely of major works. Among these, *Young Man at His Window* (cat. 59) combines a depiction of the city, not unlike similar views painted by other Impressionists, with the figure of a spectator, a dark silhouette perhaps inspired by interior scenes on which Caillebotte was also working at the time (see cat. 18). The focus on brilliant exterior light and its penetration into an apartment, the reflection in the window, the figure shown *contre-jour*, and the plunging view onto the street indicate an agenda stressing novelty as well as a search for realism.

Five years later the artist adopted the same basic compositional scheme in another painting of similar format, *Man on a Balcony* (cat. 67), treating it quite differently. Comparison of the two versions of this theme proves instructive. In the later painting Caillebotte clearly set out to avoid the overly anecdotal: the room is all but excluded by the framing, the view onto the street is obscured by foliage, and the pose of the elegant male figure, either ready to go out or on a brief visit, suggests that his gaze onto the boulevard can only be distracted. By contrast, *Young Man at His Window* implies a much more precise narrative and is pitched on a very different expressive register. Its intimacy differs in character from that of the later image, and its psychological ambiance is typical of the works in which the artist depicted members of his family in interiors. The man's posture (he is the painter's younger brother René), hands in his pockets, apparently staring at a female silhouette in the street, the armchair facing the window, the deserted city, the motionless carriage—all speak of idleness, of time wasted.

The works in which Caillebotte opened his apartment window onto the Parisian cityscape oscillate between these two tendencies: on the one hand, global acceptance of the Impressionist aesthetic in paintings dominated by sensation, a feeling for color, and a certain liveliness of handling (see cat. 61); on the other, introspection, resulting in images of the urban landscape infused with a seemingly meditative or even melancholy temperament (see cats. 66 and 68).

Windows and the Realist Project

Although abundantly represented in this catalogue,[1] paintings featuring views from a balcony or window, a group especially indicative of Caillebotte's preoccupation with compositional problems, make up only a small portion of his overall production. It has become commonplace to note that some of these paintings, those whose aesthetic quality is such that they still retain all of their suggestive force, are among the most powerful in the founding corpus of images of the modern city. But Caillebotte was far from being the only member of the Impressionist circle to depict Paris and its newly developed neighborhoods. The motifs and compositional strategies in some of his most striking images (see cat. 61) have predecessors in the work of Monet and Manet (see fig. 1). Caillebotte, however, manipulated these elements, as well as "Impressionist" handling, in the service of intentions quite different from those usually ascribed to members of the group.

The loose, scattered brush strokes in Monet's *Boulevard des Capucines* (fig. 2) reappear in Caillebotte's *Man on a Balcony* (fig. 3) and in the foliage of *A Balcony* (cat. 65)—paintings from a period in which Caillebotte adopted a mode of handling close to that most commonly associated with Impressionism. But in his work, the human figure assumes much greater importance, becoming a central focus of this painting reputedly without subject matter. On the other hand, architectural elements, their details carefully transcribed though without excessive precision, are given a prominence they do not have in more orthodox Impressionism. In *Man on a Balcony*, ornamental elements punctuate a balcony railing at regular intervals; they recur in *A Balcony*. Elsewhere the artist carefully delineated the stone balustrade outside a window (see cat. 59).

Figure 1. Edouard Manet (1832–1883). *Street Pavers, Rue Mosnier*, 1878. Oil on canvas; 59 × 79.4 cm. Private collection, on loan to the Fitzwilliam Museum, Cambridge.

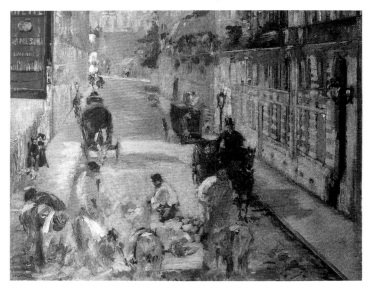

Caillebotte's exactitude was not just a response to the demands for truthfulness put forward by Edmond Duranty in "The New Painting"; such a balustrade is a plunging orthogonal (see cat. 65); a disruptive wall fragment marks the foreground (see cat. 62); and a cast-iron grille, made to seem more tangible than the almost unreal street pictured beyond it, magnifies the separation between domestic and public space, effecting in the process a radical fragmentation of the image unparalleled in its time (cat. 66).

A complete absence of the urban picturesque, so central in the work of artists such as Béraud and Jean François Raffaëlli, gives these images a peculiar evocative power, one rooted in their emphatic juxtapositions of interior and exterior—a recurrent theme in the history of Western painting, but one that here possesses a rare force. Caillebotte's windows open onto streets, rooftops, or courtyards. The landscapes they reveal, all crisply contained within architectural masses, can barely be termed exteriors at all. Only their skies allude to an unlimited space. These openings provide views of what is, in effect, another interior: that of the city.

It is significant that Paris's outlying areas, into whose largely unformed tracts the city was extending its streets and commercial workshops in the late nineteenth century, never tempted Caillebotte, despite his intent, evident from the very beginning of his career, to produce a body of work whose modernity would not only be stylistic and technical, but through which the iconography of the art of his time would be enriched by new categories. It would seem that the poetry of the pitiless suburbs celebrated by Raffaëlli and Huysmans (with some success) was too overtly narrative for his taste.

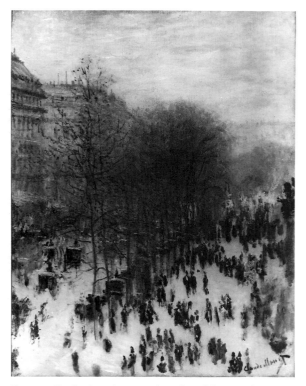

Figure 2. Claude Monet (1840–1926). *Boulevard des Capucines*, 1873. Oil on canvas; 80 × 64 cm. The Nelson-Atkins Museum of Fine Arts, Kansas City.

Figure 3. Gustave Caillebotte, *Man on a Balcony*, c. 1880. Oil on canvas; 116 × 90 cm. Private collection, Paris.

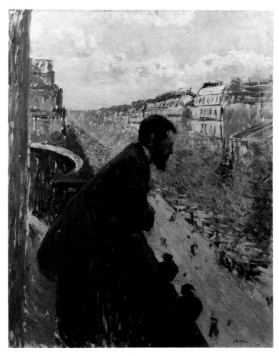

But the artist also avoided what Baudelaire called the "sinuous folds of cities old and grim."[2] Before Caillebotte, nineteenth-century depictions of the city were exercises in the picturesque or the Piranesian sublime, as in the work of Maxime Lalanne and Charles Meryon. Just as he avoided the suburbs, Caillebotte had no interest whatsoever in the *quartiers* of Paris constituting a kind of "interior province" (to cite Chantal Georgel[3]), which is to say in the reassuringly eccentric prospects so typical of the city's older sections. Instead, the painter's windows open onto taut perspectival views of the new districts—the very ones, in fact, whose construction had disemboweled the old city. His figures peer out at plunging rectilinear boulevards, sites of the intermingling of various social classes, to be sure, but also emblems of the triumph of that same bourgeoisie to which Caillebotte's family belonged. In this sense, certain paintings in which indications of comfortable apartment life are juxtaposed with views of the new neighborhoods might almost be considered celebrations of the bourgeois city, if it were not for the coolly distant air the artist cultivated in them.

According to the precepts of "The New Painting" as formulated by Duranty, there is nothing surprising in the fact that Caillebotte, a bourgeois urbanite, represented not only his city but his neighborhood and the view from his apartment. In fact, there is reason to believe that the critic, when writing his famous text, had some of Caillebotte's paintings from the 1876 exhibition in mind, notably *Young Man at His Window:* "From indoors we communicate with the outside world through windows. A window is yet another frame that is continually with us during the time we spend at home, and that time is considerable. Depending on whether we are near or far, seated or standing, the window frames the scene outside in the most unexpected and changeable ways, providing us with constantly changing impromptu views that are the great delights of life."[4]

The city, and more particularly the street, the apartment, and modern man, are the examples repeatedly cited by Duranty in his pamphlet, which doubtless encouraged Caillebotte to explore the possibilities inherent in this thematic vein. It might be argued that in the 1870s, when the question of the "real" in art remained a subject of heated debate, the cropping of the pictorial surface by window embrasures signified an emphatic endorsement of the Realist project, insofar as the principal definitions of "The New Painting" were predicated on the notion of art as a fragment of reality. "A corner of creation seen through a temperament," in Zola's celebrated formulation,[5] the work of art was construed as a piece of the "real" modified through its encounter with the artist's personality. By their very nature, windows isolate portions of the exterior world that, from a Realist perspective, are already what the French call *tableaux*, or satisfying pictorial compositions. But they are also the very image of the (ostensible) renunciation of choice, manipulation, and recomposition of nature then held to distinguish so-called "Realist" painting from the academic tradition. They effect an arbitrary cropping of the landscape, both in a literal sense, since they inscribe it within a rectangle, and, less literally, through their evocation of the artist's painting what he can easily discover right before his eyes, by simply looking outside of his studio or his apartment, the selection of "noble" components no longer figuring in the elaboration of his work.

The Sad City

Although Caillebotte produced many straightforwardly *plein-air* paintings in the course of his career, his views of Paris from above often evoke, beyond their manifest subject matter, a state of confinement in which monotonous indolence prevails (see cats. 59, 63, and 67). Interiors, another subject type initially favored by the artist, also have an inherent affinity with this theme of idleness. Although occasionally pictured in combination with city views (see cat. 59), they are sometimes implied only by a point of view so idiosyncratic that identification of the spectator with the artist standing in a specific locale—an apartment with a commanding view—becomes unavoidable, effectively taking precedence over the represented motif (see cat. 69). When the spectacle in the street has been chosen precisely because of its vacuity (see cat. 68), the resulting image becomes a metaphor for boredom.

It is worth dwelling for a moment on this penchant for views of the deserted city, another factor setting Caillebotte apart from the Impressionists, which finds its most powerful expression in works picturing the street as seen from an interior. Although this attitude is consistent with our experience of the modern city, alternately agitated and calm, peopled and empty, it stands in clear opposition to the nineteenth-century conception of the metropolis as the most perfect realization of contemporary progress, as the very image of a society constantly improving itself. The Impressionists, who favored streets full of passersby and animated crowds, seem to have embraced this idea—as did Caillebotte himself, judging from a portion of his production. On the other hand, evocations of emptiness and silence, resulting from decisions to represent deserted streets in blazing sunlight (cat. 59) or after a snowfall (cat. 60) were, in the context of late nineteenth-century artistic production, a distinctly minority view. Human activity gives life to urban space; representing it as empty and silent amounted to a gesture of defiance.

The result is a city drained of reality. Ambivalence is not the least of the admirable qualities in Caillebotte's art: while consistent with the requirements of a Realist program based on scrupulous observation, it also allows for considerable freedom in the use of models notable for their abstract character. In this connection, Kirk Varnedoe has pointed out the affinity between a painting such as *View through a Balcony Grille* and certain contemporaneous Japanese prints (see discussion in cat. 66). Exaggerated perspective, which plays an important role in many works in this section (see cat. 65) and is a constant in the artist's oeuvre, also tends to cultivate an unreal quality, for it has less in common with retinal experience than with the image of the "real" accessible to us in photographs.

Caillebotte completely recast the theme of the figure at a window, which in the nineteenth century was treated by a wide range of artists. We are very far here from Caspar David Friedrich (see fig. 4) as well as the spirit of German Romanticism more generally, in which such figures most often evoke waiting (as in Dutch painting of the seventeenth century) or an intimate fusion with nature. In this tradition, which enjoyed a resurgence in the late nineteenth century (see fig. 5), it is the interiors that take precedence, while the landscapes are only distantly evoked. Caillebotte, by contrast, avoided the very notion of the interior as a pictorial genre as well as the spatial constructs associated with it. The rather brutal confrontation between interior and exterior around which several of his works are organized (see cats. 59 and 67) results from his

Figure 5. Vilhelm Hammershøi (Danish; 1864–1916). *Interior*, 1890. Oil on canvas; 73 × 58 cm. Private collection, London.

Figure 4. Caspar David Friedrich (German; 1774–1840). *Woman at a Window*, 1822. Oil on canvas; 44 × 37 cm. Nationalgalerie, Staatliche Museen Preussischer Kulturbesitz, Berlin.

focus on the transition from private to public space, and the same could be said of his many views from a balcony.

The question of the artist's sources for the compositions grouped together in this section, all of them highly original, remains wide open. Monet, whose influence on certain of Caillebotte's works has already been noted, was not particularly interested in perspective problems. Although Peter Galassi has postulated a likely connection between some of his works—specifically, *The Pont de l'Europe* (cat. 29) and *Paris Street; Rainy Day* (cat. 35)—and photographic practice (also suggesting that they might have been influenced by results obtainable with optical instruments other than the camera),[6] photographs with plunging views like those in the two paintings, with rare exceptions (see fig. 6), postdate them. The photographs by Martial Caillebotte and Henri Rivière (see figs. 7 and 8) featuring similar compositions with figures on a balcony, for example, were taken in the 1890s. On the other hand, the way Caillebotte's work strikingly prefigures compositional strategies in photography of the 1920s has long been noted (see figs. 9 and 10).

Likewise, there is no evidence of any direct connection between Caillebotte and two artists who, earlier or at the same time as he, used compositional schemes revealing a similar understanding of space that was rare in those years: Adolf von Menzel, to whom Duranty devoted an important article in 1880,[7] and James Ensor (see figs. 11 and 12). It is not fortuitous that the analogies between Caillebotte and these artists—which, it bears repeating, have nothing to do with direct influence—encompass more than formal issues. All three clearly

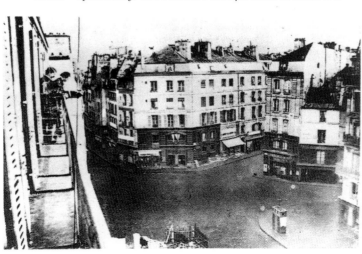

Figure 6. Anonymous. *The Old Place Sainte-Marguerite*, from the series *Paris Transformations*, c. 1866. Albumen print. Yvan Christ Collection, Paris.

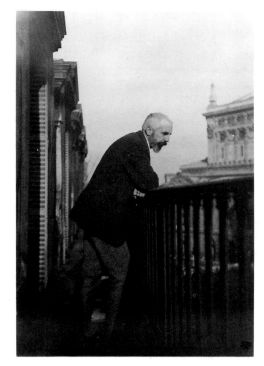

Figure 7. Martial Caillebotte. *Martial Caillebotte on the balcony; 9, rue Scribe*, after Dec. 1891. Gelatin silver print. Private collection, Paris.

Figure 8. Henri Rivière. *Mme Rivière Leaning on the Balcony of 29, Boulevard de Clichy*, 1895/96. Gelatin silver print. Musée d'Orsay, Paris.

Figure 9. André Kertész (American; 1894–1985). *Avenue de l'Opéra, Paris*, 1929. Gelatin silver print. Estate of André Kertész.

Figure 10. Alexandre Rodchenko (Russian; 1891–1956). *Assembling for a Demonstration*, 1929. Gelatin silver print. The Museum of Modern Art, New York (Mr. and Mrs. John Spencer Fund).

Figure 11. Adolf von Menzel (German; 1815–1905). *Window View of Scaffolding and a Street*, c. 1875. Pencil; 26 × 20.4 cm. National-galerie, Staatliche Museen Preussischer Kulturbesitz, Berlin.

Figure 12. James Ensor (Belgian; 1860–1949). *Rue de Flandre in Sunlight*, 1881. Oil on canvas; 107 × 84 cm. Private collection, Brussels.

held similar views about the city: where most of their contemporaries saw only movement and metropolitan magic, they perceived a peculiar poetry connected with urban solitude. This approach would reach full maturity only around the turn of the century in the Symbolist movement, most notably in the work of Léon Spilliaert and Eugène Jansson.

In any event, although Caillebotte's singular viewpoints restored to the painter some of the primacy often denied him by the Impressionists and intimately associated with the notion of composition, his exploration of vacuity is a Realist project. It is not a literal transcription of reality that is in question, but rather the selection of a particular aspect of it—one that, despite its apparent banality, reveals through the use of a specific mode of representation an uncommon intensity of expression.

In this instance, the way Caillebotte's plunging views distance the spectator from reality is reminiscent of certain aspects of the literature of his time. Gustave Flaubert, whom Caillebotte seems to have greatly admired, springs immediately to mind. How could one not think of him when standing before a painting such as *A Traffic Island, Boulevard Haussmann* (cat. 68), which evokes the same Paris—deserted, stifled by heat— evoked at the beginning of *Bouvard et Pécuchet* (1881)? "A confused clamor arose in the distance of the tepid atmosphere; and everything seemed consumed by the idleness of Sundays and the sadness of summer afternoons."[9] This idiosyncratic approach to Paris was one of the strongest and deepest connections between "The New Painting" and Naturalist literature.　R. R.

NOTES

1 Roughly two-thirds of the paintings in Marie Berhaut's catalogue raisonné that might fall under the rubric of this section have been included here.

2 Charles Baudelaire, "Les Petites Vieilles," from *Tableaux parisiens* in *Les Fleurs du mal*, repr. and trans. by Roy Campbell in *The Flowers of Evil* (Paris, 1989, 3rd. ed.), pp. 333 and 113, respectively.

3 Georgel 1986, p. 7.

4 Duranty 1876; repr. and trans. in San Francisco 1986, pp. 482 and 45, respectively.

5 Zola 1991, p. 44.

6 Galassi 1987, p. 27.

7 Edmond Duranty, "Adolphe [sic] Menzel," *Gazette des beaux-arts* 21 (1880), p. 201, and vol. 22 (1880), p. 105.

8 See the letter Caillebotte sent to Monet from Trouville dated 18 July 1884, published in Geffroy 1922, p. 180.

9 Gustave Flaubert, *Bouvard et Pécuchet*, ed. Charles Haroche (Paris, 1957), p. 1.

59

Young Man at His Window

(Jeune Homme à sa fenêtre)

1875
Oil on canvas
117 × 82 cm
Signed and dated lower left:
G. Caillebotte 1875
Berhaut 1978, no. 26; Berhaut 1994, no. 32

Private collection

Principal Exhibitions
Paris 1876, no. 20; New York 1886, no. 230; Paris 1894, no. 97; Paris 1951, no. 4; London 1966, no. 2; Paris 1974a, no. 6; Houston and Brooklyn 1976–77, no. 11; San Francisco 1986, no. 21.

Contemporary Criticism
Anonymous 1876; Blémont 1876; Boubée 1876; Burty 1876b; Chaumelin 1876; Enault 1876; Lostalot 1876a; Olby 1876; G. Rivière 1876, repr. in Dax 1876; Zola 1876a and b, repr. in Zola 1991.

Selected Bibliography
Sertat 1894, p. 382; Berhaut 1968, p. 32; Nochlin 1971, pp. 169, 171, and 265; Rewald 1973, p. 373; Picon and Bouillon 1974, no. 55; Varnedoe 1976, pp. 94–95; Berhaut 1978, pp. 7, 30, 34, and 47; Varnedoe 1987, no. 10; Herbert 1988, pp. 18–22, 33, and 48.

Caillebotte here broached for the first time the theme of looking out at Paris that was to play so important a role in his work. René, the painter's younger brother,[1] is represented with his back to the viewer. The window in question was on the second floor of a private residence then occupied by the family and situated at the corner of rue de Miromesnil and rue de Lisbonne; boulevard Malesherbes can be glimpsed in the background.

Although quite novel, Caillebotte's composition is not inconsistent with the general approach to interiors and the human figure characteristic of Impressionism. For the Impressionists, the window motif was above all a pretext for studying the penetration of light into an interior. This is the case, notably, in Monet's famous *Apartment Interior* (Appendix III, fig. 23), acquired by Caillebotte from the artist the following year.[2] The theme is also treated in two portraits of Mme Chocquet painted by Renoir in 1876, one of which figured in the Impressionist exhibition of that year.[3] In *Portrait of Mme Chocquet Standing* (fig. 1), we are presented with a figure wearing dark clothing and standing before an open window.

These compositional analogies are potentially misleading, however, for Caillebotte's work is more complex. While Monet brushed in an interior scene and Renoir used the window motif to give a new inflection to the full-length portrait, Caillebotte here staged a confrontation between interior and exterior, formulating a new theme in the process. The truth he sought to capture involves a great deal more than lighting effects.

The Impressionist intention to convey a sense of the open air is here wedded to a narrative approach more typical of Naturalism, which stressed the relationship between figures and their environment. *Young Man at His Window* introduces a psychological dimension linked to the description of the deserted city, answered by the boredom of the man who has just risen from his armchair to stare at a female silhouette crossing the boulevard. Caillebotte here explored a vein all his own whose only contemporary parallels are to be found in fiction. Excepting Degas, a special case in this regard (see cat. 63, fig. 2), Impressionism did not concern itself with the exploration of contemporary psychology.

Thus *Young Man at His Window* announced ambitions that were to inform Caillebotte's work until about 1880, ones consistent with Realist principles as formulated by art critics such as Duranty. The subject of "The New Painting" was to be the modern world, and not only its exterior aspect: modern iconography was to go hand in hand with a modernity of feeling, with evocations of the effect produced by this new environment on individual human lives.

The style of *Young Man at His Window* and the other paintings exhibited by Caillebotte in 1876, analytically precise without being finicky, was perfectly suited to such intentions. It provided the critics with criteria they could use to distinguish him from Impressionist orthodoxy, at least in those articles that examined his work closely and were favorably disposed toward it.

Many reviewers deemed the originality of the plunging view acceptable because of its clarity of draftsmanship. While Alfred de Lostalot evoked a tendency on Caillebotte's part to create scenes

continued on page 150

Figure 1. Pierre Auguste Renoir (1841–1919). *Portrait of Mme Chocquet Standing* or *Mme Chocquet at a Window*, 1876. Oil on canvas; 67 × 55 cm. Location unknown.

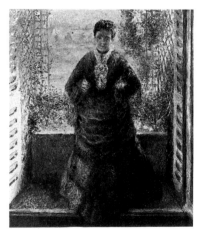

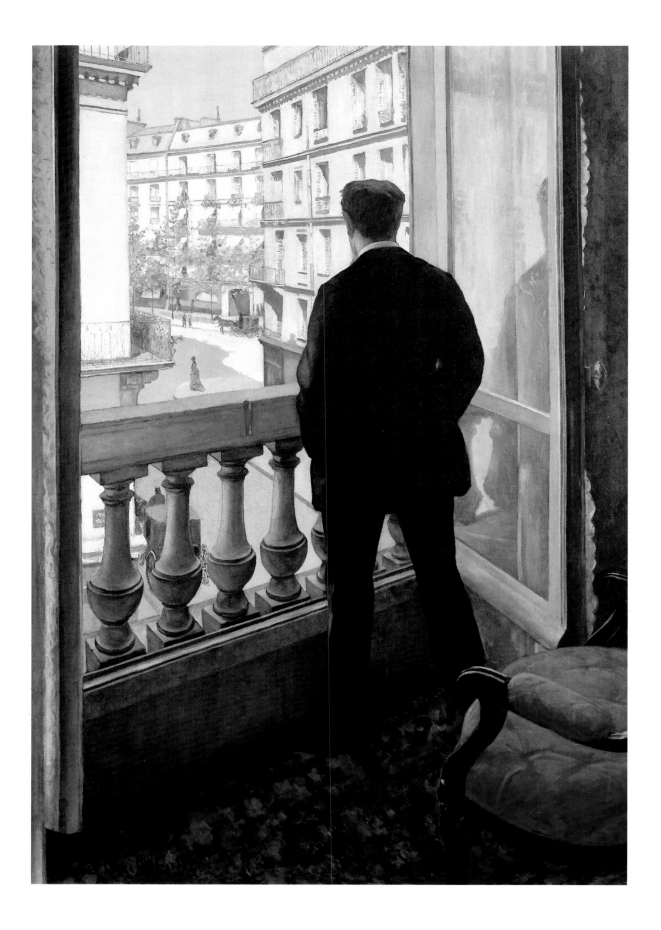

"using a bizarre perspective," he then added: "as a painter and draftsman, however, he returns shamelessly to the conservative ranks of the good school, that of knowledge, where he will certainly find the warmest welcome." Philippe Burty, who also noted the composition's originality, observed that Caillebotte's paintings were "so energetic as to drawing that they resemble the early Florentines." Marius Chaumelin compared Caillebotte to Manet, whom he found less precise, and perceived an affinity between *Young Man Playing the Piano* (cat. 71) and *Young Man at His Window*—as well as Degas's *Portraits in an Office (New Orleans)* (1873; Musée des Beaux-Arts, Pau)—and Dutch realism of the seventeenth century:

In his *Young Man at a Window* and his *Young Man Playing the Piano* he has painted what is most intangible, the air, the light, with an intensity and accuracy of effect that are extraordinary. These last two paintings reminded me of Van der Meer [*sic*], of Delft, and Pieter de Hooch, to whom Rembrandt had taught the art of capturing the sun.

If intransigence consisted of painting like this, I would advise our young school to become intransigent.

Chaumelin perceived a clear distinction between what he termed "the school of blots" and a "precise and frankly modern painting" oriented toward description. But it was Simon Boubée who most fully developed this notion that Caillebotte had escaped the imprecision characteristic of the Impressionists because he had a firmer grasp of his craft:

The tolerable Impressionists are not Impressionists: they are half-rebels, of the moderate left or even the liberal center.

Such are MM. Caillebotte, Lepic, and Manet himself, who has been outdistanced and now seems almost reactionary, as so often happens with revolutionaries.

M. Caillebotte knows how to draw and condescends to paint.

His *Young Man at a Window*, his *Piano Player*, and his *Floor-Scrapers* are very entertaining paintings, full of light, and boldly carried off. But all this simply follows from the fact that Caillebotte has at some point made the effort to study, and thus can put a degree of skill at the service of his imagination. He has gone into the rebel camp on a lark. Some day the true artists will slay a fatted calf in their camp to celebrate the return of this prodigal son.

The attribution of conservative political connota-

tions to the more rigorous aspects of Caillebotte's practice recurs in Zola's review, but in the service of an extremely stern assessment of his work:

M. Caillebotte has some *Floor-Scrapers* and *A Young Man at His Window*, astonishing in their relief. But this is very much anti-artistic painting, tidy painting, a mirror, bourgeoise in its precision. Tracings of the truth, without the painter's original expression, are poor things.[4]

Overall, the profound originality of this painting was obscured by the question of Caillebotte's problematic relationship to the Impressionist aesthetic. Certain quite novel aspects, such as the main figure's turning his back on the viewer, the almost total lack of modeling in his dark silhouette, and the idiosyncratic vision of the city, here making its first appearance in the artist's work, went unremarked in favor of a discussion of visual verisimilitude, in which it was maintained that Caillebotte's precision sufficed to clear him of the charge of subversion. R. R.

1 On the identification of the model, see Varnedoe 1987, p. 60 n. 1.

2 This painting had previously figured in the sale of works by Monet, Morisot, Renoir, and Sisley held at Hôtel Drouot in Paris on 24 Mar. 1875, on which occasion it was repurchased by Monet himself.

3 The work in question is *Mme Chocquet Reading* (1876; private collection, New York).

4 Zola 1876b, repr. in Zola 1991.

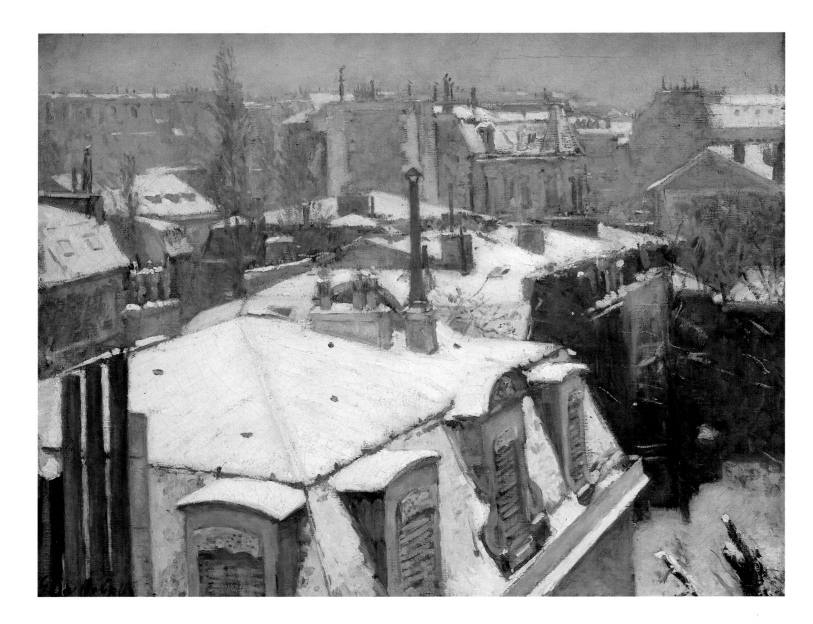

60

View of Rooftops (Snow), also known as *Rooftops in the Snow, Paris*

(Vue de toits [effet de neige], also known as *Toits sous la neige, Paris)*

1878
Oil on canvas
64 × 82 cm
Signed lower left: *G. Caillebotte*
Berhaut 1978, no. 107; Berhaut 1994, no. 96

Musée d'Orsay, Paris (RF 876)

Principal Exhibitions
Paris 1879, no. 12; Paris 1894, no. 17; Chartres 1965, no. 7; Houston and Brooklyn 1976–77, no. 42; San Francisco 1986, no. 68.

Contemporary Criticism
Anonymous 1879b; Draner 1879; Syène 1879.

Selected Bibliography
Anonymous 1894; Berhaut 1951, no. 60; Sterling and Adhémar 1958, no. 152; Adhémar and Dayez 1973, p. 139; Berhaut 1978, p. 47; Varnedoe 1987, no. 29; Balanda 1988, pp. 92–93; Wittmer 1990, pp. 300–301.

This painting is one of a set of rooftop views executed in 1878 (Berhaut 1994, nos. 93–98). Such an approach to the city has few French precedents save in photography, notably the work of Hippolyte Bayard (see fig. 1), who represented not only the monumental visage of modern Paris, but also the residual aspect of its architecture, the pervading disorder behind its decorous facade—its back courtyards, tiny streets, and neighborhoods under construction. A few works by Menzel (see fig. 2) manifest an analogous interest in banal sites where urban architecture is devoid of ostentation. Such incursions into the city's hidden spaces, a view of its normally inaccessible roofs, are not without a certain emotional charge (as can be sensed in Draner's caricature, fig. 3), for such places always imply the imminent possibility of the city's reversion from civilization to the disorder of nature.

The fourth Impressionist exhibition, in which this painting was shown, occasioned less criticism than the preceding ones. However, Caillebotte's exceptionally large contribution—at least twenty-five works, and probably more[1]—was the object of

Figure 1. E. Hippolyte Bayard (1801–1887). *View behind Rue de l'Eglise in the Quartier Batignolles*, c. 1840. Print from a paper negative. Société Française de Photographie, Paris.

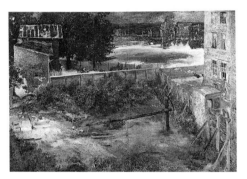

Figure 2. Adolf von Menzel (German; 1815–1905). *Rear View of a House and Courtyard*, c. 1846. Oil on canvas; 44.5 × 61.5 cm. Nationalgalerie, Staatliche Museen Preussischer Kulturbesitz, Berlin.

Figure 3. Draner (pseud. for Jules Renard, 1833–c. 1900). *View of Rooftops. Zinc-works full of feeling and poetry. Inspired by* L'Assommoir, detail from "Chez MM. les Peintures indépendants, par Draner," *Le Charivari*, 23 Apr. 1879.

often acerbic commentary. Duranty himself expressed grave doubts, suggesting that Caillebotte cultivated "a sullen, dreary tendency to rob nature, which easily fends him off."[2] But the two rooftop views exhibited by the painter solicited little comment.

In the review most favorably disposed toward Caillebotte that year, Arsène Houssaye, the author of an important book on Dutch and Flemish painting,[3] wrote as follows: "[In] two *Views of Rooftops* by the same artist, simply and powerfully painted, wavelike slates, tiles, gables, gutters, mansards, weathervanes, and chimneys extend into the distance."[4] The reference to water and the evocation of a vast expanse suggest a parallel between Caillebotte's urban views and the landscape tradition. This formulation, so reminiscent of Théophile Gautier, evidences the originality of these rooftop views, which stand apart from the Impressionist vision of the city, here made to seem static and silent.

This painting entered the collection of the Musée du Luxembourg in 1894 as a gift from Martial Caillebotte. R. R.

1 Taking into account those exhibited *hors catalogue*, it would seem that Caillebotte showed between thirty-five and forty works (see Pickvance 1986, p. 254).

2 Duranty 1879. See also Bertall 1879a, Leroy 1879, and Wolff 1879.

3 Arsène Houssaye, *Histoire de la peinture flamande et hollandaise* (Paris, 1844–47).

4 Syène 1879.

61
Rue Halévy, Balcony View

(La Rue Halévy, vue d'un balcon)

1878

Oil on canvas

60 × 73 cm

Stamped lower right

Berhaut 1978, no. 114; Berhaut 1994, no. 99

Private collection

Principal Exhibitions
Paris 1894, no. 31; Paris 1951, no. 33; Chartres 1965, no. 11; London 1966, no. 21; New York 1968, no. 31; Pontoise 1984, no. 7.

Selected Bibliography
Berhaut 1978, p. 44; Georgel 1986, pp. 74–75.

To obtain this plunging view of rue Halévy, Caillebotte mounted to the top floor of the building at 1, rue La Fayette, on the corner of rue de la Chaussée-d'Antin. The Opéra is visible in the background.

Marie Berhaut considered this painting to be a sketch for *Rue Halévy, Sixth Floor View* (cat. 62). The two works are identical in format, but they feature points of view that diverge slightly from one another. Thus this painting is better understood as a variant of the motif, even though its handling is much freer than that in the other version. R. R.

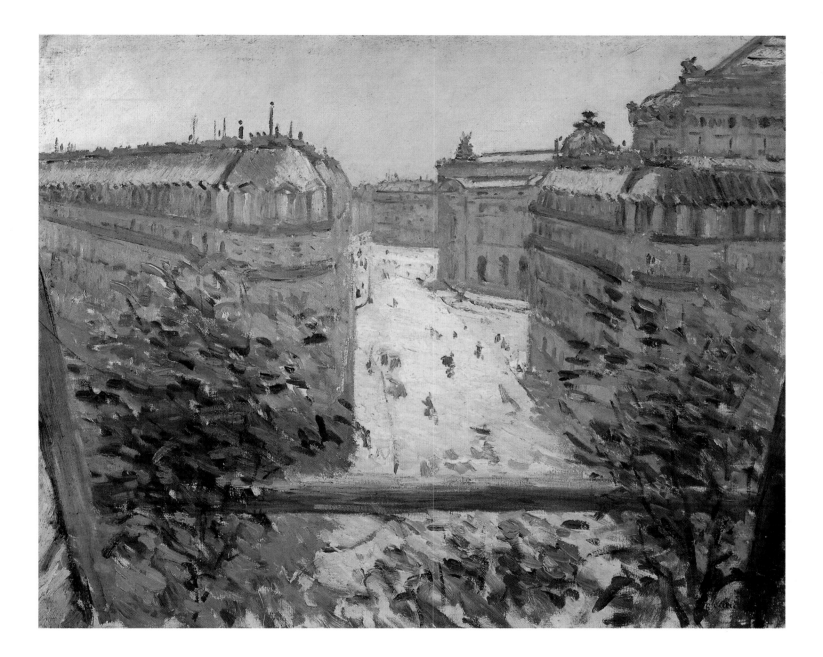

62

Rue Halévy, Sixth-Floor View, also known as *Rue Halévy, View from the Sixth Floor*

(*Rue Halévy, vue d'un sixième étage,* also known as *La Rue Halévy, vue du sixième étage*)

1878

Oil on canvas

60 × 73 cm

Signed and dated lower left: *G. Caillebotte / 1878*

Berhaut 1978, no. 116; Berhaut 1994, no. 100

Private collection, Dallas

Principal Exhibitions
Paris 1879, no. 14; Paris 1894, no. 23; Amsterdam 1966, no. 3; New York 1968, no. 20; Houston and Brooklyn 1976–77, no. 41; Marcq-en-Baroeul 1982–83, no. 12.

Contemporary Criticism
Anonymous 1879b.

Selected Bibliography
Berhaut 1968, p. 21; Pincus-Witten 1968, p. 55; Clay 1971, p. 77; Berhaut 1977, p. 49; Berhaut 1978, p. 44; Georgel 1986, pp. 74–75; Varnedoe 1987, no. 28.

In comparison with *Rue Halévy, Balcony View* (cat. 61), here the artist has shifted his point of view several feet to the right; he is in fact looking out of another window. As a result, the plunging perspective effect has been accentuated, for the viewpoint is now almost precisely above the central axis of rue Halévy.

This painting was shown in the fourth Impressionist exhibition, in 1879. While the view in the preceding work was screened by the railing and the plants on the balcony, Caillebotte here used a compositional scheme in which the foreground is completely open, aside from the window embrasure to the left, which introduces a rather brutal diagonal that further heightens the spatial plunge. In this version the two front buildings seem closer to the spectator, a difference that might be explained by the use of a camera with two different depth settings. Although the general conception of this work recalls certain paintings by Monet of similar date that also figured in the fourth Impressionist exhibition (see fig. 1), Caillebotte's approach to space differed radically from that of his colleagues. He was interested above all in the precipitous recession of the street, which he treated in a horizontal format, depicting the

recently erected buildings of the *quartier* with his characteristic precision.

This is one of the paintings in which Caillebotte comes closest to mainstream Impressionism in his use of readily discernible brush strokes. The blue-violet palette of this canvas doubtless prompted much of the negative criticism leveled at the artist's works generally in the 1879 exhibition. Edmond Duranty wrote as follows: "As for Monsieur Caillebotte, he could well be a victim of violet and blue rays."[1] R. R.

1 Duranty 1879.

Figure 1. Claude Monet (1840–1926). *Rue Montorgeuil, in Paris. Celebration on 30 June 1878,* 1878. Oil on canvas; 81 × 50.5 cm. Musée d'Orsay, Paris.

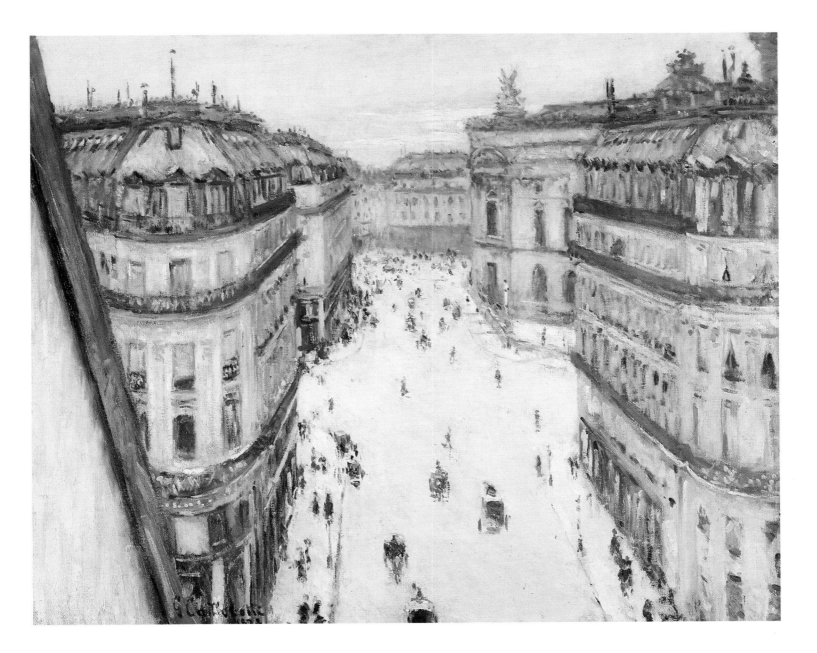

63
Interior, also known as *Interior, Woman at a Window*

(Intérieur, also known as Intérieur, femme à la fenêtre)

1880

Oil on canvas

116 × 89 cm

Signed and dated lower right: *G. Caillebotte / 1880*

Stamped lower left

Berhaut 1978, no. 130; Berhaut 1994, no. 140

Private collection

Principal Exhibitions

Paris 1880, no. 9[1]; New York 1886, no. 230; Paris 1894, no. 1; Paris 1921, no. 2720; Paris 1951, no. 32; Chartres 1965, no. 15; London 1966, no. 20; New York 1968, no. 30; Houston and Brooklyn 1976–77, no. 47; Marcq-en-Baroeul 1982–83, no. 14; Pontoise 1984, no. 8; San Francisco 1986, no. 88.

Contemporary Criticism

Dalligny 1880; Ephrussi 1880; Mantz 1880; Huysmans 1883.

Selected Bibliography

Huysmans 1889, p. 121; Varnedoe 1976, p. 98; Berhaut 1978, pp. 30, 32, and 47; Rosenblum 1987, p. 50; Varnedoe 1987, no. 35; Balanda 1988, pp. 96–97; Herbert 1988, p. 48.

When this painting was shown at the fifth Impressionist exhibition, in 1880, it prompted much commentary, mostly favorable, and notably that of Huysmans, who maintained that Caillebotte's two interiors were the most fully achieved expression of modern feeling in painting.[2] As an image of conjugal boredom, this work contributes to a theme prominent in Naturalist literature, notably in Flaubert.

The theme of the couple ensconced in, yet confined by, bourgeois comfort figured prominently in the rejuvenation of interior imagery in the last two decades of the nineteenth century. In this connection, Caillebotte's oeuvre is situated at the beginning of a development that would lead to Edouard Vuillard and the ambiguous *Intimités* series of Félix Vallotton. Paul Signac, who met Caillebotte in the early 1880s,[3] produced a variation on this painting in his *Paris Sunday* (fig. 1).

Here, as in a comparable work by Degas (see fig. 2), the composition is dominated by the protagonists, who are very close to the viewer. As for the interior, Caillebotte showed himself capable of extreme concision: elements indicating the figures' social milieu—paneling, curtains, clothing—have been kept to a minimum (as they are not, for example, in Signac's more loquacious work). Once again, psychology is the artist's principal concern. In a number of his most ambitious works, from *Young Man at His Window* (cat. 59) to *The Bezique Game* (cat. 80), Caillebotte aimed at devising a kind of descriptive coherence suitable for evoking modern forms of boredom. Huysmans, who could hold forth at length on a glass of beer on a table (as he did in his critique of *In a Café* [cat. 79]), overlooked a choice opportunity offered him here: Caillebotte placed another figure, analogous to the woman seen from the back, at the corresponding window across the street—presumably another person suffering from boredom, unless complicity of a more overt kind is in question, one to which the husband reading his newspaper remains oblivious. The vagueness with which this supplementary figure is rendered—neither its sex nor its social status are discernible—reflects the artist's intention to concentrate on essentials, avoiding excessive details that might tip the balance toward the anecdotal.

In this painting Caillebotte combined several themes that by 1880 were part of his established repertory: an interior with figures, the penetration of light into a room, a dark silhouette seen from the back, and a modern vision of the city. Apart from the figure of the seated man, which is very awkwardly rendered, the handling is quite free and assured. Huysmans characterized the work as "simple, sober . . . almost classical" in its overall effect, and he saw its intentions as unmistakably Realist:

> The woman who in her idleness gazes into the street palpitates, fidgets; we see her loins stirring beneath the marvelous dark blue velvet covering them; she is going to be tapped by a finger, she is going to yawn, turn around, exchange trivial remarks with her husband, who is only fitfully amused by the news item he's reading. That supreme quality of art, life, emanates from this canvas with a truly unbelievable intensity. . . . It is here that the light of Paris should be seen, in an apartment facing the street, the light deadened by window hangings, filtered by the muslin of inner curtains.[4]

continued on page 160

Figure 1. Paul Signac (1863–1935). *A Paris Sunday*, 1890. Oil on canvas; 150 × 150 cm. Private collection, Paris.

Figure 2. Edgar Degas (1834–1917). *Sulking*, c. 1869–71. Oil on canvas; 32 × 46 cm. The Metropolitan Museum of Art, New York (Bequest of Mrs. H.O. Havemeyer).

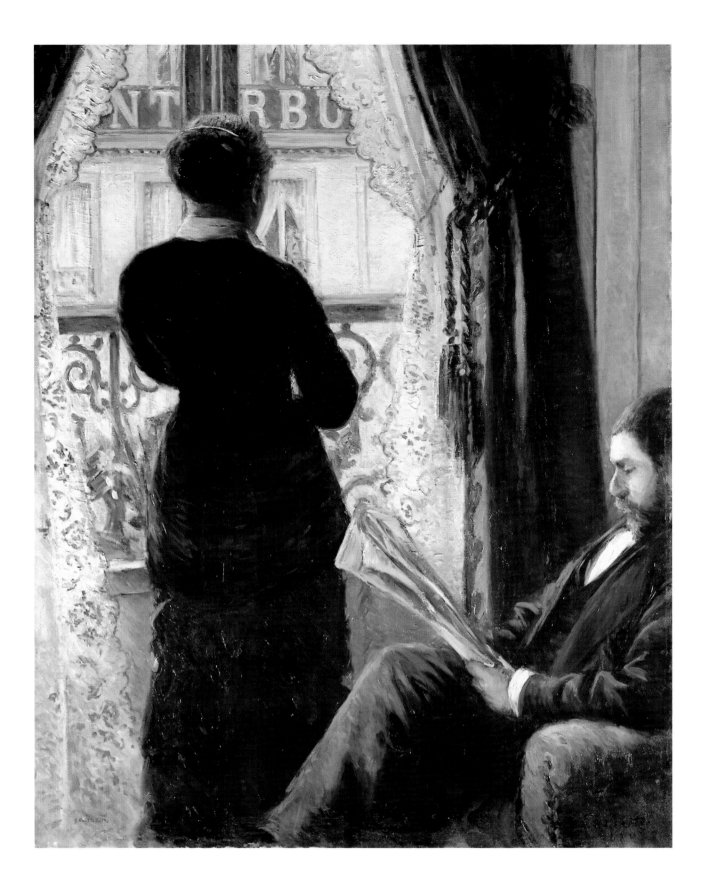

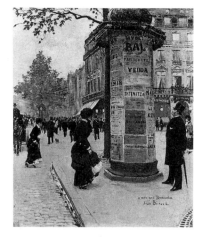

Figure 3. Jean Béraud (1849–1935). *Morris Column*, c. 1879–80. Oil on canvas; 35.5 × 26.5 cm. The Walters Art Gallery, Baltimore.

Huysmans had opened his article by praising the light of the Impressionists as the only light in contemporary painting truly based on close observation. Clearly this psychological study bathed in a very modern light could have only pleased him.

The prominence given the gold lettering of the sign across the street was not the least of this painting's innovations. The singular effect it produced was noted by both Huysmans and Paul Mantz, who saw it as damaging to the work's unity:

M. Caillebotte . . . loves to stir up the spectacle [before him]; he moves things forward that nature has placed in the background; he plunges into the depths of a distant horizon the objects closest to our eyes. This aversion for hierarchy produces singular results. In an interior where two figures are rather accurately depicted in muted half-tones, we see, through the glass of a window whose curtains are raised, the glowing sign of a store placed on the other side of the boulevard. Five gold capital letters, impertinent despite their distance, occupy the canvas's center and monopolize the attention of the viewer, who does not hesitate to acknowledge that, among all the possible means of spoiling his picture, M. Caillebotte has chosen the one most likely to succeed.

This vision of a work compromised by the intrusion of elements deemed foreign to the realm of painting is among the last significant manifestations

Figure 4. Giuseppe De Nittis (1846–1886). *La Parfumerie Violet*, c. 1880. Oil on canvas; 41 × 32.5 cm. Musée Carnavalet, Paris.

of critical perception concerning Realism. It was not the subject matter drawn from contemporary life that was judged shocking in its triviality, but the conspicuous inclusion of formal elements drawn from the modern world. Caillebotte's use of lettering here reflects his interest in certain ornamental and utilitarian configurations, such as the cast-iron arabesques in *View through a Balcony Grille* (cat. 66) and the metallic structure in *The Pont de l'Europe* (cat. 29), which in the artist's hands tend toward decorative abstraction. Although signs, posters, and inscriptions in capital letters figure prominently in the contemporary work of Béraud (see fig. 3), De Nittis (see fig. 4), and Raffaëlli, in Caillebotte's work these elements are stripped of their anecdotal and documentary character. In *Interior*, the emblem of the modern world that is lettering escapes the spatial order of the composition through its assertive color and planarity—which is why contemporary viewers such as Paul Mantz were troubled by its presence. R. R.

1 Berhaut 1994 incorrectly identifies this work as number 10. See Silvestre 1880, p. 250, which clearly indicates that number 10 in the Impressionist exhibition was cat. 77 in the present catalogue.

2 Huysmans 1883.

3 See Françoise Cachin, *Signac* (Paris, 1970), p. 10.

4 Huysmans 1883.

64
Boulevard des Italiens

(Le Boulevard des Italiens)

c. 1880

Oil on canvas

54 × 65 cm

Berhaut 1978, no. 135; Berhaut 1994, no. 144

Private collection

Principal Exhibitions
Houston and Brooklyn 1976–77, no. 57; Marcq-en-Baroeul 1982–83, no. 15.

Selected Bibliography
Berhaut 1978, p. 47; Varnedoe 1987, no. 46.

This work recalls Monet's two versions of the *Boulevard des Capucines* of 1873. The one now in the Pushkin Museum (fig. 1), whose wide format is similar to the one used here by Caillebotte, was included in the first Impressionist exhibition as well as in the show of Monet's work held at Durand-Ruel in 1883.

Caillebotte painted several such plunging balcony views around 1880. Here, the handling of the autumn or winter light and the treatment of the sky, the overlapping brush strokes delineating the distant trees, and the summarily evoked passersby all make this painting one of those in which Caillebotte came closest to Impressionism.

According to Marie Berhaut, this view was taken from a balcony at 2, rue Laffitte, the building in which lived Jules Froyez, a friend of the artist's.[1] The large structure to the left is the Crédit Lyonnais bank, which was erected in 1878. R. R.

1 Two portraits of Jules Froyez by Caillebotte are known (Berhaut 1994, nos. 130 and 181).

Figure 1. Claude Monet (1840–1926). *Boulevard des Capucines*, 1873. Oil on canvas; 61 × 80 cm. Pushkin State Museum of Fine Arts, Moscow.

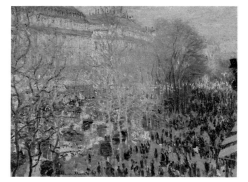

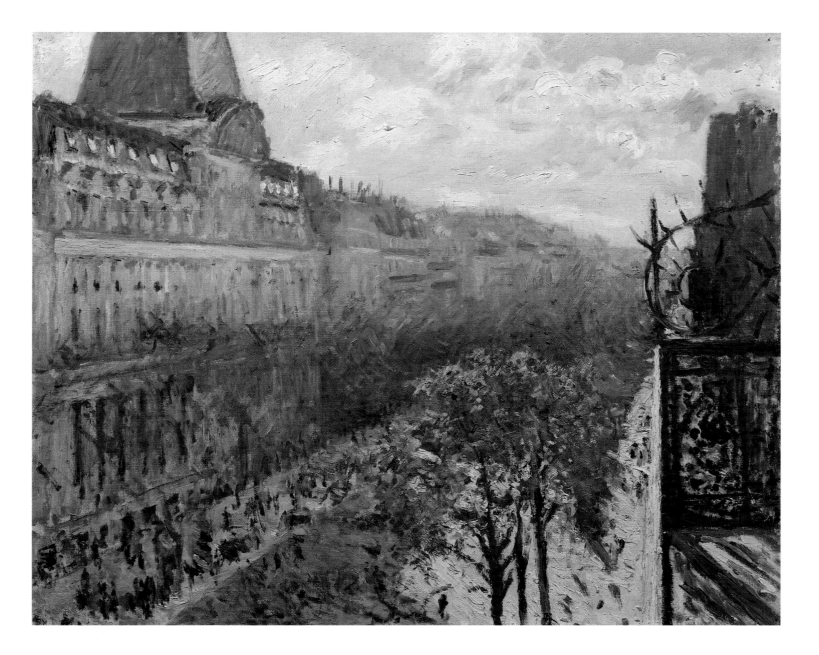

65

A Balcony,
also known as
A Balcony,
Boulevard
Haussmann

(*Un Balcon,* also known
as *Un Balcon, boulevard
Haussmann*)

1880
Oil on canvas
69 × 62 cm
Stamped lower right
Berhaut 1978, no. 136; Berhaut
1994, no. 146

Private collection

Principal Exhibitions
Paris 1882, no. 11; Paris 1894,
no. 83; Paris 1951, no. 38; London
1966, no. 23; New York 1968,
no. 33; Bordeaux 1974, no. 89;
Houston and Brooklyn 1976–77,
no. 52; San Francisco 1986, no.
116.

Selected Bibliography
Roberts 1966, p. 386; Varnedoe
1976, p. 98; Berhaut 1978, pp. 30,
33, 47, and 73; Georgel 1986,
p. 75; Varnedoe 1987, no. 41.

As with the preceding painting, this composition recalls the *Boulevard des Capucines* by Monet (cat. 64, fig. 1), which features a man in a top hat leaning over a balcony. The use of small thick dabs for the foliage, their contrasting tones evoking the play of light and shadow, is a typical example of Impressionist virtuosity. But Caillebotte also manipulated his medium in relatively traditional ways to create an impression of depth: while the leaves of the tree in the foreground are executed in crisply articulated brush strokes, in subsequent levels of depth the foliage is handled more freely to convey an effect of distance.

The sky is almost monochrome, and the bustle of the street is totally obscured by the trees. Once again, the human figure here assumes an important role. Whereas in Monet's work such figures are accessories of only secondary importance, Caillebotte made the two men observing the boulevard the focus of his painting. They are precisely rendered, and he has taken care to distinguish them from one another through their clothing and their postures, with a somewhat odd result. What are these two rather ill-matched characters, who seem oblivious to one another, doing on this balcony? The closer of the two figures is recognizable as the man in *In a Cafe* (cat. 79), singled out by critics of the day for his familiarity and vulgarity.[1] The elegant self-presentation of the man leaning on the balcony, by contrast, identifies him as a cultivated bourgeois. The precisely delineated architectural elements further reinforce the brutality of the juxtaposition of these two men.

The appeal of this painting derives from a tension between the will to exact observation and some of the more generalized pictorial means chosen by the artist. The light is faithfully transcribed: the sun shines directly onto the canted facade of the building on the corner of the boulevard and rue La Fayette, while Caillebotte scrupulously noted that the penultimate floor of this structure is partially decorated with plants and that some of its window canopies are lowered, even recording their different colors. But he did all this in a summary mode of handling that betrays no hint of careful elaboration. Likewise, the treatment of the facade on the right is remarkably successful in its perspectival illusionism: the realistic description of the upper moldings and the balcony with its iron railing is complemented by the astonishing passage on the painting's far right, in which long vertical bands of purplish-gray paint manage to create the convincing effect of depth. The balcony ironwork is quite freely rendered, too, by a network of contrasting values which captures the play of light over its forms.

The view was taken from Caillebotte's own apartment at 31, boulevard Haussmann. This building was modified somewhat between 1908 and 1912, when it became the headquarters and main office of the Société Générale: the architect Jacques Hermant added a projecting cornice above the main entrance, at the point where a balcony on the top floor can be glimpsed in the painting.[2] Boulevard Haussmann did not extend as far as rue Drouot until 1927; the buildings that close off the perspective here are those along rue Taitbout, where the boulevard ended when Caillebotte executed this canvas.[3]

During a sojourn in Paris in the spring of 1891, the Norwegian painter Edvard Munch was inspired by the composition of *A Balcony* in his own painting *Rue La Fayette* (fig. 1), in which he represented the view from the hotel room he then occupied at 49, rue La Fayette.[4] R. R.

Figure 1. Edvard Munch (Norwegian; 1863–1944). *Rue La Fayette*, 1891. Oil on canvas; 92 × 73 cm. Nasjonalgalleriet, Oslo.

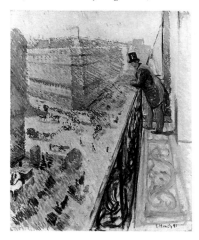

1 See Véron 1880: "It is easy to find this figure in a certain milieu. He is a type taken from life, one who really belongs to our epoch." See also the famous text in Huysmans 1883.

2 See J. F. Pinchon et al., *Les Palais d'argent: L'architecture bancaire en France de 1850 à 1930* (Paris, 1992), p. 142.

3 See J. Hillairet, *Dictionnaire historique des rues de Paris* (Paris, 6th ed., 1963), p. 623.

4 See R. Rapetti, "Munch et Paris: 1889–1891," in Paris, Musée d'Orsay, *Munch et la France* exh. cat. (1991–92), p. 102.

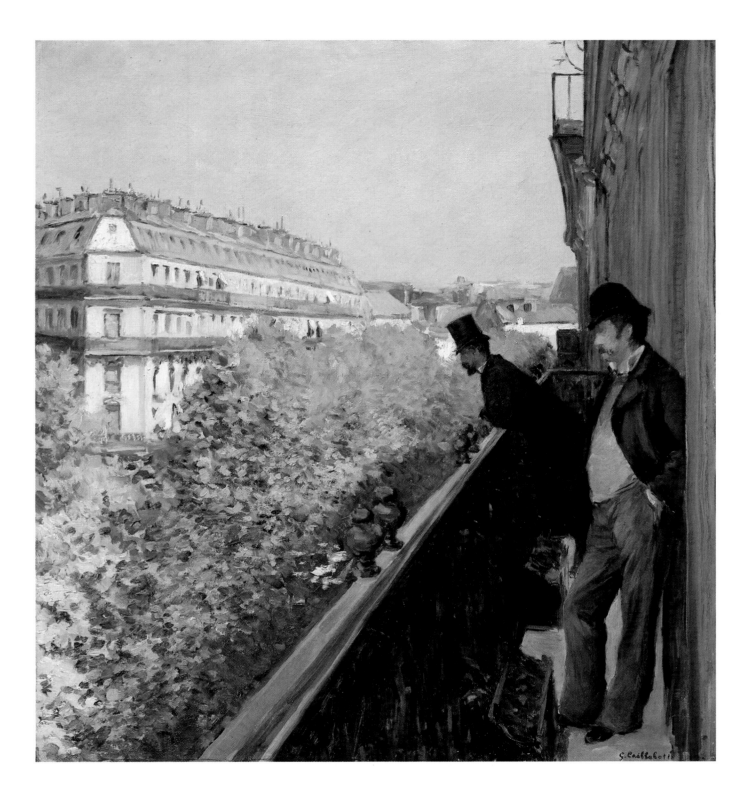

66
View through a Balcony Grille

(Vue prise à travers un balcon)

1880
Oil on canvas
65 × 54 cm
Stamped lower left
Berhaut 1978, no. 138; Berhaut
1994, no. 147

Private collection

Principal Exhibitions
Paris 1880, no. 12; Paris 1951,
no. 34; Chartres 1965, no. 12;
London 1966, no. 22; New York
1968, no. 32; Houston and Brook-
lyn 1976–77, no. 55; Ann Arbor
1979–80, no. 8.

Contemporary Criticism
Tout-Paris 1880b.

Selected Bibliography
Berhaut 1951, no. 99; Berhaut
1968, p. 35; Clay 1971, pp. 9, and
244–45; Berhaut 1977, p. 48;
Berhaut 1978, p. 47; Varnedoe
1987, no. 45.

This is probably the painting listed as number 12 in the catalogue of the fifth Impressionist exhibition. But if so, it elicited little commentary in the press, which is surprising in view of its striking originality. Only one of the reviews of the 1880 exhibition mentions a *Vue prise à travers un balcon*, and even that text offers no specifics that would enable us to confirm that it was indeed the present painting—despite the fact that other works Caillebotte showed that year were often discussed at length, especially the two interiors (cats. 63 and 77). For this reason, it seems likely that Caillebotte withdrew the canvas before or shortly after the opening of the exhibition.[1]

In a long catalogue entry devoted to this work, Kirk Varnedoe suggested that its singular compositional scheme might have been inspired by a woodcut by Andō Hiroshige (fig. 1), and he also cited works by Manet (see cat. 31, fig. 1) and the English printmaker Edwin Adwards[2] as antecedents featuring visual screens obscuring all or part of their compositions. A painting executed by Pissarro around 1877 might also be adduced in this connection (fig. 2). Willed by Lucien Pissarro to the Ashmolean Museum, Oxford, in 1952, the canvas was

probably in the possession of Camille Pissarro when he and Caillebotte were among the two most active organizers of the Impressionist exhibitions. Caillebotte's painting has certain historical importance, for it announces a series of works conceived along similar lines extending from Seurat to Moholy-Nagy, by way of van Gogh and Cézanne.[3]

Even if the idea of representing a landscape through a balcony grille originated with Pissarro, Caillebotte produced a much more radical image by making a secondary aspect of his elder colleague's work the determining feature of his own. The latter is based on an opposition between the repeated ornamental motifs and the aleatory views they provide of boulevard Haussmann beyond and below. No other painting by Caillebotte features such an abrupt and seemingly arbitrary fragmentation of reality. But the artist mitigated the potentially brutal effect by means of a few judicious compositional devices: the iron grille separating the spectator from the street is not rigorously parallel to the picture plane, as can be seen from the slightly oblique angle of the upper railing, and the leaves of a plant in the right foreground strengthen the picture's spatial coherence by restoring a sense of depth. R. R.

1 In his review of the fifth Impressionist exhibition, Huysmans listed eight works by Caillebotte on view (Huysmans [1880] 1883), whereas the catalogue includes eleven numbers under his name. Trianon 1880 mentioned only six works.

2 See Varnedoe 1987, p. 154 n. 5.

3 See ibid., p. 154.

Figure 1. Andō Hiroshige (Japanese; 1797–1858). *Moon Pine at Ueno*, 1858. Woodblock print; 37.5 × 25.4 cm. Private collection.

Figure 2. Camille Pissarro (1830–1903). *Portrait of Mme Pissarro Sewing by a Window*, c. 1877. Oil on canvas; 55.5 × 46 cm. Ashmolean Museum, Oxford.

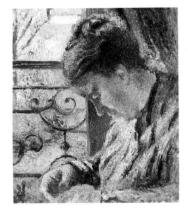

67

Man on a Balcony, also known as Man on a Balcony, Boulevard Haussmann

(Homme au balcon, also known as *Homme au balcon, boulevard Haussmann)*

1880

Oil on canvas

117 × 90 cm

Signed and dated lower left: *G. Caillebotte 1880*

Berhaut 1978, no. 139; Berhaut 1994, no. 149

Private collection, Switzerland

Principal Exhibitions
Paris 1882, no. 2; Paris 1894, no. 56; Paris 1949, without no.

Contemporary Criticism
Charry 1882; Draner 1882; Fichtre 1882; Hepp 1882; Hustin 1882; La Fare 1882; Nivelle 1882; H. Rivière 1882; Sallanches 1882; Silvestre 1882; Huysmans 1883.

Selected Bibliography
Berhaut 1977, p. 43; Berhaut 1978, pp. 30, 34, and 47; Varnedoe 1987, no. 42.

The view represented here is that from the artist's apartment at the corner of rue Gluck and boulevard Haussmann. Caillebotte revisited an idea he explored five years earlier in *Young Man at His Window* (cat. 59), a canvas of almost identical format. In the present painting he adopted a point of view much closer to the figure, whose legs are cropped by the frame. The plunging view that in *Young Man at His Window* is complemented by evocative fragments of the interior and the complex spatial construction which leads the viewer's gaze into the background via a series of diagonals have both been replaced by a compositional scheme in which the window embrasure is parallel to the picture plane. The artist is no longer interested in the activity on the street, focusing instead on the perspective of the boulevard and various light effects. The pervasive freedom of handling extends even to the figure's hands and face.

Doubtless it is in this painting that the interest in abstract decorative motifs so characteristic of Caillebotte's work around 1880 finds its clearest expression. The arabesques of the balcony grille form a screen extending over almost half the can-vas. The near edge of the open window on the right, its casement spectacularly foreshortened, is rendered as a uniform greenish band bordered by an uninterrupted gray line. As for the striped canopy, it represents a frank rupture with the harmonious color scheme, which is otherwise only slightly attenuated by a few red touches describing flowers in the planter at the bottom. In fact, both of the two major tendencies of Caillebotte's art around 1880 find expression in this canopy: an attraction toward the vibrant transcription of reality (both the iridescence of the light and the transparency of the fabric are successfully evoked), and a propensity for rather extraneous decorative motifs, reflected in the scalloped outline of its lower edge. In this connection it is worth noting that the caricature drawn by Draner on the occasion of the seventh Impressionist exhibition (fig. 1) focuses on the invasion of the canvas by the repetitive motifs of the balcony and the canopy, an indication that they were then seen as incongruous. Far from being a simple restatement of *Young Man at His Window*, this painting is indicative of Caillebotte's growing interest in more strictly formal concerns from 1880 onwards.

In 1882 the Norwegian painter Christian Krohg, then sojourning in Paris, and having seen this work at the seventh Impressionist exhibition, adapted its overall conception for his own *Portrait of Karl Nordström* (fig. 2), painted in Grez-sur-Loing.[1] It may also have influenced another painting featuring an open window with a railing overlooking a landscape, *At the Window* by Hans Heyerdahl, also Norwegian, who studied with Léon Bonnat (fig. 3).
R. R.

1 See Varnedoe 1987, p. 144 n. 1.

Figure 1. Draner (pseud. for Jules Renard, 1833–c. 1900). *Since this painting was making everybody sweat in the Salon, the heater on wheels was moved onto the balcony*, detail from "Une Visite aux impressionnistes," *Le Charivari*, 9 Mar. 1882.

Figure 2. Christian Krohg (Norwegian; 1852–1925). *Portrait of Karl Nordström*, 1882. Oil on canvas; 61.5 × 46.5 cm. Nasjonalgalleriet, Oslo.

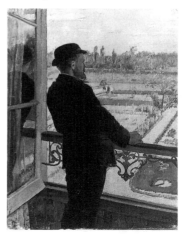

Figure 3. Hans Heyerdahl (Norwegian; 1857–1913). *At the Window*, 1881. Oil on wood; 46 × 38 cm. Nasjonalgalleriet, Oslo.

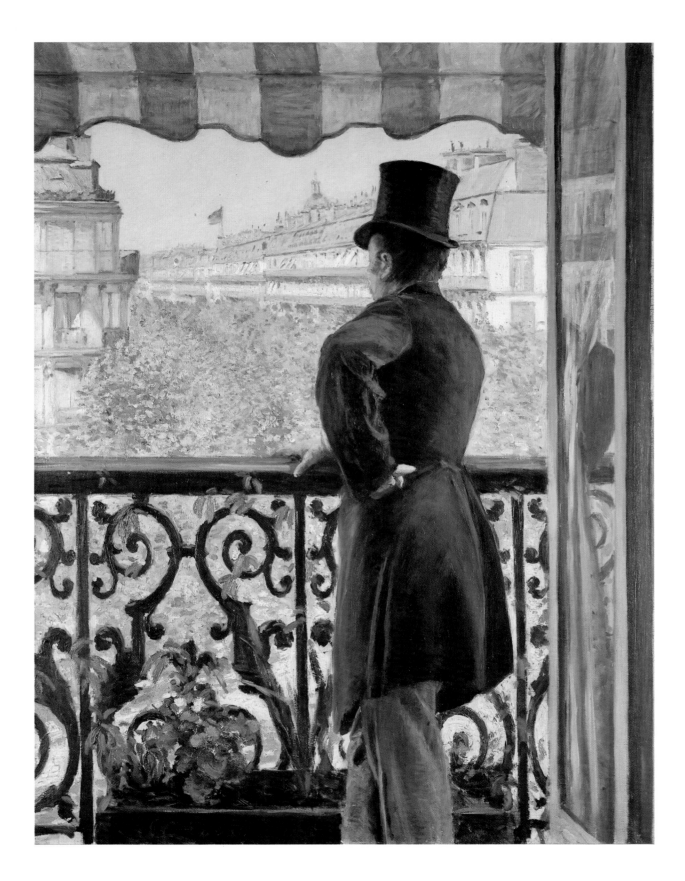

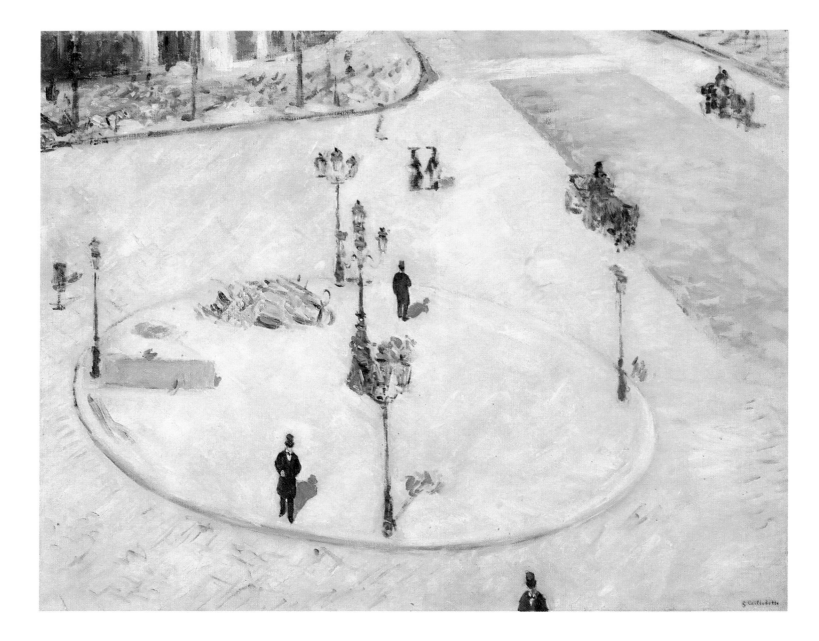

68

A Traffic Island, Boulevard Haussmann

(Un Refuge boulevard Haussmann)

1880

Oil on canvas

81 × 101 cm

Stamped lower right

Berhaut 1978, no. 141; Berhaut 1994, no. 153

Private collection

Principal Exhibitions

Paris 1894, no. 27; Paris 1951, no. 38; Chartres 1965, no. 13; London 1966, no. 25; New York 1968, no. 35; Houston and Brooklyn 1976–77, no. 53; Marcq-en-Baroeul 1982–83, no. 18; Los Angeles et al. 1984–85, no. 33.

Selected Bibliography

Berhaut 1951, no. 106; Scharf 1968, p. 133; Berhaut 1978, pp. 33 and 46; Balanda 1988, pp. 102–103; Varnedoe 1987, no. 43.

In 1880 Degas wrote Pissarro: "Caillebotte is doing *traffic islands on the boulevard Haussmann* from his windows, or so I'm told."[1] It is the juncture of rue Gluck, rue Scribe, and boulevard Haussmann that the artist represented here. Although it is no less finished than several others exhibited during the artist's lifetime, this work was not shown publicly until the 1894 retrospective of Caillebotte's work.

The vertiginous viewpoint employed here entails elimination of the horizon line and immediately sets this painting apart from conventional nineteenth-century images of the city. The space is defined by a few simplified elements easier to read as abstract pattern—see the oval of the traffic island and the lines traced by the curbs of the sidewalks—than as depicted objects. The street, especially the texture and color of its surface, is the subject of this work, in which Caillebotte has used a richly varied range of colors extending from bluish-gray to pink, applied so that their tones blend together imperceptibly. This field of nuanced color transitions is animated by several dark touches distributed over it: the silhouettes of street lamps and men dressed in black, blurry secondary figures (some of them indecipherable), marks on the pavement, tree-trunks, bluish shadows captured by small dancing strokes. The austerity of the composition and the severe constraints here imposed on the kind of conventional description then deemed suitable for such subject matter contribute to the remarkable final result: an eerie evocation of urban emptiness without parallel in its time.

The absence of homogeneity in the treatment of the figures is not a straightforward indicator of the viewer's distance from them, for Caillebotte focused selectively on the three men whose black suits absorb the light, and his crisper definition of them reinforces the strange effect produced by the picture. Such an approach to the human figure recalls Jean Louis Forain, of whom Bertall wrote in 1880: "M. Caillebotte shares his dormitory cubicle with M. Forain, an innovator who has judged it necessary to abolish half-tones. His crudely drawn men, shaped as capriciously as possible, are all dressed in completely black ink-stains in the guise of frock coats or suits. This discovery seems to delight the adepts."[2]

Few other images from the period—and certainly none set in daylight—so successfully convey a feeling of urban isolation. Giuseppe De Nittis, whose pastel *City Square in Sunlight* (fig. 1) plays on the same expressive register, features a conventional Impressionist compositional scheme similar to those favored elsewhere by Caillebotte himself.

R. R.

1 Guérin 1945, p. 54, letter 25, undated [1880].
2 Bertall 1880.

Figure 1. Giuseppe De Nittis (Italian; 1846–1886). *City Square in Sunlight*, c. 1879. Pastel; 64 × 92 cm. Pinacoteca Communale, Barletta.

69

Boulevard Seen from Above, also known as *The Boulevard Seen from Above*

(Boulevard vu d'en haut, also known as Le Boulevard vu d'en haut)

1880

Oil on canvas

65 × 54 cm

Signed and dated mid-lower left: *G. Caillebotte 1880*

Berhaut 1978, no. 143; Berhaut 1994, no. 154

Private collection

Principal Exhibitions
Paris 1882, no. 10; Paris 1951, no. 39; Chartres 1965, no. 14; London 1966, no. 26; New York 1968, no. 36; Paris 1972, no. 24; Paris 1974b, no. 3; Houston and Brooklyn 1976–77, no. 54; Marcq-en-Baroeul 1982–83, no. 19.

Contemporary Criticism
Burty 1882; Hustin 1882; La Fare 1882; Leroy 1882; Nivelle 1882; H. Rivière 1882; Sallanches 1882.

Selected Bibliography
Werenskiold 1917, p. 62; Berhaut 1951, no. 107; Roberts 1966, p. 386; Scharf 1968, pp. 133 and 135; Blunden 1970, p. 162; Nochlin 1971, pp. 176–77, and 266; Rosenblum 1977, pp. 47–49; Berhaut 1978, pp. 33 and 46; Varnedoe 1987, no. 44; Balanda 1988, pp. 104–105; Wittmer 1990, p. 12.

Here, as in *View through a Balcony Grille* (cat. 66), the artist clearly set out to do something highly original. Whatever precedents might be invoked, notably in the realm of illustration,[1] the singularity of this composition in the context of late nineteenth-century art is indisputable. It is only in twentieth-century work, and particularly in photography (see ch. 4 intro., figs. 9 and 10), that analogous approaches to space can be found.

Taking the overhead view to its most extreme form, Caillebotte considerably reduced his field of visual investigation and adopted a restricted palette dominated by grays, blacks, and greens. The spectacular foreshortenings used by the artist were unorthodox, to say the least, as indicated by the following remarks penned by the critic Jean de Nivelle: "One of the most implacable of the independents, M. Caillebotte, exhibits some twenty incredible canvases, among them a *Man on a Balcony*, who looks at the boulevards, and a *Boulevard Seen from Above*, doubtless by this Monsieur himself. A bench that seems glued to the ground and a figure that seems glued to the bench, plus the grille surrounding the base of a tree, such is the poem."

The point of view aside, the handling of the branches obscuring a portion of the second level of depth recalls certain Impressionist paintings in which foliage screens the principal motif, a device often used by Monet (see fig. 1).

Of the works shown by Caillebotte in the seventh Impressionist exhibition, it was this painting and *Man on a Balcony* (cat. 67) that elicited the most extended commentaries. It was, of course, their unorthodox viewpoints that attracted the critics' attention. Ernest Chesneau called Caillebotte "the friend of curious perspectives,"[2] and the reviewer in *Le Gaulois* (2 March 1882) devoted a bitingly ironic paragraph to *Boulevard Seen from Above*.
R. R.

1 See Varnedoe in Houston and Brooklyn 1976–77, p. 154 n. 1.
2 Chesneau 1882.

Figure 1. Claude Monet (1840–1926). *The Spring through Branches*, 1878. Oil on canvas; 52 × 63 cm. Musée Marmottan, Paris.

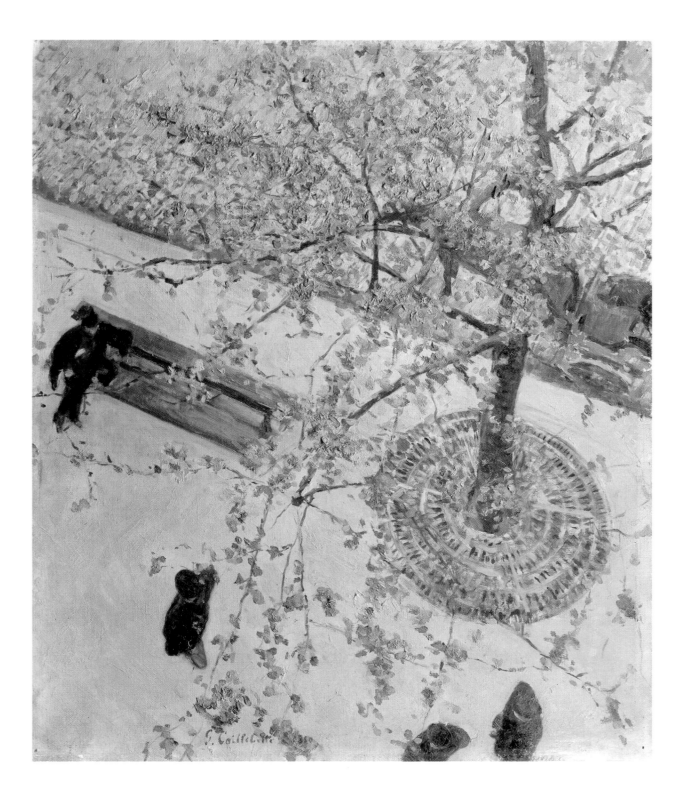

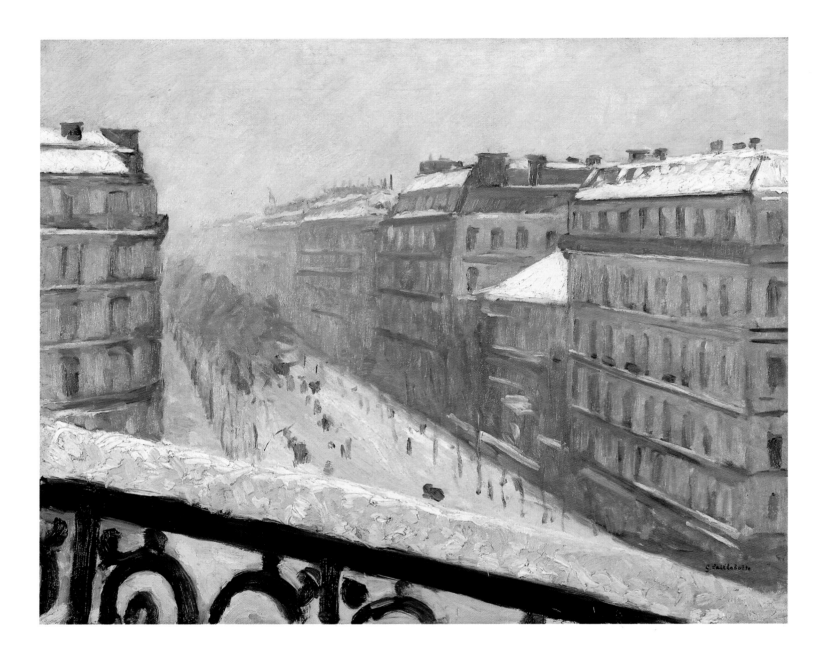

70

Boulevard Haussman, Snow

(Boulevard Haussmann, effet de neige)

1879 or 1881[1]

Oil on canvas

66 × 81 cm

Stamped lower right

Berhaut 1978, no. 333; Berhaut 1994, no. 180

Private collection

Principal Exhibitions

Chartres 1965, no. 9; London 1966, no. 14; New York 1968, no. 19; Houston and Brooklyn 1976–77, no. 56; Marcq-en-Baroeul 1982–83, no. 24.

Selected Bibliography

Berhaut 1978, p. 48; Varnedoe 1987, p. 152, fig. 45b.

Of the many Impressionist paintings of snowy landscapes, few are set in Paris. In the group's fifth exhibition, in 1880, Gauguin showed a work entitled *Snow*,[2] Morisot a *Wooded Avenue, Snow*,[3] and Guillaumin three views of the area around quai de la Gare in the snow[4] (see fig. 1). The 1879 exhibition included several winter landscapes by Monet as well as two in the snow by Pissarro whose present whereabouts are unknown, one of which represented the Palais Royal.[5] *Boulevard Haussmann, Snow* should be considered along with these canvases.

The handling here is much more fluid than in *View of Rooftops (Snow)* of 1878 (cat. 60), perhaps because of the work's relatively incomplete state. In a style clearly influenced by Impressionism, Caillebotte has captured the diffuse light characteristic of snowy weather, partly by contrasting clearly delin-

Figure 1. Armand Guillaumin (1841–1927). *Quai de la Gare, Snow*, c. 1880. Oil on canvas; 50.5 × 61.2 cm. Musée d'Orsay, Paris.

eated foreground elements with the distant boulevard, which disappears into a bluish mist.

This work is one of a group of paintings depicting views from the artist's apartment at the corner of rue Scribe. It is the only one of the set to have a horizontal format. R. R.

1 Caillebotte resided in his apartment on boulevard Haussmann from 1879 to 1888. The periods of substantial snowfall in Paris during this period were January 1879, December 1879, and January 1881. We are not altogether sure that the artist had already moved into this apartment in January 1879 (see Chronology). Thus the most likely dates for the painting are December 1879 or January 1881.

2 Number 57 in the catalogue; this painting was probably the one that is now in Szepmüveszeti Muzéum in Budapest (Wildenstein 1964, no. 37).

3 Bataille and Wildenstein 1961, no. 85.

4 *Port d'Austerlitz, effet de neige*, number 65 in the catalogue (probably Serret and Fabiani 1971, no. 53), *Port d'Austerlitz, effet de neige*, number 66 in the catalogue (probably Serret and Fabiani 1971, no. 43), and *Quai de la Gare, effet de neige*, number 67 in the catalogue (see fig. 1).

5 *Effet de neige (côté du Palais-Royal)*, number 170 in the catalogue.

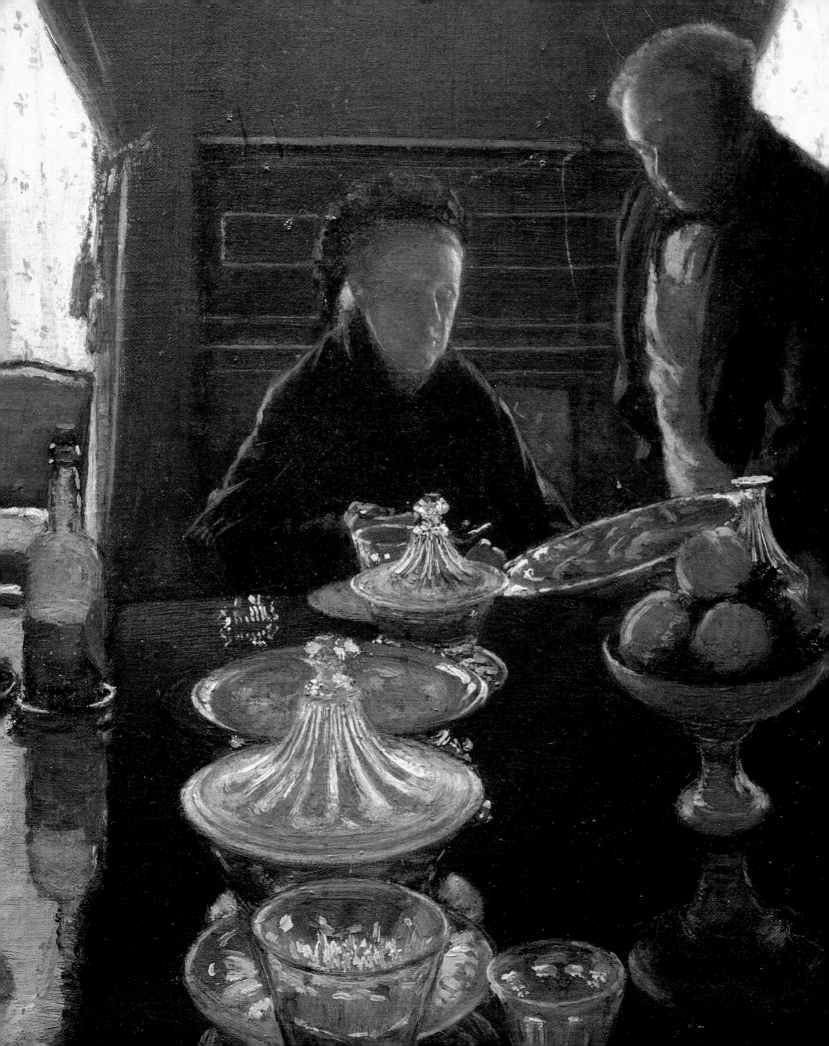

In Caillebotte's numerous representations of the domestic interior, one observes the same ambivalences that appear in his images of the modern city streets seen from street level or from the balcony. At the second exhibition of the Impressionist artists, in 1876, Gustave Caillebotte included the painting *Luncheon* (cat. 72), showing his widowed mother and youngest brother, René, being served by the family steward. The work was smaller and less talked about than the other pictures set in the interior of the family home, *Young Man at His Window* (cat. 59) and *Young Man Playing the Piano* (cat. 71). One critic approved of Caillebotte's paint handling, but regretted the artist's inability to render the reflections on the table surface[1]; another considered the skewed and exaggerated composition simply "insane."[2] Indeed, the assessments of *Luncheon* encapsulate the characteristics of Caillebotte's art that were most often targeted. Those sympathetic to the artist's work saw his subjects as truthful and intimate, and his technique as displaying a knowledge and respect for the métier of painting—contrary to the other Impressionists, who left their works unfinished and whose radical brushwork was "thrown" rather than applied to canvas.[3] The other side of the critical spectrum repeated complaints about Caillebotte's willful distortions of scale, perspective, and space.[4] However, underlying the polemics surrounding his works in general, and particularly his interiors, was a recognition of his adherence to the Realist program. Certainly Caillebotte was among the artists whose ability to translate the states of the soul, as one critic put it in 1880, "by enumerating the sofas, tables, and curtains in the apartment where the action transpires, the protagonist's clothing, in short all the accessory elements," allied them to the Naturalist novelists.[5]

More than any of the other male Impressionist painters, Caillebotte explored the domestic interior in the name of modernity. For while Degas, Monet, and Renoir focused on the private universe early in their careers, using free models from their immediate family, with few exceptions the paintings they submitted to the so-called Intransigent, and later Impressionist, exhibitions more often depicted the public spaces of modern Paris: restaurant terraces, cafés, café-concerts, cabarets, Opéra, and theater boxes. Caillebotte, on the other hand, with the exception of *In a Café* (cat. 79), showed none of these newly popular haunts that characterized the map of "modern Paris."[6] Of the sixty-seven paintings and pastels listed under his name in the catalogues for the six Impressionist exhibitions in which he participated, almost half designate or imply the private spaces of his family home or the apartment he shared with his brother Martial on boulevard Haussmann.

Caillebotte's interiors show his fascination with objects and textures: the patterns of the upholstery silks (see cat. 74),

the grids created by wall paneling (see cats. 75, 77, and 86), and the reflective surfaces of a table or piano top (see cats. 71, 72, and 81). Although his interiors were exhibited with, and sometimes linked thematically with, those of the Impressionist painter Berthe Morisot, they were never considered feminine, like Morisot's images of women in their drawing rooms, on their verandas, or in their dressing rooms. Critics distinguished between Morisot's fluttery, but radically innovative, brushwork, which they perceived as intuitive and thus "feminine"[7] (in a way that Mary Cassatt's was not), and Caillebotte's tighter, "masculine" paint handling, which showed a knowledge of drawing. Although Emile Zola considered Caillebotte's painting style "bourgeois in its precision," because of its fidelity to reality, it was nonetheless seen as masculine.[8] His figures in interiors had "firmly modeled portions" and appeared "wonderful in their truth and life, with an intimacy that is simple and straightforward."[9] Modernity was equated here with intimacy, but given a masculine emphasis.

Caillebotte's interiors were not only distinguished by their readability, a quality associated with linearity and drawing. In comparison with works by Morisot or Cassatt that focus on the experience of women within a domestic space, Caillebotte's interiors show him occupied with both the feminine and masculine aspects of family life. Thus they transcend the boundaries of the prevailing gender structure of Parisian society. Not only do men occupy spaces traditionally associated with women (see cat. 83), but men and women occupy the same domestic space (see cats. 63 and 77). In this way Caillebotte's interiors can be seen as radically modern. For at the beginning of the Third Republic, the spaces of modernity were not to be found in those polarized arenas of the masculine (bars and streets generally proscribed to the respectable *bourgeoise*) or feminine (domestic interiors in which the woman is isolated), but in their intersections, in what Griselda Pollock has termed the "marginal or interstitial spaces," where class and gender interfaced in critical ways.[10]

Private Spaces

The new Paris dramatically changed the collective, public existence of its citizens, which in turn impacted and significantly transformed the interior and private life. Charles Baudelaire's *flâneur,* who made the street his home, exemplified one type of masculine experience without a female equivalent.[11] Indeed, the experience of the *flâneur* and the city envisioned by Baudelaire thirty years earlier was no longer diametrically opposed to private space. The concept of the interior had expanded from that of the antimodern "retreat," the antithesis of the freedom offered by the street and public life, to a con-

struct with geographical, social, and psychological ramifications. Perhaps more than the street, the interior, or "home," was both the heart of individual experience and a microcosm of society, with tenuous boundaries between public and private, male and female, master and servant, parent and child, family and individual.[12]

Collectively, the home was seen as a critical institution for ensuring societal health. In Republican Paris, the home became a symbol of order, stability, and national good, reflecting Republican discipline and reconstruction. It is no coincidence that Viollet-le-Duc's *Histoire d'une maison* (1872) and the last volume of César Daly's *L'Architecture privée* (1873), published on the heels of the Commune, emphasize the broadened definition and understanding of domestic space.[13] Paralleling the developing concept of the interior and the ideal family was the equally bourgeois ideal of individualism. Both Daly and Viollet-le-Duc, for example, stressed that economic and social conditions determined the experience of the individual in an interior space. The conflict between the Republican ideal of equality and the aspirations of the emergent middle class to differentiate itself from the class out of which it had risen, fueled, in the last decades of the century, the desire for a personalized domestic space, with its associations of intimacy and "interiorization."[14] In contrast to the Second Empire, characterized as a public spectacle fed by rampant technological progress and financial speculations (see Zola's *Rougon-Macquart* series, especially *La Curée* [1872], *Nana* [1880], and *La Bête humaine* [1890]), the Paris of the Republican reconstruction opted for moderation and, on the individual level, concentrated on both the public and private sector.[15] Henri Baudrillart, a moderate Republican sociologist, saw the cause of the "terrible year" as the breakdown of the "two great forces" in society—education and the family—and recommended a system of education that would combine the agencies of private (family) and public (State): "Family, and education that's not only widespread but well adapted to our situation, there's the solution."[16] Women were seen as the providers of this education and the ensurers of the domestic order: "The wise and virtuous woman is the providence of the hearth; she instills moral values, and as a result she is the principal agent of social progress."[17] However, beginning in the last two decades of the century, publications such as Edmond de Goncourt's *Maison de l'artiste* (1881), Charles Blanc's *Grammaire des arts décoratifs, décoration intérieure de la maison* (1882), Henry Havard's *L'Art dans la maison* (1884), or the illustrated periodical *Revue des arts décoratifs* (1878–82), among many written by and intended for wealthy male amateur-collectors, reflect the increasing involvement of the man of letters and leisure in the aesthetics of the homefront as a means of self-expression.[18]

Changes in notions of modernity and the interior were manifested not only in the Impressionists' paintings, which often transformed intimate space into subject matter, but in their public exhibitions held in private galleries or apartments with a decor that evoked a domestic interior.[19] By distinguishing the ambiance in which their art was viewed from that of public institutions associated with commerce and the masses, the Impressionists hoped to stress that their work had an aesthetic rather than commercial value, and that it was for a specific private (rather than undifferentiated public) taste and appreciation.

For the critic Philippe Burty, the intimate environments contributed to the impact of the Impressionists' paintings best seen as decor (and thus associated with domestic space) rather than as pictures.[20] Burty, himself a wealthy amateur-collector, and specialist in Japanese art and culture, was among the leaders in the movement for the reform of the decorative arts launched by the Central Union of Fine Arts Applied to Industry (Union centrale des beaux-arts appliqués à l'industrie). He offered Japanese art as the embodiment of crafts genius and integrity, but advocated that the Japanese notion of decoration be combined with French tradition based on the model of the eighteenth century. It was the aristocratic legacy to which he and other publicists for the decorative-arts reforms, such as Paul Mantz (who also reviewed the Impressionist exhibitions) and Louis de Fourcaud, looked for a new national style based on the concept of the unified interior, which involved the integration of arts and crafts, artist and artisan. Impressionism, with its emphasis on colorful surfaces, was perceived as an art of decoration and thus could be viewed favorably to reactivate interest in the notion of a unified ensemble of arts and crafts.[21] Impressionists such as Degas, Monet, and Pissarro experimented with tinted frames and matting to create a surround that would complement and be an extension of the painting within a specific environment.[22] The association of the Impressionist enterprise with private space was underscored in 1877, when Caillebotte rented a five-room apartment on rue Le Peletier across from the Galerie Durand-Ruel, where the Impressionists had exhibited in 1876.[23] Although the hanging committee also included Monet, Pissarro, and Renoir, Caillebotte, who played a leading role in the location, organization, and publicity of the exhibition, would undoubtedly have involved himself in creating the appropriate viewing environment. The so-called "Caillebotte

exhibition" of 1877 was intimate and refined, with paintings arranged thematically, and with more private spaces for smaller works created by the installation of colored panels.[24]

In his 1876 essay, "The New Painting," novelist and critic Edmond Duranty put forth the idea of private space as a means of shaping and complementing the individual. For Caillebotte the interior, with its familial and social associations, was more than an identifying backdrop for class and occupation, it was an integral part of the painting's meaning. Caillebotte's attention to the details of the environment in which pictures were displayed paralleled his interest in his own interior as a subject for numerous paintings exhibited between 1876 and 1879. The family home on rue de Miromesnil was a symbol of his heritage—that of the industrious, entrepreneurial, pious, and conservative *grande bourgeoisie*.[25] While the house was suitably luxurious, the disposition and character of the rooms stressed privacy above reception and comfort over glamour. Jean Béraud's painting *A Ball* (fig. 1), for example, has been repeatedly cited as showing the Caillebottes' interior, but the rue de Miromesnil residence had neither ballroom nor other grand reception rooms to display their social status.[26] Instead, the public space of the first floor was conservatively arranged around the traditional, feminine, small and large salons and greenhouse, and the masculine library, office, and billiard room, with the dining room serving as the point of intersection.[27]

Caillebotte, like Degas, adhered to the patrician attributes of a code of family, honor, and the cult of male friendship. But perhaps more so than those of the older artist, Caillebotte's images suggest that he was uncomfortable with his class as his social identity. His early interiors, painted between 1876 and 1879, seem to convey the tedium of a relentlessly unchanging, respectable existence, and suggest a negative identification with this family sphere. Nevertheless, however much he may have rebelled against his family values, they are a subtly present element in his works, even when their influence was manifested in what he did *not* represent. He did not depict the entertainments associated with the privileged (racecourse, Opéra), or the mixed society of nocturnal haunts (cabarets, café-concerts, brothels), or those associated with making money, the latter illustrated in the famous painting Degas exhibited in 1876, *Portraits in an Office (New Orleans)* (1873; Musée des Beaux-Arts, Pau).[28] Nor did he paint the servants of the wealthy, a subject readily at hand in the domestics' quarters on the third floor of the family residence. Only in *Luncheon* (cat. 72) did Caillebotte present a family employee. Even then, he showed Jean Daurelle, the family steward and

Figure 1. Jean Béraud (1849–1935). *A Ball*, 1878. Oil on canvas; 65.5 × 11.6 cm. Private collection, Paris.

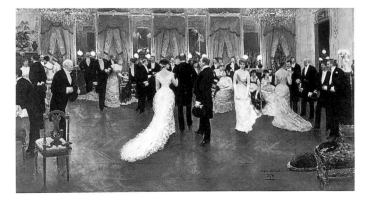

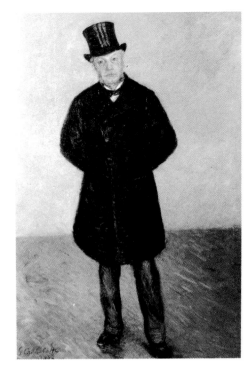

Figure 2. Gustave Caillebotte. *Portrait of Jean Daurelle*, 1887. Oil on canvas; 75 × 50 cm. Private collection, Paris.

custodian, whose position somewhere between service and the artist's own class Caillebotte blurred in later portraits where he showed Daurelle wearing the top hat and redingote of the bourgeois (fig. 2).[29]

In Caillebotte's interiors, leisure is associated with activity, not repose. Family members are shown working at leisure—playing the piano, reading, sewing. Only in the painting of René at the window (cat. 59) did the artist suggest the unimpeded idle leisure associated with family wealth.[30] Absent also from the pictures of the Caillebotte home are signs of visitors. Caillebotte's sharply focused, close-up works detailing the family, their activities, and the domestic decor reinforce the notion that this was a closed environment. The numerous windows (five on rue de Miromesnil, seven on rue Lisbonne) do not convey daylight, but are veiled (see cats. 71 and 72) or omitted altogether (see fig. 3). In his picture of the family dining room, in particular, Caillebotte emphasized the Gothic shape resulting from the light filtered through the curtained window, perhaps intending to transform the familiar into a strange and strained environment.[31]

The 1876 *Luncheon* offers clues to the personal significance of interiors and the ways in which the theme was assimilated by the artist as the site of modernity. The separateness of the server and the served, the tilting table surface, the skewed perspective, the proliferation of glassware on the table, and the near-absence of food invite different interpretations and may refer to Caillebotte's relationship to his family at this time.[32] But *Luncheon* was also an artistic representation, a distinctive way of seeing and constructing a picture that reflects Caillebotte's training in the studio of the Realist Salon painter Léon Bonnat. Caillebotte's switch from a legal career to a profession associated with a bohemian existence, his decision to train with a master whose own conflict with the Académie des Beaux-Arts had made him a sort of rebel within the ranks, his refusal to exhibit in the official Salons, and his complete submersion (financially, professionally, and socially) in the Impressionists' cause suggest a determined and willful break

with his bourgeois heritage.[33] Despite his considerable personal fortune, which would have allowed him to take his profession lightly, it is clear from the ambitious scale and complicated surfaces of many of his works of the 1870s and 1880s, as well as from his personal investment and intervention in the group's activities, that Caillebotte considered painting and membership in the Impressionist group serious undertakings.

Several critics commented on Caillebotte's discreet, hardworking, and unassuming nature. They referred to him as "a bourgeois of the inoffensive type [who] lives out of the spotlight, shuns compliments, asks only to defend his school, and would never savor victory,"[34] as a "courageous" fellow who opted for the life of the "industrious rich,"[35] and as an "*honnête homme*," alluding to mid-seventeenth-century values of cultivation, reason, reflection, and moderation.[36] The painting of the artist's family at lunch, like the ensemble of his interiors, imparts a gravity and restraint reflective of his personality. Here is neither drama nor anecdote, no relaxation of defenses even within one's private space. Caillebotte suggested instead a pervasive melancholy and uneasiness that are all the more surprising in the context of the domestic and familial setting.

Caillebotte and Modern Portraiture

After the death of Mme Caillebotte, in October 1878, the three surviving brothers, Gustave, Martial, and Alfred, sold the family properties and divided the fortune.[37] The sale of the rue de Miromesnil residence represented to the artist liberation from tangible and intangible family traditions, forcing him to make another life for himself.[38] In his next and last Paris residence, the boulevard Haussmann apartment that he shared with Martial, the interior trappings were quite different. Gone were the heavy drapes and bric-a-brac of the former abode. In place of heavy, red velvet and floral wallcoverings were predominantly blue-gray walls with simple gold-painted moldings. The crushed red-velvet chairs and lace curtains were kept, but their appearance was altered by the lighter, quieter, and emptier interior.[39] The most significant and audacious addition to the furnishings was the overstuffed couch, with its bold mauve and blue floral print, which Caillebotte used in a number of compositions to define space and scale (see cats. 77, 80, and 87) and, in some cases, to serve as the environment for a figure (see cat. 82).[40]

Caillebotte's representations of the new apartment interior emphasize the architectural details and manifest a shift in focus from the interior as a space reserved for family members to one reflecting the artist's social sphere.[41] The death of his mother seems to have provoked a change in his choices of subject and the way in which he presented himself to the public. In the fourth Impressionist exhibition, held in 1879, he showed the greatest number of works ever, representing, as the anonymous reviewer of *Le Voltaire* commented, "all genres: portraits, landscapes, decorative panels, *périssoires*, numerous studies of oarsmen."[42] Of the twenty-five works listed, eight were "portraits" identified by initials in their titles. Several of the sitters were set against the elegant, cool-gray walls of the boulevard Haussmann apartment (see fig. 6). The fact that Caillebotte painted sitters other than family members in his interior only after he had moved to the boulevard Haussmann apartment suggests that he had considered it impractical or untenable to invite outsiders into the parental home.[43]

By 1870 the standards of portraiture had loosened to allow less formulaic compositions of individuals wearing contem-

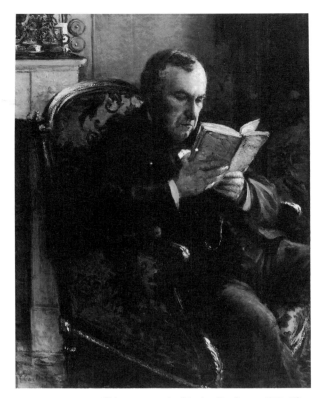

Figure 3. Gustave Caillebotte. *Portrait of Eugène Daufresne*, 1878. Oil on canvas; 100 × 81 cm. Josefowitz Collection, on loan to the Art Gallery of Ontario, Toronto.

porary fashions in interiors. However, critics such as Jules Castagnary, a moderate Republican and reviewer of the Salon in the 1860s and 1870s, continued to regard portraiture as representing "the most generalized expression of the individual," intended to image the moral character, temperament, instincts, and social and professional habits that reflected Republican values.[44] Castagnary felt those values were discernible through gesture, pose, and costume. Thus, the critic preferred the representation of the wrinkled and worn over the brand new. He also recommended that the artist show only a fraction of the individual's surroundings, which he felt detracted from the expression of the permanent nature of the subject. For Castagnary and others, the focus was to be on the sitter, preferably seen against a neutral or colored backdrop, rather than contextualized within external elements, which Castagnary considered one of the veritable "moral shortcomings" of the artist.[45]

In positioning himself also as a portraitist in the Impressionist exhibition of 1879, Caillebotte adopted a strategy similar to that of Degas, who exhibited ten portraits among his twenty submissions, including those of Duranty (fig. 4) and the painter Diego Martelli (fig. 5).[46] These portraits were "professional images," embodying Duranty's mandate to show not only the clothes and physiognomy of the individual, but also his social and professional milieu, "the relationship of a man to his home, or the particular influence of his profession on him."[47] What was radical in Duranty's recommendation was the degree to which the environment was seen as shaping the character of the individual. Four years later, the Naturalist novelist and art critic Joris Karl Huysmans reiterated Duranty's comment in his enthusiastic review of Degas's portrait of Duranty (resubmitted to the fifth Impressionist exhibition), noting that "the person to be portrayed should be depicted at home, on the

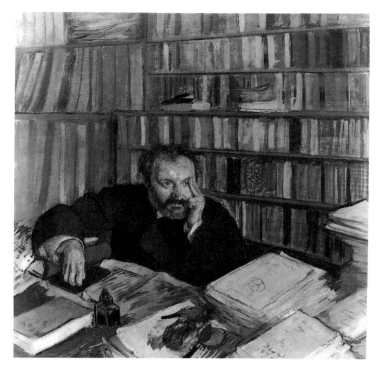

Figure 4. Edgar Degas (1834–1917). *Portrait of Edmond Duranty*, 1879. Pastel and tempera on canvas; 100.3 × 100.3 cm. Glasgow Museums and Art Galleries, Scotland (The Burrell Collection).

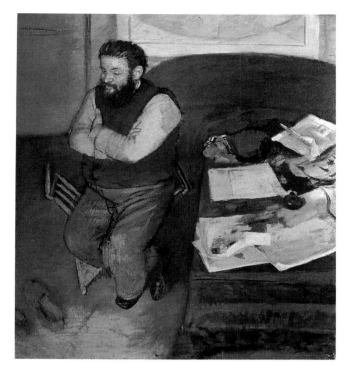

Figure 5. Edgar Degas (1834–1917). *Portrait of M. Diego Martelli*, 1879. Oil on canvas; 110 × 100 cm. National Gallery of Scotland, Edinburgh.

street, in a real setting, anywhere except against a polite backdrop of empty colors."[48]

Duranty's prescriptions paralleled the radical breakdown in the art of portraiture. To represent an individual, the Impressionists had already moved away from gesture and physiognomy to placing a figure within a specific environment. For the "modern" portrait was not about depicting well-known men and beautiful women, but about the depiction of a social type, "in his clothing, in social situations, at home or on the street."[49] Duranty's text implied the overlapping of portraiture and genre, which was demonstrated in Impressionist works beginning in the late 1860s. The conventional portrait of a model posing for the artist had evolved into a portrait showing friends, relatives, and other artists seemingly caught by the painter's brush. Most of the Impressionists' portraits were intimate, not formal, affairs, often showing the subjects engaged in social or leisure pursuits. As described by a contemporary reviewer, their goal was to capture spontaneity, and to place the sitter within a social or professional context:

To compose one's picture, not in a studio but on the spot, in the presence of the subject; to rid oneself of all convention; to put oneself in front of nature and interpret it frankly, brutally, without worrying about the official way of seeing . . . to proceed as though the figures were inseparable from the background, as though they resulted from it, and that, in order to appreciate a work, it were necessarry to embrace it as a whole and look at it from the desired distance; such is the ideal of the new school.[50]

Even in the Impressionists' portraits, however, the model continued to be "posed" and the picture "composed" by the artist. Caillebotte's portraits especially, painted with firm, descriptive brush strokes, were perceived differently than those

by the Impressionists Monet, Morisot, and Renoir in particular, who combined a freer technique with spontaneous poses. In the 1879 Impressionist exhibition, Duranty discerned in Caillebotte's portraits "a kind of cruel intensity of effect which, in three or four portraits, holds your attention through its labored insistence."[51] He specified no particular works, but no doubt had in mind the unrelenting realism of the family portraits: Caillebotte's aunt at Yerres (Berhaut 1994, no. 112); his mother's cousin reading in the rue de Miromesnil apartment (fig. 3); and the near-caricatural image of Mme Boissière hunched over her knitting needles (Berhaut 1994, no. 67). Perhaps Duranty found these too specific. This was, in any case, the opinion held by the critic Bertall, who singled out the *Portrait of Eugène Daufresne* (fig. 3), "seated motionless in an armchair that threatens to fall apart; family ties could not save this excellent man from the enthusiasm of his nephew [*sic*]. He is sad, but seems to pardon him [Caillebotte] all the same."[52]

The critics completely ignored several portraits in which the model is bracketed by the wood paneling of the Caillebottes' apartment. In these works of vertical format, the model is invariably positioned close to the viewer in a frontal, three-quarter pose. In the *Portrait of Mme H.* (fig. 6) and the *Portrait of Jules Richemont* (cat. 75) exhibited a year later, the natural poses of the models suggest spontaneity, evoking a certain class and position. Without artifice, Caillebotte flattered his sitters by showing them as members of the respectable bourgeoisie within an equally respectable domestic space. But instead of depicting his sitters in their own environments, as Duranty recommended, between 1879 and 1885 Caillebotte painted, in addition to Mme H. and Richemont, a series of predominantly male subjects (see cat. 86) on his red-velvet armchair and against his gray walls with gold moldings. With these conventionally posed portraits, Caillebotte was ideologi-

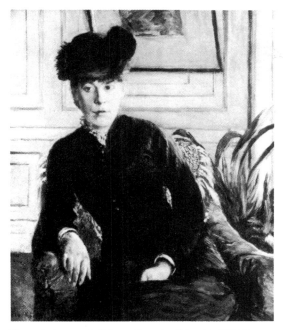

Figure 6. Gustave Caillebotte. *Portrait of Mme H.*, 1877. Oil on canvas; 81 × 65 cm. Location unknown.

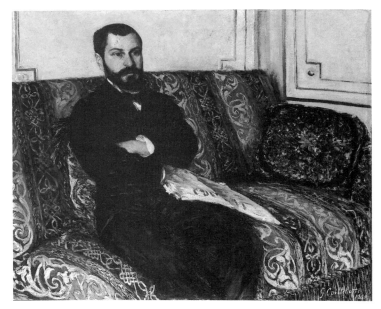

Figure 7. Gustave Caillebotte. *Portrait of Richard Gallo*, 1881. Oil on canvas; 97 × 116 cm. The Nelson-Atkins Museum of Art, Kansas City (Nelson Trust, through the generosity of Mrs. George C. Reuland, through the W. J. Brace Charitable Trust, and through exchange of the bequests of Mr. and Mrs. William J. Brace and Frances Logan, the gifts of Harold Woodbury Parsons, Mr. and Mrs. Henry W. Bloch, and the Laura Nelson Kirkwood Residuary Trust and other trust properties, 89-35).

cally and aesthetically closer to Bonnat, his teacher and the foremost portraitist of the Third Republic. He borrowed Bonnat's style of placing against a neutral background a seated or standing figure holding identifying objects such as a cane or newspaper. The influence of Bonnat is especially pronounced in Caillebotte's portrait of the family steward, *Jean Daurelle* (fig. 2), for which the artist borrowed the format, costume, and walking stick from Bonnat's effigy of the Republican leader Adolphe Thiers (1876; Musée du Louvre, Paris), praised at the Salon of 1877 and considered among his most important works.[53]

At the 1879 exhibition, Caillebotte included several other portraits which, like those of family members criticized by Duranty, were singled out for their idiosyncratic qualities. Bertall suggested that in his portraits Caillebotte presented "friends he likes and who like him: he sits them down on strange sofas, in fantastic poses."[54] One work identified as having been shown in the exhibition depicted a man seated on a brilliantly patterned sofa (cat. 74). Given Caillebotte's interest in the sofa as a compositional device, it is likely that other male portraits exhibited that year included similar "strange sofas." Caillebotte used his own floral-print sofa to reinforce the compositional and psychological structure of his portraits and paintings of modern life (see cats. 77, 80, and 82). In his *Portrait of a Man* (cat. 74), Caillebotte submerged the model in a decorative surround—as a dandy and connoisseur whose effeminacy is reinforced by his semireclining pose and gracefully crossed leg. The way in which Caillebotte subtly transformed this picture into a decorative tableau associated with female portraiture becomes clearer when the canvas is paired with the pastel of an unidentified woman seated in front of an easel that bears the portrait (cat. 74, fig. 2). Until the recent discovery of the *Portrait of a Man*, it was thought that the portrait

in the pastel might be a mirror reflection. Now, the man is not only seen against a background of decorative fabrics, but his portrait has become the decor, the background, for the portrait of an unidentified woman.

If the delicate sitter in *Portrait of a Man* seems in harmony with his decorative environment, Richard Gallo seems at odds with and out of porportion to his ornamental support in the portrait of him Caillebotte exhibited three years later (fig. 7). Caillebotte painted him with arms folded in a manner similar to the pose of Diego Martelli in Degas's portrait (fig. 5). But whereas Martelli's gesture is an extension of his contemplative expression and thus an inlet to his personality and psychology, Gallo's posture and expression suggest defiance, even a stubbornness, unexpected in conventional portraiture. And whereas Martelli is surrounded by the implements of his literary trade, Gallo's profession as editor of the conservative newspaper *Le Constitutionnel* (owned by his uncle) is only hinted at by the crumpled paper lying on his lap. Unlike Caillebotte's other images of professional men, such as *Portrait of Henri Cordier* (cat. 84) or the man writing at his desk (cat. 85), in which the sitters are shown with pens in hand against the backdrop of their book-lined studies, Gallo's setting is as unclear as his professional interests. Indeed, Caillebotte's other representations of Gallo further camouflage his profession, showing him as a cardplayer (cat. 80), as a country gentleman walking his dog (cat. 105), and as a diminutive "husband" reading a novel in *Interior* (cat. 77).

In casting and recasting Gallo as a subject for a number of portraitlike images which can be read as modern genre paintings, Caillebotte took the relationship between sitter and environment and the role of the artist as mediator one step further than Duranty suggested in "The New Painting." In this and several other paintings of modern life, Caillebotte created what one might term the "artist's portrait," a representation in

which individuals of a certain class are transposed to a milieu chosen by the artist. These "portraits" yield less information about their subjects than about Caillebotte, who re-presents his models in environments that are relevant to his own experience. Similarly, Degas's *Portrait of Friends in the Wings* (1879; Musée d'Orsay, Paris) is a genre scene in which two men converse backstage at the theater or Opéra. But it is also a portrait of Degas's friends Ludovic Halévy and Albert Cavé. Halévy remembered posing "standing in the wings, face to face [with Cavé]. There I am, looking serious in a place of frivolity; just what Degas wanted."[55] In other words, the artist manipulated his models to produce an image that is self-revelatory as well. Caillebotte's portraits of Gallo in different roles can be compared to his portraits of an unidentified male model, shown as a well-dressed bourgeois, looking out a lace-curtained window (cat. 78), standing on the balcony of a Haussmannian apartment (cat. 65), or appearing as a more slovenly "type," perhaps posed by the artist (cat. 79). By modifying the context of his model, Caillebotte controlled and obfuscated the interpretation. With the possible exception of the man in the café, however, all of Caillebotte's portraits evoked a certain social class. "M. Caillebotte is the painter of the prosperous bourgeoisie, of business and finance, making more than enough for their needs, without for all that being very wealthy, living close to rue La Fayette or in the vicinity of boulevard Haussmann," wrote Huysmans on the occasion of the fifth Impressionist exhibition, in 1880, when Caillebotte included contemporary genre scenes and portraits, such as the *Portrait of Jules Richemont*.[56] Huysmans's financial map was no doubt determined by his knowledge that Caillebotte lived on boulevard Haussmann in an apartment just a block off the intersection of rue La Fayette. For Huysmans, there was a significant difference between the social make-up of the grand boulevards around the Opéra and the new *beaux quartiers* located to the south (in the Passy district) and west (skirting avenue du Bois-de-Boulogne). He distinguished as well Caillebotte's depictions of the comfortable bourgeoisie, and the more refined and elegant (and, by extension, wealthier) bourgeoisie of Morisot and Cassatt.[57] Huysmans's description aptly describes the moderate, upper middle-class Republicans typifying Caillebotte's sitters. But whereas Cassatt's portraits were perceived as mirroring her "well-born" status, Caillebotte's portraits, including that of the family steward transformed into an urbane and dignified gentleman, reflect his liberal opinions and perhaps an ambivalent attitude toward his *grand bourgeois* upbringing.[58]

Caillebotte and Contemporary Genre Painting

The genre scenes set within the boulevard Haussmann apartment are among Caillebotte's most fascinating and "modern" paintings. However, they raise more unresolved questions than they answer about the artist's life. Unlike the rue de Miromesnil home, whose disposition and furnishings (down to the silverware and linen) are well-documented, the boulevard Haussmann residence is known only through Caillebotte's paintings and from the critic Montjoyeux's description of the interior: "which could be luxurious, [but instead] has only the very simple comforts of a man of taste."[59] Caillebotte's life there has proved equally inaccessible.[60] Shortly after moving, he seems to have made the acquaintance of Charlotte Berthier, eleven years his junior and possibly an actress. She appears later in pictures of the Petit Gennevilliers home that she shared with the artist (see fig. 8).[61] No evidence, however,

suggests that Berthier ever lived with Caillebotte prior to his definitive move to the country in 1888. The fact that in 1883 Caillebotte added a codicil to his original 1876 will and testament, providing her with a healthy annuity, points to the seriousness of their relationship by that time. If Caillebotte decided to keep a mistress and not a wife, it may have been because he wanted to break further with his conventional upbringing.[62] His decision to remain unmarried, and even his choice of mistress, whose class was significantly lower than his, may reflect his discomfort with his own class as well as with the bourgeois marriage contract, which he must have associated with the joyless and claustrophobic interiors in his early works.

Among the Impressionists in general, marriage was not entered into lightly. Roy McMullen has examined the question of Degas's bachelorhood in the context of the popular anti-bourgeois attitude among artists who feared the influence of women on their creative powers. Citing the pattern of late marriages of Cézanne, Manet, Monet, Pissarro, and Renoir, all of whom were fathers before they were husbands, McMullen described Degas as a conundrum, "concubineless as well as wifeless."[63] Caillebotte, on the other hand, did not abstain from intimacy, but seems for some time to have kept his mistress at a discreet distance from his living space. And whereas Degas's relationships with women seemed to have been fueled by a distrust of the "weaker" sex in general, there is no evidence that Caillebotte shared in the misogyny of the period.[64] On the contrary, Caillebotte's works, especially the genre scenes painted between 1879 and 1882, show an extraordinary parity between the sexes, and sometimes empower the female through the artist's treatment of the space, scale, and viewpoint typically reserved for the male gaze.

To the fifth Impressionist exhibition, in 1880, Caillebotte submitted under the neutral but potentially charged title *Inte-*

Figure 8. Gustave Caillebotte. *Dahlias, the Garden at Petit Gennevilliers*, 1893. Oil on canvas; 157 × 114 cm. Private collection, California.

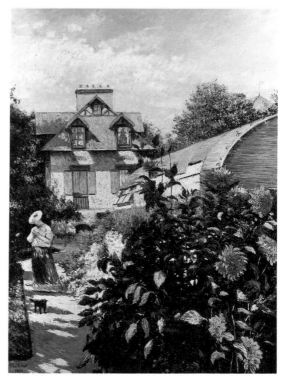

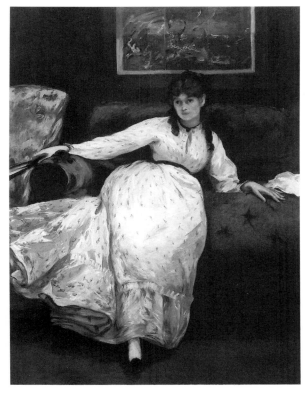

Figure 9. Edouard Manet (1832–1883). *Repose* or *Portrait of Berthe Morisot*, 1870. Oil on canvas; 155 × 133 cm. Museum of Art, Rhode Island School of Design, Providence (Bequest of Edith Stuyvesant Vanderbilt Gerry).

rior two works showing a man and woman in a domestic room (cats. 63 and 77). This was in itself an unusual combination, since men were ostracized habitually from this realm in painting as much for their gender as for their lack of decorative potential. In his 1876 essay on Manet, the poet and critic Stéphane Mallarmé stressed the importance of the *indoors* to modern existence, clearly assuming the primacy of the female within that arena. He singled out Manet's painting *Repose* (fig. 9), a picture of Berthe Morisot in a billowy white dress lounging on an overstuffed dark red sofa, "exhaling the lassitude of summertime."[65] In so doing, he underscored the central role of women as gauges of interior harmony and, by extension, domestic stability. Caillebotte depicted women on sofas (see cat. 76), but also men comfortably lounging, as subject (see cats. 74 and 80) and as decorative element (see cat. 74, fig. 2), thereby radically overturning the conventional association of the couch with the female sex (see cat. 82).

In Caillebotte's two *Interior* paintings, the male is not only situated within the feminine domain, he is subordinate to the woman, constituting a double transgression—both physical and psychological—of gender boundaries. In such instances, the man is typically shown reading or working (as the site of intellectual activity) and the woman engaged in domestic activities. Whether or not she makes eye contact with the (male) viewer, the female subject constitutes a decorative counterpart to the interior. The women imaged in these two interiors call into question the aesthetic expectations and the role given to them in contemporary society. In the larger of the two (cat. 63),

the woman is framed by the decorative lace curtains and balcony grille, but she is not patently on display. Wearing a discreetly fashionable dress, she turns away from us and silhouettes herself against the window. Here Caillebotte took literally the maxim of Duranty, according to which: "A back should reveal temperament, age, and social position,"[66] and applied it to his model—not an object of desire but an anonymous woman disassociated from the domestic duties of both hearth and family. Self-absorbed, she turns away from the seated male, soliciting and at the same time denying the gaze of the (male) viewer. Her companion plays a secondary role. He is smaller in scale and cut off by the picture edge. While they occupy the same space, the two figures do not interact. Caillebotte's positioning of this man within a traditionally feminine space can be compared to Paul Gauguin's *Flowers, Still Life* (fig. 10), exhibited in the 1882 Impressionist exhibition. Gauguin's scene, however strange, suggests an interaction between the couple and more conventional gender divisions (e.g., a woman playing the piano for the pleasure of the male). Perhaps because Gauguin's domestic image was perceived as unproblematic, it did not receive much critical attention, even from Huysmans, who noted only its "scurvy, muted color."[67]

By contrast, Huysmans found much to say about Caillebotte's two interiors, which he considered visual metaphors for the ennui inherent in conjugal bourgeois life, a subject he would challenge in his novel *En Ménage*, published the following year. In the larger of the interiors, the predominantly blue palette (which Huysmans called the artist's "indigomania")[68] and the placement of the couple, physically close but psychologically distant, convey the boredom that Huysmans sensed was the subject of the work. The image suggests an unfinished narrative, which is given a radical twist in the smaller interior (possibly a pendant) showing the same man and woman in another room. But whereas the subject of the larger interior was acceptable to the critics (most of whom mentioned only the artist's handling of the play of light silhouetting the female figure), in the smaller interior the same ingredients were perceived as unsettling and even threatening.[69] The critics' concerns were no doubt fueled by the increasing anxiety over the *femme moderne*, a negative term applied to women eschewing

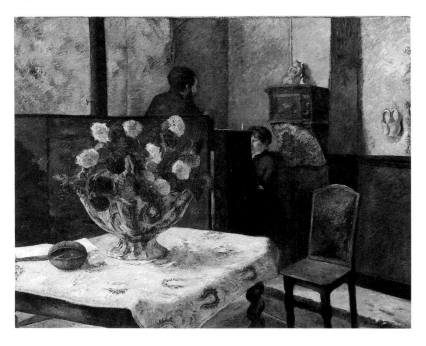

Figure 10. Paul Gauguin (1848–1903). *Flowers, Still Life* or *The Painter's Home, Rue Carcel*, 1881. Oil on canvas; 130 × 161 cm. Nasjonalgalleriet, Oslo.

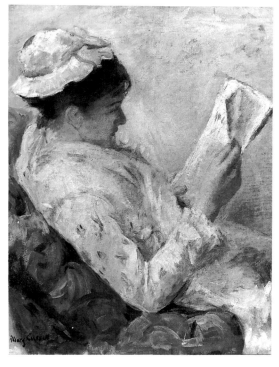

Figure 11. Mary Cassatt (American; 1844–1926). *Lydia Reading the Morning Paper*, 1879. Oil on canvas; 81.9 × 59.7 cm. Joslyn Art Museum, Omaha (Museum Purchase, 1943.38).

was attracted to a work also perceived as showing the unlady-like and, for many, predatory, nature of the female sex. Degas's prostitutes, shown sitting on the terrace of a café rather than in the brothel, were not in their proper places. The critics' problem with Caillebotte's reader (who was in her place) was clearly influenced by her relationship to the diminutive and powerless male, a relationship that subverted the moral order. Even though she occupied the domestic space appropriate to her gender, her morality was questioned. Caillebotte's picture, in fact, was compared negatively to another painting of a modern woman shown alone at night drinking a beer in a café. The painting, by the moderate independent Eugène Vidal, was shown in the same Impressionist exhibition. Although in the late nineteenth century, as recent studies have shown, single women in cafés were often working-class women involved in clandestine prostitution, the implications of the activity of Vidal's woman were not questioned, or were negated by her beauty. One critic remarked on the "pretty portrait of a brunette by M. Vidal, who has had the whimsical idea of placing his charming model in front of a beer mug."[77] For Paul Mantz, this was not merely a studio "fantasy," but a depiction of modern life stamped with a veracity lacking in Caillebotte's *Interior* (cat. 77). Mantz read Vidal's painting as showing a young woman whose bock is present but discreetly placed in the second plane, and "whose virtue is not guaranteed, and who, seated at a table, waits for the providential stranger who will pay for her dinner." Far from offensive, Mantz felt this to be a truthful and instructive representation. "What a lesson for M. Caillebotte!" he concluded.[78] While the women in Degas's monotype were read as threatening, a single woman depicted in the same place was fair game, with the implication that this was the natural relationship between men and women, based on the former's inherent social, economic, and physical superiority.

Caillebotte's carefully constructed interiors moreover offered none of the surface ambiguities created by the broken brushwork fusing figure to ground in Morisot's interiors. Instead his paintings invited the kinds of readings normally attached to the Salon Naturalists, such as Marie Bashkirtseff, Jules Bastien-Lepage, Alfred Stevens, and James Tissot. Caillebotte, however, complicated these readings by creating theatrical distances between foreground and background. As in the case of Cassatt and Morisot, who apparently reduced the foreground space to convert the more or less disinterested observer into the active participant,[79] Caillebotte's compositions in which figures are pushed up to the picture plane may well have been a pictorial strategy to focus attention within, not on, the painting. But can one say that in the act of making these interiors, in selecting the room and furniture, in arranging the lights and poses, the artist participated in a new experience: the re-presentation of his world?[80] Or were Caillebotte's two interiors highly calculated, artificial productions intended to provoke the volatile issue of the relationship between the sexes? And is it possible that his subjects, poses, and spatial disjunctions denote a response to the Naturalist literature of his time, as has been thought to have been the case with Degas's painting *Interior*, also known as *The Rape* (1868–69; Philadelphia Museum of Art)?[81] Apart from indirect references to his acquaintance with Zola, and Caillebotte's own ambiguous mentions of Flaubert and of the lesser-known author and journalist Louis Veuillot (1813–1885), his literary interests are unknown.[82] The general lack of biographical information about his social milieu (outside of the Impressionist group and the later yacht-

the values of motherhood to pursue single lives and careers, as opposed to the *honnête femme*, the respectable bourgeois wife and mother.[70] The Camille Sée Law, implemented in 1880, established State-sponsored secondary education for women. By 1884 new laws had been passed giving French women the right to initiate divorce proceedings against their husbands, and had raised the issue of the right of women to own property or share it with their husbands.[71] It is in this context of shifting power structures between the sexes that the critical attack on Caillebotte's picture should be understood.

Moreover, Caillebotte's woman was far from a decorative, feminine complement to the interior, as evident when compared with Renoir's *Reader* (Appendix III, fig. 52) and with similar treatments of female readers by Cassatt and Morisot. At the fourth Impressionist exhibition, in 1879, one critic found Cassatt's *Lydia Reading the Morning Paper* (fig. 11) a "charming work" and pointed out that the model was reading a "popular novel"[72]; thus Cassatt's work was perceived as a reassuring image of femininity. By contrast, Caillebotte's model is respectably but not ornamentally or seductively attired—unhatted and ungloved—and shown reading a nonfiction text. Because she is almost aggressively positioned front and center, she was seen as undesirable. One critic went so far as to accuse Caillebotte of deliberately seeking out unattractive types.[73] Others noted her "purplish-red" cheeks, perhaps "afflicted by inflammation."[74] Only Huysmans offered a positive if not clinical comment on her powdered cheeks. He saw them as a sign of her social class, as a reference to the "sophisticated complexion" of the modern bourgeoise, and a "simple compromise" between wearing no make-up and the heavy rouge worn by actresses and prostitutes.[75]

The attacks on Caillebotte's feminine reader were similar to those that had been launched against the "painted, blighted creatures"[76] in Degas's pastel-heightened monotype *Women on the Terrace of a Café in the Evening* (Appendix III, fig. 11), which Caillebotte acquired and lent to the 1877 exhibition. It is interesting and perhaps not coincidental that Caillebotte

ing circle) makes it equally difficult to see these images as photographic slices of life, as keyhole glimpses of objectively viewed scenes. By placing men in the same space occupied by women, Caillebotte created interiors that are experienced quite differently from those paintings by Cassatt and Morisot depicting feminine rituals (dressing, bathing, taking tea, tending to children, etc.). The tension created by Caillebotte's opposition of men and women seems intentional, inherent in the implied narrative, and achieved not only by the subversion of gendered spaces, but by the subversion of the male gaze, and by extension, the empowerment of the feminine subject.

Caillebotte's picture of a young woman at her dressing table (cat. 82, fig. 2), probably painted around 1880, makes an interesting comparison with contemporary images of women by Degas and Morisot putting on make-up or getting dressed (see fig. 12). Degas's women, often seen from the back, are objectified females by and for the masculine viewer.[83] Morisot and Caillebotte, however, presented the autonomous and practical feminine experience of dressing at the mirror. Although the women are shown looking into an object associated with feminine preening and vanity, their expressions only reinforce the noneroticized and introspective nature of their activity.

Caillebotte's other genre pictures executed in the early 1880s mediate between the feminine and masculine not only through the subject, but also through the way the subject is viewed. The compositions and subjects show a certain sensitivity to the feminine viewpoint. In *Nude on a Couch* (cat. 82), a large canvas he never exhibited, Caillebotte further explored the visualization of an intimate feminine experience. The idea

Figure 12. Berthe Morisot (1841–1895). *Psyche,* 1876. Oil on canvas; 65 × 54 cm. Fundación Colleción Thyssen-Bornemisza, Madrid.

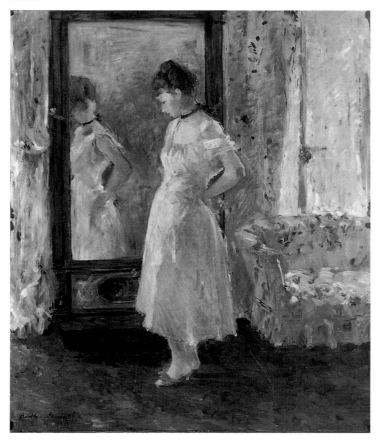

of a naked woman in a particular location—"in bed, for example, or in the bath, or in the anatomy theater"—was a theme that Baudelaire had recommended in his Salon review of 1846 to show the new "modern beauty."[84] But Caillebotte went beyond Baudelaire's prescription. Although his naked female is shown on a couch associated with sex, not love,[85] she is devoid of erotic overtones or the idealized beauty of Baudelaire's Parisienne. Although there are pictorial anecdotes—discarded clothing, shoes, a sleeping or unconscious woman on a floral-print couch—the reading is made problematic by the way these elements are handled.[86] Unlike the Realist program adopted by Degas, who reminded himself to "include all types of everyday objects positioned in a context to express the *life* of the man or woman—corsets that have just been removed, for example, and that retain the shape of the wearer's body,"[87] Caillebotte's undifferentiated mass of quite ordinary clothes provides no clue to an identification of the nude model.

Despite her vulnerability, this nude disturbs rather than invites. The painting most closely related to this near-clinical treatment of the female body is Gauguin's large-scale picture of a nude woman sewing, exhibited at the 1881 Impressionist exhibition (from which Caillebotte abstained) as *Nude Study* (fig. 13). But Gauguin's nude is "of our own times," as Huysmans glowingly described her, "a girl who does not pose for spectators, who is neither lewd nor affected, who very nicely busies herself with repairs to her old clothes."[88] Caillebotte's nude has no recognizable, gender-appropriate task with which to busy herself. By breaking with the nude as a sign of masculinity and a visual commodity created by the male for the delectation of the male gaze, Caillebotte revealed again his dualism in what can only be termed as an identification with the feminine.

Caillebotte's challenge to the male gaze is all the more flagrant in the large picture of the standing male nude drying himself and the unfinished work of a seated male nude drying his leg (cat. 83 and fig. 14). In these paintings Caillebotte focused on what is either a dressing room or bathroom, both of which traditionally were reserved for feminine activities of washing, dressing, and putting on make-up. But these nude men are not just toweling off after a bath. They have taken a bath that Caillebotte has witnessed, or staged to look as if he had done so, and are now being observed by the male onlooker. If the female body was the territory of modernity as a sign of male sexuality, what is one to make of Caillebotte's naked males which break iconographically and ideologically from the norms of nineteenth-century art and literature? Who were these men? Were they friends of the artist or part of his household staff? Was Caillebotte, like Cassatt, who used her boatmen and domestics as models, depicting his employees?[89] Whereas Degas's peephole glimpses of bathing prostitutes and their maids (to which he occasionally added the figure of the male admirer) image the acknowledged imbalance of power between the sexes and classes, Caillebotte's solitary males, engaged in toweling themselves after a bath within his boulevard Haussmann apartment, are disturbingly unplaceable. Like the figure in *Nude on a Couch*, the larger standing male nude is rendered with a detached accuracy, so that he is sexualized, but not eroticized. Similar too are his discarded boots, the brown heap of clothing on the chair, and the twisted towel which, like the woman's boots and dress, reinforce the quotidian quality of this scene and the fact that these people have only recently undressed. But while the female nude evinces vulnerability through her awkward pose, defensive gesture, and impenetrable, but decidedly withdrawn, expression, Caillebotte's

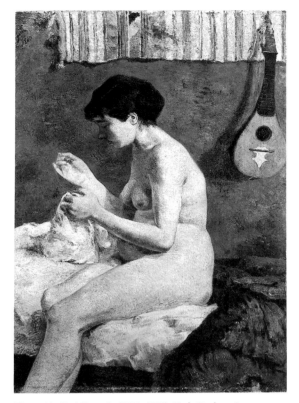

Figure 13. Paul Gauguin (1848–1903). *Nude Study* or *Suzanne Sewing*, 1880. Oil on canvas; 111.4 × 79.5 cm. Ny Carlsberg Glyptotek, Copenhagen.

male assumes a gladiatorlike stance, his muscular body tense with the exertion of his exercise. Caillebotte's robust painting style and subtle modulations of blue and brown negate the tactile qualities associated with the academic nude and with bourgeois attitudes towards the nude, which would mediate the shock-value of the confrontation with the backside of a naked male. Moreover, in stripping him of his clothes and displacing him from his (masculine) environment, Caillebotte subverted Duranty's prescription for modern painting and challenged the male gaze.

After his definitive move to Petit Gennevilliers, Caillebotte focused more insistently on the landscape, on the garden on his estate, and on his greenhouse. With the garden as backdrop, he painted females alone (see fig. 8) and together (see Berhaut 1994, no. 460) engaged in activities of admiring flowers, reading, and sewing—activities both gender-appropriate and Impressionist in spirit. His brushwork became looser, and the figure more physically integrated into the surface treatment. In many ways, Caillebotte's pictures from the late 1880s and 1890s embrace the qualities of spontaneity, the fleeting moment, and the fluttery surfaces characterizing Impressionism in the 1870s. Paralleling the increase of Caillebotte's interest in painting out-of-doors was his diminished narrative content. His images of women out-of-doors are devoid of the tension and, indeed, the psychological ambiguity of the interiors from the 1870s and 1880s that Huysmans found so compelling as documents of modernity.

For it was in his pictures of urban private space, where Caillebotte worked within the boundaries of his bourgeois existence, showing well-dressed men and women in well-furnished interiors, that he disrupted the ideological as well as visual preconceptions regarding the domestic realm. Like a Naturalist novelist, Caillebotte opened up the private, interior world to public scrutiny, sometimes on a monumental scale. These interiors reveal a different gendering of spaces, where the man is absorbed into the domestic sphere and where the woman is not a mere decorative motif. Although Caillebotte painted mostly male society, his paintings indicate his identification with women as autonomous beings whose lives were intertwined with, rather than dependent upon, the male. Perhaps his most exciting works are those in which men and women are paired or mixed equally in the street or in the interior, and where there is an aesthetic reconciliation between the genders in pictures that challenge the spaces associated with modernity. G. G.

Figure 14. Gustave Caillebotte. *Man Drying His Leg*, c. 1884. Oil on canvas; 100 × 125 cm. Private collection, on loan to The Art Institute of Chicago (32.1989).

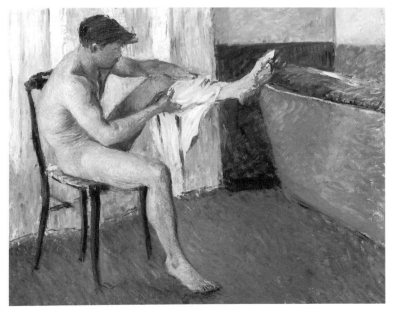

NOTES

1 Olby 1876.

2 Porcheron 1876.

3 See Charry 1882; and the entry on *The Bezique Game* (cat. 80).

4 See, for example, Mantz 1880, in which he suggested that Caillebotte deliberately denied scientific perspective.

5 Delaville 1880, reviewing the 1880 exhibition, where Caillebotte showed his two interiors (cats. 63 and 77). For a contemporary assessment, see Russell 1966, p. 23.

6 See Pollock 1988, pp. 51–55, and 205 n. 5; and Herbert 1988, pp. 28–32.

7 See Ephrussi 1880. Morisot was also frequently compared to Jean Honoré Fragonard and the eighteenth-century Rococo painters. See, for example, Burty 1880, and Mantz 1880. Burty also connected the success of women Impressionists with the fact that Impressionist art seems "feminine" in spirit: "One might be prompted to remark, in comparing these carefully executed pieces with the lively works by Mlle Berthe Morisot, that women triumph in what is called 'Impressionism.' At the least they extract from it a formula thoroughly impregnated with feminine grace" (Burty 1879, p. 3).

8 Zola 1876a.

9 Blémont 1876.

10 Pollock 1988, p. 70. Pollock discussed the works of Morisot in relation to the specific social conventions for bourgeois women in the Third Republic. Their behavior was regulated in the private as well as the public sphere, into which they were only partially allowed (pp. 69–71). Modern space, then, was that which blurred social divisions, "where the fields of the masculine and feminine intersect and structure sexuality within a class order" (p. 70).

11 As pointed out by Wolff 1985, pp. 37–48. See also K. Adler, "The Suburban, the Modern and 'Une Dame de Passy,'" *The Oxford Art Journal* 12, 1 (1989), p. 3.

12 On the parallels between the interior and the street as sites of conflict, see Perrot 1990, vol. 4, p. 346. The quintessential literary example of the home as battleground is Zola's *Pot-Bouille* (1882).

13 Perrot 1990, vol. 4, p. 343, cited as well the installation of "The Home through the Ages" in the Paris Universal Exhibition of 1889.

14 For recent studies of the phenomenon of "interiority" and its ramifications on the decorative arts, especially Art Nouveau, see D. L. Silverman, "The Paris Exhibition of 1889: Architecture and the Crisis of Bourgeois Individualism," *Oppositions* 8 (spring 1977), pp. 72–91; and N. Troy, *Modernism and the Decorative Arts in France* (New Haven and London, 1991), pp. 7–12.

15 "The redefinition of the interior world by psychological categories transposed the meaning of private space in an unprecedented and quintessentially modern way. For if the late nineteenth century produced the possibilities for a dynamic and collective existence, the space and setting of mass man, it also gave birth to the triumph of the psychological man, whose liberty and isolation were heightened by the monumental configuration emerging in the metropolis" (Silverman 1989, p. 10).

16 H. Baudrillart, *La Famille et l'éducation en France dans leurs rapports avec l'Etat et la société* (Paris, 1874), p. 44. Baudrillart expressed moderate political views in his preface (p. xi): "It will be readily apparent that the author of these studies remains *impervious to the influence of what is called sectarianism or partisan spirit*; he has but one aim in these objective explorations: social improvement, the rebuilding of France by means of *those two great forces*" [my emphases].

17 G. Le Play, *La Réforme sociale*, 1872 (1st ed., 1864), p. 189, cited in Baudrillart (note 16), p. 95.

18 In *L'Art dans la maison* (Paris, 1884) Henry Havard, scholar and inspector of fine arts, praised the eighteenth century as the golden age of interior design and the applied arts. In 1891 the government adopted his book as the official decoration handbook of the Third Republic (see Silverman 1989, p. 141). For the importance of the Goncourt publication, see ibid., pp. 18–37; on the periodical *Revue des arts décoratifs*, see ibid., pp. 112–116.

19 Ward 1991, pp. 599–622.

20 Burty 1877, cited in ibid., p. 604.

21 By the mid-1880s, the Central Union's publicists, Burty and Louis de Fourcaud, were calling for the government to support the union's developing program to revitalize the crafts through nationalism, and for a return to nature as a source for inspiration. For the emergence of a crafts aesthetic bolstered by Republican support but irredeemably elitist in concept, see Silverman 1989, pp. 110–41; on Burty as an amateur-collector, see ibid., pp. 127–31.

22 For Impressionist framing practices, see Ward 1991, pp. 610–613 and 619–620; and I. Cahn, "Les Cadres impressionnistes," *Revue de l'art*, 2d trimestre (1987), pp. 57–62.

23 Caillebotte was to be reimbursed for his expenses from the admission fees (fifty centimes, or about five dollars; see Brettell 1986, p. 191).

24 Room one, for example, contained intimate subjects—figures, interiors, and portraits—by Caillebotte, Monet, and Renoir. Degas's works on paper were hung in the last and smallest of the five rooms (see Brettell 1986, pp. 194–97).

25 See Chronology for examples of the Caillebottes' piety, among which is the stained-glass window dedicated by the "Caillebotte brothers" in the church of Saint-Georges-de-la-Villette (30 May 1875), and the trust they established for the same church to provide for Mass to be said in the memory of deceased family members (18 July 1879). One of the five bedrooms in the rue de Miromesnil residence was listed as having a "Christ in bronze and black wood" ("chambre H," item no. 37, in Poletnich 1878a).

26 See Berhaut 1978, p. 7. Béraud studied in the studio of Léon Bonnat from 1870 to 1873, thus overlapping with Caillebotte's tenure there. The Caillebottes had built another residence, on rue de Lisbonne, in which they rented rooms. See A. Daumard, *Les Maisons de Paris et les propriétaires au XIXe siècle* (Paris, 1956), for a discussion of Parisians building apartment houses: "rich capitalists or groups of investors, or more rarely single individuals disposing of more or less large sums"; this is translated in H. Lipstadt, "Housing the Bourgeoisie: César Daly and the Ideal Home," *Oppositions* 8 (spring 1977), p. 43.

27 For the disposition of the other floors in the rue de Miromesnil home, see Chronology, 1866. Indeed, the Caillebottes' Paris residence was decidedly restrained in comparison with the older house at Yerres, which was decorated with landscapes painted by Corot and Barbot, and included a white and gold salon with iconic columns and painted allegorical figures (see ch. 2 intro.).

28 On *Portraits in an Office* (New Orleans), see C. Armstrong, *Odd Man Out: Readings of the Work and Reputation of Edgar Degas* (Chicago and London, 1991), pp. 27–38. While Caillebotte was not opposed to involving himself in the "business" of art insofar as the Impressionist exhibitions were concerned, he was reluctant to have his name linked with money. He rarely bought at auction (and then only to boost his friends' sales), preferring private transactions. His financial aid to the group included his subsidization of the 1877 exhibition, his purchase of the artists' works, and his paying the rent for Monet's studio apartment on rue de Moncey, and later on rue Vintimille. See Chronology, 1877–81.

29 Caillebotte painted one other known portrait of Jean Daurelle (Berhaut 1994, no. 352), in addition to two pastel portraits of Daurelle's son, Camille, which he exhibited in the Impressionist exhibition of 1880 (as nos. 14 and 15; see Berhaut 1994, nos. 69 and 70).

30 This may also be a comment on René's occupationless existence. The declaration of Martial, senior, for example, lists among his accounts some 13,327 francs advanced to René, the only son listed as "without profession" (see Poletnich 1878b).

31 The same transformation of the familiar into the strange can be seen in Monet's depiction of his son, Jean, and of his wife, Camille, barely visible at the left in the foyer of their house at Argenteuil, *Apartment Interior* (Appendix III, fig. 23). Caillebotte acquired this painting at the end of 1876 and lent it to the Impressionist exhibition of 1877.

32 The crystal portrayed was undoubtedly part of the 300-piece service of cut glass in a diamond pattern purchased by Mme Caillebotte (see ch. 2 intro.). On the notion of modernity and human spatial relationships, see J. A. Richardson, "Estrangement as a Motif in Modern Painting," *The British Journal of Aesthetics* 22, 3 (summer 1982), pp. 195–210.

33 Supposedly, Bonnat's *Portrait of the Artist's Family* (1853; Musée Bonnat, Bayonne), a pyramidal composition in closely hued values with a severity verging on melancholy, hung in his studio on rue Lancrey, where Caillebotte studied from 1872 to 1876 (see Luxenberg 1991, p. 264). There are many similarities between what was written of Bonnat's painting style and that of Caillebotte, in terms of figural types, diffused lighting, and even brushwork, which critics referred to in Bonnat's works as "well carpentered" *("charpenté")* (Luxenberg 1991, p. 119), and in Caillebotte's as "masonry" *("maçonnerie")* (Duranty 1879).

34 Hepp 1882.

35 Montjoyeux 1879.

36 A. Lagarde and L. Michard, *XVIIe Siècle* (Paris, 1970), pp. 8–9: "Cultivated without being pedantic, distinguished without being precious, pondered, measured, discreet, attentive [but] without insipidity, without boasting, the *honnête homme* is characterized by an elegance that is simultaneously exterior and ethical."

37 Caillebotte received revenues totaling 700,000 francs, a considerable sum when compared to the total of 450,000 francs received for the sale of the family residence on rue de Miromesnil. See Chronology, 3 June 1879. The adjacent apartment buildings at 15, rue de Lisbonne, and 8, rue Corvetto, were given to Abbé Alfred Caillebotte. See Chronology, Jan. 1866 and Jan. 1879.

38 There was no dramatic break with family traditions, however, and Caillebotte seems to have settled immediately into the new living arrangements with Martial. Apart from one trip to London before the opening of the fourth Impressionist exhibition, in April 1879, Caillebotte remained in Paris until his move to Petit Gennevilliers nine years later.

39 The Caillebottes had inherited much of the heavy Second Empire furniture from their purchase of the furnished home at Yerres (see ch. 2 intro.).

40 Apparently, this piece of furniture was in Caillebotte's studio before being brought into one of the public rooms (see cat. 87).

41 With the exception of Martial, who features prominently as one of the players in *The Bezique Game* (cat. 80), Caillebotte seems not to have painted family members after moving to the boulevard Haussmann apartment in 1879. In the *Portrait of Eugène Daufresne* (fig. 3), exhibited at the fourth Impressionist exhibition, in 1879, Caillebotte depicted his mother's cousin in the same small salon in which he portrayed his mother (cat. 73).

42 Anonymous 1879b.

43 Although Caillebotte's studio on the fourth floor (converted after the death of his father in 1874) was undoubtedly spacious enough to accommodate the monumental scale of his street paintings (cats. 29 and 35) and had a separate entrance, the artist may have found it awkward to bring in models or friends, or thought the atelier lacked the necessary domestic trappings and refinement.

44 Castagnary 1892b, p. 56, in praise of Jean Jacques Henner.

45 See, for example, Castagnary 1892a, p. 10, on the portraits by Mlle Jacquemart, which he described as "real" but not "true"; and Castagnary 1892c, p. 153: "Look at this portrait of Mme H., modeled from the front with an infinite gentleness. How [strongly] one senses that it is a good resemblance! Still more, how [strongly] one senses that it is true!" Emile Auguste Carolus-Duran was often criticized for not emphasizing the costumes of his sitters in order to reflect their social station. For Castagnary's opinion of Carolus-Duran's portrait *Woman with a Glove* (1869; Musée d'Orsay, Paris), see Castagnary 1892a, p. 25: "In 1869, in the portrait of this tall young woman in formal dress adjusting her gloves as she goes out, his genre was still bearable; defying the figure's elegance and the accuracy of her gait, one forgot the scrupulous attention paid her clothing. But it was inadvisable to pursue this path any farther." See also his complaint about another female portrait by Carolus-Duran (Castagnary 1892c, p. 164): "In the *Portrait de Mme . . .* , the face is killed by the armchair, the armchair by the curtain."

46 These were the only two portraits by Degas titled by name instead of by the generic designation, *Portrait*. The artist's specificity was probably due to the fact that the sitters were men who had written favorably about his works.

47 Duranty 1876; repr. and trans. in San Francisco 1986, pp. 481 and 43–44, respectively. See also Degas 1988, no. 198, p. 310.

48 Huysmans 1883, p. 117; trans. in Degas 1988, no. 197, p. 309.

49 Duranty 1876; repr. and trans. in San Francisco 1986, pp. 481 and 43–44, respectively.

50 Ephrussi 1880.

51 Duranty 1879. Duranty's criticism had to do not only with specific physiognomic likeness, but the tightly compressed composition and thick paint application, which he termed, "tenacious masonry" (*"maçonnerie acharnée"*).

52 Bertall 1879b.

53 See Luxenberg 1991, pp. 145–48.

54 Bertall 1879b.

55 D. Halévy, ed., "Les Carnets de Ludovic Halévy," pt. 3, *La Revue des Deux Mondes* 37 (15 Feb. 1937), p. 823; trans. in Degas 1988, no. 166, p. 279.

56 Huysmans [1880] 1883, p. 109.

57 See Huysmans [1880] 1883, p. 125: "Mlle Cassatt et Mme Berthe Morisot. . . . Here it is still the bourgeoisie, but it is no longer that of M. Caillebotte; it is a prosperous world, but more refined, more elegant."

58 The women painted by Cassatt in *Five O'Clock Tea* (1880; Museum of Fine Arts, Boston) were said to be, like her, "well-born." See also Burty 1879 for the critic's comments on Cassatt's "society women."

59 Montjoyeux 1879.

60 For example, we know nothing of the servants Caillebotte and his brother Martial undoubtedly employed, although the portraits of Daurelle and his son, executed after the move to boulevard Haussmann, indicate that the family steward remained in contact, and perhaps continued his employment with them.

61 See also the entry on *Nude on a Couch* (cat. 82) for further speculation on her relationship with Caillebotte.

62 While marriage under the age of twenty-five was not permitted without parental consent, late marriages point to an authoritarian family structure, a structure that "yields large numbers of bachelors, who live all their lives as grown-up children or eternal uncles in the families of their married brothers or sisters" (see H. Le Bras and E. Todd, *L'Invention de la France* [Paris, 1981], p. 28, as cited in Perrot 1990, p. 182.

63 McMullen 1984, p. 264.

64 Unlike Degas's well-recorded barbs against women, and women artists in particular (he remarked that Morisot painted pictures "the way one would make hats"), or those of Renoir, whose opinions of women as decorative objects and dolls are equally associated with his art, we know little about Caillebotte's opinions on the subject. It is true, however, that although he included Morisot in his will (see Introduction), he did not collect any of her paintings.

65 Mallarmé 1876 in San Francisco 1986, p. 30. Monet may have painted this in reaction to Théodore Duret's 1879 Salon review, in which he praised Alfred Stevens's paintings of solitary female figures as dolls without personality (see Stuckey and Scott 1987, p. 37).

66 Duranty 1876, repr. and trans. in San Francisco 1986, pp. 481 and 44, respectively.

67 Huysmans [1880] 1883, p. 288.

68 Ibid., p 110. In *En Ménage*, André acknowledged the biological and social laws thwarting the realization of domestic harmony: "It is perhaps droll to hold women in contempt, but as one can't do without them. . . . "; see C. Lloyd,

J.-K. *Huysmans and the* Fin-de-Siècle *Novel* (Cambridge, 1990), p. 80. Huysmans [1880] 1883, p. 107. Huysmans noted that Pissarro was also afflicted by a "blue-mania," which Paul Smith has linked to the artist's (subconscious) expression of a political ideology (see P. Smith, "'Parbleu': Pissarro and the Political Colour of an Original Vision," *Art History* 15, 2 [June 1992], p. 235).

69 One critic likened the man in the smaller interior to a "Huret doll," after the latex dolls with porcelain heads that could be moved in any position (see C. Sézan, *Les Poupées anciennes* [Paris, 1930], p. 79). Even the man's reclining posture, a sign of passivity and effeminacy, may have been offensive, judging by the uproar created by the painting Paul Mathey exhibited in the Salon of 1876, described by Castagnary as showing a man "lying on a sofa, in an unembarrassed pose that quite scandalizes visitors" (Castagnary 1892d, p. 242).

70 See, for example, the subtitles for the chapter entitled "La Bourgeoisie Parisienne," in O. Uzanne, *Etudes de sociologie féminine* (Paris, 1910), pp. 336–56: "Her occupations, her shopping, her taste in toiletries, her visits and promenades, her evenings at the theater."

71 See Silverman 1989, especially pp. 66–69. It should be noted that Caillebotte's mother was only the owner through usufruct of her husband's property.

72 Silvestre 1879, trans. in San Francisco 1986, no. 72, p. 277.

73 Mont 1880: "It seems he's attracted by all that is awkward, ugly, and common. This preference for stupidity is an exasperating thing."

74 Véron 1880, pp. 92–94: "A fat woman with purplish-red cheeks"; and Goetschy 1880: "afflicted by inflammation."

75 Huysmans 1883, p. 110: "I also recommend to all painters who have never been able to render the sophisticated complexion of Parisian women the extraordinary derm of this one, a derm that's worked to a velvety surface but not made up. . . . In this household there is none of the makeup used by actresses and prostitutes, rather the simple compromise adopted by many bourgeois women who, without painting themselves like them [i.e., actresses and prostitutes], vary the color of their skin with bismuth powder, tinted pink for blonds, 'Rachel' for brunettes."

76 A. P. 1877, cited in H. Clayson, "The Sexual Politics of Impressionist Illegibility," in Kendall and Pollock 1992, p. 68.

77 Flor 1880. On the significance of unaccompanied women in cafés, see T. A. Gronberg, "Les Femmes de brasserie," *Art History,* 1984, p. 7; and Clayson (note 76), esp. pp. 69–70; and Pollock 1988, p. 74.

78 Mantz 1880: "He [Vidal] observes and he sees accurately." Jules Michelet formulated a similar assessment in *La Femme* (1859; repr. Paris, 1981), cited in McMullen 1984, p. 265.

79 See Pollock 1988, p. 87.

80 Ibid., p. 82.

81 On the association of Degas's painting with the Naturalist novels *Thérèse Raquin* and *Madeleine Férat,* see Reff 1987, pp. 200–38; and S. Sidlauskas, "Resisting Narrative: The Problem of Edgar Degas's *Interior,*" *The Art Bulletin* 75, 4 (Dec. 1993), pp. 671–95.

82 Caillebotte appreciated Flaubert's letters (notably those to George Sand). While he admired his craft as a writer, he found him "non-Olympian" in scope and spirit. See letter from Caillebotte to Monet, 18 July 1884, and Gustave Geffroy's remembrances of Caillebotte as a "great reader of books, magazines, and newspapers" in Berhaut 1994, letter 32, p. 277. On the library of Caillebotte's father, which included over 832 titles, see ch. 2 intro.

83 See R. Thomson, "On Narrative and Metamorphosis in Degas," in Kendall and Pollock 1992, p. 148. For a similar, objectified image of a woman's corseted backside, see Manet's *Before the Mirror* (1876; Solomon R. Guggenheim Museum, New York).

84 C. Baudelaire, "Salon de 1846," cited and trans. in K. Adler and T. Garb, *Berthe Morisot* (Ithaca, 1987), p. 98.

85 See R. Thomson, *Degas: The Nudes* (London, 1990), pp. 65 and 146.

86 Caillebotte's nude, for example, is definitely corsetless.

87 T. Reff, *The Notebooks of Edgar Degas* (Oxford, 1976), vol. 1, notebook 30, p. 134 (Bibliothèque Nationale, Paris, notebook 9, p. 208).

88 Huysmans 1883, p. 240, trans. in Washington, D.C., National Gallery of Art, et al., *The Art of Paul Gauguin,* exh. cat. (1988), no. 4, pp. 21–22.

89 At Petit Gennevilliers, for example, Caillebotte employed "a maid, a cook, two domestic servants, and two sailors." See Chronology, 1891. On Cassatt's male models, see Pollock 1988, pp. 88 and 207 n. 5.

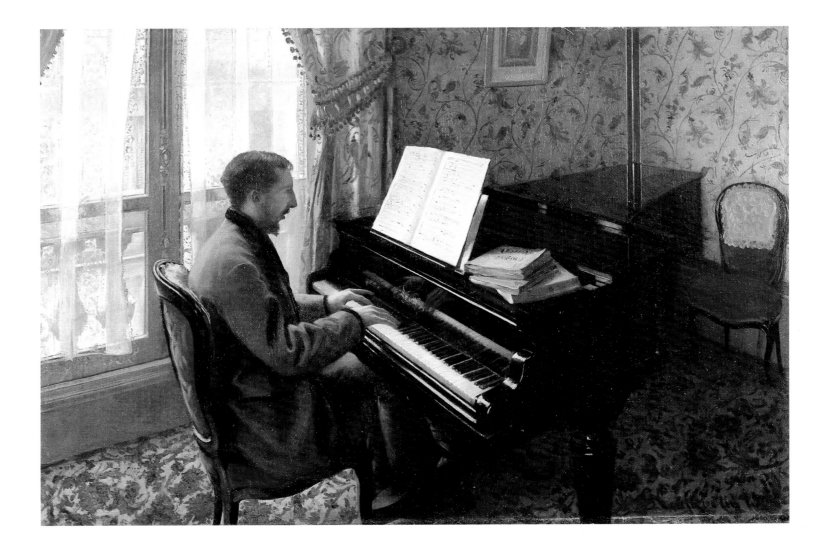

71
Young Man Playing the Piano

(Jeune Homme jouant du piano)

1876

Oil on canvas

80 × 116 cm

Signed and dated lower right:
G. Caillebotte 1876

Berhaut 1978, no. 30; Berhaut
1994, no. 36

Private collection

Principal Exhibitions
Paris 1876, no. 19; New York 1886,
no. 28; Paris 1894, no. 43; Paris
1921, no. 2704; Paris 1951, no. 6;
Houston and Brooklyn 1976–77,
no. 13; Pontoise 1984, no. 4.

Contemporary Criticism
Bertall 1876b; Blémont 1876;
Boubée 1876; Burty 1876b;
Chaumelin 1876; Enault 1876;
Lostalot 1876a; Olby 1876;
Porcheron 1876; G. Rivière 1876.

Selected Bibliography
Thiebault-Sisson 1894; Bernac
1895, p. 310; Berhaut 1968, p. 22;
Berhaut 1978, pp. 8, 30, and 37;
Varnedoe 1987, no. 12; Balanda
1988, pp. 68–69; Chardeau 1989,
pp. 26–29.

After the *Floor-Scrapers* (cat. 3), Caillebotte's picture of his brother Martial playing the piano in the rue de Miromesnil apartment was the most talked-about and critically favored of his six entries to the 1876 Impressionist exhibition. The critic Philippe Burty called the painting "marvelous in [its] sincerity," and praised Caillebotte's submissions as being honest (and therefore not suitable for the official Salon) and showing a "faithful representation of life as it expresses itself in the functions of labor, and of the members when modified by the *constant pursuit of some one particular occupation*" [my emphasis].[1] For Caillebotte's subject here is leisure, but leisure pursued with absorption and effort. It follows Edmond Duranty's prescription for the subjects of "The New Painting," which includes depicting an individual "at a piano, examining a sample of cotton in an office, or waiting in the wings for the moment to go onstage, or ironing on a makeshift table. He will be having lunch with his family, or sitting in an armchair near his worktable, absorbed in thought."[2] Caillebotte's subject concentrates as hard on the pursuit of leisure as his floor-scrapers do on their work.

The title, *Young Man Playing the Piano*, further suggests genre painting rather than portraiture. The similarity in titles and the identically sized canvases indicate that this may be the horizontal pendant to the vertical *Young Man at His Window* (cat. 59), in which Caillebotte depicted his youngest

Figure 1. Pierre Auguste Renoir (1841–1919). *Woman at the Piano*, 1875. Oil on canvas; 93.2 × 74.2 cm. The Art Institute of Chicago (Mr. and Mrs. Martin A. Ryerson Collection, 1933.1025).

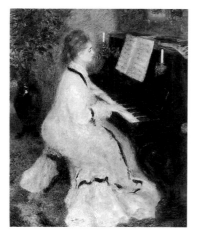

brother, René. For critics such as Alfred de Lostalot, who complained that the Impressionists were against anything "taught" and that they insisted absolutely on the "effects" over the "material practice," Caillebotte was "the real success" of the exhibition. As with the *Floor-Scrapers*, which served metaphorically to image the artist as craftsman and the maker of hand-crafted paintings, *Young Man Playing the Piano* evokes the métier of the musician. If in the *Floor-Scrapers* the act of scraping down the floor serves as a metaphor for the artist painting, and in *Young Man at His Window* the view framed by the window symbolizes the artist's canvas, so, too, the keyboard from which the pianist chooses notes to make his art could be a subtle reference to the artist's craft.

Although Martial composed music (said to be "Wagnerian" in style), neither pen nor ink nor handwritten musical notations are included to suggest this talent. Caillebotte does not present Martial as a creator, but as a "student of Marmontel," as one reviewer described him, referring to the celebrated composer and professor at the Conservatoire whose works were published in volumes resembling those stacked on top of the piano in this painting.[3] Perhaps because its subject is male, *Young Man Playing the Piano* was perceived differently from Renoir's *Woman at the Piano* exhibited that same year (fig. 1). Although the visual information is similar (a person playing the piano within a compressed domestic interior), the assumption was that Renoir's female piano player was indulging in a pastime, one of the requisite accomplishments of the well-educated and upper middle-class woman. Caillebotte's piano player, however, was perceived as a "student," a more serious occupation, and, like the female pupil in his painting *The Piano Lesson* (cat. 81), was perhaps intended to be read as an individual working at leisure. G. G.

1 But Burty also referred to the piano player as "her," indicating a misspelling or the fact that he had not seen the painting (see Burty 1876b).

2 Duranty 1876; repr. and trans. in San Francisco 1986, pp. 482 and 44, respectively.

3 Varnedoe 1987, p. 64. For "student of Marmontel," see Enault 1876.

72
Luncheon

(Déjeuner)

1876
Oil on canvas
52 × 75 cm
Signed and dated lower right:
G. Caillebotte 1876
Berhaut 1978, no. 32; Berhaut
1994, no. 37

Private collection

Principal Exhibitions
Paris 1876, no. 21; Paris 1951, no.
8; Chartres 1965, no. 1; London
1966, no. 4; New York 1968, no. 4;
Houston and Brooklyn 1976–77,
no. 14; Marcq-en-Baroeul 1982–
83, no. 5; Pontoise 1984, no. 5.

Contemporary Criticism
Bertall 1876a; Olby 1876;
Porcheron 1876.

Selected Bibliography
Anonymous 1966; Russell 1966,
p. 23; Berhaut 1968, p. 24; Pincus-
Witten 1968, pp. 55–56; Werner
1968, p. 42; Varnedoe 1976, p. 98;
Berhaut 1978, pp. 7, 30, and 37;
Nash 1984, pp. 19–20; Varnedoe
1987, no. 13; Balanda 1988, pp.
72–73; Chardeau 1989, pp. 30–35;
Wittmer 1990, p. 271.

Caillebotte's painting of his mother, his broth-er René, and the family butler in the dining room of the rue de Miromesnil home completes the painted trilogy of family life that he exhibited in 1876 (see cats. 59 and 71). Perhaps because of its traditional genre subject and its smaller scale, *Luncheon* did not receive the critical attention of the two larger scenes in the series. Compared with the three luncheon scenes on view at the 1876 Impressionist exhibition—Morisot's *Luncheon on the Grass* (1875; private collection), Renoir's *Luncheon at the Restaurant Fournaise* (possibly the painting known as *The Rowers' Lunch*, 1875–76; The Art Institute of Chicago), and Monet's large decorative panel *The Luncheon*, acquired by Caillebotte for his own collection (see Appendix III, fig. 22)—this stifling *haute bourgeois* interior must have seemed out of step with the *plein air* painting associated with the Impressionist enterprise.[1] Whereas Renoir depicted his friends enjoying the nourishment of food and companionship and Monet the quiet aftermath of a picnic in the garden, Caillebotte painted an almost painful ritual in progress, within a gloomy and heavily furnished dining room presided over by Mme Caillebotte. Indeed, Caillebotte arranged the crystalware on the table in a straight line leading to the mistress of the house. Set against a background of a blackwood buffet flanked by three chairs-in-waiting and windows whose drapes form arches that admit the filtered noonday sun, Mme Caillebotte resembles a matronly Madonna in a Gothic altarpiece. The artist's own place opposite her, however, marked by the half-moon of the china plate and the knife tilted on its rest, is empty.[2]

Just as in the carefully constructed composition of his brother Martial practicing the piano (cat. 71), Caillebotte painstakingly detailed his family not at rest, but engaged in the activity of lunching. In accord with the critic Philippe Burty's comment on Caillebotte's showing his subjects "in the constant pursuit of some one particular occupation,"[3] René industriously cuts his meat, oblivious to the fact that his mother has not yet been served. Initially, Caillebotte depicted René reading a book at the dinner table (fig. 1)—an act that would have further underscored his self-absorption and psychological isolation from his mother. Indeed, even René's concentration on his dinner plate, rather than a

book, suggests that a feeling of distance and alienation will prevail throughout the meal. Consequently, the luncheon will not provide the spiritual nourishment and emotional fulfillment it represented in Naturalist novels (and certainly in Renoir's paintings), where it was often used as a metaphor for other appetites.[4] Food itself is nearly absent from the table, which bears a display of crystal, symbols of material rather than physical consumption.

This self-reflective picture invites speculation on the artist's nearly impenetrable biography. The comfortable material existence is countered by a prevailing malaise, a result in part of Caillebotte's distortion of the table (described by one critic as being "twelve meters long," but noted in the family inventory as a "large round table on a single pedestal leg"[5]), which distances Mme Caillebotte from her sons both spatially and psychologically. Indeed, her dominating pictorial presence—presiding over *her* dining room and *her* table—may parallel her actual place in Caillebotte's life at a period when he was struggling to balance his own *haute bourgeois* roots, his role as dutiful son, and his need to identify himself publicly as a member of the economically and socially mixed Independents. Caillebotte's painting is perhaps most closely related to Manet's psychologically charged *Luncheon in the Studio* (1868; Neue Pinakothek, Munich), in which the young protagonist turns his back on and detaches himself from both the meal and his family. Perhaps for the two artists, to paint this world was to establish some distance from it, and thus, to transcend it aesthetically.

Three years later, after the deaths of both his mother and René, Caillebotte painted the same table-setting in his new residence on boulevard Haussmann (see ch. 6 intro., fig. 2). The crystalware regimentally ordered in *Luncheon* is here displayed in an inviting circular arrangement in which fruit-dishes and the substantial bounty they hold are the compositional and thematic focus. **G. G.**

1 Caillebotte did, however, exhibit an *After the Luncheon* which has not been identified (see Berhaut 1994, no. 2; and Dax 1876).

2 The motif of an empty chair implied by the unused place setting (although red wine has been poured) had already been employed by Monet in his *Luncheon* (1868; Städelsches Kunstinstitut, Frankfurt), and the conceit of the balanced knife appeared in Manet's *Luncheon in the Studio*.

3 Burty 1876b.

4 On eating as a literary metaphor, see Christopher Lloyd, *J.-K. Huysmans and the* Fin-de-siècle *Novel* (Edinburgh, 1990), p. 76.

5 Porcheron 1876. On the Caillebottes' table, see Poletnich 1878a.

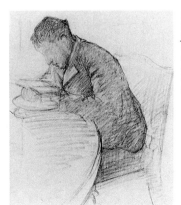

Figure 1. Gustave Caillebotte. *Study for* Luncheon, 1876. Pen and ink and charcoal; dimensions unknown. Private collection.

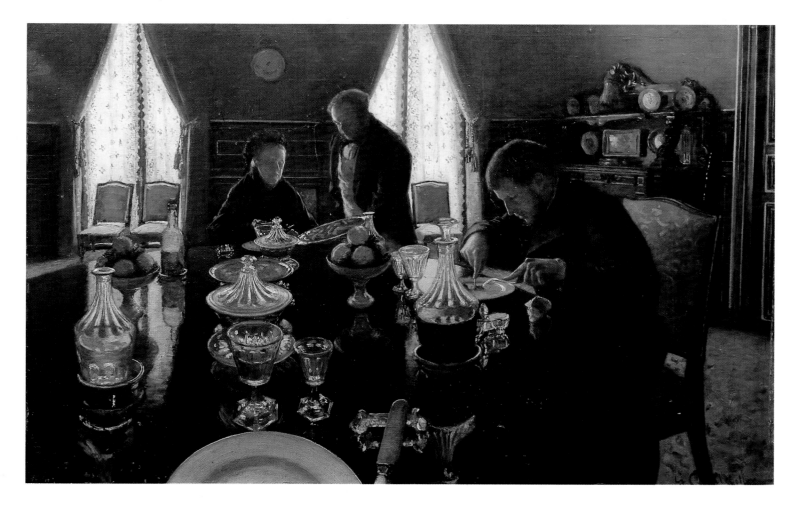

73

Portrait of Mme Martial Caillebotte

(Portrait de Mme Martial Caillebotte)

1877

Oil on canvas

83 × 72 cm

Signed and dated lower right: *G. Caillebotte 77*

Berhaut 1978, no. 53; Berhaut 1994, no. 58

Private collection

Principal Exhibitions
Paris 1877, no. 4, as *Portrait de Mme C. . . .* ; Paris 1894, no. 33; Paris 1921, no. 2701; Paris 1951, no. 14; Chartres 1965, no. 4; London 1966, no. 6; New York 1968, no. 9; Houston and Brooklyn 1976–77, no. 29; Pontoise 1984, no. 6.

Contemporary Criticism
Burty 1877; Lora 1877; G. Rivière 1877a.

Selected Bibliography
Berhaut 1968, p. 47; Berhaut 1978, pp. 7 and 52; Varnedoe 1987, no. 19; Chardeau 1989, pp. 72–75.

Despite Caillebotte's close involvement in the 1877 Impressionist exhibition, he submitted only six works, considerably fewer than any of the artists he had labored to recruit. His entries were exactly divided between the larger and more controversial street pictures (cats. 15, 29, and 35) and those showing scenes of private life (see also cat. 19 and Berhaut 1994, no. 62). For the first time, he titled works in this latter category as "portraits," instead of by the activity presented: women engaged in needlework, in the country, and in the small salon of the rue de Miromesnil apartment. Here Mme Caillebotte is clearly working on a piece of embroidery, possibly one that Caillebotte himself designed. A popular subject for writers and painters of both genders, women sewing furnished critics with a metaphor by which to refer to the artistic exigencies of finish and attention to detail—elements they felt lacking in the Impressionists' technique. "Sewing is the difficulty for the Intransigents," complained Charles Bigot on the occasion of the second exhibition, referring to what he perceived as the artists' inability to take their work beyond the stage of sketches, to paint anything other than "the distant and vague aspect of objects."[1]

In his portrait of the fifty-eight-year-old matriarch patiently "absorbed in her emboidery," as Léon de Lora put it, Caillebotte imaged a virtuous work ethic. This embodiment of familial piety and duty offered a reassuring and easily appreciated image, exuding "a tranquility full of charm."[2] The appropriateness of the subject to the setting and, by extension, its conformity with the canons of bourgeois portraiture, was noted by Philippe Burty, who lauded the work as "intelligent, tightly constructed, [truly] felt" and as meriting a medal at the Salon. Caillebotte's mother is not only absorbed in her embroidery, but also into the interior, whose material wealth is manifest. Restricting his field to a corner of the salon, Caillebotte loaded the portrait with details of his mother's affluence and taste. Just as she presided over the *Luncheon* of the previous year, here she is equally enshrined in a red-velvet armchair whose arms seem to have stretched to accommodate her figure. Framed on the right by the velvet drapes and gilt-edged table, she sits before a marble mantel adorned with a black marble clock and a sculpture, candelabra, and candlesticks of gilt bronze.[3] This visual opulence is offset by the woman's austerity, for she is dressed in a mourning gown and bonnet (for her son René) and accompanied by the tools of her labor: the sewing basket and scissors. Insofar as she is shown at work on what may be a pattern of Caillebotte's design, she is a metaphor for the artist at work, as Marie Berhaut suggested.[4] Caillebotte's duality—on the one hand, a man of leisure and wealth and, on the other, the diligent artist-worker—is reflected in his portrayal of his mother as a genteel matron whose needlework yields decorative (and, by extension, superfluous) creations, not commodities. Here Caillebotte conflated the notions of work and craftsmanship with those of volitional and elitist handiwork. His mother's dignified bearing suggests her affinities with the noblewomen who, as the writings of the Goncourt brothers made clear,[5] actively participated in the various arts of the eighteenth century. This identification and association of women with luxury crafts, an idea very much under discussion among the proponents of decorative-arts reform, may well have been in Caillebotte's mind when he conceived this portrait. G. G.

1 Bigot 1876.

2 G. Rivière 1877a.

3 For a complete inventory of these and other decorative elements in the Caillebottes' rue de Miromesnil home, see Poletnich 1878a.

4 Berhaut 1994, p. 94.

5 On the Goncourts' aesthetic preferences and eighteenth-century taste in decoration, see Silverman 1989, p. 27.

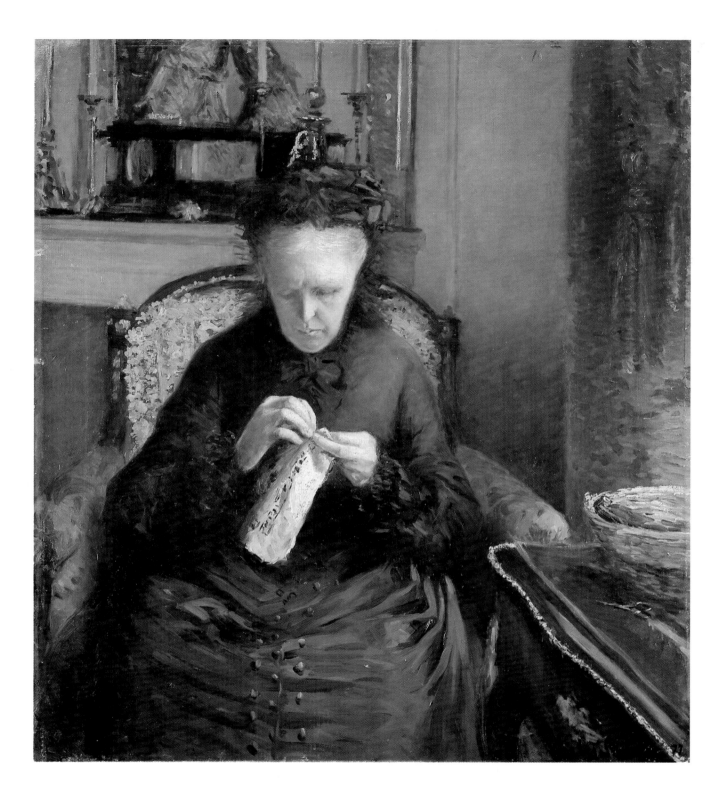

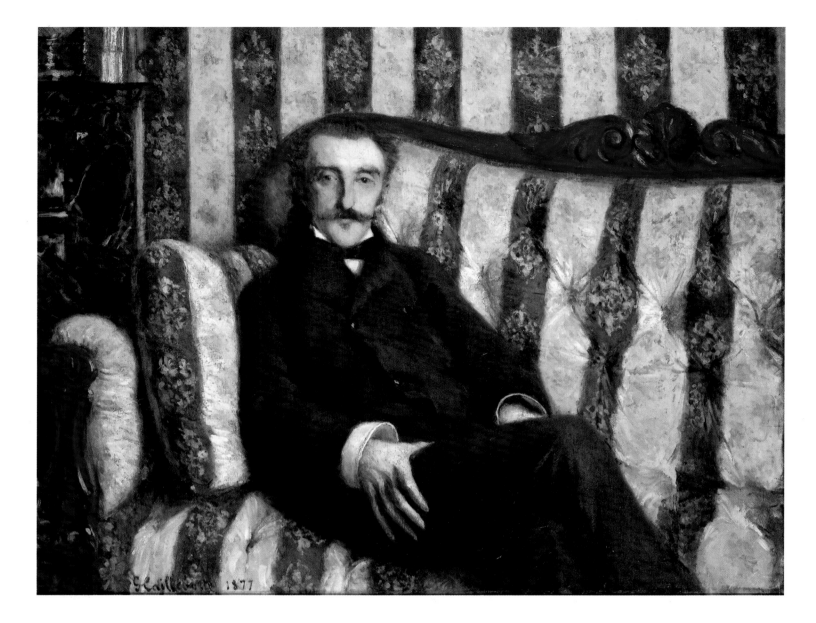

74
Portrait of a Man
(Portrait d'homme)

1877

Oil on canvas

81 × 100 cm

Signed and dated lower left:
G. Caillebotte 1877

Berhaut 1978, no. 86; Berhaut 1994, no. 60

Private collection

Principal Exhibitions
Paris 1879, no. 15, 17, or 19.

Contemporary Criticism
Bec 1879; Bertall 1879b (?); Leroy 1879.

This portrait of a man nearly subsumed by textile patterns was undoubtedly one of the works the critic Bertall referred to in his review of the 1879 exhibition, when he commented on Caillebotte's portraits of friends seated on "strange sofas, in fantastic poses."[1] The painting was satirized in Bec's caricatures of the 1879 exhibition (fig. 1). *Portrait of a Man* must therefore be one of the three portraits Caillebotte exhibited in the 1879 exhibition that have remained unidentified: *Portrait of M. F[euillerade]*. (no. 15), *Portrait of M. D.* (no. 17), and *Portrait of M. R.* (no. 19). Painted in 1877, it is one of the few portraits executed by Caillebotte before the death of his mother in 1878 that is of someone other than a family member and in an interior other than the artist's residence. Like his *Portrait of Richard Gallo* (ch. 5 intro., fig. 6), the horizontal format seems dictated by the sofa, which not only dominates but orders the composition. Caillebotte exaggerated the subordination of his sitter to the interior decor by showing him slumped into the cushions, his head barely reaching the top of the curved sofa back. Thus the artist inverted conventional gender roles by showing a male not in control of his environment, but posed as a complement to the interior decor. Manet's *Portrait of Stéphane Mallarmé* (1876; Musée d'Orsay, Paris) also shows a male seated comfortably on a printed sofa. In Manet's work, pieces of paper serve to identify the young poet, while the hazy smoke from his cigar informs his attitude of reverie and languor.

Caillebotte, too, included subtle hints as to the possible personality and profession of his prim gentleman. He may be, as has been suggested, the diminutive, well-dressed man being rowed by a muscular boatman in *Oarsmen*, also exhibited in 1879 (Berhaut 1994, no. 84). In both works, the artist's emphasis on the subject's white, starched cuffs and long, slender hands (details satirized by Bec) implies that this is a man of aristocratic bearing. In the portrait, especially, his impeccable attire, languid pose, and environment suggest his role as an amateur-collector, a scholar or connois-

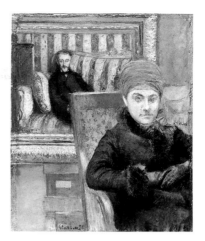

Figure 2. Gustave Caillebotte. *Portrait of Mme X . . .* , 1878. Pastel; 65 × 50 cm. Musée Fabre, Montpellier.

seur well-versed in an art period or style. A typically male preserve, the amateur-collector was one of the social "types" identified with the late nineteenth century whose influence paralleled the increasing importance of the decorative arts as a legacy of the aristocratic tradition and template for a new national style. Unlike the types presented in his portraits of Jules Richemont and Jules Dubois (cats. 75 and 86), which imaged the collective and public character of the Third Republic bourgeoisie, Caillebotte's picture of the delicate-featured man at home amidst the unified ensemble of the brocaded silk sofa and coordinating wall fabric shows the other side of the modern bourgeois, cherishing privacy and attentive to individual expression.

Portrait of a Man was discussed as one of the "thirty-five magnificently framed works" by Caillebotte exhibited in 1879.[2] It appeared again on an easel in the background of a pastel portrait of a sour-faced woman whose identity is also unknown (fig. 2). In the pastel, Caillebotte altered the benignly complacent expression of the male to one of more ominous overtones, as if to complement the narrative suggested by the imperious gaze of the turbaned sitter. G. G.

1 Bertall 1879b.

2 Ibid. The catalogue lists only twenty-three works, but Caillebotte no doubt exhibited several *hors catalogue*. Bertall's assessment, following on the heels of his remarks about Caillebotte's financial underwriting of the exhibition, must allude as much to the monetary as to the aesthetic value of the frames.

Figure 1. Bec. *There's room for one more on the sofa.— That makes it possible for the critic to settle here for a moment.—This young man dipped in blue has only one hand, M. Caillebotte. Of course you'll tell me it's big enough for two,* "Coup d'oeil sur les indépendants," from *Le Monde parisien,* 17 May 1879.

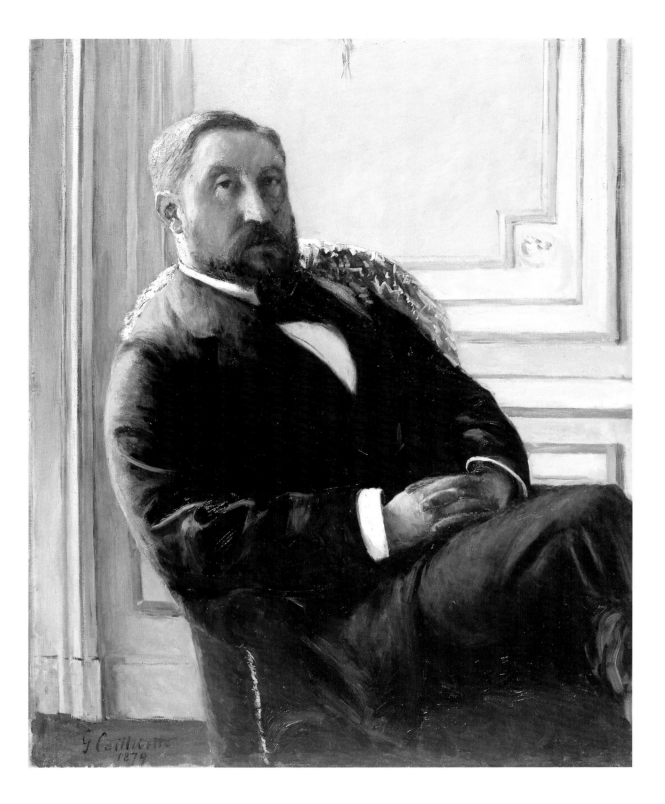

75
Portrait of Jules Richemont

(Portrait de Jules Richemont)

1879

Oil on canvas

100 × 81 cm

Signed and dated lower left:
G. Caillebotte / 1879

Berhaut 1978, no. 117; Berhaut
1994, no. 129

Private collection

Principal Exhibitions
Paris 1880, no. 7, as *Portrait de
M. J. R.*; Paris 1989, no. 59.

Contemporary Criticism
Goetschy 1880; Trianon 1880;
Huysmans 1883.

Selected Bibliography
Berhaut 1978, p. 53.

Although included in the 1880 Impressionist exhibition, this large portrait of a seated man was overshadowed by Caillebotte's interiors (cats. 63, 77, and 82), which drew the most critical attention. In general, Caillebotte's portraits provoked conflicting opinions. Marius Vachon referred to Caillebotte's crisply outlined figures as "violent brutalities," compared to the "charming" portrait of a woman by Marie Bracquemond, "in tones that are hazy and soft, enveloped in a mysteriously poetic atmosphere."[1] Charles Flor felt that Caillebotte's portaits of "cadaverous and tortured heads with green hair and blue eyes" were a deliberate subversion of natural perception.[2] Only Henry Trianon, writing for the conservative newspaper *Le Constitutionnel* (edited by Caillebotte's good friend Richard Gallo), singled out the *Portrait of Jules Richemont*, seeing in it not only the representation of a "mature man seated, without a hat, hands resting on his crossed legs," but also a modern bourgeois who, like a character from a novel by Balzac or Zola, was "imprinted with a sad truth." Trianon's appreciation of this portrait, in fact, was based on his reading into it the Naturalist concern for clinical accuracy. Instead of criticizing Caillebotte's greenish-blue palette, which he called "sickly and washed out," he saw it as a necessity dictated to the artist by the particular physiological condition of his sitter.

Both Trianon and the critic who disapproved of Caillebotte's palette were baffled by his use of green highlights. Indeed, in this portrait of his

friend Jules Richemont, Caillebotte added subtle touches of light green to the right side of the sitter's face and hair. He also highlighted the very starched collar and cuffs, which emphasize the propriety and bourgeois character of Richemont, who is shown informally, but nonetheless in a conventional pose. But the "sad truth" Trianon saw in this portrait is not a reference to Richemont's personality so much as to his general social class, implied by his costume and attitude. An interesting comparison is the *Portrait of Diego Martelli* painted by Federico Zandomeneghi (fig. 1) and shown at the Impressionist exhibition of 1879 in which the artist described a specific personality and temperament. As did Caillebotte, with whom he was sometimes paired, Zandomeneghi resisted the fluttery brushwork of the Impressionists, adopting instead more descriptive color and firmer paint handling.[3] He cast the Florentine art critic Martelli in a Frans-Hals-like pose, comfortably ensconced in front of the fireplace. The close-up focus accentuates the spontaneity of Martelli's gesture as he glances quickly, and seemingly accidentally, at the viewer. Zandomeneghi captured the personality of his sitter, who appears open, friendly, easygoing, and unpretentious. Caillebotte's portrait, by contrast, images the permanent character of his sitter, whose sartorial details, pose, gesture, and expression obey the conventions of portraiture. Although Caillebotte would also paint individuals in unusual poses, in unconventional settings, or from unusual viewpoints (see cats. 74, 84, and 85), the *Portrait of Jules Richemont* was a readily legible image, adhering to the Republican ideal of portraiture as put forth by Jules Castagnary for "the most generalized expression of the individual."[4] G. G.

1 Vachon 1880.
2 Flor 1880.
3 See, for example, Bertall 1879b and 1880.
4 Castagnary 1892b, vol. 2, p. 56.

Figure 1. Federico Zandomeneghi (Italian; 1841–1917). *Portrait of Diego Martelli*, 1879. Oil on canvas; 72 × 92 cm. Galleria d'Arte Moderna, Florence (Bequest of Diego Martelli).

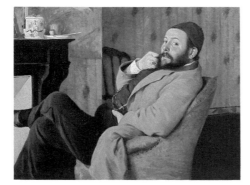

76

Woman Sitting on a Red-Flowered Sofa

(Femme assise sur une sofa à fleurs rouges)

1882

Oil on canvas

81 × 65 cm

Signed and dated upper left:
G. Caillebotte / 1882

Berhaut 1978, no. 185; Berhaut 1994, no. 202

Seattle Art Museum (Gift of Mr. and Mrs. Prentice Bloedel)

Selected Bibliography
Berhaut 1951, no. 153; Berhaut 1978, p. 53.

A woman relaxing on a sofa was a favorite theme for the Impressionists, who used it to show the casual, spontaneous poses associated with modernity. Although sometimes, as in Manet's portrait of Berthe Morisot on a red sofa (ch. 5 intro., fig. 9), the internal character of the sitter was emphasized, more often, the subject was used as a pretext for representing pretty and fashionably attired females in decorative settings, as in Manet's pastel of his wife on a blue sofa (fig. 1), Renoir's *Mme Monet Reading* Le Figaro, in which she sits on a white, slipcovered couch (1872–73; Museu Calouste Gulbenkian, Lisbon), or Morisot's *Portrait of Mme Hubbard*, in which the sitter is shown fanning herself in a white tea gown (1874; Ordrupgaardsamlingen, Copenhagen).

Caillebotte's portrait of a woman negates, in fact, the elements of feminine portraiture incorporated into the Impressionists' repertory. Instead of the woman as fashion plate, wearing the "new clothes" against which Jules Castagnary warned, since they were contrary to the truth of "everyday" life,[1] and, by extension, to the reality of their class, Caillebotte's woman is fashionably but conservatively dressed in a black silk dress ornamented by a white lace collar and cuffs and a corsage of pink

Figure 1. Edouard Manet (1832–1883). *Mme Manet on a Blue Sofa*, 1874. Pastel on paper mounted on cloth; 64.8 × 61 cm. Musée d'Orsay, Paris.

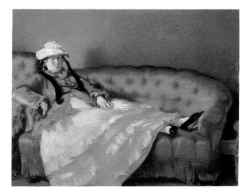

flowers. She is seated comfortably but primly on a red floral-print sofa, her pose not allowing for the exaggerated folds or billowing fabrics standard in contemporary and especially "Impressionist" (or "modern") representations of reclining women. While the Impressionists stressed the horizontality of the lounging female, down to the delicate slipper or shoe, Caillebotte's sitter is seated upright, and, like its closest counterpart, the portrait of Richard Gallo on a sofa (ch. 5 intro., fig. 7), the portrait is truncated at the knees. Here there is no suggestion of invitation, no metaphorical or physical openness. The vertical composition is banded at the top by a cantilevered picture frame that compresses the sitter into a tightly constructed space. She is neither an available female nor is her sofa to be shared by the male onlooker. Her prominent jawline (which the artist has accentuated), her averted but serious gaze, and the gesture of her hands crossed firmly on her lap suggest, but do not divulge, a specific personality. As in the case of so many of Caillebotte's portraits, we know nothing about the model or the circumstances of this canvas. Marie Berhaut listed a certain Ambroselli as the first owner of the work from 1882, when it was painted, until 1945. But that information leads nowhere, since the collector has never been identified. The sitter, whether a family friend or a servant, is presented as a serious young woman belonging to the upper middle class who appears much more in control of her environment than some of the contemporary representations of doll-like women enveloped in fashion and decor.

G. G.

1 Castagnary 1892d, vol. 2, p. 240: "Beware of new clothes. It's a question of painting living beings in the natural surroundings of their everyday lives, not of making them into figures perpetually in their Sunday best."

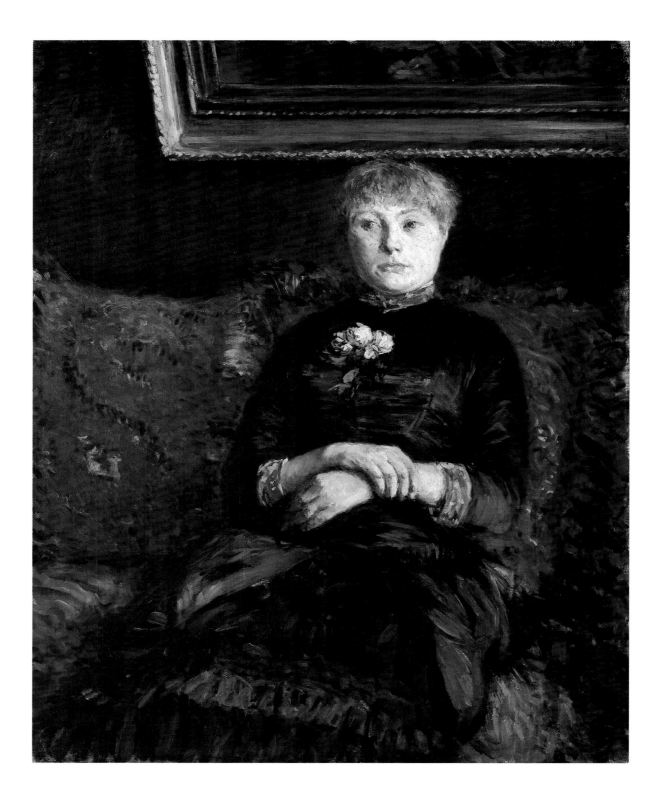

77
Interior, also known as Interior, Woman Reading

(*Intérieur,* also known as *Intérieur, femme lisant*)

1880

Oil on canvas

65 × 80 cm

Signed and dated lower left: *G. Caillebotte 1880*

Berhaut 1978, no. 127; Berhaut 1994, no. 139

Private collection

Principal Exhibitions

Paris 1880, no. 10[1]; Paris 1951, no. 31; London 1966, no. 19; New York 1968, no. 29; Houston and Brooklyn 1976–77, no. 46; Marcq-en-Baroeul 1982–83, no. 13.

Contemporary Criticism

Charry 1880; Dalligny 1880; Ephrussi 1880; Goetschy 1880; Mantz 1880; Silvestre 1880; Trianon 1880; Véron 1880; Huysmans [1880] 1883.

Selected Bibliography

Sutton 1966, pp. 7–20; Rosenblum 1977, pp. 50–51; Berhaut 1978, pp. 30, 32, 34, and 38; Varnedoe 1987, no. 34.

Unlike the portraits and landscapes, the two domestic interiors Caillebotte showed in the fifth Impressionist exhibition, in 1880 (see also cat. 63), were extensively reviewed as comments on "modern life." This painting in particular, though smaller than the other, provided the grist for a number of speculations on the conjugal state, since the man and woman pictured were presumed to be married. Marie Berhaut has identified the man as Richard Gallo, Caillebotte's friend and the editor of *Le Constitutionnel*, portraits of whom the artist also exhibited in 1879 and 1882 (see ch. 5 intro., fig. 7, and Berhaut 1994, no. 107). The identity of the woman here and in the larger interior, which features the same protagonists, remains in question.[2]

In characteristic fashion, Caillebotte's subjects are intent upon something that emphasizes their psychological distance. The absence of personal interaction is reinforced by the spatial disjunctions between foreground and background, recalling the artist's other double "portraits" from about the same time, in which the foreground figure dwarfs that in the second plane, who in turn is surrounded by the picture frame or, as here, by the architecture (see cat. 74, fig. 2). In fact, it was primarily Caillebotte's design strategy that made this painting so provocative for the reviewers who saw the discrepancy in scale between the woman and the man as a willful denial of "scientific" perspective[3] and a moral outrage against the "natural" order of male/female relationships. For Caillebotte not only dared to paint in the foreground a rather common (as she was perceived) woman engaged in reading a newspaper (the critics' unanimous assessment, even though it could just as well have been a fashion magazine), but he reduced the male component to a "Huret doll," or a "General Tom Thumb," a man one-third the size of her head and subsumed by gigantic cushions.[4] Henry Trianon even called the man a "toy," since the woman's hand appears to touch his head, implying that she was manipulating and controlling. "One draws away from her in fright!" wrote the critic Paul de Charry, who continued: "The poor woman has given birth to a monster and is obliged to keep it near her; it is a quite small [grown-up] fellow lying on a sofa by her side; she has neglected nothing in his toilette, has given him a newspaper to read; but the effect produced is unimaginable: it's as though one were in front of a sideshow at a fair, and one cries out despite oneself: 'Enter, ladies and gentlemen! Come see the little dwarf and the giant lady!'"

Under the guise of critiquing an artistic misjudgment, Charry voiced his foremost concern with *Interior:* the subversion of male and female attributes and social space. The tiny, powerless man is a "kept person," who is allowed to read (i.e., educate himself)—an anomalous situation since woman was by nature dependent on man. For the critic Paul Mantz, the spatial gulf between the couple and the fact that they were not on the same scale (referring to differences in physical size and social status) signaled their imminent divorce. The Naturalist novelist Joris Karl Huysmans saw this work and its sister image in a less pessimistic light as depictions of the ease and ennui inherent in a bourgeois marriage. He regarded the spatial distortions as "bizarre and incomprehensible," but was not offended by the disruption of traditional gender roles. Instead, he explained it as a portrait of a couple, in resigned but stable harmony, who "had nothing more to say to each other."[5] Whereas for Mantz the heavy silence was the death knell of the marriage, for Huysmans it signaled acceptance of the conjugal situation. And whereas Mantz (and several other critics) equated the diminutive scale of the male with an inequality (and thus perversion) of the natural order between genders, Huysmans assumed a parity of intelligence and control. Not only is the woman reading a newspaper, but, as Huysmans maintained, it might even be the satirical *Le Charivari* or the solidly Republican *L'Evénement*, while the man may be indulging in fiction by the popular novelist and playwright Alfred Delpit.[6]

In the end the painting, like so many of Caillebotte's images of modern life, offers only an incomplete and ambivalent narrative; the uncommunicative protagonists block access to the precise meaning. Although the silence is palpitatingly real, its cause remains obscure. G. G.

1 See cat. 63 n. 1.

2 It is possible that the woman is Gallo's mistress or a friend of the artist's who posed in his boulevard Haussmann apartment. It is also possible that this is Charlotte Berthier, the young woman with whom Caillebotte would live in Petit Gennevilliers in the 1880s, and to whom he bequeathed a small fortune.

3 Mantz 1880.

4 Dalligny 1880, Charry 1880, and Véron 1880, respectively.

5 Huysmans [1880] 1883, p. 108.

6 Ibid., p. 110. *L'Evénement* was considered the Republican arm of *Le Figaro*. See Claude Bellanger, *Histoire générale de la presse* (Paris, 1972), vol. 3, pp. 227 and 234.

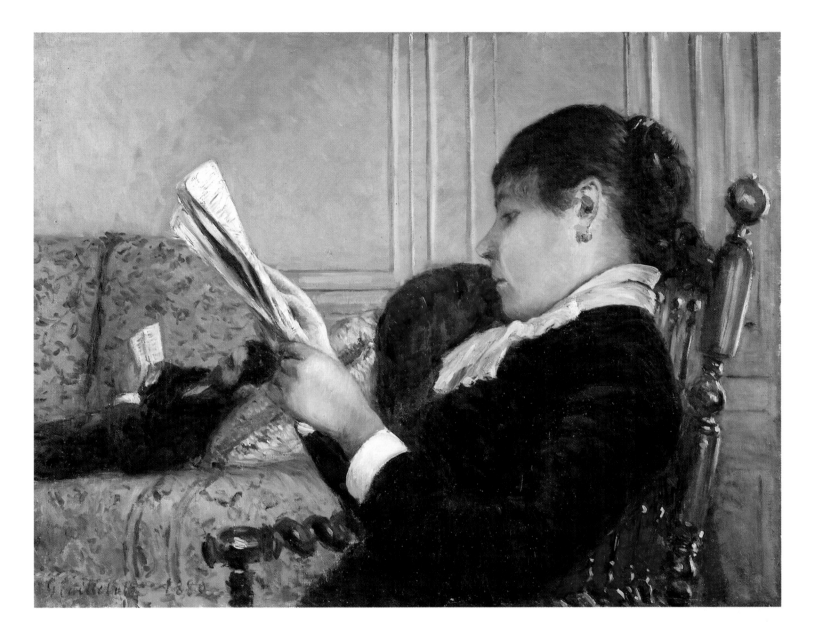

78
Portrait of a Man
(Portrait d'homme)

1880

Oil on canvas

82 × 65 cm

Signed and dated lower right:
G. Caillebotte 1880

Berhaut 1978, no. 128; Berhaut
1994, no. 138

Mrs. Noah L. Butkin

Selected Bibliography
Berhaut 1978, p. 54.

Portrait of a Man is one of numerous portraits Caillebotte painted in the apartment he shared with his brother Martial on boulevard Haussmann between 1879 and 1882, several of which were shown in the Impressionist exhibitions for those years (see cats. 74 and ch. 5 intro., fig. 7). This portrait, which was never exhibited, is distinctive because the sitter is not posed, but seemingly caught in a moment of quiet contemplation.[1] The French window opening onto the street, which could be a metaphor for the artist's canvas (see cat. 59), reveals neither the rushing diagonals of the boulevards (see cats. 59, 64, 67, and 70) nor the gridlike facades of apartment buildings (see cat. 63), but rather the natural "decoration" of the treetops lining the boulevards. Similar rich springtime foliage, along with the identical model and balcony, appear in *A Balcony* (cat. 65).[2]

In comparison with what could be termed his conventional ("masculine") likenesses of men *and* women (see ch. 5 intro., fig. 6, and cat. 76)—seated front and center and framed by wooden moldings or the edges of pictures—this is a decidedly uncommanding, decorative, "feminized" (and thus complicated) portrait. Consider, for example, a larger portrait painted the same year representing a similarly expressionless man in profile, in the same room, with the same armchair, window, balcony, foliage, and curtains (fig. 1); this work did not disrupt conventional expectations. In contrast to the hatless and gloveless figure dressed in a

casually elegant vest and redingote, the unidentified model wears the top hat and topcoat of the Third Republic bourgeois. Moreover, he is surrounded by symbols of masculine activity: a desk, heavy tome, and dice-holder (see also cat. 80). Although equally absorbed in contemplation (looking into the room rather than away from it), this is a man on the go, a boulevardier, a *flâneur*, caught only momentarily within a domestic space.

By contrast, the pose and attire of the seated model in *Portrait of a Man* indicate that he is very much at ease within this realm. Caillebotte used light to further the impression of belonging and comfort. Instead of the sharp *contre-jour* profile of the top-hatted gentleman, here daylight falls gently through the lacy, sheer curtains (freed from the heavy velvet drapes of winter) and the Rococo filigrees of the balcony grille to highlight the sitter's face, hands, and satiny blue vest and bow tie. The harsh reds and grays of the surroundings are muted in favor of a palette of soft blues, greens, and whites. This feminized setting confounds expectations: this is not the bourgeois capitalist who appropriates the city from his balcony, nor one who dominates his interior. As he did in his earlier portrait of his brother René standing in the family apartment and looking onto the city street (cat. 59), Caillebotte here substituted a man at the window where conventionally a woman was seen—a metaphor for female isolation from the outside (male) world. Although he is not turned away, Caillebotte's seated man is as psychologically inaccessible as René. A passive observer, he regards with a connoisseur's appreciation the decorative backdrop provided by nature and, by extension, the artist's painted representation of that nature.
G. G.

Figure 1. Gustave Caillebotte. *Man in a High Hat, Seated near a Window,* 1880. Oil on canvas; 100 × 81 cm. Musée des Beaux-Arts, Algiers.

1 An oil sketch (Berhaut 1994, no. 141), possibly for this portrait, suggests that Caillebotte originally had a more traditional concept in mind showing the sitter in three-quarter view. In both sketch and final version, the sitter is portrayed on the red-velvet, tufted armchair that appears in so many of his other portraits and interiors (see cats. 75, 77, and 80).

2 Caillebotte used this model several times, including for the derby-hatted "barfly" or "journalist" in *In a Café* (cat. 79), exhibited in the fifth Impressionist exhibition.

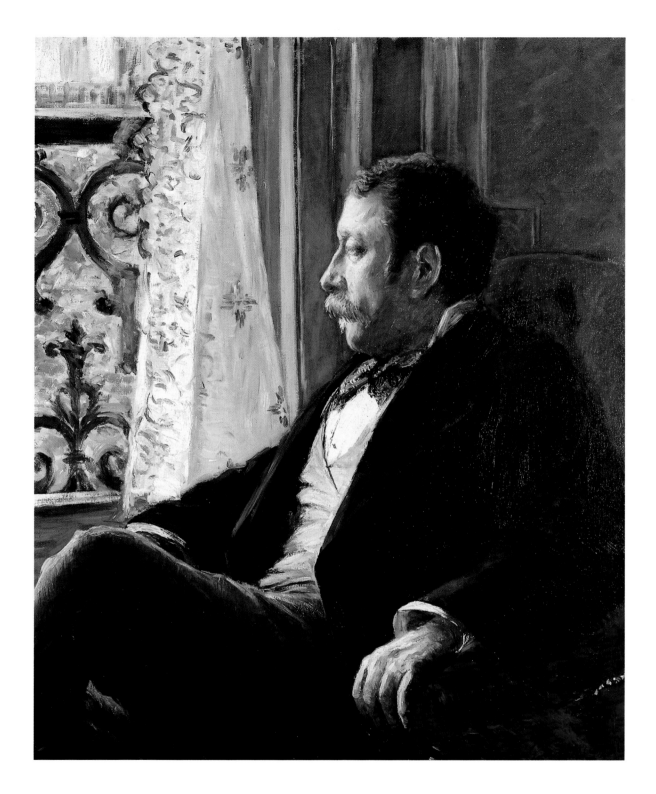

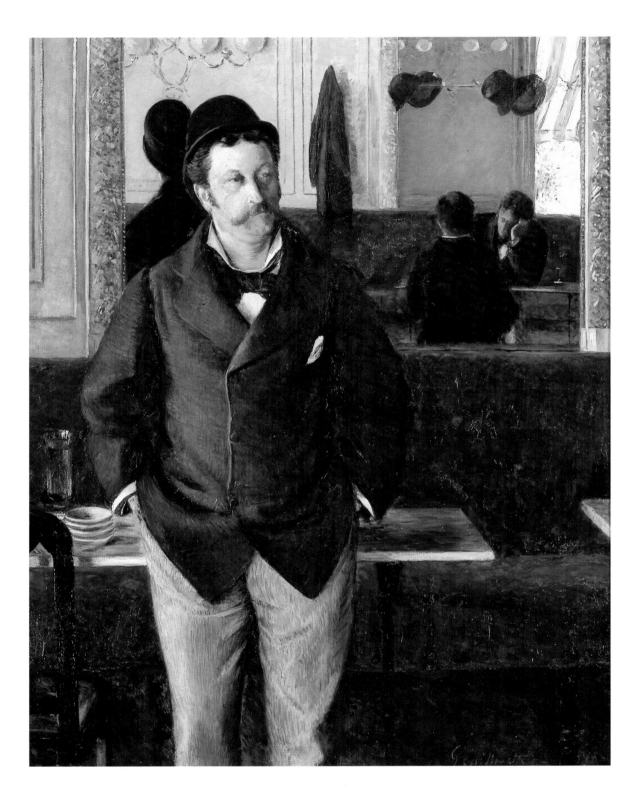

79

In a Café
(Dans Un Café)

1880
Oil on canvas
153 × 114 cm
Signed and dated lower right:
G. Caillebotte 1880
Berhaut 1978, no. 134; Berhaut
1994, no. 142

Musée des Beaux-Arts, Rouen
(1943–70)

Principal Exhibitions
Paris 1880, no. 6; Houston and
Brooklyn 1976–77, no. 50.

Contemporary Criticism
Bertall 1880; Dalligny 1880;
Ephrussi 1880; Huysmans [1880]
1883; Javel 1880; Lancelot 1880;
Renoir 1880; Tout-Paris 1880b;
Trianon 1880; Un Passant 1880;
Véron 1880.

Selected Bibliography
Berhaut 1948, p. 46; Berhaut
1951, no. 90; Sutton 1966, pp.
7–20; Popovitch 1967, p. 21;
Rheims 1973, p. 275; Rosenblum
1977, pp. 47 and 49; Berhaut
1978, pp. 32 and 38; Le Pichon
1983, p. 146; Nash 1984, p. 23;
Adler 1986, p. 220; Varnedoe
1987, no. 39; Balanda 1988, pp.
48–49, and 98–99; Chardeau
1989, pp. 92–93; Wittmer 1990,
p. 60.

Like the two interiors Caillebotte exhibited at the fifth Impressionist exhibition, in 1880 (cats. 63 and 77), *In a Café*, dominated by a life-size male figure, prompted contradictory interpretations. For while café society was a popular subject for painters as well as writers in the second half of the nineteenth century, these visual or written images normally evoked the festive, lamplit haunts of the privileged (Manet, Zola) or the humbler dives of the lower classes (Degas, Huysmans). Quite different from these was Caillebotte's all-male establishment seen at midday (evident from the sunlit foliage and red-and-white awning visible through the window reflected in the facing mirror) under the watchful surveillance of "a type taken from life."[1]

As in the other interiors, this "portrait of a man in a café"[2] blurred the lines between genre and portraiture, imaging for Eugène Véron a type, "who is very much of our time"; for Henry Trianon, a journalist and man of letters, an individual "living on the edge, or better said, ready to fly or fight"; and for the Naturalist novelist Joris Karl Huysmans, a barfly, "hailing waiters by their first names, bragging and joking about backgammon and pool, smoking and spitting, getting a head start with beers on credit!" Caillebotte represented the same model that year in front of the lace-curtained windows of his apartment (see cat. 78). Here, however, the man seems larger, coarser, and less elegant, with wrinkled blue pants and a loosely cut jacket topped off by the informal "melon" hat that had been popular in the previous decade.[3]

Huysmans saw the figure's slovenly costume and nonchalant stance as evidence of his middling social and financial standing. Indeed, for Huysmans, this café was a venue characterized by cheap beer and fly-specked mirrors, one where workers, "don't turn over great thoughts in their minds," but rather play dominos and "grease up" cards to flee from the reality of their miserable jobs and the "sadnesses of solitary or shared households." However, judging from the marble tabletops and gilt-framed mirror in which at least one silk top hat is reflected,[4] Caillebotte's interior belongs to the mirror-clad establishments lining the more expensive boulevards.[5]

Classifying the place, however, does not further our reading of the male figure who overwhelms and indeed blocks our (reflected) view into the interior. He is not participating in the urban entertainment, casual encounters, and leisure that "best epitomizes the peculiar [external] character of Paris."[6] The café, combining the commerce, mobility, and social intermingling common to life on the street with the activities (eating, drinking, resting)

and accoutrements (mirrors, lamps, tables, upholstery, and paneling) of private life, was where the modern Parisian could doff his hat and feel at home within the urban center. But Caillebotte's modern man has left his hat on. Self-absorbed, he seems detached from his surroundings. Although he is shown with the physiognomic and social signifiers recommended by Edmond Duranty in his prescription for "The New Painting" (hands in pockets and within a specific environment),[7] he cannot be readily categorized. His vacant, somewhat melancholy gaze has been likened to that of the alienated barmaid in Manet's *Bar at the Folies-Bergère* (1882; Courtauld Institute Galleries, London), but he has no professional connection to his environment and is not perceived by the male viewer in the same way as Manet's female subject was intended to be.[8] Planted in front of a mirror and staring at the reflections in another mirror on the opposite wall, Caillebotte's man receives both interior and exterior stimuli. In this way he functions as the social and geographical complement to the self-absorbed (and equally anonymous) *flâneur* in *Paris Street; Rainy Day* (cat. 35). Perceived collectively as a "type" and individually as a "portrait," he thwarts a conclusive reading of *In a Café* as a mere genre painting and raises larger sociological issues of class and moral character. G. G.

1 Véron 1880.

2 Lancelot 1880 and Un Passant 1880.

3 The "melon" hat, usually of black or brown felt, was the French form of the American derby (see R. T. Wilcox, *The Mode in Hats and Headdress* [New York and London, 1959], p. 248).

4 For a diagram and explanation of this complicated and fascinating double mirror reflection, see Varnedoe 1987, p. 136, fig. 39a; and Balanda 1988, pp. 48–49.

5 This seems to be Caillebotte's unique representation of a public entertainment establishment, although we know that he frequented the Café Riche, reinstigating the monthly artists' dinners in 1890 after he had moved definitively to Petit Gennevilliers. For the café as an Impressionist motif, see Herbert 1988, pp. 65–72.

6 See D. J. Olsen, *The City as a Work of Art: London, Paris, Vienna* (New Haven and London, 1986), p. 213.

7 Duranty 1876.

8 Varnedoe 1987, p. 138. On the female subject, visual consumption, and the male gaze, see L. Nochlin, "Morisot's Wet Nurse: The Construction of Work and Leisure in Impressionist Painting," in *Perspectives on Morisot*, ed. T. J. Edelstein (New York, 1990), p. 94.

80

The Bezique Game

(Partie de bésigue)

1881

Oil on canvas

121 × 161 cm

Signed lower left:
G. Caillebotte

Berhaut 1978, no. 165; Berhaut
1994, no. 183

Private collection

Principal Exhibitions
Paris 1882, no. 1; Paris 1894, no.
19; Paris 1921, no. 2714; Houston
and Brooklyn 1976–77, no. 49;
San Francisco 1986, no. 114.

Contemporary Criticism
Anonymous 1882; Charry 1882;
Fichtre 1882; Havard 1882;
Hennequin 1882; Hepp 1882;
Hustin 1882; Leroy 1882; H.
Rivière 1882; Sallanches 1882;
Silvestre 1882; Huysmans [1882]
1883.

Selected Bibliography
Sertat 1894, p. 382; Berhaut 1978,
p. 38; Reff 1980, pp. 104–117;
Varnedoe 1987, no. 38; Balanda
1988, pp. 106–107; Chardeau
1989, pp. 88–91; Wittmer 1990,
pp. 13, 26, 69, 166, and 285–86.

Joris Karl Huymans and others have compared Caillebotte's nearly life-size picture of card-players playing bezique[1] to a similar painting by the seventeenth-century Flemish master David Teniers the Younger, possibly *Tavern Interior* (1645; Musée du Louvre, Paris).[2] The red-velvet armchair, floral-print sofa, and wall paneling in *The Bezique Game* place it squarely within a bourgeois Parisian setting and not the tavern of traditional cardplay-ers' iconography. Here, the external distractions—food, drink, music, women—of the public space are absent. And these men are not "greasing up" the cards (see cat. 79), but rather are arsorbed by their leisure activity. Just as in his images of oarsmen, in which Caillebotte represented the intimate arena of the Yerres river on his family's property rather than the more commercialized and public leisure spots of La Grenouillière depicted by Monet and Renoir, so too he set this card game in the privacy of his apartment interior and not in the favorite cafés of the Impressionists. In addition to his brother Martial (in profile in the right foreground), Caillebotte represented a number of his privileged friends, including Richard Gallo (standing), the model for the two interiors painted that same year (see cats. 63 and 77), and Maurice Brault, a money-broker and yachting friend, who is depicted in profile directly in front of Gallo. In characteristic fashion Caillebotte presented isolated individuals absorbed in their private thoughts. Despite the wealth of these men, Caillebotte toned down any sense of excess with a muted palette of blue-grays and browns. The elegant gilt filigree which seems to float on the wall like a hanging chandelier, for example, is contrasted with the humbler dice-holder, whose exaggerated perspective makes it appear even more handcrafted and rustic, like those in Gauguin's still lifes and portraits from the 1880s.

The cardplayers produce an image of rituallike concentration and simplicity, except for the figure of Paul Hugot, who, seated on the floral-print sofa, is distanced from the circle of players. As in many of his interiors, Caillebotte created a disjunction between foreground and background so that the composition jumps from the large figural grouping around the table to the much smaller and seemingly disembodied head of Hugot. Leaning backward and looking out with heavy-lidded eyes, Hugot assumes the blasé attitude of the dandy, an attitude he affects as well in Caillebotte's full-length portrait of him (Berhaut 1994, no. 111).[3]

At the 1882 Impressionist exhibition, critics did not target the strange spatial ambiguities and the rather jarring figure of Hugot, who alone makes eye contact with the viewer. Nor did they see *The Bezique Game* as a group portrait of the artist's friends. Instead, they referred to it as an image of cardplaying—a subject with a long pictorial tradition. Perhaps because the painting fit into a well-known genre, they unanimously approved of it. Whereas Huysmans compared the gravity, absorption, and veracity of Caillebotte's cardplayers to early Dutch and Flemish paintings, these same qualities may also have been conceived and perceived as visual affirmations of the order, seriousness, and even cooperation associated with the Republican social vision. Caillebotte's *Bezique Game*, a legible and tightly ordered composition (the lower edge of the picture frame is exactly aligned with the vertical wall moldings), received the critic Paul de Charry's praise because it showed properly handled paint, "not thrown on the canvas," but "carefully prepared and skillfully contrived." Like the paintings of Martial practicing the piano and his mother embroidering, the cardplayers are absorbed in their leisure activity. *The Bezique Game*, interpreted by Charry as the representation of mental effort—"one reads the players' thoughts on their faces"—might also be seen as a metaphor for the artist's endeavors to conceive and construct a work of art.

Interestingly, at least two of the critics paired Caillebotte's cardplayers with Renoir's *Luncheon at Bougival* (1880–81; The Phillips Collection, Washington, D.C.) as the highlights of the exhibition.[4] Although seemingly antithetical, opposing indoors and outdoors, flirtatiousness and gravity, indulgence and discipline, both compositions displayed to the upper middle-class, male viewer leisure activities with which he could easily identify. Moreover, their ambitious scale and portraitlike fidelity represented "a truly martial effort," according to Henry Havard, who saw in them evidence of the artists' industry and knowledge of métier. G. G.

1 Bezique is a variant of pinochle introduced around 1820, involving sixty-four rather than forty-eight cards. See Varnedoe 1987, p. 134.

2 Huysmans [1882] 1883, p. 287. It is also plausible that Caillebotte's cardplayers, withdrawn and concentrating on their hands, had a spiritual precedent in Jean Baptiste Siméon Chardin's quiet picture of a boy building a house of cards (c. 1737; Musée du Louvre, Paris). Indeed, the figure of Maurice Brault shares a similar gesture and posture with Chardin's youthful player. See Reff 1980, pp. 108–110, fig. 7, and 110–111, fig. 11.

3 The full-length portrait was possibly shown at the Impressionist exhibition in 1880 as *Portrait of M. G. C.*, since the sitter was described by critics as a full-length, well-dressed man with a newspaper in his waistcoat (see Bertall 1880; Thémines 1880; and Trianon 1880).

4 To Charry, Renoir's painting was "full of gaiety, of animation; it is youthful folly caught in the act, radiant and vibrant, frolicking in broad daylight, laughing at everything, seeing no farther than today, making light of tomorrow" (Charry 1880).

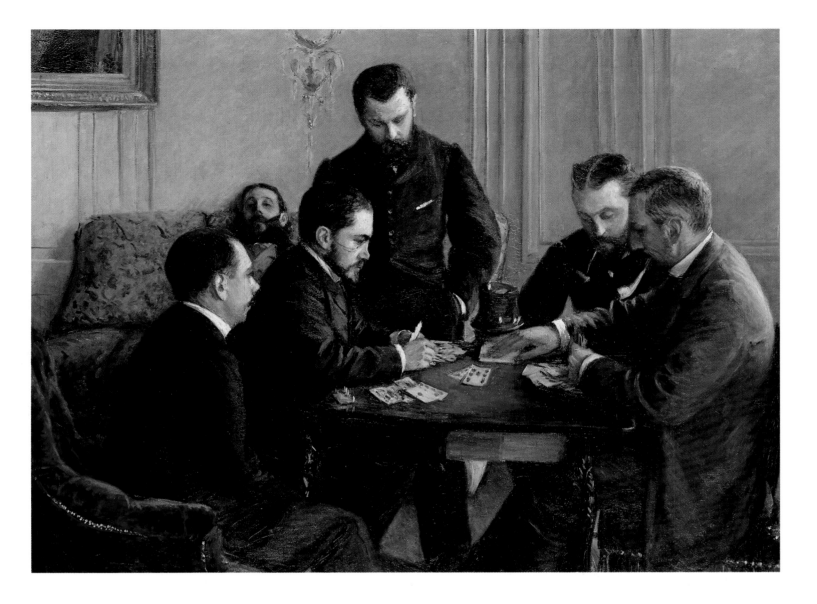

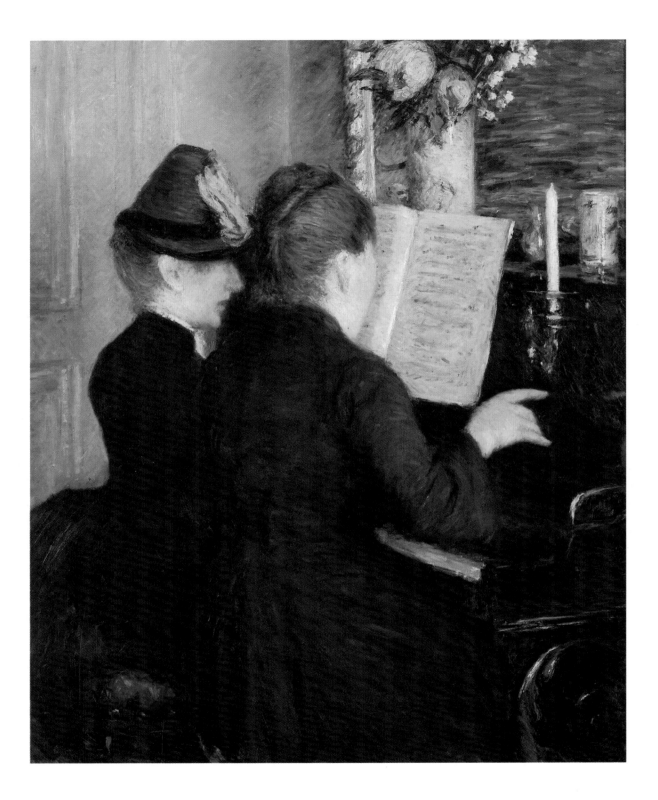

81
The Piano Lesson
(*La Leçon de piano*)

1881
Oil on canvas
81 × 65 cm
Berhaut 1978, no. 168; Berhaut
1994, no. 186

Musée Marmottan, Paris

Selected Bibliography
Daulte and Richebé 1971, no. 78;
Berhaut 1978, p. 38; Daulte and
Richebé 1981, no. 106; Delafond
1987, no. 95; Wittmer 1990,
pp. 303–304.

Apart from his pictures of women sewing (see cat. 73), *The Piano Lesson* is the only genre painting that Caillebotte populated with females. This unsigned work, which the artist never exhibited, is a seemingly straightforward but actually highly elusive variation on a subject with a rich pictorial tradition. The women have not been identified, although the fact that the work was given to Monet (in whose family it remained until 1966) suggests that it had some special significance to him.[1] The interior is not Caillebotte's boulevard Haussmann apartment, with its cool gray walls and painted gold moldings (see cats. 75, 77, 78, and 80), but one with bright green wallcoverings and brown woodwork.

Within a highly compressed composition, the women sit at an upright piano, perhaps a spinet (judging by its height), to which are attached folding candlestick holders similar to those on the piano in Renoir's *Woman at the Piano* (cat. 71, fig. 1), submitted to the Impressionist exhibition in 1876. Caillebotte's interest in material wealth is displayed in the porcelain vase filled with peonies and the other bibelots arranged on the piano top. But, in characteristic fashion, Caillebotte complicated the familiar. The rectangle in the upper right corner of the canvas, of broadly applied but entirely abstract greenish-black brush strokes framed within the L-shaped gilded moldings running perpendicular and parallel to the piano top, may indicate a mirror. It could also be a painting within a painting, a shorthand allusion to one of Caillebotte's own works, such as *Périssoires* (cat. 25), in which equally rigorous brushwork describes the watery foreground; Caillebotte left the possibilities open. As with *In a Café* (cat. 79), the frames and mirrors confuse our reading of the pictorial space. More substantial information is provided by the physiognomy, gestures, costumes, and even the

title of the painting. The woman on the left, with the stylish felt hat adorned with a feather (seen in the strict profile that Seurat would make famous some five years later in his *Sunday on La Grande Jatte—1884*, 1884–86; The Art Institute of Chicago), is the visiting student. Her more modestly attired and hatless companion marks time with her right hand, with which she will also turn the page.

Piano playing, baptized the "hashish of women" by the Goncourts, constituted one of the principal pleasures for women in the nineteenth century.[2] This theme, used in literature to connote both innocence (a young woman plays unaware that a man is listening) and passion (the piano is an outlet for repressed emotions), offered to painters a pretext for depicting feminine elegance.[3] Caillebotte, however, avoided such categories by showing women not at leisure but at work, learning and teaching a skill requiring manual dexterity and mental concentration. Unlike Renoir's *Woman at the Piano* or Manet's portrait of his wife at the piano (fig. 1), Caillebotte's piano players are not objects for male enjoyment. They do not wear billowing tea gowns, peignoirs, or morning dresses, but rather respectable daytime street attire. Concentrating upon their music, they turn away from the viewer and deny him access into their emotional state, which Manet, Renoir, and others portrayed as dreamy-eyed or wistful, to underscore the connection between music-making and feminine reverie. Although Manet's and Renoir's piano players are also set within bourgeois interiors, Caillebotte's are spiritually closer to his image of Martial practicing on the grand piano in the family home (cat. 71), where he is shown working hard at an activity associated with leisure. G. G.

1 Monet's two Paris apartments at this time were paid for by Caillebotte and Ernest Hoschedé, Monet's dealer and the husband of his then mistress and future wife (see Chronology, 1879–81). The setting might have been one of these apartments, and the piano player, Mme Hoschedé. That Monet kept the painting in his bedroom during his lifetime further underscores the significance he attached to it.

2 See Corbin 1987, p. 531.

3 Ibid., p. 533.

Figure 1. Edouard Manet (1832–1883). *Mme Manet at the Piano*, 1868. Oil on canvas; 38 × 46 cm. Musée d'Orsay, Paris.

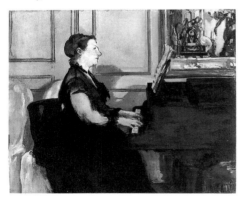

82
Nude on a Couch
(Nu au divan)

1882

Oil on canvas

131 × 196 cm

Signed lower right:
G. Caillebotte

Berhaut 1978, no. 184; Berhaut
1994, no. 201

The Minneapolis Institute of
Arts (The John R. Van Derlip
Fund)

Principal Exhibitions
New York 1967, without no.; New
York 1968, no. 38; Houston and
Brooklyn 1976–77, no. 48.

Selected Bibliography
*The Minneapolis Institute of Arts
Bulletin,* 1967, p. 67; *The Art
Quarterly, The Detroit Institute of
Arts* 31 (summer 1968), p. 220;
*European Paintings from the
Minneapolis Institute of Arts,*
1971, no. 104; Rosenblum 1977,
pp. 51–52; Balanda 1988, pp.
112–113; Chardeau 1989, pp. 84–
87; Gerstein 1989, no. 6.

Aesthetically and ideologically, this remark-able life-size female nude belongs to a trilogy of paintings of otherwise male figures absorbed in toweling their bodies (see cat. 83 and ch. 5 intro., fig. 14). While we cannot know the reasons why Caillebotte did not exhibit this monumental nude, it is likely that he recognized it as a radical departure from tradition and was not ready to present it to the public. The raw and provocative reality of this woman, who lies on the same floral-print, overstuffed sofa that appears in a number of Caillebotte's interiors and portraits (see cats. 77, 80, and 87), invites comparison with the most infamous nude of the day, Manet's *Olympia* (1863; Musée d'Orsay, Paris). But the comparison is a limited one, since we are not in a brothel but in the artist's home, and we are not looking at a courtesan who brazenly returns our gaze but at an unidentified female whose unselfconscious attitude and gesture implicate us as furtive voyeurs.[1]

Indeed, Caillebotte's *Nude on a Couch* does not correspond to contemporaneous images of reclining, languid nudes. For example, Henri Gervex's scandalous painting *Rolla* (fig. 1), which depicts a naked prostitute lying on an unmade bed, was rejected from the Salon of 1879 and particularly criticized for the starched petticoat, garter, and red corset in the right foreground.[2] The woman painted by Caillebotte has also discarded her clothes. But instead of the sexual metaphor presented by the silk and satin undergarments in Gervex's painting, Caillebotte included an undistinguished pile of white and black garments.[3] The simple black boots, lined up at the foot of the sofa, are homely objects, closer to van Gogh's famous *Pair of Shoes* (1887; Van Gogh Museum, Amsterdam) than to Gervex's satin slippers. With her hair still neatly coiffed, Caillebotte's woman apparently has taken her time to undress and is perhaps meant to seem unaware that she is being observed.

Kirk Varnedoe has remarked upon the woman's insistent nakedness, noting the visible waistband marks and pubic hair.[4] Perhaps even more unsettling are her gestures of self-defense (her raised arm) and autoeroticism (her hand touching her breast)—the latter anathema to a culture demanding that nudes be clean-shaven and that respectable women wear chemises while bathing to ensure that they did not touch their own bodies.[5] Are we to interpret the model's expression as one of guilt for having transgressed these taboos? And are we to see her gesture as a sign of a "post-coital sadness" all the more problematic since no lover is present?[6] Such a reading implies a malaise on the part of the nude, but also on the part of the artist. It is possible, however, that the painting imparts a different mood, one of equanimity between the model and

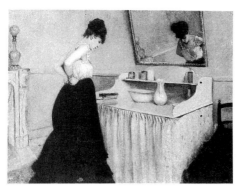

Figure 2. Gustave Caillebotte. *Woman at Her Dressing Table,* c. 1880. Oil on canvas; 65 × 81 cm. Private collection, Los Angeles.

the artist, who may well be the absent lover. This same young woman with long face, thin arms, small breasts, and hair piled high on her head is shown in *Woman at Her Dressing Table* (fig. 2).[7] Her white chemise and solid black skirt are similar to the corsetless ensemble draped across the floral-print sofa. It is quite possible, in fact, that the woman in both of these images, sequencing dress and undress, is Charlotte Berthier, Caillebotte's companion at Petit Gennevilliers, to whom he bequeathed an annuity in 1883. Although we do not know when they met, it is clear that by 1883 Charlotte was a significant part of his life; she therefore might have met Caillebotte in 1880 or 1881, when she was seventeen or eighteen years old, and posed for these paintings.

Although these biographical elements allow us to identify the woman as model or mistress, Caillebotte's *Nude* is an equivocal image. If Manet and Gervex subverted the tradition of associating the nude with classical references, Caillebotte further subverted the genre with this near-clinical analysis of the female body. The painting is all the more discomforting since the subject challenges our experience of spectatorship and activates our own anxieties about sexuality and looking.[8] G. G.

1 See Gerstein 1989, no. 6.

2 See Clayson 1991, pp. 89–90.

3 For the corset as sexual metaphor, see ibid., pp. 89–90; and D. Kunzle, *Fashion and Fetishism: A Social History of the Corset, Tight-Lacing, and Other Forms of Body-Sculpture in the West* (Totowa, 1982), pp. 51–52.

4 Varnedoe 1987, p. 130.

5 See A. Callen, "Degas' *Bathers:* Hygiene and Dirt—Gaze and Touch," in Kendall and Pollock 1992, pp. 163–65.

6 Varnedoe 1987, p. 193.

7 In Berhaut 1994, p. 63, and Varnedoe 1987, p. 46, *Woman at Her Dressing Table* was dated to 1873 on the grounds that the same model appears in the 1873 pastel *Nude Woman on a Sofa* (Berhaut 1994, no. 8). I see no similarity between the body type and coiffure of the woman lying on the striped satin sofa from Caillebotte's student days and those of the woman at the dressing table in an interior exhibiting the same subdued wall color as the boulevard Haussmann apartment.

8 Here, I am borrowing the language of spectatorship as a projective activity from S. Sidlauskas in "Resisting Narrative: The Problem of Edgar Degas's *Interior,*" *Art Bulletin* 75, 4 (Dec. 1993), p. 695.

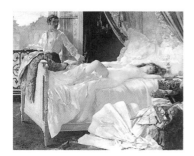

Figure 1. Henri Gervex (1852–1929). *Rolla,* 1878. Oil on canvas; 175 × 220 cm. Musée des Beaux-Arts, Bordeaux.

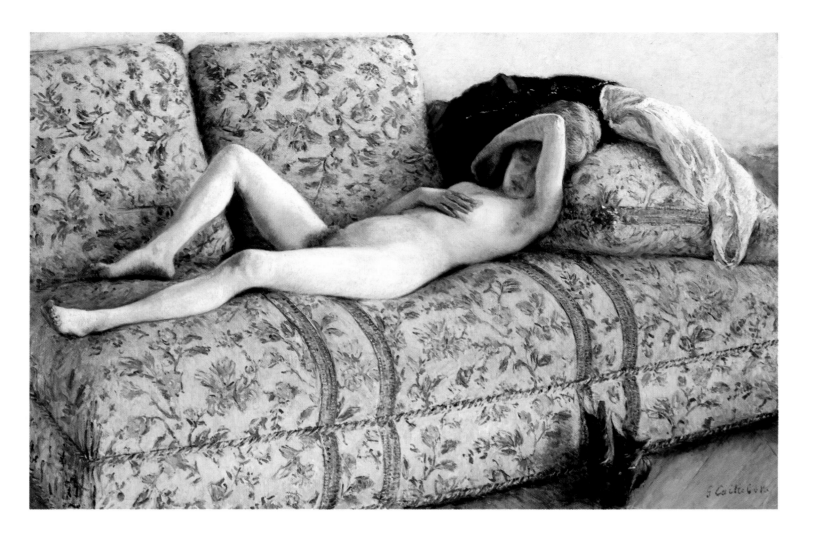

83
Man at His Bath
(Homme au bain)

1884

Oil on canvas

166 × 125 cm

Signed and dated lower left:
G. Caillebotte / 1884

Berhaut 1978, no. 267; Berhaut
1994, no. 286

Josefowitz Collection

Principal Exhibitions
Brussels 1888, no. 1 (in catalogue,
but apparently not in exhibition);
Houston and Brooklyn 1976–77,
no. 77.

Selected Bibliography
Rosenblum 1977, pp. 51–52;
Varnedoe 1987, no. 52.

Caillebotte sent this near-life-size image of a man toweling himself to Brussels in 1888 for the exhibition of Les XX. Although the artist had been invited to participate, a review published anonymously in *La Chronique* implies that the painting was removed from view and hung in a closetlike room. This would explain how it went without comment by the critics.[1]

Linked by its startling subject and scale to *Nude on a Couch* (cat. 82), Caillebotte's *Man at His Bath* eludes easy classification within the category of nudes in nineteenth-century art. Indeed, like the bather, the nude was assumed to be a feminine subject—with the exception of the academic nude—and a genre codified within Beaux-Arts training.[2] Caillebotte's male nude, moreover, is not based on an academic model. Unlike the energetic bathers of Frédéric Bazille, Caillebotte's muscular male is portrayed in the awkward gesture of drying himself. This picture of a man within the private space allotted for bathing may in fact have derived from Degas's many variations on the theme of female bathers, such as the pastel-heightened monotype (which Caillebotte owned) of a squatting woman toweling herself off next to a shallow tub (see Appendix III, fig. 13). In Degas's iconography, however, the tub is an attribute of prostitutes, who were required to bathe more frequently than respectable women.

Indeed, regular bathing was looked upon with suspicion until the 1870s, when, following Louis Pasteur's discoveries, hygiene was understood as not only a defense against microbes, but as a symbol of progressive civilization. But the change did not bring about the widespread construction of bathrooms with pipes and running water. Indeed, bathing was considered an effeminate activity, associated with the leisure and self-indulgence that so fascinated artists and writers.[3] For men, bathing was a purely functional exercise, taken less regularly, at public facilities or in portable zinc bathtubs similar to that depicted in *Man at His Bath*. We know, for example, that the Caillebottes' rue de Miromesnil home contained five bedrooms with connecting dressing rooms, but only one bathroom with an enameled, cast-iron bathtub.[4] The room depicted here has none of the permanent fixtures found in a bathroom. Instead, it appears to be a curtained-off annex or dressing room.

Caillebotte's nude, although engaged in a traditionally feminine activity, is nonetheless decidedly masculine. The rigorous brushwork and purplish-blue palette emphasize the contours of the muscular legs and buttocks; a bit of scrotum is allowed to show. His compact form is squarely anchored within an austere setting whose only decorative accents are the reflections of the tub and the carved chair upon which he has strewn his clothes. This is not a ritual of self-indulgence—the man towels himself with an almost violent intensity and impatience. The wet footprints, too, underscore his rush and desire to complete his short, but necessary, routine.

Man at His Bath can be seen as a pendant to another large but unfinished painting of a man drying his leg (ch. 5 intro., fig. 14). The implied brusqueness of the toweling movement is visualized in the latter painting by very broad and open brushwork that imparts a physical as well as metaphorical rawness to this unabashedly voyeuristic treatment of the male absorbed in grooming himself. The two paintings are perhaps the only such images to be found prior to the twentieth century. G. G.

1 See Anonymous 1888.

2 The painting of female nudes had been proscribed by the official Salons for some time (see A. Solomon-Godeau, "Male Trouble: A Crisis in Representation," *Art History* 16, 2 [June 1993], pp. 286–87).

3 See P. Perrot, *Le Travail des apparences, ou La Transformation du corps féminin XVIIIe–XIXe siècle* (Paris, 1984), p. 117, trans. in A. Callen, "Degas' *Bathers*: Hygiene and Dirt—Gaze and Touch," in Kendall and Pollock 1992, p. 183 n. 45.

4 "Cast-iron bathtub painted and enamelled," no. 76 in Poletnich 1878a. See also Poletnich 1879.

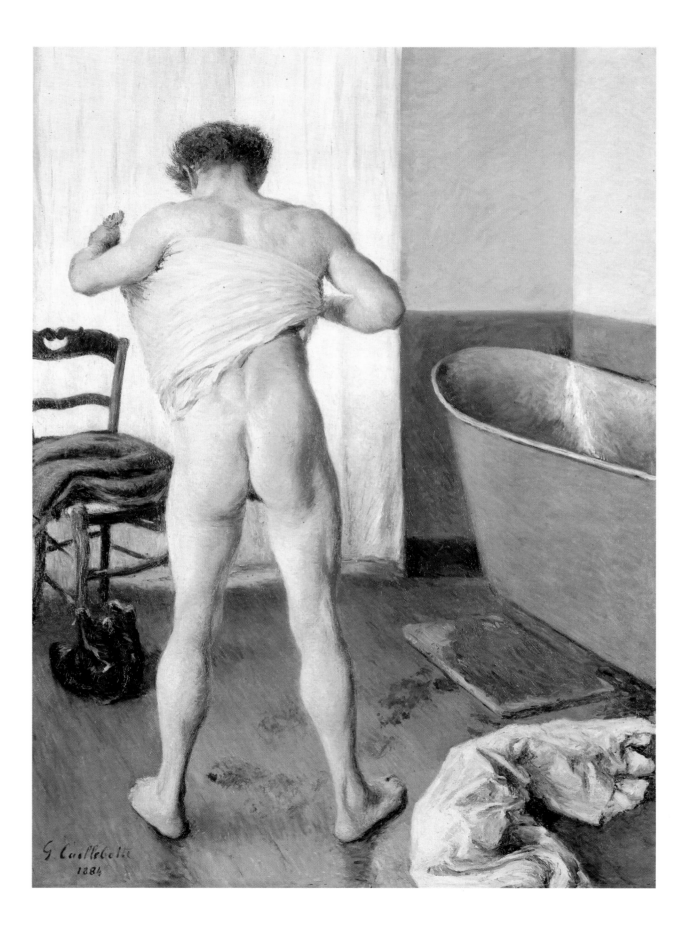

84
Portrait of Henri Cordier

(Portrait d'Henri Cordier)

1883

Oil on canvas

65 × 82 cm

Signed and dated lower center:
G. Caillebotte 1883

Berhaut 1978, no. 235; Berhaut
1994, no. 251

Musée d'Orsay, Paris (Gift of
Mme H. Cordier; RF 2729)

Principal Exhibitions
Chartres 1965, no. 21; Houston
and Brooklyn 1976–77, no. 62;
Marcq-en-Baroeul 1982–83,
no. 25.

Selected Bibliography
Berhaut 1951, no. 196; Sterling
and Adhémar 1958, no. 153;
Adhémar and Dayez 1973, pp.
139–40; Berhaut 1978, pp. 30
and 54; Varnedoe 1987, no. 51;
Balanda 1988, pp. 116–117;
Rosenblum 1989, p. 325.

The *Portrait of Henri Cordier* and the *Portrait of a Man Writing in His Study* (cat. 85) are identically sized images of professional men that attest to Caillebotte's broad range of interests, relationships, and portrait styles—from the posed and formal (see cats. 75 and 86) to the casual and private (see cat. 78). Henri Cordier (1849–1925) was the most famous of Caillebotte's sitters. One year younger than the artist, Cordier (see fig. 1) was a professor of foreign languages and an eminent China scholar whose most famous work, the *Biblioteca Sinica*, was awarded the Stanislas Julien Prize in 1880. During the 1870s Cordier lived in China before serving as the delegate for the Chinese Commission in France from 1877 until 1883, the year this portrait was painted.

Caillebotte's portrait makes no allusion to Cordier's specific profession. The bookcase, fringed lamp, desk, and especially the blue and red figurine suggesting a French cavalry soldier (perhaps a paperweight), are all nineteenth-century French accoutrements. The bookshelves, crammed with horizontal and vertical tomes and manuscripts, suggest the working library of a scholar, but do not identify Cordier as the bibliophile he is known to have been.[1] The scholarly aspect of Cordier's work is reinforced by his uncomfortable pose, which, judging by the height of the desk and the absence of a chair, suggests that he is perched on a stool, or that he is kneeling at his desk, not bothering to sit in the excitement of recording a recent finding.

Although Caillebotte's portrait invites comparison to Degas's portraits of Edmond Duranty and Diego Martelli (ch. 5 intro., figs. 4 and 5), its claustrophobic composition focuses on the profession

of writing more than on the writer. Whereas both Martelli and Duranty are shown taking a physical, if not mental, break from work, Cordier is clearly busy within the office of his rue de Rivoli apartment. The tightly controlled focus and compressed space organized by the geometry of the books and the writer's tools (lamp, quills, and paper) stress the work activity as well as the specifically nineteenth-century association of masculinity with intellect. The tight pictorial relationship between the author's eye, hand, pen, and manuscript underscores the intense concentration of his mental labor. Immersed in his work, Cordier has no time to pose. Despite the fact that this informal, spontaneous portrait shows a man in his particular surroundings, it is less portrait than genre painting; one gleans little more about the sitter himself. In contrast to Degas's handling of Duranty (an image Huysmans read as offering a wealth of character details, from "nervous" fingers to a "mocking" eye to a "wry English humorist's air" and "dry, little laugh"),[2] Caillebotte showed not a unique personality but the archetypal scholar at work. His emphasis on the gold-colored quill that Cordier holds like a paintbrush over the paper may have had special significance for the artist as a means of linking this image of a man consumed by his scholarly vocation to his own dedication to the discipline of painting. G. G.

1 Varnedoe stated that Cordier's famous library was lost at sea upon his return to France from China in 1877 (see Varnedoe 1987, p. 162).

2 Huysmans [1880] 1883, p. 132, trans. in Degas 1988, p. 310.

Figure 1. Anonymous. *Portrait of Henri Cordier,*
c. 1883. Photograph. Bibliothèque Nationale,
cabinet des estampes.

85

Portrait of a Man Writing in His Study

(Portrait d'homme écrivant dans son bureau)

1885

Oil on canvas

65 × 82 cm

Signed and dated lower left:
G. Caillebotte / 1885

Berhaut 1978, no. 291, possibly
no. 296; Berhaut 1994, no. 319

Josefowitz Collection

Principal Exhibitions
Brussels 1888, no. 4, as *Portrait
de M. E. J. F.*(?); Paris 1894, no. 44
(?); Paris 1921, no. 2736.

Selected Bibliography
Berhaut 1951, no. 225, possibly
no. 156; Berhaut 1978, p. 54;
Balanda 1988, pp. 128–29.

This picture is thought to represent Emile Fontaine, a member of the yachting club Cercle de la Voile de Paris and the owner of a bookstore located at 30, boulevard Haussmann, across the street from Caillebotte's apartment. If so, instead of a genre painting of a man bent over his work, this is a portrait of one of Caillebotte's friends, whose interests link him to the scholar Henri Cordier (see cat. 84) and to the boating amateurs around the Argenteuil basin, several of whom posed for the artist between 1879 and 1885 (see cats. 75 and 86).

Here, as in his *Portrait of Henri Cordier* (cat. 84), Caillebotte represented a man too busy with his work to pose and whose concentration is underscored by an airless and compartmentalized office space. A recent study of this "portrait" has pointed out the insistently triangular body structure upon which the orb of the head seems placed.[1] Indeed, light falls sharply upon the bald pate and hands as the true subject and points of interest. Even more so than in the *Portrait of Henri Cordier*, this is an image of mental concentration. A pipe clamped

tightly between his teeth, the man grips a pen in one hand and keeps the other on the line as if to mark his place. His gesture suggests that this is not an act of creating but of recording, and that the open book is not a manuscript, but a ledger, which confirms the identification as Fontaine. Moreover, his hunched posture, myopic vision, and awkward gestures suggest a very different type of writer than Cordier (who delicately lowers his pen to paper) and a more mundane activity than the latter's scholarly pursuits. As in the paintings of the floor-scrapers, which depict physical labor demanding manual dexterity, this is a picture of mental labor dependent as well upon manual exercise. Here, however, Caillebotte represented the hands of the sitter as clumsy, hooflike triangles clutching pen and paper, in contrast to those of the "bare-backed" floor-scrapers who hold their utensils with "aristocratic grace."[2] G. G.

1 See Balanda 1988, p. 128.
2 Rosenblum 1989, p. 322.

86

Portrait of Jules Dubois

(Portrait de Jules Dubois)

1885

Oil on canvas

117 × 89 cm

Signed and dated upper left:
G. Caillebotte / 1885

Berhaut 1978, no. 292; Berhaut
1994, no. 320

Josefowitz Collection

Principal Exhibitions
Brussels 1888, no. 2, as *Portrait
de M. J. D.*

Contemporary Criticism
L. 1888.

Selected Bibliography
Berhaut 1978, p. 53.

This is one of several portraits featuring the red-velvet chairs and paneled walls of Caillebotte's boulevard Haussmann apartment. Although the artist also painted portraits (or portraitlike images) of men within their own environments, in order to study, as Edmond Duranty had proposed, the "relationship of a man to his home, or the particular influence of his profession on him, as reflected in the gestures he makes," and to observe "all aspects of the environment in which he [the sitter] evolves and develops,"[1] the portraits of Jules Dubois, Jules Richemont (cat. 75), and Jules Froyez (Berhaut 1994, no. 181) provide little information beyond the social class of the sitter. Whether the subject is posed more casually, as is Richemont, or more stiffly, as is Dubois, Caillebotte adopted an almost formulaic composition, consisting of a vertical format, parallel viewpoint, and close-up focus that truncates the representation of the sitter at the knee. The insistent frontality recalls that of Caillebotte's *Portrait of Jules Froyez*, shown in the 1882 Impressionist exhibition and caricatured in *Le Charivari*. Although they both may be seen as subtle nods to the relentless frontality of J. A. D. Ingres's celebrated *Portrait of M. Bertin* (1832; Musée du Louvre, Paris), Caillebotte's likenesses are less psychologically penetrating.

Apart from his tilted top hat, which alone breaks the stubborn axial ordering and adds a note of informality, there is a decided absence of personality in the *Portrait of Jules Dubois*. Armed with his walking stick, topcoat, and top hat, Dubois embodies the dignified bourgeois gentleman. Dubois and Caillebotte were particularly close in 1882, having together purchased a sailboat that they had brought from England. Nonetheless, Caillebotte treated his subject with the formality of a portrait commission, magnifying his power and status rather than revealing his personality. As a social type, Dubois seems as generalized as the domestic background against which he is placed. It is only our knowledge of the sitter's identity, in fact, that distinguishes this portrait of a *grand bourgeois* from Caillebotte's full-length depiction of the family butler, Jean Daurelle, who is shown with the same sober attitude, costume, and accessories (see ch. 5 intro., fig. 2). Despite its conventionality, the *Portrait of Jules Dubois* was one of seven pictures Caillebotte chose to include in the 1888 "Salon des XX." G. G.

1 Duranty 1876; repr. and trans. in San Francisco 1986, pp. 481 and 44, respectively.

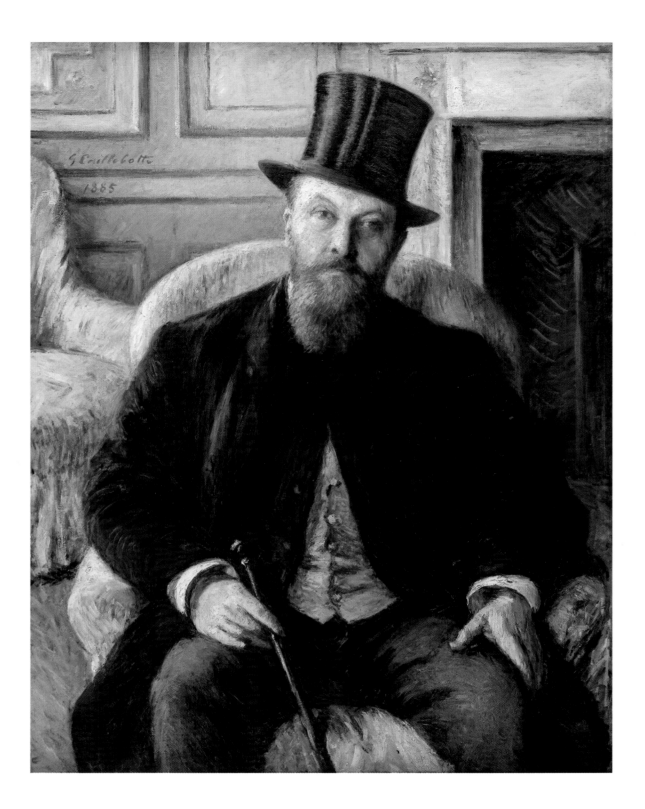

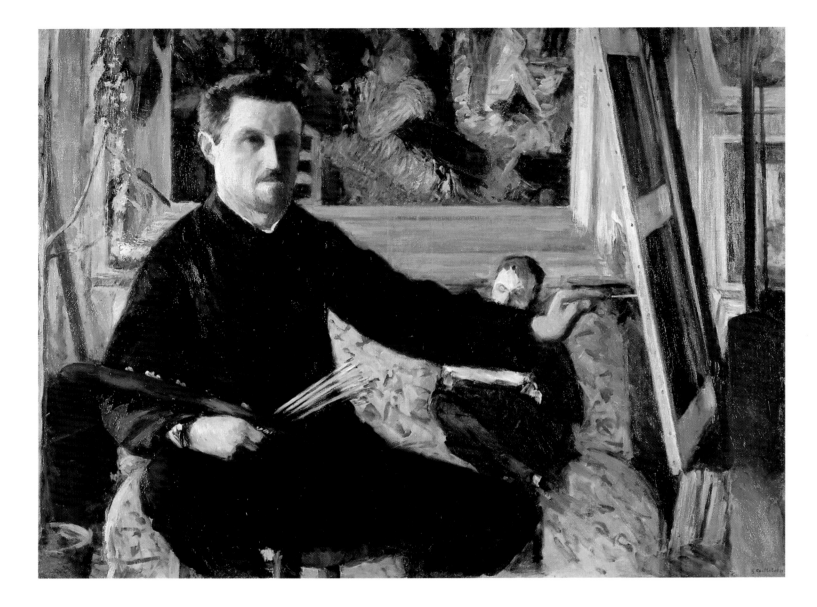

224

87
Self-Portrait at the Easel
(Portrait de l'artiste au chevalet)

1879/80

Oil on canvas

90 × 115 cm

Stamped lower right

Berhaut 1978, no. 118; Berhaut 1994, no. 132

Private collection

Principal Exhibitions
Houston and Brooklyn 1976–77, no. 45.

Selected Bibliography
Varnedoe 1987, no. 33; Wittmer 1990, pp. 60, 265, 276, and 280.

The large format, studied composition, and complex spatial conception of this work suggest that here Caillebotte set out to produce a self-portrait that was an ambitious modern image of the painter in his studio, a theme that has consistently fascinated artists. But the work was never completed, and it was exhibited for the first time only in 1976–77. Caillebotte presented himself as a painter, in household clothing notably devoid of "artistic" fantasy, brush in hand, seated in front of a canvas in progress (it is unframed, which suggests that he is really at work, not posing for a newspaper photographer, as his academic colleagues often did). Judging from surviving photographs, the head is a good likeness: thin face with gray eyes, beard, and short, prematurely graying hair. We recognize the gilt filigree of the paneling in his apartment on boulevard Haussmann, which appears in the background in many of his portraits in this period. A man whose features are indistinct reads on a sofa (see cats. 77 and 80) in the rear: this studio is not an isolated retreat, but a room in which a friend could feel at ease. There is a potted plant on the left that recalls the painter's interest in flowers. In any event, the dominant element is the large canvas in a wide, gold frame on the back wall: it is Pierre Auguste Renoir's *Ball at the Moulin de la Galette* (Appendix III, fig. 49), shown in the 1877 exhibition and doubtless purchased by Caillebotte shortly thereafter. Note that the composition is shown in reverse, perhaps not only because that is how it appeared to the artist in the mirror reflection from which he was working, but also because this precluded servile imitation. An image of the artist painting a self-portrait is here combined with that of the collector and benefactor, the "impresario" of the 1877 exhibition. Other works hang on the wall as well, but they are unidentifiable.

The composition takes up a scheme previously employed in several of Caillebotte's works and featuring a principal foreground figure seen against a compressed background space, as in *Interior* (cat. 77), which includes the same sofa. As he did so often, Caillebotte contrasted exaggerated light on one side with dark shadows on the other, a device which in this instance accords greater prominence to the face.

Marie Berhaut has dated this self-portrait to 1879, and Kirk Varnedoe to 1879/80. Their views are corroborated both by the date of Caillebotte's move into the boulevard Haussmann apartment and by similar works that are clearly dated, such as *Interior* of 1880. It follows that this is one of the painter's earliest self-portraits, for, while it seems probable that the elegant young man in a top hat in *The Pont de l'Europe* of 1876 (cat. 29), is the artist himself, and that he was also the model for an unfinished portrait that recently appeared on the market,[1] it is not certain that the small, youthful canvas picturing a man in a boating cap (see Introduction, fig. 6) is in fact a representation of him. A. D.

1 See Berhaut 1994, no. 26.

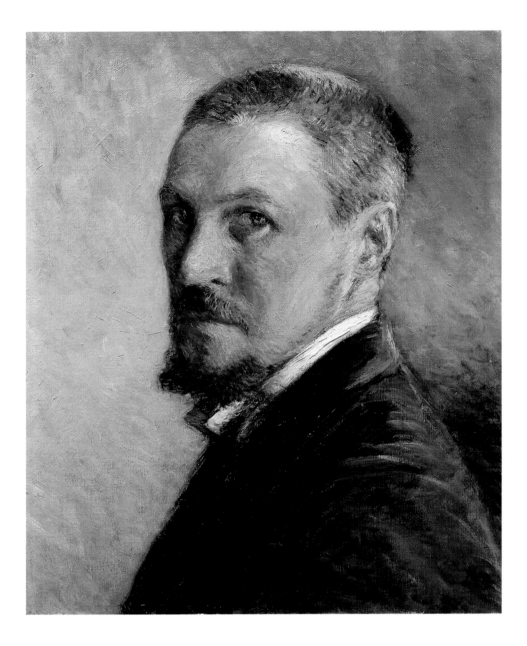

88

Self-Portrait

(Portrait de l'artiste)

1888/89

Oil on canvas

55 × 46 cm

Berhaut 1978, no. 366; Berhaut 1994, no. 404

Private collection

Principal Exhibitions
Paris 1894, no. 10; Paris 1921, no. 2700; Paris 1951, no. 71; Chartres 1965, no. 25; London 1966, no. 38; Marcq-en-Baroeul 1982–83, no. 27.

Selected Bibliography
Sertat 1894, p. 382; Rewald 1973, p. 449; Berhaut 1978, p. 54; Varnedoe 1987, p. 182, fig. 62a; Chardeau 1989, pp. 101–102; Wittmer 1990, p. 104.

It was this portrait, squarely focused on the model's face, that was chosen to represent the deceased painter's features on the occasion of his memorial exhibition in 1894. It was also used to illustrate the article on him by Raoul Sertat for *La Revue encyclopédique*. It thus became the best-known image of Caillebotte, perpetuating a semblance of his emphatically structured face gazing intently at the viewer, characteristics that recall self-portraits by Cézanne and even by van Gogh.

Dated 1888/89 by Marie Berhaut and c. 1888 by Kirk Varnedoe, this portrait seems to picture the artist as somewhat younger than does the Musée d'Orsay canvas (cat. 89), which has traditionally been assigned to the artist's last years. A. D.

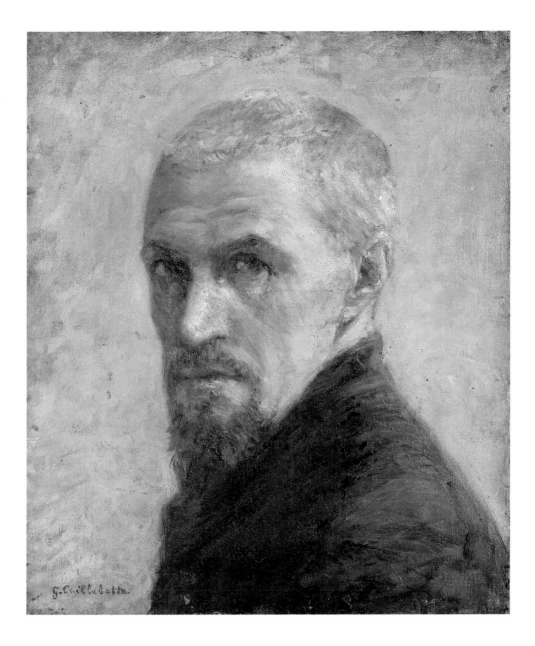

228

89
Self-Portrait
(*Portrait de l'artiste*)

c. 1892
Oil on canvas
40 × 32 cm
Stamped lower left
Berhaut 1978, no. 411; Berhaut
1994, no. 436

Musée d'Orsay, Paris (acquired
in 1971; RF 1971-14)

Principal Exhibitions
Houston and Brooklyn 1976–77,
no. 76; Marcq-en-Baroeul 1982–
83, no. 28; Pontoise 1984, no. 16.

Selected Bibliography
Adhémar and Dayez 1973, p. 140;
Berhaut 1978, p. 54; Varnedoe
1987, no. 62; Wittmer 1990, pp. 9
and 70.

This self-portrait is usually dated c. 1892, but this is at best an approximation, for our only guide is the apparent age of the artist, who died prematurely in February 1894. As in the previous painting (cat. 88), the facial expression is intense, stern. The absence of a white collar suggests this might be a portrait of the artist as a "boater," and in fact it was given to Joseph Kerbrat (note the unmistakably Breton name), who worked for Caillebotte as a "sailor" (see Chronology, 1891). Indeed, it was at the helm of his sailboat that the artist depicted himself in one of his last works (Berhaut 1994, no. 475), dated 1893. A. D.

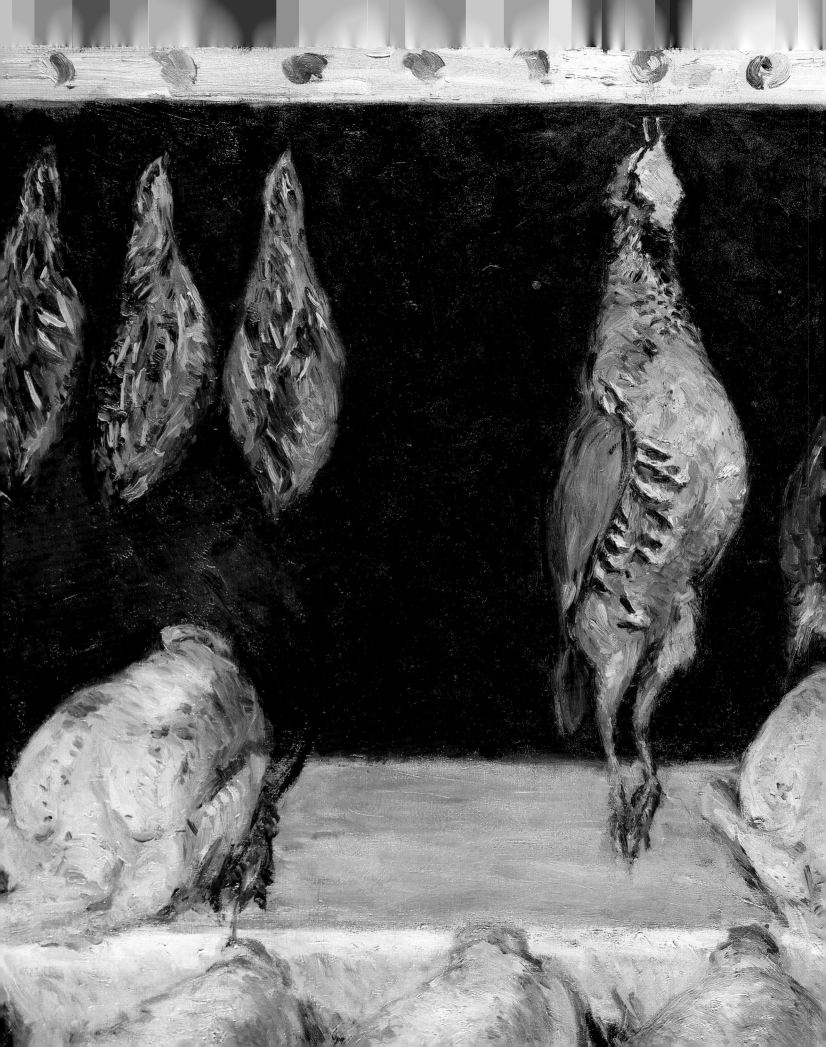

Still life was a consistent—if minor—feature of the Impressionist exhibitions, notably in the submissions of Monet.[1] Only Cézanne, however, made the genre central to his production; for the rest, it was of secondary importance. But still life had a place: especially when featuring flowers and fruit, it could be regarded as a concession to the market. "Confected goods" was the phrase Degas used for the works he made specifically with a view to the marketplace—the fans and other small, undemanding, and readily produced objects that might generate revenue in difficult times.[2] Still life, though shunned by Degas, could be similarly regarded: its inherently pleasing subject matter, together with the modest ambitions associated with the genre, glossed over the questions raised by the Impressionists' treatment of other subjects. Less challenging for the collector, still life seemed equally unproblematic for the artist. Undertaken sporadically, if at all, Impressionist still lifes often seem to have signified a kind of artistic "time out," a leisurely pictorial form of exercise and distraction from the more demanding business of producing images of modern life.

Not that still life as a genre was officially excluded from this enterprise. While not specifically mentioned in Duranty's essay "The New Painting," the role of still life could be deduced from the critic's discussion of that of the "background of an apartment or the street" in presenting a picture of the "financial position, class, and profession" of the contemporary in-

habitants.[3] But such implications remained largely unexplored in Impressionist still lifes. One of the problems in this regard was the weight of tradition attending the genre. Another, closely related, was the question of composition and specifically the problem of authorial intrusion—the artist's role in shaping the reality represented. Henri Fantin-Latour, recognized by Duranty as the leading practitioner of floral still life among the Realist precursors of "The New Painting,"[4] had explicitly confronted this issue in *Still Life: Corner of a Table* (fig. 1), which he exhibited at the Salon of 1874. Here he had set out to "realize the natural" by "representing things as they are found in nature; I put a great deal of thought into the arrangement, but with the idea of making it look like a natural arrangement of random objects. This is an idea that I have been mulling over a great deal: giving the appearance of a total lack of artistry."[5] He did so by adopting a low viewpoint and framing his subject so that on all sides forms are cropped by the edges of the composition. Critical response attested to the failure of his achievement: he was taken to task for lacking compositional ability, for his naïveté.[6] Fantin-Latour retreated to simpler compositions featuring single bouquets whose construction Monet echoed in paintings such as *Red Chrysanthemums* (Appendix III, fig. 35), lent from Caillebotte's personal collection to the 1882 Impressionist exhibition.

This sumptuous flower piece, along with another by Cézanne (*Flowers in a Rococo Vase*, Appendix III, fig. 7), were the sole still lifes in Caillebotte's collection of works by colleagues, despite its inclusion of such paintings by the notable if occasional practitioners of the genre, Manet and Renoir. A similarly restrained attraction to still life is reflected in Caillebotte's own production, where it likewise played a minor role. And yet, the artist's occasional engagements with the subject in the late 1870s and early 1880s produced some of the most provocatively original compositions within his oeuvre. These works explore the genre's implications for the Impressionists, while realizing a vision of modern life as potent and charged as his most ambitious domestic interiors or representations of the street.

Caillebotte had made only a handful of relatively insignificant still lifes prior to 1879, when he painted the picture featuring glasses, carafes, and fruit-dishes included among his entries to the fifth Impressionist exhibition, in 1880 (fig. 2).[7] Here the artist made reference to *Luncheon* (cat. 72), the composition featuring his mother and brother at the table, shown in the 1876 Impressionist exhibition. This strategy of reemploying props from a portrait constructed around the narrative of dining had direct precedent in Fantin-Latour's *Corner of a Table*, where the artist had re-presented the table and objects at the center of his group portrait of the same title (1872; Musée du Louvre, Paris), including the poets Paul Ver-

Figure 1. Henri Fantin-Latour (1836–1904). *Still Life: Corner of a Table*, 1873. Oil on canvas; 97.2 × 125.1 cm. The Art Institute of Chicago (Ada Turnbull Hertle Fund, 1951.226).

laine and Arthur Rimbaud, that had been much remarked upon at the 1872 Salon. Like Fantin-Latour's, Caillebotte's still life employs an insistently arbitrary point of view, radical croppings, and compressed space to present the accoutrements of the meal arranged in a way that subverts the narrative of its anticipation or aftermath.[8] Yet in Caillebotte's picture, this subversion takes on significance. His insistence on pairing objects, on creating intersecting diagonals of "twos" to form the compositional armature, is provocative, underscoring both the human absence and the odd lack of domestic purpose in the arrangement. The meaning is no doubt personal. Here, as has been noted, Caillebotte employed "memory laden objects" to evoke the two protagonists of the *Luncheon*—the artist's mother and youngest brother—both of whom had since died.[9] Set in the dining room of the apartment he subsequently rented with his brother Martial, their re-presentation by Caillebotte can also be read as a metaphor for the new life he had created. For now the purpose for which the objects have been brought together has shifted, the syntax of art displacing that of domestic sociability. Caillebotte's picture speaks of a life that no longer has family ritual at its center, where inheritance has been put in the service of activities revolving around the production, display, and marketing of art.

The painter's synecdochic use of still life to imply larger physical as well as social and emotional spaces suggests his interest in expanding the genre's significance within the Impressionist enterprise. Indeed he began his serious engagement with the genre at precisely the same moment that Monet and Renoir began paying it more attention. But his friends' production was economically motivated, spurred by their discovery that there was a more reliable market for still life than for their other work.[10] Freed from such financial constraints, Caillebotte's involvement with the genre nonetheless suggests, in the questions some of his pictures raise, his sympathetic response to his friends' situation and his fascination with the larger market issues involved. In a sense, Caillebotte's thoughtful picture of 1879 confronted the practice of Monet and Renoir, whose exhibition of sumptuous floral pieces catered to the consumption of paintings as luxury goods, compelling for reasons little differentiated from those of their subjects and similarly acquired for their unproblematic, sensuous beauty and decorative potential. It is true that, in the still lifes Caillebotte made in the years directly following, he occasionally adopted the formulas of both his colleagues. In so doing, he produced works that, however pictorially convincing, seem to belie his own artistic identity. But while the subject, composition, and brushwork in the *Melon and Bowl of Figs* (cat. 90)

Figure 2. Gustave Caillebotte. *Still Life: Glasses, Carafes, and Fruit-Dishes*, 1879. Oil on canvas; 50 × 60 cm. Collection of Mr. and Mrs. Aaron Spelling.

can be seen to evidence Caillebotte's moving toward what could be called canonical Impressionism,[11] it is also possible to read in them an enterprise of another sort. Much as a designer in the employ of a noted couturier might channel individual expression in the service of the identifiable "house style," so Caillebotte produced an "article" in Degas's sense of the term, a luxury commodity that stylistically bears the recognizable label "Impressionist." This more subversive reading is supported by the evidence of Caillebotte's other still lifes of the period, which display his fascination with the themes of production and consumption, of marketing and display. Stylistically and ideologically, these works, organized around the polarity of production and consumption, were his hallmark productions in the genre.

Confronting Impressionist practice, Caillebotte's still lifes also take issue with their immediate Realist antecedents. In *Still Life with Oysters* (cat. 91), he reprised a still-life subject popular with minor Realists such as François Bonvin (see fig. 3), who associated the subject with its treatment by Dutch still-life painters of the seventeenth century, acknowledging the connection by adopting such compositional motifs as the knife positioned precariously near the table edge. Caillebotte eschewed such self-conscious—and self-justifying—art-

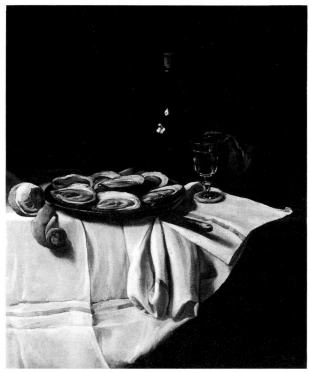

Figure 3. François Bonvin (1817–1887). *Still Life with Oysters*, 1860. Oil on canvas; 94.3 × 73.7 cm. Yale University Art Gallery, New Haven (Stephen Carlton Clark, B.A. 1903 Fund).

Figure 4. Edouard Manet (1832–1882). *Oysters and Champagne*, c. 1877. Oil on canvas; 55 × 35 cm. Location unknown.

historical references. Similarly, his treatment thwarted the eroticism that permeates Manet's *Oysters and Champagne* (fig. 4), where the presence of a Japanese fan coupled with the champagne cooler underscores the oysters' sexual symbolism, suggesting the ingredients of an amorous rendezvous presented as if arranged for the viewer's consumption. Caillebotte literally turned the tables on this strategy. By his presenting the oysters before an unoccupied place setting that seems neither ours nor his, the vantage point the painter adopted seems to have put him—and us—in the position of the waiter, thereby switching the viewpoint from consumer to provider, indeed, to the worker.

The suggested congruency here, between the painter's viewpoint and that of the provider of goods for consumption, points to the same duality and multiple class identifications evident in Caillebotte's larger projects. These characteristics are further suggested in *Still Life* (cat. 92). Departing from the traditional representation of crustaceans in still life, reiterated in recent Realist depictions, as cooked but otherwise untouched,[12] Caillebotte's crayfish, elaborately dressed and presented on a sideboard, is less about nature than about consumption. The subject is not *nature morte* so much as nature refashioned by the chef's art, raw materials transformed through labor into a product that appeals to sight as well as taste. Presentation and culinary artistry are likewise the focus of Caillebotte's depiction of cakes (fig. 5) in a double row, as one might have seen them displayed in fashionable establishments such as the Patisserie Gloppe on the Champs Elysées.

The Patisserie Gloppe, depicted by Jean Béraud in 1889 (fig. 6), and similar establishments testified to the recent developments in marketing that had structurally changed consump-

tion, replacing the notion of purchasing goods as a simple transaction predicated on need, with that of shopping, an activity based as much on the creation of desire through enticing display as on need itself. Critical to this development was the rise of the department stores, the *grands magasins* that came into being during the Second Empire, built, it was said, on the ruins of the *quartiers* swept away by the Haussmannization of Paris.[13] These vast emporiums of consumption, *quartiers* in themselves, helped determine the face of the new boulevards. For in recruiting their most ardent patrons from the moneyed bourgeoisie, the department stores impacted the new boulevards they inhabited. Not only did the boulevards seek to rival the *grands magasins* as "caravansaries of fashion,"[14] sprouting shops sumptuously decorated to attract the passersby, they also responded, in the form of establishments such as Gloppe's, to the ancillary needs of this new audience of shoppers. Central to all these developments were new merchandizing techniques wherein display became a critical adjunct to advertising. Contemporary commentators noted the great expense being lavished on the boulevard shops and the attendant proliferation of *arrivistes* and *nouveaux riches*, which included the new shopkeepers. "It's hard to imagine," wrote Georges Montorgueil, "the boldness of one-time waiters now become café-owners: one hundred thousand francs to decorate a door is nothing to them. They'll spend a million to make their customers feel welcome."[15] Developments in the technology of glass production—notably the introduction of clear plate-glass—had elided the spaces of shop and street while enlarging the possibilities of turning the passerby into a customer. Visual display became an art, the window dresser an artist who transformed goods into

Figure 5. Gustave Caillebotte. *Cakes*, 1882. Oil on canvas; 54 × 73 cm. Private collection.

Figure 6. Jean Béraud (1849–1935). *La Pâtisserie Gloppe*, 1889. Oil on canvas; 38 × 53 cm. Musée Carnavalet, Paris.

provocative still life. Presentation—form—had become as important as substance. "A vermouth," as Montorgeuil noted, "can't be had but under a gilded ceiling. Fresh pork calls for porphyry. Sauerkraut is complemented with Carrara marble and *museau de boeuf* displayed against a backdrop of authentic Gobelins."[16]

Caillebotte's *House-Painters* (cat. 15), a representation of painters decorating a store facade, speaks to his fascination with these new developments. A comparison of his representations of meat and game with those by minor Realist painters who specialized in the genre indicates these societal changes are equally at the heart of his still lifes. Although some of Caillebotte's pictures featuring game allude to traditional representations, as trophies of the hunt, symbols of rustic life and the leisure activities of the privileged, his still life featuring chickens, game birds, and rabbits (cat. 94) represents a very different and contemporary display: that of the smart Parisian shop, where game is business rather than sport and its social significance is diluted by the inclusion of plucked chickens that evoke the farmer's work and the tradition of the humble market still life. In Caillebotte's representation, as in the shop, genres merge, but as the display insists, rather than blending into a homogeneous whole, these animals coexist much as do the different classes on the boulevards outside; birds of a feather still flock together, even in a shared space.

Social and economic change are likewise implied in Caillebotte's still lifes featuring meat. In treating similar themes, Realists such as Bonvin (see fig. 7), Antoine Vollon, and Caillebotte's successful contemporary Victor Gilbert (see fig. 8) adopted an approach that reflected the outlook of the farmer or the butchers of Les Halles, the great Paris marketplace

where Bonvin for years served as meat inspector: death—and the work associated with it—is frankly acknowledged as a basic fact of life. By contrast, while confrontational, Caillebotte's double portrait of a calf's head and ox tongue (cat. 96) is disturbing precisely because of the way it disrupts this tradition. In place of the somber chiaroscuro that both Rembrandt and the Realists used to set the stage for such themes, Caillebotte's near-pastel palette, attentive to the reds, pinks, and violets in the subjects, imbues his representation with an oddly festive, almost seductive, quality that practically transforms the butchered parts into objects of desire. This would-be transformation is insisted upon in the *Calf in a Butcher's Shop* (cat. 95): the carcass has been dressed in an overtly coquettish fashion, the rose applied to the "breast" suggesting a corsage adorning the décolletage of a fashionable beauty.

While the visual pun on the femme fatale is macabre, the double sense in which the carcass is "dressed"—in terms of both the butcher's work and that of the couturier—is significant. Appropriate to the wholesale environment of Les Halles, the butcher's conventional dressing is sufficient for consumption, but not for display in a retail shop. The butcher-shop interior that Caillebotte's picture implies is therefore quite a different kind than the modest establishment depicted in Léon Lhermitte's etching of 1881 (fig. 9). Fashionable, its produce must appear likewise; to this end, the carcass, posed against the backdrop of the elegant shop interior, has been re-dressed for its debut before an affluent bourgeois audience. Caillebotte's representation thus alludes to the economic and social changes that were structuring modern Paris. The emphasis on display, on dressing the dressed, points to the new commercial structures produced by the department store, along

Figure 7. François Bonvin (1817–1887). *The Pig, Courtyard of the Charcuterie*, 1874. Oil on canvas; 61.4 × 50 cm. Musée St. Denis, Reims.

Figure 8. Victor Gilbert (1847–1935). *Meat Haulers*, 1884. Oil on canvas; 200 × 158 cm. Musée des Beaux-Arts, Bordeaux.

Figure 9. Léon Lhermitte (1844–1925). *Interior of a Butcher Shop*, 1881. Etching; 17.5 × 16.4 cm. The Newberry Library, Chicago.

with improved transportation systems without and within the city that increasingly distinguished manufacturing from marketing and wholesale from retail activities. Shops that traditionally had been directly involved in the production of the goods they sold increasingly became simple commercial outlets for items processed by separately owned food companies.[17] Caillebotte here evoked the accompanying social changes with an irony similar to that of the contemporary social commentators who produced written "tableaux de Paris." The unintentionally grotesque effort of Caillebotte's shopowner to display his wares appears to have sprung from the proverbial hope of transforming the sow's ear into a silk purse. Decked out in finery that fails to mask its nature, the carcass evokes the city's social body and the new class fluidity that Caillebotte addressed in his *Pont de l'Europe* (cat. 29). Specifically, it can be read as a metaphor for the new *parvenu* culture, for the *arriv-*

istes or "new-made bourgeois" who now, along with aristocrats and dandies, claimed the boulevard and its boutiques as their own.[18]

If Caillebotte's *Calf in a Butcher's Shop* suggests the ironic detachment of the Baudelairean *flâneur*, the intensity of its focus on strategies of display suggests the underlying empathy with the artisan-decorator earlier intimated in *House-Painters* (cat. 15). An aspect of Caillebotte's ideological "dualism," this identification can be specifically related to the role Caillebotte had played in presenting the Impressionists to the Paris public. For these exhibitions had reflected the awareness, shared by private dealers and other private exhibition societies, that art distribution and marketing was, like commodity distribution in general, in the process of being redefined.[19] In conceiving their exhibitions, the Impressionists had addressed one of the major complaints voiced by Degas and others regarding the annual State-sponsored Salons: they were so crowded, crudely appointed, and badly hung that they resembled industrial fairs or a vast, unruly marketplace. By contrast, the Impressionists, recognizing the necessity to display art in ways that would attract the new public that saw art as a luxury commodity and potential investment, took the necessary steps to create an ambiance that would properly showcase their work. To this end, the organizers paid heed to the nature and location of the exhibition space and the public hours, as well as lighting, wall color, framing, and hanging. In short, if the Salon was the Les Halles of art produce, the Impressionist exhibitions aimed to be the equivalent of the smart boulevard shops. In this marketing strategy, Caillebotte's involvement was critical.

The most complex still lifes Caillebotte painted in the early 1880s speak to this activity as well as to his own larger artistic

enterprise. They can be considered another facet of his efforts to represent the spaces of modern Paris, adding to a repertory of subjects that already included the street and the domestic interior, representations that imply the smart eating establishments and shops that completed his picture of the new urban "reality." Moreover, these pictures address the Republican vision Caillebotte had pictorially endorsed in earlier projects of social cooperation through a definition of "work" that included artistic activity. As a vehicle for a similar expression, the still lifes can be directly connected to the artist's personal and professional history. The apartment building his father had constructed in 1866, around the corner from the family house erected the same year on rue de Miromesnil, had included at ground level, below the fashionable domestic rentals, spaces that would house a tripe- and butcher's shop. This architectural expression of social order and harmony based on and achieved through work was echoed in the model chosen for the founding charter of the Impressionist enterprise in 1874: that of a baker's union.

The spirit of identification with a cooperative of working artisans sharing a métier, as well as a reference to the fruits of Impressionist labor, seems to inform the remarkable still life *Fruit* (cat. 93) which Caillebotte included among his seventeen entries to the seventh Impressionist exhibition, in 1882. Here he represented the fruit-seller's display as if undisturbed by his own compositional exigencies; he paid homage to the shopkeeper's art by making it the basis of his own. The challenge facing the fruit vendor was to group together in a confined space produce of different types, sizes, shapes, and colors in a manner that balances the need to respect their individuality with that of creating a harmonious whole. Caillebotte the painter faced a similar challenge pictorially; Caillebotte the artist-entrepreneur faced its analogue in organizing the Impressionist exhibitions of 1877, 1879, and 1880.

The last of these exhibitions failed precisely because of an inability to harmonize the diverse tendencies of the group; poorly installed, it presented to the critics a picture of compartmentalization as fragmentation. Blaming the scattered and diluted focus on Degas's insistence on including artists of a different stripe and lesser talent, Caillebotte decided against exhibiting the following year. Once again Degas's demands held sway, preventing the qualitative and stylistic coherence Caillebotte envisaged.[20] In 1882, however, he prevailed; and while his rival Degas now chose to absent himself, his friends Monet, Renoir, and Sisley once again cooperated. Celebrating a hard-won unity of related but diverse elements in an individual yet recognizably Impressionist vocabulary, Caillebotte's *Fruit* suggests his belief in the power of art to unify. It can be regarded as a metaphor for the Impressionist enterprise and Caillebotte's dual role within it as artist-entrepreneur, a brilliant reiteration of his vision of social and artistic cooperation. But the optimism it seems to express was to be disappointed. Not until 1886 would there be another Impressionist exhibition, and by that time the group was clearly no longer coherent. Caillebotte did not participate. Soon he would withdraw from the fray, moving from Paris to Petit Gennevilliers.

After 1883 Caillebotte left off making still lifes. Almost a decade later, when he again took up the genre, the works he produced were as radically different from his early paintings as were the ambitions that informed them. D. D.

NOTES

1 Monet included still lifes in his submissions to the Impressionist exhibitions of 1874 (one of nine entries), 1876 (one of eighteen), 1877 (three of thirty), 1879 (one of twenty-nine), and 1882 (four of thirty-five). Renoir showed still lifes in 1877 (three of twenty-one entries) and in 1882 (four of twenty-five). Other exhibitors of still lifes included Cézanne in 1877 (three of sixteen works) and Gauguin, who included still lifes in his entries to the exhibitions of 1880, 1881, 1882, and 1886.

2 *"Articles à confectionner"*; see the letter from Degas to Alexis Rouart [1879] in Guérin 1945, pp. 61–62, letter 32 (as [1882]). In his letter to the painter Jean Charles Cazin of 29 Nov. [1879 or 1880], he wrote, "You must also put yourself in the countryside to push your goods onto the amateur-collectors, your supporters" (see ibid., p. 59, letter 30 [as 29 Nov. 1880]).

3 See Duranty 1876; repr. and trans. in San Francisco 1986, pp. 482 and 44, respectively.

4 Ibid., pp. 480 and 42.

5 See letters from Fantin-Latour to the painter Otto Scholderer of 10 Mar. 1873 and Jan. 1874, as cited in Druick and Hoog 1982, p. 261.

6 Ibid., pp. 261 and 263.

7 The earlier still lifes, none of which are signed or dated, are identified in Berhaut 1994 as nos. 12–15.

8 Varnedoe (1987, p. 122) noted: "the formal arrangement of objects . . . has no binding thread of domestic sociability (there are no plates, no forks or knives to suggest a meal to come). . . . "

9 Ibid.

10 See Distel and House 1985, p. 229; and House 1986, pp. 40ff.

11 See Varnedoe 1987, p. 157.

12 See, for example, Eugène Boudin's *Still Life with Lobster on a White Tablecloth* (1853/56; High Museum of Art, Atlanta), reproduced and discussed in Weisberg 1980, no. 114, pp. 147–48. Lobsters presented in this manner are a staple of seventeenth-century Dutch still life. For Caillebotte's own depiction of lobster in this fashion, see Berhaut 1994, no. 284.

13 For this and the discussion that follows, see Nord 1986, pp. 60–99.

14 See Anonymous, *Les Boulevards de Paris* (Paris, 1877), cited in ibid., p. 92.

15 G. Montorgueil, *La Vie des boulevards* (Paris, 1896), p. viii, as cited in Nord 1986, p. 94.

16 Nord 1986, p. 92.

17 This was, for example, the case with charcuteries and triperies; see ibid., p. 89.

18 For "new-made bourgeois," see the articles published by Jules Valles in 1882–83, reprinted in his *Tableau de Paris*, cited in ibid., p. 94.

19 On this subject, see two important recent studies: Ward 1991, pp. 599–623; and Mainardi 1993, esp. pp. 104ff.

20 See the letter from Caillebotte to Pissarro dated 24 Jan. 1881, in Berhaut 1994, pp. 275–76, letter 11.

90
Melon and Bowl of Figs
(Melon et compotier de figues)

1880/82

Oil on canvas

54 × 65 cm

Signed (posthumously?) lower right: *G. Caillebotte*

Berhaut 1978, no. 211; Berhaut 1994, no. 238

Private collection

Principal Exhibitions
Paris 1894, no. 96; Paris 1951, no. 49; Chartres 1965, no. 19; London 1966, no. 32; New York 1968, no. 44; Houston and Brooklyn 1976–77, no. 58; Marcq-en-Baroeul 1982–83, no. 21.

Selected Bibliography
Berhaut 1978, p. 56; Varnedoe 1987, no. 47.

The similarity between this picture by Caillebotte and one painted by Renoir in 1882 (fig. 1) led Marie Berhaut to suggest that both paintings were made at the same time, the two artists working together on the subject during Renoir's stay with his patrons the Bérards at Wargemont, on the Normandy coast.[1] If this is indeed the case, such circumstances suggest why this still life is so different in subject and handling from others Caillebotte painted at or near the same time (see cats. 91 and 92).

Caillebotte here subscribed to "Impressionism" as defined by the practice of Renoir and Monet. His subject is theirs: the seasonal fruits that, like the flowers they also favored, are represented as the products of a bounteous nature and appear, as if effortlessly and according to a natural logic, on the sideboards of the domestic bourgeois interior. Notably absent are the signs of work that feature so prominently in the majority of Caillebotte's contemporary representations of produce set in spaces

Figure 1. Pierre Auguste Renoir (1841–1919). *Still Life with Melon*, 1882. Oil on canvas; 54.5 × 65 cm. Location unknown.

that imply urban commercial life (see cats. 93 and 94). But while the subject may indicate a vacation from the theme of labor, Caillebotte suggestively raised the issue of production in his handling of this picture, undertaken together with a coworker in the Impressionist enterprise. The hallmark Impressionist style as patented by Renoir and Monet is evident in Caillebotte's palette and in his attention to the play of light on the white cloth, as well as in the feathery brushwork that allows the forms of the figs to merge with the illegible pattern of the wallpaper. Similarly, the arrangement of fruit on a table covered with a white cloth arbitrarily cropped and set obliquely to the picture plane has precedent in a composition developed by Fantin-Latour in the mid-1860s, and recently adopted by Monet.[2]

Caillebotte represented the seasonal delicacies as the subject of the gaze of the affluent bourgeois consumer for whom they are largely cultivated, and whose domestic spaces their setting here implies. His *Melon and Bowl of Figs* can likewise be regarded as produce for that same market which, in recent years, both Renoir and Monet had found most reliable for their still lifes. They had increased their production accordingly.[3] Here Caillebotte, by adjusting his style to theirs, has constructed a work that might claim this same market's attention as the generic fruit of the "Impressionism" to which it proclaims affiliation. D. D.

1 See Berhaut 1994, no. 238.

2 See Fantin-Latour's *China Asters and Fruit* (1865; Mr. and Mrs. Edward Williams Carter) and Monet's *Still Life: Apples and Grapes* (1880; The Art Institute of Chicago).

3 For Monet, see House 1986, pp. 40ff. For Renoir, see Distel and House 1985, no. 59.

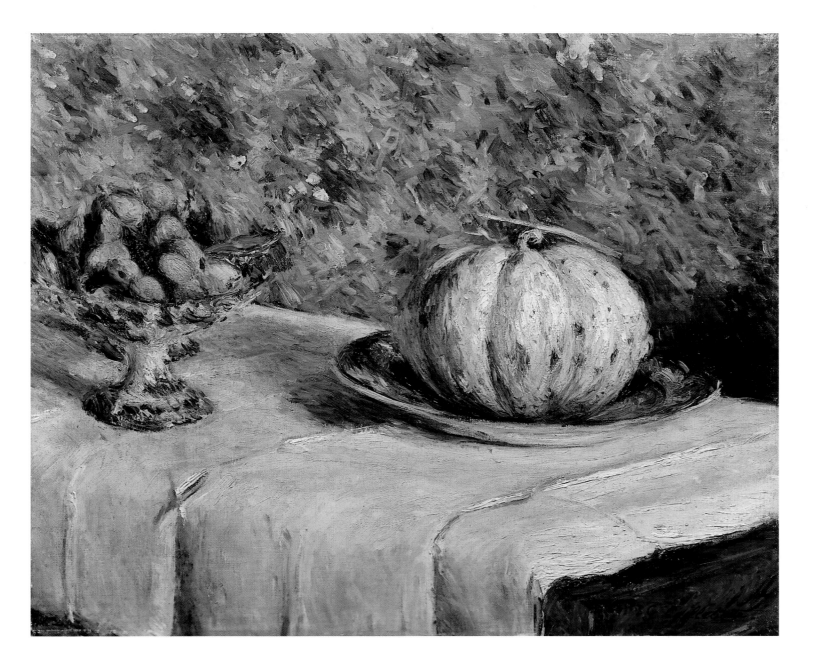

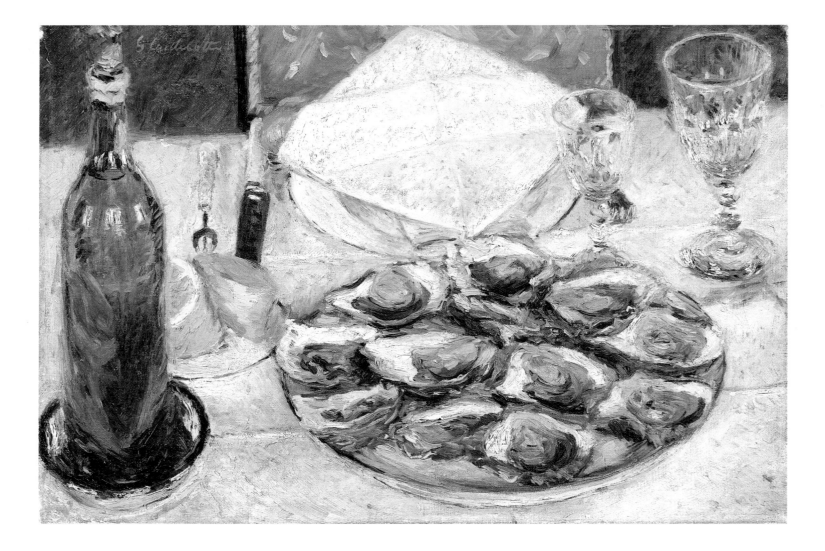

91

Still Life with Oysters

(Nature morte aux huîtres)

1880/82

Oil on canvas

38 × 55 cm

Signed upper left: *G. Caillebotte*

Berhaut 1978, no. 180; Berhaut 1994, no. 195

Josefowitz Collection

Principal Exhibitions
Paris 1894, no. 68; Paris 1954, no. 25.

Selected Bibliography
Fénéon 1948, p. 88 n. 2; Berhaut 1978, p. 55; Balanda 1988, pp. 110–111.

Here Caillebotte depicted a table set in anticipation of the imminent consumption of freshly shucked oysters. These fruits of the sea, like the fruits of summer, require virtually little or no culinary preparation. Raw but edible produce, both can be seen to symbolize nature's abundance freely given, to represent an unadorned and pre-cultural nature, "prior to social difference and hierarchy." But it is precisely this idea of the effortless "flow between nature and the table," which representations of such produce have traditionally suggested,[1] that Caillebotte's composition seems intent to disrupt.

To begin with, oysters, a delicacy traditionally harvested seasonally, had in recent times become a commodity symbolic of the new structures of consumption. The demand for oysters in all seasons had caused overfishing and the serious depletion of the oysterbeds of the Channel and other traditional sources. By 1877 protective fishing laws and the success of the aggressively pursued business of oyster-breeding had indeed resulted in increased production that promised to redouble soon. Despite this and improved means of transportation, it seemed evident that oysters would remain excessively expensive and therefore accessible only to the privileged; their distribution had become the monopoly of four of five *grandes maisons,* which controlled prices.[2]

Caillebotte's composition works to perform this message of limited access to the sea's bounty. It does so by creating uncertainty regarding for whom the oysters are intended. Set only on the "far" side across from the viewer, the table appears narrow and seems intended for a single occupant. This and the nature of the food itself suggest the locale is that of a restaurant or brasserie. Despite the meal's evident readiness, however, no one has yet taken possession of either the napkin or the chair behind. There is, nonetheless, the suggestion that the place is reserved for the artist, whose signature is set to the immediate left of the unoccupied chair. However, the point of view in the composition confuses the identification of the artist—and viewer—with the consumer. Taking in the scene straight-on and from above, the vantage point could be read as that of the passerby, if not the customer on the way to being seated. Just as likely, however, it corresponds with that of a waiter, standing in attendance.

Suggesting his identification with both provider and consumer of produce transformed by new market practices, Caillebotte's picture can be seen as alluding to his dualism as artist-worker and bourgeois collector within the economy of the Impressionist enterprise. Once again he embodied the oppositional dynamic that is at the heart of his most original contributions to the painting of modern life. D. D.

1 See the discussion of still life in Norman Bryson, *Looking at the Overlooked: Four Essays on Still Life Painting* (Cambridge, Mass., 1990), esp. pp. 17ff.

2 For the recent economic background, see the entry *"Huître"* ("Oyster") in P. Larousse, *Grand Dictionnaire universel du XIX^e siècle,* vol. 9, pt. 1 (Paris, 1866–79; repr. Paris, 1982), pp. 442–45; in idem, vol. 16, pt. 2, pp. 966–67; and in idem, vol. 17, pt. 3, pp. 1403–1404.

92

Still Life, also known as Still Life with Crayfish

(Nature morte, also known as Nature morte au plat de langouste)

1880/82
Oil on canvas
58 × 72 cm
Signed upper left:
G. Caillebotte
Berhaut 1978, no. 181; Berhaut 1994, no. 196

Josefowitz Collection

Principal Exhibitions
Brussels 1888, no. 8; Paris 1957, without no.

Contemporary Criticism
L. 1888.

Selected Bibliography
Fénéon 1948, p. 88 n. 2; Berhaut 1978, p. 55.

Here Caillebotte assertively rejected the still-life tradition of representing crustaceans as cooked but unadulterated. And as in the *Still Life with Oysters* (cat. 91), his representation here works to complicate notions of ready consumption of nature's gifts; but it does so by quite different means. The crayfish, presented on a sideboard in what must be an affluent bourgeois dining room or restaurant, is flanked by a sauce boat, stacks of plates, and silverware, creating an image of consumption that insists on its own complexity. Elaborately dressed, the food signals the refinement of the natural, the dominance of culture over nature. To prepare this dish, known as "langouste à la Parisienne," the meat is first removed from the shell, sliced, garnished with aspic and truffles, and then, along with vegetables, returned to the shell.[1] The chef thus aims not to satisfy a basic need so much as to produce appetite by appealing as much to sight as to taste. In this process, the natural almost disappears under the signs of its refinement. This is the signage of display and spectacle for an affluent consumer class, a mirror of the increasingly complex forces that were currently transforming all retail markets and the face of the city.

Caillebotte's presentation of the subject—held up and tilted forward for the viewer's delectation in a way that recalls how such a dish might actually be presented to those seated at the table—suggests once again his identification as painter with those who practice the art of display and decoration in less exalted commercial realms. His evident fascination with the work of transforming nature into art is a recurrent theme in his still lifes that deal with various contemporary aspects of marketing produce. And here, as in other of these works, the task he set himself as painter was to refine and transform the work of others; he situated himself, as painter, at the final stage in a process whereby the sign consumes the substance.

The blurring of art and commercial display was a subject that Emile Zola had explicitly explored a decade earlier in *Le Ventre de Paris* (1873), one of his *Rougon-Macquart* novels set in Les Halles. In one episode, the young painter Claude Lantier—later to feature as the central character in *L'Oeuvre* (1886)—recalls taking charge of the window display of his aunt Lisa's richly appointed charcuterie on Christmas eve: "So I produced a veritable work of art. I took platters, plates, terrines, jars; I placed my tones, I arranged an astonishing still life with exploding firecrackers of color, sustained by knowing juxtapositions. . . . I had painted, wouldn't you say? . . . It was barbaric and superb . . . it is my masterpiece. I never did anything better."[2] D. D.

1 I am indebted to Ellen Josefowitz for identifying the dish that Caillebotte represented.

2 Emile Zola, *Le Ventre de Paris* (Paris, 1873), pp. 340–41.

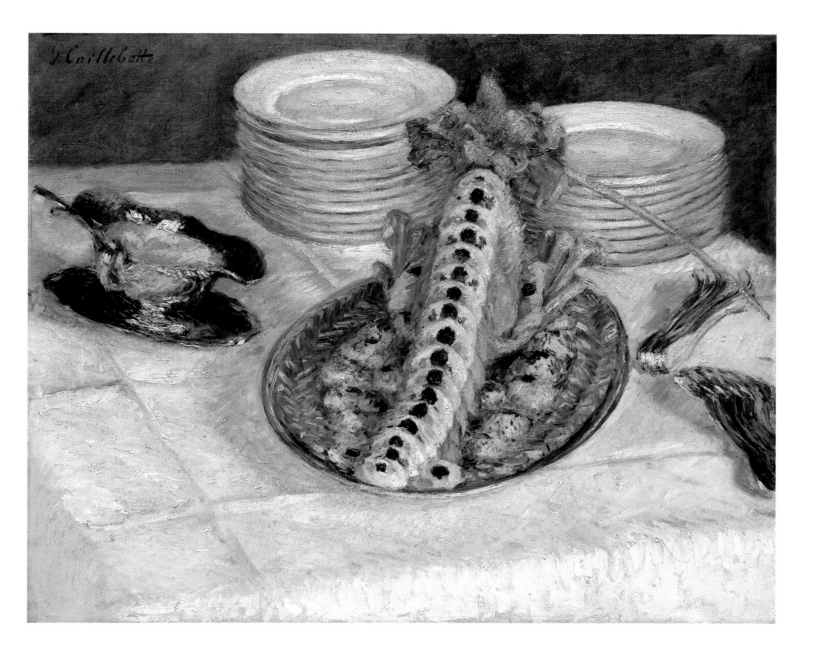

93
Fruit, also known as *Display of Fruit*

(Fruits, also known as *Fruits à l'étalage)*

1880/82

Oil on canvas

75 × 100 cm

Signed (posthumously?) lower right: *G. Caillebotte*

Berhaut 1978, no. 178; Berhaut 1994, no. 193

Museum of Fine Arts, Boston (Fanny P. Mason Fund in memory of Alice Thevin, 1979.196)

Shown in Chicago only

Principal Exhibitions
Paris 1882, no. 4; Paris 1894, no. 91; Houston and Brooklyn 1976–77, no. 59.

Contemporary Criticism
Draner 1882; Huysmans [1881] 1883.

Selected Bibliography
Berhaut 1951, no. 133; Berhaut 1968, p. 42; Berhaut 1977, p. 45; Rosenblum 1977, pp. 47 and 52; Berhaut 1978, p. 56; Varnedoe 1987, no. 48; Wittmer 1990, p. 99.

Figure 1. Draner (pseud. for Jules Renard, 1833–c. 1900). *A Display of Fruit, Bird's-Eye View,* detail from "Une Visite aux Impressionists par Draner," *Le Charivari,* 9 Mar. 1882.

Exhibited in 1882, at the seventh Impressionist exhibition, this remarkable still life attracted the notice of the Naturalist writer and critic Joris Karl Huysmans. Two years earlier, at the fifth group exhibition, he had commended Caillebotte for the keen observation and technical virtuosity evident in his still life featuring the glassware and compotiers used earlier in *Luncheon* (see cat. 72 and ch. 6 intro., fig. 2). Similarly, in now praising the artist's depiction of different fruits on their "white-paper beds" as "extraordinary," his focus, once again, was the "strict verity" with which the artist recorded surface appearance. Strangely, while proclaiming that "this is still life freed from its routine," Huysmans failed to comment directly on the boldest and most innovative aspect of Caillebotte's picture: its composition.[1]

This task was left to the anonymous author of a caption accompanying a caricature of Caillebotte as a floor-scraper, apparently published in response to the 1882 exhibition (see cat. 3, fig. 2). Here it was noted, "When he passes in front of a boutique whose display pleases him, he enters, covers it with gold—the display—and has it brought to his atelier to serve as model." This vignette underscores the sense in which Caillebotte's composition gives the impression of being a "slice-of-life," edited only insofar as it was cut out of a larger whole. The painting seems almost an appropriation of the fruit-seller's display, the decisions regarding placement and the disposition of forms and color obedient to the merchants. That such displays represented a form of popular art had been suggested in Zola's *Ventre de Paris* (1873), where the display of a vegetable seller, produce neatly laid out in bunches and "framed" with greens, was likened to "a tapestry with a balanced color scheme."[3] Caillebotte's still life, with its shallow, flattened space and brilliant, all-over disposition of competing color areas, appropriates this artisanal aspect of the display, refining its principles and transforming it in the studio into high art.

The relationship between Caillebotte's still life and commercial street display was implied in the caricature Draner devoted to the Impressionist exhibition (fig. 1), wherein he overlapped the picture he referred to as a "display of fruit, bird's-eye view" with a cartoon of Caillebotte's *Rising Road* (cat. 98), depicting a fashionable couple on a country road. Thus the caricaturist suggested both how displays of agricultural produce represented the country on the city's streets and how this functioned: he implied the sense in which, framed in the shop windows, such marketing constituted a sort of boulevard exhibition that, directly in Caillebotte's picture and suggestively in the Impressionists' practice of landscape, found extension in "A Visit to the Impressionists." D. D.

1 See Huysmans [1881] 1883.
2 Emile Zola, *Le Ventre de Paris* (Paris, 1873), p. 14.

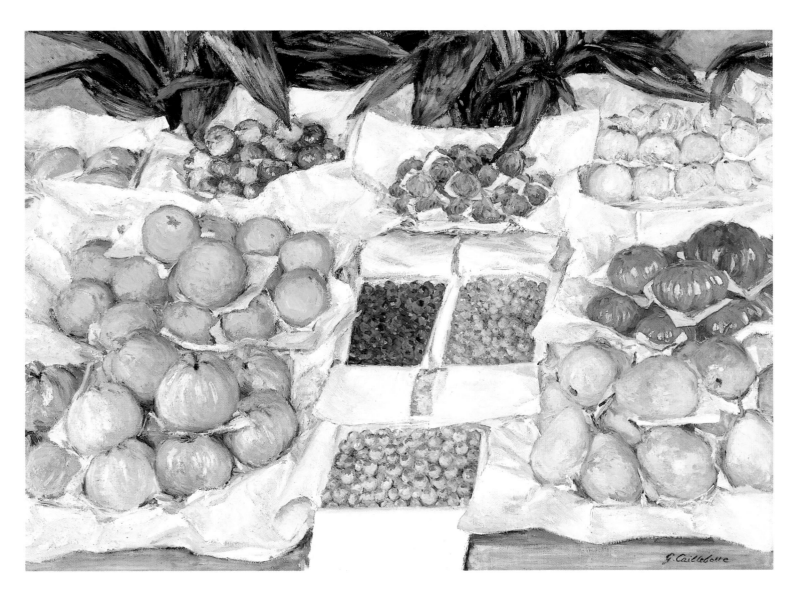

94
Display of Chickens and Game Birds

(Poulets et gibier à l'étalage)

c. 1882

Oil on canvas

76 × 105 cm

Stamped lower right

Berhaut 1978, no. 220; Berhaut 1994, no. 242

Private collection, Spain

Principal Exhibitions
Paris 1894, no. 87; Paris 1951, no. 48; Houston and Brooklyn 1976–77, no. 60.

Selected Bibliography
Fénéon 1948, p. 88 n. 2; Berhaut 1978, p. 56; Varnedoe 1987, no. 49.

Caillebotte adjusted his compositional approach to still life in accordance with the subject depicted, seeking a congruency between pictorial elegance and the refinement of the produce and its display. Here the subject is *nature morte* at its most elemental: stilled life awaiting the process that will transform it into palatable comestibles. Caillebotte underscored this compositionally. As has been observed, he remained faithful to the subject of commercial display by adopting its "insistently inelegant" arrangement, employing the "no-nonsense A-A-A, B-B-B rhythms of the butcher's display."[1] These, in turn, suggest the repetitive, mechanical nature of the work on which the display is based and which Caillebotte's representation, like its subject, makes little attempt to disguise through the artful arrangement characteristic of traditional market still lifes. D. D.

1 Varnedoe 1987, p. 160.

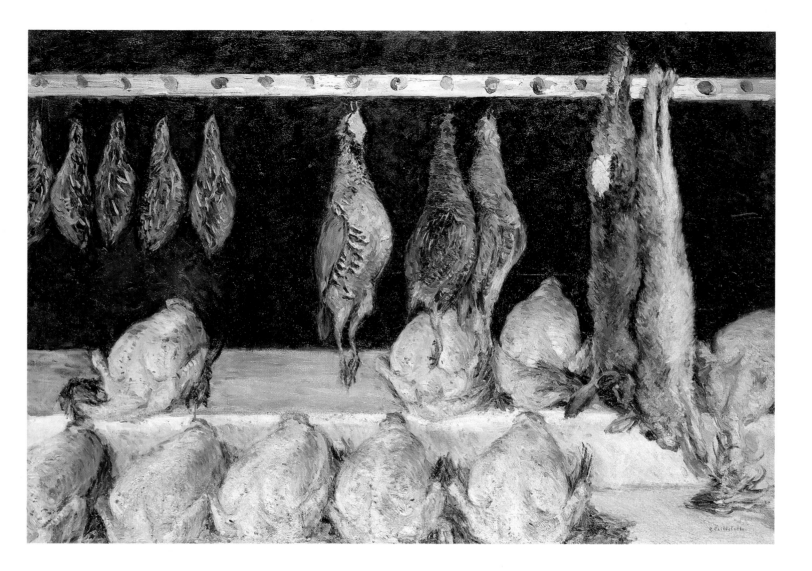

95
Calf in a Butcher's Shop
(Veau à l'étal)

c. 1882

Oil on canvas

144 × 74 cm

Stamped lower right

Berhaut 1978, no. 221; Berhaut 1994, no. 243

Private collection

Selected Bibliography
Fénéon 1948, p. 88 n. 2; Berhaut 1978, p. 56.

As subjects of still life, butchered carcasses constitute what has been termed "animal matter in its lowest and least redeemable aspect."[1] The painter's challenge thus becomes the redemption of this dead matter, its transformation through art into something of significance and value. In Caillebotte's day, Rembrandt's *Slaughtered Ox* (fig. 1), which had entered the Louvre's collections in 1857, set the standard for the genre and was the model upon which many Realist representations relied (see ch. 6 intro., fig. 7). *Calf in a Butcher's Shop* directly challenges this tradition.

Notably absent from Caillebotte's depiction are the hallmarks of the *Slaughtered Ox* and its Realist descendents: the brooding chiaroscuro, earth tones, and unadulterated presentation that together operate to transform the subject into a contemplative meditation on the transience of life. Instead, Caillebotte pointedly took as his subject the less successful artistry found in a contemporary, upscale butchershop. For the setting here is the kind of "bright modern shop" that was the dream of Lisa Quenu, the protagonist in Zola's *Ventre de Paris* (1873). It is the antithesis of the "sort of dark hole, one of those dubious charcuteries in old neighborhoods, whose worn flagstones retain a strong odor of meat, despite repeated cleanings" in which the novel's heroine first found herself. Rather, it fulfills the ambition of modern shopkeepers who, like Lisa, had "a distinct awareness of the newly luxurious imperatives of trade." Unlike the charcuterie in which Lisa subsequently realized her ambition, the walls here are not white marble, and our restricted view leaves unanswered the question of whether the ceiling, like hers, incorporates both a large mirror and a "four-armed chandelier." But, as in Lisa's shop, little cost has been spared here. Its walls decoratively detailed and skirted with a crisp white cloth, the shop is similarly a "chapel of the belly," and likewise serves as background to a rich mise en scene for its pink-skinned "hale and hearty idol."[2] But in place of Zola's healthy shopkeeper, the protagonist here is a veal carcass overtly—and disturbingly—feminized, bedecked with flowers placed as if to both suggest an alluring décolletage and create a decorative border for its gaping interior. Suspended from a wooden hanger, the delicacy of its pink flesh offset by the immaculate white

Figure 1. Rembrandt Harmensz. van Rijn (Dutch; 1606–1669). *Slaughtered Ox*, 1655. Oil on canvas; 94 × 64 cm. Musée du Louvre, Paris.

Figure 2. Edgar Degas (1834–1917). *Miss La La at the Circus Fernando, Paris*, 1879. Oil on canvas; 46 × 30.5 cm. National Gallery, London (Purchased by the Trustees of the Courtauld Fund, 1925).

cloth, the carcass assumes the aura of spectacle, the focus of our disquieted fascination not unlike the trapeze artist La La, whom Degas had recently depicted hanging by her teeth from the ceiling of the Circus Fernando (fig. 2).

Calf in a Butcher's Shop can be read as a satire both on the contemporary fascination with display and spectacle as well as on the aggrandizement implied in the artist's aspiration to elevate, purify, and transform. But it is trenchant satire. While Caillebotte's light-toned palette seems to insist on an ironic distance that separates the representation from its content, it ultimately works against its subject's seductive intent. The butcher's heavy-handed efforts at refinement, at transforming death into an object of desire through a parody of feminization and sexualization, are unmasked by the painter's seeming pictorial endorsement. In *Le Ventre de Paris*, Zola described the attractions of the fruit-seller's display in terms of a catalogue of female body parts—lips, breasts, shoulders, and hips—that constituted "an array of discrete nudities."[3] *Calf in a Butcher's Shop* is, by contrast, "indiscrete." Through a tight framing of his subject that evokes current society portraiture, and his seeming chromatic compliance in creating a flattering representation, Caillebotte made of his subject a fascinatingly macabre variation on the *vanitas* theme of death and the maiden. At once amusing and sinister, it is a work that is above all aggressively contemporary.
D. D.

1 Norman Bryson, *Looking at the Overlooked: Four Essays on Still Life Painting* (Cambridge, Mass., 1990), p. 146.

2 Emile Zola, *Le Ventre de Paris* (Paris, 1873), pp. 63, and 89–91.

3 Ibid., pp. 378–79.

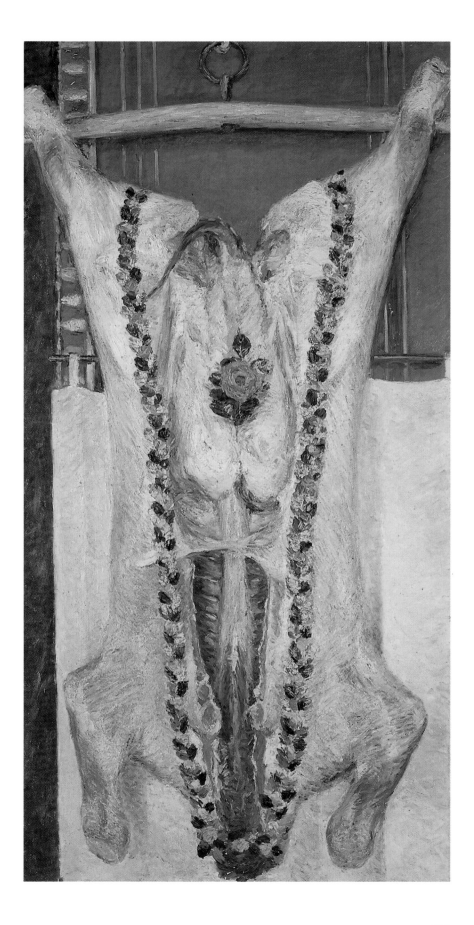

96
Calf's Head and Ox Tongue

(Tête de veau et langue de boeuf)

c. 1882

Oil on canvas

73 × 54 cm

Berhaut 1978, no. 222; Berhaut 1994, no. 244

Private collection

Principal Exhibitions
Paris 1894, no. 94.

Selected Bibliography
Berhaut 1978, p. 56.

In painting a calf's head, Caillebotte would seem the quintessential Realist, as satirized in Thomas Couture's painting of that name (fig. 1). But while featuring a subject eminently both humble and "ugly," Caillebotte's representation effectively works towards a bizarre subversion of standard Realist fare.

Focusing on the raw beef tongue and calf's head hanging from hooks in the butcher's shop, Caillebotte's composition furthers the disassociation of sign from substance begun with the butcher's assault on the animals. Isolated, the dismembered

Figure 1. Thomas Couture (1815–1879). *The Realist*, 1865. Oil on panel; 55 × 45 cm. National Gallery of Ireland, Dublin.

parts are suspended in a kind of commercial purgatory between death and consumption—dead matter cut off from life and not yet transformed and revalidated as food. Yet the pinks, mauves, and reds of Caillebotte's palette fail to connote life's blood, allowing the parts to float relatively free of associations with a vital past and to assume an oddly gay appearance—one thinks of Japanese lanterns and kites. Caillebotte seems to have employed color and composition to distance the product from the brutal reality of its production. His still life takes on qualities recalling those that the painter Claude Lantier in Zola's *Ventre de Paris* (1873) imparted to the still life he created of the window display in Lisa's charcuterie: it is "bizarre and superb," betraying a "cruelty of touch" in its insistence on the purely formal properties and potential of its subject.[1] Or does it? In his choice and juxtaposition of objects, Caillebotte appears to have been speaking to the essence of *nature morte*.

D. D.

1 Emile Zola, *Le Ventre de Paris* (Paris, 1873), p. 341.

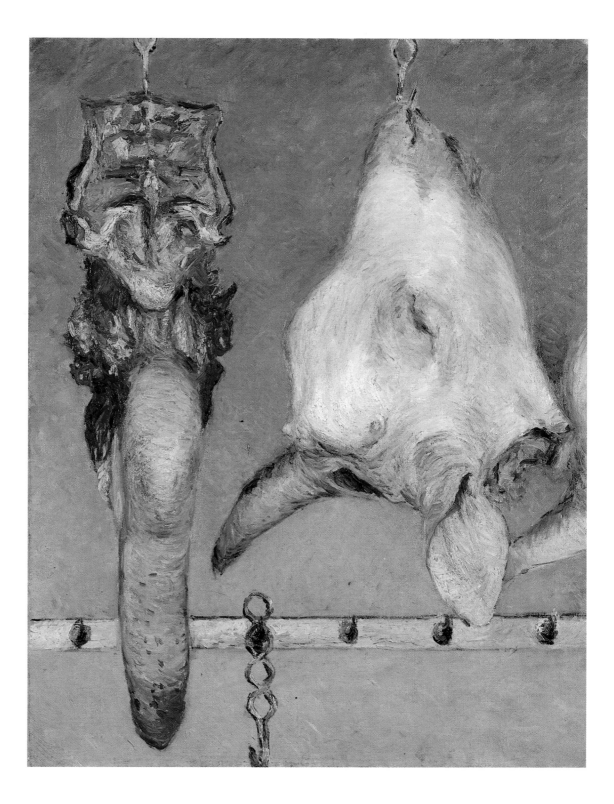

97
Rib of Beef
(Côte de boeuf)

c. 1882
Oil on canvas
38 × 55 cm
Stamped lower right
Berhaut 1978, no. 223; Berhaut
1994, no. 245
Private collection

Principal Exhibitions
Paris 1894, no. 63.

Selected Bibliography
Berhaut 1978, p. 56.

With his modest representation of a rib of beef, Caillebotte addressed the tradition of physically small but grand still lifes featuring meat, as practiced most notably, if only on occasion, by Jean Baptiste Siméon Chardin and Francisco Goya. While Caillebotte eschewed the meditative mood prevalent in these models, the straightforwardness of his presentation conveys a seriousness of purpose that survives the inherent light-heartedness of his soft-toned, "Impressionist" palette. D. D.

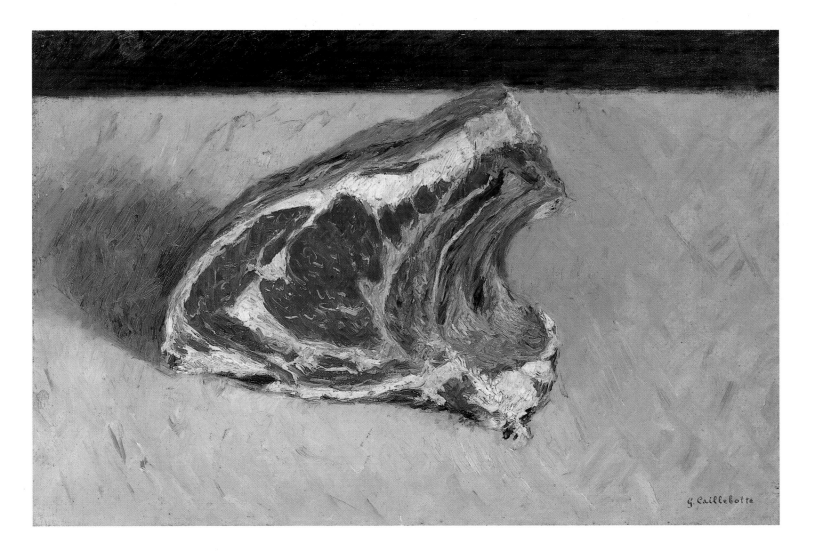

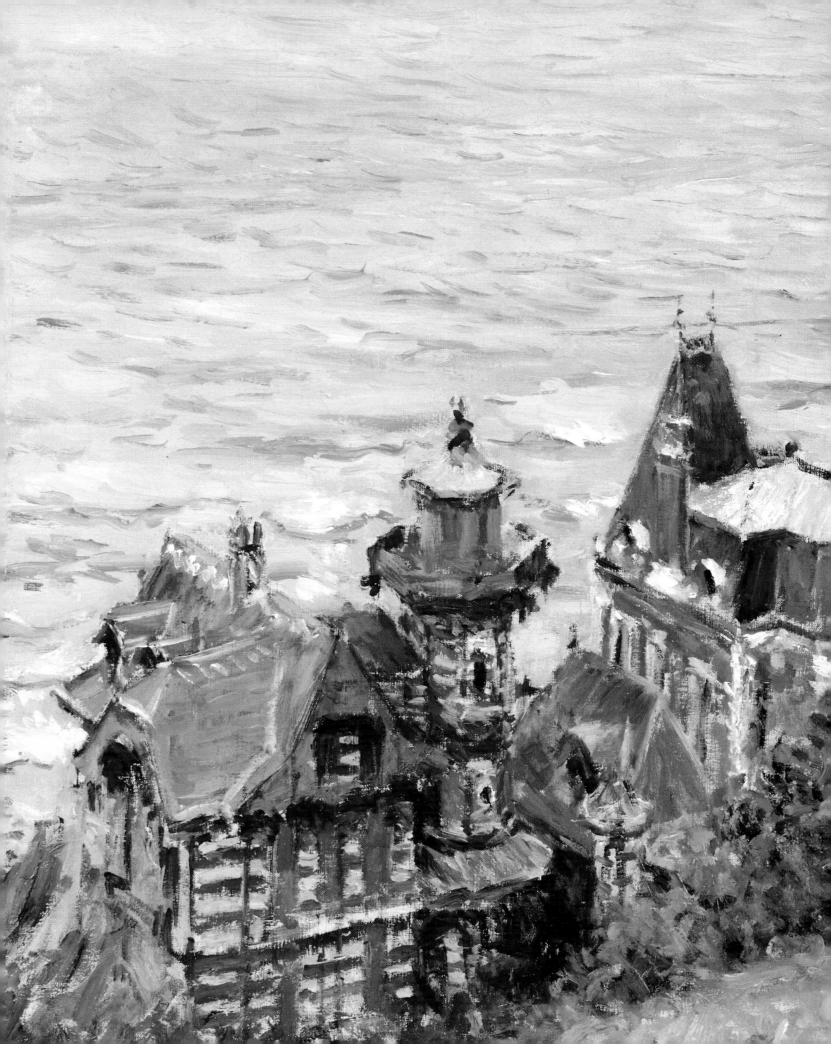

The 1882 Impressionist exhibition was the last one in which Caillebotte participated. In addition to portraits, interiors, and depictions of modern Paris analogous to those he had shown previously, his contribution that year also included several views of the Normandy coast and the areas around Honfleur and Trouville. Their presence officially announced the appearance in his work of a new theme: landscape. As Marie Berhaut has noted, these paintings constituted a kind of "introduction to the second part of Caillebotte's oeuvre, which would be devoted almost exclusively to landscapes and seascapes."[1] This new orientation proved altogether consistent with the general image presented by the Impressionist group that year. In the absence of Degas, Forain, and Raffaëlli, and with Guillaumin, Monet, Pissarro, Renoir, and Sisley each represented by many works, the seventh exhibition, in which only eight artists participated, was dominated by landscape. Huysmans, who felt that subject matter was a crucial factor in modern art, reacted as follows:

From the point of view of contemporary life, this exhibition unfortunately has little to offer. No more dance halls and theaters, no more surroundings of the Folies-Bergère and its girls, no more social rejects and common people; one note absorbs all the others, that of landscape. The circle of modernism has really shrunk too much, and one cannot overly deplore this diminishment resulting from petty squabbles in the collective work of a small group that had kept its head until now before the numberless army of official artists.[2]

Figure 1. Gustave Caillebotte. *Apple Trees by the Sea, Trouville*, c. 1880–81. Oil on canvas; 65 × 54 cm. Private collection.

These remarks are applicable to the production of Caillebotte, who in his views of the Normandy coast took up subject matter quite removed from the urban realism of his beginnings. Furthermore, this penchant for landscape appeared after 1878, when some of the artist's work began to manifest a stylistic evolution bringing him closer to Impressionist techniques (see cats. 32 and 33).

Caillebotte first went to Normandy in late June 1880 to participate in the regatta at Le Havre. A passionate sailing enthusiast, he returned to the Normandy coast each summer thereafter to compete in regattas held during the season in the waters off Cabourg, Dives, Duclair, Fécamp, Le Havre, and Trouville.[3] The only year he seems to have renounced this sojourn is 1891, for he sold his sailboat that July.

Doubtless because most of the canvases painted in Normandy and bearing dates in the artist's hand are from 1880 and 1882, Marie Berhaut maintained that the "paintings of the Normandy coast" were almost all executed in this three-year period. In her 1978 catalogue raisonné, the totality of Normandy views are assigned dates between 1880 and 1885, the latest year inscribed by Caillebotte himself on any of these works.[4] But the chronology in the present catalogue demonstrates that these paintings could have been painted in the summers from 1880 to as late as 1893, which considerably complicates the study of the artist's "second period."

In his Normandy landscapes, Caillebotte was entering territory in which several of his predecessors—notably Eugène Boudin and Monet—had previously distinguished themselves, in Impressionism's earliest years. These works inevitably bring to mind certain paintings by Monet, who sojourned frequently in Normandy beginning in 1881 (compare figs. 1 and 2). While the sea is omnipresent in the latter's work in Normandy, Caillebotte painted several inland landscapes,

Figure 2. Claude Monet (1840–1926). *Sea Coast at Trouville*, fall 1881. Oil on canvas; 60 × 81 cm. Museum of Fine Arts, Boston.

many of them similar to the views he began painting in 1885 of the orchards in Gennevilliers and Colombes. But his depictions of villas by the sea were the most original works he did there (see cat. 101). The presence of these recent constructions nestling in the otherwise unblemished coast—and Caillebotte did nothing to elide them: on the contrary, he stressed their intrusive quality—produces a strange effect, one related to his unsettling vision of the modern city. R. R.

NOTES

1 Berhaut 1968, p. 10.

2 Huysmans 1902, p. 285. On the 1882 Impressionist exhibition and the "squabbles" to which Huysmans alluded, see Rewald 1973, pp. 464ff.

3 See Appendix IV.

4 See Berhaut 1968, p. 38. Of the works painted in Normandy and dated by Caillebotte, Berhaut 1994 lists seven from 1880 (nos. 161, 165, 166, and 169–72); one from 1881 (no. 189); six from 1882 (nos. 219, 222–24, 227, and 235); one from 1883 (no. 270); four from 1884 (nos. 307, 308, 310, and 311); and one from 1885 (no. 322).

98
Rising Road
(Chemin montant)

1881
Oil on canvas
100 × 125 cm
Signed and dated lower left:
G. Caillebotte / 1881
Berhaut 1994, no. 158

Private collection[1]

Principal Exhibitions
Paris 1882, no. 3.

Contemporary Criticism
Charry 1882; Draner 1882;
Fichtre 1882.

Thanks to a caricature by Draner in *Le Charivari* (fig. 1), it is possible to identify this image of a couple walking down a country road as number 3 in the 1882 Impressionist exhibition, entitled *Rising Road*. The work did not receive as much critical attention as *The Bezique Game* (cat. 80), *Man on a Balcony* (cat. 67), or even *Fruit* (cat. 93), but two brief references to it corroborate the identification. The reviewer Fichtre poked fun at the "conjugal couple it represents, again seen from the back, and emerging from a pond, truly painful to look at," alluding to the bluish shadows in which the foreground is awash. Paul de Charry, by contrast, was won over to the work: "The *Rising Road* is a road that does not rise but that's quite pretty, quite natural, and sunlit without the customary fantasy. A few years from now M. Caillebotte will see and render nature like all artists of talent, and he will be satisfied with it."

Caillebotte did not identify the location of this country scene. Although the artist purchased his house at Petit Gennevilliers in the spring of 1881, this does not seem to be a motif on the outskirts of Paris. The brilliant white and pink villa glimpsed on the left suggests that we are in a Norman sea resort, perhaps Villers or Trouville, where Caillebotte spent many weeks each summer in connection with his participation in local regattas. Caillebotte depicted a couple—while consistent with bourgeois marital convention, does their decorous

distance from one another necessarily indicate that they are married?—emblematic of the vacationers, all wealthy city-dwellers, for whom the summer sojourn was an obligatory ritual. Such is the most straightforward interpretation of the image. But our knowledge of Caillebotte's private life, limited as it is, suggests another, more intimate reading. This man in boating attire, shown from the back, haven't we previously seen him in Caillebotte's painting of the park at Yerres (cat. 17)? Might he be the artist himself, here pretending to smoke a pipe? And might not this young woman with a parasol be Charlotte Berthier (her real name was Anne Marie Hagen), the artist's companion until his death? If this last supposition is correct, the artist here has hidden her face from view, as in other paintings executed later at Petit Gennevilliers (see ch. 8 intro., fig. 11).

Unless Draner made a mistake in his caption, Caillebotte titled this work *Rising Road*, a notably vague appellation. In fact, as Paul de Charry remarked, the path hardly rises at all, amounting to a more reasonable reprise of the unorthodox perspectives that so annoyed Caillebotte's critics. Vegetation, some of it implied by the shadows in the foreground, is present on all sides. The painter once again displayed his new interest in vigorous, animated handling. The violent deep blue of the woman's dress contrasts starkly with the beiges, greens, and bluish-grays of the landscape, which also vibrates with pink, incongruously intensified by the sky blue of the parasol. We are very far here from the finished accents of *Portraits in the Country* (cat. 19). Judging from this canvas, Caillebotte had fully embraced an Impressionist idiom close to that cultivated by Monet, Pissarro, and Renoir.
A. D.

Figure 1. Draner (pseud. for Jules Renard, 1833–c. 1900). *Rising road . . . no heads*, detail from "Une Visite aux impressionnistes," *Le Charivari*, 9 Mar. 1882.

1 A lender's generosity and the aid of a friend and colleague (who shall remain nameless to safeguard the owner's anonymity) have made it possible for us to exhibit a painting by Caillebotte unknown to both historians and the public for more than a century.

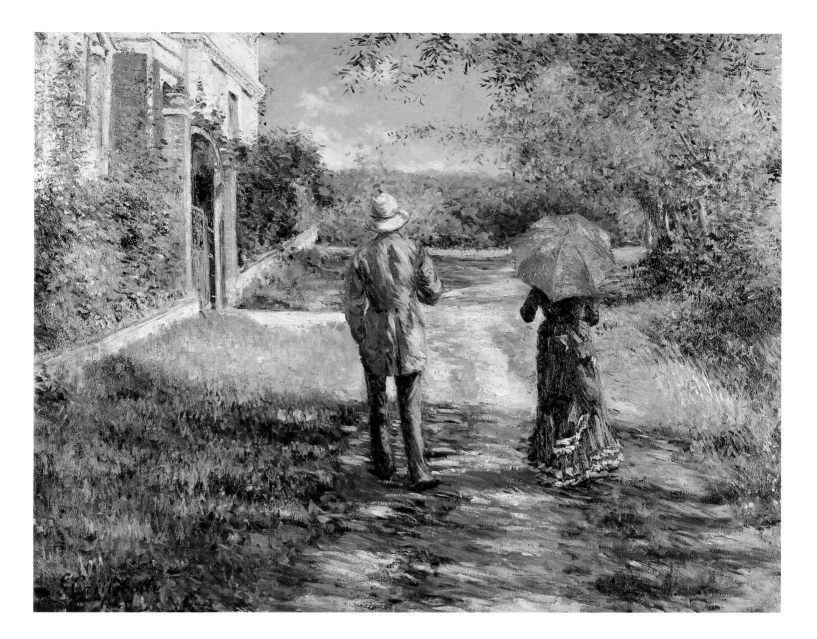

99
Cliff at Villers-sur-Mer

(Falaise à Villers-sur-Mer)

c. 1880

Oil on canvas

60 × 73.5 cm

Stamped lower right

Berhaut 1978, no. 164; Berhaut 1994, no. 178

Private collection

Selected Bibliography
Berhaut 1978, p. 62.

Of all Caillebotte's Norman landscapes, this is unquestionably the one that differs most strongly from Impressionist precedent. Monet (see fig. 1), who painted the Fécamp cliffs in March 1881, harmonized the tones of the rocks with those of the sky and the water in the manner of Renoir, whose paintings are unified by an extraordinary fluidity of handling.

Caillebotte's originality, however, is less manifest in his use of a color scheme accentuating contrasts between lights and darks than in his composition. The disposition of the cliff in three successive levels of depth and the cropping of the foreground give this work an almost brutal immediacy, further intensified by the disorienting viewpoint and the restricted visual field. Caillebotte here effected a radical isolation of the motif. On the left the sky is partly obscured by the dark mass of the rock, while the ground linking the different ridges at the bottom is completely absent. This concentration, which brings the middle ground forward toward the spectator, and the stark modeling of the cliffs anticipate formal solutions that would be adopted by Monet beginning in 1889, notably in his famous *Rocky Hilltop (Le Bloc)* (1889; Royal Collection Trust, London). R. R.

Figure 1. Claude Monet (1840–1926). *Cliffs near Pourville*, 1882. Oil on canvas; 60 × 81 cm. Enschédé Collection, United States.

261

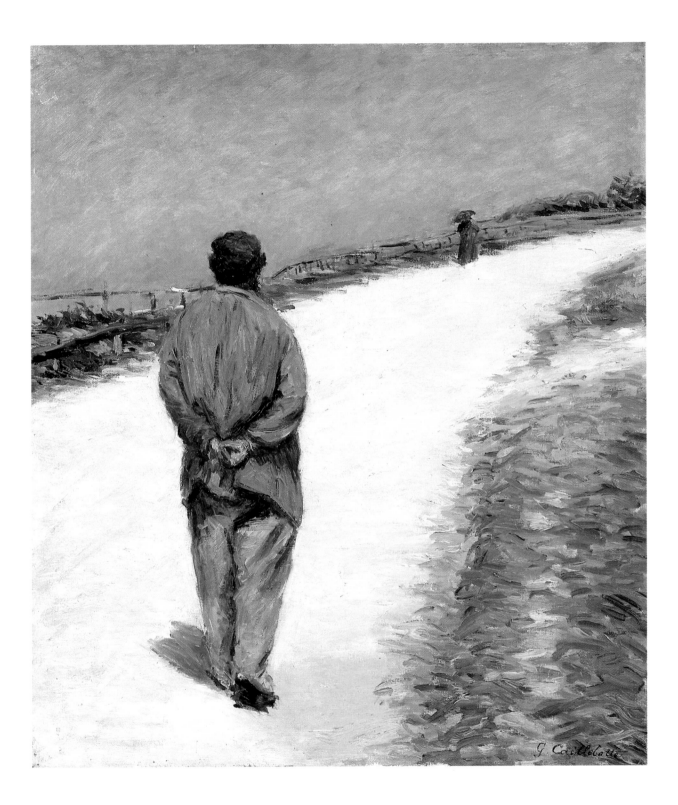

*Man in a Smock,
also known as
Father Magloire
on the Road
between Saint-
Clair and Etretat*

(*Homme en blouse*, also
known as *Le Père
Magloire sur le chemin
de Saint-Clair à Etretat*)

1884

Oil on canvas

65 × 54 cm

Signed (posthumously?) lower
right: *G. Caillebotte*

Berhaut 1978, no. 263; Berhaut
1994, no. 306

Private collection

Principal Exhibitions
Paris 1951, no. 44; Chartres 1965,
no. 16; London 1966, no. 28; New
York 1968, no. 39.

Selected Bibliography
Berhaut 1978, p. 62; Chardeau
1989, p. 105.

After the Yerres period, canvases of relatively large dimensions representing figures in the open air become rare in Caillebotte's work. He would not again undertake such compositions until 1890, when he executed a decorative panel, *The Riverbank at Petit-Gennevilliers and the Seine*,[1] for his brother Martial's new apartment. It is possible that the rather harsh criticism directed at certain of his works in the 1882 exhibition (see cat. 67, fig. 1) prompted the artist to devote more time to landscape and still life. In this context, the group of three paintings featuring depictions of Father Magloire takes on a certain significance.[2]

The work exhibited here is obviously related to the major painting of the set (fig. 1), but cannot be considered a study for it: both the composition and the lighting are totally different in the two works. Caillebotte here sought to capture atmospheric effects and faithfully transcribed the brutality of direct sunlight.

According to Marie Berhaut, Magloire Raulin (1840–1916), the Etretat gardener known as Père Magloire, was in the same confirmation class as Guy de Maupassant,[3] but this seems unlikely, for the writer was ten years his junior. Magloire attained long-lasting local celebrity—it persists to this day—because of the beauty of the garden he maintained adjacent to the old Hôtel de la Plage in Etretat. Caillebotte, like Monet a passionate horticulturalist, may well have known him.[4]

Nevertheless, this painting remains enigmatic. In the photograph albums of Caillebotte's work assembled by his brother Martial, the painting now in the Musée du Petit Palais in Geneva (fig. 1) is given the title *Man in a Smock on a Dirt Road*. The latter was also exhibited as *Man in a Smock* in the retrospective exhibition of 1894.[5] R. R.

1 Berhaut 1994, no. 406; see also nos. 476 and 477, which are clearly related to this work.

2 Berhaut 1994, nos. 306 and 307.

3 See Berhaut 1994, no. 307.

4 I would like to thank M. Henri Dupain, mayor of Etretat, for providing me with valuable information about Magloire Raulin and the site at Etretat.

5 Number 11 in the catalogue. The Geneva painting was again entitled *Man in a Smock on a Dirt Road* in Berhaut 1951 (no. 217).

Figure 1. Gustave Caillebotte.
Man in a Smock, or *Father
Magloire on the Road between
Saint-Clair and Etretat*, 1884.
Oil on canvas; 129 × 80 cm.
Musée du Petit Palais, Geneva.

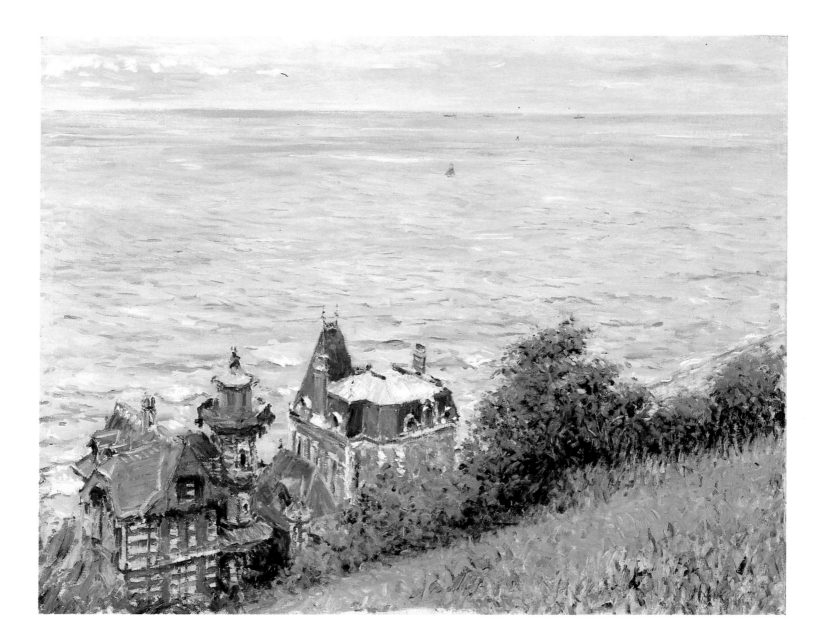

101

Villas at Trouville

(Villas à Trouville)

1884

Oil on canvas

65 × 81 cm

Signed (posthumously by Martial Caillebotte according to Marie Berhaut) lower right: *G. Caillebotte*

Berhaut 1978, no. 272; Berhaut 1994, no. 309

Montgomery Gallery/Kemper Corporation

In his views of the Normandy coast, Caillebotte abandoned the fashionable activity and seaside elegance so dear to Boudin, focusing instead on landscapes from which the human figure is absent. In several of these paintings, the ocean surface serves as a pretext for subjective explorations of coloristic effects that, in technical terms, are among the artist's most successful achievements in the 1880s. His predilection for plunging perspectives is apparent here, as it had been earlier in his Paris street scenes (see cats. 62 and 70). The abruptness with which the buildings are inserted into the landscape is underlined by the use of opposed complementaries, the pink of their walls contrasting starkly with the green hues of the vegetation and the sea. The work can be dated on the basis of its stylistic similarity to a depiction of the same site from a different viewpoint dated 1884 by the painter himself.[1] It follows that, contrary to Marie Berhaut's suggestion,[2] this cannot have been the painting exhibited as number 36 in the 1894 retrospective exhibition and identified in its catalogue as *Bord de mer à Villers (1881)—belonging to M. Hugot*.

Both the choice of motif and the compositional strategy are altogether typical of Caillebotte. The seemingly incongruous presence of recently constructed houses in the middle distance suggests the artist's desire to represent a nature vulnerable to the incursions of modern life, in this instance lavish summer villas in a rather polyglot architectural idiom. Caillebotte probably intended to exploit the transitional aspect of this landscape, then undergoing radical transformation. A similar impulse seems to inform his *Ocean Regatta, Villerville* (fig. 1), which pictures a group of modest summer homes, newly built and without gardens, that are devoid of architectural interest. A middle ground reminiscent of the Paris suburbs opens onto a seascape punctuated by the distant sails of a regatta, giving this work a dichotomous character that rather flies in the face of the conventional categorization of modern landscape painting. R. R.

1 Berhaut 1994, no. 310.

2 Ibid., no. 309.

Figure 1. Gustave Caillebotte. *Ocean Regatta, Villerville*, 1884. Oil on canvas; 60 × 72 cm. The Toledo Museum of Art.

The Yerres property and the house on rue de Miromesnil were places where Gustave Caillebotte led a life overseen by his parents. When Mme Caillebotte died in 1878, Gustave and his brothers put both of these properties up for sale.[1] They were designed to serve an elaborate way of life that was impractical for bachelors, to be sure, but it also appears that, by settling into the apartment on boulevard Haussmann, Gustave and Martial (Abbé Alfred Caillebotte resided in his parish) were deliberately adopting a simplified lifestyle that, while still quite comfortable, tended to mediate somewhat the financial distance separating them from their friends of more modest means.

The Parisian life of boulevard Haussmann, the focus of a number of paintings by Caillebotte, had its corollary in that at Petit Gennevilliers, on the banks of the Seine across from Argenteuil, about half an hour from Paris by train. Like so many city-dwellers of diverse backgrounds, Gustave and Martial were susceptible to the lure of the countryside in warm weather, but they also had a very specific reason to come to Petit Gennevilliers, namely boating.[2] At this point the Seine is over two hundred yards wide for a distance of about seven and a half miles. Rowing enthusiasts organized races there, and the Parisian sailing club known as the Cercle de la Voile had made it the center of its activities and the home port of the Argenteuil "clippers." These sailboats, regular contestants in the local regattas despite their large hulls, evidenced the growing Parisian taste for this sport, recently imported from America and prominently featured in the French press since the Second Empire (see fig. 1). Having shifted his attention

from rowing to sailing, Caillebotte won his first prizes with his vessel *Iris* in 1879; in 1880 he became one of the two vice-presidents of the Cercle de la Voile; and in the spring of 1881 he and his brother purchased a property on the river at Petit Gennevilliers. It was here that he died in 1894, having abandoned Paris after his brother married in 1887.

A famous artist had preceded Caillebotte to this riverside locale. Claude Monet had virtually become a resident of Argenteuil from 1871 thanks to Manet, whose family had long owned property in Gennevilliers. He soon made sailboats on the Seine a favorite motif of the period,[3] one that in turn attracted Manet, Renoir, and Sisley (see ch. 2 intro., figs. 2 and 3—Manet had fixed the type of the Argenteuil "boater" in his painting *Boating*). Thanks to Monet's canvases, we can observe the topography of the area as it no longer exists: on one side of the river, the Argenteuil bank, with its tree-lined promenade, its bourgeois homes, and its factories; and on the other, left bank, the summerhouses, boatyards, and Cercle de la Voile flotilla that identified Petit Gennevilliers. The two banks were linked by the Argenteuil bridge, another favorite subject, doubled upriver by the railroad bridge; both spans were destroyed in the 1870 war and subsequently rebuilt. The Ile Marante downstream provided another rich source of motifs.

There are no documents specifying when Gustave Caillebotte first went to Argenteuil. On the other hand, we know that Monet exhibited several Argenteuil canvases from 1876 onward, and that Caillebotte acquired one of them.[4] It is certain that he began to frequent Argenteuil and Petit Gennevilliers on a regular basis only after Monet's departure, in early 1878. But it is also probable that Caillebotte saw the banks of the Seine through Monet's eyes and that, his boating activities aside, this was one of the reasons the site interested him.

The lure of these motifs must have been considerable, for in many respects the town of Petit Gennevilliers was not as idyllic as one might have liked: contemporary journalists as well as recent historians, notably Noëlle Gérôme and Georges Quiqueré,[5] have informed us about the area's less engaging aspects. To be sure, the railroad had made this stretch of the Seine readily accessible to boat-loving urbanites,[6] but the river was polluted and much of the Gennevilliers plain was occupied by sewage farms connected to the Paris sewage system (see fig. 2).[7] Furthermore—and the Impressionist painters

Figure 1. Theodore Weber, *Environs of Paris.—Argenteuil*, from *L'Illustration*, 25 Sept. 1869.

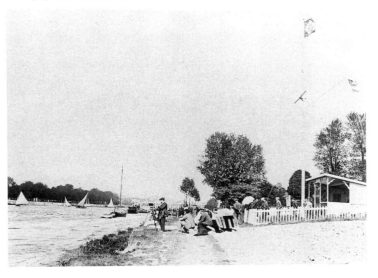

Figure 2. Victor Rose. *Gennevilliers Plain.—Reservoir and Canals Facilitating the Use of Water from the Paris Sewers in Agricultural Irrigation*, from *L'Illustration*, 17 Feb. 1877.

were the first to draw attention to this, juxtaposing factory chimneys with sailboat masts—there was much industry near the river. From his house Caillebotte could see, on the Argenteuil bank, the large bourgeois residence with a bell-tower known as "Château Michelet" (after its owner, Emile Michelet, who was vice-president of the Cercle de la Voile de Paris),[8] but

it was surrounded on all sides by factory chimneys, and there were more quite close by, upstream from the roadway bridge. The Petit Gennevilliers riverbank had not been built up and remained more rustic; many new trees appeared there between the time Monet painted it, beginning in 1872, and Martial Caillebotte photographed it, around 1891–92. But at the same time, summerhouses were proliferating beside the boatyards that Gustave helped establish there.[9]

These inconveniences do not seem to have mattered very much to Caillebotte, however, whose passion for *le yachting*, as the French then called it, was consuming. One need only examine the issues of the magazine *Le Yacht* from 1879 onward (see Appendix IV) to ascertain that the painter's life was increasingly organized in accordance with the rhythms of the boating season (see figs. 3 and 4): regattas at Argenteuil in the spring and fall, separated by a summer trip along the Seine to the Normandy coast. His successive sailing vessels, each more perfect than the last, were designed for competition and became well-known for their impressive record of

Figure 4. Martial Caillebotte. *Jury of the regatta at Petit Gennevilliers*, 1891/92. Photograph. Private collection.

Figure 3. Martial Caillebotte. *A Sailboat (the* Roastbeef *coming ashore?) at Petit Gennevilliers*, 1891/92. Photograph. Private collection.

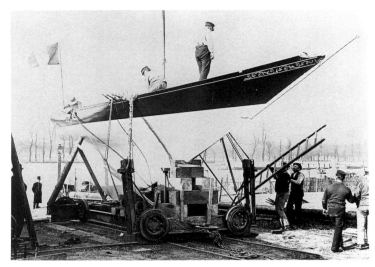

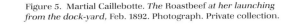

Figure 5. Martial Caillebotte. *The* Roastbeef *at her launching from the dock-yard*, Feb. 1892. Photograph. Private collection.

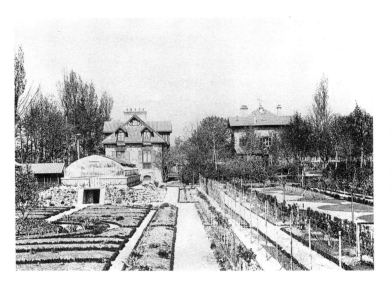

Figure 6. Martial Caillebotte. *The house, studio, garden, and greenhouse of Gustave Caillebotte at Petit Gennevilliers*, 1891/92. Photograph. Private collection.

victories. Caillebotte was an athlete who regularly took the helm at sea and on the Seine—although he had his bad days, sometimes running aground in the reeds along the bank. The Cercle de la Voile de Paris boasted many such amateurs in its membership and was thus quite different from the Yacht Club, favored by the owners of seafaring vessels (often steam-driven), whose annual membership lists contained many of the most prominent names of high finance and industry; Caillebotte did, however, employ two sailors to maintain his boats.[10] But he began to spend less time painting,[11] and at the very moment Impressionism was gaining prestige, he withdrew from the fray. His pugnacious temperament henceforth found an outlet in advocating his system for calculating more efficient hull designs. Initiated into the requisite theory by his childhood friend Maurice Brault, Caillebotte, aided by the naval engineer Maurice Chevreux, began to design sailboats for himself as well as for other amateurs (see fig. 5).[12]

Although the artist clearly came to Petit Gennevilliers for the boating, he eventually purchased property there and made it his home. The house he shared with his brother until 1887,[13] when the latter married, was considerably enlarged in 1888 and thereafter served as his principal residence; his ties to the local community were further strengthened by his election as town councilman in May of that year. Nothing remains of the residence except the photographs Martial took around 1891–92 (figs. 6 and 7), for it was subsequently demolished to make way for a large industrial complex. But our understanding of these photographs and Caillebotte's paintings of the property can now be enhanced by information contained in the detailed estate inventories of the main residence, the outbuilding housing the studio, and the garden, with its greenhouse and service structures.[14]

With its rough-textured stone, its wooden balconies, and its industrially produced red roof tiles, this was a modern resi-

dence typical of the Paris region, with the addition of certain special features tailored to meet its owner's needs. Its luxury is most evident in the support structures: the studio, greenhouse, and other outlying buildings. It is the house of an Impressionist painter who has "arrived," like those owned by Monet at Giverny and Renoir at Les Collettes, in Cagnes-sur-Mer, at the end of their lives. Caillebotte decorated the walls of the house and studio with canvases by himself and his friends (see Introduction, figs. 10 and 11; and Appendix I). The rather simply furnished salon-dining room was decorated with a collection of old faïence.[15] Finally, one of the property's principal attractions was its magnificent garden.

As we learn from Gustave's paintings[16] and photographs taken by his brother Martial (figs. 8 and 9), this garden was conceived along very different lines from the one at Yerres: with its young trees and rectangular flower beds, the garden at Petit Gennevilliers, logically arranged and newly planted, was organized such that each individual variety had its appointed place. The critic Gustave Geffroy, after having come to view once more the paintings in Caillebotte's collection a few days after his death, early in the spring of 1894, expressed melancholy admiration for "this little vegetal world that was labeled, pampered, adored by Caillebotte."[17] The hothouse made possible the cultivation of rare and new species of orchids, which were subsequently painted by the artist (see cat. 117). The new plantings occasioned frequent consultations with Monet, also a devoted gardener. They were something of a luxury, requiring the constant attention of two gardeners.[18]

The artist received his friends—bezique players, boating colleagues, and fellow-painters—in this house and garden (see fig. 10), but above all he shared them with the woman who had been his companion since at least 1883 and remained so until his death, Charlotte Berthier (see figs. 11 and 12). Aside from the painter's affection for her, corroborated by the terms of

Figure 7. Martial Caillebotte. *The house of Gustave Caille-botte at Petit Gennevilliers*, Feb. 1892. Photograph. Private collection.

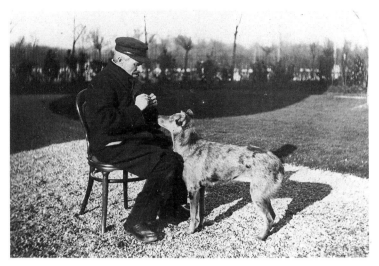

Figure 9. Martial Caillebotte. *Gustave Caillebotte seated in the garden at Petit Gennevilliers, with his dog Mama*, Dec. 1891. Photograph. Private collection.

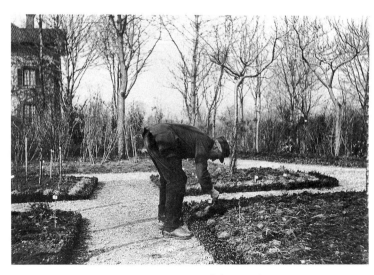

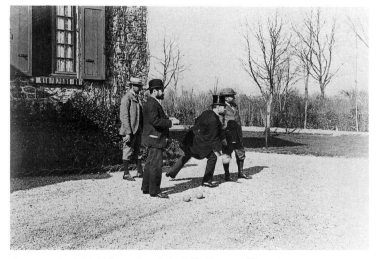

Figure 10. Martial Caillebotte. *Cassabois, Gallo, Susse, and Fournier playing boule at Petit Gennevilliers*, Feb. 1892. Photograph. Private collection.

Figure 8. Martial Caillebotte. *Gustave Caillebotte gardening at Petit Gennevilliers*, Feb. 1892. Photograph. Private collection.

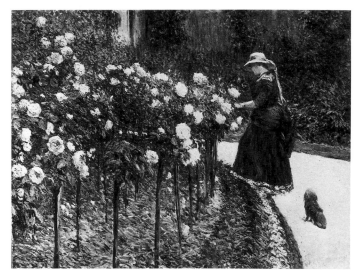

Figure 11. Gustave Caillebotte. *Roses in the Garden at Petit Gennevilliers*, c. 1881–83. Oil on canvas; 89 × 116 cm. Private collection.

Figure 12. Pierre Auguste Renoir (1841–1919). *Mlle Charlotte Berthier*, 1883. Oil on canvas; 92.1 × 73 cm. National Gallery of Art, Washington, D.C. (Gift of Angelica Wertheim Frinck).

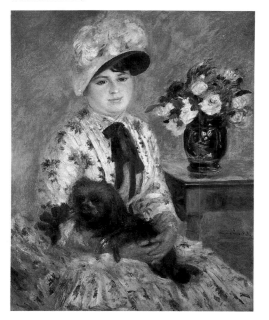

his will,[19] we know little about this very young woman (she claimed to be twenty-eight in 1891[20]), who was probably from a family of modest means. In the official record books, she was designated Anne Marie Hagen, and we do not know why she adopted the name given her by Caillebotte, Charlotte Berthier. Unlike his brother Martial, Gustave never married in conventional bourgeois fashion, but he did adhere to another classic schema of sorts—one favored by several of his painter friends—by establishing a long-term liaison similar to those frequently encountered in Naturalist literature from Maupassant to Huysmans.

From 1882 onward, Caillebotte found his principal inspiration as a painter at Petit Gennevilliers, taking up a repertory of motifs previously explored by Monet. In painting its gardens and fields, he followed Pissarro's example. Such a mimetic impulse might seem surprising coming from an imagination that had previously sought to startle through the choice of unorthodox subject matter. However, while now depicting nondescript themes (which is not to say banal ones, for no one

else treated drying laundry or sailboats gliding over the Seine so inventively), yet remaining faithful to his preference for perspective views defined by striking diagonals, Caillebotte had become increasingly interested in color, a tendency apparent in the titles of the latest works he exhibited during his lifetime, shown at Durand-Ruel in 1888: *Yellow and Pink Field* (cat. 104) and *Yellow Field* (Berhaut 1994, no. 267). Many works from the artist's final years were left incomplete, which complicates the task of establishing a chronology for this period. The fact that Caillebotte stopped exhibiting his work suggests that he felt it was not yet ready for public scrutiny. Death claimed him when he was in the midst of planning several decorative projects (see cat. 117) and before he had fully formulated a new set of goals for his painting. A. D.

NOTES

1 See Chronology, 1879.

2 It is worth noting that one of their friends and neighbors from Yerres, Maurice Brault, also became an active member of the Cercle de la Voile at Petit Gennevilliers.

3 On Monet in Argenteuil, see Wildenstein 1974 and Tucker 1982.

4 See Chronology, 1876.

5 See Gérôme 1993, pp. 75–86; and Quiqueré 1993, pp. 47–71.

6 The railroad line running from Gare Saint-Lazare to Asnières, Bois-Colombes, and Colombes reached the Seine at Petit Gennevilliers in 1851 and continued on toward Argenteuil, over a new bridge, in 1863 (Quiqueré 1993, pp. 47 and 58).

7 See P. Laurencin, "L'Assainissement de la Seine," *L'Illustration*, 17 Feb. 1877, no. 1773; and Anonymous, "Nos Graveurs. Les Eaux d'égouts de Paris," *L'Illustration*, 26 June 1880, no. 1948.

8 See Berhaut 1994, no. 423; and Musée du Vieil-Argenteuil, *L'Argenteuil des impressionnistes* (Argenteuil, 1990).

9 See Chronology, 1886, and Appendix IV, 1886, for details about the establishment of Chevreux et Luce, the new boatyard that would subsequently build Caillebotte's sailboats; it was situated not far from the dock-yard of Texier, Jr., long a fixture of Petit Gennevilliers, near the Argenteuil roadway bridge.

10 See Chronology, 1891.

11 Caillebotte does not seem to have had a real studio in the boulevard Haussmann apartment, though it seems likely that a room was set aside there to serve this purpose, as in the rue de Miromesnil house. The studio at Petit Gennevilliers was not completed until 1888.

12 See Appendix IV, 1882, 1885, and 1886.

13 See Chronology, 1881, 1882, and 1887.

14 We would like to thank Me Philippe Narbey for kindly providing us with a copy of the act of liquidation and distribution of the estate of Gustave Caillebotte, 17 May 1894, Minutier Centrale, Archives Nationales, Office of C. Didier, G. Oury, H. Lebaron, L. Theze, P. Narbey, notaries, successors of Me Poletnich, notary of the Caillebotte family. This document describes the Petit Gennevilliers property as follows:

Firstly, [a] residence erected over a cellar with a ground floor, a second floor, and third floor [that is] timbered, built of rough-textured stone, roofed in red tile, and consisting of: on the ground floor, large dining room with wooden steps in front, antechamber with hot-air stove, office, kitchen, water closet, staircase.

On the second floor, three bedrooms including two with balconies, a large bathroom.

On the third floor, a master bedroom with balcony, two servant's rooms, storage room.

Secondly, [a] pavilion a bit to the right and behind the preceding residence erected on unexcavated ground with a ground floor and a second floor, also built of rough-textured stone and roofed in red tiles, consisting of:

On the ground floor, [a] very large painter's studio with two wide bays admitting light from two sides and rising to the structure's full height, then a workroom, washstand, water closet, and stairway.

On the second floor, a mansarded bedroom above the workroom.

Thirdly, at the back of the property to the left, a pavilion serving as a residence for two gardeners, built over a basement and consisting of a ground floor with two bedrooms and a kitchen, in the front [a] large water reservoir with steam-driven hoist, large shelter for boats.

Fourthly, [a] large greenhouse divided in the center erected over a rockwork foundation with basement containing a hot-air stove.

Fifthly, at the back of the property to the right, [a] small gardener's house [built] over a cellar and consisting of a ground floor with two rooms; around this last pavilion, large chicken-coop, hen-house, kennel, another hen-house, etc., large pleasure garden surrounding these buildings, small wood at the back of the property, flower beds and kitchen garden, the whole enclosed by grilles, trellises, and earth embankments and with a surface area of roughly ten thousand forty-nine meters seventy hundredths and fronting onto the towing-path from the Seine, abutting at the back an earth embankment, on the left various, on the right various.

15 The inventory of furnishings drawn up after the artist's death (see Appendix I) mentions, notably, in the salon: "ninety-eight plates from the Revolutionary period valued at two-hundred francs—forty-nine faïence plates and dishes from Rouen, Moustiers, etc. . . . valued at a thousand francs—Three pitchers, a radish-dish, [three illegible words], an inkwell, two cruet-stands, two supports [?], an [illegible word], a mustard-pot, a salt cellar, two vases, a teapot, a milk pitcher, a flagon, all in Rouen faïence, and a gray vase, everything together valued at three hundred francs." It seems likely that some of these articles were used in the dining room.

16 See cats. 93 and 103, as well as Berhaut 1994, nos. 203, 205, 206, 257, 337, 342–46, 402, 405, 419, 420, 461, 462, and 506–508.

17 See Geffroy 1894.

18 After Gustave's death, Martial paid the wages of "Charles, premier garçon jardinier," to whom he also gave a gratuity, as well as those of a second young gardener (see Poletnich 1894b).

19 See Chronology, 1891.

20 See Chronology, 1883 and 1889. On Gustave Caillebotte's death, the young woman took possession of a small house adjacent to the property; the document closing and distributing the artist's estate (Poletnich 1894b) gives her Paris address as 11, boulevard de la Chapelle; she was still alive when Martial Caillebotte died in 1910. Her portrait by Renoir (fig. 12) was already owned by the prince de Wagram in April 1914 (inventory drawn up by Durand-Ruel; Durand-Ruel archives, Paris).

102

Kitchen Garden, Petit Gennevilliers

(Potager, Petit Gennevilliers, also known as *Le Jardin potager, Petit Gennevilliers)*

1882

Oil on canvas

66 × 81 cm

Stamped lower right

Berhaut 1978, no. 226; Berhaut 1994, no. 207

Private collection

Principal Exhibitions

Paris 1894, no. 120, priced at 1,000 francs but not sold (according to an annotated catalogue in the Durand-Ruel archives, Paris); Paris 1951, no. 53; Chartres 1965, no. 20; New York 1968, no. 47.

Selected Bibliography

Berhaut 1978, pp. 14 and 64; Wittmer 1990, p. 109.

The human figure is usually absent from the landscapes of Caillebotte, who even after settling in Gennevilliers remained a bourgeois urbanite and rarely represented the tilling of the soil. When he did, he focused on the world of the gardener (see cat. 20) and not that of the peasant, at once the incarnation of the eternal poetry of the fields and the catalyst of oppositional political controversy. Of his many depictions of the gardens in Yerres and Gennevilliers, only two, including this one, include a man bent over the earth in a posture suggesting the physical demands of his labor.[1]

Here the artist depicted the utilitarian portion of his large garden, "enclosed by grilles, trellises, and earth embankments."[2] The subject, the composition, and the important structural role allotted the isolated tree are all reminiscent of Pissarro (see fig. 1). But Caillebotte has rendered this familiar scene in a crisp, almost dry, mode of handling, particu-

larly apparent in the foreground shadows. The palette is restricted, and we encounter once again the gray and green color harmonies visible in some of the urban scenes (see cat. 69), here augmented by the purplish-pink hue of the earth. R. R.

1 The second work is *The Gardener* (Berhaut 1994, no. 79).
2 Poletnich 1894b.

Figure 1. Camille Pissarro (1830–1903). *Setting Sun at Valhermeil, near Pontoise*, 1880. Oil on canvas; 54 × 65 cm. Private collection.

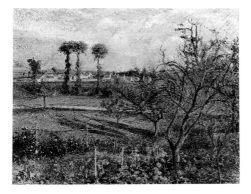

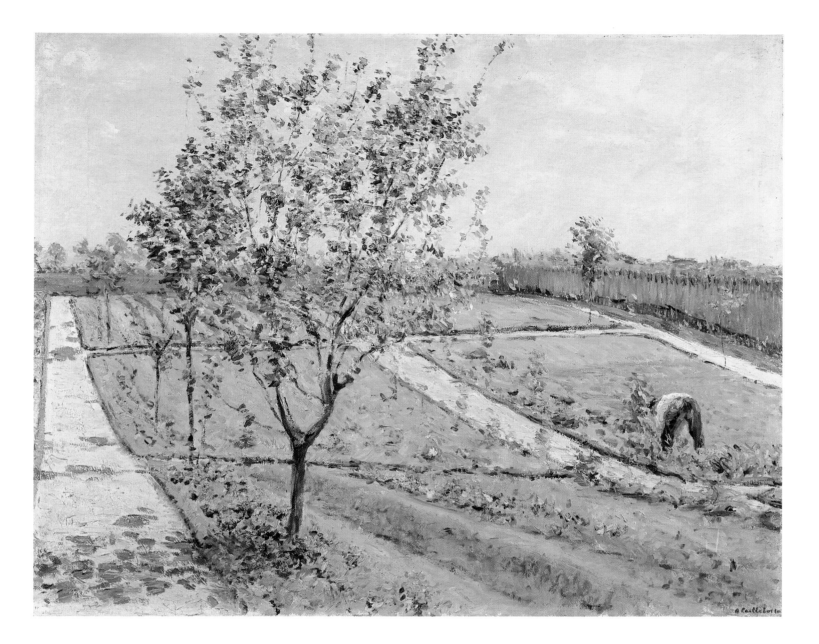

103

The Argenteuil Promenade

(La Promenade à Argenteuil)

1883

Oil on canvas

65 × 82 cm

Signed and dated lower left:
G. Caillebotte / 1883

Berhaut 1978, no. 244; Berhaut
1994, no. 263

Private collection

Principal Exhibitions
Paris 1894, no. 37, as *La Prome-
nade d'Argenteuil (1883)*; Paris
1951, no. 54; London 1966, no. 35;
New York 1968, no. 49; Marcq-en-
Baroeul 1982–83, no. 23.

Selected Bibliography
Berhaut 1968, p. 43; Rewald 1973,
p. 485; Berhaut 1978, p. 64; Ba-
landa 1988, pp. 118–119.

This is one of the rare compositions by Caille-
botte in which he forsook the banks of the
Seine to venture into the town of Argenteuil (see
also Berhaut 1994, nos. 259–62, and 264). This can-
vas bears a date, 1883, providing a chronological
benchmark at the beginning of the artist's sojourn
in Petit Gennevilliers. The title suggests we are at
one end of the Argenteuil promenade, which ex-
tended downstream along the river from the road-
way bridge. However, attempts to identify the exact
site of the Buvette du Marché, whose painted sign
draws our attention to the nondescript structure
Caillebotte chose to include, have proven unsuc-
cessful. In the early 1870s Monet and Sisley also
painted Argenteuil, then a small town of fewer
than eight thousand inhabitants halfway between
the countryside and the suburbs, and Caillebotte's
vision of the place does not seem so very different
from theirs. This wide promenade, not very ani-
mated but given a certain urbanity by its chestnut
trees and benches, also recalls Pissarro's images
of nearby Pontoise. Caillebotte would not again
take up this motif, preferring instead to explore
the banks of the Seine close to his property.

The painter devised a decentered composition
under a strong light casting deep shadows: A mass
of flowering foliage on the left, heavily worked and
contained within lines tracing the edge of the path
and the thin pole supporting a tricolor banner, is
opposed to the emptiness of the right side; incon-
gruously, two small tricolor flags cropped at the
right evoke the space beyond the frame. The palette
is dominated by rather chalky grays, greens, and
beiges, which subtly contrast with the vibrant blue
of the sky and the bluish-gray of the shadows.

In 1894 *The Argenteuil Promenade* belonged to
Paul Hugot, a friend of Caillebotte's who owned
several of his works and is the subject of a portrait
by him (see Berhaut 1994, no. 111). If we can believe
an annotation in the catalogue of the 1894 exhibition
now in the Durand-Ruel archives, Paris, this was
also one of the few paintings sold on that occasion;
it went to the amateur-collector Edmond Decap
for 1,500 francs, a rather substantial sum. A. D.

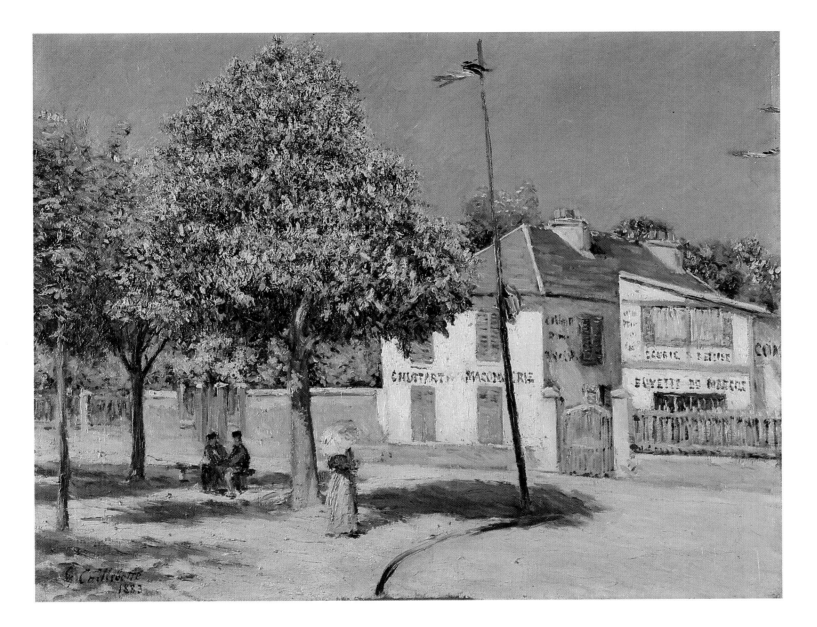

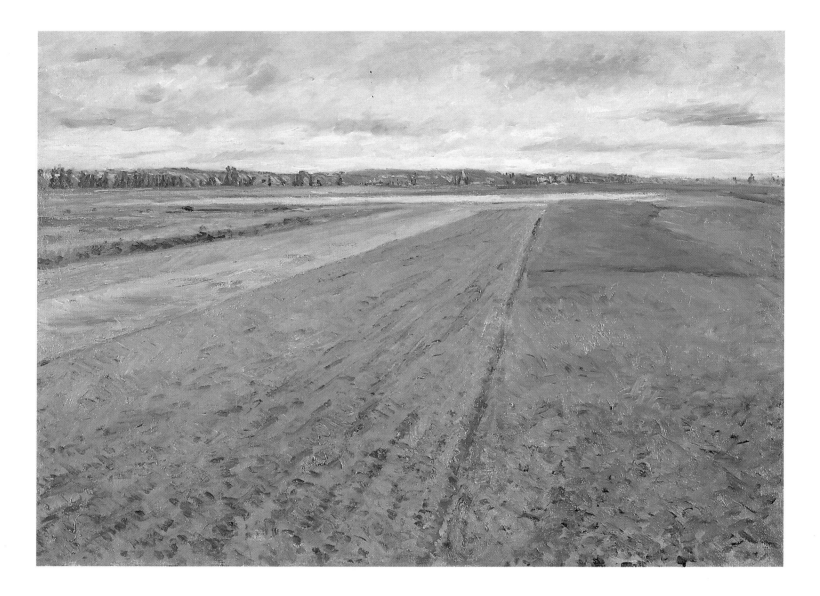

104

Landscape— Study in Yellow and Rose, also known as **Yellow and Pink Field,** and **Fields on the Gennevilliers Plain, Study in Yellow and Pink**

(Champ jaune et rose, also known as *Les Champs, plaine de Gennevilliers, étude en jaune et rose)*

1884

Oil on canvas

59 × 81 cm

Berhaut 1978, no. 279; Berhaut 1994, no. 291

Private collection

Principal Exhibitions
New York 1886, no. 135, as *Landscape—Study in Yellow and Rose,* priced at 500 francs (according to an annotated catalogue in the Durand-Ruel archives, Paris); Paris 1888, no. 62, as *Champ jaune et rose.*

Selected Bibliography
Berhaut 1978, p. 65.

Caillebotte executed several paintings of the Gennevilliers plain, a uniformly flat area planted with grains and vegetables, extending outward from the perimeter of his property. The region around Paris was one in which mechanical innovations were introduced into agriculture with great rapidity. On the other hand, under the terms of an agreement reached between Paris and the Gennevilliers township on 16 July 1873, a portion of the capital's sewage water emptied onto these lands, irrigating the crops of the local farmers[1] (see ch. 8 intro., fig. 2). Thus, in addition to the extreme bareness of the motif, the Gennevilliers plain provided the artist with the image of a countryside devoid of all agrarian poetry.

This painting belongs to a quite homogeneous set of works, in which Caillebotte represented the spreading plain with the distant horizon marked by a line of trees.[2] This compositional scheme appears in six paintings from 1883–84, proof that despite its flatness, austerity, and apparent lack of allure, the artist planned to execute several differently colored variations on this motif. Caillebotte's titles for these works evidence this intention and imply a rather subjective approach to color. The 1886 exhibition organized by Durand-Ruel in New York included a *Landscape—Study in Yellow and Green*[3] and the present work (then entitled *Landscape— Study in Yellow and Rose*), which was shown again by Durand-Ruel, two years later in Paris (under the title *Yellow and Pink Field*), along with another *Yellow Field.*[4]

According to Kirk Varnedoe,[5] these canvases were influenced by a compositional device used by Monet from the late 1870s onward, namely the setting-aside of a portion of the pictorial surface to receive broad expanses of color. However, Caillebotte's radical reduction of the motif to a series of colored bands, as here, in turn influenced analogous compositions by Monet, who began to use such schemes only in 1885–86. The most telling examples are his *Poppy Field in a Hollow near Giverny* (1885; Museum of Fine Arts, Boston) and *Tulip Fields in Holland* of 1886 (fig. 1).

In the present painting, explicitly designated a "study," Caillebotte unmistakably assigned the dominant role to color: the yellow-green of the vegetables and the brown of the earth, which keys up the pink of the two central rectangles plunging toward the horizon, their respective hues varying as little as possible. However, while the handling in these views of the Gennevilliers plain often recalls Monet's manner of building up surfaces by accumulating small dabs of color,[6] we are nonetheless very far from Impressionist lyricism. The coldness of the motif is further accentuated by a total absence of the laborers that often populate Impressionist landscapes, bringing into the nineteenth-century landscape the timeless associations of the bucolic tradition. Works such as this indicate that even after 1880, Caillebotte did not renounce a personal approach to landscape, contenting himself with the repetition of tried-and-true Impressionist formulas. Quite the contrary: in their use of broad areas of color varied only by tonal nuances to structure space, and in the austerity reflected in his choice of motif, his views of the Gennevilliers plain are close to certain landscapes executed by Seurat about the same time, such as *Field of Alfalfa, Saint-Denis* (1884–85; National Galleries of Scotland, Edinburgh). R. R.

1 See the entry *"Gennevilliers"* in *La Grande Encyclopédie* (Paris, n.d.), vol. 18, p. 748. See also P. Laurencin, "L'Assainissement de la Seine," *L'Illustration,* 17 Feb. 1877, p. 107; and Anonymous, "Nos Graveurs. Les Eaux d'égout de Paris," *L'Illustration,* 6 June 1880, p. 407.

2 See also Berhaut 1994, nos. 267, 268, 289, 290, 293 (the motif in no. 290 is in Colombes, not Gennevilliers). *Yellow Field* (Berhaut 1994, no. 292), while quite close to this set, should be dated 1889 (and neither 1888 as indicated in Berhaut 1978, nor 1884 as indicated in Berhaut 1994) if we can trust the listing in the catalogue of the 1894 retrospective exhibition.

3 Number 136 in the catalogue; Berhaut 1994, no. 318.

4 Number 64 in the catalogue; Berhaut 1994, no. 286.

5 Varnedoe 1987, p. 172.

6 See, for example, Claude Monet, *Poppy Field* (1881; Museum Boymans-Van Beuningen, Rotterdam).

Figure 1. Claude Monet (1840–1926). *Tulip Fields in Holland,* 1886. Oil on canvas; 65 × 81 cm. Musée d'Orsay, Paris.

105

Portrait of M. Richard Gallo, also known as Richard Gallo and His Dog Dick, at Petit Gennevilliers

(*Portrait de M. Richard Gallo*, also known as *Richard Gallo et son chien Dick, au Petit Gennevilliers*)

1884

Oil on canvas

89 × 116 cm

Signed and dated lower left:
G. Caillebotte 1884

Berhaut 1978, no. 290; Berhaut 1994, no. 305.

Josefowitz Collection
(on loan to the National Gallery, London)

Shown in Chicago only

Principal Exhibitions
Brussels 1888, no. 3, as *Portrait de M. R. G.;* Paris 1894, no. 51, as *Portrait de M. R. G.*

Selected Bibliography
Berhaut 1978, p. 68; Cahn 1989, p. 70.

Caillebotte's three portraits of Richard Gallo were undertaken at regular intervals, for they were painted respectively in 1878, 1881, and 1884.[1] The son of a French banker residing in Alexandria, Richard Gallo studied in Paris and was a classmate of Caillebotte's.[2] According to Marie Berhaut, in 1881 he was the editor of the newspaper *Le Constitutionnel*, which was managed by his brother-in-law, Grandguillot.[3] He was a close friend of the artist, who included him in *The Bezique Game* (cat. 80).

The title Caillebotte assigned this canvas when it was exhibited in 1888 indicates that he considered it a portrait. This no-nonsense image, a singularly unconventional exercise in portraiture, adheres to the code of truth that was the foundation of artistic Realism, revealing its inherent limitations in the frozen movement of the figure and his dog. On the other hand, the inclusion of so pervasive an Impressionist motif as the Seine riverbank, here treated as a sequence of superimposed horizontal bands, implies an intention to rejuvenate the portrait genre by combining it with a typical modern landscape composition. In the background we glimpse "the last houses of Argenteuil and the foliage of the fairgrounds,"[4] which is to say, a countryside at Paris's doorstep that was beginning to lose its rural character as a result of urban expansion.

This painting figured in the 1888 exhibition of Les XX in Brussels, in which Caillebotte had been invited to take part along with several other French artists: Louis Anquetin and Henri de Toulouse-Lautrec were represented, as were Albert Dubois-Pillet, Jacques Emile Blanche, and Paul Albert Besnard. It seems that the painter's participation in Les XX did not proceed without incident, for *Man at His Bath* (cat. 83), chosen by Caillebotte and probably sent to Brussels, was removed from the exhibition and placed in an adjacent gallery.[5] A letter from Théo van Rysselberghe to Paul Signac makes it clear that the organizers had included Caillebotte and Guillaumin on a back-up list, to which they planned to resort only if and when those on their first list refused the invitation.[6] The critics who commented on Caillebotte's works were unanimous in viewing them as the survivors of an outdated artistic tendency. "The Impressionism of yesteryear is represented by MM. Caillebotte and Guillaumin and Mademoiselle Jeanne Gonzalez [*sic*]," wrote Emile Verhaeren in his review.[7] His opinion was shared by Eugène Demolder: "Among the French painters invited to Les XX, we again find M. Caillebotte, who exhibits three portraits, a still life, some landscapes. He is, it seems, a former bold experimenter, a precursor of today's [Neo-Impressionists]. His portraits, with their awkward demeanor, are clumsily banal; in his landscapes,

coarseness, thick slabs of color, utter vulgarity."[8] Such an assessment is indicative of the way Caillebotte's fidelity to Impressionist formulas was perceived by a new generation of critics. From the late 1880s onward, both straightforward depictions of the modern world—the new iconographic strain to which Caillebotte had made such decisive contributions—and Impressionist technique were perceived as having lost their provocative force, and were relegated to a secondary role as relics of the past. After this blow the artist exhibited only once, at Durand-Ruel, where he showed six works in a group exhibition in May–June 1888.

This painting's current frame may not be the original one, for in photographs of Caillebotte's work taken by his brother Martial, this canvas is unframed,[9] but these same photographs also demonstrate that the design of its frame corresponds to a model often used by the artist. R. R.

1 See Berhaut 1994, no. 107 and ch. 5 intro., fig. 7.

2 Information provided by the subject's family.

3 The *Annuaire-Almanach du commerce et de l'industrie* (Paris, 1884) lists an establishment "Richard Gallo et Cie, commissionaires en marchandises, 87, rue Taitbout à Paris." The act of closure and distribution of Caillebotte's estate (Poletnich 1894b) stipulates that Martial paid the sum of 170 francs 50 "to M. Gallo, marchand d'essence."

4 Berhaut 1994, no. 305.

5 See discussion, cat. 83.

6 Here are those [to be] invited: I will have you, Degas, Gustave Moreau, Dubois-Pillet, Anquetin, Forain, Sisley, Puvis, Lautrec, Helleu, Blanche, Dalou et Chaplain (medalist?) whom I scarcely know and then Whistler and Cassatt (America), Zacharias (Greece?), Mellery, Joseph Stevens the dog painter and van der Stappen. I forget the twentieth [there follows a drawing of a fireman's helmet]. Then the five extras to be invited if some on the first list do not accept: Caillebotte, Guillaumin, Cross, Boechling [*sic*] (a German painter of fantasy I'm told) and Willette. Now I remember the twentieth [is] the Englishman Steer . . ." (undated letter [before Christmas 1887], Signac archives, Paris).

7 E. Verhaeren, "Chronique bruxelloise. L'Exposition des XX à Bruxelles. 1888," *Revue indépendante*, 1888.

8 Demolder 1888a. Also see Anonymous 1888.

9 Family archives, Paris.

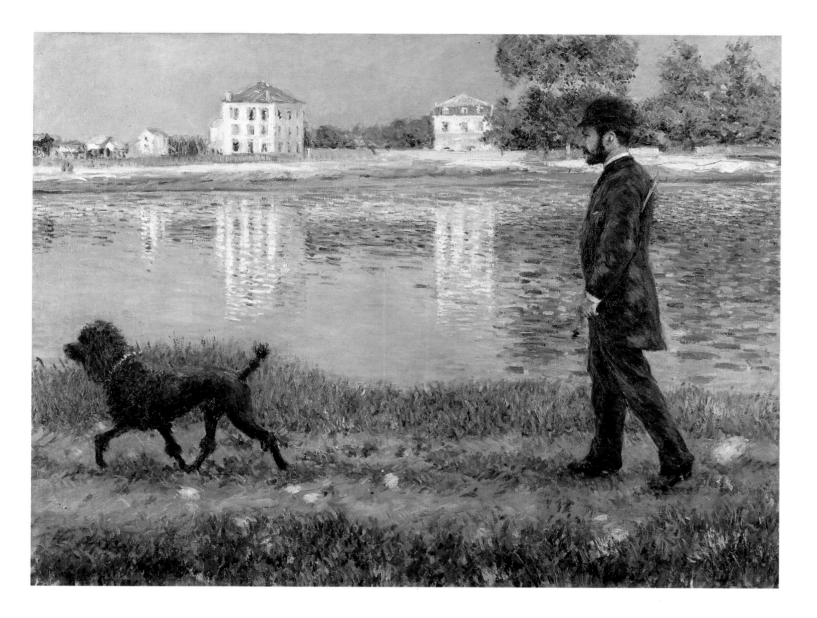

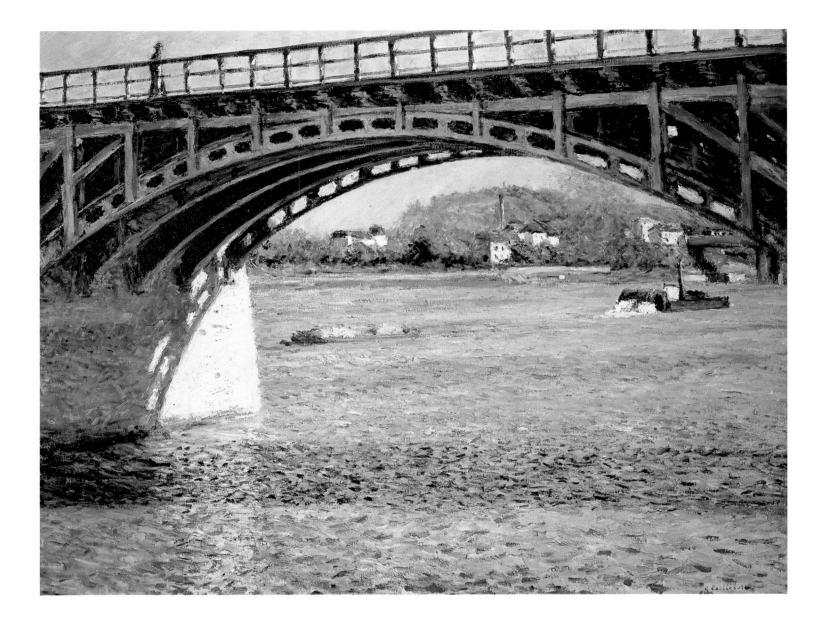

106
The Argenteuil Bridge
(Le Pont d'Argenteuil)

c. 1883
Oil on canvas
65 × 82 cm
Stamped lower right
Berhaut 1978, no. 310; Berhaut 1994, no. 334

Josefowitz Collection

Principal Exhibitions
Paris 1894, no. 21; Chartres 1965, no. 23; Houston and Brooklyn 1976–77, no. 64; Los Angeles et al. 1984–85, no. 51.

Selected Bibliography
Berhaut 1978, p. 68; Varnedoe 1987, no. 55; Balanda 1988, pp. 50–51, and 132–33.

The Impressionists painted quite a few bridges, but the roadway bridge crossing the Seine that connected Petit Gennevilliers to Argenteuil seems to have become an obligatory motif for Monet (see fig. 1) as well as for Renoir, Sisley, and Caillebotte, serving them much as the ruins of ancient Rome had served other artists. This modern structure—destroyed in the 1870 war and subsequently rebuilt in accordance with its original design of 1830–31—was a part of the world they had chosen to paint. The rhythm of its arches spanning the river is a leitmotif that appears in many canvases, variously reinvented each time.

Caillebotte here looked upstream through one of the bridge's central arches, probably from the landing stage of the Petit Gennevilliers boat-keeper (see cat. 107), which overhung the Seine. Visible in the distance are the Argenteuil riverbank, the Orgemont hill, and the beginning of the railway bridge. A paddle-wheeled towboat spits gray smoke into the landscape—one in which nature is subservient to industry—without dimming the prevailing luminosity.

Caillebotte, who of course was familiar with Monet's canvases, chose a close-up viewpoint Monet never used, but we cannot be sure just how consciously he set out to distinguish himself from Monet's example: he might just as well have been indulging his taste for surprising compositional schemes. By cropping out the pier and the arch-spring on the right, as well as a segment of the railing, Caillebotte lightened the motif and accentuated the play between different levels of depth. The attention devoted to textures and colors—in the water, the stone, the vegetation, and the smoke—is an index of the painter's evolution: he has now abandoned the polished surfaces typical of his 1870s canvases.

The catalogue of the 1894 exhibition assigns the work to 1885, a date retained by Marie Berhaut. Kirk Varnedoe suggested it might be somewhat earlier, but it cannot be prior to 1883–84, when the artist first worked in Petit Gennevilliers. With its surprising yet subtle composition and its intense color scheme, this painting is incontestably one of the most successful works executed by Caillebotte on the banks of the Seine.

An annotation in a copy of the 1894 exhibition catalogue in the Durand-Ruel archives indicates that this painting, which then belonged to Eugène Lamy, a friend of Caillebotte's, was sold for 1,500 francs to Edmond Decap, who acquired several of the painter's works (see cat. 105 and Introduction n. 49). A. D.

Figure 1. Claude Monet (1840–1926). *The Roadway Bridge, Argenteuil*, 1874. Oil on canvas; 58 × 80 cm. Neue Pinakothek, Munich.

107

Boathouse in Argenteuil, also known as *The Boat Landing in Argenteuil*

(Garage de bateaux à Argenteuil, also known as *Le Ponton à Argenteuil)*

1886/87

Oil on canvas

74 × 100 cm

Signed (posthumously?) lower right: *G. Caillebotte*

Berhaut 1978, no. 320; Berhaut 1994, no. 276

Private collection

Principal Exhibitions
Paris 1894, no. 7, as *Garage de bateaux à Argenteuil* [1889]; priced at 1,000 francs but not sold (according to an annotated catalogue in the Durand-Ruel archives, Paris); Paris 1921, possibly no. 2748, as *La Remise des canots;* Paris 1951, no. 74; Chartres 1965, no. 27; London 1966, no. 42; New York 1968, no. 57; Pontoise 1984, no. 12.

Selected Bibliography
Berhaut 1968, p. 53; Berhaut 1978, p. 66.

To paint this scene, Caillebotte positioned himself on the roadway bridge linking Petit Gennevilliers and Argenteuil; the view is downstream: on the left is the Petit Gennevilliers riverbank with its towing-path and red-tiled roofs (the Caillebotte property is a bit farther down). The floating dock was the headquarters of the boat-keeper, and the entire Argenteuil flotilla is anchored nearby. On the right is the Argenteuil riverbank, on which we can make out one end of the tree-shaded promenade, then some large residences, including a modern manor house of brick, masonry, and slate owned by Emile Michelet (a renowned competitor in the Argenteuil regatta and a colleague of Caillebotte's in the Cercle de la Voile, of which he was vice president). Finally, contiguous with this structure, is a factory with tall chimneys (see cat. 108). Caillebotte here depicted surroundings thoroughly familiar to him, but, again, this same panorama was painted by Monet between 1872 and 1875 from different viewpoints (see fig. 1 and Wildenstein 1974, nos. 314–317, and 334–35). Caillebotte excluded the human figure and, without diminishing the voluminous mass of the boat-landing, played with perspective effects by cropping, in the foreground, a sailboat mast and its stays as well as a bright green rowboat; and by shrinking the scale of the black-hulled sailboats in the background, he accentuated the effect of depth. A faded sky spreads a diffuse light over the vivid hues of the riverbank and deadens the brilliance of the river. It is difficult to date this work with precision, but the technique suggests it was executed after 1885. A. D.

Figure 1. Claude Monet (1840–1926). *The Argenteuil Basin*, c. 1874. Oil on canvas; 53 × 65 cm. Indiana University Art Museum, Bloomington.

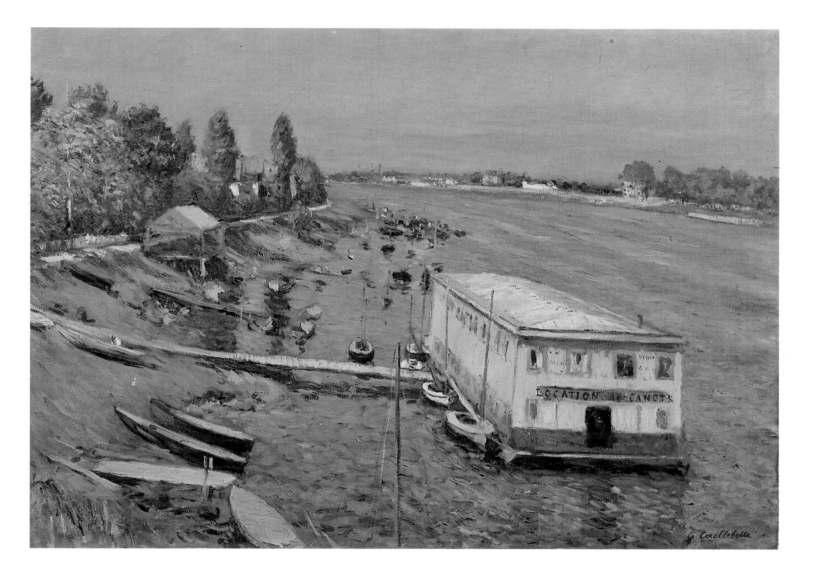

108

Factories in Argenteuil

(Fabriques à Argenteuil)

1887/88

Oil on canvas

65 × 82 cm

Stamped lower right

Berhaut 1978, no. 331; Berhaut 1994, no. 390

Private collection

This luminous, vigorously executed canvas has never been exhibited, doubtless because its subject is incompatible with the pervasive view of Impressionism as a school of lyrical nature painting. However, beginning in the early 1870s, several of the Impressionists looked squarely at the factory chimneys sown in the landscape by industrial progress: in Argenteuil, Manet and Monet[1]; in Pontoise, Pissarro.[2] It might even be described as one of the group's typical motifs—like bridges, roadways, and railways—that Caillebotte set out to reconsider. In this case the project entailed little inconvenience, for the factory in question is probably the one that was directly opposite his house—on the Argenteuil bank a bit downstream from the Michelet property (see cat. 107)—whose chimneys had already appeared in works by Manet and Monet. Marie Berhaut, on the other hand, seems to think it is another Argenteuil factory situated farther upstream.[3]

In its handling, which renders the reflections in the water with broad, free brush strokes, this canvas reveals a Caillebotte who, even as he demonstrated his complicity with the vision of Manet, Monet, and Pissarro, was capable of producing a stripped-down, austere image that is altogether characteristic of him. A. D.

1 See, among other examples, Wildenstein 1974, nos. 222–24.

2 See Pissarro and Venturi 1939, nos. 214–215, and 218.

3 She called it "Chantiers de la Seine." There were many factories along the Seine near Argenteuil, notably another one upstream from Château Michelet, which was thus literally surrounded by them; Caillebotte provided us with a glimpse of the third, situated between the two bridges (see cat. 106); there was yet another still farther upstream, not far above the railway bridge (see the photograph reproduced in Tucker 1982, p. 75).

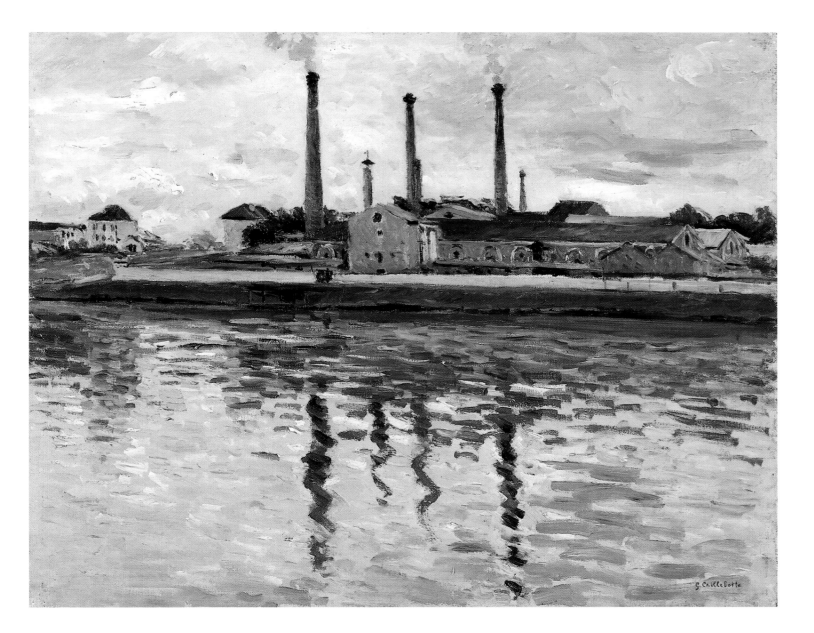

109
Sailboats in Argenteuil

(Voiliers à Argenteuil, also known as Bateaux à voile à Argenteuil)

c. 1888

Oil on canvas

65 × 55 cm

Signed (posthumously?) lower right: *G. Caillebotte*

Berhaut 1978, no. 359; Berhaut 1994, no. 214

Musée d'Orsay, Paris (acquired with funds from the Dol-Lair bequest, 1954; RF 1954-31)

Principal Exhibitions
Pontoise 1984, no. 15.

Selected Bibliography
Sterling and Adhémar 1958, no. 154; Berhaut 1968, p. 47; Adhémar and Dayez 1973, p. 140; Berhaut 1977, p. 47; Berhaut 1978, p. 66; Varnedoe 1987, no. 54; Balanda 1988, pp. 142–43.

As a boating enthusiast, Caillebotte was destined to paint the sailboats at Petit Gennevilliers; nonetheless, his vision of them was influenced by his colleagues Monet, Renoir, and Sisley, each of whom had painted these same sailboats from the same vantage point some ten years before him. Caillebotte produced countless variations on this theme. He painted boats at their moorings, boats downstream from the roadway bridge, as here, and boats competing in regattas. Curiously, although a man of his experience on the water might have been expected to highlight technical details, he consistently viewed these vessels with a painter's eye, as motifs contributing to overall compositional and coloristic effects. An analysis of this work under infrared light, conducted by the research laboratory of the Musées de France, disclosed a revision that indicates just how carefully he pondered the design of this seemingly spontaneous work: Caillebotte initially included the mast of the moored boat in the left foreground. He then suppressed this diagonal in order not to detract from the vertical line of the mast on the vessel with unfurled sails and the repeating rhythm of the two more distant masts leading the eye toward the horizon closed off by the bridge. The thick, tightly organized brush strokes on the surface also bespeak careful calculation.

It is not certain that Caillebotte exhibited any of his canvases picturing this theme during his lifetime (see Chronology, 1888), but at the 1894 posthumous exhibition it was these images that were most appreciated by amateur-collectors (see Introduction). A. D.

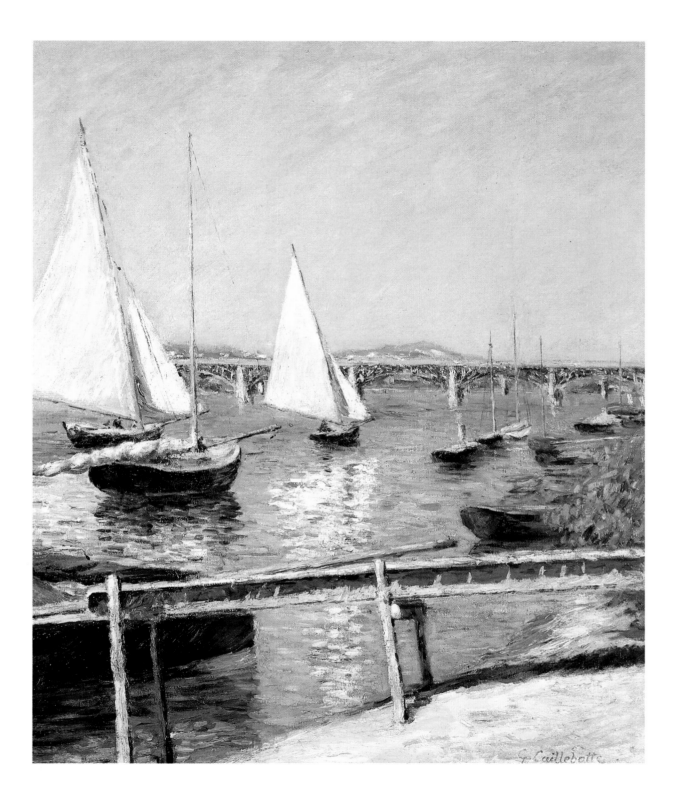

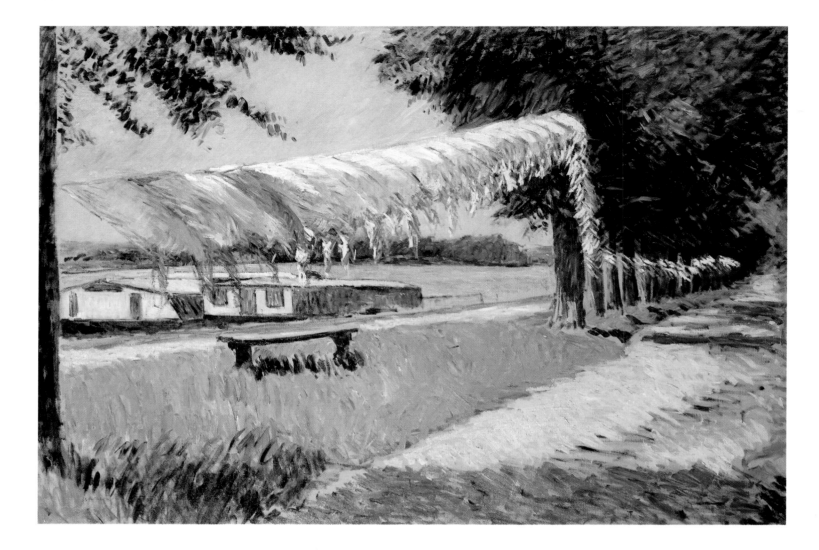

110

Laundry Drying, also known as Laundry Drying along the Seine, Petit Gennevilliers

(*Linge séchant,* also known as *Linge séchant au bord de la Seine, Petit Gennevilliers*)

1892

Oil on canvas

106 × 150 cm

Stamped lower left

Berhaut 1978, no. 348; Berhaut 1994, no. 368

Wallraf-Richartz Museum, Cologne

Principal Exhibitions
Paris 1894, no. 34 (?).

Selected Bibliography
Berhaut 1978, p. 66.

This is one of the most carefully elaborated of the artist's last works: three directly related studies for it are known (see fig. 1; cat. 111; and cat. 111, fig. 1). Caillebotte here returned to a large format (the dimensions of this canvas are close to those of *Floor-Scrapers* [cat. 3]), and it was clearly his intention to make this painting, with its novel subject, a fully realized demonstration picture comparable to *The Pont de l'Europe* (cat. 29) and *Paris Street; Rainy Day* (cat. 35). His predilection for compositions conceived around strong diagonals, which found encouragement in the architecture of modern Paris, reappears in *Laundry Drying.* The summary handling of certain passages (especially in the foreground) and the absence of a signature indicate that the painting was incomplete at the time of Caillebotte's death. Thus its process of elaboration proceeded very slowly, for we know that it was begun in 1892.[1]

The artist depicted a motif near his own property at Petit Gennevilliers. There were many public wash-houses made of wood along the Seine, and Marie Berhaut has noted that a map from the Napoleonic period designates the land subsequently owned by Caillebotte as the "Ile aux draps," or "island of sheets."[2] He had previously represented these wash-houses in another painting in which empty clotheslines already appear,[3] and it might be surmised that the idea of focusing on white shirts blown by the breeze occured to him only subsequently.

A pretext for exploring different values of white

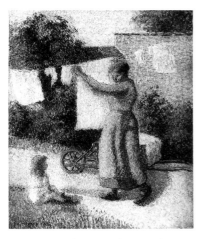

Figure 2. Camille Pissaro (1830–1903). *Woman Hanging Out Laundry,* 1887. Oil on canvas; 41 × 32.5 cm. Musée d'Orsay, Paris.

under lighting conditions juxtaposing sun and shadow, this painting is also an attempt to render the motion of fabric swelled by wind, revealing an animated network of stripes ranging from pure white to blue. Caillebotte's originality in dealing with this subject becomes apparent when we remember that in the painting of his time, and particularly in Impressionism, tasks connected with laundry—washing, hanging, ironing—were among the images of work most frequently depicted (see fig. 2). Just as he represented cultivated landscapes without laborers, in this painting the artist has carefully staged a scene in which human presence is absent yet implied—by the empty bench as well as by the laundry itself, which evokes a regular activity, a cycle of work that here is in hiatus but will soon continue. R. R.

1 See discussion, cat. 111.
2 Berhaut 1994, p. 14 n. 58.
3 Berhaut 1994, no. 366.

Figure 1. Gustave Caillebotte. *Laundry Drying along the Seine, Petit Gennevilliers,* 1892. Oil on canvas; 54 × 65 cm. Private collection.

111

Laundry Drying, also known as Laundry Drying, Petit Gennevilliers

(*Linge séchant,* also known as *Linge séchant, Petit Gennevilliers*)

1892

Oil on canvas

54 × 65 cm

Stamped lower right

Berhaut 1978, no. 350; Berhaut 1994, no. 370

Private collection

Principal Exhibitions
Paris 1894, no. 34 (?).

Selected Bibliography
Berhaut 1978, p. 66; Wittmer 1990, p. 177.

There are three known studies for the Cologne *Laundry Drying* (cat. 110), all of identical dimensions (see fig. 1 and cat. 110, fig. 1). The work exhibited here is perhaps not only a color study for the large picture, but a sketch for a different, more abstract composition with a similar subject: the site is not the one depicted in the more ambitious work, where the row of trees on the far bank continues without interruption. Caillebotte here set out to combine a study of laundry blown by the wind with a typically Impressionist riverside landscape. This painting includes, in summary form, all the essential elements of such compositions as they had been elaborated not only by Monet and Sisley, but also by Caillebotte himself (see cat. 105): an all but absent foreground acts as a foil for reflections in the water and a view of the opposite riverbank, where the rooftops of a few houses can be discerned among the vegetation, the composition as a whole being organized as a series of parallel bands. The artist did not retain this scheme for the large version (cat. 110), where the importance of the distant landscape is diluted by the prominence accorded the foreground elements.

Marie Berhaut maintained that it was this sketch, and not another version of the subject, that figured in the 1894 retrospective exhibition. Her identification is questionable, however, given that the title used in the catalogue, *Linge séchant,* could be accurately applied to five different paintings,[1] and that none of the reviews of the exhibition mentions the work. According to the annotated catalogue in the Durand-Ruel archives, the asking price for *Linge séchant* on that occasion was 500 francs. When considered in light of the other prices,[2] this suggests that the exhibited canvas was one of the small oil sketches and not the large version. On the other hand, the same catalogue assigns *Linge séchant* a date of 1892. Thus the works treating this theme should be dated four years later than the date of 1888 proposed by Marie Berhaut. R. R.

1 Berhaut 1994, nos. 366–70.
2 See Introduction n. 49.

Figure 1. Gustave Caillebotte. *Laundry Drying, Petit Gennevilliers,* 1892. Oil on canvas; 54 × 65 cm. Private collection, Paris.

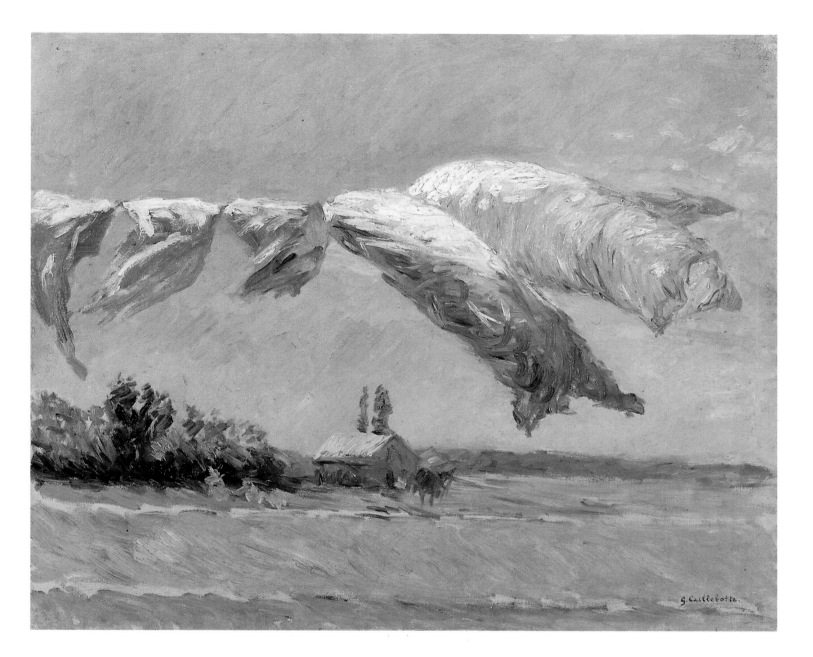

112
The Garden at Petit Gennevilliers in Winter
(Le Jardin du Petit Gennevilliers en hiver)

c. 1894

Oil on canvas

73 × 60 cm

Signed (posthumously?) lower right: *G. Caillebotte*

Berhaut 1978, no. 476; Berhaut 1994, no. 506

Private collection

Principal Exhibitions
Paris 1894, no. 58, as *Jardin (1894)*.

Selected Bibliography
Berhaut 1978, p. 70.

This *Garden at Petit Gennevilliers in Winter* is one of the last works painted by the artist, and his brother Martial kept it for himself.[1] These bare trees in winter sunlight, an Impressionist theme par excellence, provided Caillebotte with an occasion to display his audacity as a colorist by opposing the vigorous green strokes of the ground to the mauve, russet, and bluish touches spread over the rest of the canvas. While he focused above all on the capricious rhythms of the branches, Caillebotte energized the edges of the receding path according to a now familiar scheme. His passion for horticulture doubtless informed his interest in this slumbering garden, which he had also painted in all its summer glory. This melancholy vision is the painter's pictorial farewell; he died on 21 February 1894. A. D.

1 The catalogue of the 1894 exhibition in the Durand-Ruel archives, Paris, bears a manuscript annotation, "belonging to Mr. C.," beside the entry for this work and lists no price for it.

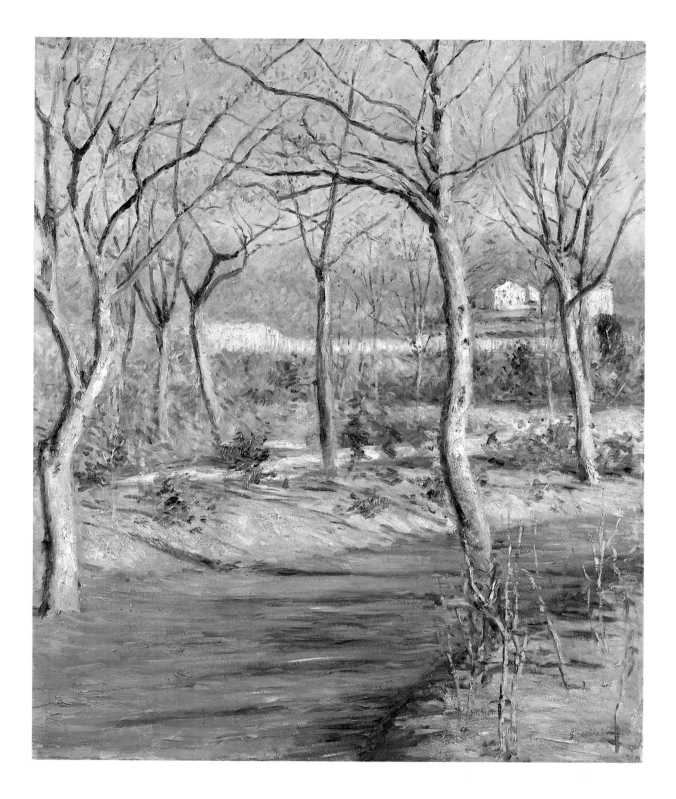

Caillebotte waited until the beginning of the 1880s, around the time he acquired Monet's *Red Chrysanthemums* (Appendix III, fig. 35), to paint his own floral still lifes. He returned to them periodically throughout his life, but much less so than Cézanne, Monet, and Renoir, who frequently painted flowers, a genre easily accessible to collectors and one that was recommended by commercial gallery dealers, such as Durand-Ruel.[1] In undertaking still lifes, and in particular flower painting, Caillebotte, and the Impressionists in general, chose a genre consigned to a low rank in the hierarchy of artistic subject matter. It involved nature, to be sure, but nature re-created and made more beautiful by the artist's attention to sensuous details. Indeed, as objects of display and consumption (see ch. 6 intro.), still lifes were subject to the same descriptive language as the actual products upon which they were based. A still life of fruits or flowers was judged successful for its freshness, its ripeness. Its aesthetic appeal was thus closely related to its carnal appeal.

Figure 1. Martial Caillebotte. *Caillebotte in his greenhouse at Petit Gennevilliers*, 1891/92. Photograph. Private collection.

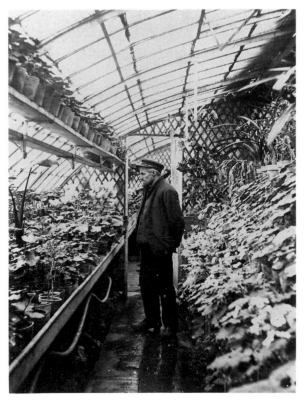

Because it addressed the senses above intellect, and because it required a sensitivity to tactile details rather than to an abstract and synthetic vision, still-life painting was associated with the feminine and with genteel female accomplishments.[2] Among the artists who exhibited with the Impressionists in 1876 was a woman listed pseudonymously as "M. Jacques François," who showed exclusively still lifes.[3] The critics, all of whom were aware of the artist's gender, had nothing but praise for her entries, commending the "masterly pieces" representing baskets of fruit and flowers, and the facture, "bold in a way that is altogether feminine."[4] The still lifes shown in subsequent exhibitions by Cézanne, Monet, and Renoir excited little, if any, interest, perhaps because of the subject's subordinate position and connection with femaleness. Unlike landscapes and portraits, which were also considered secondary subjects, floral still lifes were associated with the artifice of bouquets or floral arrangements—the transformation of the natural (as opposed to the intellectual) into decorative art. This further linked the genre to women (a feminine touch) and, by extension, to the domestic realm. Caillebotte, too, established a relationship between flowers, arranged or in nature, and the feminine in pictures such as *Portraits* (Berhaut 1994, no. 62), *Woman Sitting on a Red-Flowered Sofa* (cat. 76), and images presumably of his mistress, Charlotte Berthier, tending the flower gardens at Petit Gennevilliers (see ch. 8 intro., fig. 11, and ch. 5 intro., fig. 8).[5]

Caillebotte's interest in floral still lifes paralleled his interest in gardening, which developed after his acquisition of the house and property at Petit Gennevilliers. Caillebotte had earlier featured the garden as an extension of the bourgeois home in several of his pictures painted at Yerres showing family members within the secluded grounds of the estate. He was less interested in the urban gardens, however. He never recorded, for example, the gardens of the greenhouse annexed to the salon within the family home on rue de Miromesnil.[6] And while Caillebotte occasionally painted urban parks (see cat. 34), he was not drawn to the flower gardens of the capital. When he cast his eye onto the cityscape, he focused first on the streets and apartment houses (see cat. 59). A little later he painted views from the window (see cats. 68 and 69) and balcony (see cats. 65 and 66), looking out on the foliage of the treetops. Finally, the city disappeared from his work. The chronological and pictorial evolution of Caillebotte's art reflects his initial engagement with and ultimate withdrawal from the urban center. They image a progressive distancing from the city, from the pictures of the *flâneur* who is one with the city, to pictures in which the city is hidden by nature, to pictures of Petit Gennevilliers in which the city is totally absent. In place of the window onto Paris as the source

for a modern pictorial language, Caillebotte turned to nature, becoming, as Gustave Geffroy described him, "the wise amateur of the garden."[7]

At Petit Gennevilliers, Caillebotte combined horticulture with his artistic and decorative interests. Apart from a series of painted still lifes representing cut flowers put into vases, he conceived more innovative and daring pictures showing flower beds *(massifs)* of dahlias and chrysanthemums (see cat. 114, fig. 1), and exotic flowers cultivated in manmade greenhouses (see cat. 117). These densely painted and tightly focused works speak to his role as a creator, not mere arranger, of flowers. Shortly after he moved definitively to Petit Gennevil-

liers in 1888, Caillebotte built the greenhouse (fig. 1) featured in two of his most descriptive paintings of the house and surrounding grounds (see Berhaut 1994, no. 461, and ch. 5 intro., fig. 8). Like Monet—to whom he has frequently been compared—at Giverny, Caillebotte controlled the environment that he translated for his pictures and that, in turn, inspired his floral imagery. And like Monet, who conceived his pictures of the manmade water-lily pond and Japanese bridge he had built as a decorative ensemble, Caillebotte found in the environment of the greenhouse the "natural" motifs he would transform into decorative door panels for the doors of his dining room.[8]

G. G.

NOTES

1 Among the 565 works listed in Berhaut 1994, fifty-seven can be considered floral still lifes, including the decorative panels made for the dining room at Petit Gennevilliers. Unlike Caillebotte, who came only late to still-life painting, Cézanne, Monet, and Renoir exhibited floral still lifes at the Impressionist exhibitions. Cézanne exhibited in 1877 three *Nature mortes* and two *Etudes de fleurs*, including the *Flowers in a Rococo Vase* eventually purchased by Caillebotte (Appendix III, fig. 7); Monet exhibited *Corbeille de fleurs* in 1877 (no. 106; unidentified) and *Flowers* in 1879 (no. 142; possibly 1869, J. Paul Getty Museum, Malibu); Renoir exhibited *Flowers* in 1874 (no. 145; 1872, Museum of Fine Arts, Boston), and *Bouquet de fleurs des champs* and *Les Dalhias* in 1877 (nos. 201 and 204; unidentified).

2 See, for example, Lagrange 1860, p. 39: "The male genius has nothing to fear from feminine taste. Above all the great architectural conceptions, statuary, painting in its most elevated expression, the engraving of works that require a higher conception of the ideal—in a word, great art. Let women have the genres that [they] have preferred in all periods: the portrait, so amiable in the hands of Madame Lebrun; the pastel, in which Rosalba [Carriera] has shown herself to be the equal of La Tour; the miniature, which seems to call for the delicate fingers of a Madame de Mirbel or a Madame Herbelin; flowers those prodigies of

grace and freshness with which women alone can compete in freshness and grace."

3 See San Francisco 1986, nos. 73–80, p. 162.

4 See Dax 1876, p. 348: "M. Jacques François (a woman, I think) has exhibited a remarkable still life of grapes, pastries, boxes of figs, etc. It is a masterly piece without precedent. . . . The facture is broad and varied, quite ingenious and bold in a way that is altogether feminine."

5 One can also cite the *Portrait of Mme H.* (ch. 5 intro., fig. 6), in which the subject is literally counterbalanced by the large floor plant. None of Caillebotte's portraits of men bear witness to this association, unless one takes into consideration their relationship to the floral sofa (see cats. 77 and 80).

6 It is interesting to note that Caillebotte owned Monet's *Apartment Interior* (see Appendix III, fig. 23), in which the interior appears overwhelmed by the large jardinieres and plants that have been brought into the domestic environment.

7 Geffroy 1924, vol. 2, p. 290; cited in Berhaut 1994, p. 45.

8 As Marie Berhaut pointed out, Caillebotte's dining-room ensemble was never completely installed. Several of the decorative panels were given to Monet. See Berhaut 1994, p. 45.

113

Four Vases of Chrysanthemums

(Quatre Vases de chrysanthèmes)

1893

Oil on canvas

54 × 65 cm

Signed (posthumously?) lower right: *G. Caillebotte*

Berhaut 1978, no. 454; Berhaut 1994, no. 484

Josefowitz Collection

Principal Exhibitions
Paris 1894, no. 82; London 1954, no. 8.

One of the two still lifes in Caillebotte's art collection was a work by Monet, *Red Chrysanthemums*, shown at the 1882 Impressionist exhibition (see Appendix III, fig. 35). Monet, in part, seems to have motivated Caillebotte to return to still-life painting in the early 1890s. In this picture, one perceives an echo of certain compositional elements elaborated slightly earlier by Monet, notably in *Two Vases of Chrysanthemums* (1888; private collection, New York), shown in Paris at the important Monet-Rodin exhibition at Galerie Georges Petit and on two other occasions in 1889. Like Monet, Caillebotte chose to paint chrysanthemums—flowers associated with Japan—in tall, blue and white *japonisant* vases that were popular at the time. He likewise adopted a high viewpoint. But Caillebotte took this compositional strategy further. By tilting the tabletop more radically, so that it is almost parallel to the picture plane, he created an unan-

ticipated feeling of instability. The sense that the vases might slide off the table and into the viewer's space is reinforced by the radical cropping of the two small vases in the foreground. Thus here Caillebotte personalized Monet's formula by introducing pictorial tensions that appear in his earlier representations of domestic interiors, such as *Luncheon* (cat. 72). G. G.

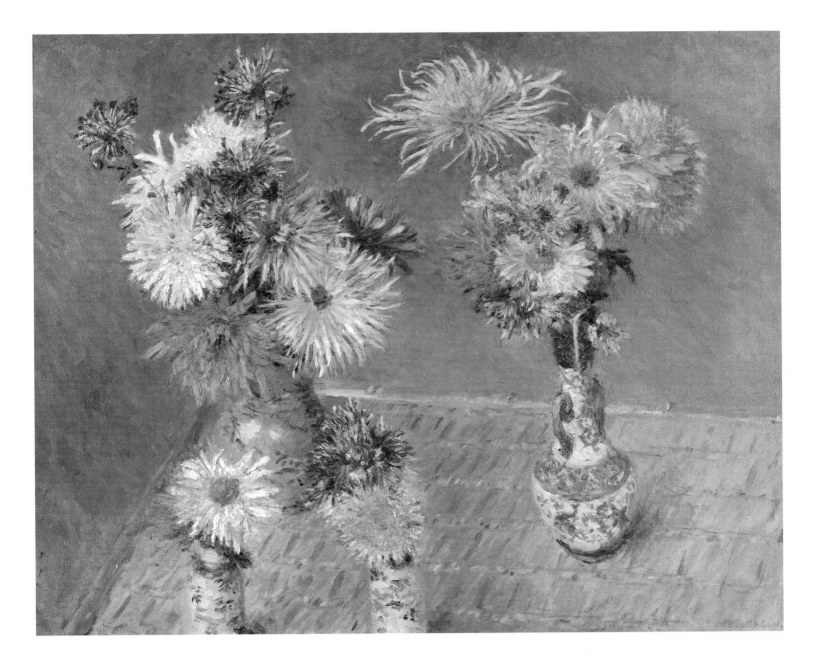

114

White and Yellow Chrysanthemums in the Garden at Petit Gennevilliers

(Chrysanthèmes blancs et jaunes, jardin du Petit Gennevilliers)

1893

Oil on canvas

73 × 60 cm

Berhaut 1978, no. 457; Berhaut 1994, no. 488

Musée Marmottan, Paris

Principal Exhibitions
Paris 1951, no. 87; Houston and Brooklyn 1976–77, no. 73.

Selected Bibliography
Daulte and Richebé 1971, no. 79; Berhaut 1978, p. 59; Daulte and Richebé 1981, no. 107; Delafond 1987, no. 96; Varnedoe 1987, no. 59; Balanda 1988, pp. 148–49; Wittmer 1990, pp. 242–43, and 303.

Caillebotte made a gift of this floral still life to Monet, thus eloquently expressing the admiration for his friend reflected in both his collecting (see Appendix III, fig. 35) and artistic practice (see cat. 113). This gift, moreover, reflects the written exchange between the two artists on the subject of horticulture. As has been observed,[1] their friendship at this time was as much based on their mutual passion for gardening as on their shared artistic enthusiasms. In letters written from his home in Giverny, Monet invited Caillebotte to come visit when his irises had bloomed, gave him names of exotic Japanese plants that he had received from Belgium, reported on an exposition of flowers he had seen in Paris, and requested information on purveyors of perennials, notably chrysanthemums, superb examples of which he had seen at the exposition.[2]

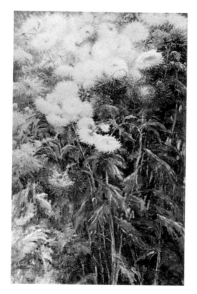

Figure 1. Gustave Caillebotte. *Clump of Chrysanthemums, Garden at Petit Gennevilliers*, 1893. Oil on canvas; 99.3 × 61.3 cm. Collection John C. Whitehead.

This exchange points to the two painters' current interest in "la décoration florale" of their respective rural properties. For both artists, the attraction to the decorative moved from the garden to the house, from nature into art. While Monet's decorative interior at Giverny is well-documented, we are unaware of how this shift manifested itself in the overall decor of Caillebotte's interior. All evidence suggests that *White and Yellow Chrysanthemums* was conceived in conjunction with the decorative project for the dining room at Petit Gennevilliers (see cats. 115 and 116). The composition makes the affiliation clear, for unlike *Four Vases of Chrysanthemums* (cat. 113), it is organized not as a decorative still life, but insistently as a decoration set in an indistinct and shallow pictorial space. In this unusual and airless composition, Caillebotte relied heavily on color to sustain visual interest. Unlike a similar composition also related to the dining-room panels (fig. 1), there is no division of blossoms at the top and stems below. There is no suggestion of a flower bed. Composed as if they were fragments from a larger visual field, the flowers take over the picture surface in a way that recalls the patterning of wallpaper rather than the figure-to-ground relationships in traditional easel painting. After receiving Caillebotte's gift, Monet responded in kind: In November 1896, he undertook four decorative panels featuring chrysanthemums (see cat. 117, fig. 2), a direct homage to the legacy of his friend, who had died two years earlier. G. G.

1 See Charles F. Stuckey and Robert Gordon, "Blossoms and Blunders: Monet and the State," *Art in America*, Jan.–Feb. 1979, p. 105.

2 See the two letters from Monet to Caillebotte, the first undated and the second dated only 24 May, both probably from around 1891, published in Berhaut 1994, pp. 278–79, letters 43 and 44. Berhaut cited other letters, as yet unpublished, in which Monet raised questions concerning gardening.

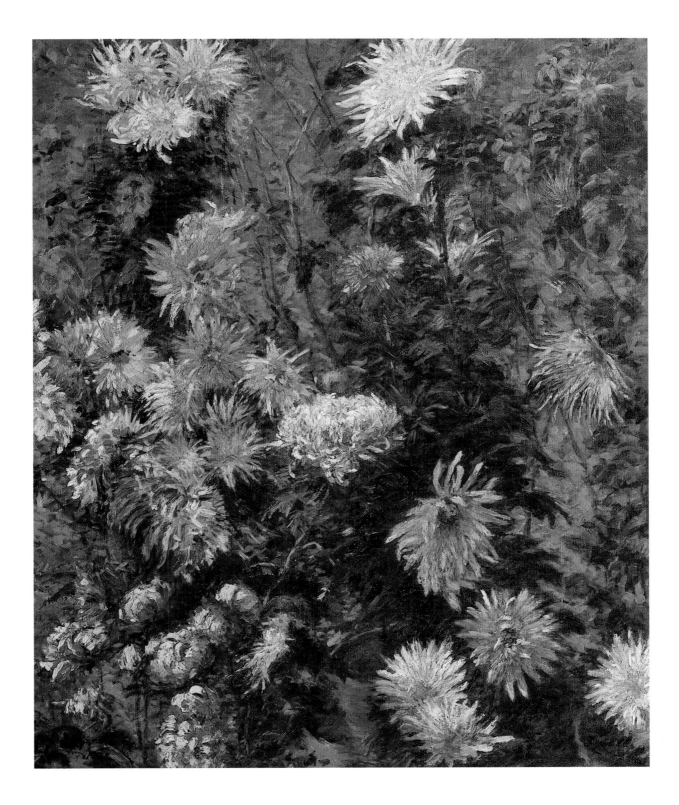

115
Nasturtiums
(Capucines)

1892

Oil on canvas

65 × 54 cm

Stamped lower left

Berhaut 1978, no. 430; Berhaut 1994, no. 452

Private collection

Principal Exhibitions
Brunoy 1987, no. 28.

The many photographs of Caillebotte's garden at Petit Gennevilliers reveal that the estate was made up of extensive ornamental and kitchen gardens, a greenhouse for the cultivation of orchids and other tender plants, and finally, more informally planted shrubs and flower beds, such as the nasturtiums pictured here. The subject as well of a larger, more tightly painted work (cat. 116), nasturtiums are both ornamental and practical, since they can be used as a garnish for salads. Perennial and self-seeding, these velvety reddish-orange blossoms on long stems grow with wild abandon—a characteristic that Caillebotte exploited in the two paintings. In both, the blossoms erupt from meandering stems, appearing to float across the entire picture surface. Indeed, the indistinct background, especially in this sketchier (and possibly unfinished) version, evokes an aqueous surround that looks forward to the water-lily canvases Monet would begin painting ten years later as a decorative ensemble. That Caillebotte conceived this and the larger canvas of nasturtiums as decorative panels for his dining room at Petit Gennevilliers further underscores the two artists' similar aesthetic and horticultural interests. G. G.

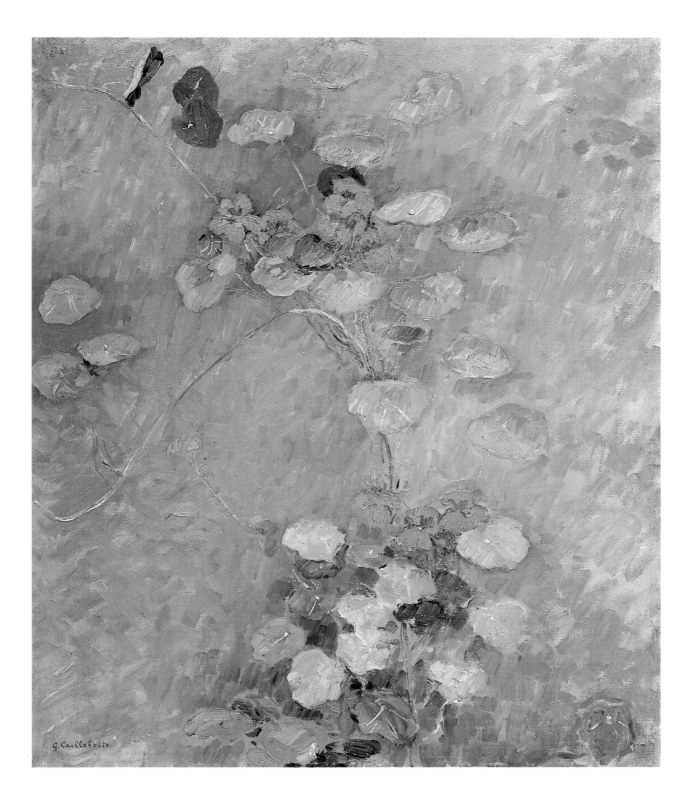

116
Nasturtiums
(Capucines)

1892

Oil on canvas

105 × 75 cm

Berhaut 1978, no. 432; Berhaut 1994, no. 453

Josefowitz Collection

Shown in Chicago only

Like the smaller work of the same subject, which Caillebotte also painted with the intention of decorating his dining room (cat. 115), the spatial context for these intertwining nasturtiums seems dictated by decorative concerns. The vertical format reinforces the plants' upward movement, although nasturtiums, with their long spindly stems, are creeping, not climbing, plants.[1] In this work especially, Caillebotte cut off the petals and foliage at the picture edges, suggesting that this is but a fragment of a larger, murallike painting. One can imagine this panel, paired with a similar composition, inserted into the upper portions of the door paneling, like the canvases of hanging orchids known to us through Martial Caillebotte's photographs of the dining-room doors (see cat. 117, fig. 1). In contrast to the images of exotic orchids cultivated within the *serre chaude*, or hothouse, the canvases of nasturtiums were intended to evoke the less formal flower beds of dahlias, roses, chrysanthemums, sunflowers, poppies, irises, and hyacinths that Caillebotte planted to border his garden paths, house, and studio. The compositional strategy Caillebotte adopted in this and the smaller *Nasturtiums* brings to mind the asymmetrical and airy patterns of Japanese prints. They look forward as well to the plant motifs and arabesque lines associated with the nascent Art Nouveau movement. G. G.

1 Nasturtiums can be seen extending horizontally across the garden path in several of Monet's paintings of the Grand Allée at Giverny (see Wildenstein 1985, nos. 1627, 1650, and 1651).

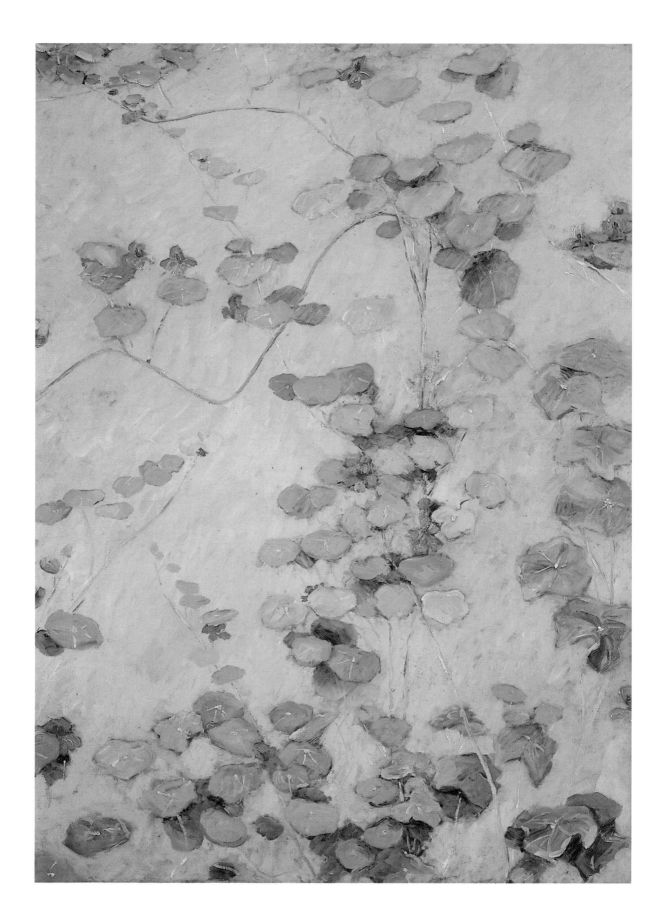

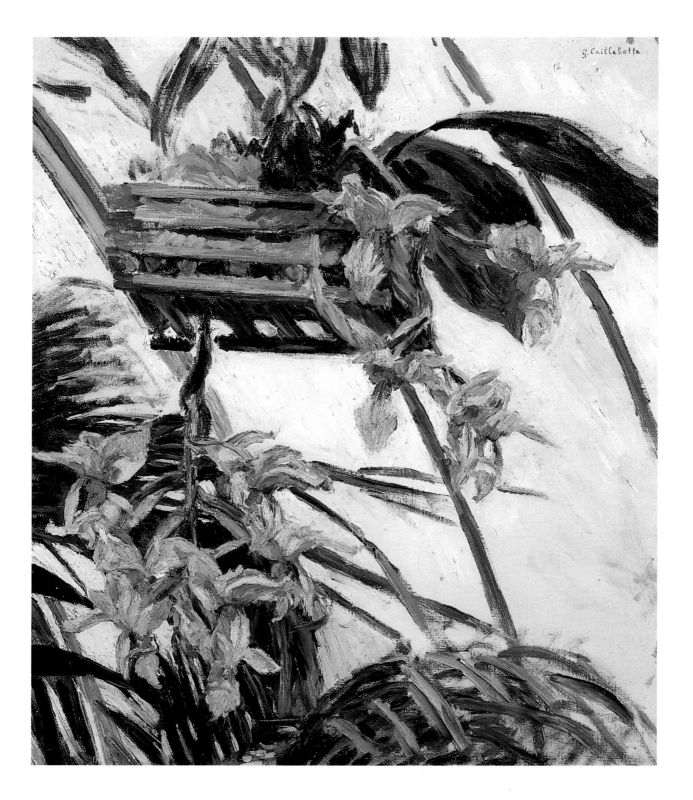

117
Orchids
(Orchidées)

1893
Oil on canvas
65 × 54 cm
Stamped upper right
Berhaut 1978, no. 463; Berhaut
1994, no. 490

Private collection

Selected Bibliography
Berhaut 1978, p. 59.

This small canvas is a study for the top portion of one of the vertical decorative door panels Caillebotte painted for his dining room at Petit Gennevilliers (fig. 1). In characteristic fashion, Caillebotte developed a highly finished fragment as part of his conceptualization of the final and larger composition. Unlike his variants and studies for the monumental *Pont de l'Europe* (cats. 30 and 31), *Paris Street; Rainy Day* (cat. 36), and what could be considered a study for *Nasturtiums* (cat. 114), Caillebotte's study of orchids is less recognizable than the final image. Indeed, the hanging basket of orchids in this smaller version resembles a flowering cart on a ferris wheel. Only in the door panel is it clearly readable as a wooden basket for rooting orchids attached by wires to the steel armature hovering above the other plants of the greenhouse (see ch. 9 intro., fig. 1).[1] In this nearly square composition, Caillebotte focused on the curved lines of the steel armature, which traverse the composition, setting up a rhythm and direction (reading from top left to bottom right) echoed by the falling and drooping foliage. By using an opaque mauvish-white pigment to depict the sky through the glass exterior, Caillebotte negated conventional figure-to-ground relationships in order to further emphasize the decorative (or two-dimensional) aspect of this small but powerful work.

The canvases Caillebotte intended to insert into the door paneling for the dining room at Petit Gennevilliers are similar to the floral still lifes on canvas that Monet painted between 1882 and 1885 as door-panel decorations for the dealer Paul Durand-Ruel (see fig. 2). But whereas Monet's paintings comprise a series of discrete still lifes representing flowers in vases, the decorative elements created by Caillebotte are more radically conceived as panoramic flowerscapes growing within the greenhouse. And whereas Monet's panels could be removed and sold as separate paintings regardless of their original context, those by Caillebotte (see Berhaut 1994, nos. 493–96 and 498–501) lose some of their meaning when detached from their function as decorative ensemble and artificial greenhouse interior. G. G.

1 See P. Larousse, *Grand Dictionnaire universel du XIXe siècle*, vol. 14, pt. 1 (Paris, 1866–79; repr. Paris, 1982), p. 612. The entry *"Serre"* ("Hothouse") recommends that the orchids be attached "with lead wire to pieces of wood to which they soon cling with their roots surrounded by moss."

Figure 1. Gustave Caillebotte. *Door Panels in the Dining Room at Petit Gennevilliers*, 1893. Oil on canvas, mounted on wood. Private collection.

Figure 2. Claude Monet (1840–1926). *Panels for Door D of the the Salon of Paul Durand-Ruel*, 1886. Oil on canvas, mounted on wood. Durand-Ruel Archives, Paris. The panels have since been separated from the door and dispersed in public and private collections.

A chronology of Caillebotte's sailing activities is listed under Appendix IV.

1848

19 Aug. Birth of Gustave Caillebotte in Paris (tenth arrondissement), at 160 (shortly to become 152), rue du Faubourg-Saint-Denis (Archives de Paris, Land Registry, D1P4, rue du Faubourg-Saint-Denis, 1852); he is baptized on 21 Aug. (family archives).

His father, Martial Caillebotte, born in Domfront in Normandy on 8 Apr. 1799, married his third wife on 14 Sept. 1847, in Quincy-Ségy, near Meaux (Seine-et-Marne). She was Céleste Daufresne, born in Lisieux on 30 Oct. 1819, the daughter of Frédéric Daufresne (1789–1873), a tax collector in that city.

Only one child from Martial, Sr.'s two previous marriages survived, from his union with Adèle Zoé Boissière: Alfred Caillebotte (1834–1896), who was ordained as a priest on 29 May 1858 (Bishopric of Paris, historical archives). His union with Céleste Daufresne will produce two more sons: René (27 Jan. 1851–1 Nov. 1876) and Martial (7 Apr. 1853–16 Jan. 1910).

Martial Caillebotte, Sr. was an "entrepreneur servicing military beds," in partnership with a certain Chambry in the maintenance and manufacture of beds and blankets for the army; its workshops, warehouse, laundry, and steam apparatus were located at 152, rue du Faubourg-Saint-Denis. The senior Caillebotte lived on the premises from 1844 onward, in a large residence separated from the workshops by a garden. All these buildings were demolished in 1868 as part of a development in which he was himself an investor, and as a result of which he became the owner of revenue-producing buildings completed in 1871 on the new rue des Deux-Gares, linking Gare du Nord and Gare de l'Est, also newly created, and rue d'Alsace (Archives de Paris, Land Registry, D1P4, rue du Faubourg-Saint-Denis, 1852, 1862, and 1876).

1852

17 Apr. For the sum of 365,000 francs, Martial Caillebotte, Sr. acquires the Champfleury farm, in Puisieux near Meaux (Seine-et-Marne), consisting of a main residence, farming and maintenance facilities, orchard, pleasure garden, and more than 150 hectares of woods, pastures, and cultivatable land (Poletnich 1878b).

1857

6 Oct. As had his half-brother, Alfred, before him, Gustave Caillebotte begins classes at Lycée Louis-le-Grand, boarding in Vanves (obituary of Alfred Caillebotte, *La Semaine religieuse de Paris*, 30 May 1896; Berhaut 1994, p. 13 n. 12).

1860

26 Apr. Gustave Caillebotte takes his first communion (family archives).

12 May. Martial Caillebotte, Sr. acquires a country property at Yerres—or "Yères," as it was then spelled—in Seine-et-Oise for 136,000 francs. This property, which he purchases furnished, boasts an extensive park of more than eleven hectares bordering the river, with various outbuildings, garden pavilions, and greenhouses, etc. The main residence features: on the ground floor, a vestibule, dining room, salon, small salon, billiard room, office, and various service facilities; on the two upper floors, a library and eighteen bedrooms (see Poletnich 1878b).

1861

Martial Caillebotte, Sr. has a house erected on the Yerres property (Land Registry, Yerres Township, OW 339).

14 Aug. The senior Caillebotte, judge on the Business Tribunal of the Seine, is named Chevalier de la Légion d'honneur (Archives Nationales, LH 406039).

1862

3 Oct. Gustave Caillebotte leaves Lycée Louis-le-Grand, Paris, where he is in the class designated 3ᵉ B (written communication from Mme Arribillaga, Archives of Lycée Louis-le-Grand); it is not known whether he finishes his secondary-school studies.

1863

Martial Caillebotte, Sr. has erected in the park of the Yerres property a pavilion, or lodge, and a chapel (Land Registry, Yerres Township, OW 339; sermon delivered by Abbé Alfred Caillebotte at the marriage of his brother Martial in 1887, family archives).

1864

4 Aug. The chapel at Yerres is consecrated and dedicated to Notre-Dame-du-Lierre by "Alfred Duquesnay, vicar of the Saint-Laurent parish in Paris, assisted by Abbé Augustin Beaumont, vicar of the Yerres parish and of Sainte-Elisabeth in Paris, and Abbé Alfred Caillebotte, pastor of the parish of Saint-Jean-Baptiste de Belleville, in the presence of the family of Martial Caillebotte and the adjunct mayor of Yerres, M. Thomas" (Bishopric of Versailles, Historical Archives).

1866

15 Jan. Martial Caillebotte, Sr. purchases from the City of Paris, represented by Baron Haussmann, for 148,780 francs (210 francs per square meter), a lot in the eighth arrondissement, at the corner of rue de Miromesnil (or "Miroménil," as it was then spelled; no. 77), and rue de Lisbonne (no. 13), with an obligation to build on it.

Nov. The new family home on this property is completed. A Land Registry document estimates its value, including the land, at close to 350,000 francs (Archives de Paris, Land Registry, D1P4, rue de Miromesnil, 1876) and describes it as "erected over a basement [*"caves de rez-de-chaussée"*], [containing a hot-water heater servicing the entire building], two full stories and a third under eaves, with a series of five windows across on rue de Miromesnil and seven on rue de Lisbonne." An addition with large bay windows, housing a spacious artist's studio and accessed by a separate stairway, will be built in 1874 to the building's right, on rue de Lisbonne, on the third floor above the carriage entrance. The ground floor proper is occupied by servants and service facilities; the next floor, reached by a stone stairway that leads to an antechamber, comprises a conservatory (above the carriage entrance), workroom, small corner salon, large salon, dining room, office, and billiard room; the third floor contains six bedrooms (each with its own dressing room) and a bathroom with heater; the fourth floor features six servants' bedrooms and various storage areas; in the courtyard is a carriage house and stables for three vehicles. In addition, "the entire house [is] equipped with running water, gas, and electric bells." The building still stands, but in 1898 two stories will be added and the whole substantially remodeled (Archives de Paris, Land Registry, VO11, rue de Miromesnil; Poletnich 1879). Martial

Caillebotte, Sr. also erects a rental building (with a shop, occupied by a tripe-seller and butcher, and apartments) at 15, rue de Lisbonne (and 8, rue Corvetto); this structure will be left to Alfred Caillebotte by the senior Caillebottes, but he never lives there.

24 June. Martial Caillebotte, Jr., Gustave's younger brother, takes his first communion, in Yerres (Bishopric of Versailles, Historical Archives).

1867

3 Feb. Martial Caillebotte, Sr. is appointed for a two-year term to the Yerres relief committee (Wittmer 1990, p. 311 n. 3).

1868

9 July. The bishop of Versailles authorizes Abbé Beaumont, vicar of Yerres, to celebrate the inaugural mass that Sunday in the greenhouse of Martial Caillebotte's property, transformed into a summer chapel (Bishopric of Versailles, Historical Archives).

1 Aug. Gustave Caillebotte receives a bachelor's diploma in law. He is called up for military service. Having drawn a "bad number," he is able to pay for a replacement, thanks to his father, who had purchased insurance for this purpose (family archives). He continues his law studies in Paris.

1870

6 July. Gustave Caillebotte is licensed to practice law (diploma, family archives).

26 July. He is drafted into the Garde Nationale Mobile de la Seine (eighth company, seventh battalion) to fight in the Franco-Prussian war. He is described as follows: 1.67 meters tall, with auburn hair and eyebrows, and gray eyes (livret militaire, family archives).

1871

7 Mar. Gustave Caillebotte is demobilized (livret militaire, family archives).

At some point after the war—the precise dates are unknown—he travels to Sweden and Norway with his half-brother, Alfred, and his brother René (obituary of Alfred Caillebotte, La Semaine religieuse de Paris, 30 May 1896).

1872

Presumably Gustave Caillebotte travels to Italy with his father (family tradition, reported in Berhaut 1994, p. 5; see cat. 1). The painter Giuseppe De Nittis, who then divides his time between Paris, London, and Italy, refers to Caillebotte as the "godfather" of his son Jacques, born in Resina, near Naples, on 19 July, but there is no documentary confirmation of his having assumed this role (De Nittis 1990, p. 138). On the basis of a letter from the painter and engraver Marcellin Desboutin to Mme De Nittis, dated 28 Oct., which alludes to another from Caillebotte to the painter Jean Béraud, it has been surmised that De Nittis will also sojourn near Naples in the fall of 1875. But the phrasing of the letter is somewhat ambiguous.

Caillebotte frequents the studio of painter Léon Bonnat at 47, rue Lancrey with the intention of qualifying for acceptance into the Ecole des Beaux-Arts, Paris.

1873

Jan. Gustave Caillebotte does a stint of military service in conformity with obligations imposed by the new government (livret militaire, family archives).

Feb. He passes the entry examination for the Ecole des Beaux-Arts under Bonnat's sponsorship (Archives Nationales, AJ 52 254, no. 2202); he is one of very few of Bonnat's students accepted by the Ecole. The titular painting professors at the time are Cabanel, Gérôme, and Pils; Yvon teaches mainly drawing. Bonnat, then still young, does only occasional service as a member of competition juries.

18 Mar. Caillebotte is ranked forty-second (of eighty students) in the competition to determine placement in Yvon's painting class (Archives Nationales, AJ 52 77); this is the only reference to him in the school archives, which suggests that he did not spend much time there.

1874

15 Apr.–15 May. Gustave Caillebotte does not take part in the first Impressionist exhibition. But it is likely that he already knows, among the exhibitors, Henri Rouart, a neighbor (at 34, rue de Lisbonne), whose family background is comparable to his own, and with whom he has friends in common; and perhaps Edgar Degas, Rouart's friend, of whom Camille Pissarro would later write: "Remember that he brought us Mlle Cassat [sic], Forain, and you" (letter to Caillebotte, dated Paris, 27 Jan. 1881, in Berhaut 1994, p. 276, letter 24). It should also be noted that Bonnat and Degas know each other.

24 Dec. Death at age seventy-five of Martial Caillebotte, Sr. at 77, rue de Miromesnil; he is survived by his widow, Céleste Daufresne, and four sons: Alfred, priest, administrator of the church of Saint-Georges-de-La-Villette; Gustave, "artiste peintre" (the first time he is documented with this designation); René, without profession, residing with Gustave at the rue de Miromesnil house; and Martial, a student at the Paris Conservatoire and a member of the army reserve corps, fifty-fourth line regiment, then garrisoned in Bordeaux. The senior Caillebotte's estate, consisting of buildings he had acquired, rental leases, and various monies owed him, comes to more than two million francs, a considerable sum at the time. His widow and children (except for Alfred) continue to reside at the rue de Miromesnil house and spend their summers in Yerres.

1875

Apr. Gustave Caillebotte's entry is refused by the Salon jury. He frequents the circle of De Nittis, who had exhibited with the Impressionists in 1874, and who is close to Béraud (another Bonnat student), Degas, Desboutin, Manet, etc.: "Of all those I saw at your house, I have scarcely had occasion to see any of them again except Caillebotte the painter, unhappy because of the Salon jury's refusal of his painting" (letter from Desboutin in Paris to De Nittis, dated 13 Apr., in Pittaluga and Piceni 1963, pp. 354–55), an impression corroborated by De Nittis: "Invite Caillebotte Gustave so he'll learn a

real lesson from the situation, so he'll make art and tell the jury to get lost, for the future is ours" (letter to Mme De Nittis, dated 17 Apr., in ibid., pp. 283–84).

30 May. Installation of Abbé Alfred Caillebotte as first vicar of the new church of Saint-Georges-de-La-Villette, in the low-income quarter of Buttes-Chaumont. A window is dedicated by the "Caillebotte brothers" and a bell is christened by Mme Caillebotte (La Semaine religieuse de Paris, 23 May and 27 June 1885).

Fall. Presumed sojourn with De Nittis in Portici, near Naples (see 1872).

1876

Gustave Caillebotte is still living at 77, rue de Miromesnil.

5 Feb. "M. Caillebotte, We thought it would be good to repeat the group effort to organize a private exhibition. To this effect, we have reached an agreement with M. Durand-Ruel, who is renting us two rooms [sic], including the largest one. We would be very happy to see you associated with us in this new undertaking. Cost: 120 francs per exhibitor payable on or before 25 February at the premises of M. Durand-Ruel. Opening on 20 March. Length: one month. Maximum number of works: five. Please respond promptly to one of us if you are with us" (letter from Renoir and Rouart to Caillebotte, dated 5 Feb., in Berhaut 1994, p. 273, letter 1).

23–24 and 26 Feb. Monet enters the following sales into his account book: "M. Caillebotte / Figures en plein air 200 F / M. Caillebotte peintre / Les Dahlias 600 F / Pochade Argenteuil 200 F" (Musée Marmottan, Paris, MM 5160 [1] fol. 10).

Apr. Second Impressionist exhibition, organized by the painters on the premises of Durand-Ruel, in three rooms at 11, rue Le Peletier. The participants are Béliard, Bureau, Caillebotte, Cals, Degas, Desboutin, François, Legros, Levert, Lepic, J. B. Millet, Monet, Morisot, Ottin, Jr., Pissarro, Renoir, Rouart, Sisley, and Tillot. Caillebotte exhibits: "17 Raboteurs de parquets. 18 Raboteurs de parquets. 19 Jeune Homme jouant du piano. 20 Jeune Homme à sa fenêtre. 21 Déjeûner. 22 Jardin. 23 Jardin. 24 Après Déjeûner."

1 June. Degas writes to the picture dealer Charles Deschamps, a London associate of Durand-Ruel: "Have you received the Caillebottes? Tell me what impression they make; he'd like to know" (Godfroy-Durand-Ruel 1989, p. 436).

July. Monet receives several advances from Caillebotte, 480 francs in all (Monet's account book, fol. 11).

9 Aug. Monet receives still more money from Caillebotte, 330 francs in all (Monet's account book, fol. 11v).

31 Aug. In his account book (fol. 11), Monet consigns to René Caillebotte "Paysage d'hiver / 200 F." De Nittis also purchases two paintings from him that day (ibid.). The word "René" is rather difficult to decipher, but this reading is more satisfactory than "remis" ("delivered" or "remitted," another possibility). De Nittis subsequently notes that it was on the suggestion of Caillebotte that he

acquired four paintings by Monet (De Nittis 1990, p. 175).

1–28 Sept. Caillebotte completes a period of military service with the seventy-fourth line regiment (*livret militaire*, family archives).

1 Nov. The artist's younger brother René Caillebotte dies at age twenty-six.

3 Nov. Caillebotte, aged twenty-eight, drafts his first will:

Je désire qu'il soit pris sur ma succession la somme nécessaire pour faire en 1878, dans les meilleurs conditions possibles, l'exposition des peintres dits intransigeants ou impressionistes. Il m'est assez difficile d'evaluer aujourd'hui cette somme; elle peut s'élever à 30, 40 mille francs ou même plus. Les peintres qui figureront dans cette exposition sont: Degas, Monet, Pissarro, Renoir, Cézanne, Sisley, Mlle Morizot [*sic*]. Je nomme ceux-là sans exclure les autres.

Je donne à l'Etat les tableaux que je possède, seulement, comme je veux que ce don soit accepté et le soit de telle façon que ces tableaux n'aillent ni dans un grenier ni dans un musée de province mais bien au Luxembourg et plus tard au Louvre, il est nécessaire qu'il s'écoule un certain temps avant l'exécution de cette clause jusqu'à ce que le public, je ne dis pas comprenne mais admette cette peinture. Ce temps peut être de 20 ans ou plus; en attendant, mon frère Martial, et à son défaut un autre des mes héritiers, les conservera.

Je prie Renoir d'être mon exécuteur testamentaire et du vouloir bien accepter un tableau qu'il choisira; mes héritiers insisteront pour qu'il en prenne un important.

Fait en double à Paris le trois novembre mille huit soixante seize" (Poletnich 1894b). For the complete text in French and English of this and subsequent wills drafted by Caillebotte, see Varnedoe 1987, p. 197.

26 Nov. Caillebotte agrees to lend a work by Pissarro as well as one by himself to an exhibition in Paris, and proposes to visit Pissarro in Pontoise (letter to Pissarro, in Berhaut 1994, p. 273, letter 2).

1 Dec. Monet receives 150 francs on account from Caillebotte, who also acquires his *"Intérieur (tableau bleu),"* now known as *Apartment Interior* (see Appendix III, fig. 23); at the end of the month, he sends Monet another advance of 700 francs (Monet account book, fols. 12v, 13r and v).

1877

Apr. Gustave Caillebotte is still living at 77, rue de Miromesnil (catalogue of the third Impressionist exhibition).

In 1877 or 1878, Gustave and Martial Caillebotte begin to assemble a joint stamp collection, a project on which they collaborate until Martial's marriage in 1887; in the process, they become first-rank philatelists (*The Philatelic Record* 12, 244 [Dec.1890], pp. 203–204; Beech 1993). At about the same time, the two brothers take up boating,

which they also pursue together (see Appendix IV).

Jan. Caillebotte makes two 100-franc advances to Monet (Monet account book, fol. 12v).

Around Jan., Ludovic Piette writes to Pissarro: "I was pleased to learn that Monsieur Caillebotte bought two pictures from you, which gave you some time to pull things together" (J. Bailly-Herzberg, ed., *Mon Cher Pissarro: Lettres de Ludovic Piette à Camille Pissarro* [Paris, 1985], p. 135).

17 Jan. Monet announces to his patron the publisher Georges Charpentier that he has moved to 17, rue Moncey, close to Gare Saint-Lazare (Wildenstein 1974, p. 431, letter 101). Caillebotte pays the rent for this two-room apartment until July 1878 (Archives de Paris, Land Registry, D1P4, rue Moncey, 1876; Monet account book).

24 Jan. Caillebotte purchases *Louveciennes* from Pissarro (see Appendix III, fig. 37); he writes of difficulties he is encountering in organizing the group exhibition, but offers assurances that it will take place (letter to Pissarro, in Berhaut 1994, p. 273, letter 3).

Mar. Caillebotte advances 430 francs to Monet (Monet account book, fol. 13).

Apr. Caillebotte advances Monet another 250 francs (Monet account book, fol. 13).

The third Impressionist exhibition is held in a large apartment on the second floor of 6, rue Le Peletier; the exhibitors are Caillebotte, Cals, Cézanne, Cordey, Degas, Guillaumin, Jacques-François, Lamy, Levert, Maureau, Monet, Morisot, Piette, Pissarro, Renoir, Rouart, Sisley, and Tillot. Caillebotte exhibits: "1 *Rue de Paris; Temps de pluie.* 2 *Le Pont de l'Europe.* 3 *Portraits à la campagne.* 4 *Portrait de Mme C.* 5 *Portraits.* 6 *Peintres en bâtiments.*"

And he lends the following works: "37 Degas *Femmes devant un café, le soir.* . . . 45 Degas *Femme sortant du bain.* . . . 47 Degas *Choristes.* . . . 115 Monet *Intérieur d'appartement.* . . . 163 Pissarro *Côte Saint-Denis à Pontoise.* . . . 180 Pissarro *La Moisson.* . . . 181 Pissarro *Allée sous-bois, à Montfoucault.* . . . 185 Renoir *La Balançoire.* . . . "

Early Apr. A dinner at Café Riche (Bignon) brings together twenty Impressionists, from "M. Caillebotte to Tillot, without forgetting MM. Piette, Monet, Pissarro, Lamy, etc. Only two admirers—but pure ones—had slipped among you, and M. Emile Zola, an Impressionist of the pen, presided" (Un Vieux Parisien, "L'Indiscret, le dîner des impressionnistes," *L'Evénement,* 8 Apr.).

May. Monet sells to Caillebotte an *"esquisse Tuileries"* (Monet account book, fol. 13v).

28 May. Along with Pissarro, Renoir, and Sisley, Caillebotte participates in an auction of paintings at Hôtel Drouot, Paris, organized by the artists themselves (commissaire-priseur Me Tual, expert A. Legrand; see Bodelsen 1968, p. 336). The works by him are: "1 *Raboteurs* [*sic*] *de parquets.* 2 *Rabotteurs de parquets.* 3 *Peintres en bâtiments.* 4 *Paysage. Parc Monceaux* [*sic*]."

According to Gustave Geffroy (1922, p. 93), *Floor-Scrapers* (cat. 3) is sold for 655 francs and *House-Painters* (cat. 15) for 301 francs. The purchaser must be Caillebotte himself.

for the paintings remain in his studio at his death.

June. Caillebotte advances Monet 140 francs (Monet account book, fol. 14v).

18 July. Caillebotte borrows 30,000 francs at an annual interest rate of five percent (Poletnich 1894b).

10 Aug. A ten-year partnership is established between Alphonse Legrand and Renoir, with Caillebotte as a limited partner, for the production and sale of white and tinted MacLean cement. This partnership—its offices are at 22 *bis,* rue Laffitte—between a picture dealer associated with Durand-Ruel and the two artists, designed to exploit a material suitable for artistic use, is dissolved soon after, on 1 Apr. 1878 (Archives de Paris, D1P4, rue Laffitte, 1876; codicil to the will of Gustave Caillebotte, 1883; according to G. Rivière 1921, p. 35, Caillebotte's investment in the venture is 30,000 francs).

31 Aug. Caillebotte advances Monet 50 francs (Monet account book, fol. 15).

Sept. Caillebotte advances Monet 200 francs (Monet account book, fol. 15v).

Oct. Caillebotte advances Monet 110 francs and purchases a frame from him for 60 francs (Monet account book, fol. 16).

Dec. Monet receives 20 francs from Caillebotte (Monet account book, fol. 17).

1878

Gustave Caillebotte still resides at 77, rue de Miromesnil. The painting by Jean Béraud entitled *A Ball* exhibited at the 1878 Salon and sometimes called, on the basis of an old label, *A Soirée in the Caillebotte Mansion* (see ch. 5 intro., fig. 1) in fact has nothing to do with the family and corresponds only in part to descriptions of the house in the estate inventory drawn up after the death of the artist's mother in Nov. 1878 (Poletnich 1878a).

Jan. Caillebotte gives Monet 5 francs on the 3rd, 100 francs on the 14th, and 150 francs at the end of the month (Monet account book, fol. 18).

28 Jan. Caillebotte sends 750 francs to Pissarro, with apologies for being unable at that time to provide him with a monthly stipend of 50 francs (Berhaut 1994, p. 273, letter 8).

After having strongly endorsed the idea of mounting another Impressionist exhibition to open on 1 June, to coincide with the inaugural festivities of the Paris Universal Exhibition, Caillebotte withdraws his support (letters from Pissarro to Caillebotte, undated, in Bailly-Herzberg 1980, p. 109, letter 53, and p. 111, letter 55; and letter from Pissarro to Murer, undated, in ibid., p. 116, letter 60). Caillebotte does not exhibit at the Universal Exhibition, and his absence is noted by Camille Lemonnier, *L'Artiste* (Brussels), 31 Aug. 1878; in any event, he visits the exhibit (above-cited letter from Pissarro to Murer), perhaps with his mother, who purchases vases which her sons will pay for after her death (Poletnich 1878b).

3 and 12 Mar., 26 May, and 24 June. Lands adjacent to the Champfleury farm are sold by the widowed Mme Caillebotte and Alfred, Gustave, and Martial Caillebotte for more

than 250,000 francs, a portion of which is to be paid over the coming years (Poletnich 1878b).

10 Mar. Monet sells Caillebotte "2 *esquisses (chemin de fer)* 300 F / *panneau décoratif* 600 F / *Gare Saint-Lazare* 685 F" (Monet account book, fol. 19), but account is taken of previously received advances and Monet nets only the difference, which is to be 50 francs each; he also receives two advances, of 10 francs each, on 10 and 22 Mar.

16 Mar. Publication of the first issue of the weekly *Le Yacht*, "Journal of Sailing for artistic, literary, and scientific pleasure, appearing on Saturday"; it is likely that the two Caillebotte brothers have something to do with the resurrection of this defunct 1860s periodical (at his death, Gustave Caillebotte will still own stock in it; see also the obituary of Martial Caillebotte in *Le Yacht* [29 Jan. 1910]). Their boating exploits are duly recorded in its pages beginning in 1879. Not once, it would seem, is Gustave mentioned as a painter, even though the publication offers regular coverage of official artistic events (see Appendix IV).

Apr. and May. Monet receives two payments of 40 francs each from Caillebotte (Monet account book, fols. 20 and 21).

5 and 6 June. After the bankruptcy of Parisian businessman Ernest Hoschedé, a sale of his collection proves disastrous for the Impressionists. Their works go for paltry sums; no works by Caillebotte are included, and he buys nothing. Hoschedé owned a property in Montgeron (very close to Yerres), where he had entertained, among others, Manet and Monet; Caillebotte probably knows him.

July. Caillebotte pays for Monet's move from rue Moncey and gives him 100 francs (Monet account book, fol. 22v).

20 Oct. Death, at age fifty-eight, of Caillebotte's mother, Celeste Daufresne, *rentière* ("woman of means"), at 77, rue de Miromesnil; she is survived by Gustave Caillebotte, *artiste peintre*, and Martial Caillebotte, *propriétaire* ("property owner"), both of whom continue to reside at 77, rue de Miromesnil.

13 Nov. From L'Estaque, Cézanne sends Caillebotte a letter of condolence upon the death of his mother, informing him that he had left Paris about nine months earlier (Berhaut 1994, p. 274, letter 13).

9 Dec. Monet writes that he is now living in Paris in a two-room apartment, on the ground floor and to the left, at 20, rue Vintimille (letter to Georges Charpentier, in Wildenstein 1974, letter 142). The rent is paid by Caillebotte (Archives de Paris, Land Registry, D1P4, rue Vintimille, 1876, where it is specified that the premises are being used as an artist's studio by Caillebotte) from Oct. 1878 until the fall of 1881 (see Monet's account book; and a letter from Monet to Durand-Ruel, dated 30 Oct. 1881, in Wildenstein 1974, letter 225).

11 Dec. A distribution is made to the surviving Caillebotte brothers from the estates of Martial Caillebotte, Sr., René Caillebotte, and Mme Caillebotte. Gustave's portion is valued at more than 700,000 francs and consists of monies owed, annuities, stocks, and real estate. Rental income alone will net him

about 30,000 francs annually until his death, the total sum sufficient to support an affluent lifestyle. The brothers retain joint ownership of the residence on rue de Miromesnil and the Yerres property, along with their furnishings, as well as of the Champfleury farm.

24 Dec. Received by Mᵉ Le Bariquand, bailiff, from M. Caillebotte, 15 francs to settle the lawsuit Courcelles-Monet, in accordance with a decision handed down on 16 Jan. 1867 (family archives); Caillebotte had previously made several payments against this old debt of Monet's, in 1877 and 1878 (Monet account book).

1879

Caillebotte henceforth resides at 31, boulevard Haussmann (catalogue of the fourth Impressionist exhibition, Apr.). As the Land Registry records for this address cannot be consulted, we have few details about the apartment with balcony occupied by Gustave and his brother Martial on the penultimate floor of this building, situated at the corner of boulevard Haussmann and rue Gluck (the upper floors of the building survive much as they were when the building became the headquarters of the Société Générale in 1909; see J. F. Pinchon in Paris, Musée d'Orsay, *Les Palais d'argent*, exh. cat. [1992]).

The Yerres property is sold (Berhaut 1994, p. 9). The precise date of this transaction is unknown: according to the local Land Registry, in which two- or three-year delays in recording such events are common, the departure of the Caillebottes from the property and the assumption of possession by the new owner, Pierre Ferdinand Dubois, takes place in 1881 (Land Registry, Yerres township, OW 339).

Early in the year (?). Caillebotte informs the critic and collector Théodore Duret that he is leaving for London the following day (Berhaut 1994, p. 273, letter 4). This trip is not otherwise documented; in any event, a postscript not published by Berhaut to the above-cited letter (Université de Paris, Bibliothèque d'Art et d'Archéologie, fonds Doucet), which Berhaut dated "1877(?)" and which arranges a meeting between the two parties, reads "4 o'clock rue Vintimille 20," indicating a date no earlier than late 1878 or early 1879, when the apartment on rue Vintimille is rented. But this trip could have taken place even later, for we know that Caillebotte rented two successive apartments at this address, which are also used by Monet until Apr. 1882 (see under this date, Archives de Paris, Land Registry, D1P4, rue Vintimille, 1876).

Caillebotte, having returned from London, summons Pissarro to dinner with Degas, Manet, Monet, Renoir, and Sisley to discuss a projected exhibition (letter to Pissarro, in Berhaut 1994, p. 273, letter 5, generally dated 1877 but redated here on the basis of the date of the only documented London trip; it is possible that Caillebotte made several trips to London).

Jan. Monet sells Caillebotte an "*Effet de neige*" for 200 francs and receives advances from him in Feb. and Mar. of 100 francs each (Monet account book, fol. 25r and v).

3 Feb. Alfred, Gustave, and Martial Caillebotte instruct their notary, Mᵉ Poletnich, to sell the residence at 77, rue de Miromesnil, fixing 11 Mar. as the date for the auction and 500,000 francs as the opening bid (Poletnich 1879); it is in fact sold, for 450,000 francs and effective 3 June, to Jean Baptiste Gravier (Archives de Paris, Land Registry).

19 Feb. The three Caillebotte brothers make an irrevocable donation *inter vivos* to their uncle and aunt M. and Mme Charles Caillebotte in the form of a 3,000-franc life-annuity (Poletnich 1894b).

Caillebotte is actively involved in preparations for the upcoming Impressionist exhibition, notably in assuring Monet's participation:

So try not to get discouraged like this. Since you're not working, come to Paris, you have time to collect all the possible pictures. I'll take care of M. de Bellio [a collector]. If there isn't a frame on the *Drapeaux*, I'll take care of it. I'll do everything to satisfy you. Send me a catalogue [a list of works] immediately, or rather send it to M. Portier [a dealer acting as the group's manager] at 54, rue Lepic. Include as many paintings as you can. I wager you'll have a superb exhibition. You're always the same. You get discouraged in a way that's frightening. . . . I'll spend the week running around for you if you wish . . . (letter from Caillebotte to Monet, undated, in Berhaut 1994, p. 273, letter 15).

10 Apr.–11 May. Fourth Impressionist exhibition at 28, avenue de l'Opéra; the participants are M. and Mme Bracquemond, Caillebotte, Cals, Cassatt, Degas, Forain, Lebourg, Monet, Pissarro, Piette (deceased), Rouart, Somm, Tillot, and Zandomeneghi. Cézanne, Renoir, and Sisley abstain. Caillebotte exhibits:

7 *Canotiers*. 8 *Partie de bateau*. 9 *Périssoires*. 10 *Périssoires*. 11 *Vue de toits, appartient à M. A. C.* 12 *Vue de toits (effet de neige), appartient à M. K.* 13 *Canotier ramenant sa périssoire*. 14 *Rue Halévy, vue d'un sixième étage, appartient à M. H.* 15 *Portrait de M. F.* 16 *Portrait de M. G.* 17 *Portrait de M. D.* 18 *Portrait de M. E. D.* 19 *Portrait de M. R.* 20 *Portrait de Mme C.* 21 *Portrait de Mme B.* 22 *Portrait de Mme H.* 23 *Pêche à la ligne*, 24 *Baigneurs*, 25 *Périssoires (panneaux décoratifs)*. 26 *Baigneurs (pastel), appartient à M. G. M.* 27 *Canotiers (pastel)*. 28 *Vallée de l'Yerres (pastel), appartient à M. E. M.* 29 *Potager (pastel)*. 30 *Rivière d'Yerres (pastel), appartient à M. K.* 31 *Prairie (pastel)*.

He also exhibits at least one canvas *hors catalogue*, which figures in contemporary caricatures (*Une Vache et son veau*). As a collector, he lends:

70 Degas *Chanteuse de café* (pastel). 143 Monet *Pommiers*. 144 Monet *Effet de neige à Vétheuil*. 181 Pissarro *L'Hermitage. Vue de ma fenêtre*. 182 Pissarro *Vue de l'Hermitage*.

183 Pissarro *Printemps. Pruniers en fleurs.*
184 Pissarro *Petit bois de peupliers en plein été.* 185 Pissarro *Planteurs de choux.* 186 Pissarro *Port-Marly.* 192 Pissarro *Soleil couchant (éventail).*

After 10 Apr. Caillebotte sends Monet the first reviews of the exhibition and asks him for a drawing for a newspaper on behalf of Duranty (letter to Monet, in Berhaut 1994, p. 274, letter 17).

17 Apr. He thanks the critic Montjoyeux (Jules Poignard, according to R. Pickvance in San Francisco 1986, p. 263 n. 54) for his favorable review of the Impressionists, but expresses regret that he did not mention "Miss Cassatt . . . [and] those absent this year, Cézanne, Renoir, Sisley, and Mlle Morizot [*sic*]" (letter to an unidentified critic, in Berhaut 1994, p. 275, letter 18).

Apr. Caillebotte sends Monet 2,500 francs and then 400 francs (Monet account book, fol. 25v).

1 May. Caillebotte confirms to Monet receipt of two canvases for the exhibition, further informing him that he had "almost" sold one of them to Cassatt (sale later recorded in Monet's account book, fol. 25v). He states that admission receipts from the exhibition are mounting (about 10,500 francs), adding that, "as for the public, [it is] always gay. One has a good time with us" (letter to Monet, in Berhaut 1994, p. 275, letter 19).

After 11 May. After having dismantled the exhibition and having overseen the return of Monet's canvases, Caillebotte draws up a final accounting: "Our profit comes to 439 francs 50 each. . . . There were a few more than 15,400 visitors. All told, that amounts to progress." At the official Salon, he admires Renoir's paintings (portraits, including *Madame Charpentier and Her Children*, [1878; The Metropolitan Museum of Art, New York]) and Manet's *Boating* (1874; The Metropolitan Museum of Art, New York]; letter to Monet, undated, in Berhaut 1994, p. 275, letter 20).

June. Monet sells Caillebotte a "*Vétheuil*" for 100 francs (Monet account book, fol. 25v) and receives 100 francs.

6–7 June. A painting by Caillebotte, *Une Rue de Paris vue d'un sixième étage (brouillard d'hiver)*, 50 x 60 cm, is included as number 60 in the catalogue of a sale at Hôtel Drouot, Paris, by the stockbroker and collector Ernest May to benefit the widow and daughter of the painter Louis Mouchet.

17 June. Caillebotte agrees to send 1,000 francs (instead of the 400 francs Pissarro requested) to Pissarro within eight days; he announces his departure for the country and adds that his desire to work is being thwarted by bad weather (letters to Pissarro, dated 17 June 1879 and "Thursday morning," in Berhaut 1994, p. 275, letters 21 and 22).

July. He advances Monet 1,000 francs (Monet account book, fol. 26).

July. Reference in *L'Artiste* to Renoir's *Ball at the Moulin de la Galette* (see Appendix III, fig. 49) "acquired by M. Caillebotte, who would not exchange it for Bouguereau's *Venus*," a reference to *The Birth of Venus* by that artist (1879; Musée d'Orsay, Paris), which the State had just purchased for 15,000 francs.

18 July. Establishment of the Caillebotte Brothers Foundation, under terms set by a private agreement dated 6 Jan., to benefit the vestry of the church of Saint-Georges, Paris, which is to see that masses are said in memory of deceased members of the Caillebotte family (Bishopric of Paris, Archives Historiques).

Aug. Caillebotte advances Monet 200 francs (Monet account book, fol. 26).

17 Sept. Caillebotte advances Monet 500 francs (Monet account book, fol. 26v).

Oct. Caillebotte advances Monet 700 francs (Monet account book, fol. 26v).

Dec. Caillebotte advances Monet 100 francs (Monet account book, fol. 27).

1880

24 Jan. The newspaper *Le Gaulois* announces that the first number of *Le Jour et la Nuit* is to be published on 1 Feb., with prints by Bracquemond, Caillebotte, Cassatt, Degas, Forain, Pissarro, Raffaëlli, and Rouart. In an undated letter to Bracquemond, written after the close of the 1879 exhibition, Degas stated: "I spoke about the newspaper to Caillebotte, he is prepared to pay the security deposit for us" (Guérin 1931, p. 45, letter 18).

24 Feb. Caillebotte advances Monet 100 francs (Monet account book, fol. 27v).

Late Mar. Degas announces the opening of the group exhibition on 1 Apr.: "The posters will go up tomorrow or Monday. They are in bright red letters against a green ground. There was a big fight with Caillebotte about whether or not we should include the names [of participating artists]. I had to give in and allow their inclusion. When will people stop playing the star?" (letter to Bracquemond, undated, cited in Guérin 1931, letter 24).

1–30 Apr. Fifth Impressionist exhibition, with works by M. and Mme Bracquemond, Caillebotte, Cassatt, Degas, Forain, Gauguin, Guillaumin, Lebourg, Levert, Morisot, Pissarro, Raffaëlli, Rouart, Tillot, Vidal, and Vignon, held in Paris at 10, rue des Pyramides (at the corner of rue Saint-Honoré). Neither Monet nor Renoir participates, both returning instead to the official Salon. Caillebotte exhibits: "6 *Dans un Café.* 7 *Portrait de M. J. R.* 8 *Portrait de M. G. C.* 9 *Intérieur.* 10 *Intérieur.* 11 *Nature morte.* 12 *Vue prise à travers un balcon.* 13 *Vue de Paris, soleil.* 14 *Portrait de M. C. D.* Pastel. 15 *Tête d'enfant.* id. 16 *Paysage.* id."

Apr. Monet sells Caillebotte "*Le Verger (Printemps)*" for 200 francs (Monet account book, fol. 28v).

8 Aug. Monet receives 200 francs from Caillebotte (Monet account book, fol. 29).

Aug. Caillebotte paints in Villers-sur-Mer (dated works, Berhaut 1994, nos. 161, 165, 166, and 169–72).

Oct. Monet receives 240 francs from Caillebotte (Monet account book, fol. 30r and v).

10 Nov. Monet records having paid 200 francs back to Caillebotte, but he also receives 300 francs (Monet account book, fols. 4 and 30v).

Dec. Monet receives 100 francs from Caillebotte (Monet account book, fol. 30v).

Year's end. Degas writes his friend Bracquemond of his disagreements with the organizers of the upcoming exhibition: "Logic and taste count for nothing against the inertia of some and the obstinacy of Caillebotte" (letter cited in Berhaut 1994, pp. 7 and 13 n. 41, citing Guérin 1931, p. 51).

1881

Caillebotte becomes increasingly involved with sailing (see Appendix IV).

Jan. Monet receives 500 francs from Caillebotte, followed by another 100 francs in Feb. (Monet account book, fol. 32).

24–28 Jan. Caillebotte complains to Pissarro: "Degas is sowing discord among us. . . . He is an immense talent, it's true, and I am the first to proclaim myself his great admirer. But let's stop there. As a human being, he has gone so far as to say to me, speaking of Renoir and Monet, 'Do you invite those people to your house?' You can see that while he has great talent, he doesn't have a great character" (letters to Pissarro, dated 24 and 28 Jan., in Berhaut 1994, pp. 275–76, letters 23 and 25). But Pissarro stands by Degas, reluctantly accepting the loss of Renoir and Monet, whom Caillebotte would have liked to see return (letter to Caillebotte, dated 27 Jan., in Berhaut 1994, p. 276, letter 24; and in Bailly-Herzberg 1980, p. 145, letter 86).

27 Mar.–8 Apr. Caillebotte does military service with the nineteenth regiment of territorial infantry (*livret militaire*, family archives).

2 Apr.–1 May. Caillebotte does not take part in the sixth Impressionist exhibition.

7 May. Gustave and Martial acquire a property on the banks of the Seine at Petit Gennevilliers, across the river from Argenteuil, where the activities of the Cercle de la Voile de Paris are centered (Quiqueré 1993, p. 47; and Gérôme 1993, p. 76). Caillebotte subscribes to the *Revue horticole, journal d'horticulture pratique* (written communication from P. Wittmer).

14 May. A painting by Caillebotte, *Paysage*, donated by the painter himself, figures in a public auction (no. 5) organized at the Hôtel Drouot by artists to benefit the bohemian musician Ernest Cabaner.

1882

Gustave and Martial Caillebotte build two new structures at Petit Gennevilliers (Archives de Paris, Registry of Developed Land, 33132/66/1, Gennevilliers, 1885). For the first time, Caillebotte dates works painted at Petit Gennevilliers (Berhaut 1994, nos. 215 and 217).

The quarrels undermining the cohesion of the Impressionist group continue, and it seems there is even talk of excluding Caillebotte; Gauguin in particular makes no secret of his hostility. Caillebotte finally writes to Pissarro: "I am disgusted, I'm withdrawing to my tent . . . I await better days" (letter dated mid-Feb., in Berhaut 1994, p. 276, letter 28).

Around 24 Feb., Pissarro announces to Monet:

For two or three weeks now, I have been making great efforts, in conjunction with our friend Caillebotte, to

reach an understanding such that our group will be constituted as homogeneously as possible. Clearly an error must have slipped into the letter which M. Durand [-Ruel] wrote you, for, as you can well imagine, we have never separated Caillebotte from our group. . . . What's more, [the plans] have long since been agreed with Caillebotte, who is with us; he set only one condition: that you take part. . . . You can count on our striving to satisfy your every wish concerning the placement of your canvases; and then Caillebotte and myself will both be there" (Bailly-Herzberg 1980, p. 154, letter 98).

1–31 Mar. Seventh exhibition of "independent artists" in Paris, 251, rue Saint-Honoré, Salon of the Panorama of Reichshoffen, with works by Caillebotte, Gauguin, Guillaumin, Monet, Morisot, Pissarro, Renoir, Sisley, and Vignon. Caillebotte exhibits: "1 *Partie de bézigue* [sic]. 2 *Homme au balcon.* 3 *Chemin montant.* 4 *Fruits.* 5 *Portrait de M. G.* 6 *Portrait de M. F.* 7 *Villers-sur-Mer.* 8 *Marine.* 9 *Route d'Honfleur à Trouville.* 10 *Boulevard vu d'en haut.* 11 *Balcon.* 12 *Paysage (environs de Trouville).* 13 *Bois près de la mer.* 14 *Marine* (pastel). 15 *Pommiers.* 16 *Chemin vert.* 17 *Pêcheur.*"

Caillebotte also loans a work by Monet, "no. 69 *Chrysanthèmes* appartient à M. C." Monet himself has asked Durand-Ruel to request this loan, "a canvas he has by me that's very good (of red chrysanthemums)" (letter to Durand-Ruel dated 23 Feb., in Wildenstein 1979, vol. 2, letter 249).

Mid-Mar. Caillebotte informs Monet and Renoir that the exhibition will probably incur a net loss of 2,000 francs (letter from Monet to Alice Hoschedé dated "Friday" [17 Mar.], in Wildenstein 1979, vol. 2, letter 255 bis; letter from Renoir to Bérard, in White 1984, p. 124).

12 Mar. Pissarro writes from Pontoise to his patron Théodore Duret: "I also am very happy that the ensemble of our exhibition pleases you. . . . I consider the success of the whole extraordinary; bringing together in only two days Monet, Renoir, Sisley, Mlle Morisot, and Caillebotte is quite simply surprising" (Bailly-Herzberg 1980, p. 157, letter 100).

15 Apr. Monet states that Caillebotte has requested he remove his canvases from 20, rue Vintimille (letter to Alice Hoschedé, in Wildenstein 1979, vol. 2, letter 270); after renting the ground-floor apartment on the left, Caillebotte takes another, on the right, which he occupies perhaps beginning at the end of 1881 and certainly in 1882 (Archives de Paris, D1P4, rue Vintimille, 1876), sharing it with Monet.

Summer. Caillebotte dates several canvases painted during his sojourn in Trouville (Berhaut 1994, nos. 219, 222–24, 227, and 235).

1883

1–25 Apr. Gustave Caillebotte lends several Renoirs from his collection—*Liseuse* (no. 23), *La Balançoire* (no. 28), *Le Moulin de la Galette* (no. 35), *Paysage* (no. 56), *Les Marronniers roses* (no. 68)—for a retrospective

of his friend's work organized by Durand-Ruel at 9, boulevard de la Madeleine.

May. Appearance of "L'Exposition des indépendants en 1880" in *L'Art moderne*, a collection of texts by Joris Karl Huysmans published by Georges Charpentier, very favorable to Caillebotte. Concerning it, Pissarro writes on the 13th to his son, Lucien: "Like all the critics, under the pretext of *naturalism*, he judges as a literary man and most of the time sees nothing but the subject. He places Caillebotte above Monet, why? Because he did *Floor-Scrapers*, *Oarsmen*, etc. So then is Delacroix nothing? Is the ceiling of the [Salon] d'Apollon [in the Louvre] nothing?" (Bailly-Herzberg 1980, p. 206, letter 148). On 18 May, Lucien responds: "I also find that he is severe regarding Puvis de Chavannes and too indulgent regarding Caillebotte, but here is the explanation of this enigma: 'They are boating buddies and "rowers" look after each other'" (*The Letters of Lucien to Camille Pissarro, 1883–1903*, ed. A. Thorold [Oxford, 1993], p. 21).

July 1. Caillebotte becomes a member in the reserve of the territorial army (*livret militaire*, family archives).

Summer. He sojourns in Trouville (dated canvas, Berhaut 1994, no. 270). He sails in regattas in Trouville, Cabourg, and Argenteuil (see Appendix IV).

Fall (?). Pissarro confides to Monet: "I am very badly off and all but reduced to beggary . . . very fortunate to have had Caillebotte to help me get past this difficult stretch of summer, without him my sales would certainly not have saved me from shipwreck" (letter in Geffroy 1922, p. 161).

20 Nov. In a second will, deposited with Albert Courtier in Meaux, Caillebotte reaffirms the terms of his 1876 will and allocates to the young woman now sharing his life, Charlotte Berthier, a life-annuity of 12,000 francs: "It is my wish that this annuity be irrevocable and payable every month; I would prefer even more every two weeks. Albert Courtier can take care of this business. This annuity must be clear of all probate duties" (family archives, duplicate of the will). This annuity will be in fact provided to the young woman, whose real name is Anne Marie Hagen (Poletnich 1894b). In 1883 Renoir does a portrait of her in summer clothing (see ch. 8 intro., fig. 12). Referring to an ill-fated business enterprise launched by the picture dealer Alphonse Legrand and Renoir for the manufacture and sale of McLean "artistic cement" (see Aug. 1877), Caillebotte specifies: "My formal intention is that Renoir should never have the least worry as a result of the money I have loaned him. I completely absolve him of his debt, and I release him completely from all joint and separate liability with M. Legrand." At Caillebotte's death, Legrand will still owe 15,000 francs, a debt deemed "desperate" (Poletnich 1894b). He also leaves 20,000 francs to Courtier's daughter and his goddaughter Jenny, born in Meaux on 20 June 1877. To his brother Martial he promises, "over and above the share that comes to him legally, all of the property that we own together, personal property and real estate."

1884

Gustave Caillebotte still figures on the electoral rolls of the ninth arrondissement as a painter living at 31, boulevard Haussmann, along with his brother Martial (Archives de Paris).

Jan. He lends *La Partie de crocket* [sic] (no. 73) to the "Exposition des oeuvres d'Edouard Manet," organized by the Ecole des Beaux-Arts, as an homage to the artist, who had died on 30 Apr. 1883.

29 Jan. Monet writes from Bordighera: "I write this evening to Caillebotte, who must think me quite odd for not having given him any signs of life since my first trip here. I inform him that the ducks will be sent to him on Saturday for arrival in Argenteuil on Sunday and that he'll only have to pick them up at the railway station" (letter to Alice Hoschedé, in Wildenstein 1979, vol. 2, letter 398).

4 and 5 Feb. At the Manet studio sale, Caillebotte acquires "no. 54 *Les courses étude*, 32 x 41, 200 F" and "no. 2 *Le Balcon*, 171 x 125, 3,000 F," this last being one of the highest prices of the sale (see Bodelsen 1968, pp. 342–44). He writes to Monet, still sojourning in Bordighera, about his purchases (letter from Monet from Bordighera to Alice Hoschedé dated 17 Feb., published in Wildenstein 1979, vol. 2, letter 421).

16 Feb. Caillebotte writes a letter to the editor of the London publication *The Philatelic Record*, which appears in the Feb. issue under the heading "Correspondence, The Un Real, Paraguay, surcharged 5."

22 Feb. Still in Bordighera, Monet notes: "I received today a new letter from Caillebotte, to whom I had sent some money for Fournaise [the Châtou restauranteur] in Argenteuil; he apologizes for not having thanked me for the ducks, which he indeed received and which he finds very beautiful and which were well received" (letter to Alice Hoschedé dated 22 Feb., in Wildenstein 1979, vol. 2, letter 427).

July. On the ocean-regatta circuit (*Le Yacht* of 5 July announces that Caillebotte's sailboats have left for Rouen and Le Havre), Caillebotte visits Monet: "I arrive from Rouen, where I accompanied Caillebotte to his boat" (letter from Monet from Giverny to Durand-Ruel dated 5 July, in Wildenstein 1979, vol. 2, letter 508; see also dated drawings in a sketchbook published in Lloyd 1988, pp. 112–113, fols. 4–9).

18 July. From Trouville, Caillebotte writes a long letter to Monet about Gustave Flaubert's correspondence, which he has just read and whose pessimism has discouraged him; he expresses admiration for Delacroix and Millet, whom he describes as "Olympian" in the face of human stupidity, which is not his view of Degas. "He'd fall terribly short on that score," he says (Geffroy 1922, pp. 180–81; Berhaut 1994, p. 277, letter 32).

9 Oct. Caillebotte dates a sketch after a drawing by Eustache Le Sueur in the Louvre (Lloyd 1988, p. 113, fol. 13).

25 Oct.–16 Nov. He sojourns in Chérence and Vétheuil (Lloyd 1988, pp. 114–115, fols. 15–21), but is in Argenteuil for the regattas.

Dec. He writes to Pissarro in hopes of convincing him to attend a memorial banquet for Manet (letter, undated, in Berhaut 1994, p. 277, letter 33; and letter from Monet to Pissarro, undated, in Wildenstein 1979, vol. 2, letter 538); the banquet is to take place at the restaurant of Lathuile, on avenue de Clichy, on 5 Jan. 1885.

1885

24 Feb. Monet writes to Emile Zola asking for two tickets—for which he will gladly pay—to Zola's play *Henriette Maréchal*, which he had promised to obtain for Gustave Caillebotte (Wildenstein 1979, vol. 2, letter 552).

Mar. Caillebotte is godfather to Pierre, the first son of Renoir and Aline Charigot, born 21 Mar.

20 May. Abbé Alfred Caillebotte becomes the vicar of Notre-Dame-de-Lorette in Paris (Bishopric of Paris, Historical Archives).

May and Sept. Caillebotte sojourns in Vétheuil (Lloyd 1988, pp. 115–116, fols. 22–26).

Nov. Publication of the first article by the Caillebotte brothers on Mexican stamps in *The Philatelic Record* 7, 82 (Nov.). This article is adapted from one previously published in *Le Timbre-Poste* of Brussels; it inaugurated a series that continues in the Dec. 1885 and in the Mar., Apr., May, and June 1886 issues.

Dec. From Etretat, Monet writes to Alice Hoschedé about the debate among the Impressionists as to whether or not they should exhibit with Durand-Ruel's rival, the dealer Georges Petit: "This morning I received a letter from Caillebotte informing me of his arrival next Wednesday; doubtless he is coming to the rescue of Pissarro's letter and that annoys me; I reply that I do not know whether I will still be here" (Wildenstein 1979, vol. 2, letter 640).

Late Dec. Monet writes to Pissarro: "I have just been visited by Caillebotte; he came to talk to me about an exhibition" (Wildenstein 1991, letter 2719).

1886

10 Apr.–10 May (reprised 25 May). Durand-Ruel includes several works by Gustave Caillebotte in the group exhibition he mounts in New York, "Works in Oil and Pastel by the Impressionists of Paris": 3 *Portrait of a gentleman* [500 francs]. 30 *The Planers* [3,300 francs]. 114 *Snow effect* [600 francs]. 132 *Landscape—Study in Yellow and Rose* [500 francs]. 136 *Landscape—Study in Yellow and Green* [500 francs]. 146 *Child in a Garden* [400 francs]. 186 *Paddling Canoe* [2,000 francs]. 191 *Trees in Blossom* [300 francs]. 230 *Before the Window* [1,000 francs]. 272 *The Rowers* [1,750 francs]. (The prices are those indicated in code in an annotated catalogue in the Durand-Ruel archives and kindly communicated by Caroline Godfroy-Durand-Ruel).

15 May–15 June. The eighth, and last, Impressionist exhibition takes place, but Caillebotte does not participate.

June. Caillebotte probably finances the boatyard established at Petit Gennevilliers,

which will henceforth build his boats (see Appendix IV).

July–Aug. Caillebotte sojourns in Vétheuil (Lloyd 1988, pp. 116–117, fols. 29–31).

Aug.–Sept. Caillebotte travels to the Loire valley, visiting Blois and Chaumont (Lloyd 1988, p. 117, fols. 32–34).

11 Oct. Monet, sojourning at Belle-Ile, urgently asks Caillebotte to send him a pipe (letter to Caillebotte, in Berhaut 1994, pp. 277–78, letter 35).

1887

8 May–8 June. Gustave Caillebotte lends Monet's *Apartment Interior* to an "Exposition internationale de peinture et de sculpture" at Galerie Georges Petit, Paris.

24 May. He buys his brother Martial's portion of the lands and buildings of the Petit Gennevilliers property (deed executed in the presence of Albert Courtier, referenced in deed of sale of the property drawn up by Albert Courtier, notary in Meaux, 28 May 1910).

7 June. Martial Caillebotte marries Marie Minoret in the church of Saint-Paul-Saint-Louis in Paris; in his sermon, Abbé Alfred Caillebotte evokes their youth together at Yerres (family archives).

Aug. Gustave Caillebotte purchases several lots and buildings in Petit Gennevilliers (deed executed in the presence of Albert Courtier, notary in Meaux, 28 May 1910).

4 Sept. Monet sends Caillebotte a basket of prunes; he complains about his work and refuses to see Sisley (Berhaut 1994, p. 278, letter 36).

15 Sept. Caillebotte dates a drawing of Vétheuil (Lloyd 1988, p. 117, fol. 34).

1888

Gustave Caillebotte has three new buildings erected at Petit Gennevilliers: a studio, a hen-house, and a house (Archives de Paris, Registry of Developed Land, 33132/66/1, Gennevilliers, 1891). This property now becomes his principal residence.

Feb. Monet considers asking Caillebotte to intervene in a public auction to prevent the prices of his work from falling too low (letter to Alice Hoschedé, published in Wildenstein 1979, vol. 3, letter 844). Caillebotte exhibits at the fifth exhibition of Les XX in Brussels (along with, most notably, Guillaumin, Signac, Toulouse-Lautrec, and Whistler): "1 *Homme au bain*. 2 *Portrait de M. J. D.* 3 *Portrait de M. R. G.* 4 *Portrait de M. E. J. F.* 5 *Etude de soleils*. 6 *Un Bras de Seine*. 7 *Cerisiers en fleur*. 8 *Nature morte*."

While *Man at His Bath* (cat. 83) is listed in the Les XX catalogue, it is not exhibited; the few references to Caillebotte in the Belgian reviews depict him as a representative of "old Impressionism" and are not favorable to his work.

20 Apr. Birth of Jean Caillebotte, Martial's son and Gustave's nephew.

6 May. Caillebotte is elected town councilman in Gennevilliers (councilman's card, family archives).

7 June. He chooses to sit on the town commission overseeing education and public festivals (Quiqueré 1993, p. 64).

25 May–25 June. Caillebotte participates in a group exhibition at Durand-Ruel in Paris: "8 *Jardin*. 12 *Petit-Bras à Argenteuil*. 62 *Champ jaune et rose*. 63 *Canotiers*. 64 *Champ jaune*. 70 *Au Bord de l'eau*." Vincent van Gogh, then in Arles, writes to his brother, the dealer Théo van Gogh, about this exhibition: "There will be some of Caillebotte's pictures—I have never seen any of his stuff, and I want to ask you to write me what it is like" (Van Gogh 1991, vol. 2, p. 571).

Sept. Renoir sojourns at Petit Gennevilliers with Caillebotte (letter from Renoir to Murer, 29 Sept., Université de Paris, Bibliothèque d'Art et d'Archéologie, fonds Doucet).

21 Dec. Caillebotte, in his capacity as town councilman, increases the salary of the lamplighter in Petit Gennevilliers (Quiqueré 1993, p. 64).

1889

30 June. Gustave Caillebotte is definitively freed of all military service obligations (*livret militaire*, family archives).

5 Nov. In a codicil to his will, Caillebotte affirms the terms of his previous wills and stipulates in addition that he leaves to Charlotte Berthier (Anne Marie Hagen) "the little house I own at Petit Gennevilliers that is presently rented to M. Luce [the builder of his boats], once again clear of all probate taxes" (duplicate of the will, family archives).

1890

18 Feb. Monet asks Gustave Caillebotte to subscribe—with 1,000 francs—to the campaign to purchase the *Olympia* from Manet's widow in view of donating it to the French State (letter to Caillebotte, in Berhaut 1994, p. 278, letter 40).

27 Mar. Monet suggests that he lunch at Caillebotte's on Thursday, 3 Apr., before the usual dinner of the Impressionists and their circle at the Café Riche, held the first Thursday of every month (letter to Caillebotte, in Berhaut 1994, p. 278, letter 41).

12 May. Monet acknowledges receipt of some dahlias from Caillebotte, gives him news of Sisley, and expresses his approval of Renoir's refusal of an official honor (letter to Caillebotte, in Berhaut 1994, p. 278, letter 42).

28 May. Birth in Montgeron of Geneviève Caillebotte, Martial's daughter and Gustave's niece.

2 June. Caillebotte takes part in Gennevilliers town-council deliberations concerning a proposal to affiliate its telegraph service with the Argenteuil post office and thus improve service (Quiqueré 1993, p. 64).

1891

The 1891 census (Archives de Paris) for Petit Gennevilliers lists as dependents in the household of "Gustave Caillebotte, 42 years old, head of household, painter, Charlotte Berthier, 28 years old, friend, Marie Alexandre, 48 years old, cook, domestic servant, Angèle Alexandre, 17 years old, domestic servant, Joseph Kerbrat, 41 years old, sailor, Marie Guémeneur, 38 years old, maid, Guillaume Kerbrat, 14 years old, Gaillard Pierre, 33 years old, sailor."

4 Feb. Monet informs the critic Gustave Geffroy: "I'm coming to Paris tomorrow. . . . Our dinner that evening with Bellio [Georges de Bellio, a collector of Impressionist art], Caillebotte etc. is on. I told you about it" (letter to Geffroy, in Wildenstein 1991, letter 2802).

Early Mar. Monet arranges a meeting with Geffroy: ". . . on Thursday. . . . We'll dine with Caillebotte and Bellio" (letter to Geffroy, in Wildenstein 1991, letter 2806).

30 Mar. Monet informs Geffroy: "I'm coming on Thursday for the Impressionist dinner" (letter to Geffroy, in Wildenstein 1991, letter 2810).

4 Apr. Cosigning with Caillebotte a petition concerning the operation of the Conseil Maritime is the writer Guy de Maupassant, owner of the boat Bel-Ami (see Appendix IV).

24 May. Monet asks Geffroy for theater tickets and adds: "I am waiting to telegraph Caillebotte" (letter to Geffroy, in Wildenstein 1991, letter 2819).

23 July. In a meeting of the Société Nationale d'Horticulture, Paul Hariot mentions having "had occasion to admire at the home of M. Caillebotte, in Petit Gennevilliers, a very complete series of perennial poppies resulting from the cross-fertilization of Papaver Orientale and P. Bracteatum" (written communication from J. P. Collaert, editor-in-chief of Jardins de France, to P. Wittmer, who conveyed this information to us).

24 Aug. From Giverny, Monet sends Caillebotte a basket of plums and alludes to a meeting with the writer and critic Octave Mirbeau, who shares the two artists' passions for gardening, boating, and of course painting (letter from Monet to Caillebotte, in Berhaut 1994, p. 279, letter 46; and undated letter from Mirbeau to Caillebotte, in Berhaut 1994, pp. 279, letter 45).

14 Sept. From Giverny, Monet asks Caillebotte to lend him a stable boat on which he can work (letter to Caillebotte, in Berhaut 1994, p. 279, letter 47).

29 Sept.–3 Oct. Renoir stays with Caillebotte in Petit Gennevilliers (letter from Renoir to Eugène Murer, in Gachet 1957, pp. 106–107).

28 Dec. In his last action as town councilman, Caillebotte sponsors a vote awarding the local road-keeper a gratuity (Quiqueré 1993, p. 68).

1892

30 Jan. Monet writes from Giverny to Geffroy: "As I don't want to spend too much time in Paris because of current projects, I'm writing Caillebotte [to suggest] that our dinner indeed take place on Tuesday" (Wildenstein 1991, letter 2850).

29 Mar. Gustave Caillebotte writes to Paul Signac, himself a boating enthusiast: "Monsieur, I am very happy to be able to oblige you and thank you for having thought of me to be your godfather [sponsor] at the yachting union. I hope that this new association will provide me with occasions to renew our friendship. Your devoted G. Caillebotte" (Signac archives, Paris).

May. Caillebotte lends several Renoirs from his collection—Le Moulin de la Galette (no.

10), Torse, effet de soleil (no. 11), La Balançoire (no. 23), La Liseuse (no. 53)—to an exhibition organized by Durand-Ruel in Paris; in his preface to the catalogue, Arsène Alexandre evokes "the excellent painter who also between 1876 and 1882 had his share of stupor and laughter."

6 May. In a letter (sale, Hôtel Drouot, Paris, 3 July 1985) from Petit Gennevilliers, Caillebotte asks an unknown correspondent not to send a photographer because he is about to go to Paris to attend a wedding. Caillebotte attends a dinner given by Renoir at the Café Riche on the occasion of his exhibition; Bellio, Duret, Mallarmé, and Monet are also present (letter from Mallarmé to Renoir, in Mallarmé 1981, vol. 5, p. 76).

10 and 16 July. Caillebotte is a witness to the marriage of Monet and Alice Hoschedé at Giverny (Wildenstein 1979, vol. 3, p. 47).

1893

31 Mar. Gustave Caillebotte writes Bellio that the second Thursday in Apr. is the date for a dinner with Monet, in accordance with the latter's wishes (Berhaut 1994, p. 279, letter 50; see also letter from Monet to Geffroy, in Wildenstein 1991, letter 2887).

24 Nov. He writes to Bellio rescheduling an Impressionist dinner to 30 Nov., at Monet's request (Berhaut 1994, p. 279, letter 51; see also letter from Monet to Geffroy, in Wildenstein 1991, letter 2900).

1894

3 Jan. Writing from Giverny, Monet informs Geffroy that he will be at the Impressionist dinner at the Café Riche the following evening (Wildenstein 1991, letter 2905).

21 Feb. Gustave Caillebotte dies at his home in Petit Gennevilliers, probably from a stroke (although some obituaries mention a "long illness").

26 Feb. Caillebotte's funeral is held in the church of Notre-Dame-de-Lorette, where his half-brother, Alfred, is the vicar; the crowd is so large that many of his friends are obliged to remain on the porch during the service; the pall-bearers are four sailors from Petit Gennevilliers; he is buried in Père-Lachaise cemetery, Paris.

1 Mar. Pissarro writes to his son, Lucien: "We have just lost another sincere and devoted friend, Caillebotte has died suddenly of brain paralysis. He is one we can mourn, he was good and generous and what makes things even worse, a painter of talent" (Bailly-Herzberg 1988, letter 991).

11 Mar. Renoir, in his capacity as estate executor, informs the Directeur des Beaux-Arts, Henry Roujon, of Caillebotte's bequest of "a collection of about sixty works by Messieurs Degas, Césanne [sic], Manet, Monet, Renoir, Pissarro, Sisley, Millet, a drawing by Gavarni," works determined by Renoir and Martial Caillebotte to constitute the bequest of the deceased to the State (Archives du Louvre, Paris, P8 1896; and Poletnich 1894a).

15 Mar. Monet writes to Geffroy about his sorrow over Caillebotte's death and adds: "I intend to be in Paris all day Saturday [because] Renoir has summoned me in con-

nection with Caillebotte" (Wildenstein 1991, letter 2908).

20 Mar. Léonce Bénédite, the curator of the Musée du Luxembourg, succeeds in convincing a committee of curators from the Musées Nationaux to accept the bequest, but no formal commitment is made to exhibit the entire collection in the museum, partly because this would inevitably entail expanding its quarters. This prompts legitimate objections from Renoir and Martial Caillebotte, who require irrevocable guarantees on this point, occasioning a controversy given extensive press coverage and lasting almost a year (Archives du Louvre, Paris, and family archives; see Introduction).

4–16 June. A retrospective of Caillebotte's art is held at Galerie Durand-Ruel, 16, rue Laffitte, and 11, rue Le Peletier (122 cat. nos.); all the designated lenders are either family members or friends. The catalogue (Paris 1894) notes that Floor-Scrapers belongs to the Musée du Luxembourg; it has been added to the bequest at Renoir's suggestion.

1896

26 Feb. A notarized agreement between the administration and the heirs of Gustave Caillebotte formally ratifies the choice of forty works, all to be exhibited in the Musée du Luxembourg, with the exception of two drawings by Millet to be accepted for the Musée du Louvre (Archives du Louvre, Paris, P8 1896).

1897

9 Feb. Public opening of the Caillebotte room in the new wing of the Musée du Luxembourg: the artist's collection is augmented by Manet's Olympia, Renoir's Young Women at the Piano, and Morisot's Young Woman in Ball Dress, which the State had previously acquired. This installation constitutes the first group of Impressionist paintings to be presented to the public by a French museum. A. D.

Gustave Caillebotte's Estate Inventory

An excerpt from the estate inventory executed on 8 March 1894 by Ernest Charles Poletnich at Petit Gennevilliers, at the behest of the painter's heirs and in the presence of Martial Caillebotte and Pierre Auguste Renoir, this document is now in the Minutier Central of the Archives Nationales, Paris. It was graciously communicated to us by Philippe Narbey with the permission of the office of C. Didier, G. Oury, H. Lebaron, L. Theze, and P. Narbey, notaries, successors of Mᵉ Poletnich, notary to the Caillebotte family, to whom we are grateful.

Besides the "Tableaux légués à l'Etat," the furniture appraisal mentions "quatre tableaux paysages signés Caillebotte prisés quatre cents francs" (in the salon), "une peinture dans cadre doré prisée cent francs" (in one of the bedrooms), and "un tableau cadre bois 'les ouvriers rabotteurs' [*sic*], un autre 'Canottiers [*sic*],' 'baigneurs,' quatre-vingt quinze toiles diverses, [word illegible] etc. le tout prisé mille francs" (in the studio).

Tableaux légués à l'Etat
Dans l'atelier:
Un grand tableau de Manet "au balcon"
Un tableau de Cézanne avec cadre doré "baigneurs"
Un tableau de Renoir "le bal"
Un dessin de Millet "paysan et brouette"
Deux toiles paysages de Sisley, un tableau du même "habitations villageoises"
Une toile de Cézanne "Pêcheurs"
Un tableau de Sisley "Régates"
Deux tableaux paysages de Pissaro [*sic*] avec cadres dorés
Un tableau de Claude Monet, marine. Un autre du même avec cadre doré "effet de neigue [*sic*]—un tableau du même avec cadre bois peint "après le déjeuner"
Une toile du même "intérieur"
Un tableau de Manet avec cadre doré "femme à l'éventail"
Deux toiles de Claude Monnet [*sic*] "voie ferrée"
Un tableau cadre doré église de Vithreuil [*sic*]
Une toile de Renoir "en plein air"
Un dessin de Degas avec cadre bois "chanteuse" un dessin du même dans un cadre blanc
Un paysage de Cézanne avec cadre doré
Une toile de Pissaro [*sic*] "sous-bois"
Une toile de Renoir "Bords de la Seine"
Un dessin de Degas dans cadre de bois "Choristes" un tableau avec cadre doré "la liseuse"
Un dessin de Degas "Café du boulevard"
Un tableau de Cézanne avec cadre doré

Un dessin de Degas "la toilette"
Un dessin de Millet "Paysage"
Un tableau de Pissaro [*sic*] "Village"
Un tableau de Claude Monet avec cadre doré "arbres et fleurs"
Un dessin de Gavarni "Souvenirs et regrets de la Courtille"
Dans le salon:
Un tableau paysage de Pissaro [*sic*] avec cadre doré
Un tableau de Claude Monet avec cadre doré "bord [? or coin, or bois] de la Seine Vithreuil [*sic*]"
Un tableau de Sisley avec cadre doré "bords du Loing"
Un tableau de Sisley avec cadre doré "île de Croissy"
Un tableau de Manet dans cadre doré "le Crocket [*sic*]"
Un tableau de Renoir dans cadre doré "la balançoire"
Dans les chambres:
Un tableau marine de Sisley avec cadre doré
Un paysage de Pisarro [*sic*] avec cadre doré
Un tableau de Claude Monet avec cadre doré "vue d'Argenteuil"
Un tableau de Sisley avec cadre doré "bords de fleuve"
Un tableau de Renoir "Coin de l'ancienne place Saint-Georges"
Une aquarelle éventail de Pissaro [*sic*]
Un tableau de Claude Monet avec cadre doré "Vue des Tuileries"
Un pastel de Degas "le bain"
Un paysage de Pissaro [*sic*] avec cadre doré
Un tableau de Claude Monet avec cadre doré "La gare Saint-Lazare"
Un tableau de Pissarro "forêt de Fontainebleau"
Un tableau avec cadre doré "la moisson"
Un tableau de Claude Monet avec un cadre doré "Plaine à Argenteuil"
Un tableau de Pissarro "paysage avec jardin"
Deux pastels de Degas "danseuses"
Un paysage de Renoir avec cadre doré
Deux paysages et un tableau fleurs de Claude Monet
Un tableau paysage de Sisley
Deux tableaux paysage de Pissaro [*sic*]
En tout soixante tableaux ou toiles estimés ensemble à la somme de quarante mille francs.

This document, along with two other lists, one published by Gustave Geffroy,[1] and one drawn up by the artist's heirs in conjunction with his bequest to the State,[2] can serve as the

basis for an attempt to reconstitute the collection of Gustave Caillebotte (see Appendix III). It should be noted that the total given at the close of the above list is incorrect: it includes not sixty but sixty-three pieces, or (if drawings and pastels are excluded) fifty paintings. Renoir was equally approximating when he evoked, in his letter informing the administration of the bequest, "a collection of about sixty works"; and he was to find ten works in another studio ("dans un autre atelier, une dizaine d'oeuvres"), including five Pissarros and a Sisley.[3] It is only in the initial draft of a final agreement between the State and the heirs that a clear list of sixty-five works first appears (it had been preceded by numerous manuscript versions).[4] Even setting aside problems raised by the use of varying titles, comparison of these lists with that of Geffroy prompts several observations.

It is clear that a selection had been made prior to the inventory by Renoir and Martial Caillebotte, who established a separate category for "paintings bequeathed to the State." A rough sketch by Manet listed by Geffroy ("petite esquisse de chevaux de courses"), which Caillebotte is known to have purchased at the 1884 Manet studio sale,[5] was probably excluded because it was found too modest. Likewise, the inventory lists four Cézannes while Geffroy described five. Finally, Renoir's *Young Girls at the Piano* (1892; private collection), which is inscribed "*à mon ami G. Caillebotte,*" is not mentioned at all; perhaps Renoir omitted it from the list because in 1892 the State had purchased another version of this painting. It is possible there were other Renoirs among the ten paintings later discovered by the artist that were not clearly identified.

A second selection took place when the list of works being proposed to the State was drawn up. The "victims" were the small drawing by Gavarni, indeed modest, and above all several Cézannes: a *Pêcheurs*, or *Société de personnages assis ou couchés au bord de l'eau* (possibly Venturi 1936, no. 232); the *Flowers in a Rococo Vase* now in the National Gallery, Washington, D.C.; and the *Bathers* now in the Barnes Foundation, Merion, Pennsylvania. Why were these works eliminated? As a result of censorship exercised by Renoir and Martial Caillebotte, who judged them unacceptable to the State before the fact and so preferred to withdraw them? Was Cézanne informed of the withdrawal of his canvases? Had Léonce Bénédite, curator of the Musée du Luxembourg, made dismissive comments about them? For the moment, these questions must remain unanswered. One painting—that chosen by Renoir in accordance with the terms of the will—disappeared: *The Dance Lesson* by Degas, now in The Metropolitan Museum of Art, New York.

The final selection, which resulted in the definitive list of works to be accepted by the administration, presents fewer problems. From "the canvases and paintings that it seems to them [i.e., to the heirs and the estate executor] should constitute the bequest to the State,"[6] the most important works were retained, in most cases with the assent of the artists, as evidenced in the case of Pissarro and Sisley by letters (see Appendix II), and as can be safely assumed in the cases of Monet[7] and Renoir, both of whom were intimately involved in the negotiations. It is possible that Degas was never consulted, given that all the works by him were accepted, and we know that he was "mad to see himself at the Luxembourg."[8] As for Cézanne, he may or may not have been in Paris at the time, and he may or may not have been consulted, but reportedly, on learning of his imminent entry into the Musée du Luxembourg, he exclaimed: "Now I'll screw over Bouguereau!"[9] A. D.

NOTES

1 "La Collection Caillebotte," *Le Journal*, 19 Mar. 1894; repr. in Geffroy 1922, p. 177.

2 Archives du Louvre, Paris, P8 1896.

3 Proceedings of the advisory committee, 28 June 1894, Archives du Louvre, Paris.

4 Archives du Louvre, Paris, P8 1896.

5 See Bodelsen 1968, p. 342: "*les courses* [étude, 32 x 41 cm] adjugé 200 francs"; and Rouart and Wildenstein 1975, no. 96.

6 Proposed agreement between the State and the heirs of Gustave Caillebotte, Archives du Louvre, Paris, P8 1896.

7 Monet scheduled a meeting with Bénédite on 28 Jan. 1895, as we learn in a letter sent by Martial Caillebotte to Bénédite on 17 Jan. 1895 (Archives du Louvre, Paris, P8 1896).

8 D. Sutton and J. Adhémar, "Lettres inédites de Degas à Paul Lafond et autres documents," *Gazette des beaux-arts*, Apr. 1987, p. 174: "Degas va bien, rage de se voir au Luxembourg, et le fait est selon moi qu'il n'y est pas dans les conditions ou il devrait y figurer. . . . N'exposent jamais il figure dans toutes les expositions, sans choisir ce qui y parait, et que les musées (sauf Pau) n'auront pas ce qu'il aurait pu desirer y voir. Nos disputes à ce sujet sont constantes. . . ."[11]

9 Vollard 1924, p. 73: "maintenant, j'emm . . . de Bouguereau!"

Letters from Sisley and Pissarro

On 3 February 1895, Léonce Bénédite, in his capacity as curator of the Musée du Luxembourg, sent identical letters to Sisley and Pissarro, submitting lists of the six works by each of them that he intended to accept from the proposed Caillebotte bequest.

In Sisley's case, the works were as follows: "*St.-Mammès; Pont de Billancourt; Farmyard; The Seine at Bas-Meudon; Regattas in London (oil sketch); A Street in Louveciennes.*" Sisley was the first to respond[1]:

Moret s/Loing 5 February 95
Monsieur,

I have just received your letter concerning the canvases from the Caillebotte collection to be placed at the Luxembourg. I regret not being able to come to Paris, but I am ill. Among the canvases by me that Caillebotte owned there is one that I would not like to see at the Luxembourg. He obtained it by exchange: it is a 30 canvas [standard format] I think 92c by 73c representing the Seine near the Pont de Billancourt but [with] the bridge not very prominent, one sees the slope of Meudon in the background; the sky is *very large*, cloudy, white, *the horizon very low*, a little passenger steamer heads up the Seine. Whether this canvas is entitled the *Pont de Billancourt* or the *Seine at Bas-Moudon,* it is this one that I ask you to eliminate. You can replace it with *Edge of the Forest in Spring*, which is one of my good ones. Regarding the other canvases that you have chosen we are in agreement.

Please accept, Monsieur, my most cordial regards.

A. Sisley

P. S. The canvas that you call *Regattas in London* should be entitled *Regattas at Moulsey (near London).*

Bénédite seems to have honored Sisley's wishes concerning his *Edge of the Forest* (Musée d'Orsay, Paris, RF 2784), but it could well be that the painting he retained, entitled *The Seine at Suresnes* (Musée d'Orsay, Paris, RF 2786), is in fact the one Sisley requested he eliminate: the dimensions are different but the description seems to apply.

In Pissarro's case, the list submitted by Bénédite was as follows: "*The Red Roofs, Corner of the Village,* Winter 1879; *The Harvest* 76; *Sloping Road through Fields* 79; *Kitchen Garden, Flowering Trees* 77; *The Wheelbarrow (Orchard)* 81; *Valley in Summer* 77.*" "I think" he continued, "that it will be possible to add a gouache without altering this number." Pissarro responded on 7 February[2]:

Eragny by Gisors/Eure 7 February 1895
Monsieur,

You ask me in your letter of 3 Feb. whether the choice of seven of my works from the Caillebotte collection included on the list you sent me meets with my approval; to the extent that I can remember these pictures it seems to me excellent. However, I would be much obliged if you could give me several days' latitude so that I can view this collection which I still have not been able to visit and which I have not seen for fifteen years; I expect to go to Paris ["in" crossed out] soon and I will be pleased to communicate my views to you.

Please accept, Monsieur, assurances of my esteem.

To Monsieur the Curator of the Musée National du Luxembourg

C. Pissarro

The letter bears the following annotation: "wrote [Pissarro] on 16 February awaiting a response." On the 17th, Pissarro promised to respond; he went to Paris on the 18th and answered on the 19th (on paper with the letterhead "Hôtel et Restaurant de Rome-Garnier-111, rue Saint-Lazare, 17, place du Havre, Paris"):

Monsieur

I have seen my pictures at M. Caillebotte's—your choice is excellent except for the little gouache, which seemed to me inferior. I would like to replace it with a small canvas "1872 *The Wash-House,*" which is rather finished and from a period absent from the collection. Cordial greetings.

C. Pissarro

Bénédite accepted this advice (Musée d'Orsay, Paris, RF 2731–2736, 3756).

Pissarro then made it known that he would like to clean his works; this request was turned down, but he was assured that whatever cleaning was necessary would be undertaken before the opening of the exhibition.　A. D.

1 Archives du Louvre, Paris, 2HH1, attrib. 1895.
2 Ibid.

Gustave Caillebotte's Collection

AN ATTEMPT AT RECONSTITUTION

The 1894 estate inventory listed in Appendix I is reproduced here with the inventory published by Gustave Geffroy in the same year (see Appendix I n.1). The bequest release drawn up for the State in 1896 by Martial, Gustave Caillebotte's brother, and Pierre Auguste Renoir, his estate executor, is included with Curator Léonce Bénédite's decision to accept or reject each work in the bequest. The current title and location of each work are listed alongside a reproduction, when available. A. D.

JEAN FRANCOIS MILLET (1814–1875). Bequest Release: *Two Millets.*

Estate Inventory: A drawing by Millet, "peasant and wheelbarrow"

Gustave Geffroy's Inventory: A pencil drawing

Bequest Release: Man with a Wheelbarrow (black pencil)

ACCEPTED

Man with Wheelbarrow, c. 1855

Black pencil; 29 × 21 cm

Musée du Louvre, Département des Arts Graphiques, fonds du Musée d'Orsay, Paris (RF 4019)

Fig. 1

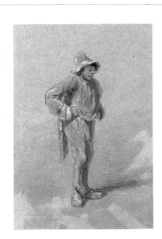

Estate Inventory: A drawing by Millet, "landscape"

Gustave Geffroy's Inventory: Mention of a watercolor

Bequest Release: Watercolor landscape

ACCEPTED

Landscape, n.d.

Pen and watercolor; 17 × 20 cm

Musée du Louvre, Département des Arts Graphiques, fonds du Musée d'Orsay, Paris (RF 4020)

Fig. 2

PAUL GAVARNI (1804–1866).

Estate Inventory: A drawing by Gavarni, "Memories and Regrets of la Courtille"

Gustave Geffroy's Inventory: [not mentioned]

Bequest Release: [not mentioned]

Memories and Regrets of la Courtille, n.d.

Pen and watercolor; 31 × 21 cm

Private collection

Fig. 3

PAUL CEZANNE (1839–1906). Estate Inventory: *Four Cézannes.* Gustave Geffroy's Inventory: *Five Cézannes.* Bequest Release: *Two Cézannes.*

Estate Inventory: A picture by Cézanne with gilt frame, "bathers"

Gustave Geffroy's Inventory: The Bathers, one of the most famous canvases by Cézanne, blue and white, firm and colored like a beautiful faïence, some nude figures, a landscape of rocks and clouds

Bequest Release: [not mentioned]

Bathers, 1875/76
Oil on canvas; 82 × 101 cm
The Barnes Foundation, Merion
Fig. 4

Estate Inventory: A canvas by Cézanne, "Fishermen"

Gustave Geffroy's Inventory: A gathering of figures, seated and reclining by the water's edge

Bequest Release: [not mentioned]

NOT IDENTIFIED

Estate Inventory: A landscape by Cézanne with gilt frame

Gustave Geffroy's Inventory: A house with a red roof

Bequest Release: Auvers landscape

ACCEPTED

Farmyard in Auvers, 1879/80
Oil on canvas; 65 × 54 cm
Musée d'Orsay, Paris (RF 2760)
Fig. 5

Estate Inventory: A picture by Cézanne with gilt frame

Gustave Geffroy's Inventory: A southern seascape, water heavy and blue, rocky hills, the stupor of things in the heat, landscape strongly constructed, with a rare alertness and boldness

Bequest Release: L'Estaque

ACCEPTED

L'Estaque, 1878/80
Oil on canvas; 59 × 73 cm
Musée d'Orsay, Paris (RF 2761)
Fig. 6

Estate Inventory: [not mentioned]

Gustave Geffroy's Inventory: A white and blue vase filled with flowers

Bequest Release: [not mentioned]

Flowers in a Rococo Vase, c. 1876

Oil on canvas; 73 × 59 cm

National Gallery of Art, Washington, D.C. (Chester Dale Collection)

Fig. 7

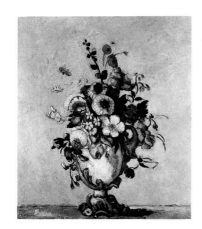

EDGAR DEGAS (1834–1917). Estate Inventory: *Eight Degas.* Gustave Geffroy's Inventory: *Eight Degas, eight pastels.* Bequest Release: *Seven Degas (pastels).*

Estate Inventory: A drawing by Degas with gilt frame, "female singer"

Gustave Geffroy's Inventory: Bust of a ballet dancer, her hair and waist ornamented with blue-green ribbons

Bequest Release: Female café-concert singer

ACCEPTED

Study for a Bust of a Ballet Dancer, erroneously entitled *Female Singer,* c. 1880

Pastel; 59 × 45 cm

Musée d'Orsay, Paris (RF 12260)

Fig. 8

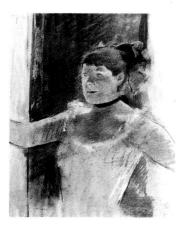

Estate Inventory: A drawing by the same Degas in a white frame

Gustave Geffroy's Inventory: A violinist and a young female dancer

Bequest Release: [not mentioned]

Portrait of a Ballet Dancer at Her Lesson (The Dance Lesson), c. 1879

Pastel; 64 × 56 cm

Left to Renoir, who sold it as early as 1898
The Metropolitan Museum of Art, New York (Anonymous gift, H. O. Havemeyer Collection)

Fig. 9

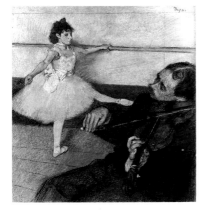

Estate Inventory: A drawing by Degas in a white frame, "The Chorus"

Gustave Geffroy's Inventory: A row of super-numeraries in sixteenth-century costume, tights, slashed sleeves, *mi-parties*, false beards, open mouths, enormous outstretched hands, bow legs, a solemn oath to the death for their country, bawled for forty sous

Bequest Release: The Chorus

ACCEPTED

The Chorus, also known as *The Supernumeraries,* 1876/77

Pastel; 27 × 31 cm

Musée d'Orsay, Paris (RF 12259)

Fig. 10

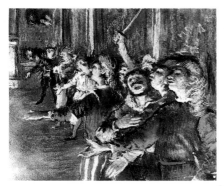

Estate Inventory: A drawing by Degas, "Boulevard Café"

Gustave Geffroy's Inventory: A café in which four women await propositions, four *demoiselles* tired, faded, with slumping bodies, and a singularly expressive gestural dialogue between two of them, one pushing her thumb up against her teeth: "Not that!," the other taking in this confidence in a dazed stupor. It is simultaneously comic and pitiful, a page of Parisian mores, rendered with superb mastery. In the background, reflected in a mirror, the landscape of the boulevard

Bequest Release: Café, boulevard de Montmartre

ACCEPTED

Women on the Terrace of a Café in the Evening, 1877
Pastel; 41 × 60 cm
Musée d'Orsay, Paris (RF 12257)
Fig. 11

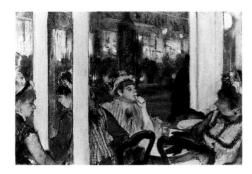

Estate Inventory: A drawing by Degas, "The Toilette"

Gustave Geffroy's Inventory: A woman at her toilette

Bequest Release: The *cabinet de toilette*

ACCEPTED

Squatting Woman Seen from Behind, 1876/77
Pastel; 18 × 14 cm
Musée d'Orsay, Paris (RF 12254)
Fig. 12

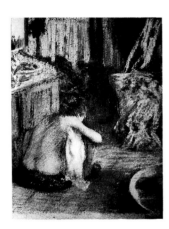

Estate Inventory: A pastel by Degas, "The Bath"

Gustave Geffroy's Inventory: A woman leaving the bath: her maid wraps her in a bathrobe

Bequest Release: Leaving the bath

ACCEPTED

Woman Leaving the Bath, 1876/77
Pastel; 16 × 21 cm
Musée d'Orsay, Paris (RF 12255)
Fig. 13

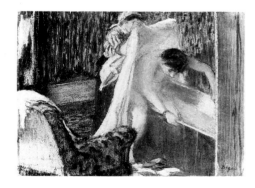

Estate Inventory: Two pastels by Degas, "ballet dancers"

Gustave Geffroy's Inventory: A ballet dancer seated, leaning over, one hand on her foot

Bequest Release: Seated dancer

ACCEPTED

Seated Dancer, 1881/83
Pastel; 62 × 49 cm
Musée d'Orsay, Paris (RF 22712)
Fig. 14

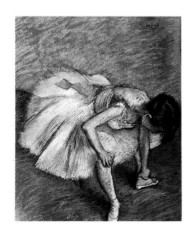

Estate Inventory: [see above]

Gustave Geffroy's Inventory: A ballet dancer who bounds onto the stage, robust yet light, alert like a bird, open like a flower, standing on one leg, her arms in arabesque

Bequest Release: Ballet dancer on stage

ACCEPTED

Ballet (The Star), 1876/77

Pastel; 58 × 42 cm

Musée d'Orsay, Paris (RF 12258)

Fig. 15

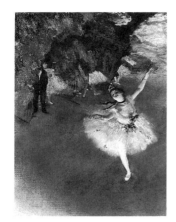

EDOUARD MANET (1832–1883). Estate Inventory: *Three Manets.* Gustave Geffroy's Inventory: *Four Manets.* Bequest Release: *Three Manets.*

Estate Inventory: A large picture by Manet, "at the balcony"

Gustave Geffroy's Inventory: The Balcony previously seen at the Salon, three figures in the light, in front of a dark room, a man and two women, summer attire, transparent sleeves, the harmony of a beautiful brunette, a white dress, the balcony, and green window shutters

Bequest Release: The Balcony

ACCEPTED

The Balcony, 1868/69

Oil on canvas; 170 × 124 cm

Musée d'Orsay, Paris (RF 2772)

Fig. 16

Estate Inventory: A picture by Manet in a gilt frame, "woman with a fan"

Gustave Geffroy's Inventory: The portrait of a woman with a black fan, an energetic, angular, battered face, from the period of Manet's return from Spain

Bequest Release: Angelina

ACCEPTED

Angelina, 1865

Oil on canvas; 92 × 73 cm

Musée d'Orsay, Paris (RF 3664)

Fig. 17

Estate Inventory: A picture by Manet in a gilt frame, "le crocket" [*sic*]

Gustave Geffroy's Inventory: The game of croquet painted at Sainte-Adresse, delicious painting, firm, calm, seven figures, an atmosphere traversed by gusts of wind visible in the gestures, the sails, the flags

Bequest Release: The Croquet Game

REJECTED

The Croquet Game, 1871

Oil on canvas; 47 × 73 cm

Location unknown (see Rouart and Wildenstein 1975, no. 173, repr.)

Fig. 18

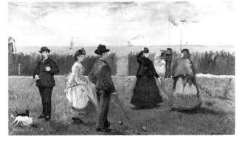

Estate Inventory: [not mentioned]

Gustave Geffroy's Inventory: A small sketch of racehorses

Bequest Release: [not mentioned]

The Races, 1865

Oil on canvas; 32 × 41 cm

Location unknown (see Rouart and Wildenstein 1975, no. 96, repr.)

Fig. 19

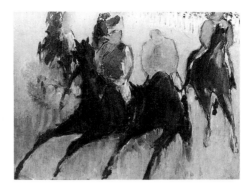

CLAUDE MONET (1840–1926). Estate Inventory: *Sixteen Monets.* Gustave Geffroy's Inventory: *Sixteen Monets.* Bequest Release: *Sixteen Monets.*

Estate Inventory: A picture by Claude Monet, Seascape

Gustave Geffroy's Inventory: Wild seacoast, the most grandiose, the most beautiful of the series painted at Belle-Ile-sur-Mer, everything of a melancholy sumptuousness, the grandeur of the solitude of the ocean

Bequest Release: The Rocks of Belle-Ile

ACCEPTED

The Rocks of Belle-Ile, 1886

Oil on canvas; 65 × 81 cm

Musée d'Orsay, Paris (RF 2777)

Fig. 20

Estate Inventory: Another by the same with gilt frame, "snow"

Gustave Geffroy's Inventory: [View of Vétheuil], the Seine under hoarfrost

Bequest Release: Hoarfrost at Vétheuil

ACCEPTED

Hoarfrost (Vétheuil), 1880

Oil on canvas; 61 × 100 cm

Musée d'Orsay, Paris (RF 2706)

Fig. 21

Estate Inventory: A picture by Claude Monet with painted wooden frame, "after the luncheon"

Gustave Geffroy's Inventory: A large canvas: the Luncheon, a cleared table, plums, peaches, bread, a coffeepot, a garden in bloom, a child in the foreground, two women in the background

Bequest Release: After the Luncheon

ACCEPTED

The Luncheon (Monet's Garden at Argenteuil), c. 1873

Oil on canvas; 160 × 201 cm

Musée d'Orsay, Paris (RF 2774)

Fig. 22

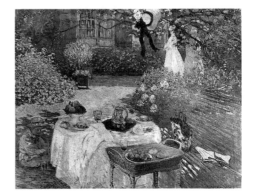

Estate Inventory: A picture by Claude Monet, "interior"

Gustave Geffroy's Inventory: A blue room lit from without, some plants, some hangings, a child

Bequest Release: Interiors [*sic*] in the country
ACCEPTED

Apartment Interior, 1875
Oil on canvas; 81 × 60 cm
Musée d'Orsay, Paris (RF 2776)
Fig. 23

Estate Inventory: A picture by Claude Monet with gilt frame, "Gare Saint-Lazare"

Gustave Geffroy's Inventory: Three views of train stations, bridges, houses, locomotives, smoke, trembling ground, the sonorous fragility of the glass shed

Bequest Release: Gare Saint-Lazare (picture)
ACCEPTED

Gare Saint-Lazare, 1877
Oil on canvas; 75 × 104 cm
Musée d'Orsay, Paris (RF 2775)
Fig. 24

Estate Inventory: Two canvases by Claude Monnet [*sic*], "railroad"

Gustave Geffroy's Inventory: [see above]

Bequest Release: Gare Saint-Lazare, the signal (study)
REJECTED

Gare Saint-Lazare, the Signal, 1877
oil on canvas; 65 × 81 cm
Niedersächsisches Landesmuseum, Hannover
Fig. 25

Estate Inventory: [see above]

Gustave Geffroy's Inventory: [see above]

Bequest Release: Gare Saint-Lazare (study)
REJECTED

Gare Saint-Lazare, Exterior View, 1877
Oil on canvas; 64 × 81 cm
Private collection
Fig. 26

Estate Inventory: A picture [in a] gilt frame, "Church at Vithreuil [*sic*]"

Gustave Geffroy's Inventory: [View of Vétheuil], church in the snow

Bequest Release: Church at Vétheuil (snow)

ACCEPTED

Church at Vétheuil, Snow, 1878/79
Oil on canvas; 52 × 71 cm
Musée d'Orsay, Paris (RF 3755)
Fig. 27

Estate Inventory: A picture by Claude Monet with gilt frame, "Tree and Flowers"

Gustave Geffroy's Inventory: Apple Trees

Bequest Release: Orchard in Vétheuil

REJECTED

Apple Trees, Vétheuil, 1878
Oil on canvas; 55 × 66 cm
Private collection
Fig. 28

Estate Inventory: A picture by Claude Monet with gilt frame, "[Corner, Forest, or Edge] of the Seine Vithreuil [*sic*]"

Gustave Geffroy's Inventory: [not mentioned]

Bequest Release: The Seine between Vétheuil and La Roche Guyon

REJECTED

The Seine between Vétheuil and La Roche Guyon, 1881
Oil on canvas; 60 × 80 cm
Private collection
Fig. 29

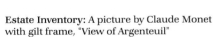

Estate Inventory: A picture by Claude Monet with gilt frame, "View of Argenteuil"

Gustave Geffroy's Inventory: A view of Argenteuil

Bequest Release: End of the Regattas at Argenteuil

ACCEPTED

Regattas at Argenteuil, c. 1872
Oil on canvas; 48 × 75 cm
Musée d'Orsay, Paris (RF 2778)
Fig. 30

Estate Inventory: A picture by Claude Monet with gilt frame, "View of the Tuileries"

Gustave Geffroy's Inventory: [Sketch] A view of the Tuileries, delicious Parisian landscape, gold and pink

Bequest Release: The Tuileries Seen from Rue de Rivoli

ACCEPTED

The Tuileries, 1875
Oil on canvas; 50 × 75 cm
Musée d'Orsay, Paris (RF 2705)
Fig. 31

Estate Inventory: A picture by Claude Monet with gilt frame, "Plain in Argenteuil"

Gustave Geffroy's Inventory: [Sketch] leafless trees in front of a hill

Bequest Release: The Plain near Argenteuil

REJECTED

The Plain near Gennevilliers, 1877
Oil on canvas; 50 × 61 cm
Private collection
Fig. 32

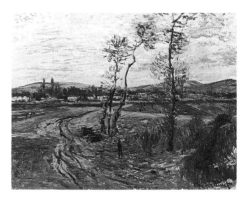

Estate Inventory: Two landscapes

Gustave Geffroy's Inventory: Mont Riboudet at Rouen

Bequest Release: Mont Reboudet [*sic*] at Rouen

REJECTED

Mont Riboudet at Rouen in Spring, 1872
Oil on canvas; 56 × 74 cm
Private collection
Fig. 33

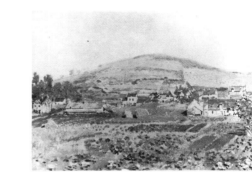

Estate Inventory: [see above]

Gustave Geffroy's Inventory: [Sketch] Blossoming Trees

Bequest Release: Blossoming Plum Trees

REJECTED

Blossoming Plum Trees, 1879
Oil on canvas; 65 × 54 cm
Private collection
Fig. 34

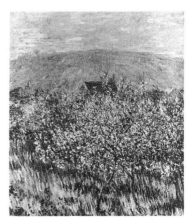

Estate Inventory: A flower picture by Claude Monet

Gustave Geffroy's Inventory: Some red chrysanthemums

Bequest Release: Red chrysanthemums

REJECTED

Red Chrysanthemums, 1880
Oil on canvas; 82 × 65 cm
Private collection
Fig. 35

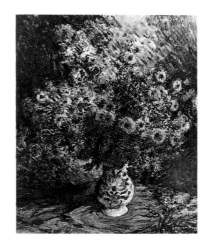

Estate Inventory: [not mentioned]

Gustave Geffroy's Inventory: [Views of Vétheuil] A pink hill

Bequest Release: [not mentioned]

NOT IDENTIFIED

CAMILLE PISSARRO (1830–1903). Estate Inventory: *Thirteen Pissarros.* Gustave Geffroy's Inventory: *Thirteen Pissarros.* Bequest Release: *Eighteen Pissarros [includes five works subsequently discovered by Renoir].*

Estate Inventory: Two landscape pictures by Pissaro [*sic*] with gilt frames; A canvas by Pissaro [*sic*], "woods"; A picture by Pissaro [*sic*], "Village"; A picture by Pissaro [*sic*] with gilt frame; A landscape by Pissaro [*sic*] with gilt frame; A watercolor fan by Pissaro [*sic*]; A landscape by Pissaro [*sic*] with gilt frame; A picture by Pissaro [*sic*], "Forest at Fontainebleau"; A picture by Pissaro [*sic*] with gilt frame, "The Harvest"; A picture by Pissaro [*sic*], "Landscape with garden"; Two pictures by Pissaro [*sic*], "Landscape."

Gustave Geffroy's Inventory: Thirteen landscapes dating from 1871 to 1879: blossoming trees, houses, fields, roads, woods, rivers, beings passing by, peasant occupations. All of the first part of the master landscapist's career is present in this series, which includes pages of unforgettable gentleness, truth, and poetry.

Estate Inventory: [see above]

Gustave Geffroy's Inventory: [see above]

Bequest Release: Corner of a village (winter)

ACCEPTED

Saint-Denis Hill in Pontoise, also known as *The Red Roofs, Corner of a Village in Winter*, 1877
Oil on canvas; 54 × 65 cm
Musée d'Orsay, Paris (RF 2735)
Fig. 36

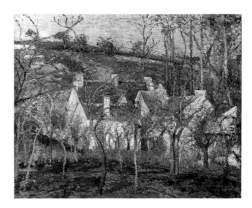

Estate Inventory: [see above]
Gustave Geffroy's Inventory: [see above]
Bequest Release: Louveciennes (71)
REJECTED

Louveciennes, 1871
Oil on canvas; 110 × 160 cm
Private collection
Fig. 37

Estate Inventory: [see above]
Gustave Geffroy's Inventory: [see above]
Bequest Release: A watering place (72)
ACCEPTED

Port-Marly: The Watering Place, 1872
Oil on canvas; 46 × 56 cm
Musée d'Orsay, Paris (RF 2732)
Fig. 38

Estate Inventory: [see above]
Gustave Geffroy's Inventory: [see above]
Bequest Release: Orchard, woman with a wheelbarrow
ACCEPTED

The Wheelbarrow, c. 1881
Oil on canvas; 54 × 65 cm
Musée d'Orsay, Paris (RF 2734)
Fig. 39

Estate Inventory: [see above]
Gustave Geffroy's Inventory: [see above]
Bequest Release: Rising road through the countryside
ACCEPTED

Rising Road through the Countryside, 1879
Oil on canvas; 54 × 65 cm
Musée d'Orsay, Paris (RF 2736)
Fig. 40

Estate Inventory: [see above]

Gustave Geffroy's Inventory: [see above]

Bequest Release: Corner of a village—Cabbages

REJECTED

Corner of a Village—Cabbages, 1875

Oil on canvas; 54 × 65 cm

Location unknown (see Pissarro and Venturi 1939, no. 312, no repr.)

Estate Inventory: [see above]

Gustave Geffroy's Inventory: [see above]

Bequest Release: Kitchen garden, trees in bloom

ACCEPTED

Kitchen Garden and Trees in Bloom, Spring, Pontoise, 1877

Oil on canvas; 65 × 81 cm

Musée d'Orsay, Paris (RF 2733)

Fig. 41

Estate Inventory: [see above]

Gustave Geffroy's Inventory: [see above]

Bequest Release: Valley in summer

REJECTED

The Valley in Summer, Pontoise, 1877

Oil on canvas; 56 × 92 cm

Location unknown (see Pissarro and Venturi 1939, no. 407, no repr.)

Estate Inventory: [see above]

Gustave Geffroy's Inventory: [see above]

Bequest Release: Edge of the woods

REJECTED

Edge of the Woods, 1878

Oil on canvas; 63 × 83 cm

Private collection

Fig. 42

Estate Inventory: [see above]
Gustave Geffroy's Inventory: [see above]
Bequest Release: The Harvest
ACCEPTED

The Harvest at Montfoucault, Brittany, 1876
Oil on canvas; 65 × 92 cm
Musée d'Orsay, Paris (RF 3756)
Fig. 43

Estate Inventory: [see above]
Gustave Geffroy's Inventory: [see above]
Bequest Release: Landscape—rocks
REJECTED

Landscape with Rocks, Montfoucault, 1874
Oil on canvas; 65 × 94 cm
Private collection
Fig. 44

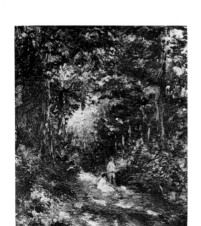

Estate Inventory: [see above]
Gustave Geffroy's Inventory: [see above]
Bequest Release: Woods
REJECTED

Woods with a Man and Seated Woman, 1876
Oil on canvas; 65 × 54 cm
Private collection
Fig. 45

Estate Inventory: [see above]
Gustave Geffroy's Inventory: [see above]
Bequest Release: Wood, summer
ACCEPTED

Path through the Woods, 1877
Oil on canvas; 81 × 65 cm
Musée d'Orsay, Paris (RF 2731)
Fig. 46

Estate Inventory: [see above]
Gustave Geffroy's Inventory: [see above]
Bequest Release: Woods, autumn
REJECTED

Woods in Autumn, Pontoise, 1879
Oil on canvas; 81 × 65 cm
Location unknown (see Pissarro and Venturi 1939, no. 505, no repr.)

Estate Inventory: [see above]
Gustave Geffroy's Inventory: [see above]
Bequest Release: Labor
REJECTED

The Laborer, 1876
Oil on canvas; 54 × 65 cm
Location unknown (see Pissarro and Venturi 1939, no. 340, repr.)

Estate Inventory: [see above]
Gustave Geffroy's Inventory: [see above]
Bequest Release: Barley
REJECTED

The Rye Fields, Pontoise, Seen from the Mathurins, 1877
Oil on canvas; 56 × 92 cm
Location unknown (see Pissarro and Venturi 1939, no. 406, repr.)
Fig. 47

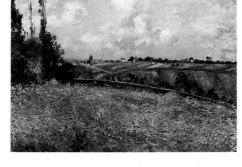

Estate Inventory: [see above]
Gustave Geffroy's Inventory: [see above]
Bequest Release: Garden in bloom
REJECTED

Garden in Bloom, Pontoise, 1876
Oil on canvas; 39 × 56 cm
Private collection
Fig. 48

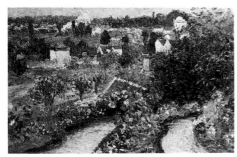

Estate Inventory: [see above]
Gustave Geffroy's Inventory: [see above]
Bequest Release: Fan
REJECTED

Workers in the Fields (Fan), c. 1883
Gouache on silk (?); 14 × 53 cm
Location unknown (see Pissarro and Venturi 1939, no. 1625, repr.)

PIERRE AUGUSTE RENOIR (1841–1919). Estate Inventory: *Eight Renoirs.* Gustave Geffroy's Inventory: *Eight Renoirs.* Bequest Release: *Eight Renoirs.*

Estate Inventory: A picture by Renoir, "The Ball"

Gustave Geffroy's Inventory: The admirable Moulin de la Galette, the poetry of Paris, the intoxication of dancing, of love, of the sun

Bequest Release: The Moulin de la Galette

ACCEPTED

Ball at the Moulin de la Galette, 1876
Oil on canvas; 131 × 175 cm
Musée d'Orsay, Paris (RF 2740)
Fig. 49

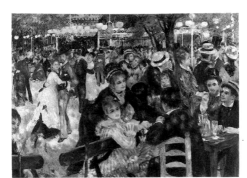

Estate Inventory: A canvas by Renoir, "en plein air"

Gustave Geffroy's Inventory: A torso of a nude woman, flesh that's delicate, healthy, speckled with light

Bequest Release: Torso of a nude woman

ACCEPTED

Study, also known as
Torso of a Woman in Sunlight, 1875/76
Oil on canvas; 81 × 65 cm
Musée d'Orsay, Paris (RF 2740)
Fig. 50

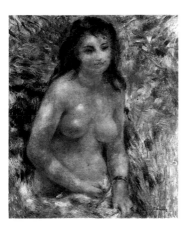

Estate Inventory: A canvas by Renoir, "banks of the Seine"

Gustave Geffroy's Inventory: The Seine at Champrosay

Bequest Release: Banks of the Seine at Champrosay

ACCEPTED

Banks of the Seine at Champrosay, 1876
Oil on canvas; 55 × 66 cm
Musée d'Orsay, Paris (RF 2737)
Fig. 51

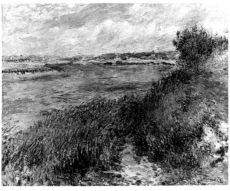

Estate Inventory: A picture with gilt frame, "The Reader"

Gustave Geffroy's Inventory: A head of a woman reading

Bequest Release: Reader

ACCEPTED

The Reader, 1874/76
Oil on canvas; 46 × 38 cm
Musée d'Orsay, Paris (RF 3757)
Fig. 52

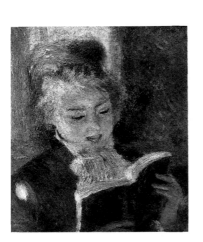

Estate Inventory: A picture by Renoir with gilt frame, "île de Croissy"

Gustave Geffroy's Inventory: The Châtou Bridge

Bequest Release: The Railroad Bridge at Châtou

ACCEPTED

The Railroad Bridge at Châtou, 1881
Oil on canvas; 54 × 65 cm
Musée d'Orsay, Paris (RF 3758)
Fig. 53

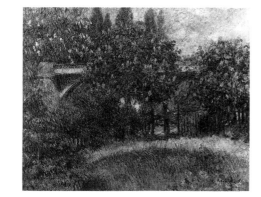

Estate Inventory: A picture by Renoir with gilt frame, "the swing"

Gustave Geffroy's Inventory: The Swing, a young woman hanging in space, an apotheosis of youth in green surroundings

Bequest Release: The Swing

ACCEPTED

The Swing, 1876
Oil on canvas; 92 × 73 cm
Musée d'Orsay, Paris (RF 2738)
Fig. 54

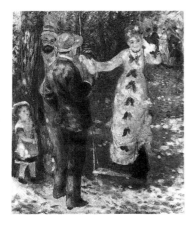

Estate Inventory: A picture by Renoir, corner of the old Place Saint-Georges

Gustave Geffroy's Inventory: Place Saint-Georges

Bequest Release: Place Saint-Georges

REJECTED

Place Saint-Georges, c. 1875
Oil on canvas; 65 × 54 cm
Private collection
Fig. 55

Estate Inventory: A landscape by Renoir with gilt frame

Gustave Geffroy's Inventory: Montmartre

Bequest Release: Montmartre landscape

REJECTED

Château des Brouillards, c. 1890
Oil on canvas; 60 × 74 cm
Private collection
Fig. 56

Young Girls at the Piano, 1892, oil on canvas; 117 × 90 cm, private collection, inscribed "*à mon ami G. Caillebotte*," should also be listed here. It is possible that Gustave Caillebotte owned other works by Renoir that the latter chose to exclude from the bequest.

Fig. 57

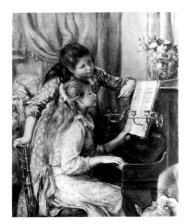

ALFRED SISLEY (1839–1899). Estate Inventory: *Eight Sisleys.* Gustave Geffroy's Inventory: *Eight Sisleys.* Bequest Release: *Nine Sisleys [includes one work subsequently discovered by Renoir].*

Gustave Geffroy's Inventory: Eight land-scapes, from 1877 to 1885: views of Saint-Mammès, the Seine, boats, houses, a farmyard, English regattas, the joyous decor of water and sky

Estate Inventory: Two landscape canvases by Sisley
Gustave Geffroy's Inventory: [see above]
Bequest Release: The Seine at Suresnes
ACCEPTED

The Seine at Suresnes, 1877
Oil on canvas; 60 × 73 cm
Musée d'Orsay, Paris (RF 2786)
Fig. 58

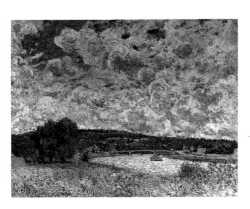

Estate Inventory: [see above]
Gustave Geffroy's Inventory: [see above]
Bequest Release: Banks of the Seine, Evening
REJECTED

Banks of the Seine, Sunset, n.d.
Oil on canvas; 50 × 70 cm
Private collection
Fig. 59

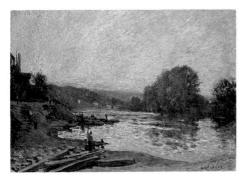

Estate Inventory: A picture by the same, "village habitations"

Gustave Geffroy's Inventory: [see above]

Bequest Release: Street in Louveciennes

ACCEPTED

A Street in Louveciennes, c. 1876
Oil on canvas; 55 × 45 cm
Musée d'Orsay, Paris (RF 2783)
Fig. 60

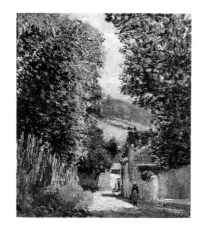

Estate Inventory: a picture by Sisley, "regattas"

Gustave Geffroy's Inventory: [see above]

Bequest Release: Regattas near London

ACCEPTED

The Regattas at Molesey, near Hampton Court, 1874
Oil on canvas; 66 × 91 cm
Musée d'Orsay, Paris (RF 2787)
Fig. 61

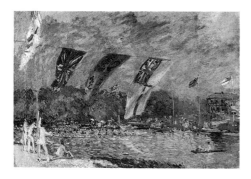

Estate Inventory: [not mentioned]

Gustave Geffroy's Inventory: [see above]

Bequest Release: Farm near Moret

ACCEPTED

Edge of the Forest in Spring, 1885
Oil on canvas; 60 × 73 cm
Musée d'Orsay, Paris (RF 2784)
Fig. 62

Estate Inventory: A picture by Sisley with gilt frame, "banks of a river"

Gustave Geffroy's Inventory: [see above]

Bequest Release: Bridge at Billancourt (under repair)

REJECTED

Seine at Billancourt, n.d.
Oil on canvas; 28 × 36 cm
Private collection
Fig. 63

Estate Inventory: A landscape picture by Sisley

Gustave Geffroy's Inventory: [see above]

Bequest Release: A courtyard in Saint-Mammès

ACCEPTED

Farmyard in Saint-Mammès, 1884
Oil on canvas; 73 × 93 cm
Musée d'Orsay, Paris (RF 2700)
Fig. 64

Estate Inventory: A seascape picture by Sisley with gilt frame

Gustave Geffroy's Inventory: [see above]

Bequest Release: Boat dock at Auteuil

REJECTED

Boat Dock at Auteuil, 1878
Oil on canvas; 46 × 55 cm
Location unknown

Estate Inventory: A picture by Sisley with gilt frame, "Banks of the Loing"

Gustave Geffroy's Inventory: [see above]

Bequest Release: Saint-Mammès

ACCEPTED

Saint-Mammès, 1885
Oil on canvas; 54 × 73 cm
Musée d'Orsay, Paris (RF 2785)
Fig. 65

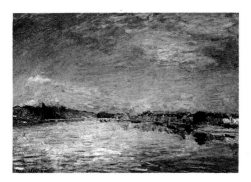

Sailing Chronology

1879

The sailing vessel *Iris* "belonging to Gustave Caillebotte" is mentioned on a poster listing the boats of members of the Cercle de la Voile de Paris in 1879 (Musée du Vieil-Argenteuil). The center of the club's activities is the Argenteuil boat basin on the Seine, twenty minutes by train from Gare Saint-Lazare, and it has Paris offices on rue Saint-Lazare. The *Iris* seems to have been Caillebotte's first sailboat (in 1878 it still belonged to one M. Durand; see *Le Yacht* [6 July]). In the course of the season, Caillebotte wins two first and two second prizes with it (*Le Yacht* [28 Feb. 1880]).

2 and 16 Nov. Caillebotte's yacht, *Iris*, wins two second prizes in regattas at Argenteuil organized by the Cercle de la Voile de Paris (medals, family archives).

1880

9 Jan. Gustave Caillebotte becomes one of the two vice-presidents of the Cercle de la Voile de Paris (*Le Yacht*, [17 Jan.]).

22 Feb. "Debut of the *Inès* belonging to M. G. Caillebotte, which from the present must be ranked first among the best Parisian vessels" (*Le Yacht*, [28 Feb.]).

Mar. The artist takes part in several regattas at Argenteuil and uses in addition a smaller yacht, the *Condor* (*Le Yacht*, 13 and 29 Mar.), also first launched in Feb. 1880 (*Le Yacht*, 18 June 1881, which publishes the plans and special features of this now-famous boat).

15 Apr. Regatta in Argenteuil in which the *Condor* competes, trying out its silk sails and leading the field (*Le Yacht*, 1 May).

30 May. Grand International Regatta of the Cercle de la Voile de Paris, in which both the *Condor*, "belonging to M. Caillebotte," and the *Inès*, "belonging to G. Caillebotte," figure among the competitors (poster, Musée du Vieil-Argenteuil); as is often the case, Martial is at the helm of the *Condor*, which takes first place; a drawing of the vessel is published in *Le Yacht* on 5 June.

Late June. The *Inès* "departs for the sea," sailing down the Seine from Argenteuil, and arrives in the port at Le Havre on 29 June (*Le Yacht*, 3 and 10 July), preceded by a favorable reputation: "The *Inès*, the 8-ton, drop-keel wherry belonging to M. G. Caillebotte, is the fastest of the Argenteuil sailing vessels."

11 and 12 July. Caillebotte participates in the Le Havre regattas, winning a first and a sec-

ond prize (*Le Yacht*, 10 and 17 July; medals, family archives).

25 and 26 July. The *Inès* competes in the Trouville regattas: disqualified because of a collision on the 25th, it wins a heroic victory on the 26th, "sailed by Gustave and Martial Caillebotte, Lamy and Emile Jean Fontaine," in conditions of "strong wind, rain, hail, gusts" that prevent many boats from leaving port, and returns half full of water (*Le Yacht*, 31 July 1880 and 30 July 1881).

22 Aug. The *Inès* wins a first prize and a *prix d'honneur* at the Fécamp regattas (*Le Yacht*, 4 Sept.).

3 Oct. The *Inès* is entered in its first fall regatta at Argenteuil (*Le Yacht*, 9 Oct.) and wins one last time on 16 Nov. (*Le Yacht*, 20 Nov.). In the course of the season, the *Inès* has garnered ten first prizes, one second prize, 1,650 francs, a gold medal, a silver-gilt medal, five silver medals, and an "objet d'art" signed by Rose Duchemin (*Le Yacht*, 19 Feb. 1881).

1881

13 Mar. The *Inès* participates in its first regatta of the season in Argenteuil (*Le Yacht*, 19 Mar.).

29 May. The *Inès* wins the third prize of the Cercle de la Voile de Paris (medal, family archives).

5 June. The *Inés* wins the third *prix d'honneur* of the Cercle de la Voile de Paris (medal, family archives).

29 June. The *Inés* is towed down the Seine from Argenteuil to Le Havre, along with other sailboats from the Cercle de la Voile de Paris, via Duclair and Quillebeuf-sur-Seine, and arrives in Trouville in early July.

July and early Aug. The *Inès* takes part in the Le Havre and the Trouville regattas, respectively, performing well in both (*Le Yacht*, 23 July, which publishes plans of the vessel).

30 July. *Le Yacht* publishes an article signed "G. C.," described by the magazine as an "amateur from Argenteuil of considerable competence," defending ballasted, drop-keel vessels such as the *Inès*, which has demonstrated the design's excellence both in river waters and at sea.

Late Aug. The *Inès* is still in the Trouville boat basin (*Le Yacht*, 20 Aug.).

3 Sept. The *Inès* leaves Trouville to take part in the small regatta of Le Havre, which it wins in conditions of strong wind (*Le Yacht*, 10 Sept.).

2 Oct. The *Inès* is back in Argenteuil and participates in the first regatta of the season, but, "tired," it only places second; this disappointment is compensated by a victory on 1 Nov. (*Le Yacht*, 8 Oct. and 12 Nov.).

Dec. Gustave Caillebotte is named president of the subcommittee of the regatta society of Cabourg, Dives, Benzeval, and Houlgate, and assumes responsibility for organizing the regattas between Cabourg and Houlgate (*Le Yacht*, 10 Dec.).

1882

May. The *Inès* is sold to a boating enthusiast in Rouen (*Le Yacht*, 3 June).

4 June. "On Sunday 4 June was launched in Argenteuil from the dockyards of [boat builder] Texier, Jr. the *Jack*, a 10-ton, drop-keel cutter belonging to M. G. Caillebotte. This yacht was specially constructed after plans drawn up by its owner and M. Brault [Maurice Brault, an engineer, boating enthusiast, and longtime friend of the Caillebotte family] in view of a match to be run . . . against a 20-ton and that will consist of a round-trip circuit from Le Havre to the Isle of Wight and then back to Le Havre" (*Le Yacht*, 10 June).

6 July. After some final adjustments, the *Jack* is towed by Brault's steam-driven vessel, the *Casse-Museau*, to the port at Le Havre, where it is to compete in the regattas (*Le Yacht*, 10 June and 1, 8, and 22 July).

23 and 24 July. The *Jack* takes part in the Le Havre regattas and places fourth in the first race (*Le Yacht*, 29 July).

6 and 7 Aug. The *Jack* is in Trouville but does not race in the regattas (*Le Yacht*, 12 Aug.).

18 Aug. While towing the *Jack* and the English yacht *Coryphée* out of the Trouville boat basin, the pilot of the *Elan*, one Bouquin, severs both his legs while trying to avoid an accident; he dies two days later (*Le Yacht*, 26 Aug.).

Late Sept. "The yachts *Jack*, *Hélène*, and *Alida*, all three from the Cercle de la Voile de Paris, have returned from an excursion they made in convoy to Cowes" (*Le Yacht*, 23 Sept.).

Nov. "MM. Caillebotte and Brault have just purchased in England a charming little 2-ton cutter, the *Diver*, built by Luke of Southampton" (*Le Yacht*, 11 Nov.). When the boat arrives in Argenteuil in the spring of 1882, it is said to belong to MM. Dubois and G. Caillebotte, and it takes part in several regattas (*Le Yacht*, 31 Mar., 14 Apr., and 5 May).

1883

5 and 6 Aug. Gustave Caillebotte sails his new vessel, the *Cul-blanc*, in the Trouville regattas, winning a first prize (*Le Yacht*, 11 Aug.).

25 Aug. The *Cul-blanc* wins a first prize in the Cabourg regattas (*Le Yacht*, 1 Sept.).

30 Sept. The *Cul-blanc* is back in Argenteuil and will participate in regattas on 21 and 28 Oct. (*Le Yacht*, 6 and 27 Oct. and 10 Nov.).

1884

Mar. The *Cul-blanc*, a competitor in the Argenteuil regattas, held on 9, 16, and 30 Mar., comes in first on the 30th (*Le Yacht*, 15 and 22 Mar., and 16 Apr.).

6 Apr. Under the chairmanship of Martial Caillebotte, a regatta is held in which the *Bibi*, belonging to Gustave Caillebotte, takes part (*Le Yacht*, 19 Apr.).

10 Apr. A night match in Argenteuil pitting the *Cul-blanc* against Brault's *Eclaireur* is canceled after the two boats collide, as is another scheduled match, and for the same reason, that between the *Cul-blanc* and the *Turquoise*, belonging to M. Michelet, owner of the Château Michelet (one of the recently built, middle-class residences in Argenteuil). A vice-president of the Cercle like Caillebotte, Michelet is one of his boating colleagues (*Le Yacht*, 19 Apr.).

13 Apr. The *Cul-blanc* comes in second after the *Condor* (*Le Yacht*, 3 May).

27 Apr. The *Cul-blanc* wins a second prize from the Cercle de la Voile de Paris (medal, family archives).

11 May. The *Cul-blanc* wins a regatta in Argenteuil (*Le Yacht*, 17 May).

May. On 24 May, *Le Yacht* declares the most famous painter of Argenteuil to be Avé, who exhibits in the 1884 Salon *La Berge et le port d'Argenteuil*, which it reproduces as a drawing. This artist also illustrates the Argenteuil international regatta on 1 June (*Le Yacht*, 14 June).

1 June. "The *Cul-blanc*, sailed by M. Martial Caillebotte, has taken its revenge against the *Condor*, sailed by Texier, Jr." (*Le Yacht*, 7 June); but Gustave Caillebotte still appears to own the *Cul-blanc*, even though he now also owns the *Bibi*, in which he takes first place on 8 June before being disqualified (*Le Yacht*, 14 June).

July. In the Le Havre regatta on 13 July, the *Cul-blanc*, "with its immense silk shoulder-of-mutton sail," starts out well but is forced to withdraw due to insufficient wind (*Le Yacht*, 19 July); things go better at the Trouville regatta on 27 July (*Le Yacht*, 2 Aug.).

28 Sept. The *Cul-blanc* takes a first prize in Argenteuil (*Le Yacht*, 4 Oct.).

4 Oct. The *Bibi*, "belonging to M. Caillebotte," is beaten by the *Pschutt*, "belonging to M. Dubois" (*Le Yacht*, 18 Oct.).

26 Oct. and 1 Nov. Caillebotte's *Cul-blanc* takes first prize on 26 Oct. The *Eclaireur*, "belonging to M. Brault [and] sailed by M. Gustave Caillebotte," beats the *Cul-blanc*, doubtless sailed on this occasion by Martial, on 1 Nov. (*Le Yacht*, 1 and 15 Nov.).

1885

14 Feb. Gustave Caillebotte and Brault publish an article in *Le Yacht* about the establishment of a new tonnage standard for yachts.

14 Mar. A letter from Caillebotte on the new tonnage standard is published in *Le Yacht*.

26 Apr. The *Cul-blanc* takes part in a regatta in Argenteuil (*Le Yacht*, 2 May).

10 and 24 May. The *Cul-blanc* races in more regattas in Argenteuil (*Le Yacht*, 16 and 30 May).

21 June. The *Cul-blanc*, sailed by Caillebotte and Eugène Lamy, competes in a match with the *Eclaireur* of Brault and Chevreux (*Le Yacht*, 30 June). On Chevreux, see 19 June 1886.

2 and 3 Aug. The *Cul-blanc* competes successfully in the Trouville regattas (*Le Yacht*, 15 Aug.).

17 Aug. The *Cul-blanc* participates in a regatta in Cabourg-Dives, following a gala dinner at the Grand Hôtel de la Plage (*Le Yacht*, 29 Aug.).

19 Sept. *Le Yacht* announces that one of the prizes in the fall regattas in Argenteuil will be an "objet d'art" donated by "G. C."

Oct.–Nov. The *Cul-blanc* takes part in the fall regattas in Argenteuil (*Le Yacht*, 10 and 31 Oct., and 7 Nov.).

1886

19, 20, and 22 Jan. Gustave and Martial Caillebotte represent the Société des Régates de Trouville-Deauville (and Brault that of Dives) at the Congrès des Sociétés Nautiques, held in Paris. Gustave is a member of the commission charged with preparing rules for sailboat races and proposing a new tonnage scale; he is vocal in the debates (*Le Yacht*, 23 and 30 Jan.).

Mar.–June. The *Cul-blanc* regularly takes part in Argenteuil competitions, with varying results (*Le Yacht*, 10 Apr.; 1, 8, and 15 May; and 19 June), but it finishes the season brilliantly: "M. G. Caillebotte and M. Lamy have proven once again not only that they pilot two of the best boats in Argenteuil but also that they are elite sailors"; Martial Caillebotte is designated as the owner of the *Cul-blanc* (*Le Yacht*, 26 June).

19 June. *Le Yacht* announces the establishment of a new boatyard at Petit Gennevilliers, operating for the last three months under the direction of Maurice Chevreux, civil engineer of nautical construction; one of the vessels then under construction is the *Mouquette*, Caillebotte's new ballasted 5-tonner. This boatyard will build Caillebotte's subsequent boats.

1, 2, and 4 Aug. The *Mouquette*, which had raced only once before, debuts in the Trouville regattas and wins a first prize on the second day (*Le Yacht*, 7 Aug.).

8 and 9 Aug. The *Mouquette*, which had entered the port at Le Havre on 7 Aug., wins a first and a second prize in the Le Havre regattas (*Le Yacht*, 14 Aug.; see drawing by M. Koerner in *Le Yacht*, 21 Aug.).

21 Aug. The *Mouquette* places second, ahead of the *Turquoise* owned by Michelet, in the Cabourg-Dives regattas (*Le Yacht*, 28 Aug.).

Early Oct. "We have been informed that management of the boatyard in Petit Gennevilliers has been turned over to M. F[erdinand]. Luce. M. Chevreux remains affiliated with the yard as consulting engineer" (*Le Yacht*, 2 Oct.); this boatyard is outfitted with modern equipment (notably the sliding carriage of the engineer Suc, used to launch the *Mouquette* and reproduced in *Le Yacht*, 23 Oct.).

3 and 10 Oct. Caillebotte once more sails the *Cul-blanc* (*Le Yacht*, 16 Oct.).

1887

26 Feb. A drawing of the *Mouquette* appears in *Le Yacht*.

5 Mar. In a letter to the editor of *Le Yacht*, published under the heading "La Mouquette et le Pingouin," Gustave Caillebotte attests to the superiority of ballasted over drop-keeled vessels.

Spring. From Mar. to May, the *Mouquette* and the *Cul-blanc* win several regattas in Argenteuil with Caillebotte at the helm; in May the *Cul-blanc* no longer belongs to him (*Le Yacht*, 2 and 30 Apr., and 14 May).

3 July. "The cutter *Mouquette* belonging to M. G. Caillebotte, having set out from Argenteuil, arrived in Le Havre on 3 July" (*Le Yacht*, 9 July).

10 and 11 July. The *Mouquette*, disqualified from the Le Havre regattas on the 10th, qualifies for those on the 11th (*Le Yacht*, 16 July).

7 and 8 Aug. The *Mouquette* withdraws from the Trouville regattas due to insufficient wind (*Le Yacht*, 20 Aug.).

22 Sept. and Nov. Caillebotte launches the *Thomas*, designed by Chevreux and built in the Petit Gennevilliers boatyard, to compete against the *Condor*, which he has just sold. This was to be one of the artist's most famous boats; it wins its first victory in Argenteuil in Nov. (*Le Yacht*, 24 Sept. 1887 and 9 Aug. 1890).

1888

Mar.–May. Gustave Caillebotte's *Thomas* takes part in the spring regattas in Argenteuil and wins a first prize on 27 May (*Le Yacht*, 17 Mar., 7 Apr., 19 May, and 2 June).

Summer. The *Mouquette*, which enters the port of Le Havre on 27 June, places first in the regattas there on 15 July, but it is not clear whether it still belongs to Caillebotte. In Aug. it is clearly identified as the property of one M. Billard (*Le Yacht*, 21 July, and 4 and 11 Aug.). The *Thomas*, with the artist at the helm, competes in the Trouville regattas on 27, 30, and 31 July, winning a first prize and a *prix d'honneur*, and in the Le Havre regattas on 11–13 Aug.; having suffered damage, it does not take part in the Cabourg-Dives regatta on 16 Aug. (*Le Yacht*, 4, 11, 18, and 25 Aug.).

Sept.–Nov. The *Thomas* participates in the fall regattas in Argenteuil, placing first in the second one, on 4 Nov. (*Le Yacht*, 6, 13, and 20 Oct., and 10 Nov.).

1889

Spring. From March to June, the *Thomas* consistently places first in the Argenteuil

regattas (*Le Yacht*, 30 Mar.; 20 Apr.; 4, 11, and 25 May; and 8 June).

6–8 July. The *Thomas* places third and second in the Le Havre regattas, and a drawing of it and its four crew members appears prominently in *Le Yacht* (13 July).

3–5 Aug. The *Thomas* enjoys further successes in the Trouville regattas (*Le Yacht*, 10 Aug.).

1890

10 Jan. Gustave Caillebotte publishes an article in *Le Yacht*.

Spring. From Mar. to June, the *Thomas* wins several of the Argenteuil regattas (*Le Yacht*, 29 Mar.; 5, 19, and 26 Apr.; and 7 June).

12 July. The *Thomas* wins a regatta in Duclair (*Le Yacht*, 19 July).

27 July. The *Thomas* is beaten in a regatta in Le Havre (*Le Yacht*, 2 Aug.).

3 and 4 Aug. The *Thomas* wins a *prix d'honneur* in the Trouville regattas; by this time, the vessel has taken part in fifty-two races, won thirty-three first prizes, five *prix d'honneur*, five second prizes, and two third prizes (*Le Yacht*, 9 Aug., with a drawing of the *Thomas*).

Mid-Aug. "The *Thomas* of M. G. Caillebotte and the *Pingouin* have returned from their maritime campaign and are once more anchored in Argenteuil" (*Le Yacht*, 16 Aug.).

28 Sept. The *Thomas* takes first place in a regatta in Argenteuil (*Le Yacht*, 11 Oct.); it is sold over the winter and resumes its brilliant career in the spring of 1891 in Brittany under new ownership (*Le Yacht*, 7 Mar. and 23 May).

1891

10 Jan. In a letter to *Le Yacht* signed "G. C.," Gustave Caillebotte participates in an ongoing debate over the viability of powerful sailboats, continuing to defend them despite their considerable cost (2,000 to 2,500 francs).

17 Jan. Caillebotte contributes 500 francs to a fund intended to support the participation of French yachts in international regattas (*Le Yacht*, 17 Jan.).

Early Apr. Caillebotte, owner of the *Haricot*, joins with other sailboat owners (including the writer Guy de Maupassant) in signing a petition sent to the Ministry of the Marine concerning the functioning of the Conseil Maritime (*Le Yacht*, 4 Apr.).

Spring. From Mar. to May, the *Haricot* competes successfully in the Argenteuil regattas; in July Caillebotte sells it to a sailing enthusiast in Bayonne (medal, family archives; *Le Yacht*, 11 and 18 Apr., 16 May, and 25 July).

Oct. A sailboat designed by Caillebotte for M. Taillandier, the *Lézard*, performs superbly in the Argenteuil regattas, which encourages the artist to begin building another vessel for himself and occasions a commission from a M. Valton for the *Rip* (*Le Yacht*, 24 and 31 Oct., and 26 Dec.).

30 Oct. Gustave Caillebotte, in his capacity as town councilman, opposes a tax on boats that, in his view, would discourage pleasure boating (Quiqueré 1993, p. 68).

1892

Mar. "The *Roastbeef*, built for the series of 30 m² sails by Luce in Petit Gennevilliers after plans by M. G. Caillebotte, its owner, is completely finished" (*Le Yacht*, 5 Mar.).

May–June. The *Roastbeef* debuts brilliantly in Argenteuil, winning one first prize and two second prizes on 22 May, 5 June, and 12 June (medals, family archives).

July–Aug. Arriving in the port of Le Havre on 21 July, the *Roastbeef* sails to Trouville on the 26th and places first in the Trouville regattas on Sunday, 31 July (*Le Yacht*, 23 July and 6 Aug.).

9 and 23 Oct. The *Roastbeef* wins a first and second prize in the Argenteuil regattas (*Le Yacht*, 15 and 29 Oct.; medal, family archives).

1893

Jan. Announcement of the construction by the Luce boatyard, after plans by Gustave Caillebotte, of the sailboat *Demi* for Dr. Trousseau (*Le Yacht*, 7 Jan.).

Feb.–Mar. M. Mantois commissions the Luce boatyard to build the *Annette* after plans by Caillebotte, who has also collaborated with Godivet on plans for the *Dahud*, which is already under construction for MM. de Guebriant and de Polignac (*Le Yacht*, 25 Feb.) and is launched on 25 Mar.

Spring. From Apr. to June, Caillebotte wins several prizes with the *Roastbeef* in Argenteuil and Meulan; on 15 Apr., *Le Yacht* illustrates a superb winner's cup (donated by "M. X.") awarded to Caillebotte (see also *Le Yacht*, 22 and 29 Apr.; 6, 20, and 27 May; and 3 June).

2 Aug. The *Roastbeef* places second in the Duclair regattas (*Le Yacht*, 8 July).

6 and 7 Aug. The *Roastbeef* places second and third in the Deauville-Trouville regattas (*Le Yacht*, 12 Aug.).

Early Sept. The *Roastbeef* is sold to M. Caillat (*Le Yacht*, 2 Sept.).

16 and 18 Sept. Caillebotte participates in a regatta at Le Havre on the *Dahud*, which he also sails in Meulan in Oct., but he does not seem to have stayed with the vessel for the entire summer circuit in Brittany (*Le Yacht*, 14 and 21 Oct., and 4 Nov.).

1894

Early Feb. Gustave Caillebotte involves himself in the purchase of land in Meulan for the new headquarters of the Cercle de la Voile de Paris, which has been forced to leave the Argenteuil boat basin because of the construction of a new bridge. He designs a final sailboat, the *Mignon*, completed after his death (Charles and Vibart 1993, p. 114) A. D.

Bibliography

Brackets after author's name indicate his or her exact identity. Author indication by initials and pseudonyms are listed by the first letter.

ANONYMOUS

1876 "Le Salon de 1876." *Le Petit Journal*, 1 Apr.

1877a "Exposition des impressionnistes: 6, rue le Peletier." *La Petite République française*, 10 Apr. Repr. and trans. in Varnedoe 1987.

1877b "L'Exposition des impressionistes." *Le Temps*, 7 Apr.

1879a "Chronique." *Le Temps*, 11 Apr.

1879b "Echos de Paris." *Le Voltaire*, 1 May.

1880 "Revue artistique: les artistes indépendants." *Le Moniteur universel*, 12 Apr.

1882 "Nouvelles parisiennes." *L'Art moderne*, 19 Mar.

1888 "Chez les XX." *La Chronique*, 10 Feb.

1894 "Les Dons au musée du Luxembourg." *Le Journal des artistes*, 22 July.

1966 "French Art Through Half a Century." *Illustrated London News*, 9 July.

A. P. [?]

1877 "Beaux-Arts." *Le Petit Parisien*, 7 Apr.

ADHÉMAR, H. AND A. DAYEZ

1973 *Musée du Louvre. Musée du Jeu de Paume*. Paris.

ADLER, K.

1986 *Manet*. Topsfield, Mass.

BACHELARD, P., ed.

1993 *De Manet à Caillebotte. Les Impressionists à Gennevilliers*. Paris.

BAIGNÈRES, A.

1876 "Exposition de peinture par un groupe d'artistes, rue le Peletier, 11." *L'Echo universel*, 13 Apr.

1880 "5ᵉ Exposition de peinture, par MM. Bracquemond, Caillebotte, Degas, etc." *La Chronique des arts et de la curiosité*, 10 Apr.

BAILLY-HERZBERG, J., ed.

1980 *Correspondance de Camille Pissarro*. Vol. 1, *1865–1885*. Paris.

1988 *Correspondance de Camille Pissaro*. Vol. 3, *1891–1894*. Paris.

1989 *Correspondance de Camille Pissarro*. Vol. 4, *1895–1898*. Paris.

BALANDA, M. J. DE

1988 *Gustave Caillebotte: La Vie, la technique, l'oeuvre peint*. Lausanne.

BALLU, R.

1877a "L'Exposition des peintres impres-

sionnistes." *La Chronique des arts et de la curiosité*, 14 Apr. Repr. in Ballu 1877b; repr. and trans. in Varnedoe 1987.

1877b "L'Exposition des peintres impressionnistes." *Les Beaux-Arts illustrés*, 23 Apr.

BARON SCHOP [BANVILLE, T. DE]

1876 "La Semaine parisienne; l'exposition des intransigeants. L'Ecole des Batignolles. Impressionnistes et plein air." *Le National*, 7 Apr.

1877 "Choses & autres." *Le National*, 8 Apr.

BATAILLE, M. L., AND G. WILDENSTEIN

1961 *Berthe Morisot*. Paris.

BAUDELAIRE, C.

1964 "The Painter of Modern Life." In Jonathan Mayne, trans. and ed. *The Painter of Modern Life and Other Essays*. London.

BEC [PSEUD.]

1879 "Coup d'oeil sur les indépendants." *Le Monde parisien*, 17 May.

BEECH, D. R.

1993 "La Collection Caillebotte formée par M. et G. Caillebotte de Paris." Trans. M. Barette. *Britannica* (Oct.).

BENJAMIN, W.

1973 *Charles Baudelaire: A Lyric Poet in the Era of High Capitalism*. Trans. Harry Zahn, London.

BERGERAT, E.

1877 "Revue artistique: les impressionnistes et leur exposition." *Le Journal officiel de la République française*, 17 Apr.

BERHAUT, M.

1948 "Trois Tableaux de G. Caillebotte." *Musées de France*, July.

1951 *Gustave Caillebotte (1848–1894)*. Exh. cat. Paris, Galerie des Beaux-Arts.

1968 *Caillebotte l'impressionniste*. Lausanne.

1977 "Gustave Caillebotte et la réalisme impressionniste." *L'Oeil* 268 (Nov.).

1978 *Caillebotte, sa vie et son oeuvre: catalogue raisonné des peintures et pastels*. Paris.

1994 *Caillebotte, catalogue raisonné des peintures et pastels*. Rev. and expanded ed. Paris, Wildenstein Institute.

BERNAC, J.

1895 "The Caillebotte Bequest to the Luxembourg." *The Art Journal*.

BERTALL [ARNOUX, C. A. D']

1876a "L'Exposition des intransigeants." *L'Audience*, 9 Apr.

1876b "Exposition des impressionnalistes, rue Lepelletier." *Paris-Journal*, 15 Apr. Repr. in "Exposition des impressionnalistes, rue Lepelletier." *Le Soir*, 15 Apr.; and in "Les Impressionnalistes." *Les Beaux-Arts*; repr. and trans. in Varnedoe 1987.

1877 "Exposition des impressionnistes." *Paris-Journal*, 9 Apr.

1879a "Exposition des indépendants." *Paris-Journal*, 14 May. Repr. in Bertall 1879b.

1879b "Exposition des indépendants: ex-impressionnistes, demain intentionistes." *L'Artiste*, 1 June. Repr. and trans. in Varnedoe 1987.

1880 "Les Indépendants. Exposition des ex-impressionnistes, ex-naturalistes, ex-nihilistes, etc., etc." *Paris-Journal*, 7 Apr.

BESSON, L.

1879 "MM. les Impressionnistes," *L'Evénement*, 11 Apr.

BIGOT, C.

1876 "Causerie artistique: l'exposition des intransigeants." *La Revue politique et littéraire*, 8 Apr.

1877 "Causerie artistique. L'Exposition des impressionnistes." *La Revue politique et littéraire*, 28 Apr.

1882 "Beaux-arts: les petits Salons, L'Exposition des artistes indépendants." *La Revue politique et littéraire*, 4 Mar.

BLÉMONT, E. [PETITDIDIER, E.]

1876 "Les Impressionnistes." *Le Rappel*, 9 Apr. Repr. and trans. in Varnedoe 1987.

BLUNDEN, M. AND G.

1970 *Journal de l'impressionnisme*. Paris.

BOCKEMÜHL, M.

1985 "Innocence of the Eye and Innocence of Meaning. Zum Problem der Wirklichkeit in der realistichen Malerei von Gustave Caillebotte." In G. Boehm et al., *Modernität und Tradition. Festchrift für Max Imdahl zum 60 Geburstag*. Munich.

BODELSEN, M.

1968 "Early Impressionist Sales, 1874–1894." *Burlington Magazine* 60, 783 (June).

BOUBÉE, S.

1876 "Beaux-Arts, exposition des impressionistes chez Durand-Ruel." *La Gazette de France*, 5 Apr.

BRETTELL, R.

1986 "The 'First' Exhibition of Impressionist Painters." In San Francisco 1986.

1987 *French Impressionists in The Art Institute of Chicago*. Chicago.

BURTY, P.

1876a "Chroniques du jour." *La République française*, 1 Apr.

1876b "Fine Art, the Exhibition of the 'Intransigeants.'" *The Academy*, 15 Apr. Repr. and trans. in Varnedoe 1987.

1877 "L'Exposition des impressionnistes." *La République française*, 25 Apr. Repr. and trans. in Varnedoe 1987.

1879 "L'Exposition des artistes indépendants." *La République française*, 16 Apr.

1880 "Exposition des oeuvres des artistes indépendants." *La République française*, 10 Apr.

1882 "Les Aquarellistes, les indépendants et le Cercle des arts libéraux." *La République française*, 8 Mar.

CAHN, I.

1989 *Cadres de peintres*. Paris.

CARDON, E.

1880 "Choses d'art: l'exposition des impressionnistes." *Le Soleil*, 5 Apr.

CASTAGNARY, J.

1876 *Le Siècle*, 29 Apr.

1892a "Année 1872." *Salons*. Paris.

1892b "Année 1873." *Salons*. Paris.

1892c "Année 1875." *Salons*. Paris.

1892d "Année 1876." *Salons*. Paris.

CHARDEAU, J.

1983 *Le Figaro*, 2 May.

1989 *Les Dessins de Caillebotte*. Paris.

CHARLES, D., AND E. VIBART

1993 "L'Architecte et son double." In Bachelard 1993.

CHARRY, P.

1880 "Le Salon de 1880: préface, les impressionnistes." *Le Pays*, 10 Apr.

1882 "Beaux-Arts." *Le Pays*, 10 Mar.

CHAUMELIN, M.

1876 "L'Actualité; l'exposition des intransigeants." *La Gazette*, 8 Apr. Repr. and trans. in Varnedoe 1987.

CHESNEAU, E.

1882 "Groupes sympathiques: les peintres impressionnistes." *Paris-Journal*, 7 Mar.

CHEVALIER, F.

1877 "Les Impressionnistes." *L'Artiste*, 1 May. Repr. and trans. in Varnedoe 1987.

CLARETIE, J.

1877 "Le Mouvement parisien—L'Exposition des impressionnistes." *L'Indépendance belge*, 15 Apr.

1879 "Le Mouvement parisien: les *impressionnistes* et les *aquarellistes*," *L'Indépendance belge*, 20 Apr.

CLARK, T. J.

1984 *The Painting of Modern Life: Paris in the Art of Manet and His Followers*. Princeton, N. J.

1985 *The Painting of Modern Life*. New York.

CLAY, J.

1971 *L'Impressionnisme*. Paris.

CLAYSON, H.

1991 *Painted Love: Prostitution in French Art of the Impressionist Era*. New Haven and London.

CREVELIER, J.

1894 *Le Soir*, 8 June.

CORBIN, A.

1987 "Le Secret de l'individu." In Perrot 1990.

COSTANZO, D.

1981 "Cityscape and the Transformation of Paris During the Second Empire." Ph.D. diss., The University of Michigan, Ann Arbor.

DALLIGNY, A.

1880 "L'Exposition de la rue des Pyramides." *Le Journal des arts*, 16 Apr.

DAULTE, F.

1973 *Tout L'Oeuvre peint de Renoir*. Paris.

1977 *Auguste Renoir, Catalogue raisonné de l'oeuvre peint*. Vol. 1, *Figures*. Lausanne.

DAULTE, F., AND C. RICHEBÉ

1971 *Monet et ses amis*. Paris.

1981 *Monet et ses amis*. Paris (2d ed.).

DAX, P.

1876 "Chronique." *L'Artiste*, 1 May.

DEGAS, E.

1988 *Degas*. Exh. cat. Ottawa, National Gallery of Canada; New York, The Metropolitan Museum of Art; and Paris, Grand Palais.

DELAFOND, M.

1987 *Monet et son temps*. Paris.

DELAVILLE, C.

1880 "Chronique parisienne, débauche de la peinture." *La Presse*, 2 Apr.

DEMOLDER, E.

1888a "Chronique artistique. L'Exposition des *XX*.—Mort de M. Mauve.—Exposition de M. Asselbergs." *La Société nouvelle* 38 (Feb.).

1888b "Le Salon des XX. L'Ancient et le nouvel impressionnisme." *L'Art moderne*, 5 Feb.

DE NITTIS, G.

1990 E. Mazzoccoli, ed., and N. Rettmeyer, trans. *Notes et souvenirs, Diario 1870–1884*. Fasano. Orig. pub. as *Notes et souvenirs du peintre Joseph de Nittis*. Paris, 1895.

DISTEL, A.

1987 *Les Collectionneurs d'impressionnistes*. Paris.

DISTEL, A., AND J. HOUSE

1985 *Renoir*. Exh. cat. Paris, Grand Palais.

DRANER [RENARD, J.]

1879 "Chez MM. les Peintres indépendants." *Le Charivari*, 23 Apr.

1882 "Une Visite aux impressionnistes, par Draner." *Le Charivari*, 9 Mar.

DRUICK, D., AND M. HOOG

1982 *Fantin-Latour*. Exh. cat. Ottawa, National Gallery of Canada; and Paris, Grand Palais.

DURANTY, E.

1876 *La Nouvelle Peinture. A Propos Du Groupe d'artistes qui exposent dans les galeries Durand-Ruel*. Paris. Repr. in Caen 1988 and repr. and trans. in San Francisco 1986.

1879 "La Quatrième Exposition faite par un groupe d'artistes indépendants." *La Chronique des arts et de la curiosité*, 19 Apr.

E[CHERAC], A. [D']

1880 "L'Exposition des impressionnistes." *La Justice*, 5 Apr.

ENAULT, L.

1876 "Mouvement artistique—L'Exposition des intransigeants dans la galerie de Durand-Ruelle [*sic*]" *Le Constitutionnel*, 10 Apr. Repr. and trans. in Varnedoe 1987.

EPHRUSSI, C.

1880 "Exposition des artistes indépendants." *Gazette des beaux-arts*, 1 May. Repr. and trans. in Varnedoe 1987.

FÉNÉON, F.

1948 "Les Impressionnistes en 1886." In *Oeuvres*, Paris. Orig. pub. in 1886.

FERNIER, R.

1977 *La Vie et l'oeuvre de Gustave Courbet. Catalogue raisonné*, vol. 1. Lausanne and Paris, Fondation Wildenstein.

FICHTRE [VASSY, G.]

1882 "L'Actualité: l'exposition des peintres indépendants." *Le Réveil*, 2 Mar.

FLOR, C.

1877 "Les Impressionnistes." *Le Courrier de France*, 6 Apr. Signed by Flor Ch. O'Squarr.

1880 "Les Ateliers de Paris: les impressionnistes." *Le National*, 16 Apr. Repr. and trans. in Varnedoe 1987.

FOUQUIER, H.

1880 "Chronique." *Le XIXᵉ Siècle*, 10 Apr.

GACHET, P.

1957 *Lettres impressionnistes*. Paris.

GALASSI, P.

1987 "Caillebotte's Method." In Varnedoe 1987.

GEFFROY, G.

1894 "Notre Temps, Gustave Caillebotte." *La Justice*, 13 June.

1922 *Claude Monet, sa vie, son temps, son oeuvre*, vol. 1. Paris.

1924 *Claude Monet, sa vie, son temps, son oeuvre*, vol. 2. Paris.

GEORGEL, C.

1986 *La Rue*. Paris.

GÉRÔME, N.

1993 In Bachelard, 1993.

GERSTEIN, S.

1989 In *Impressionism: Selections from Five American Museums*. Exh. cat. St. Louis Museum of Art et al.

GOETSCHY, G.
1880 "Indépendants et impressionnistes." *Le Voltaire*, 6 Apr.

GRIMM, T. [VÉRON, P.]
1877 "Les Impressionnistes." *Le Petit Journal*, 7 Apr.

GUÉRIN, M., ed.
1931 *Lettres de Degas*, vol. 1. Paris.
1945 *Lettres de Degas*, vol. 2. Paris.

HAVARD, H.
1879 "L'Exposition des artistes indépendants." *Le Siècle*, 27 Apr.
1880 "L'Exposition des artistes indépendants." *Le Siècle*, 2 Apr.
1882 "Exposition des artistes indépendants." *Le Siècle*, 2 Mar.

HENNEQUIN, E.
1882 "Beaux-Arts: les expositions des arts libéraux et des artistes indépendants." *La Revue littéraire et artistique.*

HEPP, A.
1882 "Impressionnisme." *Le Voltaire*, 3 Mar.

HERBERT, R.
1988 *Impressionism. Art, Leisure, and Parisian Society.* New Haven and London.

HERVILLY, E. D'
1879 "Exposition des impressionnistes." *Le Rappel*, 11 Apr.

HOUSE, J.
1986 *Monet: Nature into Art.* New Haven and London.

HUSTIN, A.
1882 "L'Exposition des peintres indépendants." *L'Estafette*, 3 Mar. Repr. and trans. in Varnedoe 1987.

HUYSMANS, J. K.
1883 *L'Art moderne.* Paris.
1889 *Certains.* Paris.
1902 *L'Art moderne.* Paris. 2d ed.

JACQUES [PSEUD.]
1877 "Menus propos: exposition impressionniste." *L'Homme libre*, 12 Apr.

JAMES, H.
1876 "Parisian Festivity: Cynical Artists." *The New York Tribune*, 13 May.

JAVEL, F.
1880 "L'Exposition des impressionnistes." *L'Evénement*, 3 Apr.

KATOW, P. DE
1882 "L'Exposition des peintres indépendants." *Gil Blas*, 1 Mar.

KENDALL, R., AND G. POLLOCK, eds.
1992 *Dealing with Degas.* New York.

L.
1888 "Correspondance de Belgique." *La Chronique des arts et de la curiosité* 9 (3 Mar.).

L. G. [?]
1877 "Le Salon des 'impressionnistes.'" *La Presse*, 6 Apr.

LACAMBRE, G.
1988 *See* Paris and Tokyo 1988.

LA FARE
1882 "Exposition des impressionnistes." *Le Gaulois*, 2 Mar.

LAFENESTRE, G.
1877 "Le Jour et la nuit." *Le Moniteur universel*, 8 Apr. Partially repr. in "Les Impressionnistes," *La Petite Presse*, 9 Apr., unsigned.
1879 "Les Expositions d'art—les indépendans [sic] et les aquarellistes." *La Revue des deux mondes*, 15 May.

LAGRANGE, L.
1860 "Du Rang des femmes dans les arts." *Gazette des beaux-arts.*

LANCELOT
1880 "Echos de partout." *La Liberté*, 3 Apr.

LE PICHON, Y.
1983 *Les Peintres du bonheur.* Paris.

LEPELLETIER, E.
1877 "Les Impressionnistes." *Le Radical*, 8 Apr. Repr. and trans. in Varnedoe 1987.

LEROY, L.
1879 "Beaux-Arts." *Le Charivari*, 17 Apr. Repr. and trans. in Varnedoe 1987.
1882 "Exposition des impressionnistes." *Le Charivari*, 17 Mar. Repr. and trans. in Varnedoe 1987.

LE SPHINX [PSEUD.]
1880 "Echos de Paris." *L'Evénement*, 5 Apr.

LEUDE, J. DE LA
1879 "Les Ratés de la peinture (les indépendants)." *La Plume*, 1 May.

LLOYD, C.
1988 "An Unknown Sketchbook by Gustave Caillebotte." *Master Drawings* 26, 2 (summer).

LORA, L. DE [FOURCAUD, L. DE]
1877 "L'Exposition des impressionnistes." *Le Gaulois*, 10 Apr. Repr. and trans. in Varnedoe 1987.
1879 "Exposition des artistes indépendants." *Les Beaux-Arts illustrés.*

LOSTALOT, A. DE
1876a "L'Exposition de la rue Le Peletier." *La Chronique des arts et de la curiosité*, 1 Apr.
1876b "L'Exposition des 'impressionnistes.'" *Le Bien Public*, 4 Apr.

LUXENBERG, A. L.
1991 "Léon Bonnat (1833–1922)." Ph.D. diss., The University of Michigan, Ann Arbor.

MAILLARD, G.
1876 "Chronique: les impressionnalistes." *Le Pays*, 4 Apr.
1877 "Chronique: les impressionnistes." *Le Pays*, 9 Apr.

MAINARDI, P.
1993 *The End of the Salon: Art and the State in the Early Third Republic.* Cambridge, Eng.

MALLARMÉ, S.
1876 "The Impressionists and Edouard Manet." *The Art Monthly Review and Photographic Portfolio* 1, 9 (30 Sept.).

1981 H. Mondor and L. J. Austin, eds. *Correspondance*. Paris.

MANCINO, L.
1877 "La Descente de la Courtille." *L'Art* 9.

MANTZ, P.
1877 "L'Exposition des peintres impressionnistes." *Le Temps*, 22 Apr. Repr. and trans. in Varnedoe 1987.
1880 "Exposition des oeuvres des artistes indépendants." *Le Temps*, 14 Apr.

MARTELLI, D.
1879 "Gli impressionisti, mostra del 1879." *Roma artistica*, 27 June and 5 July. Repr. and trans. in Varnedoe 1987.

MCMULLEN, R.
1984 *Degas: His Life, Time and Work.* Boston.

MONT, E. DE
1880 "Cinquième exposition des impressionnistes, 10 rue des Pyramides." *La Civilisation*, 20 Apr.

MONTJOYEUX [POIGNARD, J.]
1879 "Chroniques parisiennes: les indépendants." *Le Gaulois*, 18 Apr. Repr. and trans. in Varnedoe 1987.

N. [?]
1879 "Exposition des artistes indépendants, avenue de l'Opéra." *Le Journal des arts*, 9 May.

NASH, S.
1984 *Bonnard: the Late Paintings.* Exh. cat. Washington, D.C., The Phillips Collection.

NIVELLE, J. DE [CANIVET, C.]
1882 "Les Peintres indépendants." *Le Soleil*, 4 Mar. Repr. and trans. in Varnedoe 1987.

NOCHLIN, L.
1971 *Realism.* New York.

NORD, P. G.
1986 *Paris Shopkeepers and the Politics of Resentment.* Princeton, N.J.

OLBY, G. D'
1876 "Salon de 1876: avant l'ouverture, exposition des intransigeants chez M. Durand-Ruel, rue Le Peletier, 11." *Le Pays*, 10 Apr.

PERROT, M., ed.
1990 *A History of Private Life.* Vol. 4, *From the Fires of Revolution to the Great War.* Cambridge, Mass.

PICKVANCE, R.
1986 "Contemporary Popularity and Posthumous Neglect." In San Francisco 1986.

PICON, G., AND J. P. BOUILLON, eds.
1974 Emile Zola. *Le Bon Combat. De Courbet aux impressionnistes.* Paris.

PILLSBURY, E., AND W. B. JORDAN
1985 "Recent Painting Acquisitions, II: The Kimbell Art Museum." *Burlington Magazine* 127, 987 (June).

PINCUS-WITTEN, R.
1968 "A Caillebotte Exhibition at Wildenstein." *Artforum*, Nov.

PISSARRO, L. R., AND L. VENTURI

1939 *Camille Pissarro, son art, son oeuvre.* Paris.

PITTALUGA, M., AND E. PICENI

1963 *De Nittis.* Milan.

POLETNICH, ERNEST CHARLES [OFFICE OF C. DIDIER, G. OURY, H. LEBARON, L. THEZE, P. NARBEY, NOTARIES, SUCCESSORS OF Mᴱ POLETNICH]

1878a "Récolement des meubles, objets, effets mobiliers dépendant originairement de la succession de M. Martial Caillebotte." 27 Nov. Minutier Central, Archives Nationales, Paris.

1878b "Liquidation et partage des successions de M. et Mme Martial Caillebotte et de M. René Caillebotte." 11 Dec. Minutier Central, Archives Nationales, Paris.

1879 "Cahier des charges pour la vente d'un hôtel sis à Paris appartenant à Messieurs Caillebotte." 3 Feb. Minutier Central, Archives Nationales, Paris.

1894a "Inventaire après décès de M. Gustave Caillebotte." 8 Mar. Minutier Central, Archives Nationales, Paris.

1894b "L'Acte de liquidation et partage de la succession de M. Gustave Caillebotte." 17 May. Minutier Central, Archives Nationales, Paris.

POLLOCK, G.

1988 "Modernity and the Spaces of Feminity." *Vision and Difference: Feminity, Feminism and the History of Art.* London and New York.

POPOVITCH, O.

1967 *Catalogue des peintures du musée des Beaux-Arts de Rouen.* Rouen.

PORCHERON, E.

1876 "Promenade d'un flâneur—Les Impressionnistes." *Le Soleil,* 4 Apr. Repr. and trans. in Varnedoe 1987.

POTHEY, A.

1876 "Chronique." *La Presse,* 31 Mar.

QUIQUERÉ, G.

1993 In Bachelard 1993.

RAND, H.

1987 *Manet's Contemplation at the Gare Saint-Lazare.* Berkeley.

REFF, T.

1980 "Cézanne's Cardplayers and their Sources." *Arts Magazine,* Nov.

1987 *Degas: the Artist's Mind,* Cambridge, Mass., and London.

RENOIR, E.

1879 "Les Impressionnistes." *La Presse,* 11 Apr.

1880 "Exposition des impressionnistes." *La Presse,* 9 Apr. Repr. and trans. in Varnedoe 1987.

REWALD, J.

1973 *History of Impressionism.* 4th ed. New York.

RHEIMS, M.

1973 *Musées de France.* Paris.

RIVIÈRE, G.

1876 "Les Intransigeants de la peinture."

L'Esprit moderne, 13 Apr. Repr. in Dax 1876; repr. and trans. in Varnedoe 1987.

1877a "L'Exposition des impressionnistes." *L'Impressionniste,* 14 Apr. Repr. and trans. in Varnedoe 1987.

1877b *L'Artiste,* 1 Nov.

1921 *Renoir et ses amis.* Paris.

RIVIÈRE, H.

1882 "Aux Indépendants." *Le Chat noir,* 8 Apr. Repr. and trans. in Varnedoe 1987.

ROBERTS, K.

1966 "Current and Forthcoming Exhibitions." *Burlington Magazine* 108, 760 (July).

ROQUEBERT, A.

1991–92 In *Toulouse-Lautrec.* Exh. cat. Hayward Gallery, London; Grand Palais, Paris.

ROSENBLUM, R.

1977 "Gustave Caillebotte: the 1970s and the 1870s." *Artforum,* Mar.

1989 *Paintings in the Musée d'Orsay.* New York.

ROUART, D., AND D. WILDENSTEIN

1975 *Edouard Manet, catalogue raisonné.* Vol. 1, *Peintures.* Geneva.

RUSSELL, J.

1966 "Art News from London: The Perception of Caillebotte." *Art News* 65, 5 (Sept.).

SALLANCHES, A.

1882 "L'Exposition des artistes indépendants." *Le Journal des arts,* 3 Mar. Repr. and trans. in Varnedoe 1987.

SCHARF, A.

1968 *Art and Photography.* London.

SÉBILLOT, P.

1877 "Exposition des impressionnistes." *Le Bien Public,* 7 Apr. Repr. and trans. in Varnedoe 1987.

1879 "Revue artistique." *La Plume,* 15 May.

SERRET, G., AND D. FABIANI

1971 *Catalogue raisonné de l'oeuvre peint d'Armand Guillaumin.* Paris.

SERTAT, R. [PSEUD.]

1894 "Le Legs et l'exposition rétrospective." *La Revue encyclopédique,* 15 Dec.

SILVERMAN, D. L.

1989 *Art Nouveau in Fin de Siècle France: Politics, Psychology and Style.* Berkeley, Los Angeles, and London.

SILVESTRE, A.

1876 "Exposition de la rue Le Peletier." *L'Opinion nationale,* 2 Apr.

1879 "Les Expositions des aquarellistes, des indépendants." *L'Estafette,* 16 Apr. Trans. in San Francisco 1986.

1880 "Le Monde des arts: exposition de la rue des Pyramides (premier article)." *La Vie moderne,* 24 Apr. Repr. and trans. in Varnedoe 1987.

1882 "Le Monde des arts. Expositions particulières. Septième exposition des artistes indépendants." *La Vie moderne,* 11 Mar.

STERLING, C., AND H. ADHÉMAR

1958 *La Peinture au musée du Louvre. Ecole française de XIXᵉ siècle,* vol. 1. Paris.

STUCKEY, C. F., AND W. P. SCOTT

1987 *Berthe Morisot, Impressionist.* New York.

SUTTON, D.

1966 See London 1966.

SYÈNE, F. C. DE [HOUSSAYE, A.]

1879 "Salon de 1879." *L'Artiste,* May.

THÉMINES, M. DE

1880 "Causerie. Beaux-Arts. Les Artistes indépendants." *La Patrie,* 7 Apr.

THIÉBAULT-SISSON, F.

1894 "L'Exposition Caillebotte." *Le Temps,* 7 June.

THOMSON, R.

1982 "'Les Quat' Pattes: The Image of the Dog in Late 19th-Century French Art." *Art History* 5, 3 (Sept.).

1984 "Toulouse-Lautrec and Sculpture." *Gazette des beaux-arts,* Feb.

TOUT-PARIS [PSEUD.]

1880a "La Journée parisienne: impressions d'un impressionniste." *Le Gaulois,* 24 Jan. Partially repr. in "Les Impressionnistes." *L'Artiste,* Feb. Unsigned.

1880b "La Journée parisienne: les impressionnistes." *Le Gaulois,* 2 Apr.

TRIANON, H.

1880 "Cinquième Exposition par un groupe d'artistes indépendants (10, rue des Pyramides)." *Le Constitutionnel,* 8 Apr.

TUCKER, P. H.

1982 *Monet at Argenteuil.* New Haven and London.

UN DOMINO [WALTER, J.]

1879 "Echos de Paris," *Le Gaulois,* 10 Apr.

UN PASSANT [PSEUD.]

1880 "Les On-dit." *Le Rappel,* 3 Apr.

VACHON, M.

1880 "Les Artistes indépendants." *La France,* 3 Apr.

VAISSE, P.

1983 "L'Affaire Caillebotte n'a pas eu lieu." *Le Figaro,* 12 Jan.

VAISSE, P., AND M. BERHAUT

1983 Dossier on the Caillebotte bequest. *Bulletin de la Société de l'art français* (actually publ. in 1985).

VAN GOGH, V.

1991 *The Complete Letters of Vincent van Gogh.* 2d ed. Boston.

VARNEDOE, J. K. T.

1974 "Caillebotte's Pont de l'Europe: A New Slant." *Art International* 28, 4 (20 Apr.).

1976 "Gustave Caillebotte in Context." *Arts Magazine* 50, 9 (May).

1979–80 "In Detail: Gustave Caillebotte's *The Streets of Paris on a Rainy Day.*" *Portfolio* 1, 5 (Dec.–Jan.).

1987 *Gustave Caillebotte.* New Haven and London.

VASSY, G.

1877 "La Journée à Paris: l'exposition des impressionnalistes." *L'Evénement,* 6 Apr. Unsigned.

1882 "L'Actualité: les peintres impression-nistes." *Gil Blas*, 2 Mar.

VENTURI, L.

1936 *Cézanne, son art, son oeuvre*. Paris.

VÉRON, E.

1880 "Cinquième Exposition des indépen-dants." *L'Art* 21. Repr. and trans. in Varnedoe 1987.

VOLLARD, A.

1924 *Paul Cézanne*. Rev. ed. Paris.

WARD, M.

1991 "Impressionist Installations and Pri-vate Exhibitions." *Art Bulletin* 73, 4 (Dec.).

WEISBERG, G.

1980 *The Drawings and Water Colors of Léon Bonvin*. Exh. cat. Cleveland Museum of Art.

1980 *The Realist Tradition: French Painting and Drawing 1830–1900*. Exh. cat. Cleveland Museum of Art.

1992 *Beyond Impressionism, the Naturalist Impulse*. New York.

WERENSKIOLD, E.

1917 "Impressionisterne." In *Kunst, Kamp, Kultur*. Christiana. Originally publ. in 1882.

WERNER, A.

1968 "Caillebotte: a Rediscovery." *Arts Maga-zine* 45 (Sept.).

WHITE, B.

1984 *Renoir, His Life, Art, and Letters*. New York.

WILDENSTEIN, D.

1974 *Claude Monet. Biographie et catalogue raisonné*. Vol. 1, *1840–1881*. Lausanne.

1979 *Claude Monet. Biographie et catalogue raisonné*. Vol. 2, *1882–1886*, and vol. 3, *1887–1898*. Lausanne.

1985 *Claude Monet. Biographie et catalogue raisonné*. Vol. 4, *1899–1926*. Lausanne.

1991 *Claude Monet. Biographie et catalogue raisonné*. Vol. 5, *Supplement aux peintures, dessins, pastels, index*. Lausanne.

WILDENSTEIN, G.

1964 *Catalogue: Gauguin*. Paris.

WITTMER, P.

1990 *Caillebotte au jardin, la période d'Yer-res (1860–1879)*. Pref. by B. Lorenceau. St.-Rémy-en-l'Eau. English ed., *Caillebotte and the Garden at Yerres*. New York, 1991.

WOLFF, A.

1876 "Le Calendrier parisien." *Le Figaro*, 3 Apr.

1879 "Les Indépendants." *Le Figaro*, 11 Apr.

1882 "Quelques Expositions." *Le Figaro*, 2 Mar.

WOLFF, J.

1985 "The Invisible *Flâneuse*: Woman and the Literature of Modernity." *Theory, Culture and Society* 2, 3 (winter).

ZOLA, E.

1876a "Lettre de Paris." *Le Sémaphore de Marseille*, 30 Apr.–1 May.

1876b "Lettre de Paris, deux expositions d'art en mai." *Le Messager de l'Europe*, June. Partially repr. in the preceding issue, in Russian. Repr. and trans. in Varnedoe 1987.

1877 "Notes parisiennes—Une Exposition: les peintres impressionnistes." *Le Sémaphore de Marseille*, 19 Apr. Repr. and trans. in Varnedoe 1987.

1880 "Le Naturalisme au Salon." *Le Voltaire*, 19 June. Repr. and trans. in Varnedoe 1987.

1991 *Ecrits sur l'art*. Paris.

AMSTERDAM 1966
Galerie E. J. van Wisselingh. *Maîtres français du XIX^e et XX^e siècle.*

ANN ARBOR 1979–80
The University of Michigan Museum of Art. *The Crisis of Impressionism 1878–82.* Org. by J. Isaacson.

ANNECY 1964
Palais de l'Isle. *Maîtres inconnus et méconnus, de Montmartre à Montparnasse.*

BORDEAUX 1974
Musée des Beaux-Arts. *Naissance de l'Impressionnisme.*

BRUNOY 1987
Musée de Brunoy. *Gustave Caillebotte, un peintre dans son jardin.*

BRUSSELS 1888
Musées Royaux des Beaux-Arts. *Exposition des XX.*

CHARTRES 1965
Musée de Chartres. *Caillebotte et ses amis impressionnistes.* Preface by G. Besson.

DAYTON 1960
Dayton Art Institute. *French Paintings 1789–1929 from the Collection of Walter P. Chrysler, Jr.*

GENEVA 1965
Musée Rath. *Peintres de Montmartre à Montparnasse, de Renoir à Valtat.*

GENEVA 1968
Musée du Petit Palais. *L'Aube du XX^e siècle, de Renoir à Chagall.*

GENEVA 1974
Musée du Petit Palais. *Centenaire de l'Impressionnisme et hommage à Guillaumin.*

HOUSTON AND BROOKLYN 1976–77
The Museum of Fine Arts and The Brooklyn Museum. *Gustave Caillebotte. A Retrospective Exhibition.* Org. by T. Lee and J. K. T. Varnedoe; texts by J. K. T. Varnedoe, M. Berhaut, P. Galassi, and H. Faberman.

LONDON 1954
Marlborough Gallery. *French Masters of the XIXth and the XXth Centuries.*

LONDON 1966
Wildenstein & Co., Ltd. *Gustave Caillebotte, 1848–1894. A Loan Exhibition in aid of the Hertford British Hospital in Paris.* Preface by D. Wildenstein; text by D. Sutton.

LOS ANGELES ET AL. 1984–85
Los Angeles County Museum of Art, The Art Institute of Chicago, and Paris, Grand Palais. *A Day in the Country.*

MARCQ-EN-BAROEUL 1982–83
Fondation Septentrion. *Gustave Caillebotte.*

MINNEAPOLIS 1969
The Minneapolis Institute of Arts. *The Past Rediscovered: French Painting 1800–1900.*

NEW YORK 1886
American Art Gallery and The National Academy of Design. *Works in Oil and Pastel by the Impressionists of Paris.* Org. by Galerie Durand-Ruel.

NEW YORK 1968
Wildenstein and Co. *A Loan Exhibition of Paintings, Gustave Caillebotte.*

PARIS 1876
Galerie Durand-Ruel, 11, rue Le Peletier. *Catalogue de la 2^e exposition de peinture par MM. Béliard, Legros. . . .*

PARIS 1877
6, rue Le Peletier. *Catalogue de la 3^e exposition de peinture par MM. Caillebotte, Cals. . . .*

PARIS 1879
228, avenue de l'Opéra. *Catalogue de la 4^e exposition de peinture par M. Bracquemond, Mme Bracquemond. . . .*

PARIS 1880
10, rue des Pyramides. *Catalogue de la 5^e exposition de peinture par M. Bracquemond, Mme Bracquemond. . . .*

PARIS 1882
25, rue Saint-Honoré (salons of the Panorama of Reischoffen). *Catalogue de la 7^e exposition des artistes indépendants.*

PARIS 1888
Galerie Durand-Ruel, 11, rue Le Peletier. *Peintres impressionnistes et post-impressionnistes.*

PARIS 1894
Galerie Durand-Ruel. *Exposition rétrospective d'oeuvres de Gustave Caillebotte.*

PARIS 1921
Salon d'automne. *Rétrospective Gustave Caillebotte.* Text by A. Tabarant, after an article in the *Bulletin de la vie artistique,* 1 Aug.

PARIS 1949
Galerie André Maurice. *Impressionnistes méconnus.*

PARIS 1951
Galerie Beaux-Arts. *Rétrospective Gustave Caillebotte.*

PARIS 1957
Musée Jacquemart-André. *Le Second Empire.*

PARIS 1965
Palais Galliéra. *60 Maîtres, de Montmartre à Montparnasse.*

PARIS 1972
Galerie Schmit. *Les Impressionnistes et leurs précurseurs.*

PARIS 1974a
Galerie Durand-Ruel. *Cent Ans d'Impressionnisme.*

PARIS 1974b
Grand Palais, Paris, and New York, The Metropolitan Museum of Art. *Centenaire de l'Impressionnisme.*

PARIS 1989
Galerie Brame et Lorenceau. *Gustave Caillebotte—Dessins, études, peintures.* Preface and text by P. Wittmer.

PARIS AND TOKYO 1988
Grand Palais, Paris, and Tokyo, National Museum of Western Art. *Le Japonisme.*

PONTOISE 1984
Musée Pissarro. *Gustave Caillebotte.* Texts by M. Berhaut, J. Chardeau, and E. Maillet.

PORTLAND ET AL. 1956
Portland Art Museum; Seattle Art Museum; San Francisco, California Palace of the Legion of Honor; Los Angeles County Museum of Art; The Minneapolis Institute of Arts; The Saint Louis Art Museum; Kansas City, William Rockhill Nelson Gallery of Art; The Detroit Institute of Arts; Boston, Museum of Fine Arts. *Paintings from the Collection of Walter P. Chrysler, Jr.*

SAN FRANCISCO 1986
The Fine Arts Museums of San Francisco and Washington, D.C., National Gallery of Art. *The New Painting. Impressionism 1874–1886.* Org. by Charles S. Moffett.

YERRES 1987
Salle Andre Malraux. *Gustave Caillebotte au temps de l'Yerres.* Preface by J. Gautier.

PHOTOGRAPHY CREDITS

Note: All photographs of works of art in the collections of The Art Institute of Chicago illustrated in this catalogue are © The Art Institute of Chicago. All other photography credits are listed below, including material supplied by other institutions, agencies, or individual photographers. Wherever possible, photographs have been credited to the original photographers, regardless of the source of the photograph.

Front cover: Department of Imaging and Technical Services, The Art Institute of Chicago.

Frontispiece: Courtesy Brame and Lorenceau, Paris.

Page 17: Musée d'Orsay, Archives Photographiques.

INTRODUCTION

Fig. 1: Photo from Berhaut 1978, p. 8. Figs. 2–5, 7, 8, 10, 11: Musée d'Orsay, Archives Photographiques. Fig. 6: © Agence photographique de la Réunion des Musées Nationaux, Paris (hereafter referred to as Photo R.M.N.). Fig. 9: Photo from Berhaut 1978, p. 15.

CHAPTER 1

Cats. 1, 3, 4, 6–10, 13–15; cat. 3, figs. 1, 2: © Photo R.M.N. Cat. 1, fig. 1: Photo courtesy Musée Goupil, Bordeaux. Cats. 2, 5: © Photo R.M.N. (H. Lewandowski). Cats. 11, 12: © Musées de Pontoise. Cat. 15, fig. 1: Arthur Lénars & Cie. Cat. 15, fig. 2: Photo from Chardeau 1989, p. 56.

CHAPTER 2

Fig. 1: Mairie d'Yerres, Stéphane Melard. Fig. 2: Photo courtesy Durand-Ruel, Paris. Fig. 3; cat. 18, fig. 1; cat. 19, fig. 2; cats. 23, 26: © Photo R.M.N. Fig. 4: Musée d'Orsay, Archives Photographiques. Fig. 5: The Cleveland Museum of Art. Cat. 16: Indiana University Art Museum, Bloomington (Michael Cavanagh and Kevin Montagne). Cats. 17, 20, 22, 27: © Photo R.M.N. (G. Blot). Cats. 18, 21, 24: © Photo R.M.N. (H. Lewandowski). Cat. 19: Musée Baron Gérard, Bayeux. Cat. 19, fig. 1: The Museum of Fine Arts, Houston. Cat. 20, fig. 2: Konstmuseum, Göteborg. Cat. 23, fig. 2: All rights reserved, The Metropolitan Museum of Art, New York. Cat. 25: Milwaukee Art Museum. Cat. 27, fig. 1: Lauros Giraudon. Cat. 28: Musée des Beaux-Arts, Rennes (Louis Deschamps).

CHAPTER 3

Figs. 1, 6: © Cliché photothèque des Musées de la Ville de Paris, SPADEM. Figs. 2, 3, 8; cats. 40, 41, 43–45, 47–53, 55–58: © Photo R.M.N. Fig. 4: Nasjonalgalleriet, Oslo (J. Lathion). Figs. 5, 7; cat. 29, fig. 3: The Newberry Library, Chicago. Fig. 9: Philadelphia Museum of Art. Fig. 10: Northwestern University Library, Evanston. Fig. 11: Photo from San Francisco 1986, p. 97. Fig. 12: Photo from Dini and Marini 1990, no. 538. Fig. 13: Albright-Knox Art Gallery, Buffalo. Fig. 14: Photo from Berhaut 1978, no. 40. Cat. 29: Musée du Petit Palais, Geneva. Cat. 29, fig. 1: Dini and Marini 1990, no. 699. Cat. 29, fig. 2: Photo courtesy Sotheby's, New York. Cats. 30, 38: © Photo R.M.N. (P. Bernard). Cat. 30, fig. 1: Musée des Beaux-Arts, Rennes. Cat. 30,

fig. 2: Photo from Berhaut 1978, no. 43. Cat. 31: Kimbell Art Museum, Fort Worth. Cat. 31, fig. 1: © 1994 National Gallery of Art, Washington, D.C. Cats. 32, 34, 42: © Photo R.M.N. (H. Lewandowski). Cat. 33: © Photo R.M.N. (D. Arnaudet). Cat. 35: The Art Institute of Chicago. Cat. 36: Musée Marmottan, Paris. Cat. 37: Studio Lourmel 77. Cat. 39: Photo courtesy Kirk Varnedoe. Cats. 46, 54: Courtesy Brame and Lorenceau, Paris.

CHAPTER 4

Fig. 1: Courtesy Fitzwilliam Museum, Cambridge. Fig. 2: Nelson-Atkins Museum of Fine Arts, Kansas City. Fig. 3; cat. 63, fig. 3: Courtesy Walters Art Gallery, Baltimore. Figs. 4, 11: Nationalgalerie, Staatliche Museen Preussischer Kulturbesitz, Berlin. Fig. 8; cats. 60, 64; cat. 62, fig. 1; cat. 70, fig. 1: © Photo R.M.N. Fig. 9: The Art Institute of Chicago. Fig. 10: The Museum of Modern Art, New York. Cat. 60, fig. 1: Société Française de Photographie, Paris. Cat. 60, fig. 2: Nationalgalerie, Staatliche Museen Preussischer Kulturbesitz, Berlin (Jörg P. Anders). Cats. 61, 63, 68, 70: © Photo R.M.N. (H. Lewandowski). Cat. 63, fig. 2: All rights reserved, The Metropolitan Museum of Art, New York. Cat. 63, fig. 4: © Cliché photothèque des Musées de la Ville de Paris, SPADEM. Cat. 64, fig. 1: Photo State Pushkin Museum of Fine Arts, Moscow. Cat. 65: © Photo R.M.N. (G. Blot). Cat. 65, fig. 1; cat. 67, figs. 2, 3: Nasjonalgalleriet, Oslo (J. Lathion). Cat. 66, fig. 2: © Ashmolean Museum, Oxford. Cat. 68, fig. 1: Pinacoteca Communale, Barletta. Cat. 69: © Photo R.M.N. (D. Arnaudet). Cat. 69, fig. 1: Musée Marmottan, Paris.

CHAPTER 5

Fig. 1: Photo from Berhaut 1978, p. 9. Fig. 2: Photo from Wittmer 1990, p. 204. Fig. 3: Courtesy Art Gallery of Ontario, Toronto (Carlo Catenazzi). Fig. 4: Glasgow Museums and Art Galleries, Scotland. Fig. 5: National Gallery of Scotland, Edinburgh. Fig. 6: Photo from Berhaut 1978, no. 55. Fig. 7: The Nelson-Atkins Museum of Art, Kansas City. Fig. 9: Museum of Art, Rhode Island School of Design, Providence. Fig. 10: Nasjonalgalleriet, Oslo (J. Lathion). Fig. 11: Joslyn Art Museum, Omaha (Paul Macapia). Fig. 12: Fundación Colección Thyssen-Bornemisza, Madrid. All rights reserved. Fig. 13: Ny Carlsberg Glyptotek, Copenhagen. Fig. 14; cat. 71, fig 1: The Art Institute of Chicago. Cats. 71, 74, 75, 79, 80: © Photo R.M.N. (G. Blot). Cats. 72, 84, 89; cat. 76, fig. 1; cat. 81, fig. 1: © Photo R.M.N. Cat. 72, fig. 1: Photo from Chardeau 1989, p. 34. Cats. 73, 77, 87: © Photo R.M.N. (H. Lewandowski). Cat. 74, fig. 2: Musée Fabre, Montpellier (Frédéric Jaulmes). Cat. 75, fig. 1: Bardazzi Fotografia. Cat. 76: Seattle Art Museum. Cat. 78, fig. 1: Photo from Varnedoe 1987, no. 37. Cat. 81: Musée Marmottan, Paris. Cat. 82: The Minneapolis Institute of Arts. Cat. 82, fig. 1: © Cliché du Musée des Beaux-Arts, Bordeaux. Cat. 82, fig. 2: Photo from Varnedoe 1987, no. 5. Cats. 83, 85, 86: Courtesy Josefowitz Collection. Cat. 84, fig. 1: Photo from Berhaut 1994, p. 41. Cat. 88: © Photo R.M.N. (D. Arnaudet).

CHAPTER 6

Fig. 1: The Art Institute of Chicago. Fig. 2: Courtesy Barbara Guggenheim. Fig. 3: Yale University Art Gallery, New Haven. Fig. 4: Photo from Isetan Museum of Art, Shinjuku, *Edouard Manet* exh. cat. (Japan, 1986), no. 22. Fig. 5: Photo from Berhaut 1978, no. 208. Fig. 6: © Cliché photothèque des Musées de la Ville de Paris, SPADEM. Fig. 7: Photo from Weisberg 1980, no. 196. Fig. 8: © Cliché du Musée des Beaux-Arts, Bordeaux. Fig. 9: The Newberry Library, Chicago. Cat. 90: © Photo R.M.N. (D. Arnaudet). Cat. 90, fig. 1: Courtesy Sotheby's, New York. Cats. 91, 92: Courtesy Josefowitz Collection. Cat. 93: Courtesy Museum of Fine Arts, Boston. Cat. 94; cat. 95, fig. 1: © Photo R.M.N. Cats. 95, 96: © Photo R.M.N. (G. Blot). Cat. 95, fig. 2: National Gallery, London. Cat. 96, fig. 1: The National Gallery of Ireland, Dublin. Cat. 97: © Photo R.M.N. (H. Lewandowski).

CHAPTER 7

Fig. 2: Courtesy Museum of Fine Arts, Boston. Cat. 98: © Photo R.M.N. (G. Blot). Cat. 99: © Photo R.M.N. (H. Lewandowski). Cat. 99, fig. 1: Courtesy Enschédé Collection, United States. Cat. 100: © Photo R.M.N. Cat. 100, fig. 1: Musée du Petit Palais, Geneva. Cat. 101: Courtesy Montgomery Gallery/Kemper Corporation. Cat. 101, fig. 1: The Toledo Museum of Art.

CHAPTER 8

Figs. 3–10: Musée d'Orsay, Archives Photographiques. Fig. 11: The Art Institute of Chicago. Fig. 12: © 1994 National Gallery of Art, Washington, D.C. Cats. 102, 104, 108, 111, 112: © Photo R.M.N. (H. Lewandowski). Cats. 103, 109; cat. 104, fig. 1; cat. 110, fig. 2: © Photo R.M.N. Cats. 105, 106: Courtesy Josefowitz Collection. Cat. 106, fig. 1: Bayerische Staatsgemäldesammlungen, Munich. Cat. 107: © Photo R.M.N. (G. Blot). Cat. 107, fig. 1: Courtesy Indiana University Art Museum, Bloomington. Cat. 110: Rheinisches Bildarchiv, Cologne.

CHAPTER 9

Fig. 1: Musée d'Orsay, Archives Photographiques. Cats. 113, 116: Courtesy Josefowitz Collection. Cat. 114: Musée Marmottan, Paris. Cat. 114, fig. 1: Courtesy Achim Moeller Fine Arts, New York. Cats. 115, 117: © Photo R.M.N. (H. Lewandowski). Cat. 117, fig. 1: Courtesy Kirk Varnedoe. Cat. 117, fig. 2: Courtesy Durand-Ruel Archives, Paris.

APPENDIX III

Figs. 1–3, 5, 6, 8, 10–17, 20–24, 27, 30, 31, 36, 38, 39–41, 46, 49–54, 57–65: © Photo R.M.N. Fig. 4: © The Barnes Foundation, Merion, Penn. Fig. 7: © 1994 National Gallery of Art, Washington, D.C. Fig. 9: All rights reserved, The Metropolitan Museum of Art, New York. Figs. 18, 19, 26, 28, 29, 32–35: Courtesy Archives Wildenstein Institute, New York. Fig. 25: Niedersächsisches Landesmuseum, Hannover. Figs. 37, 42, 44, 45, 47, 48: Pissarro and Venturi 1939, nos. 123, 455, 282, 371, 406, 350, respectively.